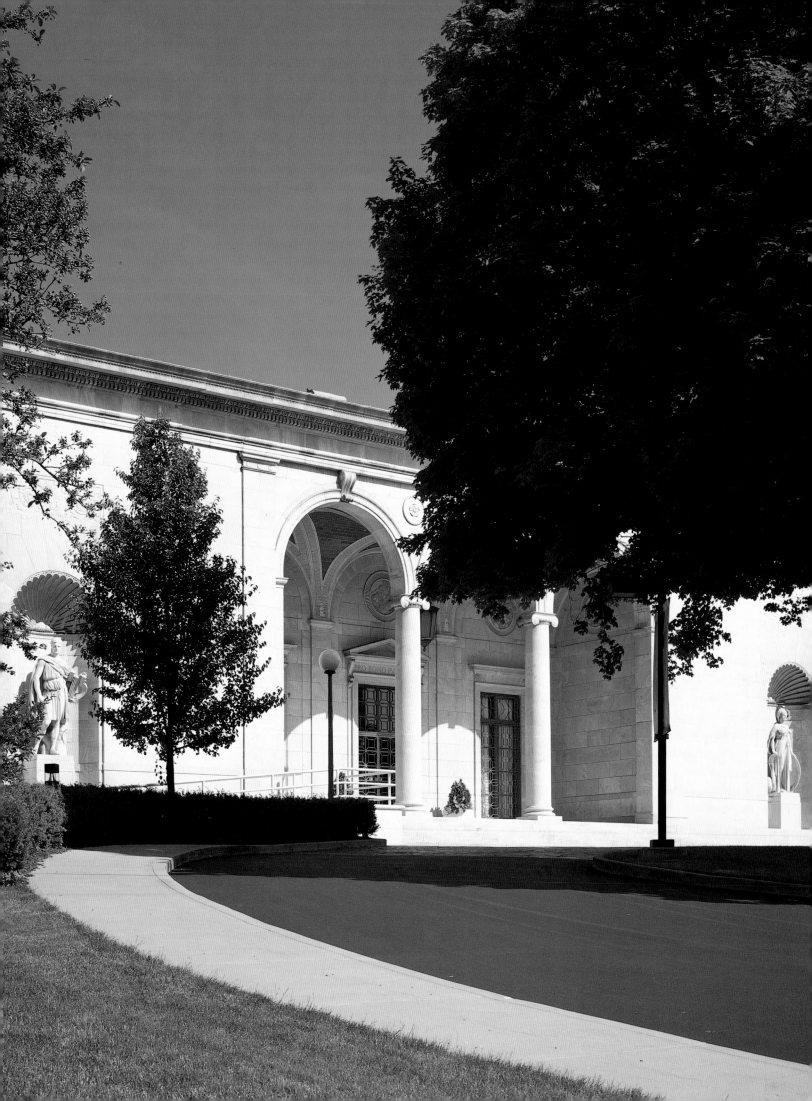

MASTER PAINTINGS

FROM
THE BUTLER INSTITUTE
OF
AMERICAN ART

EDITED BY IRENE S. SWEETKIND

CONSULTING EDITOR
WILLIAM H. GERDTS
Professor of Art History
The City University of New York

INTRODUCTION
BARBARA NOVAK

CONSULTING EDITOR
LOUIS A. ZONA
Director of the Institute

ASSISTANT EDITOR
M. MELISSA WOLFE

HARRY N. ABRAMS, INC., PUBLISHERS
in association with
THE BUTLER INSTITUTE OF AMERICAN ART

PROJECT MANAGER: *Joan Siebert*
EDITOR: *Elaine M. Stainton*
DESIGNER: *Judith Michael*

Page 2
The Butler Institute of American Art, designed by McKim, Mead and White, 1919

Page 7
Ivan Olinsky, *Portrait of Joseph G. Butler, Jr.,* 1920, oil on canvas, 51 × 41″ (129.54 × 104.14 cm.), signed, upper right, gift of Jonathan Warner, 920-O-108

Page 8
ABOVE: The West Wing, designed by Buchanan, Ricciuti and Balog, 1987, including the Burger Gallery, the Sidney Moyer Sculpture Area, and the Cynthia R. DeBartolo Gallery
BELOW: The Watson Gallery, designed by Paul Boucherle, 1931

Page 12
The Cushwa and Watson Galleries, designed by Paul Boucherle, 1931

All color photography by Dennis Ryan, The Art Farm, except for Eastman, Rondel, Inness, Melchers, Grosz, and Humphrey by The Butler Institute of American Art.

Research and publication of *Master Paintings from The Butler Institute of American Art* has been partially funded by Drs. Paul and Laura Mesaros, Mrs. Anne K. Christman and grants from the Ohio Arts Council and the National Endowment for the Arts.

LIBRARY OF CONGRESS CATALOGING-IN-PUBLICATION DATA

Butler Institute of American Art.
Master paintings from the Butler Institute of American Art / edited by Irene S. Sweetkind ; consulting editors, William H. Gerdts, Louis A. Zona ; assistant editor, M. Melissa Wolfe.
p. cm.
"In association with the Butler Institute of American Art."
Includes index.
ISBN 0-8109-3643-7 (Abrams: cloth) / ISBN 0-8109-2598-2 (Mus: pbk)
1. Painting, American—Catalogs. 2. Painting—Ohio—Youngstown—Catalogs. 3. Butler Institute of American Art—Catalogs.
I. Sweetkind, Irene S. II. Gerdts, William H. III. Zona, Louis A. IV. Title.
ND205.B83 1994
759.13′074′77139—dc20 94–2871

Published in 1994 by Harry N. Abrams, Incorporated, New York
A Times Mirror Company

Printed and bound in Japan

CONTENTS

CONTRIBUTORS

Henry Adams
Dore Ashton
Peter Bermingham
Doreen Bolger
H. Daniel Butts, III
Bruce Chambers
Nicolai Cikovsky, Jr.
Judy Collischan
Elizabeth Jane Connell
Richard Cox
Stephanie D'Alessandro
Carl David
Lauretta Dimmick
David C. Driskell
James H. Duff
Dorinda Evans
Barbara Dayer Gallati
William H. Gerdts
Kathleen Gibbons

Robert Godfrey
Alfred C. Harrison, Jr.
Eleanor Jones Harvey
Gerrit Henry
Patricia Hills
Tom E. Hinson
Robert Hobbs
Martha J. Hoppin
Sam Hunter
Anthony F. Janson
Sona K. Johnston
Mitchell D. Kahan
Joseph Keiffer
James Keny
Robert Kurtz
Ellen Lee
Valerie Ann Leeds
Diane Lesko
Gail Levin

Karl Lunde
Nannette V. Maciejunes
Mary Alice MacKay
Nancy Malloy
Patricia C.F. Mandel
Nancy Mowll Mathews
Sally Mills
Sarah J. Moore
Harold A. Nelson
Barbara Novak
Edward J. Nygren
Kate Nearpass Ogden
Marlene Park
Sharon F. Patton
James Pernotto
Joyce Petschek
Ronald G. Pisano
Dean A. Porter
Robert Rosenblum

Irving Sandler
Julie Schimmel
David L. Shirey
Linda Crocker Simmons
Clyde Singer
Gail Stavitsky
Judith Stein
David Steinberg
Diana Strazdes
Daniel Strong
Irene S. Sweetkind
William S. Talbot
Sue Taylor
Mark Thistlethwaite
James Thompson
John Wilmerding
M. Melissa Wolfe
Howard E. Wooden
Louis A. Zona

PREFACE

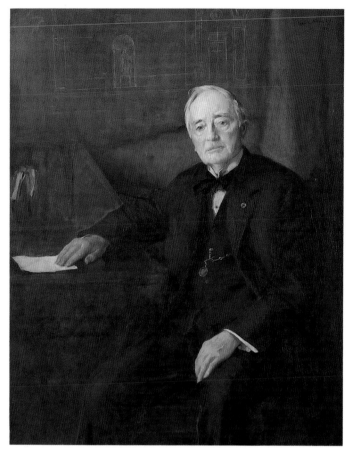

JOSEPH G. BUTLER, JR.

The publication of this catalog represents an important milestone in the history of The Butler Institute of American Art. This long awaited effort provides scholarly recognition to one of the premier American art collections and celebrates the seventy-fifth anniversary of the distinguished institution which houses it. This publication serves to salute not only a remarkable collection, but also recognizes the unique level of connoisseurship which brought it into being.

Joseph G. Butler, Jr. was indeed a visionary who believed in American art when few others thought it important. The heart and soul of this collection remains structured upon the masterworks which he acquired. His personality continues to be reflected in the collection's great strengths, particularly the Western works, marine canvases, and select genre pieces such as his beloved *Snap the Whip* by Winslow Homer. The reach of the founder's dream in 1919 extends to the twenty-first century, and assuredly beyond, as the Institution which bears his name and the collection which he created continues to grow. This catalog also pays tribute to Joseph G. Butler, III, grandson of the founder, who guided the Institute as its director for over five decades. It was he who

capably and dramatically built upon his grandfather's work, acquiring outstanding examples of American art, adding breadth and depth to an already fine collection. Joseph G. Butler, III became recognized nationally for his accomplishments as a collector as the permanent collection of the Butler grew in stature as well as size. Through difficult economic times he persevered and focused on his task of including only the best possible examples by the greatest artists.

What is perhaps most remarkable about the achievements of both men is that neither were formally educated in the arts. They approached the task of collecting armed only with a motivation to own the very best and an eye to meet that challenge.

For the last fifty years, the eye, mind, and hand of Clyde Singer has made a monumental impact on the Butler and its collection. Serving as Curator and Associate Director, Mr. Singer has overseen much of the collection's expansion, providing both the scholarly base and the studio-trained eye to the museum's acquisition program. His work and aesthetic sensibilities are also paid tribute here and it is he to whom we dedicate this volume.

LOUIS A. ZONA

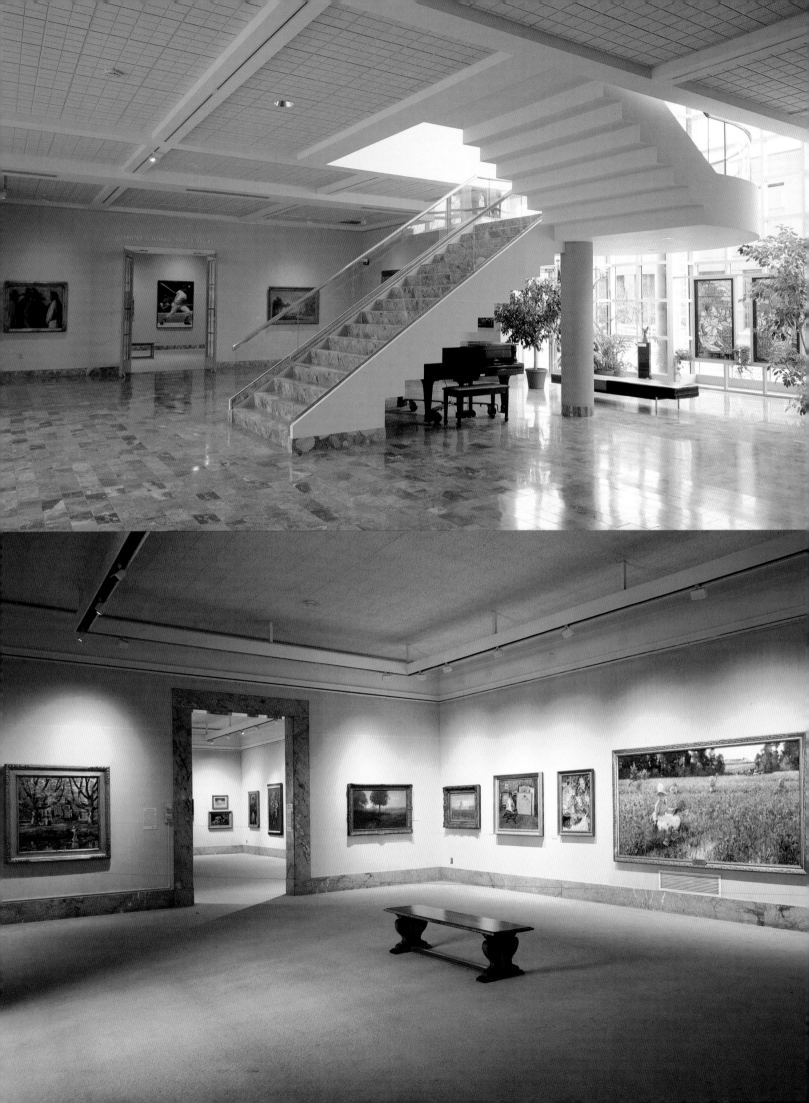

A HISTORY OF
THE BUTLER INSTITUTE
OF AMERICAN ART

Joseph G. Butler, Jr. (1860–1927), a successful Youngstown industrialist, hired the architectural firm of McKim, Mead and White in 1917 to design a building to house his collection of American art. Butler, who began collecting art in his early twenties, stated, "In erecting this building and organizing the Butler Art Institute, I have sought to provide for the people of this city an opportunity to enjoy the best work of American artists . . . and have limited the canvases permanently hung in its galleries to those by American painters." Mr. Butler's first collection, which included European as well as American works, was destroyed in a fire that enveloped the third-floor gallery of his home. The second collection assembled by Butler between 1917 and 1919 was conditioned by his interest in trends and styles in American art. The Inaugural Exhibition in the classic Italian Renaissance-Revival building included pieces that today still attest to Mr. Butler's aesthetic acumen: *Snap the Whip, Roadside Meeting, Red and Gold, Fiesta Day, In Flanders Field,* and *Twilight.*

1919 The Institute's Articles of Incorporation are finalized and the Institute is chartered by the State of Ohio with a self-perpetuating Board of Trustees. Margaret Evans appointed as Director.

1927 Henry Audubon Butler assumes the Presidency of the Board upon the death of Joseph G. Butler, Jr.

1931 The original building designed by McKim, Mead and White is expanded with the addition of two lower level wings.

1934 Upon the death of Henry A. Butler, Joseph G. Butler, III assumes the duties of Director.

1935 The Institute inaugurates The Annual New Year Exhibition, a juried exhibition.

1942 The Institute initiates public membership and encourages volunteer efforts.

1951 The Annual New Year Exhibition is expanded to include nation-wide entrants and becomes the National Midyear Exhibition.

1952 The Institute's original galleries are renovated and second floor galleries over the original structure are created.

1965 The Education Department is established.

1967 The McKim, Mead and White structure is placed on the National Register of Historic Places.

1968 The Institute is expanded with the addition of second floors to the 1931 wings.

1979 *The Index of the Permanent Collection* and *Selections from the Permanent Collection of the Butler Institute of American Art* are published.

1981 Joseph G. Butler, III dies. Louis A. Zona is appointed Director.

1983 The Institute completes the installation of a comprehensive climate control system.

1985 A Capital Campaign is launched to fund the physical expansion of the Institute.

1987 The West Wing addition is completed, doubling the size of the Institute to 72,000 square feet. The Hopper Research Library, Sweeney Children's Gallery, Donnell Gallery of Sports Art, and Beecher Court are opened.

1989 The Institute receives professional accreditation from the American Association of Museums. The Mesaros Print Gallery, to house the Institute's collection of over 5,000 prints and drawings, is completed and opened.

1990 Renovation of the three second-floor front galleries of the original building is completed.

1991 The Institute opens a branch museum in Salem, Ohio.

1993 The outdoor Sculpture Garden and Plaza are completed. Renovation of the south second-floor 1968 gallery is completed.

1994 The Butler Institute of American Art celebrates its seventy-fifth anniversary with the publication of its first scholarly catalog.

ACKNOWLEDGMENTS

The publication of *Master Paintings from The Butler Institute of American Art* celebrates the seventy-fifth anniversary of the founding of the Institute. During those seventy-five years the collection has grown from just over two hundred works to more than 11,500 paintings, watercolors, prints, drawings, sculpture, and ceramics. In choosing the works to be included in this volume the Institute strove to offer both a comprehensive view of American art and substantial, well-known and occasionally less well-known, works held in the collection. In selecting authors for the essays, the Institute sought a balance between known authorities and rising young scholars. We are particularly appreciative of the seventy-five authors, who, through their research, were able to widen our knowledge of the collection and establish a foundation for further scholarship. The Institute is indebted to Barbara Novak for her unwavering support and friendship. The Institute especially appreciates the invaluable assistance and scholarly expertise of the publication's Consulting Editor, William H. Gerdts.

No acknowledgment to those who assisted in the preparation of this volume would be complete without thanking the Director of the Institute, Dr. Louis A. Zona. He provided guidance, encouragement, and knowledge from the initial planning stages through the completion of the publication.

Any publication of this magnitude requires a substantial amount of financial support. The Butler Institute of American Art offers a special thanks to the many artists, national and local, who donated their work for the "Great American Art Auction." The successful organization, publicity, and presentation of the auction was the result of the dedicated work of Barbara Heimann, Chairwoman of the Art Auction Committee, and her committee members. To the committee and the generous people attending, the Institute owes a debt of gratitude.

The publication of the permanent collection catalog would not have been possible without the assistance of the National Endowment for the Arts and the Ohio Arts Council for the research and documentation of the collection. Also, the Institute greatly appreciates the support it received from Drs. Paul and Laura Mesaros and Mrs. Anne K. Christman.

In recognizing those who were instrumental in preparing this publication, tremendous thanks goes to M. Melissa Wolfe, Assistant Editor, who contributed so much of her time, interest, and enthusiasm to the project. We would like to thank Clyde Singer, Curator of the Permanent Collection, and Margaret Kaulback, Head of the Hopper Research Library and Archives, for sharing their insight and knowledge of the collection and history of the Institute with individual authors and the catalog project staff. Their organization and dissemination of archival material has been invaluable. We also extend our thanks to Martha Menk, David Sweetkind, and Alice Webster for their careful review of the essays. A special thanks is given to Barbara Sollenberger, an Institute volunteer, who generously donated her time and many talents to this project. Ken Platt, Registrar, Raymond Johnson, Preparator, Susan Carfano, Assistant to the Director, Samantha Kimpel, Assistant to the Registrar, Kathryn Earnhart, Information Director, and the entire staff of the Butler Institute deserve credit for their efforts and support of this project. The Institute also thanks Joan Siebert, Elaine Stainton, and Judith Michael of Harry N. Abrams, Inc., whose advice, guidance, and assistance was essential. Finally, the Butler Institute staff thanks the Board of Trustees for their enthusiasm, encouragement, and support over a number of years to the success and completion of this publication. Without their vision and commitment, this Permanent Collection catalog would not be a reality.

IRENE S. SWEETKIND

INTRODUCTION

How the vagrant shower of artworks, perennially produced, eventually come to settle in a formal museum setting is as antic, contradictory and full of colorful eccentricities as human nature itself. But settle they do, some energetically captured and purchased, some politely accepted, some coveted and generously bestowed through bequests and gifts. All artworks—and donors—seeking, it seems, entrance to the spiritual sanctuary that the museum has traditionally been. Traces of nineteenth-century idealism still linger in some museums. If we pay close attention, we may still feel the very faint breath of that yearning for immortality that artworks have exhaled. Immortality of a more definite sort is still embodied in that shift from a surname to an institutional noun, from the secular figure of Joseph Green Butler, Jr., the estimable founder of the Institute that bears his name, to the triumphant insertion of the definite article before the name: the Hirshhorn, the Frick, the Butler. Thus is a man—rarely a woman, it seems—transmuted, as his institution digests his memory and turns it into stone. And in this case, what stone! McKim, Mead and White's architectural graces have permanently endowed the Butler's art with an appropriate interfusion of lightness and *gravitas*.

In these revisionist times, however, artworks, no matter how certain of their own value, stir uneasily on their walls. For connoisseurship and the esthethic—categories with a formidable history and the very criteria of excellence—have been swamped in a radical reversal of how we view the past. Art history now is polemical, passionate and unrelenting in restoring to the art of the past its contexts, its unconscious assumptions, the social agendas it embodies, its attitudes to gender and race. Space itself, or its representation, is no longer an innocent and quasi-mystical substance, but a politicized arena in which the artwork constitutes an action. Thus, the

retrospective eye has negated the transparency of art, turning it into a vast opacity, its canons questioned and revised, its innocence—the famous American innocence—dispersed at last. If, in Jamesian fashion, Americans once doubted their culture, that very doubt, now institutionalized in art history departments and museums, paradoxically confirms its acceptance and value.

The constellation of artworks in a museum, random though it may be in the exigencies of collection, is shot through with vectors of inquiry. A museum catalog, as this one testifies, is no longer simply a celebratory authentication of received positions, but an aggressive representation not of the past to the present, but of the present to the past. Through the mirror of the Butler Institute's collections, we begin to see, dimly, our own face, our concerns, our altered modes of speculation, and thus, by proxy, receive an image of the past, a provisional and contingent picture which we, in turn, will pass on to the future for its criticism, while the artworks in this collection are borne into the future to rendezvous with other succeeding modes of inquiry.

Every art historian knows the pilgrimage to an artwork, however hidden or remote, that he or she must see. A work of the highest quality, however we define it in these relativistic times, is like a magnet. The Butler Institute has its share of magnets: Winslow Homer's magnificent *Snap the Whip*, Fitz Hugh Lane's *Ship Starlight*, Thomas Cole's *Italian Landscape*. The fine works jostle for attention: Church, Kensett, Durand, Bierstadt, Eakins, Ryder, Luks, Burchfield, Hopper. To have conceived such a collection is the great collector's correlative to the artist's vision. What interests me as much in this collection however, are lesser-known works by substantial artists: Arthur Dove's *Ice and Clouds*, Marsden Hartley's *Birds of the Bagaduce*, George Caleb Bingham's *Portrait of James H. Cravens*. And

splendid works by artists less frequently seen, such as Seth Eastman's *Hudson River with a Distant View of West Point* or Robert Vonnoh's *In Flanders Field*. This is one of the most powerful and affecting works in the museum. "In Flanders Fields the poppies blow. . . ." goes the lament for the youth fallen in one of World War I's notorious killing fields. Vonnoh's lament, a blazing field of poppies, is an extraordinary war memorial.

With the appointment of the Butler Institute's fourth director, Louis A. Zona, in 1981, the museum moved firmly into collecting and exhibiting recent and contemporary art. That move has been characterized by an openness and enthusiasm all too rare in the museum community. Thus, in its seventy-fifth anniversary year, the Butler Institute has sketched intelligently its version of the historical past and present. Only the most encyclopedic of museums can present an unbroken tissue of historical continuity. In such museums, the weight of history presses somewhat onerously on its representation and revision of the past. What smaller museums like the Butler Institute can do more easily is to transfuse its collection with the vivid intellectual inquiry that mobilizes artworks out of their inert settings. For whether artworks are documents, historical artifacts, items of commerce, transcendent repositories, or all of these, it is only through such inquiry that history can breathe again in the present. The truest context of art is not its institutional setting, but the tact, sympathy, and intelligence of its curators. That is the real continuity and tradition in which art, always subject to continuous revisions, most truly survives. As this catalog testifies.

BARBARA NOVAK

MASTER PAINTINGS
FROM THE BUTLER INSTITUTE OF AMERICAN ART

NEHEMIAH PARTRIDGE | 1683–c. 1737

Portrait of Catherine Ten Broeck, 1719
Oil on canvas, 32 × 48″ (81.28 × 121.92 cm.)
Unsigned
Gift of Josephine Butler Ford Agler, 977-O-167

Catherine Ten Broeck (1715–1801) has been identified as the subject of the portrait formerly known as *Young Girl With Rose and Bird*,[1] the earliest painting in the Butler Institute's collection. It was presented to the Butler Institute by her great-great-great granddaughter, Josephine Butler Ford Agler, maternal granddaughter of Joseph G. Butler, Jr. The painting descended in the family of the donor's father, Edward L. Ford (1856–1927) of Albany, New York.[2]

The Fords were New Englanders who settled in the upper Hudson Valley of New York during the last quarter of the eighteenth century.[3] By the early 1800s, Thomas Walker Ford (1770/71–1846) was established in Albany as a successful dry goods merchant. On June 10, 1798, Thomas married Catherine Ten Broeck's granddaughter, Renette McCarty Willard (1778/79–1828) of Stillwater, New York. Renette's parents were Elias Willard (1756–1827), a physician from Boston, and Catherine (1755–1827), daughter of John (1709–1791) and Catherine Ten Broeck Livingston. Three sons and two daughters were born to the Thomas Walker Fords including John Willard Ford (1805–1869), an Albany attorney and insurance executive who married Frances Deeming Rudd (1825–1886). Their son Edward, an engineer in the iron and steel industry, moved to Youngstown in the 1880s and married Blanche Butler (1867–1913), the oldest daughter of his employer, Joseph G. Butler, Jr.[4] This brief genealogy traces the provenance of the painting through six generations of the subject's family.

The portrait of Catherine Ten Broeck can be assigned to a body of work attributed by Mary Black to Nehemiah Partridge (1683–c. 1737), an itinerant portrait painter from New Hampshire, who began his career about 1713 in Boston as a japanner and purveyor of art supplies.[5] Later he moved to New York and, in 1718, was entered in the city's registry of freemen as a limner. That same year Partridge accepted a portrait commission in Albany, where he remained for about three years, painting over fifty portraits, twenty-five of which are marked with his distinctive red "Aetats Sua" inscription, recording the age of the sitter and the year the painting was completed. Catherine's portrait, inscribed: "Aetats Sua/3 years/1719" reflects Partridge's style of quick, prominent brush strokes with a palette of black, brown, blue, and rust. The sketchily painted background, her stiff and formal pose, based on a mezzotint source, and the unusual method of depicting the sitter's eyes as slightly narrowed by a faint smile, are all techniques associated with Partridge's work.[6] The artist painted at least six other Ten Broeck family members during his Albany sojourn, including Catherine's sister Christina (1720, Collection of Albany Institute of History and Art) and father Dirck Wessels Ten Broeck (c. 1720, private collection). Dirck, a characteristic Partridge patron, was a prominent Albany citizen and member of a notable Dutch family.[7]

Catherine, the eldest child of Margarita Cuyler (1692–1783) and Dirck Wessels Ten Broeck (1686–1751), was born September 1, 1715 in Albany. At the age of twenty-four she married John Livingston, son of Margarita Schuyler (1682–?) and Robert Livingston (c. 1683–1725).[8] Her husband's great uncle, Robert Livingston (1654–1728), Lord of Livingston Manor and one of the richest and most politically powerful men in New York, also posed for Partridge (1718, private collection).[9] Catherine's husband was engaged in trade between New York City and Montreal, Canada. At least three of the couple's children were baptized in New York and the same number were married in Montreal. At the outbreak of the American Revolution, the Livingstons returned to Stillwater, New York, where each had inherited portions of the Saratoga Patent. Upon John's death in 1791, Catherine moved back to Albany, where she died at the home of her daughter on April 6, 1801.[10]

MARY ALICE MACKAY

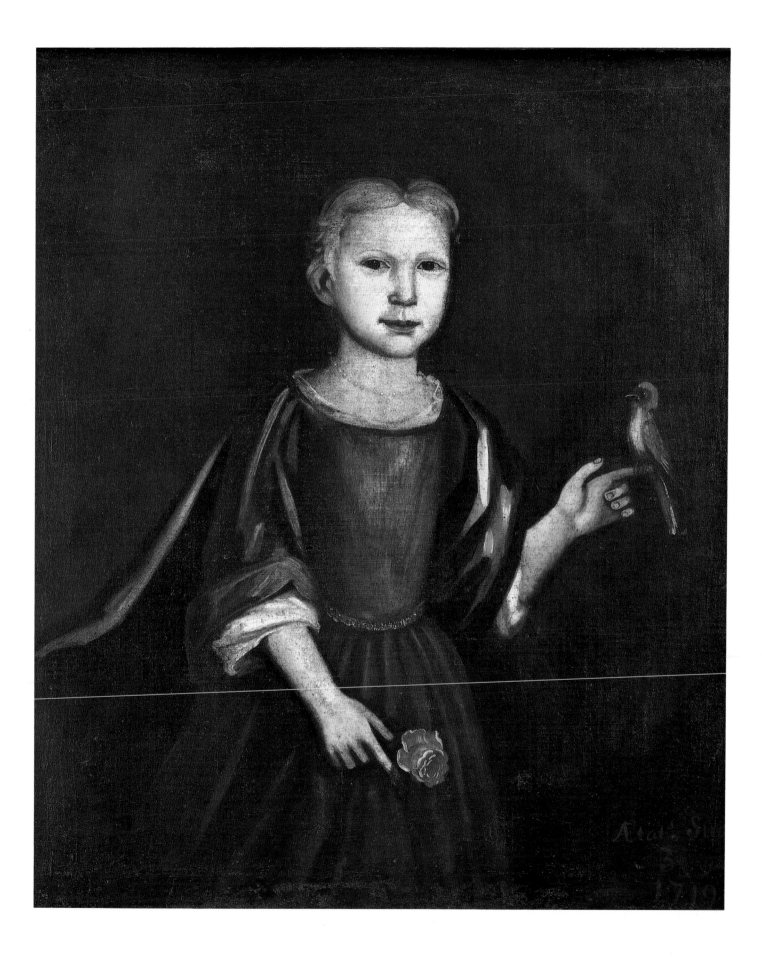

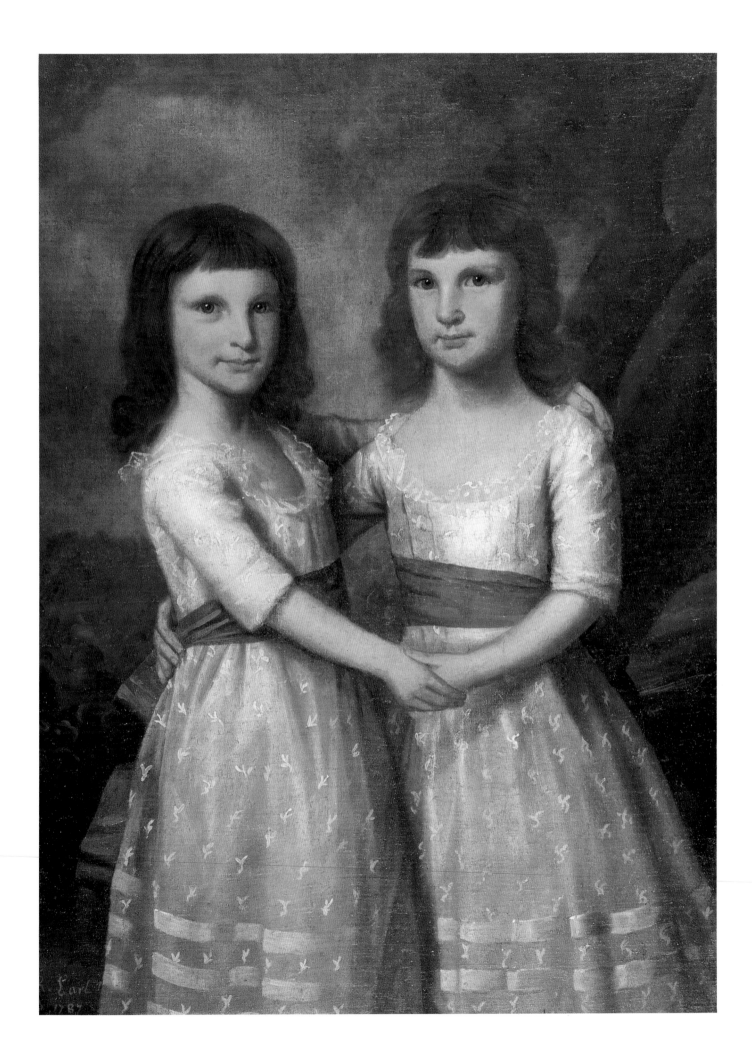

RALPH EARL | 1751–1801

The Striker Sisters, 1787
Oil on canvas, 37×27″ (93.98×68.58 cm.)
Signed, lower left
Museum purchase, 950-O-102

Although designated on his birth certificate as "Earll" and born to parents who wrote their name "Earle," the painter and his artist-brother James always signed their name "Earl." Ralph Earl was a contradictory artist. Like John Singleton Copley, the most important influence on his work, the self-taught Earl created a personal portrait vision which developed the limner tradition by incorporating sophisticated effects of texture and reflection without sacrificing its strength of shape and pattern. He was also a Tory who, before and after he fled to England, was one of the most important chroniclers of the young Republic. Earl's portrait masterpiece *Roger Sherman* (c. 1775, Yale University Art Gallery) depicts one of the original signers of the Declaration of Independence. In the same year, his four views of the Battles of Lexington and Concord became perhaps the first historical landscapes in America. Earl, a Loyalist, departed for England in 1778, fearing for his personal safety. In London he associated with Benjamin West, although never officially becoming West's pupil. Earl returned to America—on the same boat as John Trumbull—in May, 1785. After spending almost a year and a half in debtor's prison in New York, Earl regained his status as the most prominent Connecticut painter of the Revolutionists.

The Striker Sisters is one of about twenty known works painted while Earl was in debtor's prison. From September, 1786, until his release on January 29, 1788, he resided in New York's City Hall jail. What might have been a nightmarish episode was first alleviated and later ended by the passage of An Act for the Relief of Insolvent Debtors, April 13, 1786, and the formation of a Society for the Relief of Distressed Debtors, January, 1787.[1] Members of this society sent their wives, children, and friends to be painted by the prisoner, thus furnishing him with the means to secure release. Earl's most famous sitter during his confinement was Elizabeth Schuyler, daughter of one of George Washington's generals and wife of Alexander Hamilton. While incarcerated, Earl also painted many of the presiding officers from his trial.

Once mistakenly identified as twins, Ann, age six, on the left, and Winifred, age five,[2] were the daughters of James and Mary Hopper Striker, who owned a farm at Striker's Bay, what is now 52nd Street and the Hudson River.[3] Earl occupies an important place in the early development of American landscapes, both for individual topographical images[4] and for the rich backgrounds of many of his portraits. Showing minimal foliage, the background of *The Striker Sisters* is, for Earl, uncharacteristically bleak and barren, almost a metaphor of his own situation. Nevertheless, the rocky buildup on the right necessarily balances out the suggestive leftward lean of the principal figures, which follows the syncopated sequencing of their blue sashes.

The Striker Sisters demonstrates that, in contrast to Copley, Earl never exchanged his characteristic polished awkwardness for a broader European fluency during his English sojourn. Delicately poised like a dance team, the Striker sisters show a touching closeness, especially in light of their mother's premature death one year earlier. The only other double child portrait of Earl's showing such an intimate pair is *David and Sarah Hubbell* (1787, private collection, Long Island). As with many of Earl's subjects, the Striker sisters manifest several arresting and distinctive irregularities. Their front hands, which meet in the middle of the picture, are actually painted smaller than the further ones which frame their embrace. The quirky characterization of the sisters, with their flattened heads, short fringes, and feral eyes, gives the work a strongly expressive quality. As usual, Earl has wrapped his eccentric depiction of physiognomy and personality in impressive effects of painterly virtuosity, such as the pink silk slips that show through the gauzy white embroidered exterior of the sisters' dresses.

JAMES THOMPSON

JOSEPH BADGER | 1708–1765

Portrait of Mr. Daniel Rea, c. 1757
Oil on canvas, 49 × 39″ (124.46 × 99.06 cm.)
Unsigned
Museum purchase, 947-O-101

This portrait by Joseph Badger is one of a pair of paintings that unassumingly marks a turning point in American painting, one not particularly beneficial to the artist. Painted when Badger was forty-nine, the portrait serves as a pendant to one of Rea's wife painted at the same time by John Singleton Copley. The execution of pendant portraits by different artists is unusual but, in this case, functions on two levels: in practical terms to show a man proudly presenting his family to the viewer, and on an historical level to represent the moment of transition from the older Badger to Copley, the young genius who, only nineteen years of age in 1757, dominated American portraiture in the 1760s and early 1770s.

Badger rose to prominence following the retirement in 1746 of James Smibert, the most accomplished portraitist in Boston. Largely self-taught, Badger forged a career as an artist by painting houses, signs, and heraldic devices as well as portraits that captured a facial likeness of the sitter but relied heavily on European conventions for representation of the human figure. *Portrait of Mr. Daniel Rea* is typical of Badger's conservative style: dark in tone and of predominantly cool colors, it shows Rea standing before a mountainous landscape varied only by a few feathery trees. Rea stands out from the background by virtue of the sky, which brightens to form an aura around him and sets off the bold, undulating contour of his left sleeve. Looking at the viewer, as Badger's sitters often did, Rea's rigid stance emphasizes the presentational gesture of his left hand. Found in many English portraits of the seventeenth and eighteenth centuries, this gesture is often used as a rhetorical device or to direct the viewer to symbols of the sitter's authority—scholarly materials, military accessories, or, as in this case, a wife and child represented in a portrait that would hang next to it. Such austere formality could also be found in the work of Badger's contemporaries Robert Feke and Joseph Blackburn, who, like Badger, filled the void left by Smibert but were effectively surpassed by Copley's transformation of Boston portrait painting between the late 1750s and his departure for England in 1774. Relinquishing the sober aspects of his predecessors, Copley exploited the richness of fabric and varieties of texture to animate the surface of his pictures, replacing Badger's upright postures with more relaxed poses, and his oratorical gestures with expressions that alluded less to the material world than to the interior realm of the spirit.

Badger's association with Daniel Rea, a Boston tailor, can be dated to June 22, 1752, when an entry in Rea's surviving record books credits the artist with painting "a Pitcher" for Rea in payment for "a Hatt and sundrys."[1] Little such evidence of Badger's activity has been uncovered, and because he did not sign any of his pictures, the reconstruction of his oeuvre has depended on attributions made by the artist's few scholars.[2] The portrait of Mrs. Rea was once included among his work, but scientific examination has supported its attribution to Copley.[3] As such, the two portraits provide a telling representation of the generational and stylistic shift that precipitated the success of Copley and, with it, the first great age of American art.

DANIEL STRONG

18

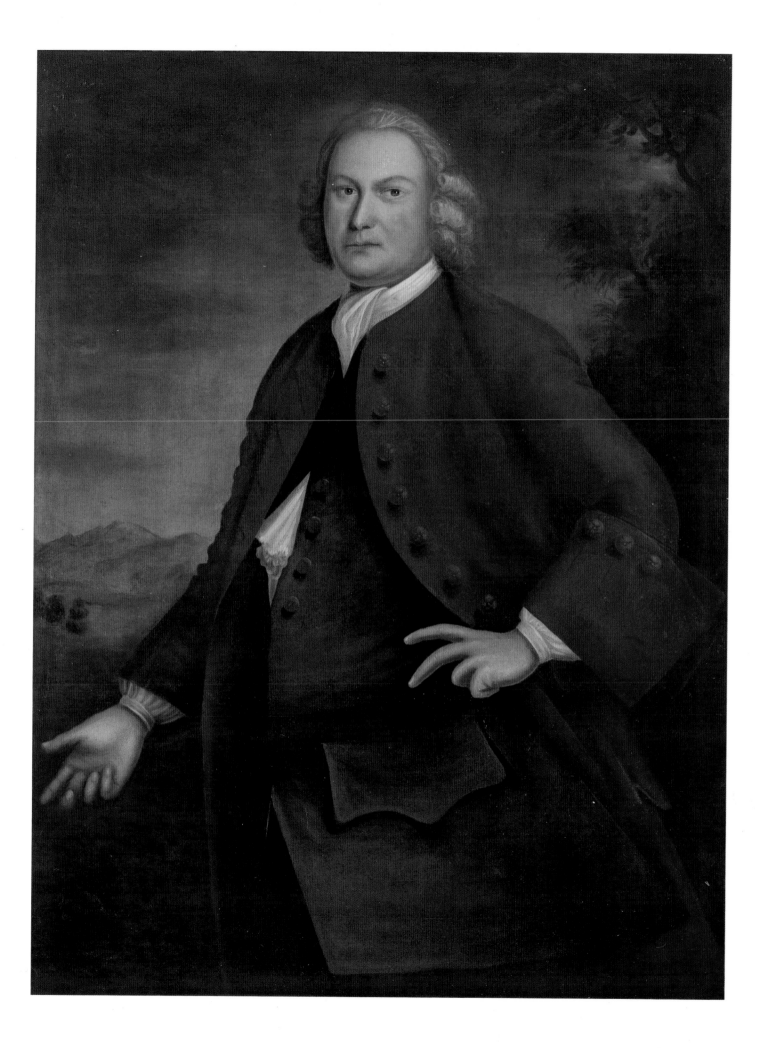

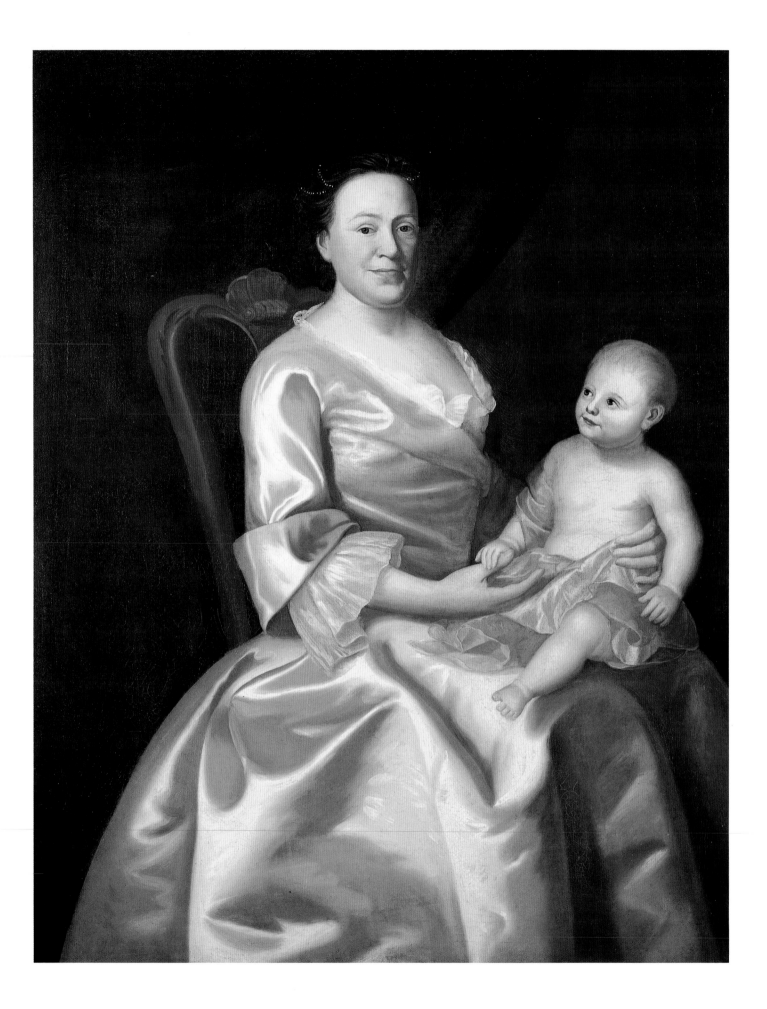

JOHN SINGLETON COPLEY | 1737–1815

Mrs. Daniel Rea and Child, 1757
Oil on canvas, 49 × 39″ (124.50 × 99.10 cm.)
Unsigned
Museum purchase, 947-O-103

Along with his friend and some-time rival Benjamin West, John Singleton Copley was the first native-born American painter to achieve fame at home and abroad. Born on Boston's Long Wharf, Copley was instructed in art by his stepfather Peter Pelham, a mezzotint engraver and portrait painter. Copley also learned from the paintings of Joseph Blackburn and Robert Feke, but he was, to an extraordinary degree, self-taught. Like West, Copley aspired from the start to be a history painter, but was forced to find his principal livelihood in portraits. Copley's likenesses perfected a style that gave special attention to technical dexterity in surfaces—the sparkling sheen of fabric and the detailed reflections of polished furniture, rendered with strong chiaroscuro—yet still probed the inner personalities of the prosperous sitters who commissioned them. Emboldened by the favorable reception in England of *Boy with a Squirrel* (1765, private collection) and by the encouraging words of West, Copley sailed on June 10, 1774 to England, where he would remain for the rest of his life. There he became extremely successful, loosening his brushwork in the bravura Rococo manner favored in Europe. He painted many individual and group portraits and some remarkable, large-scale epic narratives, which introduced modern dress into history painting.

Mrs. Daniel Rea and Child is one of two portraits bought by the Butler Institute from the great-great-great-great grandson of Mr. and Mrs. Rea.[1] The picture of Daniel Rea was done by Joseph Badger. The painting of Mrs. Rea, née Miss Sarah Salter, can be dated to around 1757, since her daughter Elizabeth, who looks little more than a year old, was born in 1756.[2] Whereas Badger was near the end of his artistic life, Copley, at age nineteen, was just beginning his. Thus this portrait becomes a significant document of his remarkable early development.

From the start of his precocious career, Copley demonstrated an aptitude for depicting children. Prior to *Mrs. Daniel Rea and Child,* he had painted *Jonathan Mountfort* (1753, Detroit Institute of Art) and *The Brothers and Sisters of Christopher Gore* (1755, Henry Francis Du Pont Winterthur Museum). A distant but significant precedent for the grouping of Mrs. Rea and Elizabeth can be found in the figures of Bishop Berkeley's wife and child in John Smibert's famous painting of *The Bermuda Group* (1728–29, Yale University Art Gallery), which Copley must have seen in Smibert's Boston studio. In Smibert's composition, the infant is held closer, but the affectionate interaction established between child and mother, repeated in *Mrs. Daniel Rea and Child,* is a quality few other colonial artists managed to capture. Copley's infant is further enlivened by having her delighted gaze aimed towards her mother and her tiny hand playfully grasping her mother's thumb.

This painting evidences the provincial stiffness as well as the strong, stark patterning of the limner tradition from which Copley evolved, coming quite close to the hardness of outline and flatness of modeling seen in the portraits of Joseph Blackburn. Copley went to some pains to demonstrate his youthful virtuosity, particularly in the silvery sheen of Mrs. Rea's white satin dress and the pale pink scarf swaddling her daughter. He was also concerned with capturing his subject; Burroughs called this picture, "a subordination of grace to the necessity for catching the likeness."[3] Documenting the point at which Copley's youthful promise began to evolve into his mature achievement, *Mrs. Daniel Rea and Child* provides a significant early stepping-stone to the masterworks of Copley's long and distinguished career.

JAMES THOMPSON

JACOB EICHHOLTZ | 1776–1842

Eliza Cook, 1816
Oil on canvas, 29¼ × 24″ (74.30 × 60.96 cm.)
Unsigned
Gift of Mrs. William L. Little, 979-O-104

Jacob Eichholtz was a leading portraitist in Pennsylvania during the early nineteenth century, and perhaps the first to be recognized in the periodical press of the young American republic with a biographical sketch.[1] He was born in Lancaster, Pennsylvania, of German heritage, and entered the first class of Franklin College there in 1787. The same year he received lessons in drawing from a sign painter. As early as 1806 he was painting profile portraits, having observed the visiting profile painter William Woolett in Lancaster. In 1808 or more probably 1809, Thomas Sully, at the beginning of his career himself, visited from Philadelphia and offered advice and encouragement to Eichholtz,[2] and about 1811 Eichholtz visited Gilbert Stuart in Boston. But it was probably the wealth of professional portraiture created in a variety of styles to which he was exposed at the annual exhibitions held at the Pennsylvania Academy of the Fine Arts in Philadelphia from 1811 on—where Eichholtz himself exhibited—that accounts for his growing professionalism and sophistication. Though Eichholtz painted in Baltimore in 1820 and again in 1833, and in Pittsburgh in 1834, his career was centered in Lancaster until he moved to Philadelphia about 1823. He was back in Lancaster in 1831 following the death of his mother, though he continued to maintain professional connections in Philadelphia.[3]

The portrait, *Eliza Cook*, was painted in Lancaster in 1816; the subject, who was born in 1791, died in 1817, a year after the picture was painted. In 1814, Eliza Cook married Andrew Boggs, a commissioner of the Lancaster Trading Company who a year later purchased a hotel in the city. In 1816, Eichholtz was commissioned to paint Boggs and his wife for twenty-two pounds, ten shillings; Boggs's portrait is unlocated.[4]

Eliza Cook is depicted in a simple interior, seated in and leaning on the arm of an empire sofa, upholstered in red velvet. She wears a long-sleeved empire dress, with sleeves gathered at the wrists and with a starched, triple-layer pointed ruffled collar. The costume was evidently quite stylish; that same year, Eichholtz painted both *Jane Howell Evans* and *Mrs. George Washington McAllister* (both private collections) in comparable white dresses, while a similar, though not identical collar adorns the neck of his portrait of *Eliza Schaum* (1816, Pennsylvania Academy of the Fine Arts). The majority of Eichholtz's depictions of women of this period also include a fashionable shawl; Eliza Cook's portrait is unusual in the absence of such a motif.

Eliza Cook's likeness reflects the mature ease in portraiture at which Eichholtz had arrived by the mid-1810s. Gone are the pursed mouths and glazed stares that appear in many of his portraits of about 1810 and earlier. Eliza Cook appears quite relaxed and gazes at the viewer in a forthright manner, suggesting intelligence and reserved charm. Her pose is fairly unusual for Eichholtz, with her right arm comfortably resting upon the arm of the sofa, and her left hand covering her right, creating a strong geometric containment for the figure and adding to the appearance of self-possession.

The planes of Eliza Cook's face are smooth and simply outlined. The figure is lighted from the right front, but the illumination plays rather evenly over the face and figure, and shadows are soft. A few years later, Eichholtz turned to more dramatic lighting and stronger modeling. The major influence on him, even in 1816, is unquestionably that of Thomas Sully, who by then had risen to the rank of Philadelphia's premier portraitist; later, particularly after he moved to Philadelphia, Eichholtz would emulate Sully more consciously, seeking a similar romantic grace in his female portraits and more commanding presence in his male likenesses.

Eichholtz was never to achieve the suavity for which Sully was renowned and which his sophisticated urban clientele sought. Perhaps Eichholtz never fully aspired to do so, for his harder likenesses and simpler, plain style may have better suited the traditional, unaffected populace of interior cities such as Lancaster.[5] But many of his Lancaster portraits of the mid-1810s, including that of *Eliza Cook*, rank among his most individual and distinct works.

WILLIAM H. GERDTS

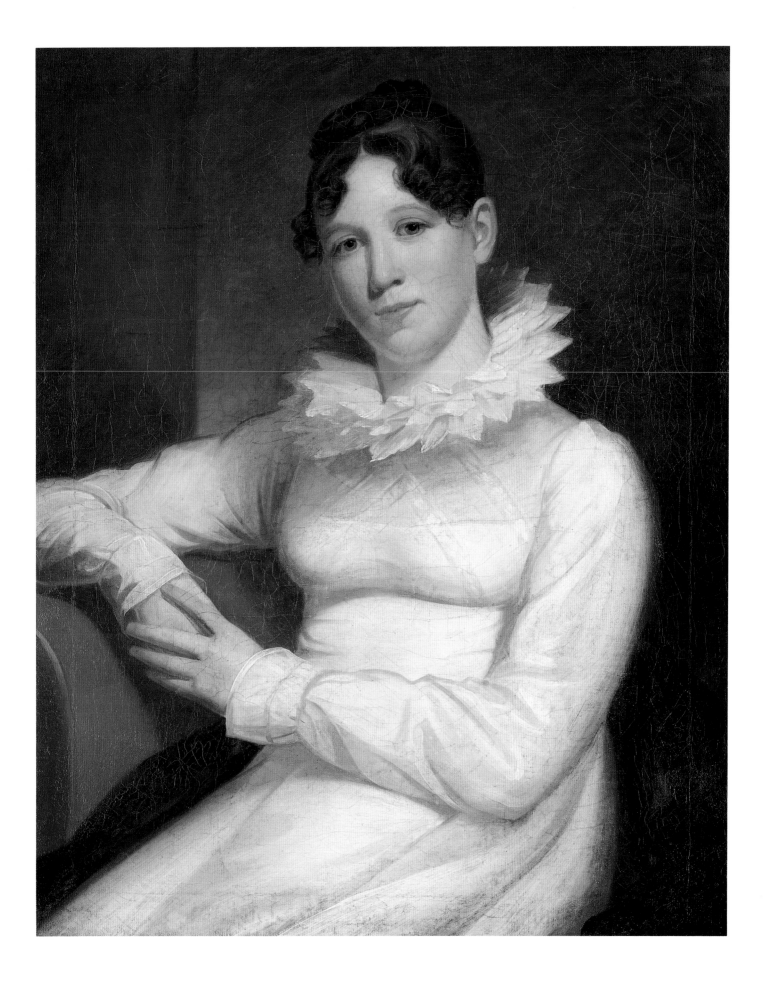

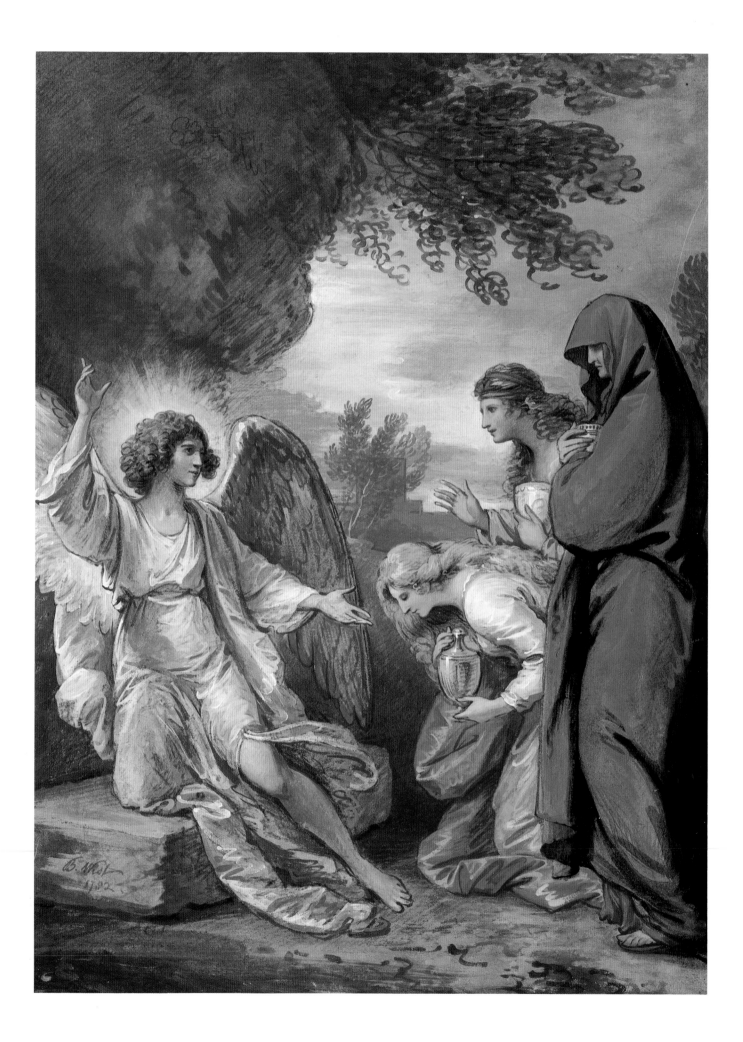

BENJAMIN WEST | 1738–1820

The Sepulchre, 1782
Gouache on paper, 18½ × 14″ (46.99 × 35.56 cm.)
Signed, lower left
Museum purchase, 968-W-122

Pennsylvania-born Benjamin West settled in London in 1763, where he became a key contributor to the establishment of history painting in Britain. From about 1780 on, he also became Britain's most energetic promoter of biblical subjects painted on an epic scale. His most important such commission came from George III in 1779 to furnish paintings for the Royal Chapel at Windsor Castle, "for the purpose of displaying a pictorial illustration of the history of revealed religion."[1] Notable in West's religious subjects after 1779 was his continued depiction of moments of divine revelation. In this West proved England's acknowledged master. The expressive potential of such subjects was obvious; the mystery of Divine power offered the viewer an intensity of emotional experience that subjects from classical history and literature could not match.

The Sepulchre is not a working drawing but a finished composition, which may have served as a presentation to a client for a proposed painting. The drawing illustrates Matthew 28:1–8, in which an angel of the Lord, dressed in a white robe, with a face "like lightning" rolled away the stone of Christ's empty tomb and sat on it before the astonished women who arrived there to anoint Christ's body. West painted the subject of the women at the sepulchre of Christ at least seven times between 1768 and 1818. The first version, dated 1768, does not survive, but an engraving from the work shows an elaborate, dark, vertical composition in a wooded setting, with soldiers by an open tomb entrance along with three women and an angel. The immediate precedent for the Butler Institute's drawing is a large, three-part work that West painted to serve as a design for another royal commission, a stained glass window in a lower chapel at Windsor Castle.[2] The central *Resurrection* (c. 1782, Ponce Museum of Art, Puerto Rico) was paired with two side windows, one of which, *The Three Marys Going to the Sepulchre* (c. 1782, National Trust, Tatton Park, Cheshire), depicted the women described in Luke 24:1–8, who

return to the tomb with spices and ointments at the first sign of dawn. In *The Sepulchre*, West constructed a new picture from elements of his window design. He arranged the three women and a blond-haired angel as in *The Resurrection*, against a landscape background, much like that of his other side picture, *Saints Peter and John Running to the Sepulchre* (c. 1782, location unknown).

The Sepulchre was evidently not made into a large painting. However, in 1792 West painted the women at the tomb again, adapting the composition of the gouache drawing to a horizontal format.[3] Each time he repeated the composition, he made the poses more animated and the scene more dramatic. The angel became progressively more brightly lit and more active, and the work's expressiveness was increasingly concentrated in the figures themselves. West, demonstrating his skill at giving new life to previously used motifs, owed his prolific lifetime production largely to this practice.

The Sepulchre shows West's characteristic tendency to combine Neoclassical elements with the more exuberant motifs of Italian seventeenth-century painting. The revived enthusiasm for classical antiquity to which West was introduced while studying in Rome from 1760–1763 remained part of his style after he settled in London and turned increasingly to subjects outside classical history and literature. Here, a nod to Neoclassical taste can be seen in the firm contours, sharp profiles, silvery palette, and the classical urns and fillet. And, like other artists of his generation, West became interested in the techniques of the Italian seventeenth-century painters, exemplified here by the landscape setting, the brilliant color of Mary Magdalene's orange-yellow dress, and by the radiant angel astride the entrance of the empty tomb. More importantly, the visionary character of Italian art of the Counter Reformation made a lasting impression on West's religious art.[4]

DIANA STRAZDES

GILBERT STUART | 1755–1828

Portrait of Mr. Webb, c. 1787
Oil on canvas, oval, 29 × 24″ (73.66 × 60.96 cm.)
Unsigned
Museum purchase, 921-O-110

This oval portrait is entirely characteristic of work by Gilbert Stuart, although it bears some minor retouching by a later hand.[1] When the Butler Institute purchased the portrait, the sitter was thought to be a Mr. Webb of County Donegal, Ireland. The portrait's earliest known owner, Sir Hugh Lane, a prominent picture collector and dealer, supplied this identification when he brought the picture to the United States, along with several other paintings, probably in April of 1915.[2] On his return trip to England in May of that year, Sir Hugh drowned when the Lusitania was sunk, and the portrait passed, with its present title, from Ehrich Galleries of New York to Vose Galleries of Boston. Since then, the sitter's identity has been questioned by Charles Merrill Mount, who listed the portrait in his 1964 biography of Stuart as "probably" of William Temple Franklin, grandson of Benjamin Franklin.[3]

The costume and hairstyle, fitting for a fashionable gentleman, date from around 1785. If the portrait is of an Irishman, then Stuart painted the picture sometime after his arrival in Ireland in October of 1787 and before his departure for New York in 1793.

The artist had traveled in 1775 from Newport, Rhode Island, to London, at that time the art capital of the English-speaking world, in hopes of improving his artistic ability and his financial prospects. But his success with patrons in England, where his brushwork became freer and his colors more decorative, encouraged him to spend money far beyond his means. For a while he was able to entertain lavishly and keep up a convincing show of living well, as did many of the London artists. Finally, his debts had so accumulated that he had to face arrest or flee his creditors. He chose the latter course and accepted a commission from the Duke of Rutland, Lord Lieutenant of Ireland, to visit him and paint his portrait in Dublin. Stuart's career continued in the same seesaw manner in Ireland, until he left for the United States with the characteristic intention of making a fortune by painting pictures of George Washington.[4]

In the portrait of Mr. Webb, the hand inserted inside the waistcoat is a conventional gesture. Considered appropriate for a gentleman, the pose can be found in eighteenth-century books on deportment designed to teach ladies and gentlemen how to be socially correct in polite society.[5] In this case, the position of the hand suits the oval format. Although Stuart could paint hands and objects as well as most of his contemporaries, his portraits and the testimony of those who knew him indicate that he was primarily interested in the head. Like the English artist Sir Joshua Reynolds, he left the secondary areas in a number of his portraits to be completed by others.

DORINDA EVANS

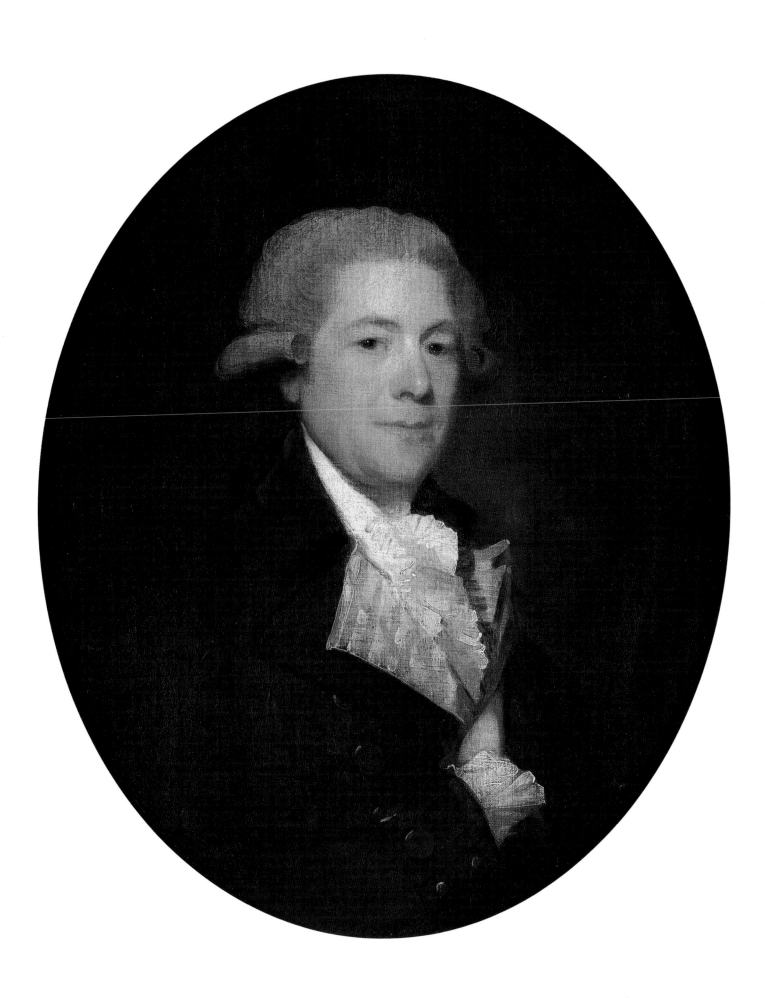

Portraits of Mr. and Mrs. Thomas Russell, c. 1784
Oil on canvas, 30¼ × 25¼" (76.84 × 64.14 cm.)
Unsigned
Museum purchases, 969-O-111 and 969-O-112

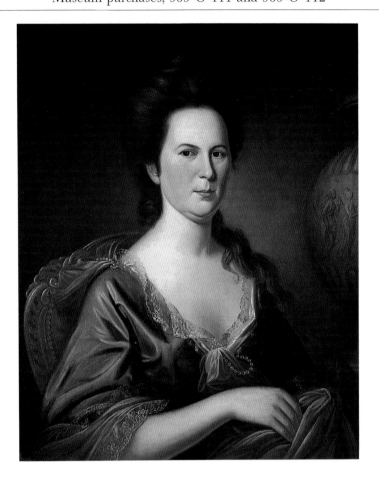

Thomas Russell (1741–1786) ordered two pairs of portraits of himself and his wife, née Ann Thomas (b. 1751), during a trip to Philadelphia from Cecil County, Maryland around 1784.[1] At that time, Peale, his patron's exact contemporary, dominated the local portrait market. Because the Russells enjoyed greater financial and material prosperity in the early 1780s than ever before, they probably intended these commissions to mark their recently-achieved status. The sitters kept the pair painted from life (c. 1784, The Crane Collection, Boston).[2] With both a daughter Frances (b. 1776) and a son Thomas (b. 1779),[3] they could expect their portraits to become heirlooms situating them at the origin of a line of inheritance. Thomas Russell sent the second pair, the Butler Institute's paintings, as gifts to his older brother William in their native Birmingham, England.

These pairs of portraits offer significant evidence about Peale's habits of thought as a painter, for the difference between the gaunt physiognomy of Mr. Russell's life portrait and the oval face of the Butler Institute's replica attests to a penchant for conforming sitters' faces to an ideal geometry. The sentient, sensible faces in all four canvases are typical as well as exemplary of the painter's achievement in portraiture. To the extent that desires to shape reputations often prompt portrait commissions, these paintings include many elements suggestive of how the Russells wanted to be known among their contemporaries. The figures' orientation towards one another and receipt of illumination from the same direction identifies each sitter as one half of a couple joined in wedlock. Even though their wealth was relatively new, the conservative chair forms and the

classicizing vase in Mrs. Russell's portrait suggest the sitters' membership in long-established lines.[4] Depicting neither chair with arms, Peale portrayed Mr. Russell as if resting his left forearm on the painting's edge, a device that institutes a spatial barrier between the viewer and the otherwise

ironworks of the eighteenth century.[7] The brothers inherited their father's financial interests upon his death, with Thomas assuming an active role in the firm. Directing the company's American operations, Thomas first lived in the colonies between 1764 and 1769. Returning in 1771, he gradually alienated

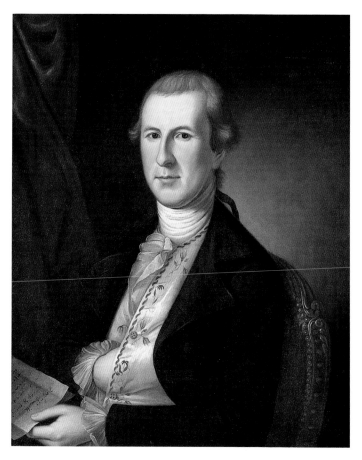

immediately-presented figure. Of Russell's left arm, Peale painted only the bent elbow and waistcoat-inserted hand that, at the time, signified gentlemanly refinement and ease.[5]

When William Russell received his presents around 1784, he beheld effigies of a kinsman whom he had not seen since 1771 and, because Thomas married Ann in 1774, of a sister-in-law whom he had never seen. Only this version of Thomas's portrait bears the inscription "Friend & Brother/W:m Russell" on the unfolded paper at lower left. The painting thus depicts a souvenir of the fraternal bond that the patron intended to affirm with his gift.[6] Because the basis for the wealth enjoyed by Thomas had been laid by his father, the pair of portraits would have probably brought to William's mind memories of the brothers' deceased parents.

In the early 1720s, Thomas Russell, Sr. traveled briefly to the middle colonies to establish iron furnaces for the British-owned Principio Company, one of the earliest and most important American

himself from the British management, probably due to a growing commitment to colonial independence. In 1778 he signed an oath of allegiance to the state of Maryland. By supplying iron for the military needs of the newly-declared states he parlayed his father's holdings into a fortune. In 1781, the Maryland General Assembly confiscated the Principio Company. The subsequent order to sell its considerable holdings distinguished Russell for his loyalty, reserving for his indemnification a portion of the profits to be received from the sale of company lands. Russell received this boon in the form of company buildings, slaves, equipment, and over 6,000 acres, all of which were valued at about £5,550. With the portraits that he gave as gifts, then, Thomas Russell acknowledged in the familial sphere trans-Atlantic ties that had been recently and permanently severed in the realms of both business and politics.

DAVID STEINBERG

REMBRANDT PEALE | 1778–1860

Porthole Portrait of George Washington, 1795
Oil on canvas, 36 × 29″ (91.44 × 73.66 cm.)
Signed, lower left
Museum purchase, 957-O-124

Although known as a member of one of America's most famous artistic families, only recently has Rembrandt Peale emerged from the group as an individual who virtually embodied the industrious, experimental, yet above all fickle age of capitalism in which he lived.[1] Ever seeking imaginative means by which to weave the production and appreciation of art into the fabric of the American democratic enterprise—working in many of America's growing cities and founding a museum to foster national taste—Rembrandt Peale forged a career for himself characterized as much by failure as success. But, whereas such fits and starts were once considered reason to overlook him, the persistence with which he met them is now thought by one scholar to be the quality that makes him "quintessentially American."[2]

Raised in the long shadows of his accomplished artist-father, Charles Willson Peale, and the heroes and statesmen whose portraits lined the walls of his father's gallery, Rembrandt was, in a sense, surrounded by the achievements of past masters. The challenge to distinguish himself as an artist was compounded by a lack of public interest in the arts, his poor business skills, and his desire to depart from the well-trodden path of portrait painting. However, it was as a portraitist that Peale was able to support his large family and combine his high-minded, nationalist ideals with an art that appealed to a large audience. Having first painted George Washington in 1795, and having won acclaim for his *Patriae Pater* (1824, Collection of the United States Senate, Washington, D.C.), Rembrandt stated in the 1850s that his true calling was "to multiply the Countenance of Washington."[3] By his death in 1860 he had done so no less than seventy-nine times, systematically producing simplified versions of the *Patriae Pater* that became known as the porthole portraits, of which the Butler Institute's is one.

Possibly seeking to surpass his father in painting America's great figures, Rembrandt sought to capture the visage of the founding father both for the edification of the public and as the crowning achievement of his career. He perceived himself singularly qualified to paint what he called the "standard likeness" of Washington, writing that, "Among the few persons now living, who can speak of their own impressions . . . concerning the personal appearance of Washington, I may be supposed to have some claim on the confidence of the rising generation—educated to venerate the memory of *him*, who will always be 'first in the hearts of his countrymen.'"[4] Emphasizing the fact that he had painted Washington from life, Rembrandt supported his claim by soliciting testimonials from other men who knew Washington personally and could confirm the accuracy of his portrait. He sought to distinguish himself from other artists who had painted the first president from life,[5] and at last to match the accomplishments of his father, whom he acknowledged as having painted "the *first* portrait of Washington in 1772."[6]

Rembrandt's insistence on the importance of his direct contact with Washington is ironic. With his subject long dead, his *Patriae Pater* and the subsequent porthole portraits were actually composites of his 1795 portrait and others he had admired, such as the famous bust by the French sculptor Jean-Antoine Houdon. Nevertheless, his enterprise was a success, coming at a time of renewed interest in Washington as a national hero. The importance of Rembrandt Peale's icon-making to the evolution of American culture has been confirmed most recently in the potency of 1960s Pop Art images, and by that movement's revelation of our society's ongoing interest in icon creation.

DANIEL STRONG

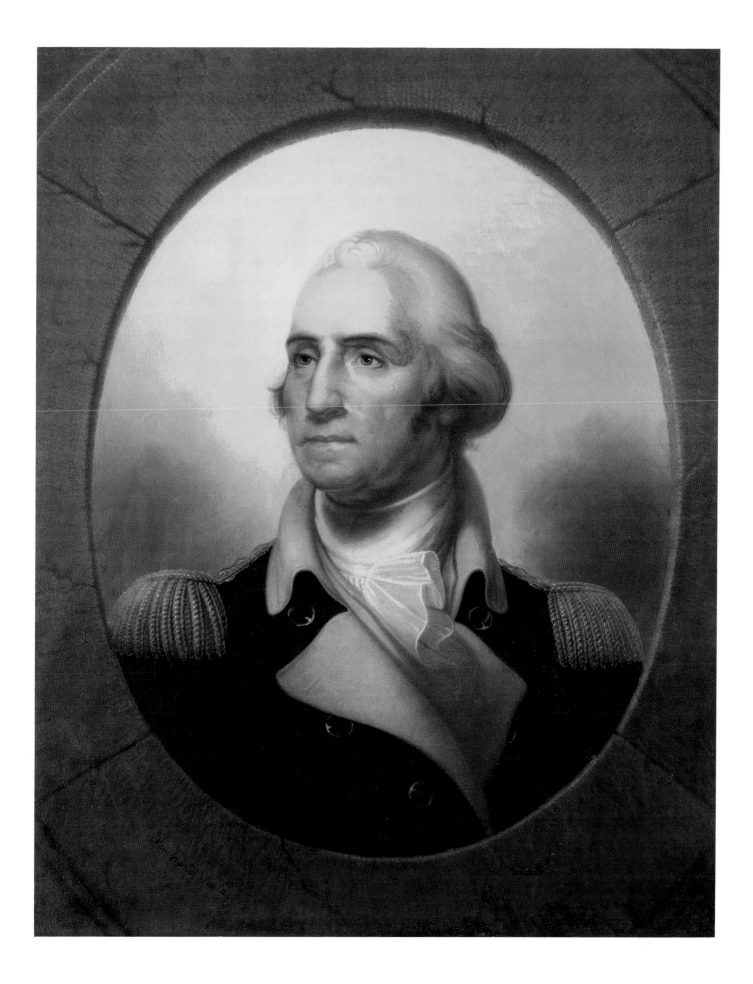

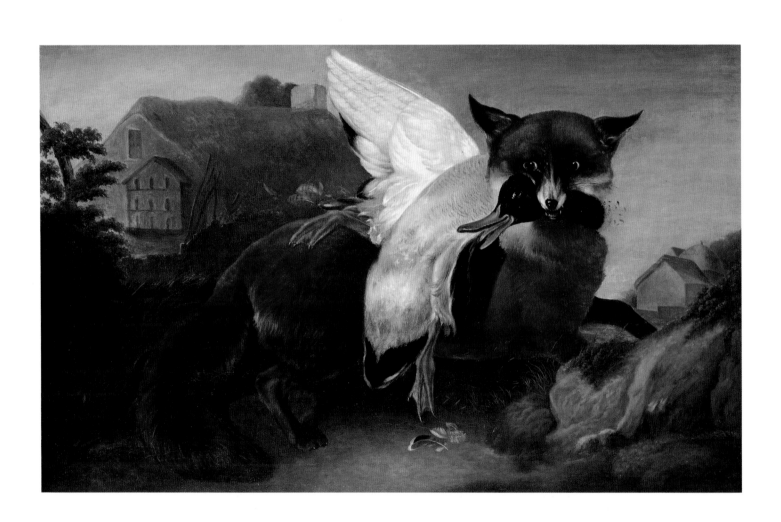

JOHN JAMES AUDUBON | 1785–1851

Fox and Goose, c. 1835
Oil on canvas, 21½×33″ (54.61×83.82 cm.)
Signed, lower right
Gift of Mrs. Arthur McGraw, 940-O-101

Fox and Goose was painted in England, where collectors increasingly urged John James Audubon to convert his ornithological drawings into the more lush medium of oil.[1] This life and death drama set in the American backwoods reveals an artist who was at once a diligent natural scientist and a wilderness poet.

Audubon could have stepped out of a novel. Born in Santo Domingo, the illegitimate son of a French sea captain and a Creole chambermaid, he grew up in Nantes during the bloody Reign of Terror that followed the French Revolution. He studied briefly in Jacques-Louis David's atelier before fleeing to the United States in 1802 to avoid conscription in Napoleon's army. By 1808, Audubon was married and running a general store in Louisville, Kentucky, a business that went bankrupt probably because he spent most of his time observing and drawing birds in the Ohio Valley region. In time the avocation became a passion. In 1820, he set out down the Mississippi River on a flatboat to study migratory birds; with its vast swamps and marshlands, the Mississippi Valley was a Garden of Allah for the birds and for Audubon. Showing the tenacity of a conquistador, he slogged his way through the tortuous terrain, determined to learn everything he could about the wild turkey, great white heron, Canada goose, and other birds. He read natural history texts, spied on birds from his hiding places, hunted and trapped species, tried domesticating those he caught, and even picked up rudiments of the taxidermist's craft.

Until the late 1820s, Audubon made New Orleans his base of operations for the drawings and watercolors he was preparing for publication. American book firms did not show interest, but in 1830 the skilled English engravers Robert Howell Sr. and Jr. reproduced Audubon's watercolors on copper plates; the engravings were then hand-colored and published in a double elephant folio titled, *The Birds of America*. Subsequent volumes of ornithological writings and watercolors, reproduced as lithographs, secured Audubon's reputation as the premier natural history artist of the nineteenth century. His highest acclaim came in Victorian England where, in the 1840s, he was elected to the Royal Society and enjoyed the life of a social lion.

By the time *Fox and Goose* was painted, Audubon's art radiated with vigor and confidence. He may or may not have witnessed this mammal-bird struggle. He rarely rendered or wrote about the North American Fox,[2] although he must have known it was a major menace to nesting birds. Canada Geese, on the other hand, were among Audubon's special interests. He spent long periods studying their migratory and breeding habits; he watched them in the wild, trapped them, and tried occasionally to raise them like barnyard fowl. At times he shot them out of the sky or purchased them to set up in his studio as a *nature morte*.

Fox and Goose is a drama made taut by the extreme close-up vantage point which places the spectator on eye level with the combatants in a tightly-wedged space. Audubon's Oriental-like design with its alternating cadences of light and dark notes and its crisply drawn, decisive forms hovering against a sparse, abstract setting, exercises a spell on the viewer not unlike that of Winslow Homer's powerfully designed landscapes of the 1890s. Audubon laminates a Neo-Classical regard for the rational and empirical to his Romanticist love of instinct and the exotic. His meticulous natural history renderings cross the threshold into visual theater. His legacy is an imaginative art linked to that of the nature poets of his era such as Frederic E. Church and Martin Johnson Heade.

RICHARD COX

ATTRIBUTED TO JAMES PEALE | 1749–1831

Still Life with Grapes and Apples on a Plate
Oil on canvas, 16 × 22″ (40.64 × 55.88 cm.)
Unsigned
Museum purchase, 945-O-105

James Peale, the youngest brother of Charles Willson Peale, was born in Chestertown, Maryland.[1] He received painting lessons from Charles Willson before serving in the Continental Army during the American Revolution from 1776 to 1779. He resided in Philadelphia with his brother until his marriage in 1782, after which he established his own household and an independent artistic career. For much of the late eighteenth century, both Charles Willson and James were active in the field of portrait painting, Charles Willson painting in oil on canvas, and James working in watercolor on ivory. It is for these lovely, diminutive images that James is frequently remembered today. But it is in still life that James Peale made his most lasting contribution to the history and development of American art.

The painter and teacher Sir Joshua Reynolds outlined the hierarchy of art subjects for the eighteenth-century students of the Royal Academy in London. His theory, then widely accepted in Europe and the United States, placed history painting with its noble themes at the highest level, and still-life painting at the lowest.[2] Artists were discouraged from merely painting an imitation of nature, which could only demonstrate technical skills and not inform or elevate the intellectual content of the subject. However, at the end of the eighteenth and into the nineteenth centuries some American painters broke rank to engage in an on-going exploration of that lowest of genres, still life. Chief among them were members of the Peale family.

Charles Willson Peale, founder of the "Peale Dynasty,"[3] established a tradition of painting which matured in assorted forms through the family's various branches. The two who became involved with still life were his sons Raphaelle and James. Together they laid a foundation for still-life painting upon which succeeding generations of Peales and other artists would build.

James and Raphaelle each developed his own style, but their work had a number of features in common which have come to define "the Peale type" of still life. Usually fruit or other edible items are arranged parallel to the picture plane on a ledge, shelf, or elevated surface. These are lit from the upper left, the light falling over and defining the forms. Often a second light source illuminates the right background, visually pushing the objects forward out of what would otherwise be shadowed obscurity. The depictions emphasize the spatial clarity of solid, simple shapes. A knife and fruit peel occasionally serve as a punning signature. James's arrangements are more casual than Raphaelle's, usually presenting a profusion of fruit, flowers, or vegetables, with a sense of fullness and abundance, and emphasizing the passage of time. As William H. Gerdts has observed, in James's work there are "age spots, worm holes and other blemishes . . . [he was] conscious of and concerned with change and age."[4]

The Butler Institute's painting has many characteristics of the Peale-type still life: mounded fruit casually arranged, illumination from left to right, and a sense of captured time.[5] In it luminous green grapes casually spill across a gilt-rimmed porcelain plate, covering part of it. Rolling over the edge and out on to the gray-surfaced ledge are bunches of red grapes whose curved surfaces vary in color from coppery brown to ruby red. These grapes pile up on the left against a group of yellow apples tinged with red to green streaks and spots. Laid across the grapes is a woody stalk from a grape vine still bearing brown and green colored leaves.[6] The light falling across the fruit defines the colors and accentuates the transparent, taut skins of the different types of grapes. Time has been arrested by the painter at a peak of fullness shared by all the fruit; a moment of ripeness that cannot last but will very soon end with a change of color, loss of firmness, and the sweet fragrance of decay.

This sensitivity to the mutability of nature and the passage of time, as well as the deft rendering of light and surfaces, indicates an experienced eye and hand at work. But these qualities are also expressive of a combined artistic interest and insight into life found in the best work of this extraordinary family of painters.

LINDA CROCKER SIMMONS

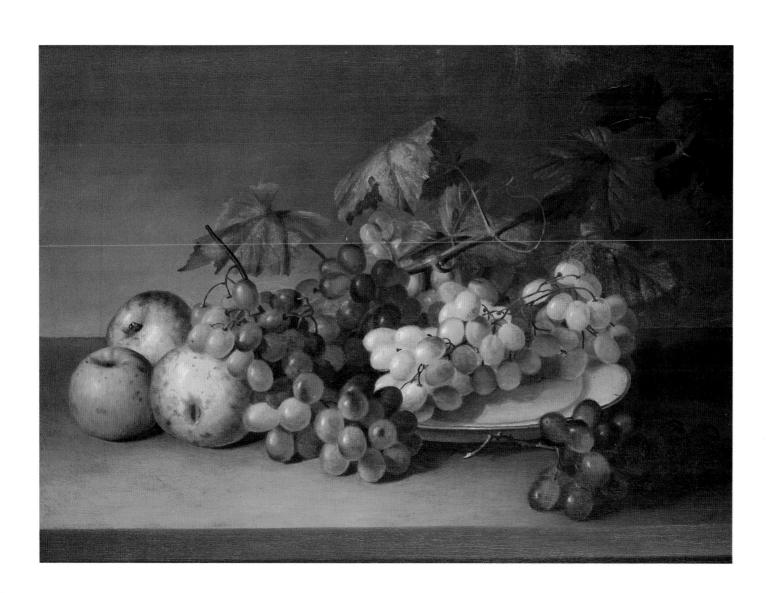

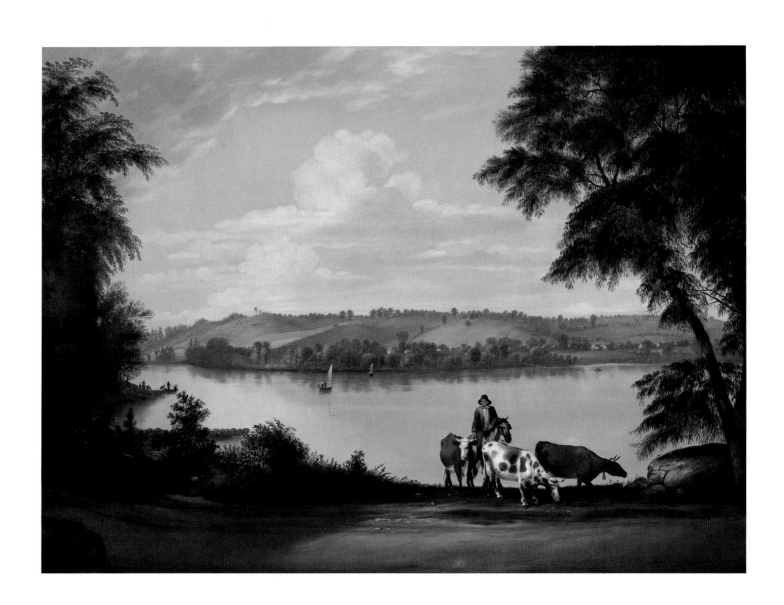

ALVAN FISHER | 1792–1863

View Near Springfield, Massachusetts, 1819
Oil on canvas, 32 × 44″ (81.28 × 111.76 cm.)
Signed, lower left
Museum purchase, 979-O-116

Born in Needham, Massachusetts, Alvan Fisher studied for almost two years with John Ritto Penniman, an ornamental painter. He established a studio in Boston in 1814. During his long career, Fisher produced a large body of work that included portraiture, landscape, and genre and he was one of the first native-born American artists to devote himself to landscape painting in a significant way. According to his own report, he first took up the subject around 1815.[1] Initially, his landscape compositions, which often included genre elements, were imaginary scenes that owed more to English models than to the direct observation of nature. Within a few years, however, Fisher had abandoned the formulaic qualities characteristic of his initial work for a more realistic representational style. Undoubtedly based on drawings done during one of his many trips through the region, *View Near Springfield, Massachusetts*, despite the conventional use of trees to bracket the scene, is an early product of that shift in artistic expression.

The Butler Institute painting is one of several works by Fisher that focus on the Connecticut River Valley, admired by the artist's contemporaries for its natural beauty and agricultural productivity. It clearly is a variation on another oil of the same size and date, *View Near Springfield Along the Connecticut River* (1819, Brooklyn Museum). Given the emphasis both compositions place on the pastoral nature of the countryside, with its slow flowing river, herds of cattle, neat but modest houses, rolling hills and cultivated fields, *View Near Springfield, Massachusetts* could well

have been conceived as a companion piece for the Brooklyn Museum canvas. Certainly, both project an image of an idyllic land, an arcadia, that expresses the ideals of Jeffersonian America and speaks eloquently of the promise of the young Republic.

Although Fisher undertook sublime and nationalistic subjects such as *Niagara Falls* (1820, National Museum of American Art), he repeatedly turned to the Connecticut River Valley for inspiration and made its varied landscape from the mountains of Vermont and New Hampshire to Hartford one of his special concerns. His views of the Springfield area with their soft undulating lines and crystalline light glorify the beautiful and picturesque aspects of the countryside, presenting that part of New England as an American Eden. In 1835, Thomas Cole remarked: "Whether we see it [the Connecticut River] at Haverhill, Northampton, or Hartford, it still possesses that gentle aspect; and the imagination can scarcely conceive Arcadian vales more lovely or more peaceful than the valley of the Connecticut—its villages are rural places where trees overspread every dwelling, and the fields upon its margin have the richest verdure."[2] Cole's remarks could well be applied to Fisher's paintings of the area, which so perfectly convey a sense of the quietude and fecundity of the valley even at a time when the Connecticut River Valley was "bustling with activity" and its bucolic nature "was being invaded, altered, and molded by agents of industrialization and urbanization."[3]

EDWARD J. NYGREN

JOSHUA SHAW | 1776–1860

Landscape with Cattle, 1818
Oil on canvas, mounted on masonite, 31 × 41″ (78.74 × 104.14 cm.)
Signed, lower right
Museum purchase, 961-O-117

Joshua Shaw was born in Bellingborough, Lincolnshire, in northeast England. Apprenticed in his youth to a sign and house painter, he was primarily self-taught as an artist. During his residence in Bath from 1805 to 1812 and later in London, he exhibited regularly at the Royal Academy and the British Institution. In 1817, Shaw immigrated to Philadelphia. A key figure in the development of landscape painting in America, he actively participated in the artistic life of his adopted city. *Landscape with Cattle*, among the first canvases Shaw executed after his arrival, is a prime example of his mature style.

Like many of the compositions Shaw created in America, *Landscape with Cattle* is a remembrance of rural England that speaks of the healthful pleasures of country living far removed from urban congestion. With its meandering river and rolling countryside sprinkled with houses, this particular view projects a sense of man's harmony with a world basically untouched by industrialization. Its glorification of a pastoral existence would have been particularly appealing to a Jeffersonian audience. The setting, while not topographically accurate,[1] is the Avon Valley not far from the fashionable city of Bath. It was an area admired for its natural beauty. There is an almost identical composition of slightly larger size, *Untitled* (n.d., private collection, Louisville, Kentucky),[2] and a related but smaller view of the same site, *Avon Valley Near Bath* (c. 1815, Lyman Allyn Museum, New London, Conn.); the elimination of cattle from the foreground as well as the addition of shipping and more buildings increase this work's topographical flavor. Perhaps *Landscape with Cattle* is a simplification of the Lyman Allyn painting, filtered through the eyes of a nostalgic expatriate. Certainly the Butler Institute painting seems less a portrait of a specific place than a landscape of mood, a poetic expression of a particular attitude toward nature.

Shaw's compositions owe a debt to those of the seventeenth-century Franco-Italian painter, Claude Lorraine, and to his British followers, especially Richard Wilson.[3] While their influence is clearly evident in *Landscape with Cattle* and other works by the artist, the overall composition as well as the landscape elements are part of the vocabulary of the picturesque, one of the leading aesthetic concepts of the day. Such works also have artistic affinities with paintings by Shaw's older contemporaries—Julius Caesar Ibbetson, Philip James de Loutherbourg, George Barret—whose numerous, seemingly topographical views of mountainous landscapes, often populated with cattle, bear a close resemblance to his conceptions.[4] As exhibitors at the Royal Academy, they would have been known to Shaw. Certainly the atmospheric clarity, achieved through subtle gradations of pink and blue tones, touched with yellow, recall not only the effects achieved by these artists but also those developed by seventeenth-century Dutch masters such as Nicolaes Berchem, whose paintings Shaw is known to have copied.

Although Shaw drew on his American experience for inspiration, especially in his depictions of Native Americans in historical settings,[5] he nevertheless continued to paint British landscapes virtually until the end of his life, often including picturesque remnants of castles as well as peasants in what were essentially imaginary compositions. Despite the pronounced British flavor of paintings such as *Landscape with Cattle*, Shaw remains a critical figure in the development of American landscape painting. As an artist born and trained in England, who revisited his native country on at least one occasion, he was in touch with current artistic developments and aesthetic theories. Through him, the American public as well as his colleagues came to know the work and techniques of some of Britain's leading artists.[6]

EDWARD J. NYGREN

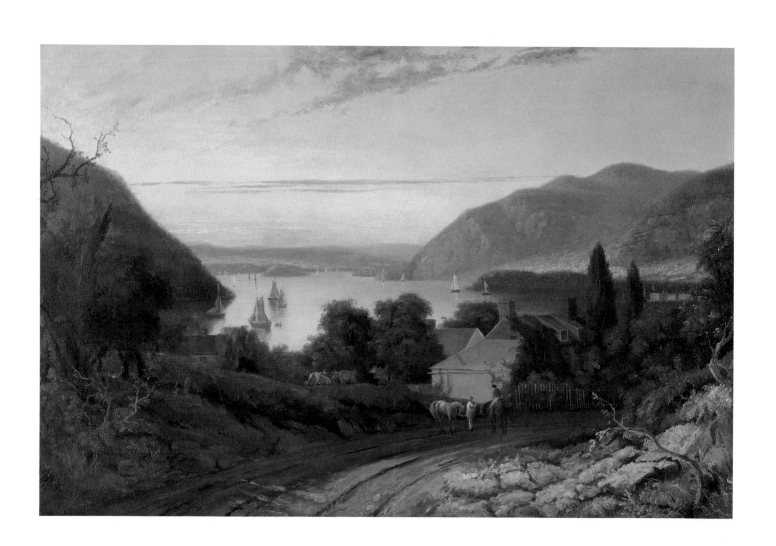

SETH EASTMAN | 1808–1875

Hudson River with a Distant View of West Point, 1834
(View of the Highlands from West Point)
Oil on canvas, 33 × 50″ (83.82 × 127.00 cm.)
Signed, lower right
Museum purchase, 968-O-174

S eth Eastman is best known for his pictorial documentation of the Native American. A writer of 1848 considered Eastman "the best painter of Indian life the country has produced," further declaring him "a superior artist to [George] Catlin,"[1] another well-known artist who specialized in the subject. The National Academy of Design made Eastman an honorary amateur member, and Congress commissioned paintings from him to adorn committee rooms in the House of Representatives.

Eastman, a graduate of West Point Military Academy, pursued a successful career with the United States Army. After initial postings in Wisconsin and Minnesota, he was stationed at West Point from 1833 to 1840 as the assistant teacher of drawing. Eastman spent the rest of his career in the army, attaining the rank of colonel by the time of his retirement in 1863. *Hudson River with a Distant View of West Point*[2] was painted while he was teaching at the Academy. During this time, Eastman published a treatise on topographical drawing advocating that scientific attention to detail be applied to landscape art. He advised that "A knowledge of geology is of great assistance to the draughtsman, for if he understand[s] the nature of rocks, he can better represent them."[3]

Hudson River with a Distant View of West Point

depicts the view looking north from West Point toward the Highlands of the Hudson River. The sloping mountain on the left is either Crow's Nest or Storm King. On the right are Breakneck Ridge and Bull Hill, and the low-lying peninsula in the shadows before them is known as Constitution Island. Pollepel Island is visible in the gap between the banks of the Hudson. Eastman's view was painted from an elevated vantage point southwest of the military academy, and some of the school's academic buildings appear as tiny white shapes at the far right. The river disappears downstream behind them.

While stationed at West Point, Eastman frequently exhibited work at the National Academy of Design in New York. Between 1836 and 1840 he exhibited seventeen paintings at the academy, nearly half of them landscapes depicting West Point and vicinity.[4] Relatively few of Eastman's eastern landscapes have survived, making *Hudson River with a Distant View of West Point* a rarity within the artist's oeuvre. Despite their scarcity, his Hudson River landscapes establish him as an important predecessor of the Hudson River School, America's first indigenous group of landscape painters.

KATE NEARPASS OGDEN

JUNIUS BRUTUS STEARNS | 1810–1885

The Marriage of Washington, 1849
Oil on canvas, 40 × 55″ (101.60 × 139.70 cm.)
Signed, lower right
Museum purchase, 966-O-135

During the middle years of the nineteenth century no American historical figure was more revered and celebrated than George Washington. Orators, authors, and artists contributed to the apotheosis of this great American hero; "In all branches of Art and in all shape of Literature, WASHINGTON is now the leading subject," asserted an 1859 writer.[1] Of the many painters to render images of Washington, only one, Junius Brutus Stearns, offered a cyclical representation of the hero's life.

Vermont-born and trained at the National Academy of Design, Stearns began working on *The Marriage of Washington* in 1848. The *Alexandria Gazette* of September 30, 1848 noted, "Mr. J. B. Stearns . . . has been for some days at Arlington House . . . engaged in making very beautiful and successful copies from the original pictures of Colonel and Mrs. Washington, the one of the date of 1772, by Peale, and the other of 1759, by Woolaston [sic], with a view to the painting of a large picture of Washington's Marriage. . . ."[2] The painting, signed and dated 1849, appeared in the American Art-Union exhibition of 1850 and was part of the Art-Union's annual painting lottery, going to John M. Merrick of Wilbraham, Massachusetts.

The Marriage of Washington depicts thirty-seven elegantly-clad figures surrounding the bridal couple as the ceremony takes place on January 6, 1759 in St. Peter's Episcopal Church, New Kent County, Virginia. Behind the handsome George and the demur widow Martha Dandridge Custis stand three bridesmaids and Martha's daughter, who looks toward her brother seated with their grandparents. The composition, with its emphasis on fine costume, successfully evokes the mid-nineteenth century's conception of the chivalric days of the Old Dominion. Also, the work significantly contributes to the contemporary interest in humanizing Washington and in making the hero accessible.

The Marriage of Washington triggered Stearns's desire to paint a cycle chronicling the life of the hero.

He indicated this to the Executive Committee of the American Art-Union when soliciting a commission to undertake a cycle in four works, which the American Art-Union declined.[3] Stearns, however, not only proceeded with his plan, expanding the series to five works,[4] but also wrote Merrick asking him to send his marriage painting to Paris so that a print could be made, which appeared as the lithograph, *Life of George Washington: The Citizen* (1854).[5]

While the artist's letters and an American Art-Union label affixed to the stretcher of the Butler Institute's painting testify to its being exhibited and distributed by the Art-Union, the painting's precise chronological relationship to a nearly identical composition—also signed and dated 1849—in the Virginia Museum of Fine Arts is problematic. Both pictures' rendering of figures, their rounded top corners, and their dimensions appear virtually identical. The only difference is that the two figures on the right, male and female, are depicted as African Americans in the Butler Institute work. Why Stearns chose to include an African-American couple in one image and not the other remains a mystery. Occurring at a moment of increasing national division over the question of slavery, Stearns's inclusion and exclusion of two African Americans in the margins of the scene is certainly intriguing. While slavery proponents and opponents alike cited Washington as a benign master, the historical veracity of showing slaves attending his wedding is highly questionable.

Although he painted numerous historical, portrait, genre, and fishing pictures, Junius Brutus Stearns remains best known for his images chronicling the life of George Washington. Historically important, the Butler Institute's *The Marriage of Washington* inspired the artist to create his series and wonderfully exemplifies the mid-nineteenth-century desire to humanize America's greatest hero.

MARK THISTLETHWAITE

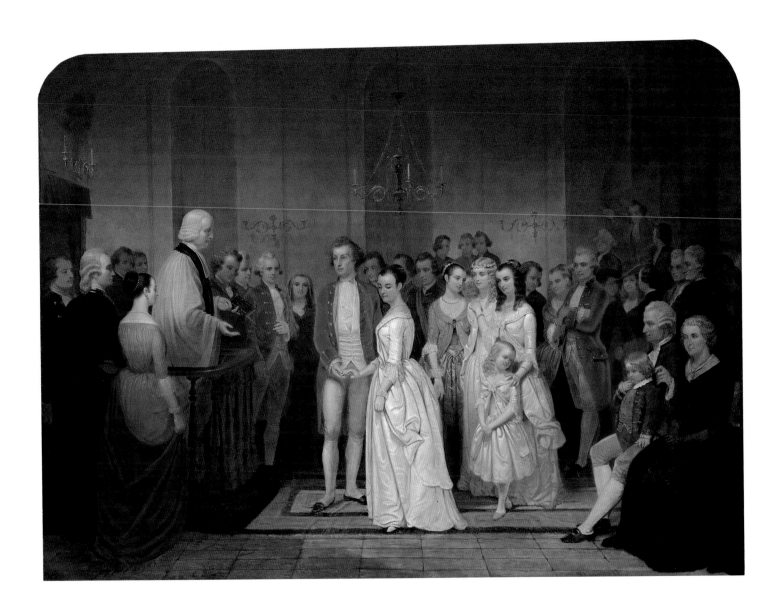

THOMAS SULLY | 1783–1872

Mother and Child, 1827
Oil on canvas, 26½ × 43½″ (67.31 × 110.49 cm.)
Unsigned
Gift of Dr. John J. McDonough, 970-O-121

Not long after his return from eight months of study in London in 1810, Thomas Sully came to be recognized as the most celebrated portrait painter in Philadelphia, a reputation he maintained for over half a century; indeed, he was arguably the most accomplished portraitist of the Romantic era in the United States. Sully was born in Horncastle, England, and was brought as a boy to Charleston, South Carolina, by his actor-parents. His initial instruction in painting was provided by his Charleston schoolmate, Charles Fraser, his brother-in-law, Jean Belzons, and his older brother, Lawrence Sully, all able miniature painters. In 1799, Thomas followed his brother to Richmond, Virginia, and later both artists worked in Norfolk. In 1806, he moved to New York City, and in 1807 traveled to Boston for three weeks of instruction from Gilbert Stuart, who undoubtedly advised the younger painter to go to London. At the end of that year, Sully settled in Philadelphia, which remained his home for the rest of his career.[1]

Sully was not only a masterful portrait painter, but a most prolific one. He first established his reputation with a number of theatrical portraits, notably those of *William Burke Wood in the Role of Charles de Moor* (1811, Corcoran Gallery of Art) and *George Frederick Cooke in the Role of Richard III* (1811, Pennsylvania Academy of the Fine Arts, Philadelphia). Among his other most celebrated likenesses were those of the Episcopal Bishop of Pennsylvania, *Bishop William White* (1814, Washington Cathedral, Washington, D.C.) and *The Marquis de Lafayette* (1825–26, Independence National Historical Park Collection, Philadelphia).

Later critics have faulted Sully for his sometimes too-facile brushwork and the soft, idealizing likenesses of his male sitters, but he is still praised for the romantic sensitivity of his female portraits. Here, his quintessential images are those of *Elizabeth Eichelberger Ridgely*, also known as *The Lady with the Harp* (1818, National Gallery of Art, Washington, D.C.), and the many portraits he painted of the celebrated actress, Frances Anne "Fanny" Kemble. The spirit of dreamy sentiment which infuses these likenesses is also present in Sully's *Mother and Child*, one of the best-known of over five hundred non-portraits that Sully also created.

Sully has aimed here to evoke both the innocence of childhood and the maternal spirit which he had already embodied a decade earlier in his portrait of *Rebecca Mifflin Harrison McMurtrie and Her Son, William* (1817, Westmoreland County Museum of Art, Greensburg, Pa.). Nevertheless, the gentle eroticism of the sleeping mother's bared bosom suggests a comparison with and perhaps a debt to John Vanderlyn's *Ariadne Asleep and Abandoned by Theseus on the Island of Naxos* (1812, Pennsylvania Academy of the Fine Arts, Philadelphia), one of the best-known, if somewhat notorious, American historical pictures of the period. In turn, the image of the child in Sully's painting, inviting the viewer into the scene with an excellently foreshortened left arm, prefigures what may be Vanderlyn's final treatment of his subject. In *Ariadne: Half Length* (by 1833, Neville Public Museum, Green Bay, Wis.),[2] a vapid infant Cupid holds back a curtain to reveal the sleeping heroine, now lying amid pillows on a bed, similar to Sully's *Mother*, and with her garment pulled back only slightly further than those covering the figure in Sully's painting. The soft sfumato of Sully's gentle shading bespeaks an aesthetic antithetical to the emphatic lighting in Vanderlyn's sharply linear Neoclassic canvas.

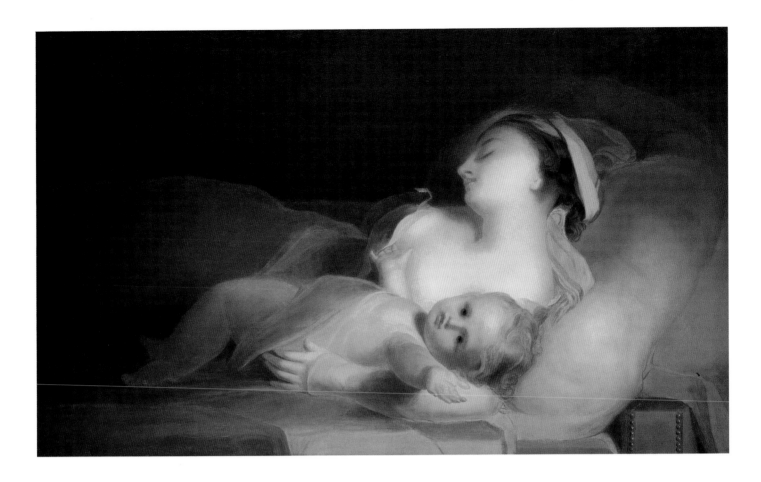

The juxtaposition here of Sully's *Mother and Child* and Vanderlyn's image of *Ariadne*, both of which combine sentiment and sensuality, is not, in any case, fortuitous, for both images were meant for public exhibition. In fact, yet another of Vanderlyn's *Ariadnes* (1825–26, Senate House State Historic Site, Kingston, N. Y.), joined one version of Sully's *Mother and Child* in the main salon of the steamer, *Albany*, one of the most celebrated ships of the day, built by Colonel James A. Stevens, of Hoboken, New Jersey.[3] The *Albany*, built in Philadelphia, plied the Hudson River from New York to Albany beginning April 11, 1827, and was considered the finest vessel afloat; presumably all the paintings commissioned for the salon, including Sully's *Mother and Child*, were completed and installed before that date. Stevens provided an art gallery of twelve pictures for the delectation of his passengers, which also included works by Thomas Cole, Thomas Doughty, Samuel F. B. Morse, Thomas Birch, and Charles B. Lawrence, all the same size, approximately 27 × 44".[4] Indeed, the salon of the *Albany* may have constituted the finest public art gallery of its day in the United States.

It is almost certain, however, that the *Mother and Child* in the Butler Institute is actually not the painting created for the *Albany*, but rather a replica commissioned for two hundred dollars by Dr. Philip Tidyman, a work which was begun on February 10, 1827, and completed August 3, 1827;[5] the latter date is inscribed on the picture's stretcher. Sully lists this as a "Copy," referring to one or both of two paintings he created for Colonel Stevens. One was a "Study" for a *Mother and Child*, 36 × 18", begun on December 4, 1826 and finished in March, 1827 for "Mr. Stevens"—presumably James A. Stevens. Then, on January 17, 1827, he began "Mr. Stevens picture for steam boat" for $200, and completed it on February 9.[6] Dr. Tidyman's version of the subject was the next work that Sully commenced. All the *Albany* paintings were painted on heavy mahogany panel for installation in the ship's salon.[7] Thus, the Butler Institute's painting is almost certainly a reflection of Sully's prestigious commission for the steamer. This work was described in terms identical to the Butler Institute's painting in a reminiscence of 1857: "Sully produced a reclining half-length of a young and beautiful mother asleep, and of course, unmindful of her lovely infant lying awake and playful by her side. This was a warm and glowing picture, and one characteristic of the grace and refinement of this accomplished artist."[8]

WILLIAM H. GERDTS

45

ROBERT W. WEIR | 1803–1889

Saint Nicholas, 1838
Oil on wood panel, 30×25″ (76.20×63.50 cm.)
Signed, lower left
Gift of Mr. Sidney Hill, 962-O-101

Robert W. Weir's *Saint Nicholas* is filled with arcane iconographical features which attach it to the liveliest cultural group in early nineteenth-century New York, the Knickerbockers.[1] This coterie of artists, writers, and art patrons consciously linked themselves with New York's Dutch heritage and, as part of that heritage, with their chosen patron saint, Nicholas. Although he was not the first to connect Nicholas and the group, Washington Irving gave the legend increased momentum in 1809 when he published his landmark comic history of New York under the pseudonym of Diedrich Knickerbocker.[2]

Weir first executed a horizontal formatted *Saint Nicholas* (1837, private collection) during a decade when the theme of the saint was enjoying particular attention and there was a conscious formalization of a Knickerbocker self-concept. A prominent Knickerbocker himself, the artist exhibited the work at the National Academy of Design in 1837 and reviews praised it as an illustration of the "children's Christmas friend."[3] Perhaps Weir was insulted by having his work thus described; at any rate, the following year he made his image more arcane in the vertical formatted painting now in the Butler Institute. Weir would replicate this second image of the saint at least four times, but of the entire group of Nicholas paintings, only the Butler Institute's is signed and dated.[4] The fact that the overmantel in the Butler Institute version lacks the three golden balls which are Nicholas's traditional Christian symbol and the New York City coat of arms, and which appear in the other vertical versions, suggests it was the first version. Apparently, the artist had not yet decided upon the escutcheon and ball motif.

The painting depicts an impish saint, wearing high boots and a red-hooded cape. As a nod to his Christian heritage, a rosary hangs on his right side. Nicholas stands before a fireplace lined with Delft tiles and prepares to ascend the chimney. He turns to momentarily confront the observer. We, the viewers, are thus engaged in the work, for a sweep of light crossing the floor implies that we have opened a door from the adjoining room. In response, Nicholas places his left index finger next to his nose, a gesture of complicity which both acknowledges our intrusion and asks us to keep his secret.

Nicholas's snapping right hand serves as a compositional device to direct our attention to the accoutrements on the floor. Many of these elements have symbolic content and pay tribute to Nicholas, not as the Christian saint, but as the patron of the Dutch-descended Knickerbockers. In front of the Atlas-figure andirons lies a broken Delft clay pipe, reference to the ceremony of becoming a knight in the order of Saint Nicholas. The half-peeled orange has double meaning: it is both a Christmas delicacy and an allusion to the Dutch House of Orange. Inside the fireplace smoke rises from burning embers; smoke played a significant role in Nicholas's association with New York in the literature of the time. Weir's Nicholas paintings invoke seventeenth-century Dutch genre pictures in the use of a wooden panel as a support, the meticulous handling, and the warm palette. The way in which the still-life elements demarcate the space on wooden floorboards is also reminiscent of Dutch painting.

Most of Weir's Nicholas paintings were purchased by Knickerbockers, which proves how successfully he captured the group's image of their patron saint.[5] The ribald appearance of Weir's Nicholas perfectly matches the droll quality of contemporary Knickerbocker writings and their description of Nicholas in particular. The iconography of Weir's paintings is erudite, complex, and ambitious, expressing the cultural values and aspirations of the Knickerbocker circle, thus the image can truly be seen as a Knickerbocker icon.

LAURETTA DIMMICK

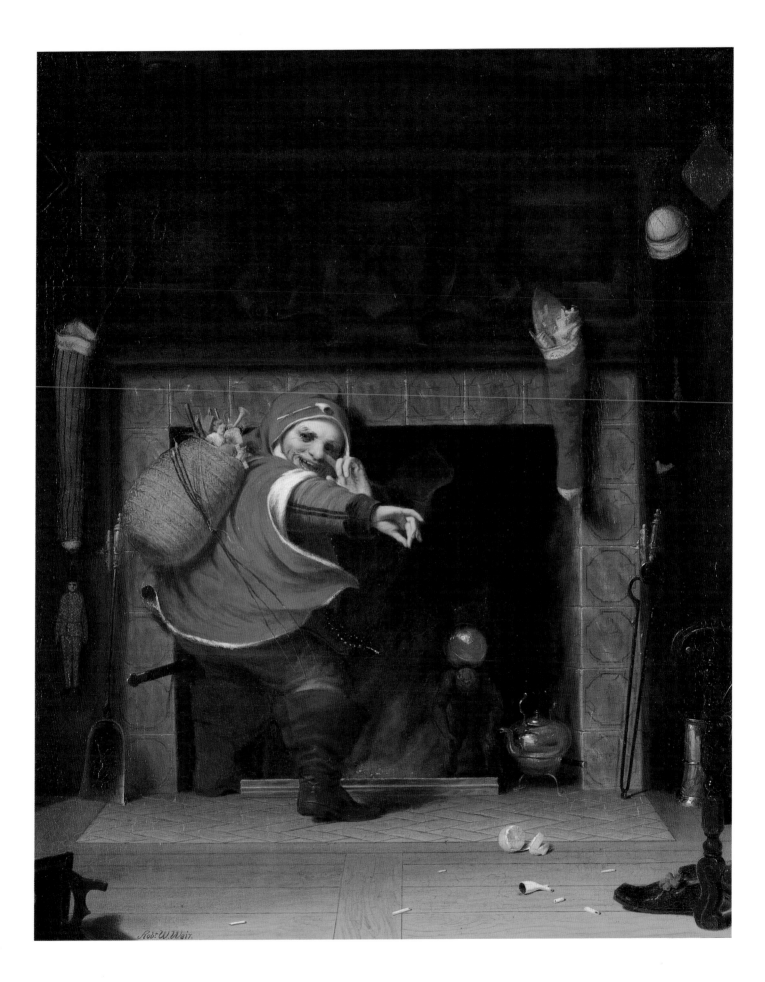

JOHN F. FRANCIS | 1808–1886

Still Life with Fruit
Oil on canvas, 23 ¼ × 30″ (59.06 × 76.20 cm.)
Signed, lower left
Gift of family and friends in memory of Grace Heath Butler, 973-O-115

Born in Philadelphia, by 1832 John F. Francis, who was largely self-taught, was supporting himself and his new bride as an itinerant portrait painter in eastern Pennsylvania. In 1845, he established residence in Philadelphia and began exhibiting at the Pennsylvania Academy of the Fine Arts and the Philadelphia Art-Union which promoted American artists through large, annual exhibitions and by awarding paintings in lottery-like drawings to subscribers. During this period Francis turned to still-life painting, selling nine of the twelve works he exhibited at the Art-Union in 1851. In subsequent years, his still lifes were purchased for lottery distribution, firmly establishing him as a leader in this genre which was only then gaining public acceptance.[1]

During much of the nineteenth century, the majority of artists, collectors, and critics subscribed to the academician's thematic hierarchy which regarded still life as distinctly inferior to history painting, portraiture, and landscape. As James Thomas Flexner noted, "only in Pennsylvania was there a continuous still-life tradition . . . anchored in a single family"[2]— that of Charles Willson Peale. While Francis's familiarity with the Peales' work is debated, this unprecedented dynasty of still-life specialists, including the elder Peale's brother James, son Raphaelle, and five daughters and nieces, undoubtedly prepared the way for Joseph Biays Ord, Severin Roesen, and Francis. Raphaelle Peale's austere neo-classic arrangements and James Peale's marvelously romantic orchestrations may have found acceptance initially because the large Germanic population around Philadelphia was already accustomed to both a folk tradition of fruit-and-flower painting and the Dutch school of still-life painting. Roesen and Francis, on the other hand, appealed to the growing middle-class American desire to celebrate the rich bounty of their own land. The mid-Victorian still life of abundance, featuring opulent piles of ripe fruit and costly bric-a-brac soon became a necessary feature of every genteel dining room.

Still Life with Fruit is a paradigm of the genre, combining a number of features of Francis's mature work. On a slightly tilted slab, which just touches the lower edge of the frame, is a simple market basket piled high with glowing golden peaches and apples, surrounded by still more peaches and apples as well as sliced yellow melons and a ripe watermelon, broken open to reveal rosy pulp, dark seeds, and green rind. The whole is laced together by drooping bunches of grapes and vine leaves and enlivened by a white napkin. A saturate amber light floods the picture from the left, picking out Francis's typical blue-white highlights and casting strong, dark shadows which further unify the solid geometry of the fruit. The subdued, neutral background plane, set off from a landscape vignette by a vine-hung classic column, was a common portrait setting of the period and may well have been adapted from his earlier profession.

Francis also specialized in luncheon still lifes, which added wine bottles and glasses, a plate of cheese, and perhaps some "jaw breakers" or oyster crackers, and dessert still lifes, presenting an elegant grouping of silver, glassware, and porcelain containing fruit, cakes, nuts, and wine. All three types were attuned to the Victorian love of luxurious objects, beautifully and precisely rendered in virtuoso pieces in which the artist set and solved increasingly complex visual problems. Francis continued to paint variations on these still-life themes, frequently combining elements from previous pictures and, in some cases, replicating entire pictures almost exactly.[3] This, combined with the fact that his style remained relatively unchanged over the decades, makes it almost impossible to date uninscribed works with any degree of certainty. Few pictures dated after 1872 are known and none after 1880. By the time of his death "the best American still-life painter of mid-century"[4] was forgotten in his native city.

H. DANIEL BUTTS, III

CHARLES BAUM | 1812–1877

Boy with Still Life, 1850s or 60s
Oil on canvas, 40×30″ (101.60×76.20 cm.)
Signed, lower right
Museum purchase, 958-O-114

When this picture was acquired by the Butler Institute, there was no doubt that the artist who created it was Severin Roesen. Roesen was a German painter from the Rhineland who immigrated to America in 1848, along with many thousands of his countrymen, in the wake of the unsuccessful liberal revolutions in Europe. While Roesen never achieved great renown in his own lifetime, either during his years in New York City, 1848–57, or in his later career living in a number of Central Pennsylvania communities through 1872,[1] most of that period in Williamsport, he was one of the most prolific still-life specialists of his time. Furthermore, he appears to have heralded something of a revolution of his own in the United States in the art of still-life painting, initiating a vogue for monumental pictures of fruit and flowers, or both, around which a room decor could be constructed, rather than the modest pictures which had constituted the genre in this country up to his arrival.

While Roesen's present reputation rests entirely on his still-life painting, tradition also mentions some portraits; three which may be by him are known today.[2] While the inclusion of a prominent figure in *Boy with Still Life* was unusual, the tradition of Roesen's activity in portraiture made the attribution to him acceptable. The profuse still life, with many motifs common to Roesen such as the champagne bottle and glass, the curling grape stems, and the marble support, seemed indisputably his.

The attribution to Roesen, however, was drastically revised when a pendant to *Boy with Still Life* was discovered in 1971 in a private collection in Richmond, Virginia. Here again is a boy in an elegant costume and white, open-necked shirt, wearing a soft beret, and placed behind a profuse still life of fruit. In the second picture the boy's body is turned to the right, and his head turned back toward the viewer, while the wall is now on the right. This painting is clearly signed "Baum." The present owner has reported that the picture was owned by her grandfather in the 1850s, and if *Boy with Still Life* is, in fact, a mate, then it, too, would date from that decade. On the other hand, Baum exhibited *The Fruit Seller* at the annual exhibition held at the

Pennsylvania Academy of the Fine Arts in 1864, which suggests that this picture, its mate, or a similar work, was probably painted early that year or in those immediately preceding.

Charles or Carl Baum, like Roesen, was from the Rhineland in Germany, where he had been a schoolteacher; he married a former pupil, Susanna Schneider from Darmstadt. Family tradition has suggested that Baum and his future wife eloped to America, and that they arrived about 1854, but as his *Still Life of Fruit* was included in the Artists' Sale held by the American Art-Union in New York City at the end of December, 1852, he was certainly in this country by then, and may, in fact, have arrived with the great influx of Germans in 1848–49.[3] Subsequently, the Baums moved to Egg Harbor City, New Jersey. This remained Baum's home for the rest of his life, except for a period from 1867–69 when he lived in Philadelphia.

Though little is known about Baum's professional life, he appears to have been fairly versatile; a good number of paintings by him remain in Egg Harbor City in private collections, including some owned by the artist's descendants. Still lifes were his specialty, but animal pictures are known by him, as well as a self portrait. He also painted landscapes, and judging by his admittedly meager exhibition record, his investigation of this theme may have been a later development. Several landscapes appeared in New York City in December, 1871, in the First Annual Exhibition of "The Palette," or The Palette Club, an art society originally, at least, devoted to promoting the work of artists of German descent; Baum, however, seems never to have been a member of that organization.

Baum's still lifes do, indeed, bear a generic similarity to Roesen's but there appear to be a number of fairly clear distinctions. No flower still lifes by Baum have so far come to light, nor any pictures combining flowers and fruits. Baum appears to have preferred a vertical format for his fruit arrangements, perhaps exclusively; and the majority of his known works are presently framed, and probably painted, as ovals. Among Baum's favorite motifs are a bird's nest and a split pomegranate; he appears not to have been

attracted to the multiplicity of different fruit which appear in so many of Roesen's pictures. The support for his arrangements appears invariably to be a white marble slab, atop a stone pedestal; consistently, the slab angles forward in the lower center, pushing up to the picture plane. Baum's decorative containers are quite different from Roesen's, and include a tall multi-dished metal epergne. Baum's fruit arrangements can appear even more bounteous than Roesen's, so that the metal and ceramic containers are almost hidden in the confusion. And Baum's palette is somewhat different and more restricted than Roesen's; Roesen's palette was not only more diverse but generally warmer. Baum preferred the contrast of greens in the leaves and grapes, with whitish-yellow and vermilions, especially in his emphatically painted peaches, and these coloristic qualities can be found in the still life that appears in *Boy with Still Life*.

The question arises as to whether or not Baum and Roesen were acquainted; it seems quite likely they were. Baum may have lived for some time in New York City after arriving in the United States and, as a fellow Rhinelander, may well have known Roesen. Roesen was a professional painter before he came to this country; there is no indication that this was true for Baum. In fact, it seems likely that Roesen developed a workshop in New York City, in order to handle the abundant orders for large-scale compositions he appears to have enjoyed. Possibly Baum was one of a number of immigrants who got their artistic start in such a manner, and who subsequently emerged as independent still-life specialists.

WILLIAM H. GERDTS

THOMAS COLE | 1801–1848

Italian Landscape, 1839
Oil on canvas, 35 × 53″ (88.90 × 134.62 cm.)
Signed, lower center
Museum purchase, 945-O-102

Thomas Cole has long been known as the founder of the Hudson River School. He has also come to be recognized as a romantic landscape painter of comparable importance to American culture as John Constable is to England's or Caspar David Friedrich to Germany's. Born in England in 1801, Cole emigrated with his parents to Pennsylvania in 1818. Already trained as an engraver, the aspiring painter set out to capture the still largely unexplored American wilderness. In a now familiar story, when Cole first exhibited his landscapes in New York City in 1825, they enthralled two of America's most prominent artists, John Trumbull and William Dunlap, both of whom immediately recognized the freshness and vitality of the young artist's vision.[1]

From essentially topographical records of America's mountains, rivers, and forests, Cole moved quickly to incorporate incidents from James Fenimore Cooper's newly-published novels in his landscapes, thereby elevating those landscapes to the stature of history painting.[2] Indeed, Cole seemed happiest when he could give full rein to his poetic imagination, as in such monumental series as *The Course of Empire* (1836, New-York Historical Society), initially conceived by the artist during his first trip to Europe, from 1829 to 1832. *The Course of Empire* traces, through five views of the same landscape, the rise and fall of a fictional civilization, from its inception in savagery, through an arcadian stage, culminating in urban magnificence. The glories of civilization are followed by war and destruction and then melancholy desolation. This pessimistic view of history, in which humans are seemingly doomed to repeat their errors, was consciously countered at the time by the promise of progress, seen by Cole, among others, as uniquely embodied in the American wilderness, a place of inexhaustible resources, a place where there were no ruins.

Europe, and particularly Italy, abounded in ruins, those "speaking ruins" that, in the words of the American poet Edward Pinckney, "have been but hallow'd by the hand of time."[3] After returning from Europe in 1832, Cole continued to paint imaginary Italian landscapes alongside his views of American scenery. These Italian compositions, as Cole called them, inevitably depict the remains of ancient temples, aqueducts, and towers. The Butler Institute's painting, one of the largest of these Italian views, was commissioned for five hundred dollars in 1839 by Frederick J. Platt of Newburgh, New York, and was exhibited in the *Cole Memorial Exhibition* in 1848 under the title of *The Improvisator.*[4]

As in Cole's other views of Italy, *Italian Landscape* shows an expansive summer landscape peopled by

goatherds and travelers, often with an Italian town
and mountains in the distance. Here there is also a
prominent craggy outcropping on the left and a river
on the right. Sometimes dancers appear in these ideal
scenes, as in *Dream of Arcadia* (1838, The Denver
Art Museum); often, as here, there are mothers with
small children, a fisherman, or a troubadour with a
lute, who may be singing to a roadside Madonna (*An
Italian Twilight*, 1841, Toledo Museum of Art), or, as
in this instance, to an assembly of picnickers. *Italian
Landscape* contains eighteen such figures, including
the artist himself, seen sketching the scene from the
shelter of a grove of trees in the extreme lower left of
the painting.

It is no accident that this Claudian reverie
deliberately recalls Cole's *Pastoral State* in the *Course
of Empire* series. But this is a post-desolation
landscape, a time after the fall of Rome when
humans have returned to a "chaste and harmonious"
serenity that, in the artist's terms, is mankind's proper
goal.[5] "What is Fame, if the mightiest empires leave
so little mark behind?"[6] Instead, we are counseled by

Cole to seek the solace of music, the art of harmony:

Sit thou enthroned where the Poet's mountain
Above the thunder lifts its silent peak,
And roll thy songs down like a gathering fountain,
That all may drink and find the rest they seek.
Sing! there shall silence grow in earth and lower heaven,
A silence of deep awe and wondering;
For listening gladly, bend the angels even,
To hear a mortal like an angel sing.[7]

Such landscapes have several purposes in Cole's
large view of history. In them we are reminded of the
transience of human endeavor, which is deliberately
contrasted to the permanence of God's creation in the
rocks and mountains that enclose the scene. They also
serve as statements of what makes a culture livable,
which for the artist was not the bustle of industrialism
and commerce, but rather a peaceable coexistence
with nature, enlivened by the arts.

BRUCE W. CHAMBERS

ASHER BROWN DURAND | 1796–1886

The Trysting Tree, 1868
Oil on canvas, 27½ × 42″ (69.85 × 106.68 cm.)
Signed, lower right
Museum purchase, 979-O-117

Asher Durand spent the first two decades of his working life as an engraver. During the 1830s he turned to painting portraits, and then, encouraged by Thomas Cole, to landscapes. By the 1840s Durand was concentrating on landscapes exclusively. Working in New York City, he became a close colleague of Cole, and served as president of the National Academy of Design. He regularly ventured into remote areas of the Catskill, Adirondack, and White Mountains to make sketches, which he used in the landscapes composed in his studio during the winter. These works evolved from staged, largely imagined idylls to ennobled portraits of specific places, compelling in breadth and detail, showing greater focus on literal transcription of nature and less reliance on conventional formula. Durand enjoyed a productive painting career that lasted through the 1860s. Although he enjoyed the respect of his fellow artists, his later years were described by his son as clouded by the American public's declining appreciation for native artists and subjects in favor of those from abroad.[1] During a tribute staged by his friends in 1872, the painter John F. Weir said of him, "I think we do too little . . . to show our respect for the pioneers of our pathways which have now become highways."[2]

Among Durand's last major landscapes, *The Trysting Tree* was commissioned by Benjamin Hazard Field, a wealthy merchant, as a gift for his wife, Catherine M. Van Cortlandt de Peyster, on their thirtieth wedding anniversary. The painting was intended to illustrate a verse by Field to her. Inscribed on the frame, the poem accompanied the painting when it was exhibited at the National Academy of Design in 1869 under the title *Moonlight*:

Among the hills, the woods and clouds,
 Where Hudson winds to sea,
'Twas there that Floy Van Cortlandt
 First gave her heart to me.
First gave her heart to me—
 Amidst the cannon's roar,
As I knelt with Floy Van Cortlandt
 Upon the moon-lit shore.

In 1867, evidently in anticipation of making a grand gesture on his wedding anniversary, Field prevailed upon his friend Fitz-Greene Halleck to invent a second verse:

And that I am all the world to her,
 It joys my breath to say,
For her beating heart has told me so
 For many a happy day.
For many a happy day—
 And her bonny lip and eye,
Oh! my darling Floy Van Cortlandt,
 'Tis for thee I'd live and die.

Then, Field asked Durand to complete the three-way collaborative gift.[3]

It was not unusual for Durand to accept a landscape commission in which setting and various details were stipulated by the patron. He enhanced Field's memory image of thirty years by setting the courting couple, moon, clouds, and the shores of a

winding Hudson River into the type of landscape in vogue when both he and his patron were young men by reverting to the classical landscape formula of the seventeenth-century French painter Claude Lorrain, on which he had frequently relied thirty years earlier. During the 1860s, Durand occasionally created landscapes in which such older formulas reappear. The evidence of *The Trysting Tree* suggests that he did so with a specific purpose in mind. Durand applied the Claudean formula: a tree framing a shadowy foreground, a body of water in the middle ground, low hills in the distance, and golden light suffusing the sky and reflected in the water. Into this Durand injected the rougher characteristics of Hudson River scenery: bare, rugged hills, choppy dark water, unkept foliage. He then added two of his own early signatures, the gnarled tree dominating the foreground and backlit with a glowing sky.[4]

In *The Trysting Tree*, Durand used nature as he had in his early landscapes, as symbolic of the psychology of the picture's human element. The absence of a deep vista, for example, corresponds to the intimacy of the young lovers, already protected under the spreading tree. That the orb in the sky looks more like a setting sun than a moon may be an

allusion to the impending "sunset years" of the real Mr. and Mrs. Field.

Durand also reflected on a bygone rural era in *The Trysting Tree*. The courtship spot, "where the Hudson winds to sea," is presumably in New York City or just a little north. Here it is scarcely touched by humans, for the cottage nestled in woods behind the lovers barely disturbs nature's pristine state. Although neither he nor Field ever owned such a home, both grew up in country settings, Durand in Maplewood, New Jersey, and Field in Yorktown, Westchester County. Both had long lived in lower Manhattan, and Durand had seen his once-quiet neighborhood on Amity Street become noisy, run-down, and filled with tenements. This painting seems to confirm the often-stated thesis that the appreciation for paintings of rural subjects in New York City in the 1850s and 1860s was fueled by the nostalgia of businessmen there for lives they once knew. If *The Trysting Tree* is an example, it suggests that escape to an idyllic setting and nostalgia for one's rural youth represented much the same thing.

DIANA STRAZDES

THOMAS DOUGHTY | 1793–1856

Denning's Point, Hudson River, c. 1839
Oil on mounted canvas, 24 × 30″ (60.96 × 76.20 cm.)
Unsigned
Anonymous gift, 961-O-104

Thomas Doughty was much admired and recognized in his day "one of the pioneers of our landscape Art," and as an artist who had painted "many noble pictures."[1] Doughty exhibited frequently at the Pennsylvania Academy of the Fine Arts, the National Academy of Design, the Boston Athenaeum, and the American Art-Union, and was an honorary professional member of the National Academy of Design.

Doughty first tried his hand at painting around 1816 while working as a leather currier in his native city of Philadelphia. In 1820, he dedicated himself to painting full time, frequently traveling to New York and New England in search of new scenery. Doughty's *Cabinet of Natural History and American Rural Sports*, a magazine co-published with his brother John, contained the first series of sporting prints made in America. In 1832, Doughty moved his residence to Boston, where he enjoyed his greatest financial success. After a two-year stay in England, he lived briefly in Newburgh, New York and, in 1840, settled in New York City.

Denning's Point, Hudson River was probably painted near the beginning of the artist's stay in Newburgh. In October of that year he exhibited two related landscapes at the Apollo Association in New York.[2] One, entitled *View from Denning's Point, Looking Up the Hudson*, depicted scenery in the opposite direction from the view shown here. The other, *Opening of the Highlands, from Below Newburgh, Looking Down the Hudson*, must have included much the same terrain as the Butler Institute painting.

Denning's Point, Hudson River exemplifies the type of quiet, pastoral landscape that made a name for the artist in the first half of the nineteenth century. In 1867, the art critic Henry T. Tuckerman praised Doughty for his "woodland landscapes, especially [his] many small, picturesque, and effectively colored scenes."[3] The painting is named for a small peninsula or spit of land jutting into the Hudson River from its eastern shore near Beacon, New York.[4] The peninsula, Denning's Point, is located in the center of Doughty's painting. In the background are Storm King and Crow's Nest mountains, and the rounded dome to the left is Sugarloaf Mountain. Directly across the river from Denning's Point, but not visible in this work, is the town of Newburgh.

Denning's Point, Hudson River is stylistically similar to much of Doughty's work from the mid-1830s and later. Frank H. Goodyear, Jr. has characterized this phase of the artist's work as broader and more painterly in handling than his earlier paintings, darker and more restrained in value, and with more emphasis on tonal values than variety of color or detail.[5] After the mid-1830s, Doughty's paintings reflect the influence of the picturesque English school of landscape painting. They also recall the French painter Claude Lorraine, whose landscapes were well-known among American painters. In general, Doughty's later paintings appear more idealized and less specific in their details than his earlier, more topographic views.

Doughty is an important predecessor of the Hudson River School, the loosely-affiliated group of painters who popularized views of the Catskills and the Hudson River region in the middle of the nineteenth century. Like them, Doughty created a variety of American landscapes ranging from the topographic and specific to the evocative and poetic. In *Denning's Point, Hudson River*, a romanticized view of an actual site, we find a little of each.

KATE NEARPASS OGDEN

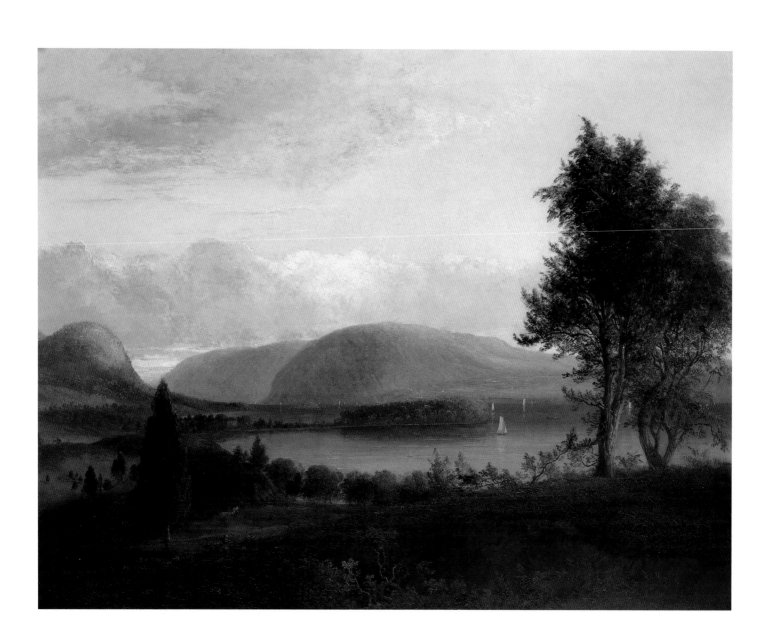

THOMAS HILL | 1829–1908

Bridal Veil Falls, Yosemite, c. 1870–84
Oil on canvas, 72 × 95″ (182.88 × 241.30 cm.)
Signed, lower left
Museum purchase, 969-O-109

The name of the painter Thomas Hill has long been linked with that of Yosemite Valley, California, his most frequent subject. When the artist was seventy, an art critic called him "The most ardent devotee at the shrine of Yosemite and the most faithful priest of the valley.[1] His enormous Yosemite panoramas were purchased by many of the social and business leaders of San Francisco, and one of his landscapes won a bronze medal at the Centennial Exposition in Philadelphia.

Born in England, Hill moved to Massachusetts with his family in 1844. He lived in Boston, Philadelphia, and Cambridge before moving to San Francisco in 1861. Hill first visited Yosemite Valley in 1862, a fact recently confirmed by the diary of a nineteenth-century tourist.[2] Following a visit to Europe in 1867 and a stay in Boston from 1868 to 1872, Hill made the San Francisco bay area his home, actively participating in the early artistic circles of the city and traveling frequently to Yosemite. In 1883, he established his first summer studio at Yosemite, and in 1886 he moved to Wawona, fifteen miles southwest of the valley, where he maintained a studio and residence the rest of his life.

Bridal Veil Falls, Yosemite depicts the Yosemite valley as seen from its western entrance. On the left is El Capitan, and on the right is Bridal Veil Falls. The formations named Sentinel Rock and Half Dome are faintly visible in the right background, as are the distant peaks of the High Sierra. This view of Yosemite is one Hill painted frequently, both in horizontal and vertical formats. The Native American encampment and the woman carrying a papoose in the foreground are elements he frequently included in his Yosemite landscapes to provide a focal point and a note of human interest. In romantic terms, the Native Americans add an element symbolic of wilderness, a suggestion of the way the valley looked before Anglo-Americans discovered it in 1851 and drove out the Southern Sierra Miwoks, the native inhabitants of the region.

Bridal Veil Falls, Yosemite is probably from the 1870s, when Hill painted several of his largest Yosemite panoramas for wealthy Californians. The painting's thick, impasto handling also relates it stylistically to other works of this period. An art critic of 1870 noted Hill's change from his earlier, sketchier style to the heavier technique seen here. "Thomas Hill," he wrote, "has ignored that free sketchy style in which he was so felicitous, and adopted the dry impasto mode of the French school. In the latter he is as yet a probationer; but time may ripen him into a master."[3] It is unlikely that *Bridal Veil Falls, Yosemite* was painted between 1884 and 1887, as it does not seem to be listed in the artist's business notebook from that period, and after 1890, Hill's style became freer and even less detailed than it appears here.

Hill's business notebook from 1884–1887 explains a great deal about his working methods. Standard subjects are listed with titles like "Morning in Yosemite Valley," and "General View from Bridal Veil Meadow." The last is a reference to the type of view shown here. Clients even requested specific seasons and times of day, and Hill duly noted their preferences: "early morning," "mid-day spring time," and "sunset with Indians."[4] According to the notebook, Hill's clientele came from around the world, although most hailed from San Francisco, the eastern and midwestern United States, and England. Hill's most notable British clients and visitors included the Earl of Durham, the Honorable Evan Charteris, and Lord Henry Paulet. *Bridal Veil Falls, Yosemite*, which found its way back to America from a collection in England, was very likely purchased by British tourists visiting California.[5] Hill continued to paint Yosemite for the rest of his career, working in his studio at Wawona and spending the cold Sierra winters in nearby Raymond, California.

KATE NEARPASS OGDEN

GEORGE CALEB BINGHAM | 1811–1879

Portrait of James Harrison Cravens, 1842
Oil on canvas, oval, 27 × 22″ (68.58 × 55.88 cm.)
Unsigned
Museum purchase, 966-O-126

In our quite justified admiration for George Caleb Bingham's paintings of Missouri River flatboatmen and frontier political events—images which create much of our mythic vision of the American West—we forget that his portraits are more numerous by far and provided the greater part of his livelihood.[1] Born in Virginia, Bingham emigrated with his family to Missouri in 1819, where by the age of twenty-one he had become an itinerant portrait painter along the Missouri and Mississippi rivers, ultimately settling in St. Louis. He studied briefly in Philadelphia and visited Baltimore and possibly New York, where his first boatmen picture was exhibited in 1838. Upon returning to Missouri he continued to paint portraits, but in 1840 sent a landscape, two versions of a literary subject, and three figure pieces to the annual exhibition at the National Academy of Design. It was also in 1840 that Bingham gave a political speech and painted a banner supporting William Henry Harrison, the presidential candidate of the Whig Party, of which Bingham was an ardent member.[2] As much a politician as a painter, after Harrison's victory Bingham moved to Washington, D.C. in 1840, where he hoped to establish a wider reputation by painting the notables of the new Whig administration. It was there, in August 1842, that Bingham painted James Harrison Cravens (1801–1876).[3] Like Bingham, a native of Virginia and a Whig, Cravens had moved to Indiana, where he served in the state House of Representatives from 1831 to 1832 and the state Senate in 1839, before being elected to the Twenty-seventh Congress in 1841.[4] Cravens was elected again to the Indiana House in 1856, and served during the Civil War as a Lieutenant Colonel in the Indiana Volunteer Infantry.

Simple in structure, the Cravens portrait is one of Bingham's best from his Washington years. It is crisply drawn and firmly modeled. Although Bingham did not leave out the scar on Cravens's left cheek, detail is, in general, less insistent than before his Washington years. Bingham has softened the contrast between highlights and shadows, contours are no longer hard and glaring. The successful suggestion of the satin coat lapel is an uncommon accomplishment.

Bingham returned to Missouri from Washington in late 1844 to paint portraits of prominent politicians, and himself became a member of the Missouri Legislature and later State Treasurer and Adjutant General. In 1845 he sent to the American Art-Union *Fur Traders Descending the Missouri* (1845, The Metropolitan Museum of Art), and during the following years he produced the genre pictures which have established his enduring reputation.

WILLIAM S. TALBOT

WORTHINGTON WHITTREDGE | 1820–1910

Landscape Near Rome, 1858
Oil on canvas, 33 × 54″ (83.82 × 137.16 cm.)
Signed, lower right
Museum purchase, 965-O-107

In 1849 Worthington Whittredge left Cincinnati, where he and William Sonntag had established a distinctive regional variant of the Hudson River school, for Europe. His avowed intention, unusual among American landscapists, was to find a teacher. Like many artists from the Midwest, he was essentially self-taught. Finding Paris too expensive and not being impressed by the Barbizon painters, he soon journeyed to Düsseldorf, where he remained for nearly seven years. In the autumn of 1856, after spending the summer sketching in Switzerland, he settled in Rome with Sanford R. Gifford and Albert Bierstadt. Although his friends left the following summer, Whittredge remained in Rome another two years. Whereas he had been well armed with commissions from Cincinnati patrons while in Germany, he was forced to turn to the open market in Rome. As he wrote in his autobiography: "The necessity of selling our work made us bestir ourselves in society, and in making the acquaintance of all the strangers we could, who had come to town."[1] In this he seems to have been successful enough, for he was able to survive in reasonable comfort in a city legendary as one of the cheapest in all of Europe.

The works he painted for the tourist trade fall into two broad classes: Swiss scenes, mainly of Lake Lucerne, and standard picturesque views of the Roman Campagna. The Butler Institute painting, however, partakes of both. Long called *Landscape Near Rome*, it was executed when he spent the summer around Lake Albano and in the Sabine mountains.[2] A slightly smaller variant, with different figures in the foreground, was called *View of Lake Albano* when it passed through auction in 1984.[3] Nevertheless, the landscape does not look like the scenery to the south and east of Rome. If the artist intended to show that area, then he has transformed it completely to conform to his Swiss scenes, so that the setting suggests instead a view in the alpine region of northern Italy. The figures, which are standard in Whittredge's European canvases, add a picturesque note. Their costumes further indicate that the locale may be northern Italy, as do the boats, which are indigenous to that area. This, interestingly enough, agrees with the views of the donor, who also regarded it as "probably of a lake in the Italian alps."[4] The painting is similar in composition and style to Whittredge's pictures of Switzerland. Like them, it is horizontal in format, and keeps the mountains at a safe remove. He noted in his autobiography, "I never got into the way of measuring all grandeur in a perpendicular line. . . ."[5] And like them, it is painted in the academic manner he had absorbed from Carl Friedrich Lessing, Andreas Achenbach, and Johann Schirmer in Düsseldorf, which had much in common with that of the Swiss school led by François Diday. It differs, however, in the darker tonality and freer execution. The artist must have regarded the canvas as especially successful, since, as noted above, he repeated it at least once, something that is quite rare in his oeuvre.

ANTHONY F. JANSON

JAMES E. BUTTERSWORTH | 1817–1894

Ship: Valparaiso, c. 1855
Oil on canvas, 24×36″ (60.96×91.44 cm.)
Signed, lower right
Museum purchase, S28-O-122

Considered among the foremost American ship portraitists of the nineteenth century, James E. Buttersworth was born in Middlesex County, England in 1817 and studied painting with Thomas Buttersworth, the noted British marine painter.[1] He moved to the United States around 1845 and settled in West Hoboken, New Jersey. He is also recorded as having had a studio in Brooklyn in 1854.[2]

Through the 1850s, Buttersworth developed a prominent reputation as a ship portraitist. He is known, in retrospect, for his precisely drawn and finely detailed renderings of the sleek new clipper ships which were circling the globe in record-breaking times during this period. Underscoring both his importance as artist and the wide popularity of these extraordinary new vessels, Nathaniel Currier and James Merritt Ives modeled numerous popular lithographs on his fine paintings executed between 1847 and 1865. Buttersworth also exhibited his work frequently throughout the 1850s at the American Art-Union.

In *Ship: Valparaiso*, while the detailed rendering of the vessel's sails and rigging clearly define this image as a ship portrait, there is also a narrative element indicated by other vessels in the distance suggesting a race, typical of Buttersworth's approach to this genre.

Buttersworth painted another very closely related version of this sleekly elegant 1,158 ton clipper ship built at Newburyport, Massachusetts by John Currier, Jr. in 1863. The Butler Institute *Ship: Valparaiso* and the other version, also *Ship: Valparaiso* (n.d., private collection), differ only in minor details—the placement of the gulls, the handling of the water and sky, and the treatment of the ship's reflection in the water.

HAROLD B. NELSON

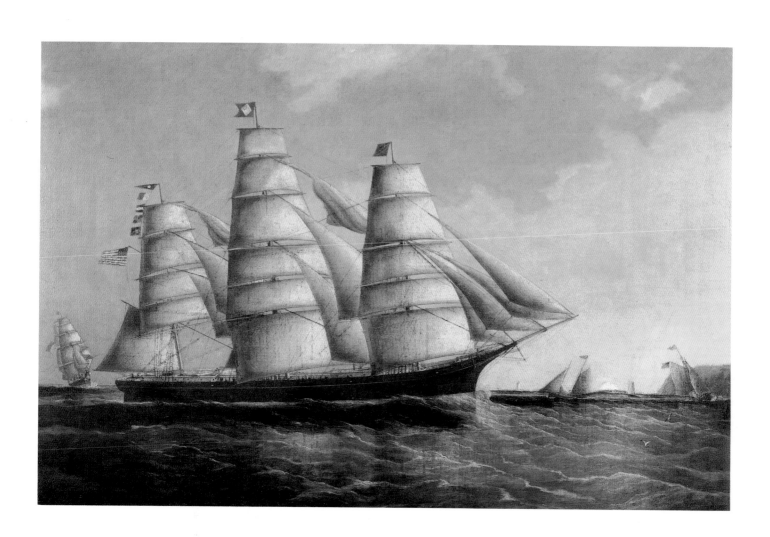

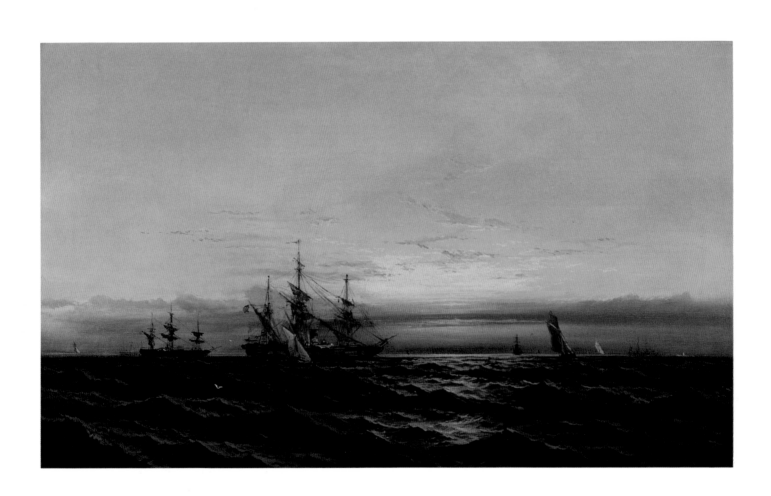

JAMES HAMILTON | 1819-1878

From Sail to Steam, c. 1870s
Oil on canvas, 30 × 50″ (76.20 × 127.00 cm.)
Signed, lower right
Museum purchase, 968-O-215

Esteemed by his peers as "our ablest marine painter," James Hamilton won fame as an artist who, "in his best works, exhibited the higher mental powers of the poet, as well as rare technical skill."[1] Born in Entrien, near Belfast, Ireland, Hamilton emigrated with his family to the United States in 1834, settling in Philadelphia. He exhibited his first paintings six years later, having secured instruction in drawing along with advice from older artists and lessons from engravings and books. Philadelphia boasted a strong tradition of marine painting in the figure of Thomas Birch (1779–1851), from whom Hamilton likely drew inspiration. Hamilton also learned of the contemporary school of English landscape painters through printed sources. His admiration for Samuel Prout and J. M. W. Turner was established well before 1854, the year Hamilton traveled to England and had the opportunity to study those artists' work directly.[2]

By 1850 Hamilton had demonstrated a proclivity for marine subjects. While selling and receiving commissions for paintings, he also worked as an illustrator. Between 1853 and 1856 he collaborated on publications by the arctic explorer Elisha Kent Kane, transforming rough field sketches into artful illustrations. Continuing to work out of Philadelphia, Hamilton apparently traveled no farther north than Boston in search of coastline scenery. Literature, engravings, and poetic imagination inspired his paintings of foreign coasts and historic naval battles, images which Hamilton animated with distinctive brushwork and dramatic color.

In 1875 Hamilton sold most of his books, engravings, sketches, and paintings, anticipating a journey around the world. Arriving in San Francisco the next year, he received a warm welcome from the artistic community there. He was still in San Francisco when he died unexpectedly in 1878.

From Sail to Steam may well record a view looking west across the swells of the Pacific Ocean. Yet the very absence of landmarks in Hamilton's painting serves to underline the central role of light. The long, hot rays of a dying sun, stretching across the water below a low horizon, gently and gradually coloring the sky above, align Hamilton with the luminist tradition in American landscape painting. This same light, however, divides the composition vertically, recalling the legacy of Turner. Likewise, the choppy waves suggest an underlying turbulence antithetical to luminist repose.[3] Contrasts beloved by the earlier Romantics still linger: the dark sea below an atmospheric sky; two white birds, one above, one below the horizon; weighty steamers, pushing into the wind with their sails furled, juxtaposed against small and spritely craft with their sails open. The title *From Sail to Steam* is not one that Hamilton would have given to this painting,[4] but the phrase still suggests its central theme: the passage of time and the undeniably altered mood of post-Civil War America, blessed with technological prowess but nostalgic for innocence lost.

SALLY MILLS

EDWARD MORAN | 1829–1901

New Castle on the Delaware, 1857
Oil on canvas, 40 × 60″ (101.60 × 152.40 cm.)
Signed, lower left
Museum purchase, 976-O-113

Edward Moran, the oldest of the artistic Moran brothers, was acknowledged as the impetus behind the family's entry into the art world. "He taught the rest of us Morans all we know about art," stated his famous younger brother Thomas.[1] During a long and successful career, Edward Moran became a member of the Philadelphia Academy of the Fine Arts and an Associate of the National Academy of Design. After working at a variety of trades, he turned to painting in the early 1850s. The first twenty-seven years of his artistic career were spent in Philadelphia, where he studied painting with the marine painter James Hamilton and with the landscapist Paul Weber. Moran's training with Hamilton and Weber is clear in *New Castle on the Delaware*. Stylistically, the painting exhibits the careful details and truth to nature of his more detailed early phase. In 1861, Moran traveled to London for additional instruction at the Royal Academy, and in 1871 he relocated to the New York area, where he remained for the rest of his life.

Seascapes were Moran's forte. By the 1880s, the artist was considered such an expert on the subject that his "hints for practical study" of marine painting were published in the September and November, 1888, issues of the *Art Amateur*. After his death, an admirer wrote that "As a painter of the sea in its many moods and phases, Edward Moran . . . had no superior in America."[2]

In the year *New Castle on the Delaware* was finished, Moran exhibited two paintings with that title; one was shown at the annual exhibition of the Pennsylvania Academy of the Fine Arts, and the other was exhibited at the National Academy of Design in New York. One of these paintings may be the version now at the Butler Institute.

The painting depicts the town of New Castle, located on the west bank of the Delaware River. Settled by the Dutch as New Amstel in the 1650s, New Castle is situated about six miles south of Wilmington and less than three miles southwest of the present-day Delaware Memorial Bridge. The building in the center with a cupola is the terminal building of the New Castle and Frenchtown Turnpike Company, located on the battery, now Battery Park. Immediately in front of it is the Banks Building, with its porch front, the site of an old market on the wharf. Near the center of town is a square tower that probably represents the unfinished new Presbyterian Church, construction of which began in 1854. Further back, at the top of the hill, is the white spire of Immanuel Church, built in 1689 and given its present spire in 1820–22.[3]

As painted by Moran, New Castle harbor contains the usual complement of sailing vessels, including a boat in the foreground appropriately named the New Castle. Surprisingly, only two boats in the harbor are side-wheelers, the steam-powered vessels introduced earlier in the century that led to the decline of the clipper ships. Moran continued to paint nautical subjects for the rest of his career. After a trip to France from 1877 to 1879, however, his work became broader in handling, less detailed, and more painterly than the Butler Institute painting.

KATE NEARPASS OGDEN

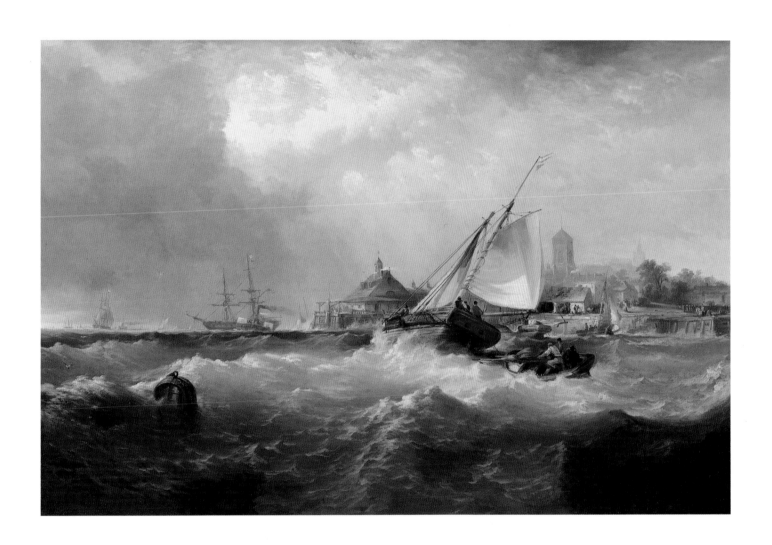

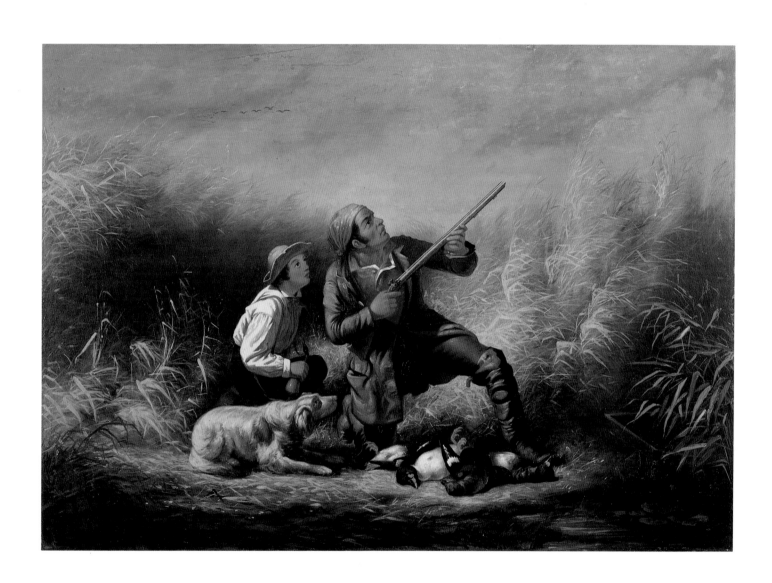

WILLIAM TYLEE RANNEY | 1813–1857

On the Wing, c. 1850
Oil on canvas, 32 × 45″ (81.28 × 114.30 cm.)
Unsigned
Museum purchase, 964-O-102

Well regarded in his lifetime as a genre painter, William T. Ranney was especially known for his sporting scenes. Such scenes attracted numerous mid-century artists and enjoyed a large audience. Ranney, along with Arthur F. Tait, stood in the front rank of painters of sporting pictures. *On the Wing* was one of his most popular, evidenced by Ranney having created at least four versions of the image.[1] Widely known through an engraving published by the American Art-Union in its *Bulletin* for October, 1850, *On the Wing* also appeared in the gift book *Ornaments of Memory* (1856 and 1857). Precisely where the Butler Institute painting fits into the chronology of the four versions (only one of which is dated) is not known, although, like the others, it was apparently executed around 1850. While all four painted versions offer nearly identical compositions, the Butler Institute's *On the Wing* sets the figures in a more dynamically rendered, wind-blown environment.

A writer of 1850 deemed the image "capital, in its style. Sportsman and dog are both in the best spirits, and are transferred to the canvas without losing anything of their keen relish of the sport."[2] The appeal of Ranney's painting lies in its convincing portrayal of the alert, poised hunter and the tense, crouching boy and dog, all motionless, yet charged with potential energy. Dead game on the ground underscore the figures' vitality. Ranney plants the compactly rendered, centralized group in the midst of wind-blown marsh vegetation. More than the other versions, the Butler Institute's painting presents a

dramatic contrast between the still, yet tense figures and the agitated reeds. Ranney accomplishes this by defining the marsh grass and reeds with much looser, broader, and quicker strokes than those he employed in the figures. The sense of dramatic intensity is further conveyed by the shared concentration of the man, boy, and dog. All eyes focus skyward, leading the viewer to search also for the rising ducks and to anticipate the explosive action to follow. Besides providing a pleasing visual narrative, *On the Wing* contributed to the era's nationalistic imagery with its striking portrayal of vigorous American outdoorsmen in the natural world, enjoying its bounty.

Throughout his career, Ranney rendered sporting scenes as well as genre and history paintings. He was also known as a painter of the American West, a part of the country he had come to know while serving in the Republic Army of Texas in 1836. As a mature artist, Ranney lived in New York and New Jersey and regularly exhibited with the American Art-Union and at the National Academy of Design. The respect with which his peers regarded him manifested itself in a special exhibition, to benefit his family, held at the National Academy of Design the year after he died. In response to this exhibition a contemporary declared: "A specimen of Ranney is indispensable wherever a collection of American art exists."[3] *On the Wing* certainly warrants this claim.

MARK THISTLETHWAITE

FITZ HUGH LANE | 1804–1865

Ship Starlight, c. 1860
Oil on canvas, 30 × 50″ (76.20 × 127.00 cm.)
Unsigned
Museum purchase, S28-O-127

A painter of ships and marine views for all of his life, Fitz Hugh Lane has created, in *Ship Starlight*, one of the magical images of his late career. Born and raised in Gloucester, Massachusetts, where he returned in the late 1840s after several years of training in Boston, he found most of his inspiration for subjects along the Massachusetts and Maine coasts. Apprenticed in Boston at Pendleton's lithography shop, he learned the technical and expressive values of drawing in black and white, which gave all his subsequent art a fundamental command of two essential elements: tonal contrasts and meticulous delineation of details. Even this work of his late maturity reflects his mastery of that graphic training, for although it is a painting of the most delicate nuances of coloring and of atmospheric unity, its clarity, not just of form but of vision, derives from his very calculated balancing of lights and darks and equally controlled handling of line and outline.

Characteristic of Lane's work at this time, the subject of this painting only partially reveals itself. While we know the name of the vessel from the small sign on the headboard at the bow, and the date of the painting, 1860, we cannot be certain of the ship's cargo or purpose; we do not know if the artist or a patron initiated the painting; and the location of the scene is obscured in the veil of bright fog. This tantalizing fusion of the specific and identifiable with the elusive and transcendental is one of his most imaginative achievements in his last years. It was not always so in his work. Lane had learned all the conventions of ship portraiture primarily from the prevalent examples he saw of Robert Salmon's work and from English and Dutch "marines" at the annual Boston Athenaeum exhibitions.[1] Salmon was an established English marine artist who had emigrated to Boston in 1829, and became the fashionable painter of the genre there during the next decade and a half. One of Lane's earliest harbor scenes centering around a ship portrait was *The Yacht "Northern Light" in Boston Harbor* (1845, Shelburne Museum, Vt.), which had an inscription on the reverse, visible before relining, "Painted by FH Lane from a sketch by Salmon/1845."[2] Although Lane would later give up the rather dense, cluttered composition typical of the older artist, he took over the same format of a vessel depicted in full broadside profile and occupying much of the middle ground. The motion of vessels, figures, water, and air also gives these earlier works a lively narrative underpinning, which Lane will likewise transform into the more suggestive and contemplative air seen in *Ship Starlight*. Throughout his career he continued to paint such conventional ship portraits of both locally familiar and nationally famous vessels, usually on commission from a ship captain or owner.[3] At the same time, especially from the later 1850s on, his personal style and subject matter was evolving in the signature images of the New England coast, often stilled in the delicate transitional moments of dawn or twilight. In these works the dominating presence of light and atmosphere increasingly became the principal expressive elements of his vision. Having depicted countless specific sections of harbors or shorelines around Cape Ann, Massachusetts and Mount Desert Island, Maine, documented by pencil drawings on successive summer trips through the early 1850s, Lane gradually relied less on factual recording and more on the powers of his memory and imagination. The Butler Institute canvas is a classic result of this overlay of meditation and recollection, in which a known and observed vessel is projected into a ghostly world of suspended luminosity.

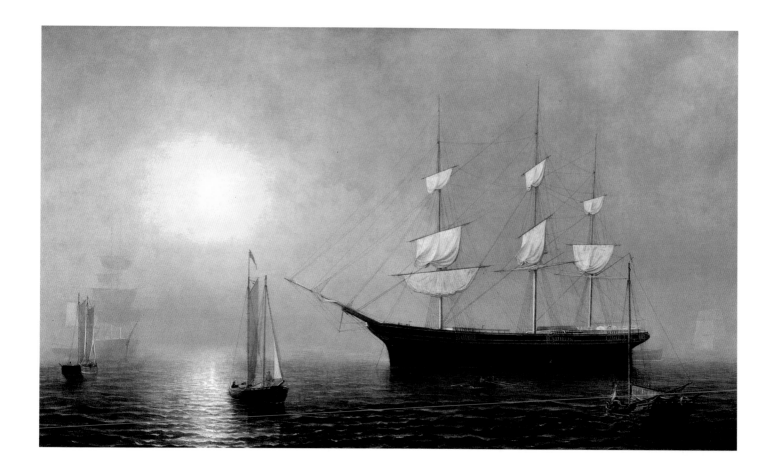

Preceding this work, Lane had only occasionally attempted the challenge of painting scenes of mist or fog, the most notable examples being *Shipping in Down East Waters* (c. 1850, William A. Farnsworth Library and Art Museum, Rockland, Me.), *Sunrise Through Mist* (1852, Shelburne Museum, Vt.), and *Bear Island, Northeast Harbor* (1855, Cape Ann Historical Association, Gloucester, Mass.). Even with their special technical effects, these remain essentially depictions of recognizable places, in comparison to the silvery atmosphere enveloping the *Starlight*. Lane had, in fact, portrayed this vessel once before, in 1854 (Richard York Gallery, New York), and that earlier picture shows a vessel with a quite different, lower, profile of the bow.[4] She is also anchored just off a wharf, most likely in Boston Harbor. Called a medium clipper ship, she was built by E. & H. O. Briggs of South Boston, and her launching early in 1854 probably occasioned Lane's first portrait. Over the next decade she made several passages around

South America to San Francisco and from there to points across the Pacific.[5] During conservation, examination, and treatment of the Butler Institute canvas in 1985, not only were various abrasions noted in the paint surface, but multiple layers of pigment showing changes were discovered, and beneath them evidence of careful underdrawing in many areas of the composition. As he worked on the canvas, Lane made a number of critical adjustments, including lowering some of the spars and sails on the mizzen mast, and raising the stern and bowsprit. This last, which accounts for the discrepancy with his earlier rendering, was purely a refinement to the overall design.[6] Here the bowsprit's line angles up to converge with the rising masts of the small schooner off the *Starlight*'s bow; together they point to the sun burning through the fog and illuminating everything in its perfect place.

JOHN WILMERDING

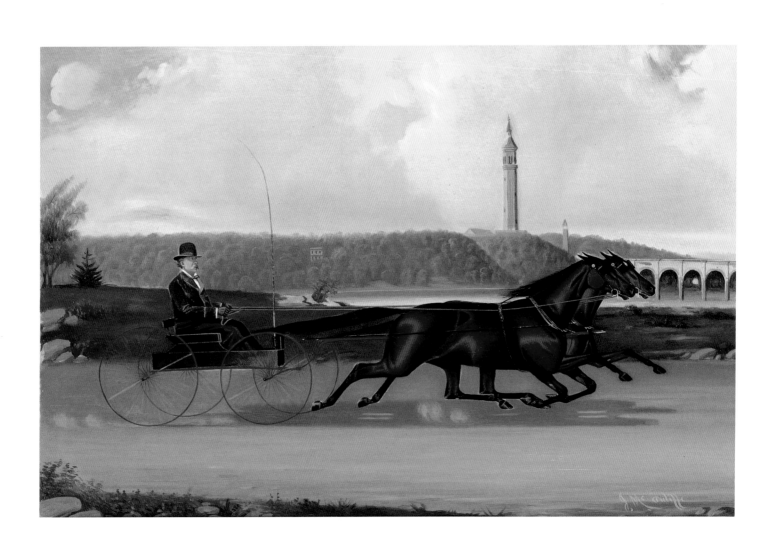

JOHN MCAULIFFE | 1830–1900

Colonel Jim Douglas and His Trotting Mares
Oil on paper, 14×21″ (35.56×53.34 cm.)
Signed, lower right
Museum purchase, 965-O-149

Born in Ireland, John McAuliffe came to America in 1847 and spent much of his life in New York City. He began his career as a house painter, but soon found an outlet for his horse-drawing talents rendering portraits of individuals active in the sport of harness racing, or trotting, as it was known.[1] Trotting first gained popularity in New York before the Civil War and grew to become the leading spectator sport in the country by the early 1870s.[2] Following the depression of 1837 and the concurrent collapse of thoroughbred racing in the northern states, trotting took precedence as an American sport. According to an English observer in 1857, trotting "is the people's sport . . . and consequently is, and will be, supported by the people."[3] Less aristocratic than thoroughbred racing, trotting originated not on the race track but in informal contests on urban roads. It required neither professional jockeys nor horses of great distinction, providing instead an opportunity for horse owners to hone their riding and horsetraining skills. The practicality of trotting was noted by one columnist in 1847, who wrote that it was "a more useful sport, as the qualities in the horse which it is calculated to develop are more intimately connected with the daily business of life."[4]

Colonel Jim Douglas was a Louisville, Kentucky businessman who participated in the popularization of trotting in the South, developing Douglas Park in Louisville in 1890 for the sport. It is unknown how much time Douglas spent in New York, but it was likely that he was first exposed to trotting there. In the painting, dated after 1872, Douglas is shown driving two of his mares along the Harlem River in the Bronx, with the High Bridge, the High Bridge Water Tower, and the Morris-Jumel Mansion in the background.[5] The High Bridge, the oldest remaining bridge joining Manhattan to the mainland, was constructed in 1842 to carry the first dependable supply of fresh water into Manhattan. To accommodate the demand for increased water pressure in the growing city, the two-hundred-foot High Bridge Water Tower, which concealed a 47,000 gallon tank behind its granite walls, was completed in 1872. To the left of the tower, nestled in the trees, is the Morris-Jumel Mansion, an estate that once ran the width of Manhattan Island. Built in the 1760s by the royalist Roger Morris, it served as a headquarters for George Washington during the Revolution, a tavern until 1810, and a residence for Aaron Burr during his year-long marriage to Madame Jumel, who lived in the house until her death in 1865. As they clearly were in Douglas's time, the bridge, tower, and mansion remain landmarks above the Harlem River Valley.[6]

McAuliffe is known to have executed similar works for New York patrons, including Robert Bonner, owner of the *New York Ledger*, whose friendly competition with Cornelius Vanderbilt for the best trotting horses in New York lent the sport its first taste of upper-class respectability. The adoption of trotting as a subject for society portraits was beneficial to artists such as McAuliffe, but at the same time marked the end of trotting's popularity as an all-American sport. By the 1880s, this designation had fallen definitively to baseball.

DANIEL STRONG

ARTHUR FITZWILLIAM TAIT | 1819–1905

Barnyard, 1860
Oil on canvas, 16 × 26″ (40.64 × 66.04 cm.)
Signed, lower right
Museum purchase, 948-O-121

Arthur Fitzwilliam Tait arrived in New York City from Liverpool in 1850.[1] In the early 1840s in Manchester, England, he had worked for Agnew's Repository of the Arts where he was exposed to the art of Edwin Landseer and John Frederick Herring and was encouraged to try his own hand at the lithographer's art.[2] *Barnyard*, meticulously recorded in Tait's Register as item 155 for the year 1860, demonstrates his strong familiarity with English sporting paintings and prints.[3]

Tait's kinship with Herring is apparent in the similarity of this painting of December, 1860, to Herring's account of his own painting (1861, title and location unknown) less than a year later: "It represents a stable, a white horse . . . white ducks, brown ducks and a black cat," and Herring continues, noting his "colourman's compliment" on his "management of white, at all times a difficult colour to treat without appearing dirty."[4] Like Herring, Tait was above all a colorist, and the white horse dominates his scene, its whiteness enshrouded by a dark background and circumscribed by a blue-green wall with shuttered window at the right. The white horse is solitary in his stature and nurturing role.

After 1862, Tait's production of horse paintings declined as he turned increasingly to deer hunting and Adirondack sites for his sporting subjects. However, his pride in this genre is evidenced by his having exhibited a painting of the same size and date as *Barnyard* in the National Academy of Design show in the spring of 1861.[5] His choice of *Feeding Time* (1860, location unknown) over *Barnyard* for the exhibition may have been determined by its inclusion of a figure raking hay, which suggested greater academic proficiency. *Barnyard* was purchased by Mr. C. B. Wood, whose name occurs a year earlier in Tait's Register when he purchased a small oil, *Deer, Buck and Doe* (n.d., location unknown).[6] The same painting appears in the National Academy of Design Exhibition of 1859 as *Deer*, owned by Mr. C. B. Wood.[7] Mr. Wood's importance as a collector of Tait can be readily established by the hefty price he paid for *Barnyard*.[8]

Tait's specificity in signing "Morrisania" on this oil marks a moment of joy in his life. He and his wife Marian had purchased a farm in Westchester County just a year before, which provided him with the opportunity to paint animals out-of-doors, thereby capturing the effects of light and color in a manner that was not available to the prestigious Mr. Herring.[9]

PATRICIA C. F. MANDEL

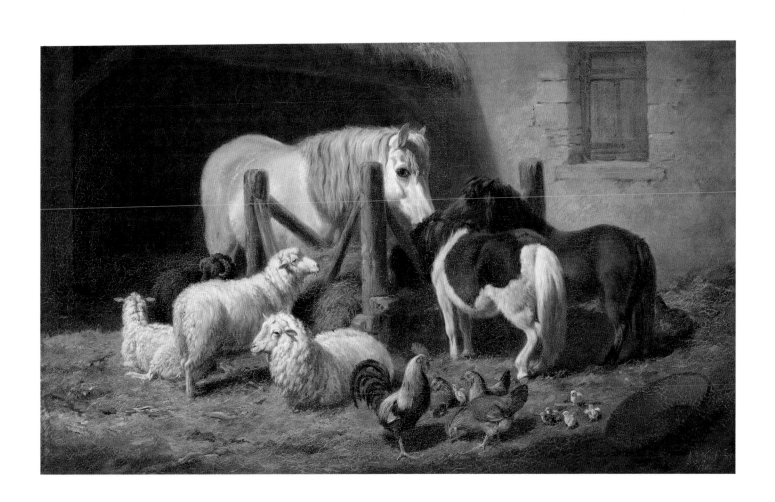

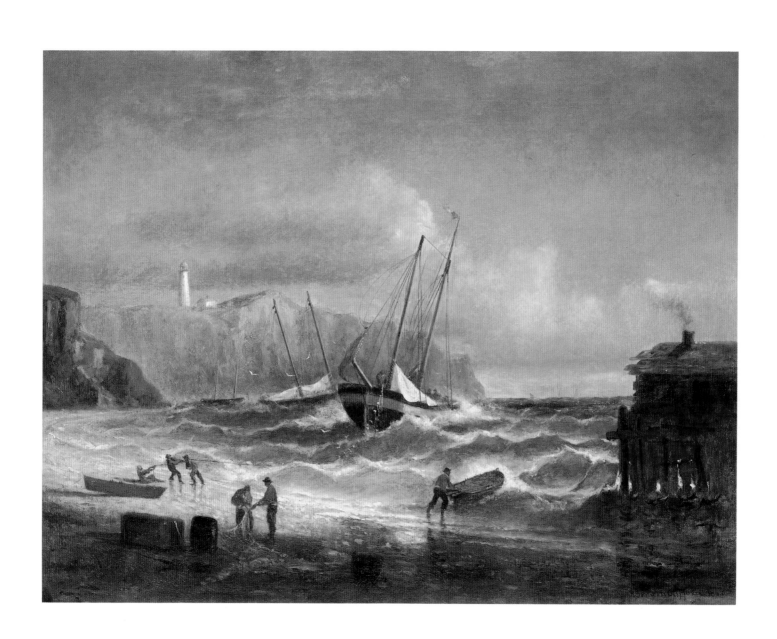

ROBERT SWAIN GIFFORD | 1840–1905

Cliff-Scene, Grand Manan, 1865
Oil on canvas, 21×27″ (53.34×68.58 cm.)
Signed, lower right
Museum purchase, 969-O-115

During his lifetime, Robert Swain Gifford was a member of the National Academy of Design and a founding member of the American Society of Painters in Watercolors. His paintings won awards at the Centennial Exposition in Philadelphia and the 1889 International Exposition in Paris. Gifford taught at the Cooper Union in New York from 1877 to 1896 and was afterwards promoted to art director, a position he held until his death in 1905.

Gifford traveled widely in search of new and interesting landscape subjects. Grand Manan Island, the subject of the work shown here, is located eight miles off the easternmost tip of Maine, at the border of the United States and New Brunswick, Canada. Grand Manan was brought to public attention by Frederic E. Church, who painted its scenery in the early 1850s. Other artists who followed his lead include Alfred T. Bricher and John G. Brown.

Gifford visited Grand Manan in June, 1864, with the sculptor Walton Ricketson, with whom he shared studio space in New Bedford, Massachusetts. He was inspired by the island's rocky cliffs and dramatic scenery, using them in several paintings over the next few years. Most of Gifford's Grand Manan paintings are coastal subjects similar in composition to *Cliff-Scene, Grand Manan*. Three are dated 1864, the Butler Institute painting is dated 1865, and still another was finished in 1867. In 1865, Gifford exhibited one of his paintings, *Scene at Grand Manan, Bay of Fundy*, at the National Academy of Design, and again, in 1867, he exhibited *Cliff Scene on Grand Manan Island Bay*. Either of these might be the version now owned by the Butler Institute. The painting shown in 1865 seems the more likely candidate of the two, since artists generally exhibited their most recent work in the Academy exhibitions.

Gifford loosely based the setting of *Cliff-Scene, Grand Manan* on the setting of Pettes Cove and the Swallow Tail Light situated at the northeastern end of the island, although he has exaggerated the height of the cliffs to increase their dramatic impact. He has also substituted a cylindrical, American-style lighthouse for the actual Swallow Tail Light, which is octagonal and thus more typical of New Brunswick lighthouses. Gifford painted Pettes Cove "before the infamous gales that carried away all the fish stands or sheds, such as the one seen on the right."[1] A storm out at sea could account for the combination of blue sky and heavy surf and could have driven the three fishing boats this dangerously close to the beach. The fishermen, however, are engaged in routine activities, seemingly unconcerned about the high waves and the tossing ships' proximity to shore.

Gifford painted *Cliff-Scene, Grand Manan* "at a time when the influence of his sometimes mentor, Albert Van Beest, [was] strongly evident."[2] The Dutch artist Van Beest had arrived in Fairhaven, near New Bedford, in 1854, while Gifford still lived there with his family. The Dutchman soon took the younger painter as a student and assistant. Gifford's early paintings, like those of his mentor, are mostly marine subjects; stylistically they are similar in their tight, carefully detailed handling of paint. After traveling in Europe and North Africa in the early 1870s, Gifford's style became considerably looser, less detailed, and more painterly. After his death, an admirer noted the artist's preference for the "stern, strong, severe phases of nature," adding that his best works impress the viewer "with an air of nobility and power."[3]

KATE NEARPASS OGDEN

FREDERICK RONDEL | 1826–1892

The Picnic, c. 1864–66
Oil on canvas, 19½ × 34″ (49.53 × 86.36 cm.)
Signed, lower left
Museum purchase, 965-O-167

Picnic scenes became an increasingly popular genre subject in American painting during the nineteenth century.[1] Though Frederick Rondel, born and trained in Paris, is known most often as a landscapist, it is his genre scenes set within rustic landscapes such as *The Picnic*, which recall the era's genteel charm.

By 1855, Rondel was living in Boston, where he was a lithographer and painter. He moved to New York City in late 1859 and, in 1861, became a member of the National Academy of Design. In 1862 Rondel accepted a commission from Matthew Vassar to paint documentary pictures of Vassar's homes. He moved to Poughkeepsie the following year, probably to finish this commission.[2] In 1868 he returned to New York City and, except for trips in 1862 to Europe, and in 1875 to San Francisco, Rondel stayed in the East, painting mostly landscape scenes of the Hudson River Valley and the Adirondack Mountains.

It was while Rondel was in Poughkeepsie that Henry S. Frost (1796–1879), a Poughkeepsie businessman, commissioned the artist to paint *The Picnic*.[3] Although the location depicted is yet unknown, it is most likely a clearing in the woods near Poughkeepsie, and, from the hint of orange in the foliage, the season is early autumn. The presence of the seated soldier and the cavalry man in Union uniforms, the celebratory mood of the scene, and the costume fashions of the other figures date the work rather firmly between 1864–66.[4] Within these years, however, the work could have vastly different interpretations. If painted earlier, it could be a celebratory interlude for the family during a period of heightened warfare and tension or, if painted later, a celebration of relief, the future secure. Although Frost's son, William, was of the age to have been in the Civil War, it is unknown whether he actually served or if this painting commemorates such a service since the exact purpose of the commission is unknown.

While *The Picnic* was never exhibited by Rondel, it is among his best genres scenes, quite similar to his *A Hunting Party in the Woods, In the Adirondac, N.Y. State* [sic] (1857, The Adirondack Museum, Blue Mountain Lake, N.Y.), which was probably also done as a commission.[5] Both works are characteristically serene, but with complex composition and action. The lush, verdant landscape is clear evidence of Rondel's training under the French romantic landscape artists, Auguste Jugelet and Théodore Gudin. Rather than merely a backdrop to showcase the figures, the landscape is a permeable environment within which the figures are busily engaged in an activity at hand. In *The Picnic*, one servant carves away at a ham while another brings refreshments, children sneak tidbits as energetically as they unpack, and a couple intently engage in an amorous tête-à-tête. Rondel has included himself leaning against a tree, serenely observing the family's activities; a part of the scene, yet not active in it.[6] In both paintings a group enjoys the landscape, free from the demands and constraints of urban life. In the Adirondack work, it is sportsmen who take their ease after a day of hunting or fishing. In *The Picnic*, it is a family who enjoy the day's celebration, readying a meal possibly after partaking of the activity on the large and still crowded dance floor in the background. *The Picnic* is clearly a work of celebration. Though its narrative is one of a dance, it is also one of life—squirmy children, starry-eyed couples, and a bountiful land of prosperity.

M. MELISSA WOLFE

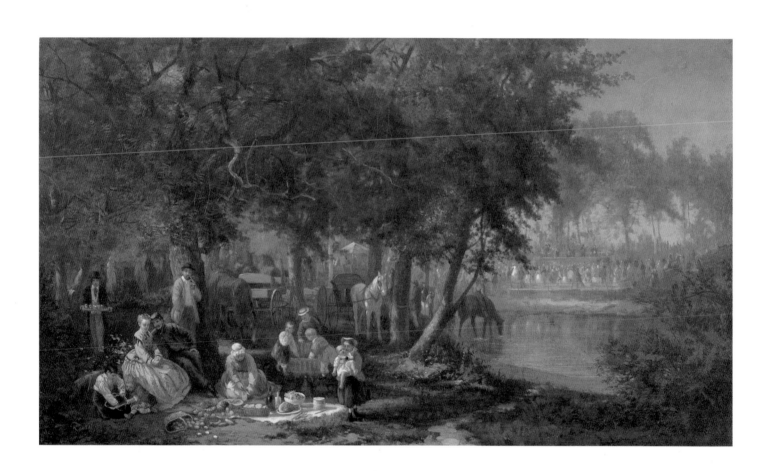

ALBERT BIERSTADT | 1830–1902

The Oregon Trail, 1869
Oil on canvas, 31 × 49″ (78.74 × 124.46 cm.)
Signed, lower right
Gift of Joseph G. Butler, III, 946-O-101

Albert Bierstadt went west for the first time in 1859, a young, ambitious painter in the party of Colonel Frederick W. Lander, who had been charged by the Interior Department to survey a new wagon route to California which would go north of Salt Lake and thus prevent further friction between emigrants and Mormons. Lander was also to placate the Native Americans whose trading would be disrupted by relocating the California and Oregon wagon trails that had been in use for years.[1] The expedition offered the artist an opportunity to see America's fabled mountains, known to a fascinated public through written descriptions and photographs in black and white, and to encounter Native Americans in their natural setting. If the Rockies were as grand as the Alps, paintings of them would find buyers already enthusiastic at the prospects of westward expansion, especially merchants and boosters of the railroads. When Bierstadt set out he was a better landscape painter than previous artists who had gone west, having studied for three years in Düsseldorf and painted in Italy. In Boston and his hometown of New Bedford, he was enjoying success with his paintings of landscape and European genre, due in no small measure to a talent for self-promotion.

Lander's expedition crossed Nebraska, and continued northwest following the North Fork of the Platte River into western Wyoming.[2] Along the way Bierstadt sketched and took photographs of Native Americans and emigrants, some bound for Pike's Peak but others returning discouraged, like those he encountered near Fort Kearny with their 150 wagons. Yet three sketches published in 1859 as woodcuts in *Harper's Weekly* are among the very few Bierstadt images which include what was a common sight along the trail and the subject of *The Oregon Trail:* emigrants, animals, and wagons under way.[3] By late June Bierstadt had left Lander, who continued on to California. Bierstadt stayed three weeks in the Wind River Mountains, sketching and photographing Native Americans and scenery. It was here, after exploring the mountains, that Bierstadt wrote a letter to *The Crayon*, an artistic journal, declaring the Rockies true rivals of the Alps and marking the beginning of his occupation with the subject which was to bring him fame and enormous fortune.

Bierstadt exhibited his first Rocky Mountain picture by March, 1860, and hoped to travel west again that year. However, helping his brothers Edward and Charles establish a photography studio and the beginning of the Civil War delayed his next trip until 1863. He was also faced with the difficulty of obtaining permission to accompany an army unit since Native Americans were attacking Overland mail stations. By the time Bierstadt again went west his reputation for painting the Rocky Mountains had been established by the exhibition of *The Rocky Mountains, Lander's Peak* (1863, The Metropolitan Museum of Art), large at 6 by 10 feet, which had been shown in New York, Boston, New Bedford, and Portland, Maine, often with an admission charge.[4] Emanuel Leutze had painted *Westward the Course of Empire Takes Its Way* (1862, United States Capitol), and the West was on many minds.

In May, 1863, Bierstadt and the prominent writer, Fitz Hugh Ludlow, having failed to find a willing army unit, set out from St. Joseph, Missouri, trusting the Overland mail stagecoach to get them safely to California where they planned to visit Yosemite and then go north through the Oregon and Washington territories into lower Canada.[5] Ludlow planned to send back letters about their adventures and gather notes for a book. Bierstadt sought more Rocky Mountain and Western subjects which he knew would be made even more popular by Ludlow's writings.[6]

Near Fort Kearny, Nebraska, they passed a wagon train described by Ludlow as:

. . . a very picturesque party of Germans going to Oregon. They had a large herd of cattle and fifty wagons, mostly drawn by oxen, though some of the more prosperous "outfits" were attached to horses or mules. The people themselves represented the better class of Prussian or North German peasantry. A number of strapping teamsters, in gay costumes, appeared like Westphalians. Some of them wore canary shirts and blue pantaloons; with these were intermingled blouses of claret, rich warm brown, and the most vivid red. All the women and children had some positive color about them, if it only amounted to a knot of ribbons, or the glimpse of a petticoat. I never saw so many bright and comely faces. . . . The whole picture of the train was such a delight in form, color, and spirit that I could have lingered near it all the way to Kearney.[7]

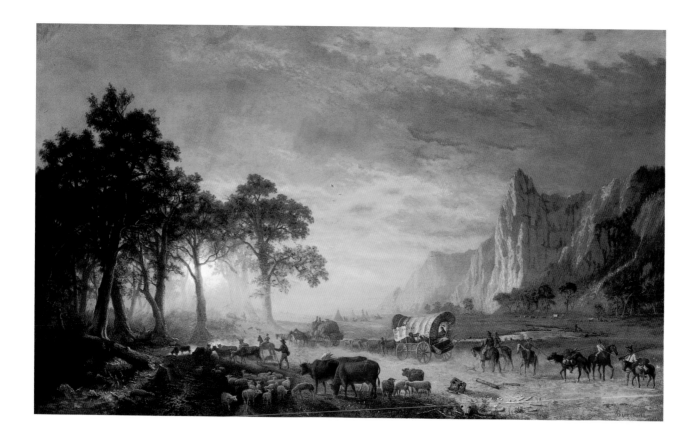

Over three years later Bierstadt was reported to be working on a large painting representing an emigrant train on its way across the Plains.[8] *Emigrants Crossing the Plains* (1867, National Cowboy Hall of Fame, Oklahoma City) was finished by November 27, 1867 and went on exhibit in a San Francisco art gallery. It was sold a year later to Amasa Stone of Cleveland, Ohio.[9]

The Oregon Trail is identical in subject to the Oklahoma City painting but only one-half its size. It could have been painted during Bierstadt's European sojourn from 1867 to 1869 when he took studios in London, Rome, and Paris, showed Rocky Mountain pictures to Queen Victoria, and made pictures of the American West popular in Europe and Britain. The Butler Institute picture, probably painted after the artist's return to America, was bought in Washington, D.C. from the artist and descended in the same family until 1946.[10]

Except for the *Harper's Weekly* woodcuts and a wood engraving after a Bierstadt drawing of an Overland mail stagecoach in Ludlow's 1870 account of the 1863 trip, there are no images by Bierstadt of any coach or wagon actually en route west. This seems even more curious when we read a description by Bierstadt from 1865: "The wagons are covered with white cloth; each is drawn by four to six pairs of mules or oxen; and the trains of them stretch frequently from one-quarter to one-third of a mile

each. As they move along in the distance, they remind one of the caravans described in the Bible and other Eastern books."[11]

The Oregon Trail turns what to Ludlow was a jolly encounter with a colorful band of emigrants into a spectacular allegory of westward expansion. Under a dramatic orange-red sky the travelers trek into the western sun, which tinges the high cliffs as it sets beyond a grove of ancient trees. They pass animal bones and a broken stove which testify to previous unlucky travelers. Native American tepees in the distance are reminders of a constant menace. No matter that by sundown camp should have been made, accuracy of fact is no more a goal here than in any other historical allegory of America's westward migration.[12] This subject first appeared soon after the end of the Civil War when America, with heightened interest in the West, turned its attention to peaceful rather than military matters. The Butler Institute version was painted in 1869, the completion year of the transcontinental railroad which would soon make history of the emigrant wagon. There may have been, even in 1869, on the part of Bierstadt or his patrons, a degree of nostalgia for this particular aspect of the pioneer experience soon to disappear in fact, but to persist in myth for over a century as one of the iconic images of America's expansion westward.

WILLIAM S. TALBOT

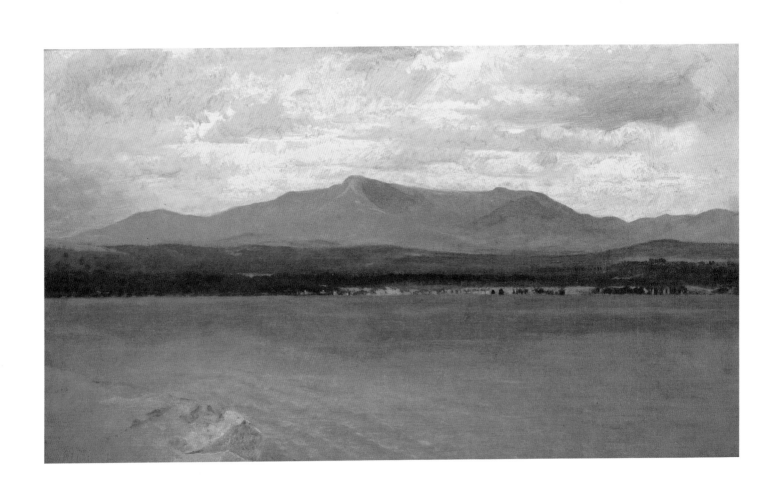

ALEXANDER HELWIG WYANT | 1836–1892

Lake Champlain, c. 1868
Oil on canvas, 15 × 25″ (38.10 × 63.50 cm.)
Signed, lower left
Museum purchase, 947-O-112

The title, *Lake Champlain*, has been associated with Wyant's luminous waterscape in the collection of the Butler Institute since it was purchased at public auction in New York City.[1] The only explicit link between the site and the artist appears in Eliot Clark's 1916 monograph on Wyant in which the author moves quickly from a discussion of *Ausable River* (1872, location unknown), whose "color is rather dead and monotonous," to rhapsodizing over another Wyant water subject with a "more comprehensive brushstroke, a greater freedom in painting and more consideration for mass."[2] Clark describes the later painting as "seen from the hills over-looking Lake Champlain" and mentions a field in the foreground "terminated by a dark hedge, over which are the trees bordering the lake."[3] Clearly, Clark is not speaking of the Butler Institute's *Lake Champlain* in which the sand-colored rock spit in the left foreground is a treeless, natural jetty formed by years of wind and tide pressing upon the beach shore. So too, Clark's references to the painting's distant view with its "long line of hills and mountains lost in heavy atmosphere" have no bearing on this version in which the green and blue shadowed mountains separate a bright, cloud-strewn sky from a shore-line settlement.[4] The mountains here are a definable presence that seals the architectonic clarity of the composition.

Clark notes that "Wyant often remarked that the key to a landscape was the sky. If one could paint a sky, he could paint a landscape."[5] *Lake Champlain* is a "sky painting" in which the sky "not only indicates through its form and color the season, [but also] the kind and time of day."[6] It is a panorama of the great lake as seen from the Vermont side on a late summer afternoon.[7] The town at the base of the mountain range is Port Henry.[8] In spite of the painting's chief emphasis on the nebulous sky and its mirror reflection in water, it is topographical and realistic. The specificity of *Lake Champlain* suggests Wyant's middle period—around 1868—when he first began to make summer visits to nearby Keene Valley in the Adirondacks, New York, at the instigation of his artist friend, Roswell Shurtleff.[9]

Lake Champlain was executed shortly after Wyant's return from Düsseldorf in 1866, where the Ohio-born artist had studied with Hans Gude, the Norwegian landscape painter. *Lake Champlain* fits into this particular time in the artist's career because after 1873, when he suffered a paralyzing stroke to his right side, his painting style changed completely.[10] It became supercharged with a subjective artistic vision, as seen in *Rocky Ledge, Adirondacks* (c. 1884, Munson-Williams-Proctor Institute), painted in Keene Valley. In this later work, his brushstrokes are thicker, forming a gnarled mosaic of color which entices the viewer into an immediate and intense visual experience far from the calm, objective clarity of *Lake Champlain*.

PATRICIA C. F. MANDEL

EASTMAN JOHNSON | 1824–1906

Feather Duster Boy, c. late 1860s–1870s
Oil on canvas, 22 × 16″ (55.88 × 40.64 cm.)
Unsigned
Museum purchase, 967-O-135

When Eastman Johnson painted *Feather Duster Boy*, he was turning to a theme that had considerable appeal to American art patrons in the mid-nineteenth century, that of the young entrepreneur eagerly hawking his wares or his skills. These young street people—peddlers, chimney sweeps, itinerant fiddlers, and street musicians—evolved from "fancy pictures," done by English and Continental painters of the late eighteenth and early nineteenth centuries. Such pictures were "types," usually children presented as half-length or full-length figures without anecdotal incident, although intended to have sentimental appeal.[1] But Johnson's American versions, including *Feather Duster Boy*, differ from their European counterparts in their emphasis upon trade and work as opposed to picturesque poverty.

Johnson's understanding of European genres of painting, such as the "fancy picture," and his ability to transform them into images appealing to American patrons, guaranteed his success. Growing up in Augusta, Maine, he mastered the technical skills to render portrait sketches of his hard-working neighbors in crayons and pastels. He lived for a brief time in Washington, D. C., where his father had taken an assignment with the government. In 1846 he moved to Boston, where for three years he drew such literary and political personalities as Henry Wadsworth Longfellow, Ralph Waldo Emerson, and Charles Sumner. In the fall of 1849, determined to move beyond drawing to painting in oils, he went abroad. He stayed in Europe for six years, studying first with the German-American artist Emanuel Leutze in Düsseldorf, then four years developing a portrait business in The Hague, and studying briefly with Thomas Couture in Paris. While in Europe, Johnson developed the "fancy picture," such as *The Savoyard Boy* (1853, The Brooklyn Museum), which would be transformed into images appealing to American patrons. The work was singled out by

Henry Tuckerman: "The figure is expressive and admirably designed; the face full of character, and the color rich, mellow, and finely harmonized; it is such a boy as Murillo would have painted. . . . There is a finish in this picture . . . a truth of expression . . ."[2]

Feather Duster Boy has neither a signature nor a date, nor is there any mention of it in the exhibition catalogs of the 1860s and early 1870s.[3] However, there is no question of Johnson's authorship. Johnson draws a solid figure with a convincing contrapposto, and he understands the massing of lights and darks. The shadows on the ground and background wall firmly fix the figure in space. Moreover, while presenting a fully volumetric head, Johnson also delicately renders the features of the boy's face with graphite, outlining the full lips and the right edge of the nose.[4] The quick, painterly strokes that indicate the knuckles and fingers and the feathered strokes for the feather dusters impart a spontaneity to the image. Typical also of Johnson's work are his use of the brown underpainting to represent the middle tones in the composition and his deployment of delicate highlights to animate the surface of the painting, such as the blue lights on the boy's shoes.

While the full history of *Feather Duster Boy* is lost to us, we might surmise that the painting had considerable contemporary appeal. Unlike the beautiful, languid figure of *The Savoyard Boy*, the youth in *Feather Duster Boy* projects seriousness of purpose and business know-how. While some of the dusters are wrapped up, others are unfurled, and our protagonist seems about to demonstrate the one in his left hand. And whereas *The Savoyard Boy* is highly finished, *Feather Duster Boy* is sketchy, a painting in process, one that invites the viewer to participate in its action, and to enter into a dialogue with both the subject and the work of art itself.

PATRICIA HILLS

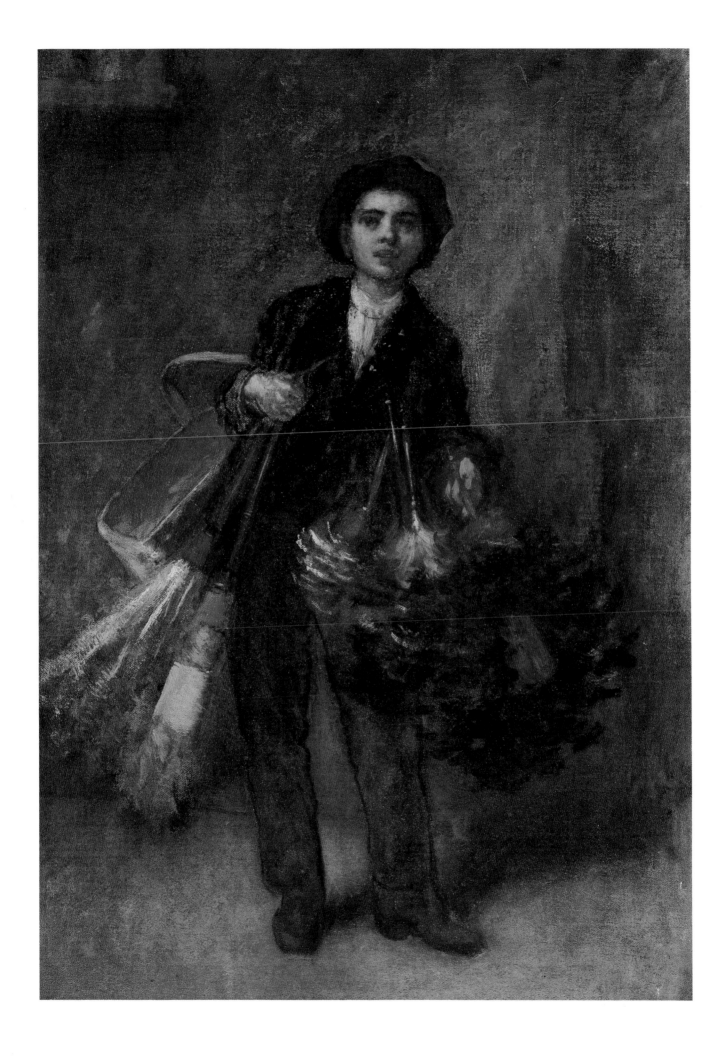

DAVID GILMOUR BLYTHE | 1815–1865

Street Urchins, c. 1856–58
Oil on canvas, 26¾ × 22″ (67.95 × 55.88 cm.)
Signed, lower right
Museum purchase, 946-O-102

Almost totally forgotten by 1940, David Gilmour Blythe has since re-emerged as America's foremost social and political satirist of the mid-nineteenth century. In the 1860s, his sly pictorial digs at the follies of urban life and his complex allegories of the Civil War had made this colorful character a popular favorite in his chosen home of Pittsburgh, but his inability or unwillingness to send his works east to the markets of Philadelphia and New York denied him the wider recognition he deserved.

Born to immigrant Scotch-Irish parents in East Liverpool, Ohio, like many other frontier artists Blythe began his career as an itinerant portrait painter, a self-taught limner begging commissions among the more prosperous families of the towns along the Ohio River. His travels took him not only to Philadelphia and Baltimore, in the East, but as far west as Indiana and possibly even New Orleans. His ambition led him to loftier goals: a monumental carved-wood statue of General Lafayette for the courthouse at Uniontown, Pennsylvania, and a "Great Moving Panorama of the Allegheny Mountains" were among his early projects.

By 1855, discouraged by the death of his young wife and the financial failure of his panorama, Blythe turned increasingly to satire. Through his poetry he had already been an active participant in the heated political debates of the era and, like the Missouri artist-politician George Caleb Bingham, had begun to make sketches of frontier types. His artistic models were the works of William Hogarth, Thomas Rowlandson, and George Cruikshank; his politics were those of a typical Midwesterner of the time, shifting rapidly between the poles of the Free-Soilers and the Know-Nothings, depending on whether the issues were the expansion of slavery or of immigration, both of which Blythe opposed. But Blythe saved his sharpest cuts for the politicians, be they Abolitionists or fire-breathing Secessionists, who

manipulated public opinion to their own self-serving ends.

Much of Blythe's satirical painting, however, was aimed at humbler subjects, the vanities of the aspiring middle class, the petty corruptions of the bureaucracy that arose to serve it, and the degradations of the immigrant poor. Among his favorite motifs were the children—homeless, underfed, and uneducated—who swarmed the streets of Pittsburgh by night and day. Just as in a Dickensian novel, these newsboys, pickpockets, and vagrants both shamed the society which had failed them and threatened its disruption with their random mischief.

Street Urchins serves almost as a summary of Blythe's opinions. Jammed into a space seemingly only large enough for one or two figures are eight small pudding-faced boys, their caps worn insouciantly like badges of honor. Most of them are smoking cigars in defiant imitation of grown-ups, though the foremost has found a more creative use for his smoke as he prepares to light a toy cannon mounted on a stack of bricks. A comparison with Blythe's *The Firecracker* (1856–58, Duquesne Club, Pittsburgh, Pa.) makes the artist's message clearer; in that work a somewhat older boy prepares to light a firecracker with his cigar, while flames and smoke rise over the city behind him. Fire, set deliberately or accidentally, was a major threat to all American cities at the time, and the boys of the streets, with their disorderly habits, were often blamed when it erupted. Yet the cannon in *Street Urchins*, though a toy, is also a tool of war, through which Blythe may have meant to presage the imminent national conflict, an inevitable result in his mind of the lack of social and political order personified by these children.

BRUCE W. CHAMBERS

CLYDE SINGER | b. 1908

An Incident in the Life of David Blythe, 1955
Oil on panel, 22 × 28″ (55.88 × 71.12 cm.)
Signed, lower left
Museum purchase, 965-O-150

Among Clyde Singer's gifts is his irrepressible sympathy for the human condition, for its peculiarly American expressions, and for the artists who have brought those expressions to life. His heroes are John Sloan, George Luks, and their successors—George Bellows, Reginald Marsh, John Steuart Curry, Thomas Hart Benton, and especially his teacher and friend, Kenneth Hayes Miller—all of whom were keen observers of the American scene.

Born in Malvern, Ohio, after graduating from high school Singer decided to apprentice himself to a sign painter. With his savings from that job, he was able to enroll, first, in the Columbus Museum of Art School, and then as a scholarship student at the Art Students League, where he studied with Benton, Curry, and Miller, among others. He has since sought to capture, as they had, what he calls the "juice of life,"[1] everyday incidents and personalities candidly recorded in all their victories and flaws. Although his style is that of a realist, he has brought to it a gently satirical eye that heightens movement and color to focus our attention on his subjects' small self-revelations—the body language by which we tell more than we want, or sometimes should, about ourselves.

When he is not painting scenes of contemporary urban life, Singer enjoys quoting his favorite artists of the past. McSorley's Bar in New York City—the Ashcan School painters' home away from home—is one of the subjects to which he has frequently turned, sometimes "accompanied" by Sloan and Luks and their own paintings' characters. *An Incident in the Life of David Blythe* is another such work, created by Singer especially for an exhibition, *The First 100 Years of Pittsburgh History*, that was held at the Western Pennsylvania Historical Society in 1955.

An Incident in the Life of David Blythe portrays Wood Street in Pittsburgh as it might have been when Blythe was working there in 1860. The street is crowded with people, most of them gathered around the windows of the art dealer, J. J. Gillespie & Co., to catch a glimpse of Blythe's most recent exhibition. Although it is now closed, at the time Singer painted this work Gillespie's was the oldest art gallery in continuous operation in the United States, founded in 1832 and a center of Pittsburgh art life (as well as a glass, mirror, and frame shop) throughout the nineteenth century. To the spectator's delight, three of Blythe's paintings have been hung in Gillespie's windows—but at least five other Blythe paintings are quoted in the figures that appear on the street. Among these figures is Blythe himself, the lanky, unkempt man (borrowed from Blythe's self-portrait) who is standing on the left side of Singer's painting, leaning against a stack of boxes. Next to him is a friend, the sculptor Isaac Broome, and behind them both, Gillespie, above whose head the shop's address is identified.

Along the curb are a number of street urchins, all of them borrowed from known Blythe works, including a group at the extreme right that is a direct quote of the Butler Institute's painting of that title. The crush of people in the middle of the painting, dominated by the billowing dress of the lady pushing her way towards the window, is even more obviously a Blythe quotation, since the painting they mimic, *The Post Office* (c. 1862–66, Carnegie Institute Museum of Art, Pittsburgh), is the centerpiece of Gillespie's display.

BRUCE W. CHAMBERS

J.G.Brown N.A.
1885

JOHN GEORGE BROWN | 1831–1913

Perfectly Happy, 1885
Watercolor on paper, 20 × 13″ (50.80 × 33.02 cm.)
Signed, lower left
Museum purchase, 967-W-118

In *Perfectly Happy*, John George Brown depicted his favorite subject, the city shoeshine boy, clearly recognizable by his blacking box and brushes. By 1885 Brown had established himself as a leading genre artist working in a polished realist style. He first painted the bootblack in the 1860s, but did not focus on this subject until later in his career. Between 1880 and 1910 he produced hundreds of works showing bootblacks alone or in groups, sometimes working but most often passing the time between customers. While some of his contemporaries occasionally painted these same children of the streets, Brown defined the type for his age.

From the 1850s on, New York City's streets teemed with roving children who sold flowers, fruit, or newspapers, swept crossings, or blacked boots. Most came from poor immigrant families living in wretched lower Manhattan tenements. They worked because their families desperately needed the money, or because they themselves lived on the streets, barely surviving. Brown could depict these children as "perfectly happy" largely because most people believed that personal failings, not economic forces, caused poverty. Brown's audience wanted to see his bootblacks as independent, resourceful young entrepreneurs. His partially—but not wholly—idealized vision reassured a middle class, fearful that street children symbolized a decaying society.

The smiling boy in *Perfectly Happy* jauntily sticks his thumbs in his suspenders, enjoying the freedom of his unstructured, unsupervised existence. Brown usually presented his street children as self-reliant and engaging, and although wearing worn clothing and not always smiling, they appear remarkably healthy. Brown's boys resemble the literary creations of Horatio Alger, whose popular stories about the rise to respectability of hard-working street children began appearing in the late 1860s.

Brown recruited and paid actual street children to model, often using the same child for a number of paintings. The model for *Perfectly Happy* was Paddy Ryan, based on his resemblance to the boy in *Paddy's Valentine* (1885, location unknown), who holds an envelope addressed to "Paddy Ryan, 512 W 38th St., N.Y.C."[1] Brown later recalled "I cannot conclude . . . without reference to one of the urchins who did much to promote my interest in the youngsters of the street. He called himself Paddy Ryan. . . . He was with me for a long time, posing for many pictures. His chief delight was to get to the studio ahead of me . . . and arrange my palette. . . . One Thanksgiving I remember sending to his folks a fine big turkey, for they were very poor."[2] Paddy posed for at least six other known bootblack paintings by Brown.[3] A contemporary photograph showing Paddy on the model's stand underscores how young, or at least small, he was.[4] Many of Brown's street boys were young, a reflection of fact but also a device to allay fears and gain sympathy for the children. *Perfectly Happy* also typifies Brown's work in that, like Paddy, many of Brown's subjects lived with their families, not on the streets, and many were Irish, a fact often indicated through names on blacking boxes or similar devices. Although Brown often varied his single-figure compositions by adding the bootblack's dog, he usually employed, as here, a shallow stage with a plain wall and city sidewalk for setting.

Today Brown is not known as a watercolorist, but in his time he was very active and widely recognized in this medium.[5] Frequently he made watercolor replicas of his oils. *Perfectly Happy* is nearly identical to a lost oil painting called *I'm Perfectly Happy*.[6] The differences between the works, however, suggest that the watercolor is not a replica, but another version of the same pose executed before or after the oil painting. The oil has more detail; Paddy's socks are striped, his boots clearly laced, and Paddy looks directly at the spectator. In the watercolor, by contrast, Brown achieved greater breadth and freshness with his brushwork, and Paddy's side-long glance lends the piece a more subtle and natural expression. Painted at the height of his bootblack years, *Perfectly Happy* is one of Brown's finest works in the watercolor medium.

MARTHA J. HOPPIN

JASPER F. CROPSEY | 1823–1900

Sailing (The Hudson at Tappan Zee), 1883
Oil on canvas, 14 × 24″ (35.56 × 60.96 cm.)
Signed, lower right
Museum purchase, 946-O-104

Jasper F. Cropsey had painted the Hudson River since the 1850s. His *Autumn—On the Hudson River* (1860, National Gallery of Art) was a sensational success in London, where he lived from 1856 to 1863. It is a very large panoramic painting with such bright autumnal foliage that the painter, in order to convince his audience of the veracity of his colors, exhibited with it some genuine autumn leaves from America.[1] After returning to America in 1863, Cropsey pursued a highly successful career painting the landscape of New York, New Jersey, Pennsylvania, and the White Mountains with occasional views of the Hudson in oil or, with growing frequency, watercolor. In 1869, his ambition and reputation prompted him to design and build Aladdin, a twenty-nine room Victorian mansion high on a hill in Warwick, New York.[2] During the 1870s, Cropsey did not paint the Hudson as frequently as he did European subjects, panoramic views of other American valleys, mountains and lake scenes, often done with great sensitivity to water reflections and the effects of moist atmosphere.

Although he exhibited three pictures in the 1876 Philadelphia Centennial Exhibition, one of which, *The Old Mill* (1876, The Chrysler Museum, Norfolk, Va.), set in the blazing colors of autumn, not only received favorable notice but reproductions of which remain popular today, Cropsey's fortunes had passed their peak.[3] Debts incurred building Aladdin, the acquisition of property in New York City, other debts surviving from England, and reduced painting production due to the artist's preoccupation with building and illness finally led to such dire financial straits that Aladdin had to be sold in 1884.[4] The Cropseys moved to Hastings-on-Hudson, New York and into a house with a view of the river which appeared frequently in his later work.

A close examination of *Sailing* reveals that it is dated 1883, not 1888 as previously thought. It was thus painted when Cropsey's fortunes were at their lowest ebb, just before the mortgage sale of Aladdin. The view takes in part of the Tappan Zee, where the Hudson widens above Hastings at Tarrytown. Cropsey's frequent panoramic breadth is narrowed here by the foreground trees which flank the distant view across the river to the highlands on the west bank. Trees and brush are animated not only by bright colors but also by the vigorous lines of the drawing, which are clearly visible through the thin paint. These sketchy strokes, many of which are not part of the final design, give a somewhat unfinished, rough vitality to the work. Instead of the smoother, more finished surfaces and rounder forms of earlier pictures, one finds in the later oils flatter shapes and rougher surfaces closely related to Cropsey's increasing activity in watercolor, with its flat color areas and visible texture. Beyond the vigorous foreground and beneath a sky made more dramatic by the thickly painted pink and yellow clouds, commerce moves along the river under steam and sail. It is an autumn image by the American who is still master of that season.

WILLIAM S. TALBOT

WINSLOW HOMER | 1836–1910

Snap the Whip, 1872
Oil on canvas, 22 × 36″ (55.88 × 91.44 cm.)
Signed, lower right
Museum purchase, 919-O-108

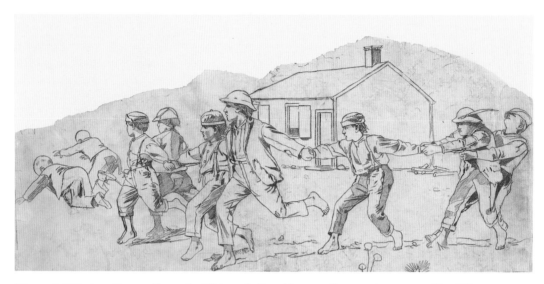

Figure 1. Winslow Homer. *Snap the Whip*, n.d. Graphite pencil on tracing paper, 10 × 20″ (25.40 × 50.80 cm.). Unsigned. The Butler Institute of American Art. Museum purchase, 941-D-102.

Figure 2. Winslow Homer. *Snap the Whip*, September 20, 1873. Wood engraving, 15¾ × 21¾″ (40.01 × 55.25 cm.). Unsigned. The Butler Institute of American Art. Museum purchase, 963-P-131.

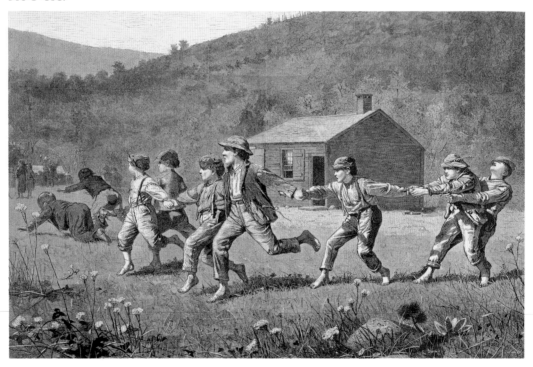

Because it seems the quintessential embodiment of the American spirit, this painting is one of Winslow Homer's most discussed and reproduced works. As one of our greatest artists, Homer and his life are justifiably the subject of a voluminous body of scholarly writing. *Snap the Whip*, dating from just about the mid-point of his life, tells us a good deal about some of the critical transitions in his artistic development at that time. However familiar and appealing such a work seems to us, it delights and informs with each new look we bring to it. One of the reasons it is so well known is that it exists in several versions: a large figure drawing for the central group of boys (1872, Cooper-Hewitt Museum, New York), a finished oil study (1872, Metropolitan Museum of Art), the final Butler Institute canvas, and another figure drawing believed to be a cartoon (Fig. 1), for the nearly exact replica executed as a wood engraving and published in *Harper's Weekly*, September 20, 1873 (Fig. 2).[1] In addition, there are a few closely related works also dating from the early seventies, *School Time* (n.d., Collection of Mr. and Mrs. Paul Mellon, Upperville, Va.) and *Country School* (1871, Saint Louis Art Museum). As Homer moved from drawing to study to larger painting, he made a number of compositional adjustments and refinements, a characteristic process for him in his treatment of a subject in different media or scales. For example, there is only one tumbling figure to the left in the Cooper-Hewitt and Metropolitan images, and five instead of four boys in the central grouping. Homer began the oil study by including the background hillside, which he then painted out, possibly to keep some spaciousness in this small format. Clearly, the larger size of the Butler Institute's painting allowed him to maintain the mountain setting, a formal echoing of the curving diagonal line of boys in the foreground.

From his early training as a draftsman and printmaker in Boston and subsequent experience as an illustrator for *Harper's Weekly*, Homer entered his artistic maturity with a consummate skill for compositional organization and telling detail. Here he fuses in perfect equilibrium the three principal elements of his painting—mountainscape, school building, and figures—both as subject and as design. This tripartite balancing has a further expression in the whip line itself: the three anchoring boys at the right, the four running figures in the middle, and the two flying off at the left. As Jules Prown has shown us, Homer's visual theme is that of interdependence and interconnections, held and broken, among human

beings.[2] Painted just as the artist was moving from his own youth into middle age, this, and a number of related images from the mid-1870s, suggests he increasingly had in mind his own sense of relatedness and separateness within family and society.[3] As obviously lighthearted, dynamic, and spontaneous as *Snap the Whip* appears in both form and content, a number of subtle internal tensions heighten its meaning; the play of stillness and motion, running and falling, stones and flowers, interior and exterior, wilderness and construction, physical and mental. This latter contrast is especially pertinent, for the game is taking place during a midday break— indicated by the shadows of a high sun—from the disciplines of learning inside the schoolhouse behind.

Speculation about the location has proposed Easthampton, Long Island, and upstate New York, where Homer had painted at the beginning of the 1870s. But both the hilly landscape and the sketch for a later schoolteacher picture are more specifically associated with the inland location, though typically Homer generalizes his image beyond the moment. At this time there was nostalgia for the disappearing "little red schoolhouse" contrasted with significant reforms taking place in American education, the new role of the teacher, and changes in the curriculum emerging in the decades after the Civil War.[4] Homer must have thought more broadly about these matters, for this thematic series of paintings depicted play as well as study, freedom as well as detention, the teacher alone and with students, and the schoolhouse as a classroom, a solitary building, and a backdrop. Indeed, its clean cubic form stands as a central focus of order, proportion, and intellectual clarity within the encircling arms of boys and mountainside.

Along with Mark Twain's writings, Homer's pictorial visions in the 1870s are among America's supreme celebrations of youth and the cult of the "good bad boy" of the time, when humor mixed with serious truths, and play, like work, held risk as well as pleasure. We cannot be certain how much Homer identified with his subjects then, as we know he did in later decades,[5] but the critical issue of aloneness versus community that seems to underlie works like *Snap the Whip* and *Dad's Coming* (1873, National Gallery of Art, Washington, D.C.) was one that his life and art would face from here on out. Significantly, after *Snap the Whip*, there would never be another painting of a large and active group of figures in Homer's art.

JOHN WILMERDING

FREDERIC EDWIN CHURCH | 1826–1900

In the Andes, 1878
Oil on canvas, 15⁵⁄₁₆ × 22⁵⁄₁₆″ (38.57 × 56.35 cm.)
Signed, lower left
Museum purchase, 978-O-102

American artists of the mid-nineteenth century usually went to Europe or the western frontier in order to expand their repertoire. Frederic Church went first to the tropics and volcanoes of South America. His reasons make a fascinating chapter in the history of American art and thought.

Church was the best known pupil of Thomas Cole, who recognized the singularity of American wilderness landscape and was the first to invest it with heroic grandeur. Church, like other painters of his generation, John Kensett, Sanford R. Gifford, and Jasper Cropsey, sketched and painted the Catskills and mountains of New England. In his early pictures he gave to water a reflective, burnished surface, to sunset clouds dramatic color and substance, and painted distant detail so clearly that his picture space seems filled with transparent radiance. By the early 1850s, Church was not only painting views of specific American places with topographical exactitude, he was also combining separate elements of meticulously detailed scenery into landscapes of heroic breadth and depth.

Church was inspired by the fascinating variety and complexity of nature as extolled by John Ruskin, the English writer, critic, and champion of J. M. W. Turner. Church also believed, like his contemporaries, that close study of nature was essential to grasp unique underlying truths which had moral implications. Thus, he was very impressed by the writings of the German naturalist, Alexander von Humboldt, whose influential *Cosmos: Sketch of a Physical Description of the Universe* first appeared in English in 1849. Von Humboldt's goal was to synthesize existing scientific knowledge into a theoretical system proving that nature was one great whole animated by internal forces which tended towards harmonious unity.[1] He sought to prove that behind the complexity of the natural world was a divine order and he recognized the importance of landscape art in revealing this order. Von Humboldt specifically encouraged landscape painters to travel to those parts of the world having the greatest botanical and geological variety. Von Humboldt, who had set off for the tropics of South America in 1799, so inspired Church that in

1853 he retraced Humboldt's 1802 route from Barranquilla, in what is now Colombia, to Guayaquil, Ecuador, through the northern Andes where he made sketches of rivers, waterfalls, and volcanoes. One result was *The Andes of Ecuador*, 4 × 6 feet (1855, Reynolda House Museum of American Art, Winston-Salem, N.C.), Church's largest painting to date. Seen from a lofty viewpoint, amid rich, tropical vegetation, a river tumbles into a lake which empties into a deep, misty gorge. The gorge leads into the distance and range after range of mountains suffused with a sunlit haze. The depth and breadth are so vast that it may be more accurately called, rather than landscape, earthscape.

With his reputation firmly established by such tropical scenes, Church returned to the tropics in 1857 accompanied by Charles Remy Mignot (1831–1870), a fellow landscape painter from the United States.[2] He landed this time on the coast of Ecuador at Guayaquil and pushed east into the interior to sketch the volcanoes Chimborazo, Cotopaxi, and Sangay. By January, 1858, he had begun his most ambitious, complex, and largest tropical scene, *Heart of the Andes*, almost 6 × 10 feet (1858, The Metropolitan Museum of Art). Technically brilliant in its detailed rendering of an immensely wide and deep vista, the painting was seen on payment of twenty-five cents by more than twelve thousand people during three weeks in Church's New York studio.[3] The artist brought together into one scene a tropical river flanked by lush dense vegetation, upland plains, and towering mountains, snowcapped at their highest elevation—geographically and climatically more than one region could possibly contain—dazzling in grandeur and mesmerizing in detail.

In 1859, however, Charles Darwin's *The Origin of Species* turned on its head Humboldt's concept that nature evolved toward harmony as the result of a guiding divine force. According to Darwin the state of nature was competition and struggle, not harmony. Thus was shattered a basic American concept of nature and landscape painting, namely, that man could turn to nature for moral guidance. By the late 1870s, the very ability to detail miles of scenery had

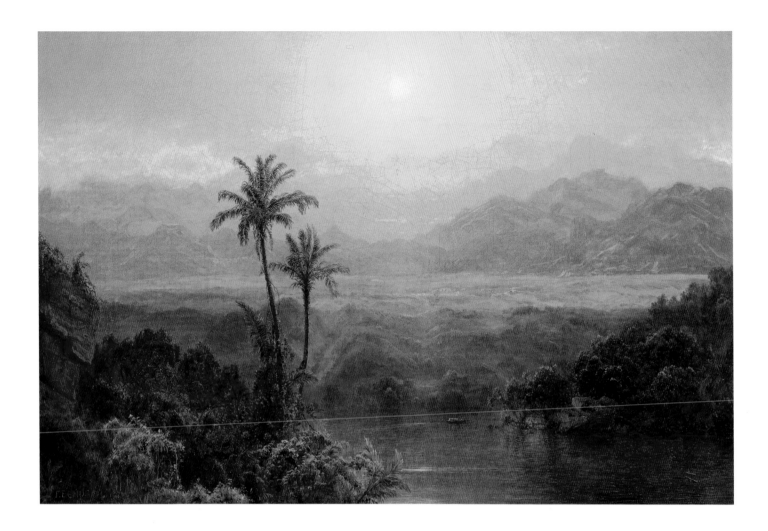

become less admired than the creation of poetic visions.

In the 1860s and early 1870s, Church turned away from the crystal clear, meticulously detailed views of vast expanses of the tropics in favor of sunlit landscapes of America, icebergs of the far North, and the coast of Maine. In 1867 he made his first trip to Europe and visited the Middle East, which provided exotic subjects for paintings of the Old World. When he did paint scenes of the tropics in the 1870s, they were quite different in both style and mood, as we see in the Butler Institute's *In the Andes* of 1878.

The left foreground suggests the generally rich abundance of tropical flora, while the two palm trees convey individual and specific natural histories. This we would expect from Church, but the shadowed foothills and distant violet-gray mountains separated by a layer of yellow cloud and a hazy atmosphere which blurs distant detail reveals a new and different vision. The scope of this view is expansive, but great distance is implied rather than described, and we must draw on our imagination to complete the landscape. In the absence of a single mountain protagonist the wake of a riverboat catches our attention. We feel linked to this human element, which is not lost in a superabundance of botanical and geological detail as in earlier pictures. Light has now become a major concern, and we look into a sun whose dazzle unifies the water of the river, the distant mountains, and the sky into a shimmering whole. The painting has a quiet rather than an epic mood. The setting is exotic, but the mood is pensive. Darwin had injected randomness into nature, hitherto seen as tending toward unity. Church, at the end of his active painting career, like many American painters in the last decades of the nineteenth century, sought through light a poetic unity in place of a scientific one based on a painstaking detailing of the physical world.

WILLIAM S. TALBOT

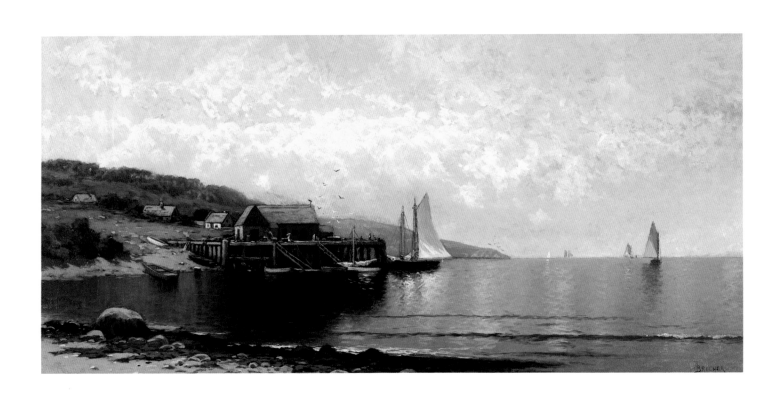

ALFRED THOMPSON BRICHER | 1837–1908

The Landing at Bailey Island, Maine, c. 1907
Oil on canvas, 15 × 32″ (38.10 × 81.28 cm.)
Signed, lower right
Museum Purchase, 970-O-146

For over forty years Alfred Bricher sketched and painted scenes along the East Coast from New Jersey to easternmost Maine. He painted his first shore subject in 1864, when close observations of nature, both in details and in larger effects, were highly valued. He created compositions in which a strong horizon line, often no more than one-third of the way up the picture surface, and an uncommonly wide canvas, created a panoramic effect. In the foreground there is usually a thin wedge-shaped expanse of beach, then two or three slightly diagonal ranks of breaking waves. The waves and water are often within a cove created by the shore sweeping around in a tight curve, the apex of which is cut off by the picture's border. The shore then reappears to form a prominent headland in the middle distance, sloping gently or dropping steeply to a horizon punctuated only by the tiny white triangles of sails. Filling well over half the picture surface is a sky animated by a remarkably convincing combination of white and gray-edged clouds interspersed with patches of blue. Bricher was also a master of the breaking wave, able to catch the translucency at its crest, the heaving fluidity of the body and the rush of foam down its forward slope.

Bricher painted the islands of Maine in storm and lifting mist as well as sunny calm. During the last few years of his life he concentrated his sketching on the northern islands in Casco Bay including Bailey Island, northeast of Portland, one of the larger of the over two hundred islands which dot these waters. From 1905 to 1908, Bricher exhibited no less than twelve watercolors and oils of Bailey Island subjects. In 1908, Gill's Art Gallery in Springfield, Massachusetts exhibited the Butler Institute's picture. At the Bricher estate sale of 1909, there were ten additional watercolors of Bailey Island subjects.[1]

The Landing at Bailey Island, Maine is a calm distillation of Bricher's accomplishments. Every detail is deftly drawn, from the foreground rocks to the landing and its buildings in the middle distance, to the distant sailboats, but not so meticulously as to make the picture the sum of many parts. On the left are active colors in the seaweed and a greenish tint to the water as it becomes shallow. The sea approaches the beach in three wavelets which lap lazily against the stones. With a light impasto of lively roiling brushstrokes a placid sea mirrors the sky above. One characteristic which distinguishes Bricher's work from that of many of his contemporaries is the darkness of his shadows. Even on a sunny day his quite dark shadows create a somewhat somber effect. The structure of the landing is in shadow; but a shadow that is transparent with details of buildings and pilings readily visible.

Characteristic also is the calculation with which Bricher has composed his picture. The horizon divides it into thirds and the end of the landing pier reaches exactly the picture's midpoint. In sketches that the artist made from several different vantage points, the buildings on the pilings are in other positions and the distant shore has very different profiles. The pier itself looks just the same today, but it is in a cove which Bricher has substantially eliminated.[2] The sailboat off the end of the pier appears in only one sketch, but in a very different relation to the distant shore beyond. Bricher has exercised substantial license in shaping and repositioning elements, creating balance and harmony for a picture of singular tranquility.

WILLIAM S. TALBOT

JOHN FREDERICK KENSETT | 1816–1872

Bash Bish Falls, c. 1855
Oil on canvas, 34×27″ (86.36×68.58 cm.)
Signed, lower left
Museum purchase, 989-O-102

The forest and gorge surrounding Bash Bish Falls in South Egremont, Massachusetts, were considered in the mid-nineteenth century to be one of the most picturesque pleasure-tour destinations in the Berkshire Mountains. The falls themselves were described in *The Crayon* as "one of the wildest and most beautiful cascades in the country."[1] They became John Frederick Kensett's favorite among the American waterfalls that he visited and painted during the 1850s.

Kensett painted Bash Bish Falls at least five times. This version is most closely related to a small oval canvas (1851, Lyman Allyn Art Museum, New London, Conn.) and to a larger painting made for his friend, James Suydam (1855, National Academy of Design). The Butler Institute's version is unfinished and therefore the date is uncertain, but it may have been originally intended for Suydam, as both paintings were probably once the same size.[2] The small *Bash Bish Falls* that Kensett painted in 1851 shows a pair of boulders in the middle ground linked by a foot bridge, a cataract below that, a pool of water in the foreground and, as a backdrop, a thicket of trees. Kensett completed the first composition in the year that he painted a number of views of Niagara Falls, rendering the Berkshire falls as Niagara's compositional opposite. Far from a powerful, horizontal waterfall along an open horizon as in Niagara Falls, the Bash Bish Falls are made delicate, vertical, and closed-in. Later, Kensett returned to Bash Bish Falls to paint another version of them, where he presented the cascade as a grand panorama, which contrasts with this work's concentration on their more sheltered, less spectacular, aspect. It appears that Kensett painted the Butler Institute's canvas to enlarge the view he had painted in 1851. As he did so, he perhaps decided that moving the cataract to the center foreground, in place of the still water, and giving greater variety to the boulders, rather than flattened profiles, would result in a livelier effect. Rather than overpaint a composition already well progressed, a practice Kensett consistently avoided, he seems to have set the canvas aside to begin afresh on another of the same size, that is, the work presented to Suydam. In making the new version, he also altered a number of minor details as he saw fit, from the crevices in the boulders to the arrangement of the surrounding trees.

Bash Bish Falls reveals Kensett's willingness to give himself over to nature's detail and plunge deeply and irretrievably into the woodland interior. The composition is organized upon a series of receding horizontal planes which makes the viewer lose all sense of deep space.[3] The vertical format reins in the horizontal expanse of sky and, by decreasing the viewer's lateral eye movement, locks all attention into the center of the forest, where the viewer is forced to concentrate on the plethora of tree branches, scrub, rocks, and moss. Such a rendering is indebted to the precedent of the on-site oil sketch, particularly those of Asher B. Durand, exemplified by such works as *Interior of a Wood* (c. 1850, Addison Gallery of American Art, Phillips Academy, Andover, Mass.) and *Study from Nature* (c. 1855, The New-York Historical Society).

The Butler Institute's version of *Bash Bish Falls* presents an opportunity to see the underpinnings of Kensett's animated painting technique of the 1850s. Still exposed is much of the thin, reddish priming applied to his canvases before adding the highlights and shadows. Kensett applied the finishing highlights and darkest tones together, working from the top of the canvas down. To paint over his reddish priming he employed an elaborate scumbling technique. With brushes of various degrees of fineness, he scrubbed in layers of very thin paint, which allowed him to create a richly textured image with minimal build up of the canvas surface.[4]

Kensett was the most influential member of the second generation of the Hudson River School of landscape painters. He began his career as a commercial engraver, studying landscape painting in his spare time. He went abroad to study in 1840 and after his return to New York in late 1847, his career as a landscape painter quickly flourished. He is best known for his depictions of the mountains and coastal regions of New York and New England. In contrast to

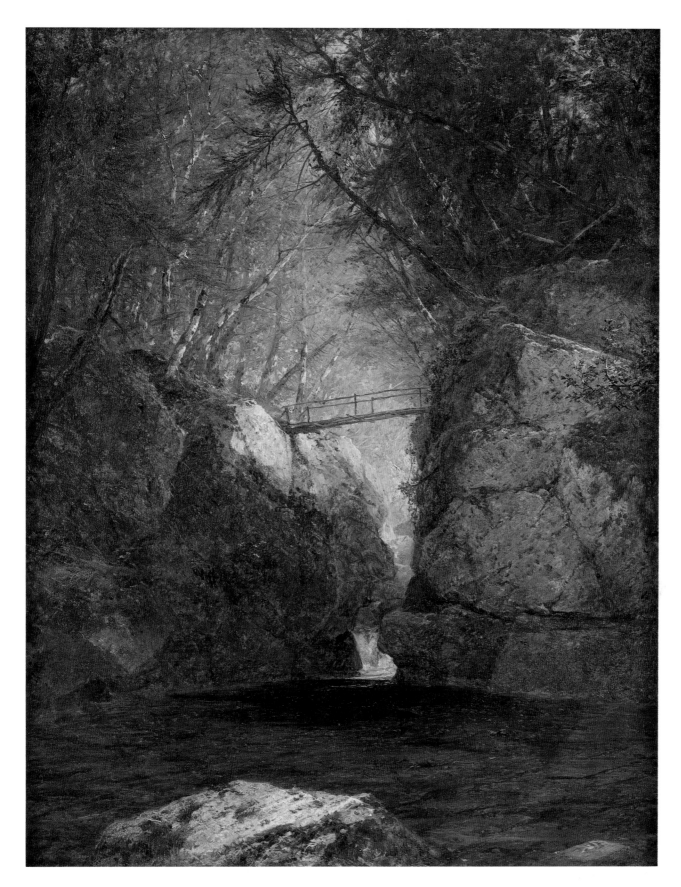

his contemporaries, Albert Bierstadt and Frederic E. Church, Kensett's work was distinguished by an enduring modesty. Avoiding overscaled and overly dramatic scenery, he earned great praise for his sensitivity to modest views of nature and his fidelity to its most minute detail.

DIANA STRAZDES

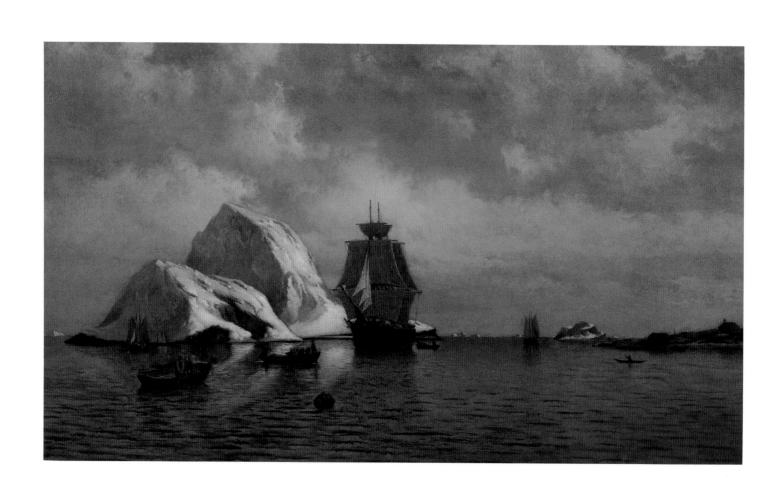

WILLIAM BRADFORD | 1823–1892

Afternoon on the Labrador Coast, 1878
Oil on canvas, 28 × 48″ (91.12 × 121.92 cm.)
Signed, lower right
Museum purchase, 975-O-136

William Bradford was raised a Quaker in Fairhaven, Massachusetts, across the harbor from the busy whaling port of New Bedford where, by 1855, he had his own studio. He specialized in ship portraiture done with painstaking detail but with a sensitivity for the effects of light and atmosphere which so occupied the Gloucester, Massachusetts painter, Fitz Hugh Lane, whom Bradford probably knew. By 1861 Bradford had moved to the Tenth Street Studio Building in New York City. There he met Frederic Edwin Church, whose adventurous travels to the Andes, and those of fellow New Bedford artist, Albert Bierstadt, to the American West, must have encouraged Bradford to continue an interest he already had in the Arctic.

In the late spring of 1861, probably well aware of such recently published reports as *Arctic Explorations* (1857) and *After Icebergs with a Painter* (1861), as well as the iceberg paintings of Church, Bradford outfitted a twenty-ton schooner and set out for the coast of Labrador.[1] For four months he made sketches and photographs, which he later incorporated into paintings of icebergs under glowing Arctic skies, bold Labrador headlands, Eskimos, and polar bears. Such was the success of these pictures that Bradford traveled to the Arctic seven times between 1861 and 1868.

In early July, 1869, he chartered the small whaling steamer, *Panther*, and set out from St. John's, Newfoundland, for Greenland. Among the passengers were two Boston photographers, who made collodion plates of icebergs, coastal promontories, and Eskimo villages while Bradford sketched from shipboard and on shore. From this voyage came 125 photographs which illustrated Bradford's book *The Arctic Regions*, published in London in 1873. Such an ambitious undertaking bears witness to Bradford's goal "to study Nature under the terrible aspects of the Frigid Zone."[2]

Whereas his paintings of the Arctic usually emphasize ships dwarfed by vast icefields and towering icebergs sparkling under glowing skies, the Labrador paintings tend to be scenes of ships, men fishing, and Eskimos in their kayaks. In *Afternoon on the Labrador Coast* the low horizon makes ship and iceberg into dramatic silhouettes, one brilliant, the other shadowed. The sky provides a background animated with a turbulent mixture of light and dark clouds, with only bits of blue sky showing through. In their multiple activities set in a tranquil seascape, the Labrador paintings are closer to Bradford's earlier harbor scenes. Though painted in a looser manner, they are still far less dramatic than such turbulent seascapes as his *Shipwreck off Nantucket* (1859–60, The Metropolitan Museum of Art), done very much in the Dutch style, with a dismasted ship amid heaving waves.

By the mid 1870s, Bradford was wintering in New York, summering in New Bedford, painting pictures of the Arctic and giving lectures on the frozen North. These he illustrated with his photographs of the frigid northern wilderness, whose untouched beauty, overwhelming scale, and crystal clear atmosphere continued to provide inspiration for paintings throughout his career.

WILLIAM S. TALBOT

WILLIAM KEITH | 1838–1911

An Autumnal Sunset on the Russian River, 1878
Oil on canvas, 36×60″ (91.44×152.40 cm.)
Signed, lower right
Museum purchase, 924-O-102

In reviewing the Spring Exhibition of the San Francisco Art Association in April of 1878, the critic of the *San Francisco News Letter and California Advertiser* took notice of Keith's painting *An Autumnal Sunset on the Russian River*, calling it "something of a new departure for Keith, who usually delights in cool greens, with but a slight tinge of color." The critic continued, "But this picture is red-hot—to speak plainly, he gives us the glowing atmosphere which lingers but a few minutes in this climate of short twilights. The effect of the coming darkness, as it spreads suddenly over the glowing sunset, is admirably done."[1] It is likely that the Butler Institute's Keith is the painting reviewed in the *News Letter* and is also the "just finished" Russian River painting in Keith's studio described in the *San Francisco Chronicle* of July 19, 1877: "The point of view is an elevation from which is seen the valley with a portion of the river and beyond a range of higher hills and a sunset with clouds of that rich gold seldom seen in other regions. The whole canvas is suffused with warmth and color, and is as dreamy as a still Indian summer afternoon."[2] Keith may have kept retouching this work, a frequent practice of his, until 1878, when he signed it, dated it, and sent it off for exhibition.

William Keith launched into a career as a landscape painter in 1866 after having practiced the trade of wood engraving in his youth. His early paintings depict mountain subjects bathed in pastel tones borrowed from the style of his friend and mentor Charles C. Nahl. Between 1869 and 1871 Keith spent a year and a half in Europe, living in Düsseldorf, but absorbing the influence of the French Barbizon paintings he saw during an extended visit to Paris. A season in Boston reinforced his admiration for Barbizon technique. When he returned to San Francisco in 1872, he emulated Thomas Hill and Albert Bierstadt in producing huge mountain panoramas, while executing smaller-scale landscapes in the looser French style.

Towards the end of the 1870s, Keith started to experiment with more spiritually-charged landscapes that took the darker, more impressionistic Barbizon aesthetic to its extreme. *An Autumnal Sunset on the Russian River* is one of his earliest and largest works in this mode. Although this particular landscape was praised when first exhibited, other paintings in the same style done the following year were criticized. "It is a great mistake in Mr. Keith," wrote the critic of the daily newspaper *Alta California*, "to suppose that the public taste will be satisfied with landscapes in which there is a yellow sunset, with distant mountains, middle ground and foreground so vaguely painted that nothing can be seen distinctly save the sky."[3] The *San Francisco Chronicle* critic attempted to explain Keith's new manner: "He is searching for Rembrandt effects, or something akin to the startling contrasts which made that artist, who saw nature in a few simple and strong moods, so greatly impressive."[4] Keith seems to have been responding to a visionary inspiration in paintings of this sort. In describing a sunset scene in 1879, the *Chronicle* reporter noted a "sky . . . rich with green, gold and crimson . . . the sunset, presumed to represent to the imagination the end of life and the glories to come after."[5] This visionary style would become Keith's chief inspiration in his later career under the influence of the Swedenborgian minister, the Reverend Joseph Worcester. *An Autumnal Sunset on the Russian River* demonstrates that it was already part of the artist's repertoire during the 1870s.

ALFRED C. HARRISON, JR.

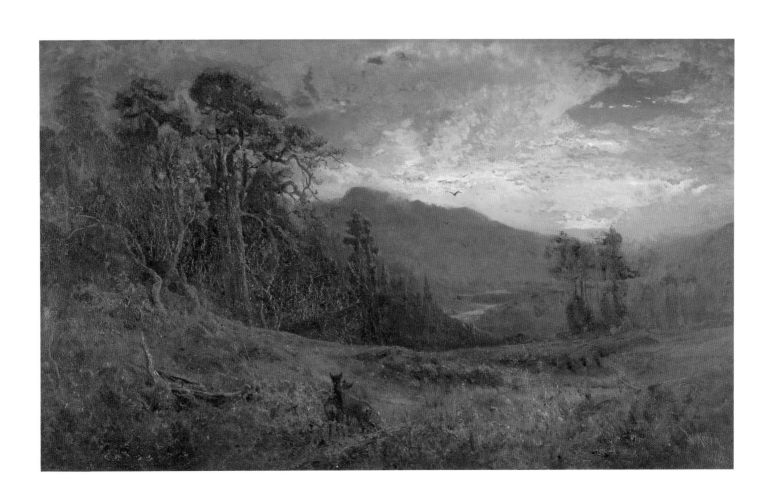

MARTIN JOHNSON HEADE | 1819–1904

Salt Marsh Hay, c. 1865
Oil on canvas, 13×26″ (33.02×66.04 cm.)
Signed, lower left
Museum purchase, 955-O-121

The marsh is a unique landscape, and Martin Johnson Heade made it his special province. Why and how he did gives us an insight into the turbulent state of the nation in the Civil War period and its aftermath. *Salt Marsh Hay* is one of just a handful of paintings by Heade, in a very prolific career, to combine this favored landscape subject with stark storm imagery. He did not come to paint the marsh immediately, but only after working his way through the more conventional portraits, genre scenes, and seascapes that occupied his early career through the 1840s and 1850s. Born in Lumberville, Bucks County, Pennsylvania, on the Delaware River, he grew up familiar with vistas of trees and water. Unsettled travel would dominate much of his life, and that restlessness appears to have found perfect expression in the undulating and constantly changing marshscapes, first in New England, later in New Jersey, and finally in central Florida. After an early trip to Europe, he returned to the New York area, with trips in the 1850s to Philadelphia, St. Louis, and Chicago, and during the early 1860s to the north shore of Boston and then to South America; 1865 found him in London and shortly after in the Low Countries.[1] His search for a personal subject matter coincided directly with the profound and unsettling disruptions of national civil strife, and while his thunderstorm images are not necessarily direct correlations to specific historical events of the period, they surely cannot be separated from the pervasive trauma artists, no less than citizens at large, must have felt.

During the early and mid-1860s, Heade and other contemporaries such as Fitz Hugh Lane, Frederic E. Church, William Bradford, Albert Bierstadt, and Alfred Thomas Bricher took up the related themes of breaking storms, shipwrecks, violent sunsets, and suggestive cross images.[2] The most celebrated and published examples by Heade include *The Coming Storm* (1859, The Metropolitan Museum of Art), *Approaching Storm: Beach Near Newport* (c. 1865–1870, Museum of Fine Arts, Boston), and *Thunderstorm over Narragansett Bay* (1868, Amon Carter Museum, Fort Worth).[3] Soon after beginning

these marine scenes he turned to his first marsh landscapes, and on the basis of the few dated works among them, *Salt Marsh Hay* can be firmly set in a sequence of the mid-1860s. Closely related pictures which place it in context are *Gathering Hay Before a Thunderstorm* (specifically dated 1862, private collection), along with *Newburyport Marshes: Passing Storm* (c. 1865–1875, Bowdoin College Museum of Art, Brunswick, Me.), *Sudden Shower: Newbury Marshes* (c. 1865–1875, Yale University Art Gallery), *Marsh in a Thunderstorm* (c. 1860–1870, The Governor's Mansion, Atlanta), and *Jersey Meadows, Sun Breaking Through* (c. 1865–1875, private collection).[4]

Of all this landscape group, *Salt Marsh Hay* is one of the starkest, focusing attention, as in *Thunderstorm over Narragansett Bay*, on the black mirror reflection in the middle of the composition. This increases our sense of an almost surreal world held in a tension of oppositions about to shatter in noise and light. Where Heade's marshes before and after this period were painted in cool greens and yellows, and either bright sparkling daylight or dreamy twilights (Fig. 1), here he purposefully exploits impenetrable blacks, acid greens, and ghostly whites. Throughout his life he painted in series, but given his large output over a long career, his variations on such favored subjects as hummingbirds, flower blossoms, and marsh haystacks were often as much repetitions as they were fresh and individual versions. While elements of the Butler Institute's picture dominate other paintings of this time, *Salt Marsh Hay* clearly stands out with its own memorable distillation of forms. The location is most likely the Newburyport meadows, with their flat expanses and broad curving streams, seen here at high water. During the later decades of the nineteenth century, farmers had a productive business in the harvesting of salt hay from these marshes for cattle feed. But the narrative of those activities is only incidental to Heade's concentration on the drama of barometric pressure and the impending changes in nature's moods. In *Salt Marsh Hay*, Heade heightens both the visual focus and psychological intensity by isolating in the smoky light the one illuminated

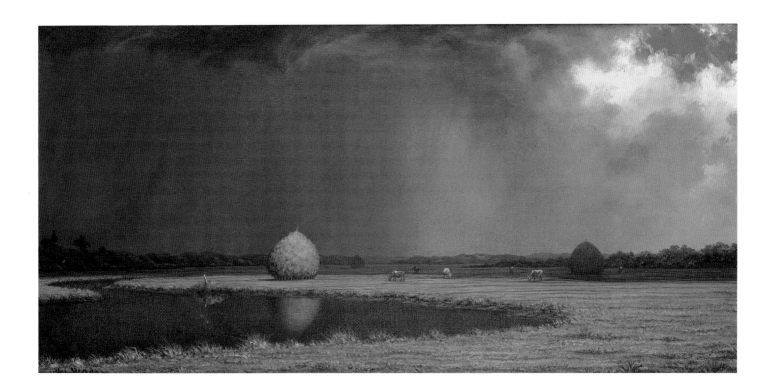

Figure 1. Martin Johnson Heade. *Sunset,* n.d. Oil on canvas, 7 × 18″ (17.78 × 45.72 cm.).
Signed, lower left. The Butler Institute of American Art. Gift of the Ernest Rosenfeld Foundation,
958-O-141.

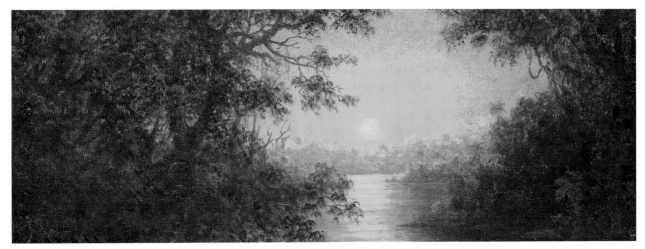

haystack. This he counterpoints twice: in its own
duller reflection below and by the dark stack shrouded
in shadow at the right.

This great simplicity of design seems paradoxically,
at once serene and threatening, a balancing of
sensibilities as subtle as the close range of lights and
darks in the composition.[5] Holding it all together are
the sweeping foreshortened arcs of the marsh
shoreline, which rhythmically carry our eye back and
forth from the foreground across the flat plane of
water and grass to the dense stormy horizon, where
sky and earth fuse in blackness. As controlled as the
whole might appear, we must finally remember that
the marsh is the one landscape in constant flux. In
fact, it is literally half land, half water, with its
composition shifting from one to the other and back
approximately every six hours in the changing tides.
These inexorable, virtually unseen, currents are but
another reminder of nature's charged forces, like the
building storm, which reveal something of both a
restless artist and a restive nation.

JOHN WILMERDING

WILLIAM LOUIS SONNTAG | 1822–1900

Landscape, 1865
Oil on canvas, 32 × 48″ (81.28 × 121.92 cm.)
Signed, lower left
Gift of Mr. and Mrs. Joseph P. Sontich, 970-O-123

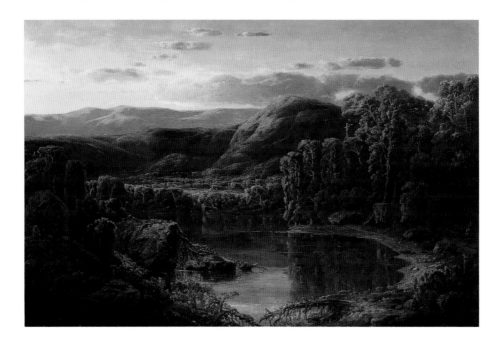

William Sonntag's first landscapes may have been the dioramas he painted about 1846 for the Western Museum in Cincinnati, where his family had moved about 1823 from the painter's birthplace, East Liberty, Pennsylvania, now part of Pittsburgh.[1] His father, a prosperous apothecary and wholesale grocer, tried to discourage his interest in art. An apprenticeship to a carpenter lasted only three days; one to an architect, three months. A trip through the wild country along the upper Mississippi River to the Wisconsin Territory about 1840, probably connected with his father's business, only served to whet the young man's appetite for landscape painting, and subsequent travels were the sources for a Kentucky river scene exhibited at the American Art-Union in 1846. The next year he sold seven pictures to the newly founded Western Art-Union in Cincinnati.

By the 1850s, Sonntag's career was at its height in Cincinnati. Around 1852, he painted for the Baltimore and Ohio Railroad the wild scenery in the Allegheny Mountains along its route. An eight-month trip to Europe in 1853, with five thousand dollars in commissions to fulfill, and another in 1855 provided such opportunities that he formed, but never carried out, plans to settle permanently in Florence, Italy, though he did go abroad in 1861 and quite possibly again in 1862. By 1857, Sonntag had moved from Cincinnati to New York, where he lived until his death. In 1858 he sketched in Virginia and in the summer of 1860 in West Virginia. When the Civil War closed the South to travel, Sonntag began to spend summers in the White Mountains of New Hampshire, where he continued to go the rest of his life.

Landscape follows the formula on which Sonntag settled for many of his paintings. The season is early autumn and from an elevated viewpoint the viewer looks toward successively higher and more distant mountains across a small body of water, whose shining surface reflects the sunset pink of the sky and silhouettes the foreground rocks and fallen trees. The manner in which this red glow tinges the edges of rocks and trees and the density of the deeply shadowed forest with its twisted, writhing trees is reminiscent of Thomas Cole and Sonntag's style of the 1850s. The painting may indeed be earlier than the 1865 seemingly indicated by the almost illegibly inscribed date. Like so many Sonntag landscapes, it lacks a specific title, but its closer resemblance to his scenes of the Alleghenies in Virginia rather than the White Mountains of New Hampshire would argue for a southern subject.

WILLIAM S. TALBOT

HARRISON BIRD BROWN | 1831–1915

Grand Manan Island
Oil on canvas, 13×23″ (33.02×58.42 cm.)
Signed, lower left
Gift of Joseph G. Butler, III, 967-O-126

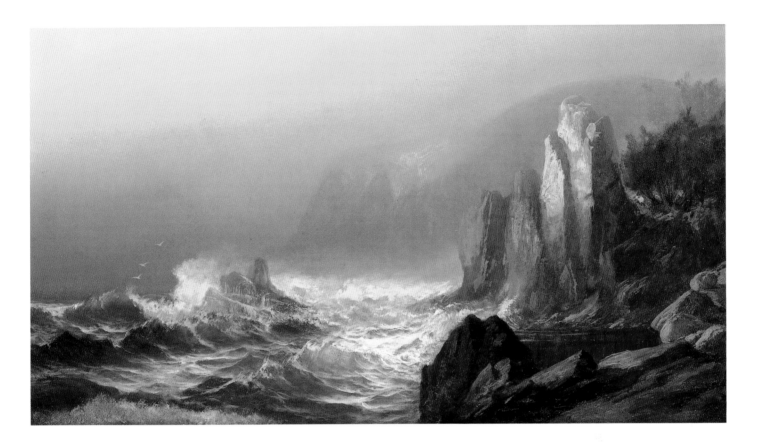

Variously recorded as Henry B., Harry B., or Harrison Box Brown, Harrison Bird Brown was born in Portland, Maine and apprenticed at age fifteen to Forbes and Wilson, house and ship painters. By 1852, he was active as H. B. Brown, Banner & Ornamental Painter.[1] He vigorously pursued landscape painting in the 1850s and became a professional easel painter, exhibiting marine subjects at the National Academy of Design in New York in 1858, 1859, and 1860, as well as at the Boston Athenaeum and later at the Philadelphia Centennial Exposition of 1876.[2] By 1860, he was praised as a leading American marine painter.[3]

With Benjamin Champney and John Casilear, Brown painted in the White Mountains where his name can be found in the guest registers of boarding houses frequented by artists.[4] For over thirty years Brown actively painted the Maine coast, especially the Casco Bay area and Grand Manan, a popular summer island off the coast of New Brunswick, Canada. When he moved to London in the 1890s, he was the best known native Maine painter of his time. He gained fame for himself and the state of Maine with a large canvas in the Maine pavilion of the 1893 World's Columbian Exposition in Chicago.[5] He spent the last twenty-three years of his life in England.

The Butler Institute painting is quite possibly the spectacular Headlands of Grand Manan Island which Brown painted a number of times. The light impasto used to depict the large foreground rocks with their creamy highlights sets them sharply off from the thinly painted distant cliffs. Water and whitecaps are adroitly captured, and the surf breaking at the lower left, as if against the picture frame, is a clever touch.

Grand Manan Island is undated, as is much of Brown's work. Judging from a few dated paintings, this picture might be placed in the late 1870s or 1880s.

WILLIAM S. TALBOT

FRANK DUVENECK | 1848–1919

Portrait of a Boy, 1872
Oil on canvas, 22 × 18″ (55.88 × 45.72 cm.)
Unsigned
Museum purchase, 920-O-104

Between 1870 and 1879, Frank Duveneck distinguished himself at home and abroad as a virtuoso painter and inspiring teacher at the Royal Academy in Munich. Munich, at this time rivaling Paris as a leading art center, was a magnet for many American artists, such as Duveneck, who came from German-speaking areas of the country, especially Cincinnati. While teaching in Munich and the neighboring countryside around Pölling, Bavaria, Duveneck attracted a talented group of American students known as "The Duveneck Boys," through his thorough understanding of the Munich technique and his congenial personality. A number of these artists, including William Merritt Chase, John Twachtman, and Joseph DeCamp, would later become leading American painters and teachers.

Portrait of a Boy is a fine example of the figure painting Duveneck perfected in Munich at this time. In the early 1870s, the artist painted some of his most daring examples of this form of bravura painting. These paintings were compelling character studies in which the artist depicted only the head and shoulders of a solitary figure, painted in a broad, gestural style which emphasized technique for technique's sake. The dramatically lit and sensitively sculpted face of the model stands out against a relatively flat, broadly-washed ground of deep browns, grays, and blacks. The resulting emergence of the figure, as if by magic, from a sea of darkness imparts an uncanny psychological intensity, and further enhances the work's vitality. In *Portrait of a Boy*, the dark background which threatens to engulf the youthful sitter suggests a vulnerability and an inevitable mortality, giving the alla prima study a timeless, monumental quality.

Duveneck was particularly influenced by the German artist Wilhelm Leibl, who greatly admired the paintings of the seventeenth-century Dutch masters, particularly Frans Hals. The dramatic juxtaposition of lights and darks, expressive painterly brushstrokes, and telling command of gesture found in *Portrait of a Boy*, reveal Duveneck's deep understanding of his instructor, Leibl, and in turn, Frans Hals.

After leaving Munich, Duveneck established his own school in Florence at the urging of his student, Elizabeth Boott, whose family lived there. From there he ventured to Venice where he painted, etched, and conducted summer studies, continuing to attract a bright following of students. When Boott, an extremely talented artist and a beautiful woman who had become his wife in 1886, died tragically in 1888 of pneumonia, Duveneck retreated to America. In Cincinnati he taught and eventually directed the Art Academy with skill and devotion until his death in 1919. He continued to paint in a broad style throughout his later career, spending winters in Cincinnati and summers in Gloucester, Massachusetts, but his Munich period remains the high-water mark of his oeuvre.

JAMES KENY

116

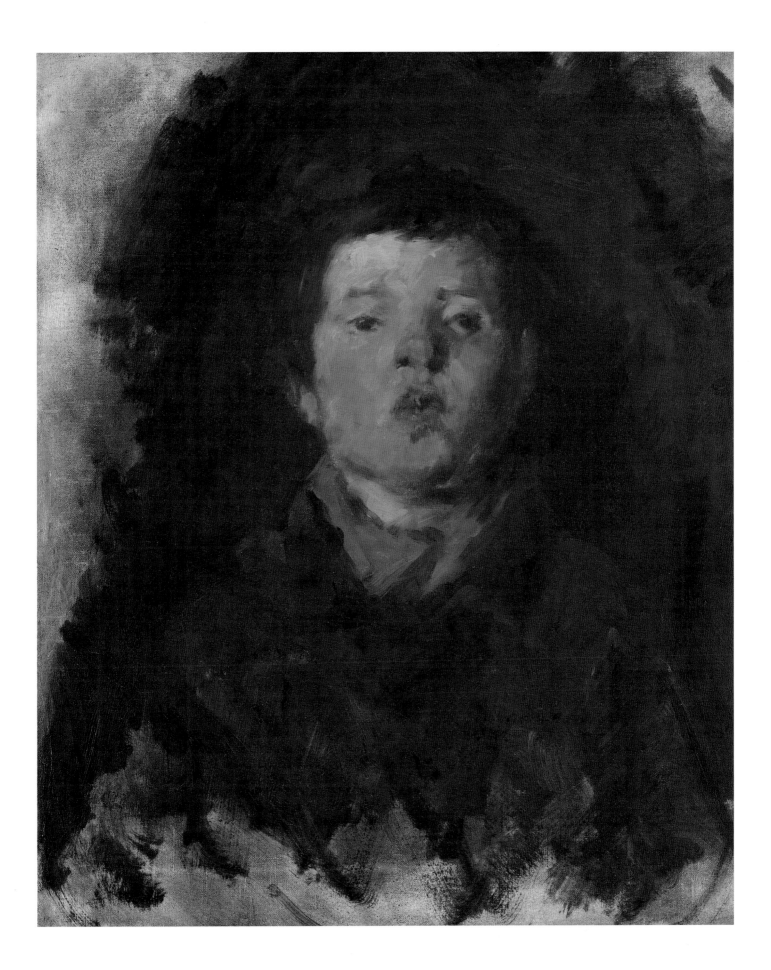

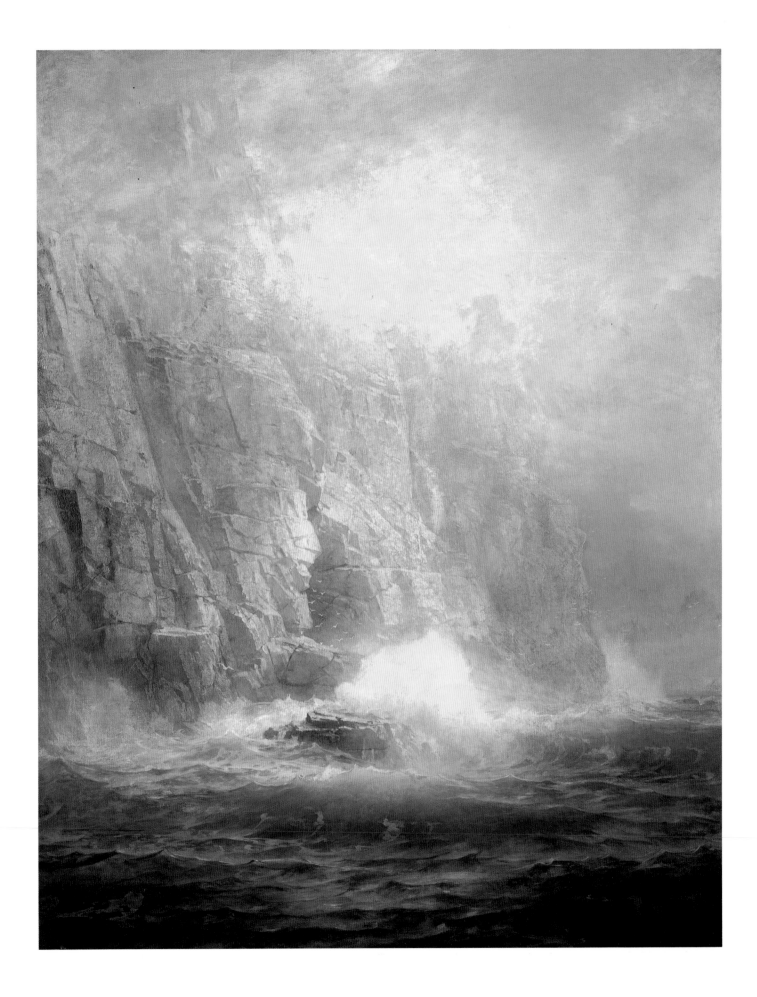

WILLIAM TROST RICHARDS | 1833–1905

Land's End, Cornwall, 1888
Oil on canvas, 62 × 50″ (157.48 × 127.00 cm.)
Signed, lower left
Museum purchase, 919-O-111

William Trost Richards first visited England in 1878 after having established a successful career painting landscapes and shore scenes in America. He went first to the Cornish coast to find new coastal subjects for the American art market, which was beginning to tire of native subjects painted with mid-century descriptive realism.[1] The cosmopolitan subjects favored in Munich, Düsseldorf, and Paris, where American painters were now going for study, were attracting an increasing number of patrons, and painting in which sunlight created a general mood rather than describing objects was gaining increased favor. Richards hoped not only to strengthen his repertoire with attractive foreign coastal subjects but also to establish himself in the London market. He succeeded in doing both. From the numerous Cornish sketches made on two more visits to the British Isles came paintings, two of which were exhibited at the Royal Academy in 1879 and quickly sold. Richards was to return to Europe once more but he would go back to England no less than four more times. He returned to America in 1880, and by 1882 he had built a house on Conanicut Island, across Narragansett Bay from Newport, with a spectacular view of the bay and sea. The market for his European and American coastal subjects in oil and watercolor continued and, although in 1885 he traveled to the Pacific coast in search of other subjects, Cornwall continued to remain popular.

Land's End became a frequent subject with its lofty granite cliffs weathered into a striking network of vertical and horizontal fissures defining great blocks of stone. Below the towering broken cliffs the Bristol and English Channel waters meet in restless confrontation. In *Land's End, Cornwall* we are suspended precariously above the heaving waves and dangerously close to the rocks. The cliffs, with tops lost from view in blowing mist, rise to awesome heights made more lofty by the picture's vertical proportions, uncommon in Richards's seascapes. The cliff is abruptly cut off at the left border making its continuation even more majestic in our imagination. A pervasive misty atmosphere and lack of strong local colors promote an overall mood, but the physical reality of the cliff persists, its shadowed crevices and projections emphasized by pale sunlight and heavily textured paint.

This is one of Richards's largest paintings. It called upon not only his detailed Cornish drawings but also such paintings as *The League Long Breakers Thundering on the Reef* (1887, The Brooklyn Museum), a view of Tintagel, the legendary home of King Arthur, perched high on a Cornish seaside cliff. Instead of that picture's view of miles of seaside cliffs, however, *Land's End, Cornwall* concentrates on only a small part which, seen close up, looms high above, immense and massive, creating a dramatic effect and powerful mood which express the grandeur of Land's End without losing touch with the details of its physical realities.

WILLIAM S. TALBOT

119

THOMAS COWPERTHWAIT EAKINS | 1844–1916

The Coral Necklace, 1904
Oil on canvas, 43 × 31″ (109.22 × 78.74 cm.)
Signed, right center
Museum purchase, 958-O-101

Thomas Eakins was assuredly one of America's greatest artists, and at the heart of his accomplishment was the elevation of portraiture to a level equal with the highest precedents of the past. Although we know he admired the masters of seventeenth-century Dutch and Spanish realism from his early years of study in France and Spain, Eakins did not consciously aim in his own later portraiture to emulate directly Diego Velazquez, Frans Hals, or Rembrandt van Rijn. However, his best images achieve a comparable poignancy and power. Born in Philadelphia, he studied there in two disciplines that would shape all of his mature art: anatomy at Jefferson Medical College and art at the Pennsylvania Academy of the Fine Arts.[1] Reinforced by academic training in Paris with Jean-Léon Gérôme and others during the mid-1860s, this combined sensibility for scientific observation and technical craft resulted in organically understood human figures placed in clear and coherent compositions. Returning to teach at the Academy with a new freshness of vision and directness of approach, Eakins became a popular and influential figure during the 1870s and early 1880s. But his most ambitious early work, *The Gross Clinic* (1875, Jefferson Medical College, Philadelphia), drew severe criticism for its perceived brutal realism, and a decade later, Eakins lost his position running the Academy for a similarly insistent honesty in teaching methods.

Understandably, he increasingly turned inward during his later career, embattled and often lonely. Over time he undertook fewer narrative or group subjects, and eventually none set out of doors. But throughout, the human form and the portrait, explicitly or implicitly, remained the core of his art, for in the figure were always the fundamental elements he cared about: specificity and individuality, character and achievement, and ultimately the triumphant as well as tortured ingredients of the human condition. By means of a resolute self-reliance, Eakins searched himself and those close to him among his family and friends to scrutinize and record unflinchingly the truths of existence before him. Occasionally, he had little sympathy for his sitters, whom he saw as vain, or weak, or lazy, and the results accordingly were dry or in some instances too severe and revealing for the owners to accept. There is much interesting discussion whether he was a finer painter of women or men. Fortunately, the Butler Institute owns compelling examples of each, and the comparisons between them are revealing in the ways Eakins could make use of costume, pose, and coloring to express the distinctions of personality and profession. *General George Cadwalader* (Fig. 1),[2] shows the figure frontally and hieratically, with the severe monochromatic palette and the rhythmic alignment of brass buttons rising to the attentive face, all suggesting a disciplined military presence.[3] By contrast, the relaxed pose of Beatrice Fenton in *The Coral Necklace*, the delicate and almost elusive play of colors, and her introspective gaze, instead suit the creative meditations of a young sculptress in Eakins's artistic circle.

Such isolation of a brooding single individual is characteristic of the artist's late work at its best. The loose clothing not only reveals the solid weight and organic unity of the body beneath, but the gentle rising curves of the arms and long bright necklace

Figure 1. Thomas Cowperthwait Eakins. *Portrait of General George Cadwalader*, 1878. Oil on canvas, 39 × 25″ (99.06 × 63.50 cm.). Unsigned. The Butler Institute of American Art. Museum purchase, 945-O-103.

lead our eye up to concentrate on Fenton's head, face, and eyes, and thereby we feel both a physical and psychological presence. Eakins often employed color as an expressive device in his portraits, and a variety of pinks for the dresses of women sitters in this period expresses a strong emotional range from tenderness to passion. Among the most memorable related works, for example, are *Maud Cook* (1895, Yale University Art Gallery), *Amelia Van Buren* (1890, The Phillips Collection, Washington, D.C.), *The Concert Singer* and *The Actress: Suzanne Santje* (1890–1892, 1903, both Philadelphia Museum of Art). In pose, *The Coral Necklace* is close to two other of Eakins's most moving portraits of nearly the same date: *Alice Kurtz* (1903, Harvard University Art Museums), and *Edith Mahon* (1904, Smith College Museum of Art).[3] Stripped of all incidental detail, they bear hints of strain and vulnerability in a taut neck tendon or watery eyes.

Many of these sitters also shared artistic temperaments or talents with Eakins, as painters, sculptors, pianists, or singers. Well known from this period are his portraits of fellow artists, William Merritt Chase and Henry O. Tanner, and of his students Samuel Murray, Jennie Dean Kershaw, and Susan MacDowell, who later married Eakins. But others, as indicated in their early exhibition titles, were intended as portraits both of particular individuals and professional or occupational types: *The Critic, The Veteran, The Bohemian, The Dean's Roll Call, The Thinker, The Art Student, The Actress,* and *A Singer.*[4] As in *The Old Fashioned Dress: Helen Montanverde Parker* (1908, Philadelphia Museum of Art), Beatrice Fenton's portrait also bears a title of a dominant article of clothing. Her necklace is strikingly large and elongated, the color coral, a distinctively bright pink, here perhaps a note of the exotic and idiosyncratic. Ultimately, these pensive self-absorbed faces seem reflections as much of the artist, accumulated expressions of his own troubled self, as he sought obsessively to confront the burdens of life and the possibilities of art.

JOHN WILMERDING

WILLIAM MICHAEL HARNETT | 1848–1892

After the Hunt, 1884
Oil on canvas, 55 × 40″ (139.70 × 101.60 cm.)
Signed, lower left
Museum purchase, 954-O-120

It is to a quartet of trompe l'oeil game pictures that William Michael Harnett owes much of his recognition as the leading painter of illusionistic still lifes in late nineteenth-century American art. The pictures, each entitled *After the Hunt*, represent the artistic culmination of Harnett's European experience and its passage to America.[1] The last version, making an unusual journey from the Paris Salon to a New York saloon, met with instant success and became the prototype for still lifes by other artists who worked in the trompe l'oeil style such as George Cope, Victor Dubreuil, and Charles Meurer. These monumental still lifes of antique hunting gear and small game hung on old wooden doors are the artist's most intense explorations of a single theme. The Butler Institute's version is his third—the last and most complex of three painted in Munich. While it exhibits the somber, contemplative aura of the first two versions, its composition is more closely paired with the final 1885 work because of its larger scale, dominant X-form, and depiction of massive elaborate hinges.

After the Hunt is invested with an air of connoisseurship joining the affluent tastes of two continents. The picture is steeped in the still-life traditions of Dutch and Flemish Baroque game pieces and their nineteenth-century European and American interpretations. It is informed by still-life vignettes, found in nineteenth-century genre paintings and prints, of hunting gear hanging on walls. Counterparts for these models are found in photography, such as the large-scale photographs of gear and catch pioneered by the Alsatian Adolphe Braun. Braun's compositions were probable sources for Harnett, among many still-life arrangements with game which were popular photographic subjects in Europe and America.[2] Moreover, the hunting equipment that Harnett depicts is of European origin, reflecting the vogue for collecting antique bric-a-brac. The whole is seasoned with the ritual of Victorian-era dining which, befitting international cosmopolitan style, was heralded in sideboards lavishly carved with trophies of the hunt.[3]

The Butler Institute picture is among Harnett's

greatest testaments to the art of trompe l'oeil. The illusionistic objects project in strong relief, their three-dimensionality underscored by the brooding darkness of the "door" on which they hang. Light and shadow, line and curve, lift and gravitational pull are carefully orchestrated to afford each object its full descriptive measure. Equally celebrated are the texture of fur, the patina of wood, the sheen of bone, and the polish of brass. Such convincing tactility further sustains the remarkable deception. Harnett's skill at effecting deceit gained the attention of admiring crowds. Probably referring to the Butler Institute picture, a Munich newspaper critic observed: "One would think it possible to remove the hat, the hunting horn, the flintlock, the sword, the powder horn and the game bag from their nails and with them equip one's self for the hunt one does not know which to admire more—the artist's gigantic patience or his astonishing powers of observation and imitation."[4]

Despite their immense popular appeal, Harnett's still lifes received little critical acclaim. Indeed, the Munich critic referred to the Butler Institute picture's "pedantry," and expressed his distrust in its artistic integrity. Today we recognize the inventiveness and conceptual complexity of Harnett's style. Transcending illusionism for its own sake, Harnett chose objects for their expressive potential and storytelling qualities. We are drawn to the impenetrable volume of the Tyrolean hat placed above the revealing circumference of the hunting horn; we are charmed by the carved lion of the sword hilt which snarls at the axe-wielding warrior of the key plate.

After the Hunt does not record the rigid, pungent death of a particular shoot. No excitement of the chase or anticipation of a feast is suggested. The thick, soft, unbloodied fur of the hare is meant to be admired as much as the carved stag decoration of the wheel-lock rifle. The picture instead ennobles the hunt and its artifacts. It venerates a world of gentlemanly leisure and retreat, of wealth and elegance, of memorable bygone days. The dented brass surface of the hunting horn portrays affectionate use and wear, the fine craftsmanship of the

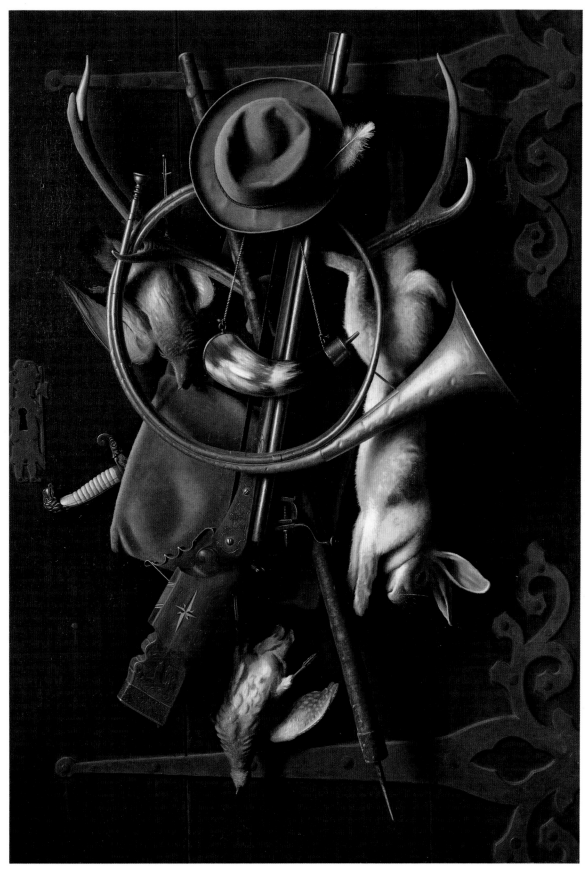

eighteenth-century rifle commemorates mellowing age and distinction, and the rusty hinges and weathered door evoke the passage of time. Mirroring a darker, introspective side of the Gilded Age, which sought comfort in a simpler past, this picture resounds with nostalgic reverie.

ELIZABETH JANE CONNELL

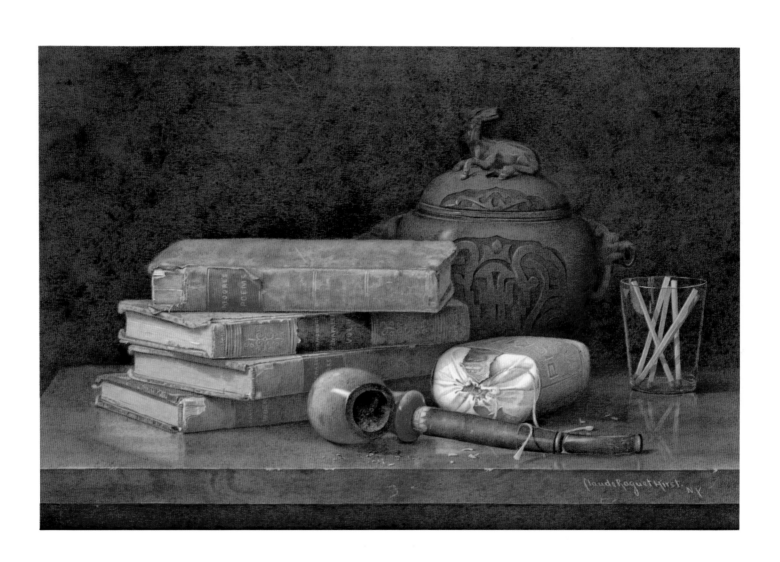

CLAUDE RAGUET HIRST | 1855–1942

Companions, c. 1895
Watercolor on illustration board, 10 × 14½″ (25.40 × 36.83 cm.)
Signed, lower right
Museum purchase, 968-W-123

Claude Raguet Hirst, born in Cincinnati, Ohio, studied painting between 1884 and 1885 under Thomas Noble at the Cincinnati Art Academy. She continued her studies in New York City under Agnes Abbatt and George Smillie,[1] taking a studio at 30 East 14th Street. Hirst first exhibited at the National Academy of Design in 1882 with two paintings entitled *Gathered Beauties* and *Pansies* and continued to exhibit similar floral still lifes each year through 1886. After a four year hiatus, Hirst once again exhibited at the National Academy. However, in this year the titles of her three entries, *Bachelor's Solace, Crumbs of Comfort,* and *Ye Ancient Tale,*[2] no longer reflect her former interest in floral subjects but rather the subjects and style of the famous trompe l'oeil painter William Michael Harnett, who had set up his studio at 28 East 14th Street, just one door away from Hirst. It is most probable that the close proximity of working quarters exposed Hirst to Harnett's bachelor subjects and style, both of which she quickly adopted. Another factor credited for her change of subject matter was suggested in this account from the San Francisco *Argonaut*, ". . . . Miss Hirst lent her studio to W[illiam]. C. Fitler, the landscape artist, who left the studio cluttered with pipes and books. Miss Hirst was inspired to paint a group of the untidy landscapist's belongings, which sold immediately. Since the sale of that picture Miss Hirst has painted nothing but old books and pipes"[3] While it may be true that Fitler's detritus gave Hirst the opportunity to paint "masculine" objects, only Harnett could have influenced her style so dramatically.

During the next twenty years Hirst enjoyed quiet success with her bachelor still lifes. While this may seem an unusual genre for a woman at this time, a contemporaneous account suggests it may not have been so: ". . . . the energetic, hopeful female art student, abreast with the most advanced theories, and differing from her male fellow workers neither by her choice of subjects nor her manner of execution, is, as

a class, essentially a product of to-day [sic]."[4]

Hirst exhibited yearly at the National Academy from 1890 to 1905, missing only 1892. She also exhibited frequently at the National Association of Women Painters and Sculptors and at the Pennsylvania Academy of the Fine Arts. It was there, in 1895, that she exhibited *Companions*. On the back of the work is an old label, quite possibly her own, that bears this title. However, the work is often listed as *Books, Pipe, and Tobacco Sack*, as it was retitled this for a time before being purchased by the Butler. The original title may refer to the companionship between the objects depicted, or it is also possible that it refers to Fitler, the apparent owner of the objects, Hirst's own companion and, later, her husband.

Whatever the title's reference, *Companions* is a fine example of Hirst's trompe l'oeil still lifes. The meerschaum pipe, tattered books, matches, tobacco sack, and ceramic vase are objects common to many of her works and comprise a theme from which she seldom strayed after 1886. The painting is small, as are the majority of Hirst's works, and her "fool-the-eye" effects are softened by the use of watercolor rather than oil. Her composition is straightforward, showing less interest in the virtuoso trickery and abstract relationships used by Harnett and other artists of his circle. The shallow space draws attention to elegant details such as the smooth reflections of the objects on the highly polished wood shelf and the delicate draping of the tobacco sack string over the pipe stem. A companionship between the objects and their owner is subtly indicated. The ashes appear to have been knocked from the pipe bowl as it was laid aside, possibly after a relaxing evening of reading. The pipe stem has been handily whittled to fit the bowl, and the glass of extra matches anticipates yet another evening of use. It is this attention to delicate detail that instills in Hirst's work its unique charm.

M. MELISSA WOLFE

GEORGE COPE | 1855–1929

Fisherman's Accoutrements, 1887
Oil on canvas on board, 42 × 30″ (106.68 × 76.20 cm.)
Signed, lower right
Museum purchase, 957-O-105

With happy memories of the past summer, he joins together the three pieces of his fly rod. . . . With what interest he notes the swelling of the buds on the maples . . . and looks forward to the day when he is to try another cast! and . . . with what pleasing anticipations he packs up his "traps," and leaves his business cares and the noisy city behind

Thus does the nineteenth-century writer, Thaddeus Norris, describe the delights of the "gentle art" of angling.[1] Cherished as a gentleman's pastoral retreat from the clamour of urban life, the sport is commemorated in George Cope's *Fisherman's Accoutrements*. The West Chester, Pennsylvania artist, a skilled angler and huntsman whose career was devoted to painting subjects drawn from the Brandywine River Valley countryside, excelled in illusionistic still lifes of dead game and hunting and fishing paraphernalia.

In *Fisherman's Accoutrements*, Cope portrays no brace of trout from clear-running streams so prized by nineteenth-century anglers, but instead pictures the traditional equipment of the fly-fisherman, depicted in an orderly yet expectant array. Hung from a large brass nail is a jacket, the signature feature of Cope's hunt pictures of the 1880s and 1890s, overlapped by a net and split willow creel. The central grouping is flanked by a hat bedecked with hand-tied artificial flies, and a fly wallet set on a wooden shelf, whose stag's head decoration evokes associations with hunt and fishing clubs. Below these, another shelf supports the butt, mid, and tip sections of a fly rod, delineating a triangular composition whose opposite side is marked with a flask. Between rod and flask lie a tobacco pouch, pipe, and a book or journal, other appointments of the angler's contemplative recreation.

The subject of a fisherman's "uniform" has its roots in seventeenth-century Dutch and Flemish fish still lifes, and more immediately in mid-nineteenth century American and English still lifes of the day's catch with fishing equipment arranged on grassy banks of streams.[2] Cope chose, however, to isolate the gear in quiescent light, referring the fishing experience to the viewer's imagination. A persuasive contemporary influence on this work is William M. Harnett's *After the Hunt*. Cope adopted a Harnett-like trompe l'oeil style with *Fisherman's Accoutrements* and other still lifes of 1887, a year after Harnett returned from Europe. While Cope's hanging game still lifes arranged in interior settings anticipated his transition to trompe l'oeil, the vertical format of this fishing subject, its emblematic presentation, and masculine emphasis profited from Harnett's example. The play of textures and shapes—the checkered pattern of the flaccid net against the ribbed swell of the creel, the soft folds and curves of the jacket against the straight edges of rod and shelf—are also hallmarks of Harnett although, in Cope's hand, they seem more descriptive than expressive in intent.

The art of trompe l'oeil and the painter-angler's accuracy of detail, from the hexagonal Calcutta cane rod to the snelled flies, heightens the work's realism.[3] Cope's hard-edged brushwork, however, lacks a certain ease of expression, and inconsistencies in perspective and proportion inhibit the fluid passage from real to illusionistic space. Yet these shortcomings afford Cope's still life its distinctive character. *Fisherman's Accoutrements* was admired as "an artistic triumph" when it was displayed at Bailey, Banks & Biddle, Philadelphia's leading jewelry establishment, and at the West Chester *Daily Local News*.[4] Cope's paintings were treasured by Philadelphia businessmen and West Chester residents alike, and many remain in Chester County collections.

ELIZABETH JANE CONNELL

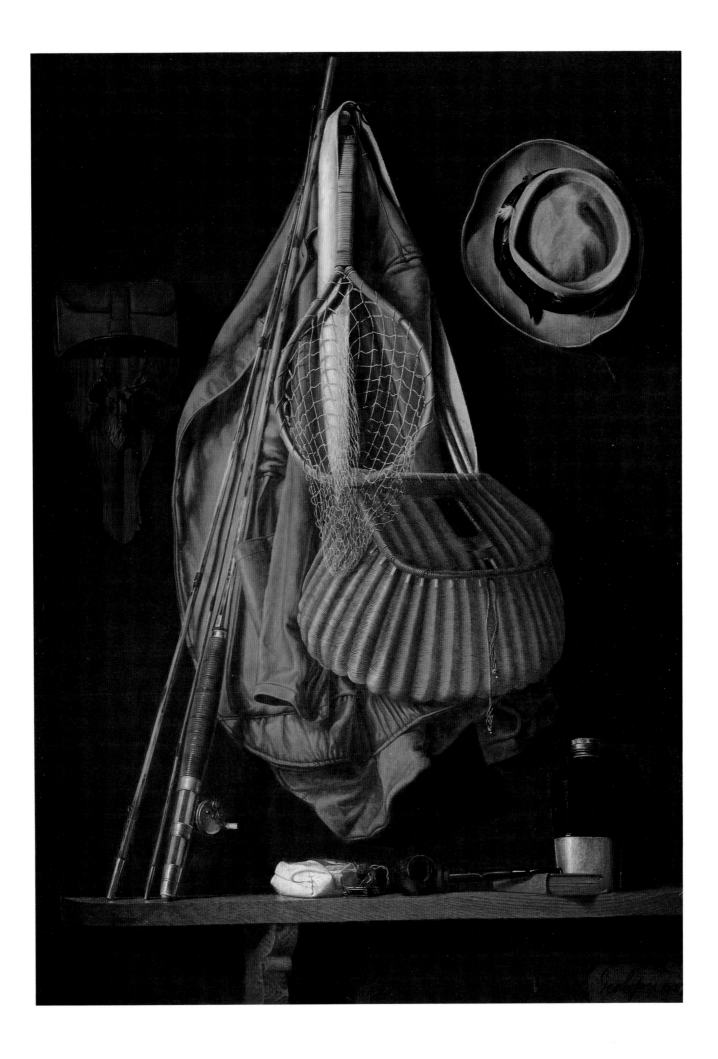

Book, Mug, Candlestick and Pipe, c. 1890s
Oil on canvas, 12¼ × 16″ (31.12 × 40.64 cm.)
Signed, lower left
Museum purchase, 967-O-102

John Frederick Peto's dark and brooding still life tells us a great deal about both himself and America in the latter half of the nineteenth century. At a glance, in a quick comparison with a Butler Institute still life from the mid-1850s by John F. Francis (no. 18), we can see how austere Peto's mood is; how concerned he is with the inert and inanimate things of the material world. Instead of Francis's optimistic celebration of ripened fruits, set, if not in, at least adjacent to nature, Peto moves indoors to a shadowy corner of his study or library, where a guttering candle is extinguished and the last glowing coals of the pipe are expiring. Instead of sustenance, there is a sense of quiet, inevitable erosion; instead of ripeness and effulgence, wear and tear; not the fullness of time but an anxious sense of its passage and change.

Among the powerful reasons for this stark shift of mood, subject, and coloring were the profound disruptions in the nation's political and intellectual life occurring in the years following 1850. Throughout this period, industrialization was transforming America's ingrained notions of the pastoral ideal, while the outbreak of the Civil War in 1861 physically as well as psychologically traumatized the nation's sense of self-identity. The publication of Charles Darwin's *On the Origin of Species*, in 1859, caused an immediate upheaval in the inherited beliefs about nature's spiritual perfection, and forever undermined the vision of landscape as beneficent, always regenerative and theologically inspiring. When Peto began to paint in Philadelphia in the 1870s, the

difficulties and ultimate disappointments of the Reconstruction period bred a growing cynicism, exacerbated by the bank and market failures in mid-decade. No wonder he and his contemporaries would become obsessed with images of currency and material wealth.

Born and raised in Philadelphia, Peto entered the Pennsylvania Academy of the Fine Arts for training in 1878.[1] This was a critical moment of heightened interest in the arts in the wake of the ambitious national Centennial Exposition, held two years before in Philadelphia's Fairmont Park, where a large international display of painting and sculpture strengthened the city's reputation as an influential artistic center. At the Academy, Peto had the opportunity of familiarizing himself with the venerable local tradition of tabletop still-life painting represented in several examples on exhibition and in the collections by Raphaelle and James Peale from the early nineteenth century and by Severin Roesen and Francis from mid-century.[2] Not surprisingly, his own first attempts at still life were devoted to similar fruit compositions in bright colors. Another key influence in the development of his style, at this moment, was the influential presence at the Academy of perhaps America's greatest teacher and artist, Thomas Eakins. At this time, Eakins was the center of controversial attention over the perceived brutal realism of his recently completed and exhibited work, *The Gross Clinic* (1875, Jefferson Medical College, Philadelphia). Eakins insisted that students in his classes study not only casts but live models directly,

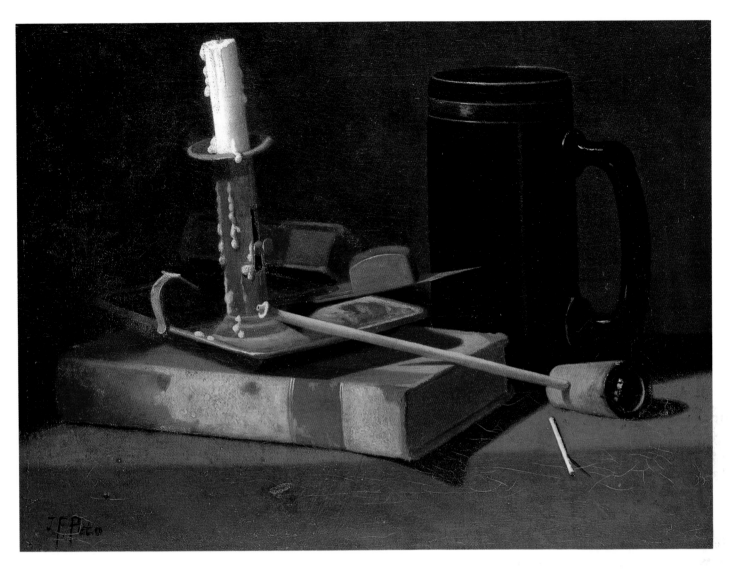

and from his own experience in anatomy and mathematics, he taught the close observation of human form as well as technical exercises like perspective drawing. Class records indicate that Peto was enrolled in Eakins's night class, which included elements of still-life composition, such as the scrutiny and rendering of light and shadow, as means of modeling solid geometric forms. In addition, Eakins's own recent portrait and genre paintings, such as *Benjamin Howard Rand* (1874, Jefferson Medical College, Philadelphia) and *The Chess Players* (1876, The Metropolitan Museum of Art), would have been striking examples for Peto with their exquisitely rendered still-life objects carefully situated within spatial compositions.

Aside from this early inspiration of still-life forms, Peto also appears to have taken from Eakins his sense of painting as a meditative, almost psychological, act; and as with so many of Eakins's later portraits of isolated introspective individuals, *Book, Mug, Candlestick and Pipe* bears a similar mood of quiet closure. After working in Philadelphia

and exhibiting occasionally at the Pennsylvania Academy throughout the 1880s, Peto married and moved to the resort community of Island Heights on the New Jersey shore. There he built a house and studio and his only daughter, Helen, was born. This painting probably dates from the 1890s and includes familiar objects around the house: worn leather-bound books, candle and snuffer, pipe and match, and porcelain mug. Its casual and angular clutter of shapes, the not quite successful foreshortening of the match extending over the table's edge, and the dark green and muted oranges, are all typical of his mature style. Hardly a quarter of his known output has any inscription, but the blocky signature here is consistent with those that are signed. Ultimately, the painting reveals itself as a modest yet intense contemplation on the pleasures of life, whether they be the immediate comforts of drinking and smoking or the timeless knowledge of a book.

JOHN WILMERDING

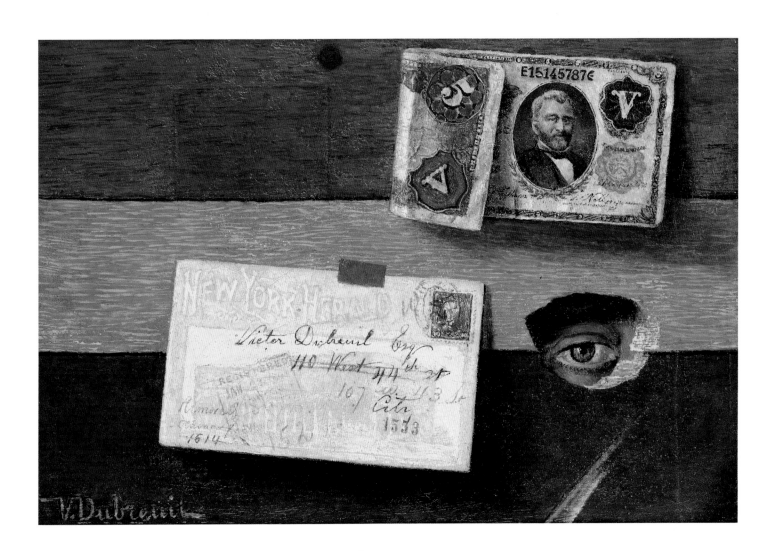

VICTOR DUBREUIL | ACTIVE 1886–c. 1900

The Eye of the Artist, c. 1898
Oil on canvas, 10 × 14″ (25.40 × 35.56 cm.)
Signed, lower left
Museum purchase, 967-O-148

Toward the end of the nineteenth century, a number of American trompe l'oeil still-life painters began to focus on the subject of money. Led by William M. Harnett, such artists as John Haberle, John F. Peto, and Nicholas A. Brooks created exact images of paper currency. They had several aims: to show off their replicative skills, to confound federal counterfeiting laws, and, perhaps most importantly, to join in the then-highly-emotional debates over American monetary policy. At the time there were significant differences between using "hard" gold- or silver-backed paper currency and "soft" Treasury Notes, or "Greenbacks," whose value was based solely on the government's promise to redeem them.

Among the most enigmatic of these painters was Victor Dubreuil, born in New York City to French emigré parents. While Dubreuil's training is unknown, his name appears in Manhattan directories in 1886, and the first of his money paintings dates to about 1890. Dubreuil had a satirical streak, frequently painting rows of money-stuffed barrels or safes full of cash, underscoring America's preoccupation with wealth in the age of the robber barons. Among his best-known works is *The Cross of Gold* (1896, private collection), which depicts bills arranged in the form of a cross tacked to wood planks with gold-headed pins, a literal embodiment of Presidential candidate William Jennings Bryan's words at the 1896 Democratic Convention: "You shall not crucify mankind on a cross of gold!", that is, create economic hardship for ordinary farmers and workers through the "hard" money policies of East Coast banks. In Dubreuil's version, however, "Greenbacks" form the cross, now nailed down by gold.

Another of Dubreuil's paintings is titled *Don't Make a Move!* (c. 1898, private collection), a view of two robbers, who have caricatured Jewish features, one armed with a pistol, holding up a bank cashier who is identical with the viewer. Such seemingly anti-Semitic sentiments would not have been unusual for a French artist working at the time of the Dreyfus Affair. In 1894, a French army officer and a Jew, Captain Alfred Dreyfus, was convicted and imprisoned as a German spy. Although the evidence was subsequently found to be falsified, French conservative politicians still used the occasion to blame their country's financial woes on a conspiracy of Jewish bankers.

This background is necessary to explain Dubreuil's complex work, *The Eye of the Artist*. The painting depicts a folded five-dollar Treasury Note glued to a thick wood plank. Below the bill is a letter addressed to the artist and, to our right, a hole cut into the plank, through which a human eye stares back at us. According to the painting's title, this eye is the artist's, looking at us through his creation. It has been noted that ". . . this eye, or *oeil*, is the trompe l'oeil of the piece . . . the *I* of the artist who draws his material from the visual realm (and) the eye from the pyramid (on the back of) the American dollar bill."[1] That eye above the pyramid is an Egyptian symbol of divine watchfulness, the eye of an all-knowing, omnipresent God—or of an especially vigilant artist.

The letter had been sent from the *New York Herald*, which had run several articles on January 23, 1898 relating to the uproar in France's Chamber of Deputies over Emile Zola's letter, "J'accuse." Zola produced evidence that the real spy was Major Ferdinand Esterhazy, who had been acquitted, through forged evidence, of the blame that had fallen on Dreyfus. The *Herald*, a politically conservative newspaper, ran Zola's text and the opinion of a French doctor that Zola suffered from a "pathological nervous condition"![2]

The discovery of these articles, when paired with a five-dollar "Greenback" bearing the portrait of Ulysses S. Grant, whose Presidential administration was noted for its financial corruption, might indicate that *The Eye of the Artist* was another attack on Jewish robber-bankers and/or their unsound monetary policies. Dubreuil's motives, however, are never entirely decipherable. What, for instance, did he intend by painting the plank with the colors of the Hungarian national flag; the presence of the words "Havana" and "NimoreiS" on the letter; or "D Nellborgen" named as Secretary of the Treasury on the bill? While we may never be able to explain all of Dubreuil's puns and references, the evidence indicates that he was an artist with international interests, and more than just money on his mind.

BRUCE W. CHAMBERS

131

CHARLES A. MEURER | 1865–1955

A Doughboy's Equipment, 1921
Oil on canvas, 68 × 40″ (172.72 × 101.60 cm.)
Signed, lower right
Gift of Elmer G. Engel, 959-O-130

Charles A. Meurer died in his Cincinnati home on the eve of his ninetieth birthday. He had lived long enough to see the art world proclaim him "the last living member of the great school of American trompe l'oeil."[1] Indeed in the last years of the artist's life, his painting *A Doughboy's Equipment* achieved national acclaim as a modern descendent of William Harnett's *After the Hunt* (no. 53) "in military form."[2] Surviving newspaper interviews with Meurer frequently repeat the tale of the aspiring artist's decision to become a master of trompe l'oeil after seeing Harnett's *The Old Violin* at the Cincinnati Industrial Exposition of 1886.[3] In fact, it was through the sale of the Harnett-inspired still lifes he painted over the next few years that Meurer financed his European training, beginning in 1891.

The year of Harnett's death, Meurer painted *My Passport* (1892, location unknown), the trompe l'oeil still life which would establish his reputation. The painting won honorable mention at the 1893 Chicago World's Fair, and, it also drew the attention of the Secret Service. Like Harnett's notorious paintings of money, Meurer's composition, featured illusionistic images of American currency, which was considered a violation of counterfeiting laws. And, again like Harnett's, it was confiscated until Meurer returned from his studies at the Académie Julian in Paris, and agreed to paint "red lines of cancellation" across the face of his "money."[4]

He abandoned the subject of illusionistic money only in 1909, after Congress passed a stringent law barring all facsimiles of American currency. Meurer seems to have forsaken trompe l'oeil altogether for the next twelve years, preferring to concentrate on landscape and portraiture. He returned to the genre in 1921 with the creation of two trompe l'oeil still lifes devoted to the subject of World War I, *A Doughboy's Equipment* and *Memories* (United States Military Academy, West Point).[5] *A Doughboy's Equipment* commemorates the service of an enlisted man, while *Memories*, with its pistol, spurs, and officer's cap, commemorates that of an officer.

Memories, depicting a profusion of objects crowding the face of a fireplace, reflects a calculated disarray, a literal accumulation of material memories.[6] The more simplified composition of *A Doughboy's Equipment*, however, evokes the spit and polish of military life, with the permanence and ordered symmetry of a war memorial. Tucked among the impersonal, regulation-issue objects are hints of an ordinary soldier's life: an I.D. tag, an Individual Record Book, a Croix de Guerre medal, and an open pack of Camel cigarettes. This picture clearly enshrines not military service in general but a specific historic moment, The Great War, alluded to on the meticulously painted envelope addressed to John J. Pershing and postmarked May 26, 1917, Washington D. C. The end of the war is announced by an illusionistic newspaper clipping which declares "Armistice Signed/ Paris Nov 11."

A Doughboy's Equipment transcends the use of illusionism simply for its own sake; the bravura of trompe l'oeil deception, however, remains at the heart of Meurer's intention. His contemporaries marveled at his ability to "faithfully reproduce the minutest details" of each life-sized object found in his paintings, declaring that his work "cannot be equaled for realism."[7]

Meurer has subtlely drawn on the age-old tradition of *vanitas* in his exploration of the theme of life and death. The sightless eyes of the skull-like gas mask stare out at the viewer with a disquieting assurance of the inevitable bond between war and death. The brevity of life is further alluded to in the juxtaposition of the bullet and the smoldering cigarette balanced on the bottom ledge of the door.[8] The finality of death is tempered, however, by the hope of immortality symbolized by the image of the Christian cross formed by the creases in the campaign hat.

NANNETTE V. MACIEJUNES

132

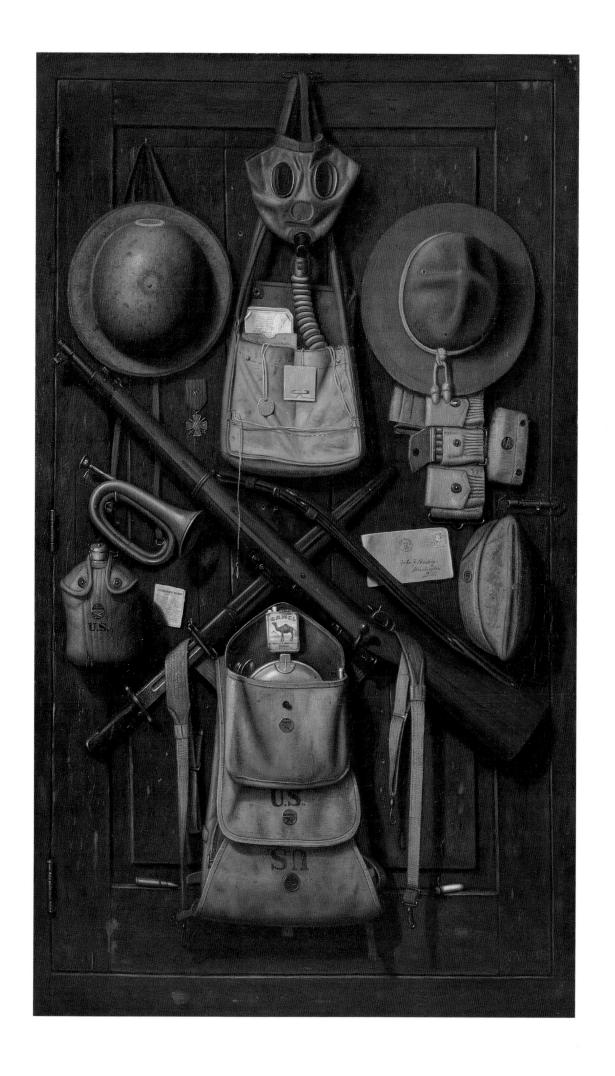

Roadside Meeting
Oil on canvas, 15 × 12″ (38.10 × 30.48 cm.)
Signed, lower right
Museum purchase, 917-O-106

Albert Pinkham Ryder's earliest formal art training was with the noted portrait painter and engraver William Marshall, and between 1871 and 1875, he attended classes at the National Academy of Design. During the 1870s, Ryder moved in an orbit that included John La Farge, J. Alden Weir, Robert Louis Stevenson, and Stanford White, nurturing his deep love of literature and art. In 1878, he was included in the list of founding members of the Society of American Artists, established in protest against the restrictive policies of the National Academy of Design, though in 1906 he was admitted as a member. After the turn of the century he gradually became more reclusive in his behavior, a condition that worsened until his death in 1917.

Throughout his career, Ryder maintained an interest in subjects derived from literature, poetry, and legend, especially themes of redemption and salvation, and of women in distress. Women who are the undeserving victims of fate or circumstance are the subject of some of Ryder's most powerful works, notably in *Lord Ullin's Daughter* (n.d., National Museum of American Art), based on Thomas Campbell's poem of the same name, set in Scotland; *Constance* (n.d., Museum of Fine Arts, Boston), derived from Chaucer's "Man of Laws Tale" in *The Canterbury Tales*; and *Little Maid of Acadie* (n.d., Mr. and Mrs. Daniel W. Dietrich, II), a character taken from Longfellow's poem, "Evangeline: A Tale of Acadie."

Roadside Meeting, a variation on this theme, depicts a horseman stopped in a glade, turning in his saddle to address a woman who stands with one hand protectively placed on her child's head. Although this painting bears no date, its overall blond tonality and reddish highlights are typical of Ryder's early works from the 1880s.[1] With meticulously applied brushstrokes, Ryder built his composition, taking particular care in rendering the forms of man and horse. The artist's concern with equine form, a hallmark of his work, is readily evident on both the painting's surface and in its X-ray, and relates closely to horses found in several of Ryder's other paintings, notably *King Cophetua and the Beggar Maid* (n.d., National Museum of American Art). *Roadside Meeting* appears to have been adapted from a scene in Sir Walter Scott's novel *The Monastery*, written in 1820, and set in Scotland at the close of the sixteenth-century religious wars with England. In a scene from Scott's novel closely corresponding to Ryder's painting, the English soldier Stawarth Bolton halts his horse to speak with Dame Glendinning, who fears he will take her children to be raised among the heathen English.[2] In *Roadside Meeting* this encounter takes place under a grove of trees. The opening of a dark, Gothic portal is just visible at the far right, recalling medieval monastic architecture. Ryder made one significant alteration in the painting's composition, lifting the horse's head and neck from grazing to a semi-alert stance, thereby implying a more brief and immediate encounter.[3] Although this encounter carries a note of tension, Ryder's empathy for strong women facing adversity lends an emotional quality to this work.

Ryder was not alone in his interest in Sir Walter Scott, who enjoyed great and consistent popularity in the United States long after his death in 1832, especially among children.[4] *The Monastery* was the first of Scott's gothic romances, invoking the ideals of chivalry in a medieval setting, and its popularity coincided with the gothic revival in architecture and the decorative arts. British influence on American taste was subtle, but pervasive. With the publication of Charles Eastlake's *Hints on Household Taste* in 1868, gothic subjects gained prominence in the work of artists and craftsmen, ushering in the aesthetic movement.[5] The writings of John Ruskin and the works of the Pre-Raphaelites presaged the general interest in Anglo-Scottish heritage that flourished in America during the late nineteenth century.

Ryder's interest in Scotland and its literary heritage was no accident. His primary dealer, Daniel Cottier, was a stained-glass artist, born and raised in Glasgow, who worked with Louis Comfort Tiffany and La Farge. Cottier cultivated a group of Scottish patrons, including one of Ryder's most important ones, John Gellatly. During the fifteen years he spent with Cottier & Co., Ryder was thus exposed to the Anglo-Scottish culture from which several of his major paintings emerged. Along with *Roadside Meeting*, Ryder's most prominent works set in Scotland are *Macbeth and the Witches* (n.d., Phillips

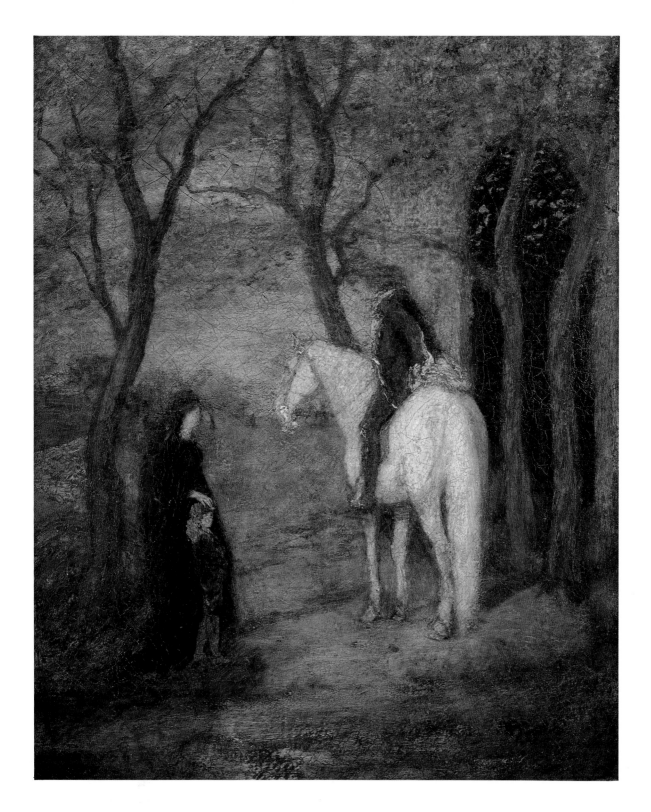

Collection, Washington, D.C.), and *Scottish Castle* (n.d., Tom Fidelo, Edinburgh), which may have served as a study for *Macbeth*, *The Monastery* (n.d., Parrish Museum, Southampton, N.Y.), and *Lord Ullin's Daughter*, based on the tale of a Scottish chieftain.

Interest in Anglo-Scottish heritage was an important component of late nineteenth-century American culture, a milieu in which Ryder was

steeped from early in his artistic career.[6] Among the complex influences permeating Ryder's oeuvre, Scotland played a significant, if understated, role in the paintings derived from his love of literature. In *Roadside Meeting*, Ryder has translated into paint the emotion vested in Scott's words, extracting the essence of the encounter to convey a larger truth.

ELEANOR JONES HARVEY

RALPH ALBERT BLAKELOCK | 1847–1919

Twilight, c. 1898
Oil on canvas, 20 × 30″ (50.80 × 76.20 cm.)
Signed, lower right
Gift of H. H. Stambaugh, 919-O-103

Twilight is representative of a large body of poetically conceived nocturnal landscapes produced by Ralph Albert Blakelock almost exclusively from 1883 to 1898 that share the artist's signature chiaroscuro treatment of anonymous pastoral settings. Like other works from this stylistic phase, *Twilight* displays Blakelock's characteristically reductive approach to composition in which dark foliate shapes placed in relief against the light of a night sky provide the principal formal scheme. The hallucinatory qualities of these evocative images have become emblematic of the subjective response to nature that emerged in late nineteenth-century American painting, causing Blakelock's name to be linked with artists Albert Pinkham Ryder and George Inness. In a narrower, more compelling context, however, Blakelock's unique language of light and dark has come to be interpreted as a metaphor for the alternating emotions of hope and despair that threaded through his troubled mind.

It is impossible to discuss Blakelock's art without referring to the tragic ironies of his life. His rise from the ranks of the unknown and untrained to the unlikely status of being the most highly publicized American artist at the turn of the century had as much to do with the press's sensationalized accounts of his plight as an insane, unrecognized genius as it did with the merit of his art. Public fascination with the artist, whose career was described as "one of the saddest romances of American art," generated a flood of spurious Blakelock canvases as early as 1903.[1] The numerous forgeries, and Blakelock's obsessively repetitive imagery, his failure to date most of his work, and the lack of thorough documentation, have complicated the task of analyzing his oeuvre and heightened the romantic aura surrounding his life.[2]

Blakelock was born and raised in New York City where he attended the Free Academy of New York, now City College of New York, from 1864 to 1866. He left school prior to graduating and within a short time and apparently with no formal training, made his exhibition debut at the National Academy of Design in 1868, exhibiting there annually until 1873 and sporadically thereafter. Blakelock's early efforts are largely prosaic demonstrations of his assimilation of the Hudson River School landscape aesthetic. However, like *Landscape with Cows*, a work he probably executed in the 1870s, his early paintings

Figure 1. Ralph Albert Blakelock. *Landscape with Cows*, c. 1870s. Oil on canvas, 18 × 32″ (45.72 × 81.28 cm.). Signed, lower left. The Butler Institute of American Art. Gift of Mr. and Mrs. John Tyler and Mr. and Mrs. William T. Deibel in memory of Mrs. C. P. Deibel, 982-O-109.

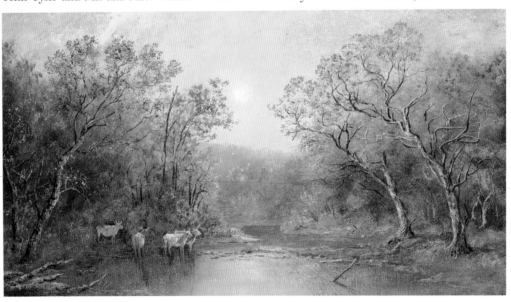

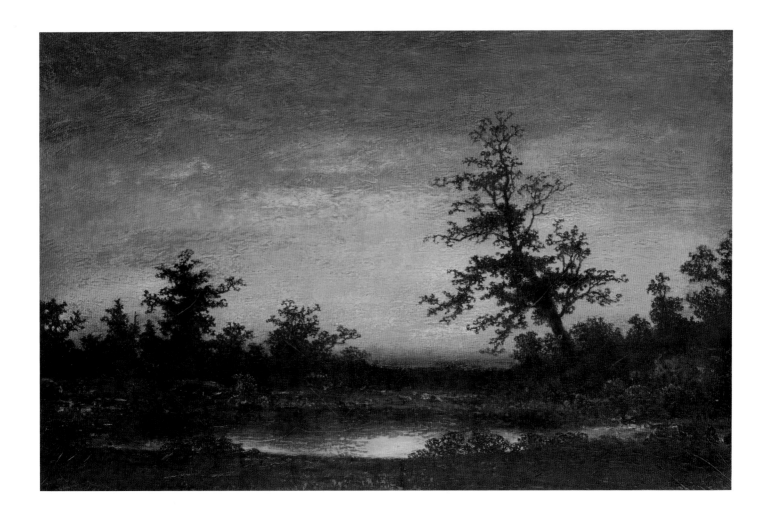

occasionally prefigure his later style in the patterned effects of foliage against sky, a particular attention to light, and a prevailing sense of stillness. The simple landscape vocabulary established in Blakelock's early work assumed a greater atmospheric resonance with his stylistic response to the Barbizon aesthetic in the 1880s. The rich, dark tonalities, enhanced by Blakelock's often idiosyncratic glazing techniques, fused with his preference for moonlit or sunset scenes to create hauntingly introspective visions whose origins lay in the imagination rather than observed reality.

Blakelock's 1877 marriage and his eight surviving children placed him under enormous financial and emotional stress. Despite occasional sales to important collectors and the supportive friendships of a number of artists, Blakelock's uniquely subjective canvases failed to find wide appreciation. Apparently predisposed to melancholia, the artist suffered a mental collapse in 1891 and was institutionalized briefly. Throughout the 1890s his emotional state gradually deteriorated, manifesting in delusions of grandeur and eccentric dress. A violent episode in 1899 resulted in the artist's uninterrupted confinement until 1916, after which he was hospitalized periodically until his death. Ironically, the recognition that he had long sought came to him only after he was institutionalized. One reporter observed in 1903, "Now that he is confined in an asylum for the insane . . . no collection . . . is thought to be complete without a canvas or two by him."[3] By that time, however, he was beyond recovery and forged canvases bearing his name competed with his own in an active market.

The essential quietude of Blakelock's landscapes belies the tensions of his daily existence. As in *Twilight* and comparable works of the 1890s, Blakelock seems to have found relief in repeatedly expressing the poetic resolution of the light and dark aspects of the diurnal cycle that paralleled the opposing emotions that gripped him. A short poem signed R. A. Blakelock affixed to the painting's frame sums up the artist's enduring concerns:

What if the clouds one short dark night,
* hide the .blue sky until morn appears*
When the bright sun that cheers soon
* again will rise*
to shine upon earth for endless years.[4]

BARBARA DAYER GALLATI

ELBRIDGE AYER BURBANK | 1858–1949

Snake Dance, copyright 1909
Oil on canvas, 30 × 40″ (76.20 × 101.60 cm.)
Signed, lower right
Museum purchase, 916-O-501

Throughout his travels, Elbridge Ayer Burbank befriended many Native Americans and western personalities including Chiefs Sitting Bull and Red Cloud, Buffalo Bill Cody, and William Jennings Bryan. Born in Harvard, Illinois, he began his art training in 1874 at the Academy of Design in Chicago. In the early 1880s, Burbank accepted an offer from the *Northwest Illustrated Monthly* to sketch towns along the Northern Pacific Railroad advertising opportunities available to prospective immigrants.[1] After studying in Munich, Germany, Burbank opened a studio in Chicago in 1892. Burbank returned to the West when his uncle, Edward E. Ayer, president of the Field Museum of Natural History, commissioned him to paint the Apache Chief, Geronimo. Arriving at Fort Sill, Oklahoma Territory, in 1895, he began not only a life-long friendship with Geronimo, but a career that would include the portrayal of Native Americans from over 125 western tribes. During his travels through Native Amerian country, Burbank befriended J. L. Hubbell, owner of a trading post in Ganado, Arizona, where the artist stayed for periods between 1897 and 1911. At Hubbell's request, Burbank agreed to draw two portraits from every western tribe in the United States. This agreement, though not completed, accounts for his prodigious output of red conte drawings known as "Red Heads."[2]

In 1902, Burbank visited Joseph G. Butler, Jr., who purchased 118 portraits.[3] Butler continued to purchase works by Burbank, the majority being acquired in 1912.[4] Their importance lies not only in the clear, sensitive portraiture, but also in their rare accuracy as records of traditional tribal and ceremonial costumes. This exactitude can be traced to the fact that Burbank found a guaranteed entrance into the Native Americans' circle with his scrapbook of past drawings. The Native Americans, intensely interested in these depictions and critical of every particular of costume, would allow him to paint them if the details were correct.[5] Burbank's accuracy and sensitivity can also be attributed to the respect and deep friendship he felt for his sitters. As Charles F. Lummis wrote, ". . . . One of the reasons why Mr. Burbank can paint Indians . . . was not learned in art schools. He can not only see, but understand. They

are to him not merely line and color, but human character. . . . He neither idealizes nor blinks."[6]

One of the finer Burbank portraits is *Chief Joseph* (Fig. 1), leader of the Nez Perce, who in the late 1870s attempted to flee the United States by leading his tribe into Canada. Burbank felt that Chief Joseph was probably the most remarkable man the Native American race had produced, stating that he ". . . reminded me very much of a Quaker . . . an imposing Indian, gentle, dignified, serious. . . ."[7] The year the portrait was painted Joseph claimed to be 53 years old, and the last living Nez Perce chief. The loose but assured brushstroke evidences the familiarity of the sitter's features to the artist. Clearly, this was a countenance Burbank had studied intensely.

Another especially sensitive portrait is *Chief Geronimo* (Fig. 2). The simplicity of design, devoid of ornament, the loosely brushed background with strong, rather flat, areas of red and yellow costume

LEFT, BELOW:
Figure 1. Elbridge Ayer Burbank. *Chief Joseph*, 1899. Oil on canvas, 13 × 9″ (33.02 × 22.86 cm.). Signed, lower left. The Butler Institute of American Art. Museum purchase, 912-O-515.

RIGHT, BELOW:
Figure 2. Elbridge Ayer Burbank. *Chief Geronimo*, 1899. Oil on canvas, 13 × 9″ (33.02 × 22.86 cm.). Signed, lower left. The Butler Institute of American Art. Museum purchase, 912-O-582.

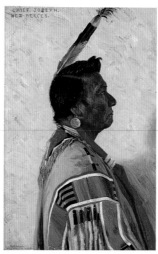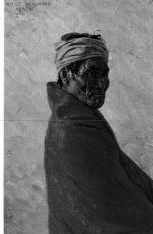

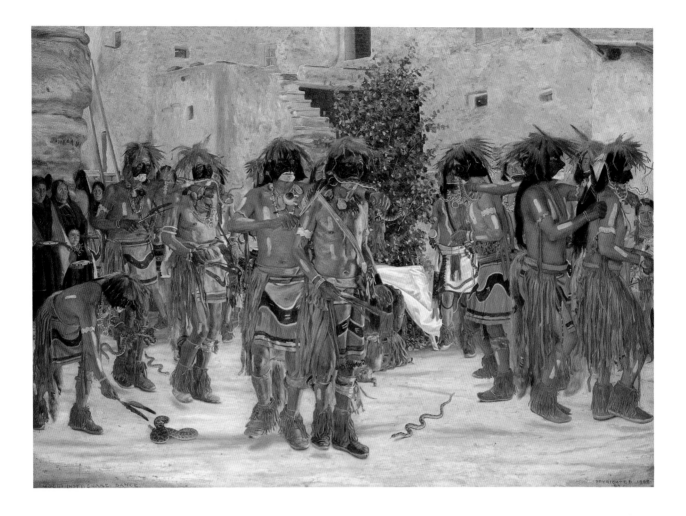

both balance and frame the intensely personal description of Geronimo's face. Burbank stated, "His keen, shrewd face was deeply furrowed with strong lines. His small black eyes were watery, but in them there burned a fierce light. . . . I tried to get Geronimo's real character into the portrait every wrinkle in his face and even a mole on his cheek." As for Geronimo's verdict, ". . . he turned, laughed, and slapped me on the back."[8]

While the Butler Institute collection of Burbank's work consists mainly of portraits from life, the work that is artistically most significant is *Snake Dance*. The Snake Dance, an elaborate, nine-day prayer for rain, was one of the most famous Hopi (Moqui) ceremonies. At the request of the Smithsonian Institution, the ritual was performed in 1907 at Walpi, Arizona, and Burbank went there specifically to paint it. Although many of the tribal dances were forbidden to outsiders, because of Burbank's close relationship with the Hopis he was allowed to witness the full ceremony.[9] In September of 1907, the Kanst Gallery exhibited fourteen canvases done at Walpi, three of which were large. Illustrating the exhibition's review in the *Los Angeles Times* is a *Snake Dance* (copyright 1908, Hubbell Trading Post National

Historic Site). The Butler Institute's *Snake Dance*, copyright 1909, was probably painted a year later. As was common with Burbank, the two versions of *Snake Dance* are nearly identical.[10] The color scheme of the brown, orange, and black of the dancers contrasted with the light sand background, and the snake shrine with a kneeling snake dancer in the middle ground center are similar. The dancers' faces are blackened and their chins covered with resin to represent a rain cloud. Burbank's academic training is most notable in the dancers' well-modeled bodies in various stepping positions, grouped in twos, as they circle the shrine; the figure on the left is using an eagle feather to distract a snake from coiling.

The change from portraits to large genre scenes seems to have begun with the three large canvases in the 1907 exhibition.[11] The *Los Angeles Times* critic reviewing the 1907 exhibition noted, "These pictures are not portraits, as most of his former work has been. They are close and sympathetic studies of Indian life"[12] This Native American life, long since vanished, survives in the clear depiction and insight of Burbank's work.

CLYDE SINGER

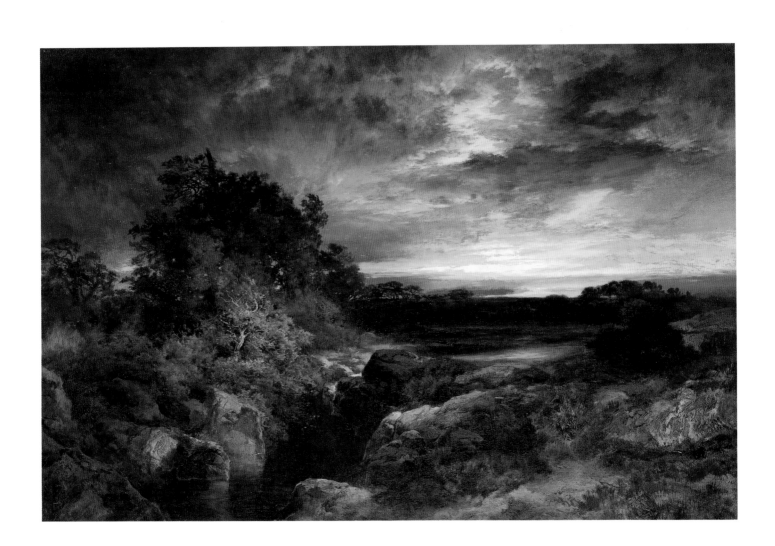

THOMAS MORAN | 1857-1926

An Arizona Sunset Near the Grand Canyon, 1898
Oil on canvas, 20 × 30″ (50.80 × 76.20 cm.)
Signed, lower right
Museum purchase, 958-O-128

Thomas Moran apprenticed to a Philadelphia wood engraving firm, but by 1858 at the age of twenty-one, he had exhibited an oil painting at the Pennsylvania Academy of the Fine Arts. Encouraged by the marine painter, James Hamilton, Moran traveled to London in 1861, where he was deeply impressed by the dynamic effects and glowing color of J. M. W. Turner. He also visited France and Italy in 1866 to study the Old Masters, but his early American reputation was gained as an illustrator. In 1871 Moran went west with the Hayden Expedition to record the wonders of the Yellowstone area, making annotated drawings and watercolors later used to illustrate articles in the popular press as well as the official report. Moran's watercolors and his very large oil painting, *The Grand Canyon of the Yellowstone*, 84 × 144 inches (1872, National Museum of American Art, lent by the U.S. Department of the Interior), convinced the U. S. Congress to set this area aside as America's first national park.

Moran first visited the Grand Canyon of the Colorado in 1873, and the resulting *Chasm of the Colorado* (1874, National Museum of American Art, lent by the U. S. Department of the Interior) further enhanced his reputation as the preeminent painter of the Southwest. In 1879, Moran traveled to the Tetons, the Sierra Nevada, and to Lake Tahoe. Although during the 1880s he based some pictures on his journeys abroad and to Mexico, his reputation rests mainly on the paintings of the American West.

Thomas Moran painted *An Arizona Sunset Near the Grand Canyon*, based very possibly on sketches done during his second visit to the Grand Canyon of the Colorado in 1892. The Santa Fe Railroad, which had begun using scenic art to promote its routes in the Southwest and was luring artists there to record the spectacular landscape, had provided Moran transportation in return for the copyright to a canvas to be reproduced for railroad publicity.[1] Moran arrived for the first time at the south rim of the canyon after a day's stagecoach ride from Flagstaff, Arizona, then the end of the railroad line. The title of the Butler Institute picture does not give a specific location, but it is known that the artist sketched for a number of days not only the canyon of the Colorado but neighboring canyon country as well.[2]

After leaving the Grand Canyon, Moran went with his good friend, the frontier photographer William H. Jackson, into the mountains of Wyoming, ending with another visit to the Yellowstone area. He then returned home to East Hampton, Long Island with scores of pencil, watercolor, and oil sketches.[3] *The Grand Canyon of the Colorado* (1892, Philadelphia Museum of Art) was finished by the end of August and lithographed by the Santa Fe Railroad as a promotional piece.[4] From this and numerous other Moran paintings, late nineteenth-century America gained its images of the Southwest.

The flaring red-orange sky of *An Arizona Sunset Near the Grand Canyon*, made even more dramatic by the contrasting gray clouds, reflects Moran's debt to the coloristic freedom of J. M. W. Turner. The sharp drop from the edge of the foreground to the river flowing between rocky outcroppings is similar to the increased drama created in the 1892 painting of the Grand Canyon, which, instead of a foreground filling the lower edge of the picture, is only anchored at the right and left corners, the center falling away with awesome suddenness into a deep gorge. Moran's earlier pictures also tended to give landscape sharp, clearly defined features suggesting truth to topographical reality when, in fact, elements seen from different viewpoints were often combined in order to recreate the effect of the actual site. In his later paintings, landscape features tend to be less insistent in outline, more gentle in contour and enveloped in a more poetic atmosphere. Here the glowing sunset sky impressively silhouettes trees seen as a dark green mass and picks out the edges of the rock formations, separating them from deep shadow. It is more a picture of general atmospheric mood than the sum of topographical details, reflecting the late nineteenth-century taste for poetic image rather than sunlit description.

Moran continued to paint the landscape moods of the Southwest, returning almost every year between 1901, when the Santa Fe completed the rail line to the Grand Canyon, and his death in 1926. Since his first visit in 1873, he had traveled to the Rockies, Europe and Mexico, yet he was drawn back again and again to the Southwest. Alongside him now came travelers attracted to the region for the first time by the landscape images he had created.

WILLIAM S. TALBOT

GEORGE INNESS | 1825–1894

Hazy Morning, Montclair, New Jersey, 1893
Oil on canvas, 30 × 50″ (76.20 × 127.00 cm.)
Signed, lower right
Museum purchase, 928-O-101

Since the beginning of Inness's artistic maturity, the appearance, inspiration, and expressive effect of his paintings was most frequently described as poetic. And as, over time, the style of his paintings became increasingly more suggestive, as their form became broader and their resemblances to natural appearance less and less direct, their poetic content seemed to grow in direct proportion, reaching its highest and purest state in paintings of the last few years of his life. Painted the year before Inness's death, *Hazy Morning, Montclair, New Jersey* is one of those late poetic paintings.

The allusiveness of its style, with all solid form blurred, corroded, and reduced to a pervasive vaporous substance more metaphysical than physical in nature—"a subtle essence which exists in all things of the material world" that constitutes "an atmosphere about the bald detail of facts,"[1]—could be regarded as a logical development and climax of Inness's lifelong belief in the value of spiritual meaning, emotional expression, and suggestion: "You must suggest to me reality—you can never show me reality."[2] Inness, however, disclaimed poetic vagueness unequivocally: "Poetry is the vision of reality . . . [not some] gaseous representation. . . . What is often called poetry is a mere jingle of rhyme—intellectual dish-water. The poetic quality is not obtained by eschewing any truths of fact or of Nature which can be included in a harmony or real representation."[3] To Inness the poetic representation of reality consisted in the same facts of nature as reality itself: color, distance, air, space, and contrasts of light and dark.

Inness's creative impulsiveness was well known. There are many descriptions of his frenzied "attack" on a canvas, and of the wholesale changes he could make in a painting's subject or effect in a seizure of inspiration. Nevertheless, by the last decade of his life

Inness painted according to a fairly fixed artistic method, working "in mass from generals to particulars" and finishing with "glazing, delicate painting, and scumbling."[4] In the last years of Inness's life this method did not change, but his productive energy did. As he wrote late in 1892, "I am inclined to think that my days of impetuous painting are ended and that I shall be obliged to consider longer and do less."[5] He admitted that his paintings were often less highly finished. "Until lately," he wrote, "when I became disgusted with slow progress I could take a clean canvas and under the impulse paint a satisfactory picture." But now, unable to do that, he had "accumulated a number of unfinished work [sic]."[6]

In December 1894, five months after Inness's death, two hundred and forty works in his estate were exhibited in New York, preceding their sale at auction two months later. They were picked, "from a total of some six hundred completed and unfinished canvases and drawings which were found in the studio and residence of the late artist."[7] Only about twenty had been shown before, most painted during the last fifteen years of his life. "They were finished and unfinished and framed and frameless, sketches, studies and memoranda of moods and impressions. . . . Inness himself would probably be surprised at the resurrection of canvases that he had thrown aside and forgotten."[8] Announcing the result of the sale in February 1895, the *New York Sun* said that the $108,670 the paintings brought was "really a remarkable achievement, for these were works left in the painter's studio at his death, only a few of which had ever been regarded as finished and ready to be offered for sale."[9] *Hazy Morning, Montclair, New Jersey* was number 187 in this sale.

NICOLAI CIKOVSKY, JR.

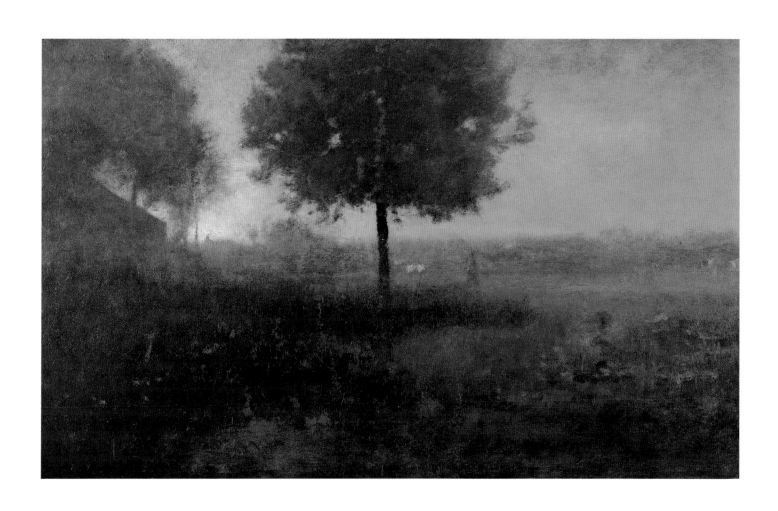

The Thames from Battersea Reach
Oil on canvas, 16 × 24½″ (40.64 × 62.23 cm.)
Signed, lower left
Museum purchase, 958-O-152

Since the time of its first owner, New Yorker Edward Holbrook, *The Thames from Battersea Reach* has been attributed to James Abbott McNeill Whistler. The painting shows the embankment at Battersea Reach overlooking the Thames from Whistler's neighborhood in Chelsea, with the factory smokestacks and church steeple of Cremorne visible on the opposite shore, and interprets these much as Whistler did around 1863–64, with predominantly gray coloring and swift, thin brushwork. In recent years, it has been suggested that the painting is a document of Whistler's friendship with Walter Greaves, and partially or wholly Greaves's work.

When Andrew McLaren Young examined the painting around 1971, he felt that the embankment and figure in the foreground, and the docked boats in the middle distance did not ring true to Whistler, conjecturing that it might instead be the work of Whistler's former pupil, Walter Greaves (1846–1930), an attribution in which Young's co-author, Margaret MacDonald, concurred.[1] A technical examination of the painting revealed that the boats, embankment, and figure were all made with the same paint, and that the inscription at the lower left, "Whistler—1863," which is not in Whistler's handwriting, was applied at the same time as the surrounding passages of paint.[2]

Walter Greaves was a native of Chelsea who met Whistler about 1863. He and his brother Henry (1844–1904) operated rowboats for hire and regularly ferried Whistler across the Thames so that he could make pastel sketches of the river, particularly at night. When Whistler learned of the brothers' interest in art, he invited them to his studio, where they gladly worked as his assistants and errand boys. Whistler and his mother frequently visited the Greaves home, which was very close to their own. Whistler described them as "the boat people, a sort of Peggoty family. . . . The two brothers were my first pupils."[3]

The Greaves brothers became ardent admirers of

Whistler, emulating his manner of dress and comportment as well as his approach to art.[4] Their only art instruction seems to have consisted of carefully copying Whistler's sketches. Walter Greaves worked alongside Whistler on some of his paintings and created some of his own works by adding to canvases begun by Whistler.[5] He also produced etchings, pastels, and nocturnes reminiscent of Whistler's style.

Whistler, notoriously capricious in personal relationships, abruptly broke with the Greaves brothers around 1872–73. Whistler's early biographers all agreed that the loss of friendship was devastating to Walter Greaves, who took the rejection personally. Although Whistler's associates still occasionally approached Greaves for information about Whistler's painting technique and early years in Chelsea, Greaves became increasingly withdrawn and isolated from the company of artists. He continued to make paintings and drawings of Chelsea, many of which contained memory images of Whistler, which he often inscribed with the date that corresponded to the memory.[6] As the years passed, Walter Greaves suffered considerable impoverishment. He was reduced to selling scraps from Whistler's studio and his own pastels and paintings for small sums to Chelsea visitors.[7] The manner of their sale led to their being later touted as previously unknown works by Whistler.

Both Andrew McLaren Young and Margaret MacDonald suggested that here Greaves may have depicted Whistler standing at the embankment at Battersea Reach, sketching the Thames as he would have done in 1863 when Greaves first knew him. The inscription "Whistler—1863" would then be Greaves's identification of the subject rather than the date of his contribution, which may have been in the 1880s. The background is possibly Whistler's work, an unfinished view to which Greaves may have added.

DIANA STRAZDES

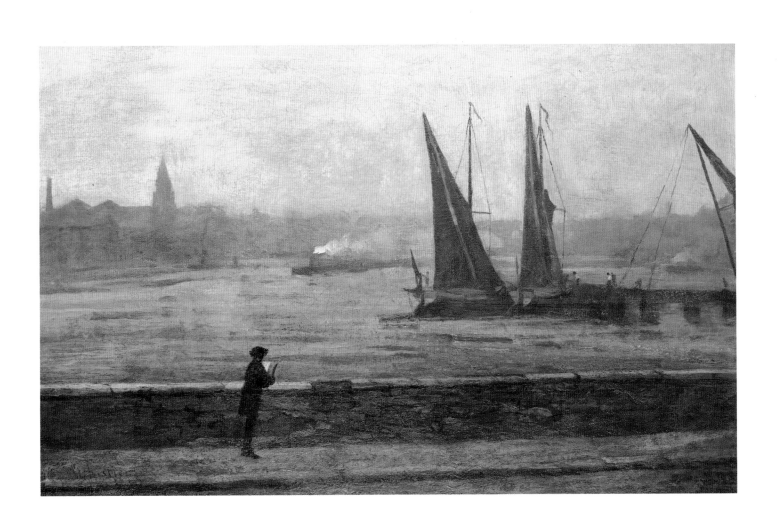

CECILIA BEAUX | 1855–1942

The Dreamer, 1894
Oil on canvas, 33×25″ (83.82×63.50 cm.)
Signed, lower left
Museum purchase, 929-O-101

The Dreamer is an excellent example of the compelling portraits painted by Cecilia Beaux during the 1890s. Considered by many to be the finest woman painter active in America at the turn of the century, Beaux was not only technically masterful in her rich, vigorous manipulation of paint and her subtle orchestration of color, but also as a keen observer and an innovative designer. By 1902 Beaux was recognized as one of the top portrait painters in America. She had exhibited her work and garnered prizes in museum exhibitions from Philadelphia to New York to Paris.[1] She was awarded full membership in the male-dominated National Academy. And perhaps just as telling of her popularity, she painted a portrait of Mrs. Theodore Roosevelt and her daughter in the White House, *Mrs. Theodore Roosevelt and Daughter Ethel* (1901–02, private collection).

Beaux was born in Philadelphia. Due to her mother's early death and her French father's subsequent departure to Europe, she was raised by her maternal grandmother and aunt. The example of her aunt, the artist Eliza Lewitt, was a very positive one for her. With her family's support and her aunt's inspiration, Beaux set out to be a painter. At the age of sixteen she studied drawing under Catherine Drinker, an historical and religious painter whose brother later married Beaux's sister. In 1872 or 1873, she took instruction from Adolf Van der Whalen, a Dutch artist active in Philadelphia. She also appears to have taken classes at the Pennsylvania Academy of the Fine Arts between 1877 and 1879 under Thomas Eakins. Additionally, between 1881 and 1883, Beaux studied semi-privately in a friend's studio with William Sartain. Between 1888 and 1889, Beaux traveled to Europe where she studied at the Académie Julian and the Colarrosi Académie under Bouguereau, Fleury, Dagnan-Bouveret, and Courtois, as well as privately with Benjamin Constant. In 1895, she became the first full-time woman faculty member at the Pennsylvania Academy of the Fine Arts, where

she would teach drawing, painting, and portraiture for the next twenty years.

The Dreamer is a wonderfully evocative work from Beaux's finest period. Through the placement of the sitter's expressive face and hands in the immediate foreground, Beaux draws us into the woman's contemplative world. Intriguingly, she makes the dreamy vision more immediately palpable through the juxtaposition of the crisply-observed features of the beautiful, somewhat melancholy young woman to her vaguely delineated immediate surroundings. The sitter's riveting, dark-eyed gaze and upright posture first engage, then confound us with their lack of context, suggesting her isolation through reverie.

Beaux's rich use of buttery strokes and exquisitely fine-tuned orchestration of whites and blacks reveal her respect for the preeminent portrait painter of her day, John Singer Sargent. The flattened picture plane, cropped forms, and bold reductive masses also indicate her thorough understanding of Japanese art as interpreted by such leading French Impressionists as Edouard Manet and Edgar Degas. Yet the sensitively sculpted features, deeply expressive eyes, and candidly engaging pose reveal Beaux's distinctly personal mastery of the art of portraiture. Although the sitter, Caroline Smith, was a close friend of Beaux's from Philadelphia, the artist sought in *The Dreamer* to evoke a mood rather than to present an identifiable personality. In such intimate works depicting friends or family, as in *Ernesta with Nurse* (1894, Metropolitan Museum of Art) and *Henry Sturgis Drinker* (1898, National Museum of Art), Beaux excelled as an insightful portraitist. After 1900, however, her work became increasingly more superficial despite her extraordinary technical facility. By the time she had gained virtually universal recognition as one of America's leading portrait painters in the teens and early twenties, much of her early edge had eroded.

JAMES M. KENY

147

JOHN SINGER SARGENT | 1856–1925

Mrs. Knowles and Her Children, 1902
Oil on canvas, 72 × 59½″ (182.88 × 151.13 cm.)
Signed, upper right
Museum purchase, 929-O-104

Although John Singer Sargent exhibited great facility and accomplishment with all subjects he painted, his reputation was achieved by portraiture. A United States citizen by birth, he remained an expatriate with a peripatetic existence, residing in Italy, France, and London. His style was formed by exposure to international influences, extensive travel, and study of the Old Masters, in particular the noted portrait painters Diego Velazquez and Frans Hals, combined with natural facility and astute visual perception. Cosmopolitan internationalism, blended with mastery in rendering the likenesses of late Victorian and Edwardian society, led to a flourishing career, and he was inundated with portrait commissions from both continents. Sargent's style, at once traditional and revolutionary, provided a stylistic bridge in portraiture between eighteenth-century British masters, such as Joshua Reynolds and Thomas Gainsborough, and American portrait painting in the late nineteenth and early twentieth centuries.

The largest body of Sargent's portraits are composed in a recognizable format: a single figure seated, full-length, posed in the Grand Manner. However, he also painted group portraits that number among his most acclaimed compositions. *Mrs. Knowles and Her Children* is a leading example of these multi-figured compositions. Related family portraits featuring three sitters include *The Misses Vickers* (1884, Sheffield City Art Galleries, England); *The Wyndham Sisters: Lady Elcho, Mrs. Adeane, and Mrs. Tennant* (1899, The Metropolitan Museum of Art); *The Acheson Sisters* (1902, Devonshire Collection, Chatsworth, England); and *The Younger Children of Asher Wertheimer* (1902, The Tate Gallery). His reputation established, Sargent's output was at its height in the 1890s and early 1900s, during which time he produced some of his most notable, mature masterworks.

Despite its artful arrangement, the unstudied, unpremeditated quality of *Mrs. Knowles and Her Children* contributes to the particular success of the painting. It is not a stiff, ceremonial Grand Manner portrait, but instead shows a mother and her two sons in an informal family setting. Sargent captures the viewer's interest through acute attention to detail. The barefoot child's playful pose, his toy horse in the foreground, the rendering of the gray and white folds of the young woman's gown, delineating the varied textures and fabrics, and the mother's embracing gesture all contribute to the seemingly effortless realism of the scene.

The national notices of the Butler Institute's purchase of *Mrs. Knowles and Her Children* underscore the importance of the acquisition. The painting's entry into an American collection was heralded in an article favorably comparing it with one of Sargent's most celebrated works, *The Wyndham Sisters*, which had been purchased two years earlier by The Metropolitan Museum of Art. It stated that *Mrs. Knowles and Her Children* is "a work of great skill and arresting human appeal, it is reminiscent in its proportions, if not in its content, of the charming 'Wyndham Sisters,' also known as 'The Three Graces,' . . . Much spirit is shown in the artist's revelation of the character of the fascinating young matron, who is seated on a sofa with her two small sons reclining one on either side of her as she smilingly and spontaneously glances up from the picture book in her lap. The instantaneous quality of the portrait, too, adds greatly to its charm."[1] Sargent uses a raised perspective in *Mrs. Knowles and Her Children*, an approach he favored for group compositions, also evident in *The Wyndham Sisters* and *Mrs. Carl Meyer and Her Children*. However, the artist's compositional arrangements in other multiple portraits were not always met with such warm approval. Often criticized for the artificiality of settings and contrived poses, other groupings lack the immediacy, casual naturalism, and balanced composition of *Mrs. Knowles and Her Children*.[2]

The subject of the painting is Mrs. Arthur Knowles, formerly Mildred Clare Buchanan, third daughter of Captain James Buchanan of the 70th regiment. Mildred Buchanan married Arthur Lees Knowles of Alvaston Hall, Nantwich, Cheshire, who became High Sheriff of Lancashire in 1894. The two children are John Buchanan Knowles and Richard Arthur Lees Knowles, who were seven and five years old, respectively, at the time of the sitting.[3] *Mrs. Knowles*

and Her Children was undoubtedly painted in London, in Sargent's Tite Street studio, his preferred location. Props, such as the flowered fabric used as a backdrop and the canape on which the subjects are seated are common to other paintings of the period and also appear in photographs of Sargent's studio.

The tedium of steady commissions resulted in Sargent's increasing reluctance to accept portrait assignments. "I have vowed a vow not to do any more portraits at all . . . it is to me positive bliss to think I shall soon be a free man," Sargent wrote in 1907.[4] His declining interest can be traced to the early 1900s, though it was some years before he was able to act on his resolve to give up portrait painting.

VALERIE ANN LEEDS

The Lady Anne, 1899
Oil on canvas, 48×24″ (121.92×60.96 cm.)
Unsigned
Museum purchase, 923-O-101

Edwin Austin Abbey, born in Philadelphia, began his training as an artist under Isaac Williams, a portrait and landscape painter who had studied with John Neagle and Christian Schussele, a German-born history painter. By the age of fourteen he had moved to New York, taking a full-time position drawing for Harper and Brothers, the publisher of a news weekly, a literary monthly, and books. In 1878, Harper's sent him to England to do background research for an edition of Robert Herrick's poetry. Every year thereafter he made trips to the Continent or England, where he finally settled in 1882, an expatriate at the age of thirty. Several years later he moved to Gloucestershire, where he became friendly with Frank Millet, Lawrence Alma-Tadema, one of England's great painters of historic subjects, Frederick Barnard, and John Singer Sargent.

The principle monuments of his career are his murals, *Quest for the Holy Grail* (1890–1902, Boston Public Library), *The Coronation of Edward VII* (1902–1904, Buckingham Palace), and the decorations of the Pennsylvania State Capitol in Harrisburg which, unfinished at his death in 1911, were completed by Sargent. Two of his principal oil paintings were *May Day Morning* (1890, Yale University Art Gallery), his well-received first Royal Academy entry, and *Richard, Duke of Gloucester, and the Lady Anne* (1896, Yale University Art Gallery), which was based on a scene in Shakespeare's Richard III.

The Lady Anne was painted in 1899, several years after the major painting, *Richard, Duke of Gloucester and the Lady Anne* was exhibited at the Royal Academy. *The Lady Anne* cannot, therefore, be called a study for the larger painting, but might more aptly be termed an "afterthought," or a kind of remarque. Looking at this painting from the vantage point of today, one would not guess at the historical or narrative content, and so we must assume that Abbey's motivation in making the painting was more an abstract interest in composition, and in that sense *The Lady Anne* is closer than most of his other work to fine art than illustration. The romantic pose is typical of Abbey's work, but the dramatic contrast of light and dark are somewhat unusual. The sinuous line made by the figure, with the hands as an important focus, reminds us of Sargent's portrait compositions. The painting lacks the obsessive historic detail for which Abbey was renowned in his day, but now this very lack of interference from details makes this a more accessible and attractive example of his work.

Edwin Abbey was a man whose facility for illustration subverted his potential and reputation as a fine artist. A major portion of his career was spent in the fulfillment of illustration and mural commissions. He was fascinated by medieval England and English literature, and was lucky to have an equally interested public. Because of his affiliation with Harper's, Abbey's audience was large.

Abbey's career was driven more by his imagination of historic events than by his direct observation of the light and life around him, for he surely had sufficient ability to place him among the best of his contemporaries. In choosing to be an illustrator of medieval life he satisfied a personal and public interest, rather than breaking new ground as an observer or technician.

JOSEPH KEIFFER

DANIEL RIDGWAY KNIGHT | 1839–1924

Life is Sweet, c. 1900–1915
Oil on canvas, 32½×25½″ (82.55×64.77 cm.)
Signed, lower left
Gift of the estate of Mrs. Robert Bentley, 959-O-101

Daniel Ridgway Knight could have titled the vast majority of his paintings *Life is Sweet*. The pastoral portrait of that name at the Butler Institute does, in fact, offer a modest vignette of French peasant life, which he tirelessly presented for fifty years to eager patrons in Europe and America.

Born into a strict Quaker home in Philadelphia, Knight was groomed for work in a local hardware store. He chose art instead, enrolling in 1858 in the Pennsylvania Academy of the Fine Arts, where his fellow students included Mary Cassatt, Thomas Eakins, William Sartain, and Everett Shinn. A student from France, Lucien Crépon, plied Knight with stories of fine classes and fine wine to be found in Paris. After helping to establish the Philadelphia Sketch Club in 1861, Knight sailed for France that same year, the first to do so among his Philadelphia peers.

In Paris, Knight enrolled in the Atelier Gleyre and the classes of Alexander Cabanel at the Ecole des Beaux-Arts. While with Gleyre, Knight began long-term friendships with the young Impressionists Alfred Sisley and Auguste Renoir, an unusual relationship for an aspiring history painter. As the American Civil War moved closer to Philadelphia in 1863, Knight returned home to enlist.

Knight spent the next ten years in Philadelphia, continuing his studies after the war with fellow Sketch Club members or on his own. He exhibited historical subjects but, for money, painted portraits and taught in his studio. In 1871, Knight married one of his students, Rebecca Webster, and set out for his beloved Paris on his honeymoon. Although he had over fifty productive years ahead of him, he never returned to America.

By 1874, Knight had decided to specialize, almost exclusively, on the French peasantry, their (usually *her*) environment at home and in the open air of the fields. The precedent for this choice had already been set decades before by the Barbizon school, particularly by Jean-François Millet. Unlike Millet, Knight seemed disinclined to strike the epic note in his depiction of peasants, most of whom are engaged in leisurely rather than laborious activities. In this respect, he was peculiarly American, an outsider to the heroic struggle and displacement of the French farmers throughout the industrial revolution in France.[1]

From his cottage in Poissey with its glass-enclosed studio and gardens, Knight was able to work in the "open" protected from the weather in an aesthetically controlled environment.[2] His clients, in France and America primarily, filled his waiting lists because his moist gardens and distant rivers were pleasingly rendered, but also because his models filled a sentimental need for an agreeable human reference. In 1888, Knight told author and critic George Sheldon, "These peasants are as happy and content as any similar class in the world. They all save money and are small capitalists and investors. . . . They work hard to be sure but plenty of people do that."[3]

Life is Sweet represents Knight at his best and most typical within his production of smaller scale pieces for his usual clientele. He also painted several large canvases for major exhibitions, the best known of which is *Hailing the Ferry* (1888, Pennsylvania Academy of the Fine Arts), which won the third gold medal at the Paris Salon of 1888.[4] This painting is a highlight of the early work that shows social and stylistic affinities to Jules Bastien-Lepage, to Jules Breton, the artist he is most frequently compared to, and even, in overall "finish," to J.-L. Ernest Meissonier, the godfather to Knight's daughter. *Life is Sweet*, on the other hand, is a later version of Knight's academic Impressionism, looser, more varied in color, and more unified in effect.

PETER BERMINGHAM

JOHN LA FARGE | 1835–1910

Kwannon Meditating on Human Life, 1908
Oil on canvas, 36 × 34″ (91.44 × 86.36 cm.)
Signed, lower left
Museum purchase, 918-O-106

Perhaps the most versatile American artist of his time, John La Farge produced innovative flower and landscape paintings which anticipated the work of the French Impressionists, created the first major American mural programs, assembled stunning stained glass windows, and executed remarkable watercolors of Japan and the South Seas.

In the late 1850s and early 1860s, La Farge became a pioneer in collecting Japanese art and incorporating Japanese effects into his work. He may have purchased his first Japanese prints in Paris in 1856, and this interest was probably encouraged by his marriage in 1860 to Margaret Perry, niece of the Commodore who had opened Japan to the West. By the early 1860s, La Farge was not only collecting Japanese prints, but was also making use of Japanese compositional ideas in his paintings to create effects which looked strange, empty, and unbalanced by Western standards. In 1869, La Farge published an essay on Japanese art, the first ever written by a Western artist, in which he particularly noted the asymmetrical compositions, high horizons, and clear, heightened color of Japanese prints.

The radical qualities of La Farge's art in the 1860s were tempered during the following decades. Beginning with Trinity Church in Boston, the first major decorative project in this country executed by a painter, he became increasingly involved in large-scale decorative and mural projects, both for churches and the residences of America's emerging class of millionaires. In the 1870s and early 1880s, he began to style his own work on that of the European old masters.

In 1886, La Farge embarked for Japan with his friend Henry Adams, whose wife had just committed suicide. Seeking escape in travel, he asked La Farge to join him. No doubt, partially due to his personal unhappiness, Adams was highly critical of what he saw in Japan. Nonetheless, he seems to have been deeply moved by the Japanese statues of Kwannon, the embodiment of the wisdom of compassion. After returning to the United States, Adams commissioned the sculptor Augustus Saint-Gaudens to create a similar figure for his wife's grave in Rock Creek Cemetery, Washington, D.C., delegating to La Farge the task of supervising the sculptor, and of explaining to him the Japanese concept of Kwannon. La Farge's painting of Kwannon can be seen as an offshoot of this statue, now often titled "the Adams Memorial," as well as a reaction to the paintings of Kwannon that he viewed when he was in Japan.

His attitude towards Japanese art at this late stage of his career, however, had changed greatly since the 1860s. In the 1860s he was looking for new approaches and new viewpoints; in his later life he was interested in reaffirming the lessons of the European old masters. Ernest Fenollosa later described taking La Farge to the Daitokuji Temple in Kyoto to see the famous painting by Mokkei, which showed Kwannon seated in a rocky cave, with water washing at her feet. "The old priest was delighted to have it specially brought out for such a sage," Fenollosa recalled. "Mr. La Farge, devout Catholic as he is, could hardly restrain a bending of his head as he muttered, 'Raphael.'"[1] Given this bias towards a synthesis of Oriental and Western ideas, it is not surprising that La Farge's Kwannon has a rather Western appearance, merging the Japanese deity with the Madonna of Roman Catholicism.

According to La Farge's studio assistant, Ivan Olinsky, the painting was based on an earlier drawing. "One day," Olinsky recalled, "while rummaging amongst a lot of old truck I came upon a drawing which to my young mind seemed unusually beautiful. I called La Farge's attention to it and perhaps it was due to my youthful enthusiasm that the Butler Kwannon was painted."[2] Work on the painting seems to have proceeded over a long period, starting sometime after La Farge's return from Japan. The French novelist, Paul Bourget, mentioned it in his book, *Outre Mer* (1895), in which he described visiting La Farge's studio.[3] According to an old inscription on the painting, now largely obliterated, but visible in an old photograph, it was completed in 1908, two years before the artist's death.[4]

HENRY ADAMS

MARY STEVENSON CASSATT | 1845–1926

Agatha and Her Child, 1891
Pastel on paper, 26 × 21″ (66.04 × 53.34 cm.)
Signed, lower left
Museum purchase, 947-W-102

Mary Cassatt, the only American to exhibit with the Impressionists, owes her reputation to the honesty, sympathy, and directness with which she represented subjects from contemporary domestic life. Between 1875, when she saw some pastels by Edgar Degas in a Paris art dealer's window, and 1879, when she began to exhibit with the Impressionists, she developed a distinctive style that combined a light, bright palette with the strong contours and confident volumes of Degas. She applied this style to subjects that demonstrated her commitment to the "new realism" espoused by the Impressionist group.

Cassatt frequently chose as models her family and friends, whom she depicted at their frankly bourgeois pastimes. Although intended to be anonymous to her audience, her sitters possess startling specificity in their appearance and actions. Because they neither pose for nor acknowledge the viewer, they convey on paper or canvas something authentic and immediate.

Mothers with children are perhaps the subject most often linked with Cassatt.[1] Although she rendered the theme throughout her career, her most intensive involvement with it took place between 1888 and 1894, when she made more than twenty mother-and-child pictures in both oils and pastel, as if heeding Degas's advice to his sculptor-friend, Albert Bartholomé: "It is essential to do the same subject over and over again, ten times, a hundred times."[2] Six of these pictures date from 1890–1891, including *Agatha and Her Child*. It was listed in Paul Durand-Ruel's account books as having been purchased from the artist on June 1, 1891, and was probably made in Paris not long before that. In 1893, it was exhibited at Durand-Ruel's gallery in New York as part of a large display of her mothers and children.

Cassatt's pictures of mothers and children of the late 1880s and early 1890s were created at a time when she had begun to present her subjects as symbolic of universal ideas. Her mothers and children of this period shared certain formal characteristics; all half lengths with little or no background detail, they show at close range and in a quiet, controlled mood, a mother displaying one child in her arms. These features suggest that Cassatt's depictions may have been attempts to create "modern madonnas," contemporary renditions on the timeless theme of new life and maternal love.[3] Many of her fellow painters, including Eugène Carrière, George Hitchcock, Gari Melchers, and George deForest Brush, contributed to this genre, which reached a peak of popularity around 1890–1900. Unlike these other artists, Cassatt did not simply update the traditional madonna-and-child formula but instead sought out gestures and psychological subtleties that ring true to life.[4] In *Agatha and Her Child*, for example, a sense of visual honesty is well conveyed by the baby assertively pushing up from the mother's lap.

Despite the apparent spontaneity of these mother-and-child images, Cassatt planned the compositions meticulously and took pains in selecting her models, who, it has been pointed out, were not always mother and child.[5] In *Agatha and Her Child*, she links the mother's and child's right arms to show them as complements of one another. Here, complementary hues dominate the palette; the auburn-haired mother wears a dark blue dress and the blue-eyed toddler a pinkish shift, while the flesh areas show unexpected passages of green and blue. At the perimeter of the picture, strokes of the pastel stick become bold and loose, paper shows through, and shapes become flat. However, Cassatt retains a convincing bulk for the figures by building up flesh areas with short, repeated strokes of her pastel sticks.

Cassatt's contemporaries recognized both the religious allusions of her mother-and-child pictures and her departure from their traditional expression. In an 1892 account of the Impressionist art owned by Paul Durand-Ruel, the author, after noting that Cassatt's mothers and children suggest a modern Holy Family, added: "It is no longer a matter of ecstatic virgins holding without affection, on rigid knees, a child aware of his destiny and who already goes on his way. These are infinitely human and loving mothers who squeeze against their bosom the rosy flesh of certainly lively babies who have no care except for their mother's caresses."[6]

DIANA STRAZDES

garnered tremendous attention when they were included in the first great American show of French Impressionist art held in New York City at the American Art Association in April of 1886.[4] Poppies had been painted in Grez in 1885 also, by the Swedish painter, Karl Nordström (Malmö Museum, Sweden) and the American, Theodore Robinson (formerly, Kennedy Galleries, Inc., New York City).[5] And in 1886, a group of American painters, John Singer Sargent, Edwin Blashfield, Edwin Austin Abbey, and Frank Millet, were all painting poppy pictures in the art colony of Broadway in the West of England.[6] At the same time that Vonnoh was completing *Coquelicots*, Childe Hassam was investigating the theme in the garden of the poet, Celia Thaxter, on the Island of Appledore off the coast of New Hampshire and Maine.

None of these paintings, however, were as ambitious as Vonnoh's *Coquelicots*. Though *Coquelicots* is undoubtedly a studio composition, Vonnoh maintains the free, unoutlined and unstructured character of his earlier small poppy pictures throughout the landscape elements, while the figures of the young woman picking flowers, the two children behind her, the distant farm wagon and horses, and the buildings on the horizon are more firmly rendered, each defining a distinct spatial plane and providing organization to the spatial recession of the vast canvas. Of his involvement with Impressionism, Vonnoh wrote: "I gradually came to realize the value of first impression and the necessity of correct value, pure color and higher key, resulting in my soon becoming a devoted disciple of the new movement in painting."[7] Vonnoh's wife posed for the principal figure, and for a small oil study of the principal figure, formerly entitled *Study for Picking Tulips* and now called *Picking Poppies*, which was bequeathed to the Corcoran Gallery of Art in Washington, D.C. by Vonnoh's widow, his second wife, Bessie Potter Vonnoh, in 1955.

With its vast scale, *Coquelicots* was designed as an exhibition piece, meant to appeal to its many viewers. Despite the small farm wagon, the agricultural field here is a source of pleasure, not backbreaking labor. The attractive young woman in the foreground is linked in beauty with the brightly colored flowers, a bunch of which one of the children waves jubilantly in the air. The painting was exhibited at the (Old) Salon annual exhibition in Paris in 1891, and then at the International Exposition held in Munich in 1892. It was in Munich that *Coquelicots* achieved tremendous renown, the great art historian, Richard Muther, writing of the "gleaming and flaming picture of a field of poppies . . . less like an oil-painting than a relief in oils. The unmixed red had been directly

pressed on to the canvas from the tube in broad masses, and stood flickering against the blue air; and the bluish-green leaves were placed beside them by the same direct method, white lights being attained by judiciously managed fragments of blank canvas. Never yet was war so boldly declared against the conventional usages of the studio; never yet were such barbaric means employed to attain an astounding effect of light."[8]

Coquelicots, now entitled *A Poppy Field*, was included in Vonnoh's one-artist show held in February, 1896, at the Durand-Ruel Gallery in New York City. On the one hand, the American critics admitted their astonishment at his advanced strategies: *The New York Times* noted that Vonnoh "has achieved capital results in the matter of vibrating color, light and astonishing brilliancy . . ." and that "Broken color, touches of various pale tones of blues, yellows, reds, violets and other tints, never crude or spotty, rarely obtrusive, give a vibration, a realism quite remarkable." Yet, pictures such as *Poppies* were felt by that same critic to "utterly lack the sentiment and poetry with which the portraits are invested."[9]

Coquelicots did not sell. Vonnoh went on to create only one more large-scale figural work set out-of-doors, *The Ring* (1898, Museo de Arte de Ponce, Puerto Rico). After many years, *Coquelicots* resurfaced as *Poppies* in the December, 1914, winter exhibition at the National Academy of Design in New York City, and then appeared in the Panama-Pacific International Exposition held in San Francisco in 1915, where Vonnoh won a gold medal. By then, the original signature and date had been removed, and the picture had been resigned with a copyright date of 1914.[10] *Poppies* then was shown early in 1916, first at the City Art Museum, St. Louis, and then at the Memorial Art Gallery, Rochester, in a two-artist exhibition of Robert Vonnoh's paintings and Bessie Potter Vonnoh's small sculptures. By 1919, when the Butler Institute acquired the picture, the work had been retitled again. The sculptor, J. Massey Rhind, had suggested to Joseph G. Butler, Jr., the title *Flanders—"Where Soldiers Sleep and Poppies Grow,"* a reference to the German invasion of Belgium during World War I, and to the 1915 poem, "In Flanders Fields," by the Canadian surgeon, John McCrae.[11] Though the joyous sentiments projected by the painting are antithetical to the tragic expression of McCrae's poem, Vonnoh did, in 1919, finally succeed in finding a proper repository for his masterwork in the Butler Institute collection.

WILLIAM H. GERDTS

163

THEODORE ROBINSON | 1852–1896

Watching the Cows, 1892
Oil on canvas, 16 × 26″ (40.64 × 66.04 cm.)
Signed, lower left
Museum purchase, 961-O-132

Like many of his fellow American artists, Theodore Robinson received his early training in the United States; first, briefly at the Chicago School of Design and later at the National Academy of Design in New York, prior to his first trip abroad in 1876. During this sojourn, he studied with Carolus-Duran, Jean-Léon Gérôme, and probably Benjamin-Constant. He also painted at the villages of Barbizon and Grez near the Fontainebleau Forest. Returning to New York three years later, he taught painting and worked on mural decorations for the noted nineteenth-century muralists John La Farge and Prentice Treadwell. It seems likely that his interest in the figure, which would prevail throughout his career, was reinforced at this time. In 1884, he departed once again for France, which would become the focus of his creative energies for nearly a decade and nurture his evolving Impressionist style. The Guest Register for the Hotel Baudy in Giverny records Robinson's arrival in September, 1887, as one of the first visitors.[1] The small village, nestled in the Seine Valley halfway between Paris and Rouen, was most attractive to him and he quietly took his place, befriending many of the local inhabitants whom he often employed as models. It was his custom to spend extended summers at Giverny, arriving in April or May and remaining well into the autumn.

A recurring theme in Robinson's production during his Giverny period is the young peasant woman, head bowed, absorbed in her sewing as she tends cows.[2] That the artist was often attracted to this simple, common activity is apparent through a notation in his diary for October 23, 1892: "Cold, grey day—walked p.m. to the Seine—returning, the Durdants—mère and two girls sewing seated, their 14 cows feeding. . . ."[3] In *Watching the Cows*, the model is seated in a lush green pasture on a tranquil summer day. At her side is a small child who wears an elaborate bonnet and looks intently at the viewer. Behind, two tethered cows graze quietly. Patches of sunlight add luminosity to the canvas and lead the eye back to a clearing in the foliage at the edge of the meadow. The pronounced horizontal composition and the use of multiple figures are somewhat unusual for the artist, who tended to focus on a single model in both interior and exterior settings.

As Robinson's last stay at Giverny drew to a close, his contacts with Claude Monet increased, the two visiting each other's studios on a number of occasions. On November 29, 1892, he wrote in his diary, presumably referring to *Watching the Cows*: "Call from Monet & family after breakfast . . . he liked the 'cows and Baby'[sic]." Several weeks later, following his return to New York, he mentioned the painting again: "The 'Mill' was done in a good spirit of endeavor and . . . also the 'Baby and Cows' but how foolishly I let time pass and did not get more time on both figures and baby."[4]

In his remaining years, the artist would search for a sympathetic locale in which to apply his fully developed Impressionist style. During the summer of 1893, he painted a series of landscapes at Napanoch, New York, and the following spring, produced a small group of exquisite works at Cos Cob on the Connecticut shore. He spent his last summer in Vermont, the place of his birth, rejoicing that he had finally "found a country in America that charms as much . . . as certain parts of France."[5] His hope to paint there, however, went unfulfilled. In April, 1896, Robinson died of chronic asthma in New York at the age of forty-three. Prior to his early death, Robinson, often called America's first Impressionist, successfully achieved a balance in his art between the American realist tradition which had always been present and the Impressionist concern for the elements of light and atmosphere.

SONA JOHNSTON

FREDERICK CARL FRIESEKE | 1874–1939

Good Morning, c. 1912 or 1913
(originally, *In the Doorway* and also, *The Neighbor*)
Oil on canvas, 32 × 26″ (81.28 × 66.04 cm.)
Signed, lower left
Museum purchase, 959-O-126

Born in Owosso, Michigan, Frederick Frieseke studied at The Art Institute of Chicago beginning in 1893, before going East to the Art Students League in New York City in 1897, and then to Paris in 1898. There, he studied at the Académie Julian, and with James Abbott McNeill Whistler for a short period at the Académie Carmen. Frieseke's earliest mature works, images of individual women in interiors painted in fairly close tonalities, reflect Whistler's influence, but once he and his wife settled, in 1906, in the art colony at Giverny, where Claude Monet resided, Frieseke rapidly developed a very original aesthetic which would have an impact upon almost all the later figural painters among the colonists. The Friesekes rented a house, surrounded by tall walls, which had been the residence of Theodore Robinson, one of the founders of the Giverny art colony. There they developed a sumptuous, colorful garden which served as the setting for many of Frieseke's pictures. The outside of their house was painted in strikingly bright colors, yellow with green shutters, while the living room walls were lemon yellow and the kitchen, a deep blue. The artist also maintained a second studio on the Epte River, which ran through the town, where he painted many of his renderings of the nude outdoors.

In Giverny, Frieseke concentrated upon monumental images of women, usually single figures, posed in domestic interiors or sun-filled outdoor settings, often in the floral garden his wife tended so conscientiously. But the rendition of sunlight, not flowers, was Frieseke's primary concern. As he himself acknowledged in 1912, "It is sunshine, flowers in sunshine, girls in sunshine, the nude in sunshine, which I have been principally interested in for eight years. . . ."[1] Unlike the earlier artists in Giverny, such as Robinson, Frieseke's Impressionism was an unreal construct, his sunlight and color entirely synthetic; one modern writer has noted that "His light hardly seems to be *plein air* light at all. In fact it seems entirely artificial . . . a stunning concoction of blues and magentas frosted with early summer green and flecks of white."[2]

These qualities are abundantly apparent in *In the Doorway* (now, *Good Morning*),[3] probably painted around 1912 or the following year, with its counterpoint of pinks, greens, and yellows, depicting his model entering the Friesekes' Giverny home from the garden. Frieseke's art has often been identified as "Decorative Impressionism." Despite the immediacy of the pose, and the moment of introduction defined by the picture's present title, the emphasis on pattern and decoration in the model's striped dress, contrasted with the sparkling color pattern of the garden's blooms, and the concomitant flattening, two-dimensional effects, ally the work more with the painting of the Post-Impressionists than with the perceptual aesthetics of orthodox Impressionism.

Though the Friesekes remained in Giverny for fourteen years, until 1920, neither they nor any of their fellow artists who arrived in the early twentieth century became close to Monet. Frieseke acknowledged the influence of and his admiration for the art of Auguste Renoir;[4] certainly his rounded and sensual figural types, as in the present work, are very close to those of the French master. The model here is probably Marcelle, one of the artist's favorites, who appears in many of his pictures. The parasol—a literal sun shade—is a very common motif in Frieseke's art; it both protects his lovely female models and further emphasizes their position as articles of beauty and recipients of the spectator's gaze.[5] Positioning the female figure on a threshold, between the interior and the outdoors, between shadow and sunlight, was a favorite motif among American Impressionists.

Whether under its present title of *Good Morning*, the original *In the Doorway*, or the alternative, *The Neighbor*, the picture projects the ease and comfort of well-established, domestic living, and harmonious intercourse among sophisticated residents and visitors. This, in fact, reflects the character of the Giverny art colony by the first two decades of the present century, one which had little interaction with the local peasant population that had figured so prominently in the paintings of the 1880s and 1890s by Robinson and his colleagues. For both their subject matter and their life styles, the later art colony members retreated within the walls of their increasingly genteel residences.

Frieseke's aesthetic influenced a whole generation of Americans in Giverny; significantly, almost all of the major figures of this group were from the Midwest, and like him, had first studied in Chicago; these included Lawton Parker, Louis Ritman, Karl Anderson, and Karl Buehr. Frieseke's innovative techniques gained him international fame following his abundant representation in the 1909 Venice *Biennale*, while he and his colleagues achieved great renown in their native land after successful exhibitions held in New York City in 1910.

WILLIAM H. GERDTS

WILLIAM MERRITT CHASE | 1849–1916

Did You Speak to Me?, 1897
Oil on canvas, 38 × 43″ (96.52 × 109.22 cm.)
Signed, lower left
Museum purchase, 921-O-102

Shortly after Chase's death, the prominent American art collector, Duncan Phillips, reflected on the particular appeal of Chase's interiors, describing them as having an "immediate charm." "It is more than a trick of cool light on reflecting surfaces, mahogany table-tops and hard wood floors," he explained. "It is the hint of once familiar moments long forgotten, a sentiment of the quiet dignity of a patrician home."[1] Although Chase deplored the poetic, storytelling nature of Victorian art, his interiors do possess a nostalgic quality and do engage the viewer as a participant in the scene. This is especially true in his painting, *Did You Speak to Me?*. Both in its compositional devices and its title, the work solicits a response from the viewer. While the painting clearly focuses on the girl's implied movement as she has turned to face him, the rest of the composition is sketched in more loosely. Although Chase is not known to have used the camera as a direct aid in composing his works (unlike his fellow American artists, Thomas Eakins and Theodore Robinson), he was well aware of how it could be used to highlight and emphasize an image, and he put this knowledge to good use. "You can have only one focus in a picture," he advised his students, ". . . be like a camera, and as you focus one spot the others lose in distinctness."[2]

The setting of, and attitude conveyed by, *Did You Speak to Me?* reflects Chase's patrician life as a gentleman artist. Most likely painted the summer of 1897, the model for the painting is Chase's first child, Alice Dieudonnée, at age ten, seated in the artist's studio at his summer home at Shinnecock Hills, Long Island (Fig. 1). Alice is surrounded by her father's paintings in various states of completion. Clearly, the setting is the studio of a successful practicing artist. The genteel milieu and the graceful attitude of Alice, wearing silver bracelets and a gold hair band, underscore a sense of prosperity. The painting also captures a moment in time. One distinctly feels Alice's movement as she turns to face the viewer, her left foot slightly turned behind the neoclassical stool, indicating her previous position, in which she was most likely viewing the landscape balanced on the chair on the right. Furthermore, the scene suggests a happy, carefree life, unencumbered by financial concerns or other personal problems. In reality, the image was to some extent a facade, or at the very least, a tenuous rendition of the artist's true situation at the time.

Just a year before painting *Did You Speak to Me?*, Chase was forced to give up his celebrated studio in the Tenth Street Studio Building, and auction off its contents due to financial difficulties. Although recognized as an important American artist of international acclaim, Chase was unable to support his somewhat extravagant style of living on the sale of his paintings, even when augmented by income earned as a teacher. Commenting on Chase's personal misfortune, and the disappointing results of the auction, one critic lamented: "Altogether it was a sad affair, and made one heartily ashamed of our so-called patrons of American art, who by their lack of appreciation of the productions of one of the best painters on the continent, make such a result possible. Mr. Chase has long been recognized as the head of the profession. Contrast the beggarly recognition accorded him outside of the profession with the splendid treatment of men occupying a similar position in London, Paris, or Berlin."[3] In response to the dismal result of the sale, Chase threatened to relocate abroad where he believed he would attain greater stature as an expatriate artist. However, after spending the spring of 1896 in Madrid, he returned to America to carry on as best he could. Whatever bitter feelings Chase harbored in his heart, his art continued to celebrate the gentle, carefree life of an important member of the American art community and to chronicle the life of his growing family.

Did You Speak to Me? was first exhibited in a one-man exhibition held at The Art Institute of Chicago (November 23–December 26, 1897, no. 3). Included in this exhibition were five paintings lent by the Potter Palmers, important patrons of the French Impressionists. The fact that Chase was represented in the Palmer collection was of great significance to him; not only did it place his work in an international context, it signaled his status as a world class artist. It is not unreasonable to speculate that one of the artistic forces behind *Did You Speak to Me?* was to create a work which could directly compete with work by the French Impressionists. Although Chase never fully adopted their principles, considering them to be too scientific, he did adjust his approach to incorporate those practices he thought were effective.

Figure 1. Photographer unknown. *Alice Dieudonnée and Chase family dog, with painting in background, The Feather Fan*, c. 1895. Gelatin printing-out paper, 1½ × 2″. Courtesy of The Parrish Art Museum, Southampton, N.Y., The William Merritt Chase Archives, Gift of Mrs. A. Byrd McDowell.

In particular, he mastered the ability to create a casual image of life suspended in time which, while looking effortless and unpremeditated, was actually carefully composed to reflect the movement of real people in real life situations. This is, of course, one of the most appealing aspects of *Did You Speak to Me?*. The work is, however, not merely a charming painting in which the artist set out to engage the viewer; it is a tour-de-force of American Impressionism, bold in color and compositional devices. It also attests to the enduring belief that Chase had in his own genius as an artist; in spite of his personal financial problems and lack of support by American collectors at the time, he continued to paint pictures with all the verve and mastery at his command. *Did You Speak to Me?* is an elegant testament to his faith in American art and in himself as one of its most eloquent practitioners.

RONALD G. PISANO

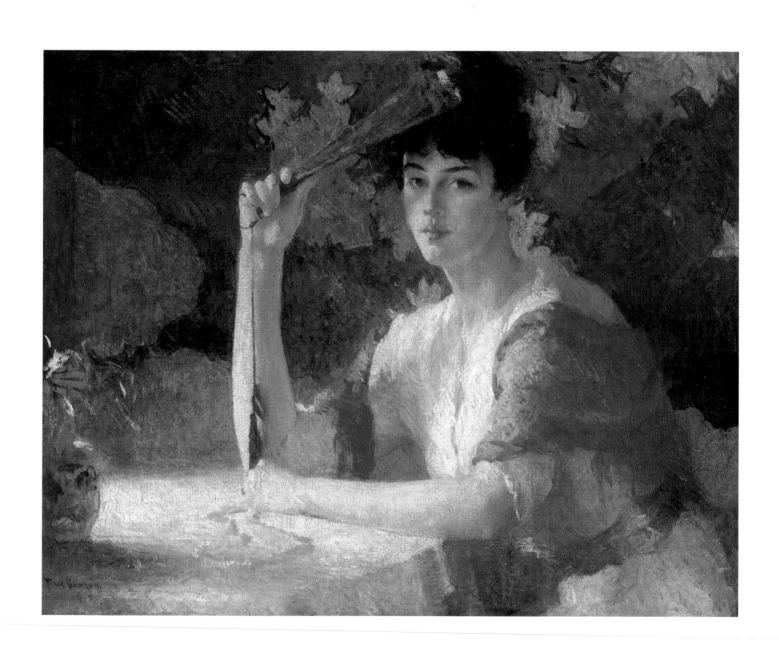

FRANK WESTON BENSON | 1862-1951

Red and Gold, 1915
Oil on canvas, 31 × 39″ (78.74 × 99.06 cm.)
Signed, lower left
Museum purchase, 919-O-102

Through his paintings, teaching, and involvement in professional artists' organizations, Frank Weston Benson was one of the leaders in the development of an American Impressionist style. In the 1940s, late in his life, he would look back on a long and varied career that included landscapes, still lifes, sporting subjects, and birds, painted in oil and watercolor and etched on copper plates. But Benson is best-remembered for his figurative paintings, most of which he had completed by 1920. His images of young ladies in white dresses standing contemplatively on windswept hillsides gave ineradicable definition to one aspect of American Impressionism. And, with the closely-related works of his friend, Edmund C. Tarbell, his portrayals of the same women reading or sewing in elegantly-appointed interiors shaped the central motif of what came to be identified as a distinctively Bostonian tradition.

Born in Salem, Massachusetts, to a prosperous mercantile family, Benson overcame his father's early skepticism about his choice of an artistic career to study, first, at the School of the Museum of Fine Arts in Boston, and then at the Académie Julian in Paris, which for many young American artists of the era had become a mandatory stop on the road to artistic respectability. After returning to New England in 1885, over the next four years Benson opened a Boston studio which he shared with Tarbell, began teaching at the Museum School, and was elected to membership in the Society of American Artists, the progressive alternative to the National Academy of Design. In 1898, Benson further distanced himself from the academic establishment by helping found the Ten American Artists, an organization dedicated to the exhibition and promotion of Impressionism.

From its beginnings in the work of James Abbott McNeill Whistler and Mary Cassatt, American Impressionism had explored a variety of themes and styles, from the broken brushwork and chromatic analyses of light pioneered by Claude Monet to the bravura strokes and psychological penetrations of John Singer Sargent. Benson's style, which had matured by 1898, combined the brushwork and color of Monet—a Boston favorite since the early 1890s—with his own characteristically American subjects.

Like most American Impressionists, Benson was conservative in his approach; his figures solidly occupy spaces and, though his surfaces sparkle with the effects of reflected light, they never dissolve into a coloristic haze. He deliberately chose subjects that, in one critic's words, celebrated a civilized "ideal of grace, of dignity, of elegance";[1] his subjects also proclaim the defining traits of the modern American woman as he understood her: glowing with health, virtuously domestic without being stuffy, wrapped in a mantle of material privilege yet independent and inquisitive, direct in the expression of opinions yet self-controlled.

The young lady in *Red and Gold* exemplifies the type. In lesser hands, she might have ended up as but one more decoration in a highly decorative composition, the tone of which is instantly proclaimed by the bold black and gold Japanese screen that forms the backdrop. Her white dress and bright red shawl thus immediately gain our attention, from which we then turn to the details: the black fan that she holds so elegantly above her head, its tassel falling alongside the cream-white flesh of her arm; the gold necklace laid out across the tablecloth, one end of which she casually grasps with her left hand. It is a rich tapestry of possessions, yet when we look into her classically pretty face, with its bright red lips, raven-black hair and ruddy cheeks, she looks right back at us. Her frank yet somewhat wistful gaze speaks of a complex world of feelings which we are not asked so much to share as to appreciate.

BRUCE W. CHAMBERS

WILLARD LEROY METCALF | 1858–1925

Spring Landscape, Giverny, 1887
Oil on canvas, 19½ × 25¾″ (49.53 × 65.40 cm.)
Signed, lower left
Gift of Dr. John J. McDonough, 973-O-127

Willard Leroy Metcalf, known to all his friends as "Metty" (he refused to answer to Willard), is recognized as the "poet laureate of the New England hills"[1] for his quiet Impressionist landscapes of the farms and villages of that region. A founding member of The Ten, Metcalf brought an Impressionist's understanding of color and light to the seasonal cycles and shifts of weather that characterize New England. At the same time, his observations of nature were built on particularity; what some have called his "Yankee reticence" was in fact a naturalist's love of specifics combined with a deep understanding of the underlying pattern of the whole.[2]

For the first twenty years of his career Metcalf had been in turn a Hudson River School painter, a prolific illustrator, and a Barbizon landscapist. His early artistic gifts were noted and embraced by his parents; at age sixteen he was apprenticed to the painter George Loring Brown and two years later was admitted to the Boston Museum of Fine Arts School, where he studied under William Rimmer. In 1881, in order to earn passage to France, Metcalf worked as an illustrator of magazine articles on the Zuni Native Americans. His fascination with Zuni cosmology and ritual led him to postpone study abroad for another year to join the pioneer anthropologist, Frank Hamilton Cushing, on a Smithsonian expedition.

In the fall of 1883, Metcalf enrolled in the Académie Julian in Paris, where he was joined by other young Americans, among them Frank Weston Benson, Edward Simmons, and Arthur Hoeber. For the next five years Metcalf remained in France, not only acquiring professional polish at the academy but, far more importantly, joining his artist-companions on extended explorations of the countryside. There were trips to Pont-Aven in Brittany, where he met the American painter Alexander Harrison and the French artist Jules Bastien-Lepage, and to Grez-sur-Loing, center of the international community of Barbizon painters. But perhaps the most formative experiences in Metcalf's artistic development were his visits to Giverny, home of the most famous Impressionist, Claude Monet.

Metcalf possibly first visited Giverny in 1886, where he sought out Monet and was invited to lunch. He hiked and sketched in the countryside around Giverny in the company of Monet's step-daughters, discovering a wealth of subjects—the river and the red-roofed houses, the grainstacks and the gardens—that Monet was transforming into brilliant chromatic essays. Theodore Robinson also spent considerable time in Giverny and together, Metcalf's and Robinson's discoveries attracted other Americans, to the point that Giverny soon became a veritable colony of American Impressionists.

At the same time, Metcalf moved cautiously toward the more radical aspects of Monet's style: the high-keyed color, the division of light into its component hues, and the broken brushwork that became the movement's signature traits. However, as is evident in *Spring Landscape, Giverny*, Metcalf also continued to work through his near-simultaneous discoveries of the merits of the Barbizon painters and James Abbott McNeill Whistler, whose works he had encountered in Paris. Although painted in Giverny, the emphasis of *Spring Landscape, Giverny* is on closely-related harmonies of russets, greens, and grays. Though the landscape extends to buildings and hills in the far distance, its composition reads more as a series of shallow planes; its larger forms are broadly painted, its details mere swift flicks of contrasting hue. There is nothing here yet to suggest Metcalf's later style save that the scene is flooded with the peaceful warmth of a summer day that could only have been observed *en plein-air*.

BRUCE W. CHAMBERS

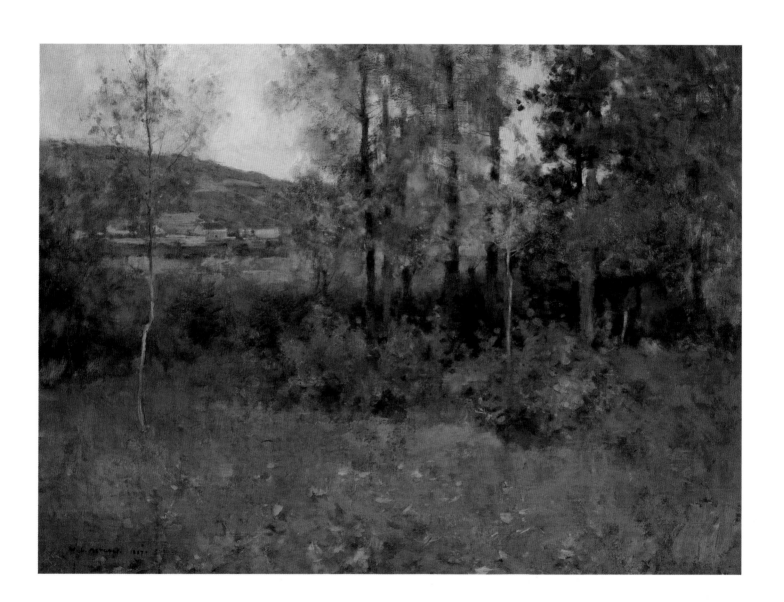

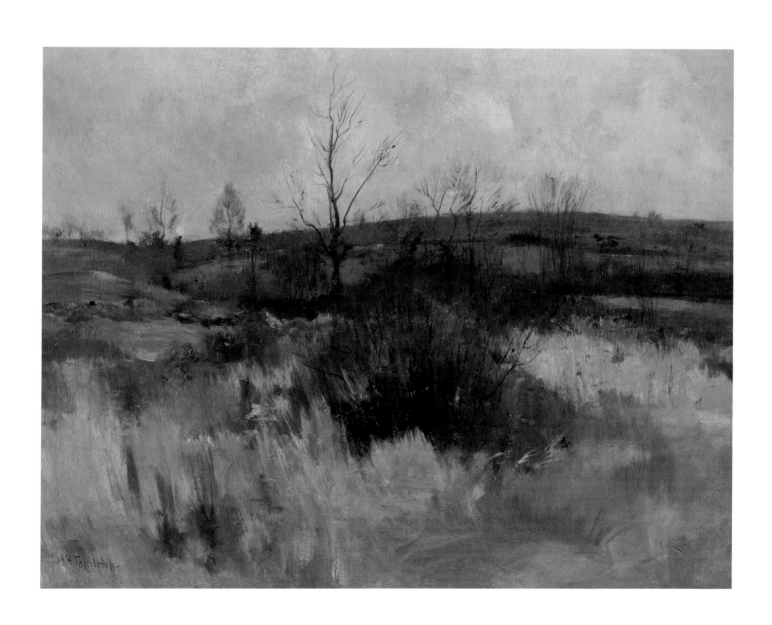

JOHN HENRY TWACHTMAN | 1853–1902

Landscape, 1889
Oil on canvas, 20 × 29″ (50.80 × 73.66 cm.)
Signed, lower left
Museum purchase, 937-O-101

John Twachtman was born in Cincinnati. His first artistic efforts were painting floral window shades for his father's business during the day while spending his evenings training at the Ohio Mechanics Institute. In 1874 he studied at the Cincinnati School of Design with Frank Duveneck, who sent him in 1875 to Munich, where he worked with Ludwig von Loefftz at the Royal Academy. In 1877 Twachtman went with Duveneck and William Merritt Chase to Venice. From 1883 to 1885 Twachtman was instructed by Jules Lefebvre and Louis Boulanger at the Académie Julian in Paris, where he was influenced by the paintings of James Abbott McNeill Whistler and the French Impressionists, and became friends with Childe Hassam and Theodore Robinson. Twachtman returned to the United States, and by 1888 had settled in Connecticut where the core of his work was executed. That same year he won the landscape prize for the Society of American Artists, and in 1889, he had a successful two-man show with J. Alden Weir. He acquired property in Connecticut around the time he was hired to teach at the Art Students League. With Weir and Hassam, he helped found the American Impressionist group called The Ten in 1898.

Twachtman's artistic evolution began with a naturalism based on the earth tones and the fluid brushwork he learned from Frank Duveneck and the Munich school, progressing through the muted harmonies and abstract patterning of Whistler, and finally comprehending more closely than any other American landscape painter the mature Impressionism of Claude Monet. Twachtman's pictures lack Monet's scale or symphonic fullness, but they emulate some of the Frenchman's subtleties of perception, densely woven color harmonies, built-up impasto, and scumbled, broken brushwork.

Although *Landscape* follows the traditional horizontal format, it is nevertheless eccentrically constructed. Twachtman was notably exceptional, and modern, in the frequency with which his landscape compositions were square or vertical, with a high or even absent horizon line. In contrast to the Dutch and French landscape painters, who commonly structured their pictures around a dominant sky and low horizon, Twachtman, like many other American landscape painters, gives over most of his composition to the land. His works are usually centered around a principal, generally darker, motif which forms a calligraphic flourish and focus, often connected to the picture's diagonal axes. The main marshy mass of *Landscape* orders the composition more in terms of organic centrifugal outgrowth than of geometrically parallel horizontals. Its somber shape dominates the sloping horizon and vertically sprouts into wiry wintry trees, set against a pale gray sky. Two years after this painting was done,[1] Twachtman wrote to Weir: ". . . I feel more and more contented with the isolation of country life. To be isolated is a fine thing and we are all then nearer to nature. I can see how necessary it is to live always in the country—at all seasons of the year."[2] Twachtman's use of the word "isolation" is instructive, since, like *Landscape*, his other works are generally devoid of figures and quite often lack evidence of human habitation. His paintings richly document seasonal change, with fall and, especially, winter, much more frequently depicted than the spring and summer favored by the French Impressionists.

Twachtman was fond of poetry, and loved especially Heinrich Heine. Music was even more of a passion for him, especially the works of Romantics like Johannes Brahms, Frederick Chopin, and Franz Schubert. Taken as qualities, both music and poetry are terms which could be applied to Twachtman's work, full as it is of the atmosphere, harmony, and "color" that characterize the other two art forms. *Landscape* sings an autumnal lyric of growth and decay, of seasonal death and renewal.

JAMES THOMPSON

175

JULIAN ALDEN WEIR | 1852–1919

The Oldest Inhabitant, 1876
Oil on canvas, 65½×32″ (166.37×81.28 cm.)
Signed, upper left
Museum purchase, 922-O-105

J. Alden Weir is best remembered as a leading American Impressionist, but he did not always embrace this progressive style. "They do not observe drawing nor form but give you an impression of what they call nature," he wrote to his parents after viewing the French Impressionist exhibition in Paris. "It was worse than the Chamber of Horrors."[1] Weir's reaction is a reflection of his training from 1873 to1877 at the Ecole des Beaux-Arts under Jean-Léon Gérôme, who emphasized the careful observation of detail, precise drawing, and high finish that was challenged by the Impressionists.

The Oldest Inhabitant typifies the oeuvre of Weir's student years and reveals his involvement with the European artists working in France. Weir had spent the summer of 1874 in Brittany, where he met Robert Wylie, a painter of peasant life, whose dark, rich palette and love of local French costumes and customs is reflected in *The Oldest Inhabitant*. During 1874, Weir became friendly with students of Jules Bastien-Lepage, whose scenes of French peasant life are rendered with exacting detail.[2] That summer, Weir decided to paint in Cernay-la-Ville, a village southwest of Paris, where he knew his companions would be French painters, stating, "I know I will learn more and be more serious if I remain with the Frenchmen."[3]

The Oldest Inhabitant, the largest painting of his student years, resulted from this summer's work, although it took him another year to complete it. Weir began the painting by September 10, 1875, but was still working on it the following July 5, when he wrote home from Cernay-la-Ville: "Yesterday was the glorious 'Fourth.' I celebrated in a quiet way by leaving Paris on the 8 A.M. train. . . . I have brought my large canvas with me, which I expect to finish for the ex[hibition] of the end of the year . . . the old peasant is in good health . . . I lost little time and all goes well. . . ."[4] Weir's sojourn at Cernay-la-Ville ended dramatically when he was unexpectedly summoned back to Paris to take an examination at the Ecole. Riding the stage coach to the train station, he remembered he had left *The Oldest Inhabitant* behind. "I got out to run back, being assured that I would never catch the train . . . [but] everything counted on my canvas."[5] When he reached the hotel he ordered the best horse in town and galloped off, canvas in hand. He rode on to the next stage stop, where it was market day, and, "[i]n the most dangerous part . . . my horse balked at something, and walked all through the butter and egg pots. The peasants were bawling at me at the top of their lungs."[6] There Weir was able to join his fellow travelers, who applauded his great effort.

In *The Oldest Inhabitant* the importance of the model's advanced age is underscored by the inscription Weir painted as though carved into the wood of the cabinet: "July 4th 1876/La plus Vielle de Cernay/née le 4 Juin/1794." The date, July 4, 1876, cannot refer simply to the painting's completion or of the model's death because she continued to pose for him. This eighty-two-year-old woman's life had spanned a tumultuous period of her nation's history, reaching back to the French Revolutionary War. Weir may have also been marking the passage of time in America. Independence Day was a special holiday for the painter, who was raised at West Point, and who, a year earlier, had written warmly of the festivities that marked the holiday there.[7] Of course, Weir's elderly subject, with a wrinkled visage reflecting character and implying wisdom, also draws on a strong artistic tradition that stretches back to seventeenth-century paintings by Rembrandt van Rijn, whom Weir greatly admired.[8]

Though Weir wished to remain in France, in the spring of 1877 he submitted *The Oldest Inhabitant* for exhibition at the National Academy of Design in anticipation of his return home that October.[9] The work received favorable placement and was hailed by one critic as an "admirable performance, coming near truly great."[10] Peasant subjects continued to appear in Weir's work, largely because of his frequent foreign travel, but in the late 1880s, he turned decisively to painting scenes of contemporary American life in a style that increasingly found its inspiration in Impressionism.

DOREEN BOLGER

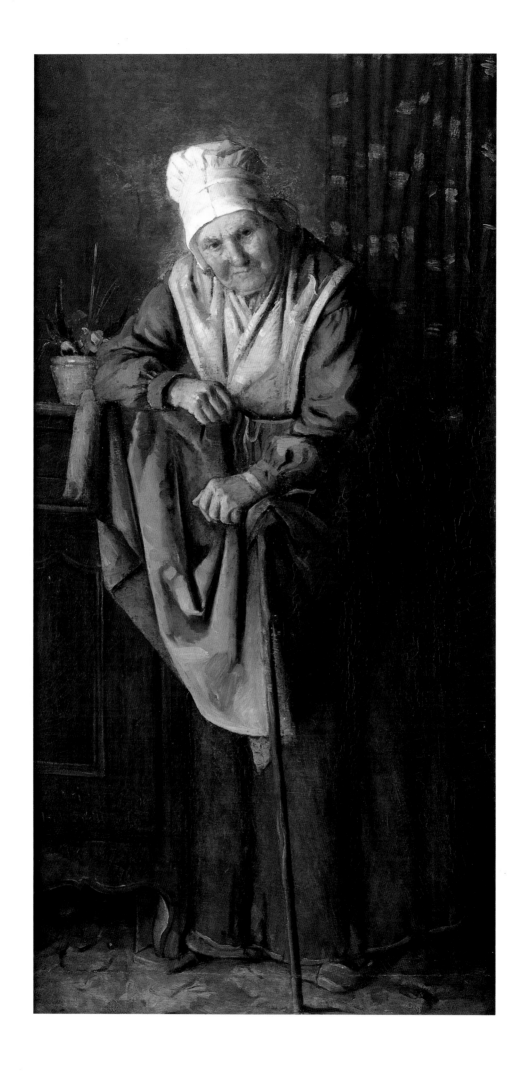

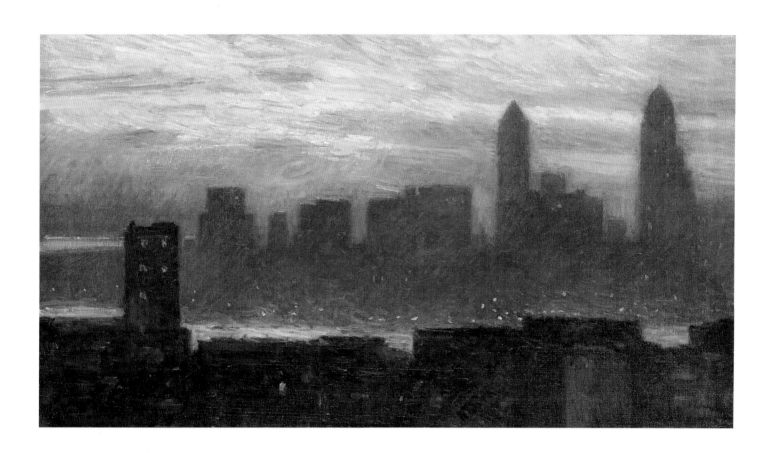

CHILDE HASSAM | 1859–1935

Manhattan's Misty Sunset, 1911
Oil on canvas, 18 × 32″ (45.72 × 81.28 cm.)
Signed, lower left
Museum purchase, 967-O-151

Childe Hassam was the premier Impressionist painter of New York City. From 1890 through World War I he painted its fashionable boulevards, genteel park lanes, festive military parades, new neighborhoods, and occasionally, as in *Manhattan's Misty Sunset*, the new skyline that was prompting many to call New York the eighth wonder of the world. Like many American Impressionists, Hassam was a New Englander. A charter member of The Ten, he began drawing in the 1870s, studying in Boston under William Rimmer and the Munich academician, Ignaz Gaugengigl. Influenced by the tonalist painter, George Fuller, Hassam became well-known for his street scenes such as *Rainy Day, Columbus Avenue, Boston* (1885, The Toledo Museum of Art). He went to Paris in 1886, making numerous rural and urban plein-air paintings that put him in the center of the emerging American Impressionist brotherhood. He returned to Boston in 1889, eventually settling in New York City.

In this painting, Hassam shifts away from the sunny, smiling atmosphere of his pre-1900 city scenes. *Manhattan's Misty Sunset* still shows an allegiance to plein-air painting; yet despite the attention to light, atmosphere, and weather conditions, the work was probably done in Hassam's studio on West 67th Street.[1] Hassam had painted other twilight rainy scenes before 1911, seizing on the way the cold drizzle blurred the detail of objects and made bold, abstract designs out of the big city structures. Such calculations brought his work closer in spirit to James Abbott McNeill Whistler's nocturnes than to the sun-drenched boulevard documents of Claude Monet and Pierre-Auguste Renoir. Here, the failing moments of the evening, which the French Impressionists seldom painted, cast a veiled mystery over the constructed scene, linking the painting to Whistler's Thames paintings and the pictorialist photography of Hassam's contemporaries, Alvin Langdon Coburn and Alfred Steiglitz.[2] Hassam's color range is narrow and organized around cool tones; there is a controlled thickness in the brushwork and the shades of green paint are slathered over the generalized shapes of the Brooklyn warehouses, the East River, the lower tip of Manhattan, and the distant glimpse of the Hudson River.

One senses Hassam's ambivalence toward modern industrial America. He had first pictured the massive excavations and constructions in *The Hovel and the Skyscraper* (1904, private collection), where the elevated viewpoint suggests a metropolitan impersonality. Hassam defined the ". . . changing character of New York from a city of brownstone hovels and pedestrian walks to one of skyscrapers and elevated railways."[3] Still, *Manhattan's Misty Sunset* shows New York on the verge of the skyscraper era, not fully in it. The two tall structures, whose identity is unknown, pierce the Manhattan skyline but do not overwhelm the human scale of the smaller commercial buildings. Hassam's distant Brooklyn vantage point, the ribbons of mist partly shrouding the solid forms, as well as the evening light, soften the effect of the concrete canyons across the East River. There is a melancholy poetry here, a poignant transition between the realities of the nineteenth and twentieth centuries that Edward Hopper would also occasionally suggest in his paintings.

In later years, Hassam preoccupied himself with patriotic, decorative paintings of war-time New York City. These festive interpretations of people and flags in the streets of the increasingly skyscraper-dominated New York brought him great popular and critical success.[4]

RICHARD COX

GEORGE DEFOREST BRUSH | 1855–1941

Thea, c. 1910
Oil on panel, 16 × 12″ (40.64 × 30.48 cm.)
Signed, middle right
Museum purchase, 920-O-103

Although today we think of American painting at the turn of the past century as dominated by Impressionism, this was actually one of the most diverse periods in the history of American art. Realists like Winslow Homer and Thomas Eakins, visionaries like Albert Pinkham Ryder, and a wide variety of still-life and landscape painters all reached the height of their powers at the same time as John Singer Sargent, Mary Cassatt, and the members of The Ten. As American painters matured, so too did American sculptors and architects: Augustus Saint-Gaudens, Stanford White, and Louis Sullivan appeared in the same generation, as did Walt Whitman, William Dean Howells, and Henry Adams, giving fresh impetus to American letters. It was thus with reason that, in the decades between the nation's Centennial and 1900, the cultural leaders of the age thought of themselves as participating in an artistic revitalization, as belonging to an American Renaissance.

Within this creative ferment there were some painters who inclined towards a more literal emulation of Italian Renaissance art, as that art was filtered through the academic teaching and example of their mentors at the Ecole des Beaux-Arts in Paris. Among the many young Americans who deliberately sought such instruction was George deForest Brush, the son of a successful Connecticut businessman. Brush first encountered the systematic artistic professionalism of the French Academy through his teacher at the National Academy of Design, Lemuel Wilmarth. In 1874, Brush went to Paris and placed himself under the tutelage of Jean-Léon Gérôme, one of France's most illustrious art teachers, who demanded the close study of the human form and instilled a spirit of romance in his students through his preference for exotic subjects drawn both from the classical past and from the contemporary Near East. After completing his studies and returning to the United States in 1880, Brush began to paint his own exotic romances as he saw them embodied in the anatomical perfection and noble ideals of the Native American.

By the late 1880s, Brush began to move away from the Native American subjects that had first won him fame towards elegantly composed and painted images of mothers and children, based on the madonnas of the High Renaissance. His wife Mittie and his blond-haired brood of one son and six daughters served as his models. In 1898 Brush embarked on the first of a long series of visits to Florence. One of the products of these stays was *Thea*, a portrait of his youngest daughter, born in Florence in 1903. Thea, later Mrs. Thomas Handasyd Cabot, is depicted as a girl of about seven or eight, carefully posed in a fanciful costume completely dominated by a large red hat. Her long, blond tresses fall like watered silk across the front of her green velvet dress, whose lace collar and embroidered sleeves complement the hat's feathery plumes in their delicacy.

The painting's oval format and ornately-carved frame suggest the artist's Renaissance preoccupations. From the time of his first Italian visit, Brush had made a study of Renaissance painting techniques, grinding his own pigments and applying them to carefully-prepared gesso grounds to recreate the luxuriant colors of sixteenth and seventeenth century Italian painting. As much as it is a portrait of a disarming young lady, *Thea* is also an essay in those colors, one whose principal intent is to evoke its Old Master prototypes.

BRUCE W. CHAMBERS

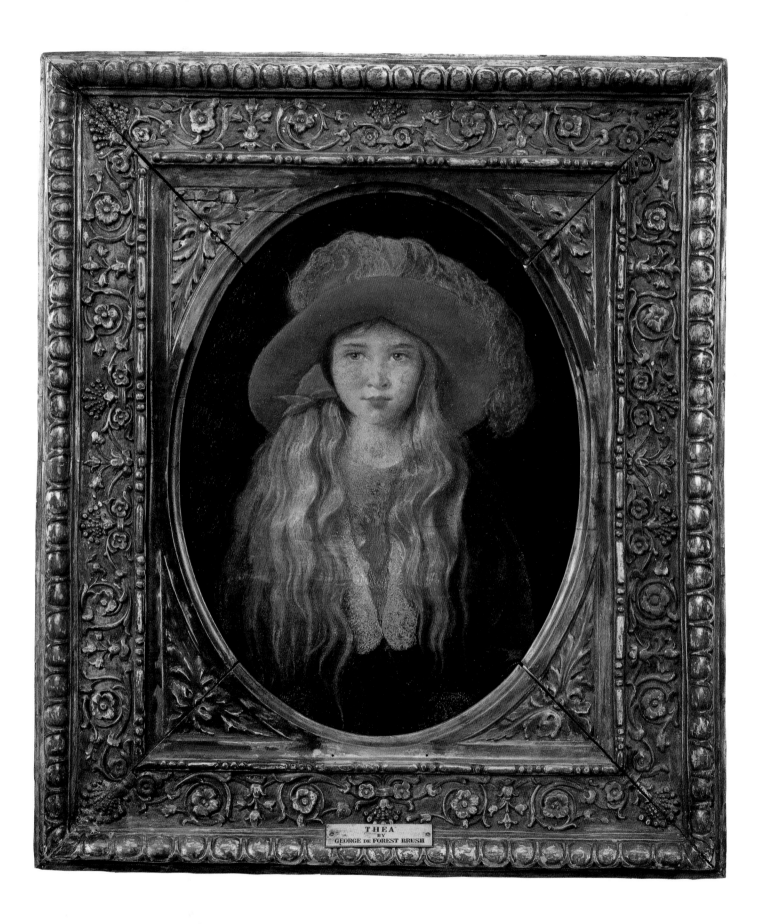

THEA
BY
GEORGE de FOREST BRUSH

ABBOTT HANDERSON THAYER | 1849–1921

Meditation, 1903
Oil on canvas, 24 × 19″ (60.96 × 48.26 cm.)
Signed, upper right
Museum purchase, 922-O-107

Painted in the twilight of his career, *Meditation* epitomized Abbott Thayer's search for moral truth, which he believed could be divined through the earnest contemplation of a beautiful female. Thayer, from a prominent New England family, studied art in Boston, and, in the early 1870s, painted animal portraits in Brooklyn, New York. From 1876 to 1878 he traveled abroad, before enrolling in Jean-Léon Gérôme's atelier. Thayer and his young wife, Kate, maintained a Right-Bank apartment, keeping away from the Latin Quarter bohemian haunts frequented by other painting students. After some critical success in the early 1880s,[1] Thayer returned to America a more confident and cosmopolitan artist with European sensibilities that marked his portraits of New England women done during the rest of the decade.

Gratified by the patronage of Albert Freer, Thayer, weary of commissioned portraits, was now free to paint what he called "expressions."[2] His first major example, *Angel* (1888, The National Museum of American Art), excited reviewers when it was shown at the 1889 Universal Exposition in Paris. Throughout the 1890s and into the early years of the twentieth century, Thayer produced a succession of idealized angels, goddesses, and madonnas, painted for reasons psychological and historical. His search for feminine innocence may have been a way of shutting the door on tragic memories in his life. Two of his young sons died in 1886, and his first wife, Kate, never recovered from a clinical case of melancholy.[3] Thayer was also among many artists and writers who were beginning to feel that America of the Gilded Age was deficient in beauty, breeding, and morality. Thus, he attached his art to the new Cult of the Virgin, which social historians say offered refuge for sensitive souls from the crass, business culture of post-Civil War America. George deForest Brush, Kenyon Cox, Thomas Dewing, and Augustus Saint Gaudens joined Thayer in nurturing the concept of the ennobled female, a symbol of the moral purity needed to ward off the distressing realities of a money-crazed age.[4]

While Thayer shared these general biases, his own symbolic art was not identical to Cox's Virgilian tableaus or to Dewing's green, gauzy dreams. In *Meditation*, Thayer eliminates all allegorical props—wings, halos, etc.—as well as the Arcadian setting, concentrating instead on extracting the ideal from the concrete. Partly aided by photographs, he carefully delineated the individual facial features of his favorite model, Bessie Price, who posed for a number of his allegorical or symbolic works.[5] Her stern expression and severe frontal stance creates a watchful atmosphere, while the restricted palette tuned to the chocolate brown dress demonstrates Thayer's respect for the portraits of Titian and Diego Velazquez. This personified female is, in effect, an icon; by prolonged contemplation we can be led to believe, as Thayer did, that she is touched with grace. The specific features of her face gradually release noble moral truth, evoking a quiet strain of "pleasurable melancholy."[6]

Thayer was living in semi-seclusion in Dublin, New Hampshire when he painted *Meditation*. He had been an active member of the progressive Boston art colony and had been invited to join The Ten. But Symbolist art, so much in favor during the *fin de siècle*, lost almost all its following after 1910, and Thayer's reputation entered a period of steady decline, despite the fact that he then began painting some of the most abstract landscapes seen in America.

RICHARD COX

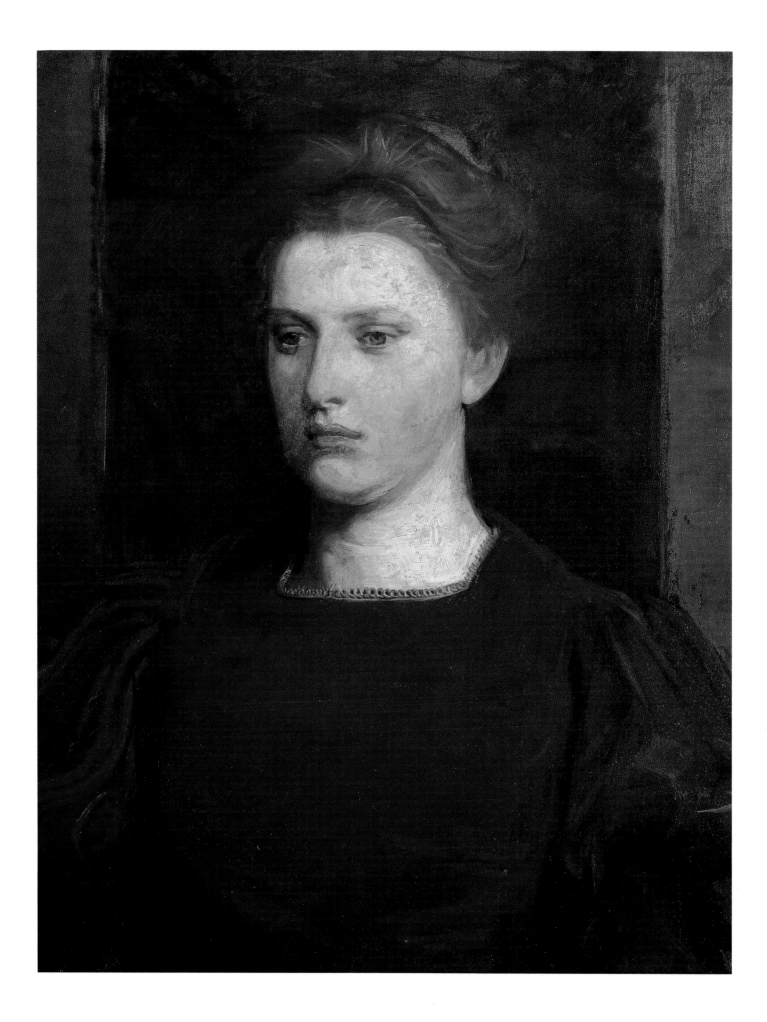

PHILIP LESLIE HALE | 1865–1931

Hollyhocks, c. 1922–23
Oil on canvas, 36 × 24″ (91.44 × 60.96 cm.)
Unsigned
Museum purchase, 966-O-137

Hollyhocks is a particularly captivating example of Philip Leslie Hale's decorative Impressionism. Depicting healthy, sun-drenched young women engaged in genteel leisure activities outdoors, Hale, a well-known Boston painter, art critic, and unofficial spokesman for the Boston School, was drawn, as were many of his peers, to this theme and style. Hale's approach to this subject, however, varied rather dramatically throughout his career.

After study at the Boston Museum School with Edmund Tarbell and at the Art Students League with J. Alden Weir and Kenyon Cox, in 1887 Hale traveled to Paris. There he was profoundly influenced by what he learned as a student at the Académie Julian and Ecole des Beaux-Arts, and observed as an art critic and regular visitor to Claude Monet's home and the emergent art colony of Giverny. Unlike many of his more cautious American contemporaries, Hale quickly adopted the most progressive aspects of the modern French art movements and by the mid-1890s, was producing dazzling, Neo-impressionist scenes of diaphanous women bathed in golden light. In *The Water's Edge* (c. 1895, private collection) and *Girl in Sunlight* (c. 1897, Museum of Fine Arts, Boston), Hale dissolved the figures within an envelope of light in a classic French Impressionist manner. But he also gave the works an other-worldly, contemplative quality that relates to the frozen world of Georges Seurat's Pointillist figural landscapes and Symbolist painting. Of his Boston contemporaries, only Thomas Wilmer Dewing embraced such a rarefied, dreamy version of Impressionism, but, unlike Dewing, Hale used more dramatic, blazingly arbitrary colors to achieve his effect. This series of works culminated in an exhibition of Hale's paintings at Durand-Ruel's New York gallery in 1899.

Unfortunately, the largely conservative contemporary press was not supportive of Hale's visionary efforts. Their negative response, coupled with his marriage in 1902 to a more conservative figure painter, and the constraints of teaching at the strongly academic Boston Museum School probably led to his return at this time to a more academic form of Impressionism. Hale's *The Crimson Rambler* (c. 1908–09, Pennsylvania Academy of the Fine Arts) is a well-known example of such an approach to the fully illuminated female figure. The figure, although bathed in light, is not dissolved by it, but fully modeled, with carefully delineated facial features. This blend of an academic treatment of the figure and Impressionist use of high-keyed color and broken brushwork represents the classic American Impressionist approach to such a subject and anticipates *Hollyhocks*. Shortly after completing this work, Hale once again adjusted his focus. From roughly 1910 to 1920, he became preoccupied with meticulously rendered, quietly lighted interiors, peopled with painstakingly modeled figures in the tradition of Jan Vermeer. Hale had completed a major book on Vermeer in 1913, and was largely responsible for a revival of interest in his work which came to virtually define the Boston School of painting. During the first decade of the twentieth century, Hale had been interested in Vermeer's style, but through the second decade he became even more focused on it, and imparted more detail and increasingly overt sentiment to its treatment, as in *A Family Affair (Grandmother's Birthday)* (c. 1912–13, private collection). Concurrently, Hale painted a series of allegorical scenes of idealized female figures, which today appear dated and overstated. Perhaps sensing that this drift toward overtly metaphorical and sentimental paintings was pushing an aesthetic extreme, Hale returned in the early 1920s to painting and exhibiting works such as *Hollyhocks*, which recall his earlier painting, *The Crimson Rambler*.

Hollyhocks, exhibited in Philadelphia, Boston, Worcester, and Venice between 1923 and 1924, is an excellent example of Hale's sun-bathed garden scenes. The artist not only captured the glaring white heat of a midsummer day through the careful orchestration of sensitively valued whites, lavenders, blues, and varying shades of green, enlivened by a bold dash of cherry red, but he also successfully captured the myriad textures of the scene. The girl's fine, shiny black hair glows blue in the bright sun. The old shutters have a mellow, scumbled quality. The tissuey petals of the hollyhocks have a short-lived, fragile delicacy, and the rich vegetation is well differentiated through the fluent handling of varied brushstrokes.

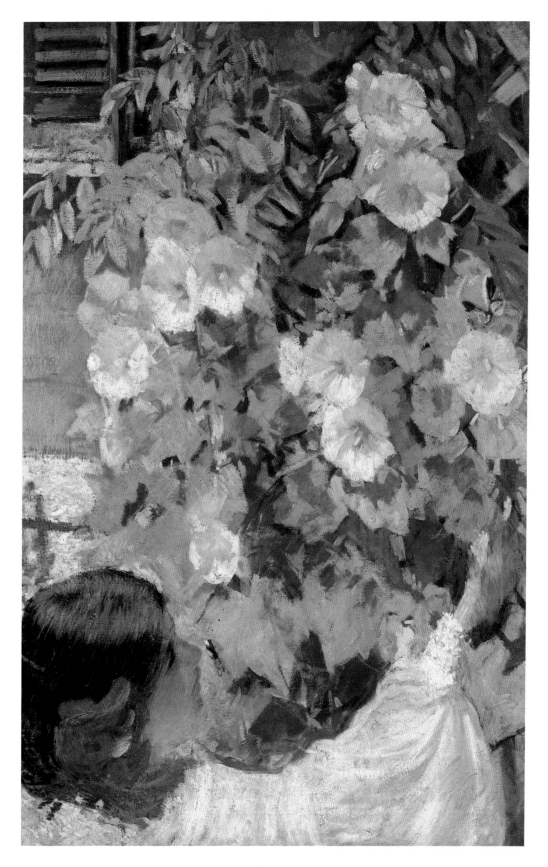

Hale centered the well ordered composition with an oval bounded by the woman's face and uplifted arm and anchored it with block-like forms in each corner of the canvas. After completing this work, Hale continued to exhibit, if less regularly, at national and regional institutions until the late 1920s, retiring from teaching in 1928.

JAMES KENY

185

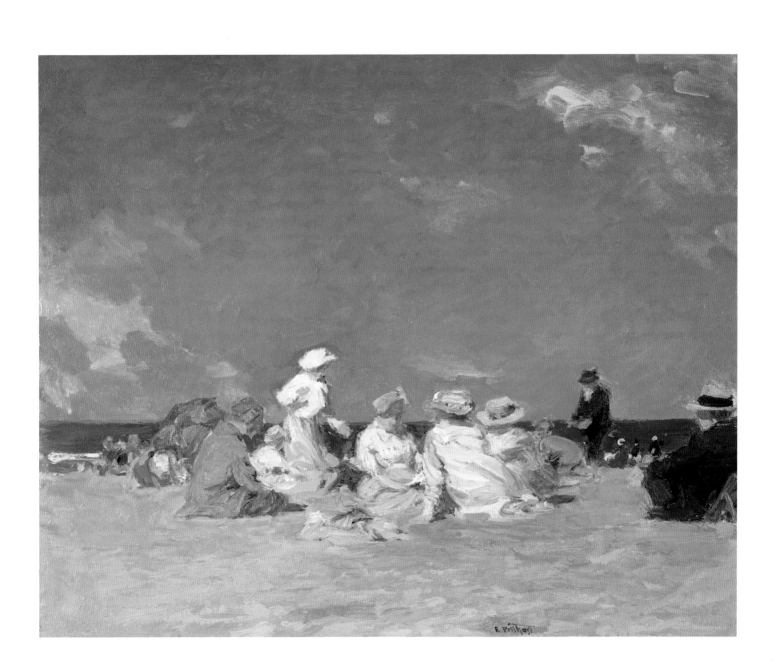

EDWARD HENRY POTTHAST | 1857–1927

Afternoon Fun
Oil on canvas, 24 × 30″ (60.96 × 76.20 cm.)
Signed, lower right
Museum purchase, 989-O-103

As seen in the gem-like oil, *Afternoon Fun*,[1] Edward Potthast created a personal form of open-air painting, unlike the feeble, phrase-book French Impressionism that characterized the work of many painters associated with the National Academy of Design.

First educated in painting at the McMickin School of Design in his native Cincinnati, Potthast went abroad to academies in Antwerp, Munich, and Paris during the 1880s, and began producing colorful landscapes of French subjects that showed the influences of Robert Vonnoh and the Irish Impressionist, Roderic O'Conor. *A Brittany Girl* (1889, The National Museum of American Art) was one of the critical surprises of the French Centennial Exposition.[2] With its combination of tight drawing and high-keyed Impressionist color, this small oil gave Potthast a leg up on the scores of young American painters who desperately wanted to achieve exhibition success in Paris.[3] Still not yet a confident artist, Potthast returned in late 1889 to Cincinnati, supporting himself as a commercial lithographer and as an illustrator for *Scribners* and *Century*. In 1896, he moved to New York and, after another extended trip to Europe, started fulfilling his early promise as an Impressionist painter. By the early twentieth century, he had settled on his trademark subject, New York families taking the waters at the resorts near the city.

Deceptively casual, *Afternoon Fun* is a calculated nature study in which Potthast has orchestrated the details of the beach, selected the viewpoint, eliminated distracting details, and enhanced key elements. The eye moves from the foreground figure group, firmly drawn as in Winslow Homer's *High Tide* (1870, The Metropolitan Museum of Art), to the secondary bathers at the distant shoreline, who balance the picture. A similar discipline is imposed on the color scheme: areas of white peak at the kneeling female figure and are set off by a man wearing a navy blue blazer, whose hue is echoed in a second male figure in the middle ground, and by the thin line of cold sea water in the distance. Such contrasting blocks of color became a specialty of Potthast's. The brushwork varies from the broken Impressionist strokes that highlight the lavender puddles in the sand to the more evenly coated banks of saturated blues that define the blazers, water, and wide expanse of sky. It is a hard, clear American light against which the heads and shoulders of the bathers are clustered. The intensity of the hot sunlight dyes the air above the beach; perhaps there is a slight cooling effect in the gentle winds that typically blow off Long Island Sound late in the afternoon.

Afternoon Fun is an unabashedly sentimental picture. In the main, of course, American Impressionist painters were not intent on making probing queries into the condition of man. These are the smiling realities of the American bourgeoisie early in the new century, when a rush of leisure activities seized the New York middle classes. The soft and honeyed voice of *Afternoon Fun* sings with style and charm. The painting radiates the vigor and confidence of life in what historians call the Age of Innocence.

After World War I, Potthast increased the production of his pleasurable images and participated in the late burst of American Impressionist painting. He produced dozens of new compositions of seaside genre, many revealing a strong stylistic similarity to Maurice Prendergast's art.[4]

RICHARD COX

CHARLES WEBSTER HAWTHORNE | 1872–1930

Girl in Yellow Scarf, 1904
Oil on canvas, 40 × 30″ (101.60 × 76.20 cm.)
Signed, upper left
Museum purchase, 967-O-142

Perhaps Charles Hawthorne's greatest contribution to art in America was his gift of teaching. In 1899, in Provincetown, Massachusetts, he established his own summer school, the Cape Cod School of Art, which flourished under his direction until his death thirty years later. In this first outdoor school of figure painting he gave weekly criticisms and instructive talks, advising his pupils and setting up ideals, but never dictating his own techniques or method.[1] One of his students, the American painter Edwin Dickinson, said that Hawthorne was "The best teacher I ever knew; better than Chase, who was . . . very good. . . ."[2] While Hawthorne was a teacher par excellence, he was also highly esteemed as a painter whose superb craftsmanship and personal vision earned him a most respected position among American artists. While he rejected the exotic tones of the European avant garde, Hawthorne embraced a more traditional style of painting, yet always experimented with technique, light, and color, and built upon a structural solidity that reflected the rugged and hardy natures of his subjects, the fishing people of Cape Cod, Massachusetts.

When he was eighteen, Hawthorne went to New York and studied painting at the National Academy of Design and the Art Students League. Among his teachers were Frank Vincent DuMond and George de Forest Brush. But Hawthorne declared that the most dominant influence in his career was William Merritt Chase, with whom he worked as both a pupil and assistant. Both men were naturally talented teachers and figurative painters who were drawn to rich color and the lusciousness of oil paint as a medium.[3] Chase passed on a Munich tradition of tone values and tone painting, and Hawthorne learned all he could.

Chase's influence is evident in this early work, *Girl in Yellow Scarf*, with its bravura brushwork and rich tonality. This is one of several small portraits painted in the early 1900s of young women bearing impersonal titles and painted from an almost idealistic angle. Reveling in the fluidity of his pigments, Hawthorne displays a myriad of subtleties within the folds of the girl's white gown. Following the advice that he gave to his students, Hawthorne allows color to create contour. "Painting," he said, "is just getting one spot of color in relation to another spot. . . . Let color make form, do not make form and color it."[4]

At first glance *Girl in Yellow Scarf* appears to belong to that world of international high society reflected in similar paintings by Chase and John Singer Sargent, but a closer look reveals her to be far less sophisticated. She is less fashionable than old-fashioned. Her gown is quite simple and it isn't too far fetched to suggest that her elaborate yellow scarf might have been borrowed from the artist's studio.

Hawthorne's women reflect his own sincerity and reticence. Unlike Chase's world of drawing-room sophisticates, Hawthorne's world was filled with hard-working, simple people with whom he never stopped being fascinated. He was always able to penetrate the surface and reveal his subjects' aspirations, longings, hopes, and fears, and a glimpse of such private sentiments is afforded in *Girl in Yellow Scarf*. Shortly after this picture was painted, Hawthorne left Providence and spent two years in Italy where he was deeply impressed by the painters of the Renaissance. He admired their use of highly simplified outlines, broad, flat planes of slightly modulated color, and the noble calm that cloaked their humanity. In paintings executed after 1906, Hawthorne revealed a new clarity in ideas of style, but more importantly, he instilled in his subjects a quiet dignity that reaffirms the beauty and glory of human experience.[5]

KATHLEEN GIBBONS

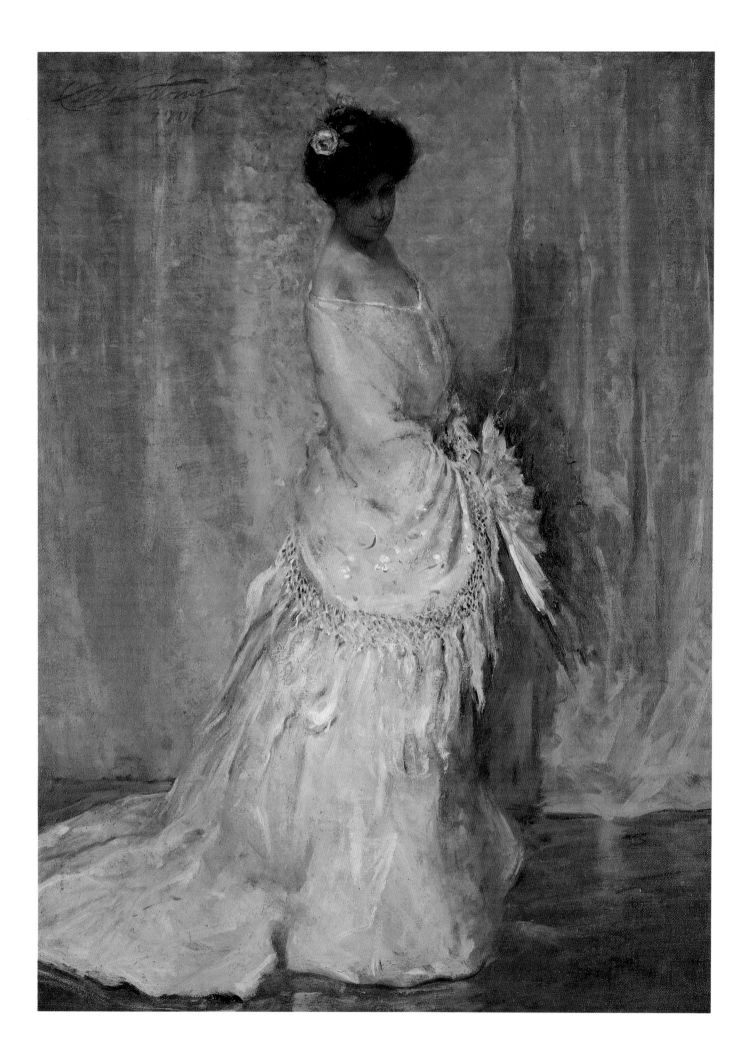

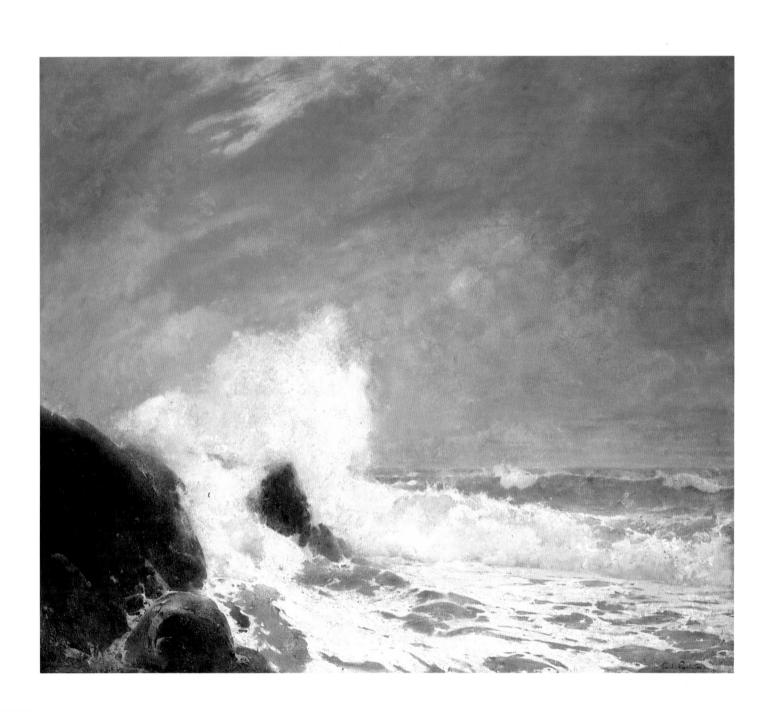

SOREN EMIL CARLSEN | 1853–1932

The Surf, 1907
Oil on canvas, 64 × 74″ (162.56 × 187.96 cm.)
Signed, lower right
Museum purchase, 923-O-102

Born in Copenhagen, Denmark, Emil Carlsen studied architecture at the Danish Royal Academy for four years. He emigrated to the United States in 1872 and worked under the Danish marine painter, Lauritz Holst, in Chicago. Carlsen visited Europe in 1875, where he encountered the work of the French master Jean-Baptiste-Siméon Chardin, whose still-life paintings provided an important influence. In 1884, he returned to Paris, attending classes at the Académie Julian. At this time, his painting style changed, employing a brightened tonal range. He returned to New York in 1886, but left the following year to become director of the San Francisco Art School, returning again to New York in 1891. In 1905, Carlsen purchased a house in Falls Village, Connecticut. Spending summers there until the end of his life, he often used subjects and scenery from the region in many of his works.

First achieving recognition as an accomplished still-life painter, landscape, notably woodland interiors and marine scenes, became increasingly prominent in Carlsen's oeuvre after 1900. Friendships with American Impressionists Willard Metcalf, John Henry Twachtman, and J. Alden Weir were influential in his landscape work. Although not rigidly Impressionistic in his approach, soft, seamless brushwork, careful draughtsmanship, and pastel hues created by subdued filtered light are the essential characteristics of Carlsen's understated, reflective scenes of nature. His landscapes exhibit a serene sensibility that has commonly been associated with Carlsen's Danish origins. His approach to landscape relates to the work of George Inness, whose paintings evoke mood and allude to the spirituality and mysticism of nature.

Naturalistic and idealized, Carlsen's marine scenes are defined by a lustrous paint surface and a certain opalescent effect created by building up thin layers of pigment. The horizon line is generally positioned low in the composition, while an expansive band of sky dominates. About the artist's seascapes, a critic wrote "nature is never harsh, austere, or powerful. . . . When great waves dash upon rounded rocks it is the decorative vaporous mass of white flying water that fascinates the eye. . . . We have nothing of the power of Homer as seen in his rugged, resisting rocks, turbulent water and onrushing waves. Carlsen's work projects the serenity of nature rather than its more dramatic and destructive interpretation."[1] *The Surf* shows an unusually climactic view of breaking waves, though even Carlsen's most dramatic seascapes are characterized by tranquil composure.

The Surf was exhibited in the Carnegie Institute's *12th Annual Exhibition* in 1908 and at the *84th Annual Exhibition* of the National Academy of Design in 1909. When Joseph G. Butler, Jr. acquired *The Su.f* in 1923, it represented a six-year struggle to purchase what he believed was one of the finest American seascapes. The artist had been extremely reluctant to part with one of his most important marine scenes, having already changed his mind several times about its disposition.[2]

While highly regarded by colleagues and critics, Carlsen did not receive popular recognition until midlife. Called a "great painter" by writer Elisabeth Luther Cary at the time of his death, his reputation seemed assured.[3] However, his artistic independence, as well as the qualities which define his work, understatement, refinement, and lyricism, did not ultimately sustain the stature he achieved during his lifetime.

VALERIE ANN LEEDS

191

GARI MELCHERS | 1860–1932

My Garden, 1900–03
Oil on canvas, 41 × 40″ (104.14 × 101.60 cm.)
Signed, lower left
Museum purchase, 922-O-102

Internationally celebrated as a major late nineteenth-century painter, Gari Melchers produced hundreds of paintings in studios in France, Holland, Germany, and America.[1] His success began early when his painting, *The Letter* (c. 1882, The Corcoran Gallery of Art, Washington, D.C.), was accepted at the Paris Salon in 1882. In 1889, Melchers was awarded a grand prize medal in the American painting section at the Universal Exposition in Paris, an honor bestowed only upon Melchers and John Singer Sargent. That Melchers was an honored painter in Europe and America is clear from his long exhibition history, the awards he won, the commissions, and the number of his works purchased by museums and collectors in this country and abroad.

The basis for Melchers's art can be found in his childhood within Detroit's German immigrant community and his early instruction, both from his German-born artist father and at the academy in Düsseldorf, where he learned sound academic principles and a commitment to solid images. After graduation Melchers entered the Académie Julian in Paris and subsequently was accepted at the Ecole des Beaux-Arts. In 1884, he joined George Hitchcock in establishing a permanent studio in the Egmonds, Holland. Monumental paintings like *The Sermon* (1886, National Museum of American Art), and *In Holland* (1887, Belmont, The Gari Melchers Estate and Memorial Gallery, Fredericksburg, Va.), which used as models the townsfolk of the Egmond area, established Melchers's reputation as a painter of Dutch scenes that celebrate the virtues of an unsophisticated life of hard work and pious reverence. However, Melchers's diversity of styles and subjects is remarkable. At the beginning of his career in the early 1880s, he painted the peasants of Brittany and Holland in realistic depictions based upon his Düsseldorf training, the Hague School artists, and the Paris Salon. In the late 1880s and the 1890s, his art was influenced by Symbolism, and at the turn of the century he turned to Impressionism for inspiration. Melchers's interest in Impressionism, as with other styles of painting, was assimilated from sources in France, Germany, and America. This combination,

seen in *My Garden*,[2] has been appropriately described as a "lightened palette of academic Impressionism, which, combined with careful drawing, constitutes an international style hailed by contemporary critics."[3]

My Garden was painted at George Hitchcock's home, "Schuylenburg," in Egmond aan den Hoef, one of three Dutch villages clustered along the North Sea shore that share the name of Egmond.[4] Beginning in 1884 when they shared a studio, Melchers and Hitchcock maintained an enduring friendship. By the early 1890s, Egmond had become the summer home to students attracted by their success. Because of this influx, including many Americans on break from art schools in Paris, Hitchcock established a school at Schuylenburg. While Melchers chose not to teach on a formal basis, he was active in art discussions and critiques. In 1903, Melchers married Corinne Mackall, who had studied with Hitchcock. Although they established their own home and Melchers painted a number of outdoor scenes there,[5] he continued to paint at Schuylenburg as well.

Exact dating of the landscapes and interior genre scenes from this period is not always possible. In *Gari Melchers: A Retrospective Exhibition*, the work is dated c. 1903 and described as "the first of several intimate garden scenes. . . ."[6] Based upon its style and title, suggesting the period before Melchers and Corinne had their own garden, the date of 1900–1903 seems likely.

The scene is from across the pond towards the impressive seventeenth-century farmhouse and large tree-shaded lawn where three servant girls, dressed in black and white uniforms, share a moment of conversation. A postcard from the same period, with a similar viewpoint and showing the statue of a cherub standing in the pond, may have served as Melchers's initial inspiration for the painting, or the picture may have inspired the postcard. Whatever the case, the bold, robust brushstrokes and glorious palette of yellows, pinks, blues, and green infuse the setting with vitality and with the glowing warmth of an idyllic autumn day.

DIANE LESKO

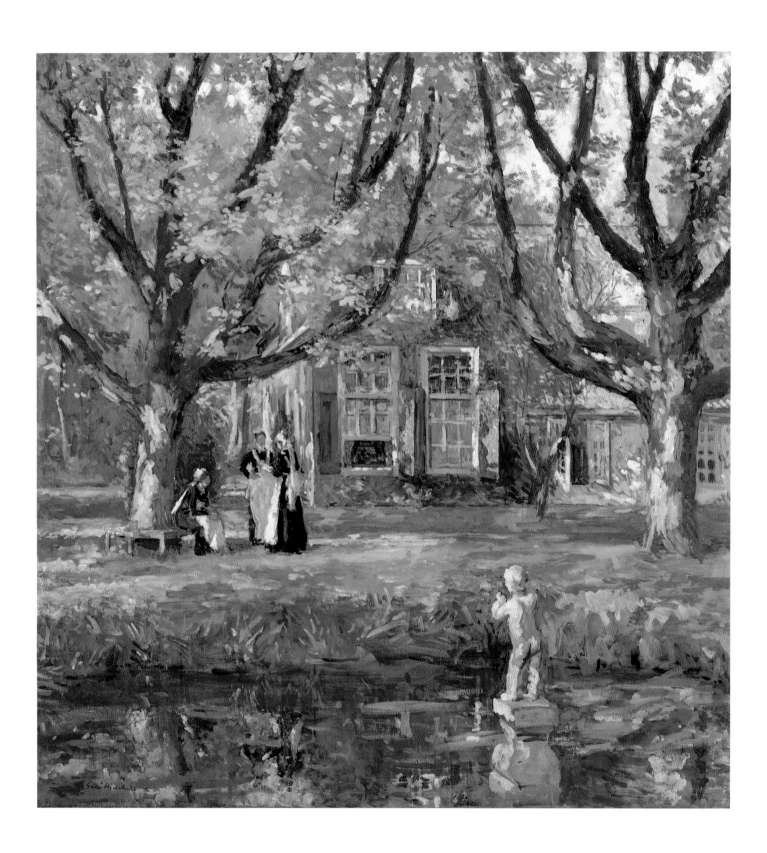

JOHN WHITE ALEXANDER | 1856–1915

Portrait of a Lady, 1900
Oil on unsized jute canvas, 40 × 22″ (101.60 × 55.88 cm.)
Signed, lower left
Museum purchase, 920-O-102

During the last quarter of the nineteenth century, American art's internationalism and cosmopolitanism, perhaps its most characteristic features, were fostered by a generation of artists who sought foreign training, self-consciously reveling in their art's very lack of "Americanness." Their increased attention to formal issues, with little regard to subject matter, realism, or national expression, contrasted with ante-bellum concerns grounded in native subject matter and narrative.[1] John White Alexander developed and flourished during this period. Born in Allegheny City, Pennsylvania, Alexander's early interest in drawing led him to New York in 1875, where he worked as an illustrator for Harper Brothers. In 1877, he sailed for Europe and, after a brief stop in Paris, enrolled at the Munich Royal Academy studio of the Hungarian artist Gyula Benczur. In 1878, he joined the circle of artists working around Frank Duveneck in Pölling, Bavaria, and later in Venice and Florence. Upon his return to New York in 1881, Alexander began his career as a portraitist, gaining public recognition almost immediately after his first participation in exhibitions.

Alexander moved to Paris in 1891 and remained there for a decade, rising to the forefront of American expatriate painters and achieving international recognition. His participation in the annual Paris salons of the Société Nationale des Beaux-Arts, beginning in 1893, signaled his direct and vital involvement with several international art organizations and exhibitions including the Carnegie *International Exhibition*, the International Society of Sculptors, Painters and Gravers, London, and the 1900 Paris Universal Exposition. Upon his return in 1901, Alexander became increasingly involved in the development and promotion of American art, culminating in his presidency of the National Academy of Design from 1909 until shortly before his death in 1915.

Portrait of a Lady was painted during Alexander's expatriate period, during which time decorative figure paintings of women dominated his work. *Portrait of a Lady* is characterized by a simplification and flattening of form through surface patterning, elegant linear contours, asymmetrical composition, and a restricted, low-keyed palette with a single dominant tone. Influenced by the pervasive example of James Abbott McNeill Whistler, champion of art-for-art's sake, Alexander's painting from the 1890s asserts the decorative potential of figure painting whose primary impulse is aesthetic and formal rather than referential or representational. The generic title of the work and the aversion of the woman's face from the viewer further underscore Alexander's interest in decorative arrangement and design at the expense of verisimilitude, which had been among his primary concerns in male portraiture from the 1880s. This gender distinction—the overtly decorative treatment of female figures emphasizing surface design at the expense of realistic details, in contrast to a depiction of men emphasizing character and physical likeness with only incidental decoration—paralleled internationally current trends.[2]

SARAH J. MOORE

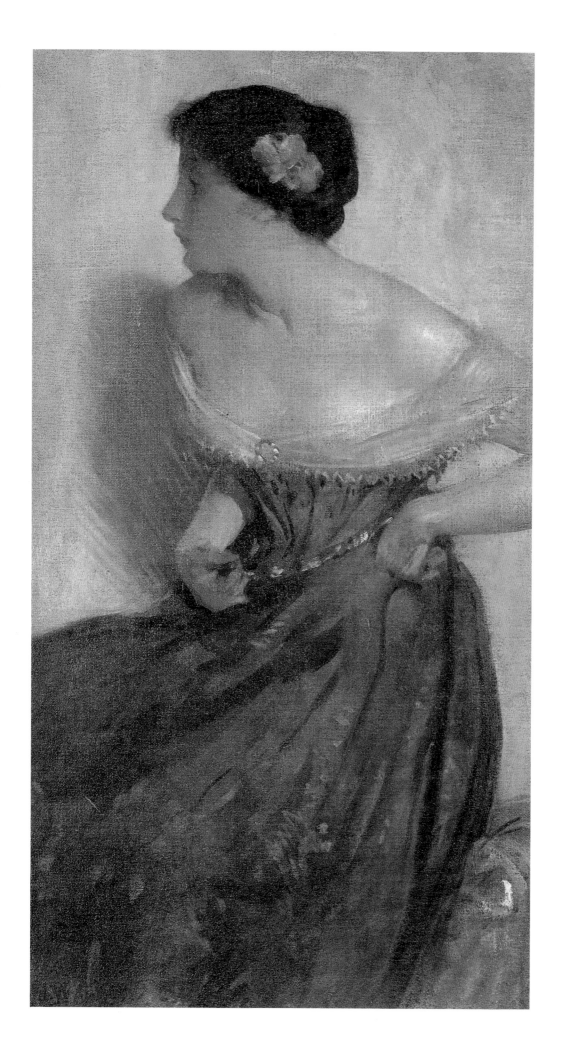

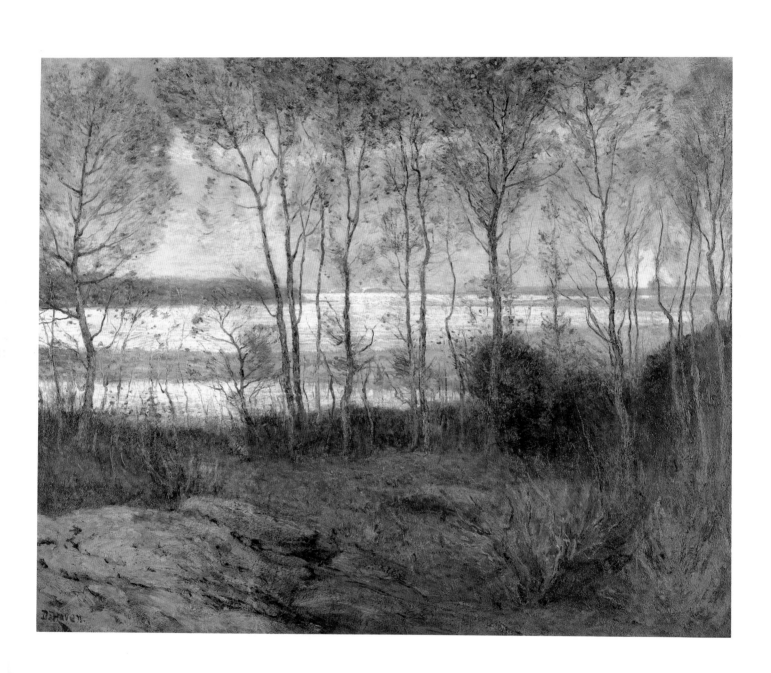

FRANKLIN DE HAVEN | 1856–1934

Silvery Waters, 1916
Oil on canvas, 39 1/2 × 49½″ (100.33 × 125.73 cm.)
Signed, lower left
Museum purchase, 918-O-102

Born in Bluffton, Indiana, Franklin De Haven arrived in New York in 1886. He studied with George Henry Smillie who, having made a reputation as a poetic landscape painter of Rocky Mountain and Florida subjects, was concentrating upon rural New England and Atlantic shoreline scenes, especially around East Hampton, Long Island, which had by the mid-1880s achieved the status of "The American Barbizon." It is not surprising to find latter-day Hudson River School influences and an intense Barbizon or, perhaps more specifically, Tonalist sensibility in much of De Haven's work.

For nearly three quarters of a century Hudson River School painters had transformed on-the-spot studies into large, emotionally charged studio pieces which combined accurate topographic detail with an idealized, transcendental vision of landscape as direct evidence of the hand of God on earth. Light, as an aesthetic and a divine element, became increasingly important by mid-century, especially among the group of artists often referred to as Luminists. Emerging from this cultural milieu, American artists like William Morris Hunt, who traveled in France in the 1850s, were almost inevitably fascinated by the French artists Theodore Rousseau and Jean-François Millet, who were painting moody, low-keyed, proto-impressionist landscapes around the village of Barbizon. Hunt's influence as a teacher and painter was instrumental in creating an American Barbizon aesthetic, as was the work of George Inness, Alexander Helwig Wyant, and Dwight Tryon. Tonalism, a stylistic refinement of the American Barbizon manner in the 1880s characterized by static composition, color schemes of closely related tones, and a quiet, misty reverie, is evident in the work of all three painters. A number of Tonalist painters were attracted to the New England coast between Newport, Rhode Island and Mystic, Connecticut, where Charles H. Davis settled in 1892, subsequently organizing the Mystic Art Association in 1913.[1]

Silvery Waters was painted from a study made near Mystic, Connecticut at 4:00 p.m. on a November afternoon.[2] Framed between the dark browns and grays of the foreground and the lavender-mauves of the lowering sky, the silver-white water is layered with golden ochre reeds and crossed by the calligraphic silhouettes of trunks and branches in a tightly composed evocation of the Japanese screens which had been such a pervasive influence on American painting and decorating for decades. The brushwork is loose and impressionistic, as are the individual touches of orange, olive, lavender, and ochre which enliven the fallen leaves in the foreground and those still attached to the branches above. Scumbling and impasto further enrich the painted surface. The patterned repetition of verticals and horizontals, the closely controlled tonality, and the pale, cold light which casts no shadow all contribute to the calm atmosphere of wistful melancholy that pervades *Silvery Waters*. As Whittier Montgomery noted with reference to De Haven's total oeuvre, "one feels in all not merely the man's ability as a draughtsman and technician, but the scope of his sympathies and the genuine character of his interpretation."[3]

H. DANIEL BUTTS III

Sylvia, 1908
Oil on canvas, 49 × 39½″ (124.46 × 100.33 cm.)
Signed, upper right
Museum purchase, 917-O-105

When William Paxton completed *Sylvia*, he was an artist entering the prime of his creative life. An esteemed portraitist, a respected teacher, and a prolific painter with a growing list of exhibition credits, the thirty-nine-year-old Paxton had assumed his place as a mature member of the Boston School. *Sylvia* exemplifies his confident draughtsmanship, his gifts as a colorist, and his undeniable preference for elegant figural subjects.

Paxton grew up in Newton, Massachusetts, a Boston suburb. He studied under Dennis Miller Bunker at Cowles Art School in Boston, and in 1889 embarked for Paris and four years of study at the Ecole des Beaux-Arts and the Académie Julian. The precise drawing and smooth surface texture employed by Jean-Léon Gérôme, his teacher, were abiding influences. By 1893, Paxton had returned to Newton and soon began to support himself as a portraitist, and to participate in numerous exhibitions and art clubs. A trip to Madrid in 1897 allowed him intense study of the works of Diego Velazquez.

Paxton's first one-man show at the St. Botolph Club of Boston in 1900 brought positive critical reviews; the second show saved many of his best works from a fire that destroyed his studio in 1904. The next year Paxton joined his senior Boston School colleagues, Edmund Tarbell and Frank Benson, in the new Fenway Studio Building and, in 1906, on the faculty of the School of the Museum of Fine Arts. By 1907, Paxton had perfected his version of the subject that remains the hallmark of the Boston School: elegant women in well-appointed parlors. Like Tarbell, Paxton took inspiration from the luminous effects and intimate settings of the seventeenth-century Dutch master Jan Vermeer. In 1913, Paxton assisted artist/critic Philip Hale in editing the first American book on Vermeer.

Not all of Paxton's work was divided between commissioned portraits and domestic interiors with subtle narrative elements. Paxton often chose to paint figural studies of beautiful models, deftly posed within shallow studio settings. *Sylvia* epitomizes this genre, in which Paxton placed the model's arms and hands into an unusual—yet still graceful—configuration to create what his pupil, Ives Gammell, termed "handsome arabesques."[1] The delicate chair and Japanese screen were standard accoutrements of a proper Boston School studio. In this canvas Paxton contrasts the screen's rectangular panels with the gentle curves of his fashionable subject. For a consummate colorist with an instinct for piquant harmonies, the subtle grays and tans of *Sylvia* might seem like great artistic self-restraint. Yet Paxton's delicate modeling and textural distinctions produce a rich tonal range, suffused with the soft light he consistently favored. While the model gazes directly at the viewer, her expression is ambiguous. One Boston critic called her "arch, roguish, half-timid and half-bold."[2] The same woman, wearing the same gown but holding her arms overhead and gazing at a necklace, appears in another 1908 canvas of the same dimensions, *The String of Pearls* (1908, private collection). The screen that closes the composition in *Sylvia* has been replaced by an oval mirror, opening up the painting's background. Though Paxton never exhibited the pictures as a pair, their variations in pose and setting seem to act as foils in Paxton's rich repertoire of composition design. After circulation in several major exhibitions, *Sylvia* was purchased in 1910 by the American collector George A. Hearn.

Paxton's commissions and exhibition participation continued at a vigorous pace, and by 1935 he had earned more popular prizes than any other American artist. In New York, however, where the genteel subjects and style of the Boston School were less revered, Paxton's solo exhibitions, in 1919 and 1926, met with mixed reviews. His experience was symptomatic of that of the Boston School as a whole as their leadership role was eclipsed by the shift of attention to modernist painting.

Sylvia was one of sixty-five works in Paxton's memorial exhibition at the Museum of Fine Arts, Boston. A local critic reported that Sylvia was actually a Virginia belle of a different name and that Paxton borrowed his title from a popular song.[3] If that is the case, the artist may well have been painting his response to:

"Who is Sylvia? What is she?"[4]

These questions, written by William Shakespeare, became the lyrics of one of Franz Schubert's best loved art songs. With his enigmatic reply to Shakespeare's query and Schubert's haunting melody, Paxton sustains Sylvia's mystique.

ELLEN LEE

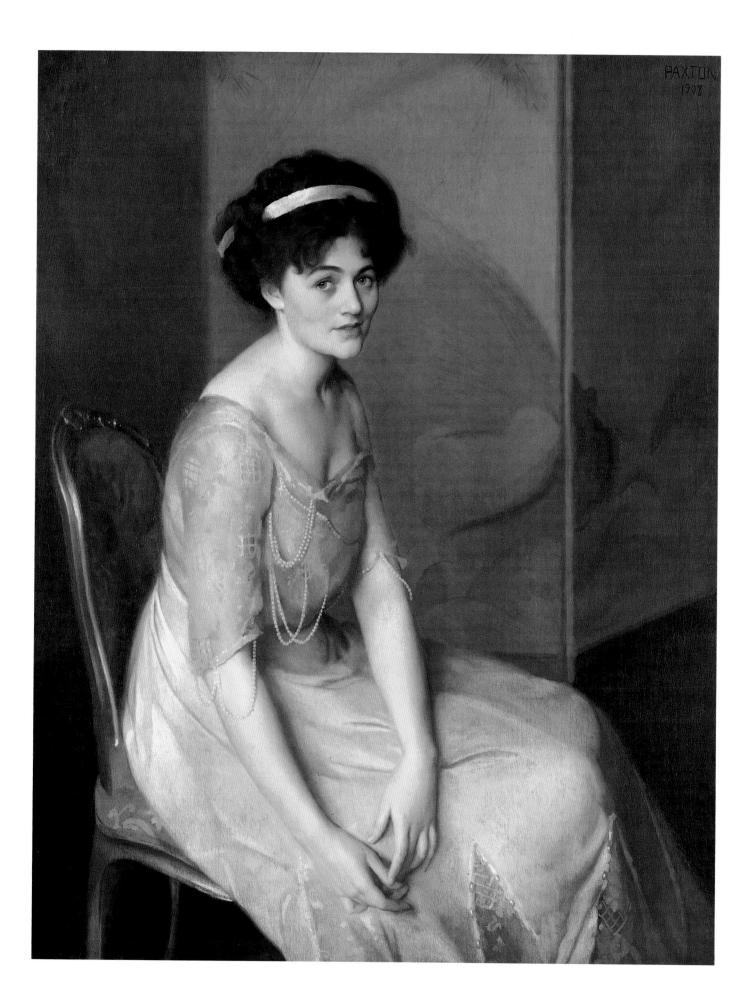

EDWARD WILLIS REDFIELD | 1869–1965

Laurel Run, 1916
Oil on canvas, 38 × 50″ (96.52 × 127.00 cm.)
Signed, lower right
Museum purchase, 922-O-103

When Edward Redfield painted *Laurel Run* he was riding the crest of a wave of popularity as one of America's pre-eminent landscape painters. Both the American public and art establishment had embraced Redfield's distinctive, broadly-brushed works as individual, virile, and dynamic answers to French Impressionism. Influenced by his friend and fellow painter, Robert Henri, Redfield rejected the French Impressionist aesthetic as too perfumed and genteel for capturing the frank, rugged vitality of America.[1] Rather, he felt that spontaneous, energetic, yet deeply-experienced, gestural interpretations of his home environment near New Hope, Pennsylvania would result in better portraits of his much-loved Delaware River Valley and, in turn, America.

Redfield, born in Delaware, moved shortly thereafter with his family to Philadelphia. As a youth, he frequently spent summers in the rural parts of the Delaware River Valley. After extensive and varied study in Philadelphia, from 1881 to 1887, Redfield gained admittance to the Pennsylvania Academy of the Fine Arts. He graduated in 1889 and immediately sailed for Europe. In France, joined by Henri, he attended the Académie Julian and matriculated in the Ecole des Beaux-Arts in 1890. What he enjoyed most in France, however, was not the instruction or the Old Masters, but the great contemporary landscapes by Claude Monet and Camille Pissarro. After marrying the daughter of an innkeeper in the art colony of Fontainebleau, Redfield returned to live in the Philadelphia area from 1893 to 1898. From then on, except for a trip to France in 1899, he lived in Center Bridge, Pennsylvania in the Delaware River Valley.

As early as 1891, when he was in Fontainebleau, the artist was fascinated by the beauty of a landscape cloaked in snow. During his visit to Paris in 1899, he and Henri would paint views of the snow-covered city at night, using broad brushstrokes and somber palettes punctuated with black. By 1904, Redfield had begun to use larger canvases to capture more luminous, panoramic, snow scenes of the New Hope region. Concurrently, he had begun to use more expressive, calligraphic brushstrokes creating the style for which he would become famous and attracting a whole group of landscape painters to this region.

Laurel Run, a stream in Bucks County, Pennsylvania, is a particularly fine example of Redfield's snow scenes. The sun-dappled winter landscape with a stream flowing rapidly through it is one of a handful of motifs in which he specialized. In this work, the artist was especially fluent in his mastery of texture. Rich, heavily-impastoed pigments spontaneously, yet eloquently, capture the delicate tracery of the wintry screen of leafless branches, trunks, and bushes, the icy wet flow of the rushing stream, and the varied bulk of the wet, fallen snow as outlined in the crisp light and further defined by the dancing blue shadows. Further interest is created through careful design. The intriguing, V-shaped composition, defined by the elbow of the rushing stream and the curve of the row of trees, enlivens the painting by breaking through its richly-painted surface to carry the viewer into the landscape. Redfield painted all of his works on site and energetically, at one go, to impart a direct spontaneity and truth to their interpretation of the surroundings. In *Laurel Run*, there is an intimacy which results from the artist's familiarity with his subject and spontaneous depiction of it.

Redfield continued to paint landscapes in the Delaware River Valley until 1953. During these five decades of activity, he exhibited extensively in group and solo exhibitions and earned more medals than any other American artist except John Singer Sargent. The height of Redfield's career was certainly the period of *Laurel Run*. It was then that Redfield, George Bellows, and Henri were at the aesthetic vanguard of contemporary painting in America with their various forms of painterly realism. And it was then that Redfield was at the technical peak of his dexterity in handling paint.

JAMES KENY

201

FREDERICK JUDD WAUGH | 1861–1940

Breakers at Floodtide, 1909
Oil on canvas, 35 × 40″ (88.90 × 101.60 cm.)
Signed, lower right
Museum purchase, 919-O-116

Frederick Judd Waugh's prodigious output is defined by his achievements as a marine painter. *Breakers at Floodtide* is an accomplished, ambitious seascape, painted shortly after his return from Europe. The expressive and realistic effects were the result of Waugh's exhaustive study of light, shadow, and motion of waves breaking on rocky shores. As he wrote, "one should not conflict actualities in nature with artistic representation. . . . It is impossible to paint the sea in literal movement or to carry to the nostrils the tang of the salt sea brine, yet all these are somehow felt in a work of art. Being able to present such feeling is where the artist should excel."[1] By adhering to this philosophy, Waugh attained great stature as a marine painter, garnering a strong popular and commercial following during his lifetime.[2]

Born in Bordentown, New Jersey, Waugh's father was Samuel Bell Waugh, the noted portrait painter. From 1880 to 1883, he studied at the Pennsylvania Academy of the Fine Arts with Thomas Eakins and Thomas Anshutz, and in 1883, enrolled in the Académie Julian, Paris. However, it was a visit in 1893 to the Island of Sark, off the French coast, that proved to be a decisive turn. Waugh remained for two years, studying the rocky shoreline, making notes, sketches, and studies. He traveled to St. Ives, Cornwall, in 1895, where he continued intensive analysis of the seascape subject. Waugh left England for the United States in 1907, in an effort to establish his reputation as a marine painter on his native continent.

Breakers at Floodtide shows an assured virtuosity in paint application, rendering, and composition. Works of this period are characterized by vigorous brushwork and a rich surface texture created by the building up of layers of impasto. Waugh outlined his outlook and working methods in several essays and manuscripts, stating that "it [the sea] is a pliable element and the wind and rocks and sands heave it up and twist it and turn it, pretty much the same way every time, until the observer learns to know the repeated forms he sees, and becomes at last so familiar with them that they can be painted from memory. . . . I spend part of each summer studying the sea . . . and what I learn from it then, lasts me until the next time."[3] *Breakers at Floodtide* is likely taken from studies executed in the summer of 1908 or 1909 at Bailey Island, Maine. Waugh's studies done during these summer visits were later worked into finished compositions, enlarged or integrated into composite views upon returning to his studio.[4]

Waugh exhibited *Breakers at Floodtide* in the 1916 *Spring Annual* at The Detroit Institute of Arts. Joseph G. Butler, Jr. purchased the work, and later, his grandson noted that "this picture is a great popular favorite at the Museum. . . . I consider it one of the finest Waughs I have ever seen."[5] *Breakers at Floodtide* is a fine example of the painter's style, typical of the period, and executed in a controlled manner with more detail evident than in his later works. His passionate exploration of this subject resulted in a singular ability to capture the aura and movement of the tumultuous waves and the generalized sensation and atmosphere of the sea, establishing Waugh as one of America's foremost marine painters.

VALERIE ANN LEEDS

ELIHU VEDDER | 1836–1923

Cliffs of Volterra, 1860
Oil on panel, 12 × 25″ (30.48 × 63.50 cm.)
Signed, lower right
Gift of the American Academy of Arts and Letters, 955-O-145

During his long residence in Italy, Elihu Vedder visited not only the usual picturesque Italian sites such as the Roman Campagna and Subiaco but also those such as San Remo, Bordighera, and Capri, not on the traditional nineteenth-century tourist route because of their inaccessibility, but which offered the ruggedness and desolation that Vedder found attractive. From 1858 on he made small oil sketches of local landscape views, keeping most of them because he liked them so much, showing them to friends when they visited, and, on occasion, exhibiting them.[1] After his death, his daughter bequeathed them to the American Academy of Arts and Letters, which subsequently distributed them to various American museums. *Cliffs of Volterra* is among the finest of these landscape studies.

On his first visit to Italy from 1858 to 1860, Vedder developed a close relationship with Giovanni (Nino) Costa, who belonged to the Macchiaioli, a group of young Italian painters committed to new developments of plein-air painting. Vedder and Costa traveled together to the hill towns around Tuscany where they painted directly from nature, at times selecting the same subject so as to compare their techniques and results. Costa "delighted in stealing upon Nature in her most intimate moods, taking her by *tradimento* [treachery]," noted Vedder,[2] referring to the startling landscape sketches in which Costa betrayed traditional standards for natural beauty in landscape painting. Vedder's friendship with Costa seems to have brought him into contact with the Macchiaioli style at an early stage in its formation and prompted his appreciation, unique among American artists, for the innovative naturalism of the Macchiaioli landscape-sketching technique. Using rather broad patches of chalky colors in thick, grainy paint, Vedder began to paint landscapes very different from those of his American colleagues, in which clear geometry, a preference for plain, flat surfaces, and an exaggerated canvas width prevail.

In August, 1860, Vedder accompanied Costa to Volterra, a medieval town of Etruscan origin in Tuscany, southwest of Florence. In a letter to his father Vedder stated, "the extensive views in all directions are the things that interest us most . . . on one side of the town there is a great ravine and the hillside has been crumbling away in it for centuries . . . the gullies and pinnacles left in it by the rain make the [s]cene one of the wildest beauty."[3] He was describing the deeply furrowed clay precipices called Le Balze whose parched, desolate appearance went very much against the stereotypical Italian scenery. Yet Vedder liked this stark, lifeless terrain from the beginning. This trip resulted in two oil sketches: *Cliffs of Volterra* and another of the same dimensions, *Volterra* (1860, National Museum of American Art, Washington, D.C.).[4] For their date, they are astonishingly innovative compositions. *Volterra* depicts a bird's eye view of the cliffs with the mountains of Carrara visible on the horizon. *Cliffs of Volterra*, depicted from a lower viewpoint, is daringly truncated at top and bottom, so that sky and foreground are cut off, while the dry cliffs and gullies loom before the viewer. The parched, mountainous landscape became a feature of a number of Vedder's works on which his reputation as a painter of Symbolist fantasies is based. The cliffs of this oil sketch reappear as the background of *The Lost Mind* (1864–65, The Metropolitan Museum of Art), one of Vedder's most memorable images, whose haunting, disturbing quality comes largely from the inhospitable landscape through which a troubled young woman, dressed in a long cloak, wanders.[5]

DIANA STRAZDES

205

JOSEPH HENRY SHARP | 1859–1953

Ration Day at the Reservation, 1919
Oil on canvas, 40×55″ (101.60×139.70 cm.)
Signed, lower right
Museum purchase, 921-O-504

The genesis of the Taos Art Colony began with Joseph Henry Sharp, who first visited Taos in 1893. He publicized the town's qualities in illustrations contributed to popular magazines and by encouraging fellow artists to visit Taos.[1] Like most other painters associated with the Taos Society of Artists active between 1915 and 1927, Sharp embraced the academic tradition, studying periodically between 1881 and 1898 with trained artists or in academies located in America or Europe. The application of his rigorously developed skills to the subject of Native American culture formed the basis of his artistic career.

Sharp was fortunate to find several patrons around 1902 who routinely purchased the Native American portraits he painted at the turn of the century, among whom were Phoebe Hearst in California and Joseph G. Butler, Jr. in Ohio. Sharp's Native American heads, which had also been purchased by the Bureau of Ethnology at the Smithsonian Institution in 1902, were frequently identified as historical documents, but Sharp clearly intended to be known not just as an historian, but as an artist.

Undoubtedly created to establish Sharp's artistic credentials, the elements of *Ration Day at the Reservation* are drawn from a variety of sources. The plastered building with a blue-frame door is reminiscent of the architecture of Sharp's own home in Taos, which he purchased in 1908, including the buffalo skull, which hung over a door in the building he used as a studio. The Native Americans, not specific to any one tribe, are wrapped in commercial blankets, frequently of government issue. From yet another source, Plains beadwork is evident in several pairs of moccasins and on the leather dress worn by the seated woman to the left.

When Butler purchased *Ration Day at the Reservation* in 1919, he commented on the painting's subject, "It is a composition showing the Indians applying for rations at the Government Agency."[2] The painting relies on Sharp's familiarity with the federal bureaucracy at the Crow Agency, where he lived largely among United States government employees, including his close friend, the Crow agent from 1902 to 1910, Samuel Reynolds.[3] The relationship between the federal government and Native Americans was a troubled one in Sharp's eyes. He explicitly protested government interference in tribal life when he wrote the Department of the Interior in 1902, asking them not to enforce a new rule requiring the men to wear short hair.[4]

Ration Day at the Reservation suggests the encroachment of not just the federal government but of Euro-American values, which, through the Bureau of Indian Affairs and boarding schools such as those found at the Crow Agency, worked to turn tribes from a life based on hunting to one based on agriculture. The transition was rarely successful and led to tribal dependency on the government for food and housing. The stooped figures, dark tones, and generally somber mood of the painting indicate that Sharp felt that ration day on the reservation marked a dark moment in Native American survival. The presence of the broken buffalo skull over the door further emphasizes the sense of loss, since artists routinely used the buffalo skull to suggest the destruction of the Indian's way of life. Sharp had on other occasions, in such paintings as *The Mourners* (1911, Thomas Gilcrease Institute of American History and Art, Tulsa) and *Young Chief's Mission* (1919, The Butler Institute of American Art), chosen a frieze-like format in which figures are shown in a shallow space in front of a vertical backdrop to stage sorrowful or somber subjects, as he does in *Ration Day at the Reservation*.

JULIE SCHIMMEL

A Vision of the Past, 1913
Oil on canvas, 59 × 59″ (149.86 × 149.86 cm.)
Signed, lower left
Museum purchase, 919-O-501

E. Irving Couse, who became an Academician at the National Academy of Design in 1911, worked within the European traditions practiced in the institutions he attended: The Art Institute of Chicago (1882), the National Academy of Design (1883–85), the Académie Julian (1886–91), and the Ecole des Beaux-Arts (1891).[1] This background served him well, and by the time he had completed *A Vision of the Past*, his paintings had sold in major New York galleries, had been purchased by national museums, and had been accepted in competitive exhibitions in Paris salons, international expositions, and American painting annuals. Couse routinely garnered awards, including the Second Altman Prize at the National Academy of Design in 1916 for *A Vision of the Past*.

In the academic tradition, paintings were based on careful preparatory work intended to place realistic detail at the service of noble subjects. Exemplary of this process, Couse relied on photographs of Taos Native Americans when creating *A Vision of the Past*. Three photographs, one of Ben Lujan and children, another of Jerry Mirabal in a feather headdress, and a third of Francisco Gomez,[2] served as models for the first three figures from left to right. The photograph of Ben Lujan and children demonstrates "squaring," a traditional academic technique of using a gridwork overlay to transfer a small study image to a larger canvas for the final painting (Fig. 1).[3]

Couse had routinely painted peasant subjects during the first years of his career, imbuing rural subjects with the simplicity and dignity fundamental to lives based in nature and the land. Couse found the same noble attributes in Native American life, while observing the Northwest tribes in the 1890s. Upon visiting Taos in 1902, and subsequently establishing a summer residence there in 1906, the Pueblo people became the central subject of his art.

In 1916, Couse met J. Stuart Blackton, a movie producer who intended to make a film based on the novel, *The Captain of Gray Horse Troop*, by Hamlin Garland. When Garland and Couse met, they further envisioned a jointly created book which would include paintings by Couse illustrating modern reservation life. Couse wrote Blackton, commenting that artist and writer together hoped "to remove the misconception and contempt in which the Indian has been held, and to show that they are human beings worthy of consideration and a place in the sun."[4] Further, the book would portray the "whole history of the vanishing race."[5] Couse was to contribute fifteen subjects to this ambitious project, including one described as "Dreams of a Captive Race, group on hilltop seeing visions of ancient Buffalo Hunt in sky."[6] *A Vision of the Past*, based on several sketches created earlier in 1913, was the visualization of this scene, although neither the movie nor the book was ever realized.

In *A Vision of the Past*, Couse contrasted the past and present, suggesting that the future held little promise for tribal culture. In doing so, he contributed

Figure 1. E. Irving Couse. *Photo study for A Vision of the Past, Ben Lujan and children*, n.d. Courtesy of Couse Family Archives, Couse Enterprises, Ltd., Tucson, Ariz.

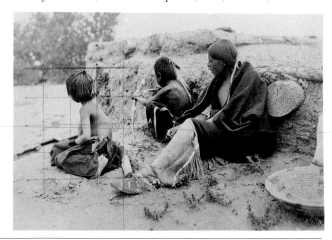

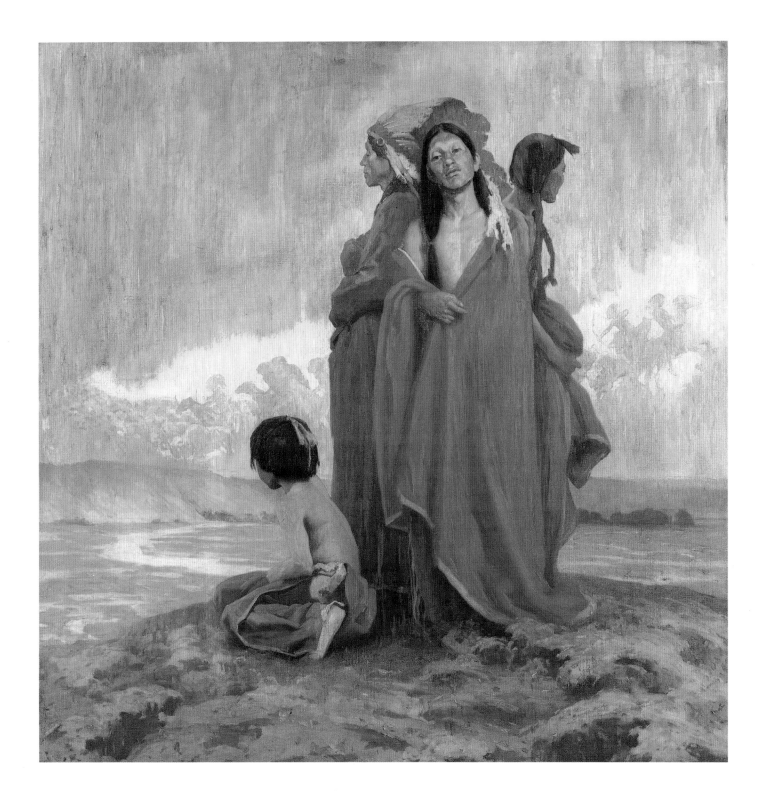

to a tradition of imagery first popular in the 1830s, that of the vanishing race of "doomed" Native Americans. As had others before him, Couse presented his subjects standing on barren land at water's edge, symbolically indicating that Native American culture was coming to an end. Equally typical, the ages of man are suggested by the static figures in the foreground: a seated boy and three male adults of varying maturity and status. Couse intensifies the poignancy of these figures by contrasting them to the visionary forms in the background, who are in the thrall of a buffalo hunt. By the twentieth century, the active, independent life of the warrior-hunter, in which the hunter kills his prey and supports his tribe, can only be found in an ephemeral formation in the clouds.

JULIE SCHIMMEL

OSCAR E. BERNINGHAUS | 1874–1952

Braves of the Taos Mountains
Oil on board, 16×20″ (40.64×50.80 cm.)
Signed, lower right
Museum purchase, 971-O-104

Born and raised in St. Louis, Missouri, Oscar Berninghaus, who received his only fine arts training while attending three terms of night classes at the St. Louis School of Fine Arts, began his career in the applied and commercial arts. At sixteen, Berninghaus joined the lithography firm of Compton and Sons and then, three years later, labored as an apprentice and errand boy at a large and well-known printing company, Woodward and Tiernan, also in St. Louis. Between his work and self-studies, Berninghaus eventually established a diversified career that included at its extremes the production of scenes of western life to advertise the products of the Anheuser-Busch Brewing Company (1910 to mid-1920s) and the design of pioneer subjects to decorate the Missouri State Capitol in Jefferson City, Missouri (1924), the Federal Building in Fort Scott, Kansas (1937), and the Post Office in Phoenix, Arizona (1938). However, it was easel painting and the land and Pueblo people of New Mexico which finally dominated Berninghaus's artistic career.

In 1899, Berninghaus traveled the Southwest as a guest of the Denver and Rio Grande Railroad. The brakeman, who noticed that Berninghaus stepped from the train to sketch his surroundings during the train's frequent stops, took an interest in the artist-passenger. He subsequently changed the course not only of Berninghaus's travels but of his career as well, by suggesting that the artist visit the picturesque town of Taos. Berninghaus stayed only a week on his first trip to Taos but, thereafter, he returned from St. Louis each summer until 1925, when he settled in Taos permanently.

Berninghaus's artistic instincts led to the depiction of commonplace incidents and scenes of daily life, in contrast to the dramatic western conflicts created by such artists as Frederic Remington and Charles M. Russell, or the romantic and idealized scenes created by other Taos artists during the same time period. *Braves of the Taos Mountains* is an example of the artist's interest in seemingly routine and untroubled moments. The painting depicts two horsemen riding through desert sagebrush in front of the Taos Mountains, located at the southern end of the Sangre de Cristo range north of Taos. Their braids identify them as Pueblo men, dressed in shirts and pants. In addition, the rider on the left wears leather chaps while the central figure has a blanket wrapped around his lower torso. The horses they ride are small ponies. Berninghaus has made no effort to glamourize either the men or beasts, but rather has presented a life of commonplace activity. While the scene may be low-key, it carries with it a nostalgia for a way of life based in nature, in contrast to the fragmentation and speed of the modern industrial world.

The quiet harmony of the figures and the mountain desert landscape is paralleled by the deft balance of the composition, which divides the painting into unequal but satisfyingly arranged areas of foreground, middle ground, and background. The generally muted colors of the palette and the range of values from the whites of the desert sands to the darks of the mountains do not move to extremes, but stay in middle ranges of intensity and shade, contributing further to the scene's quietude.

JULIE SCHIMMEL

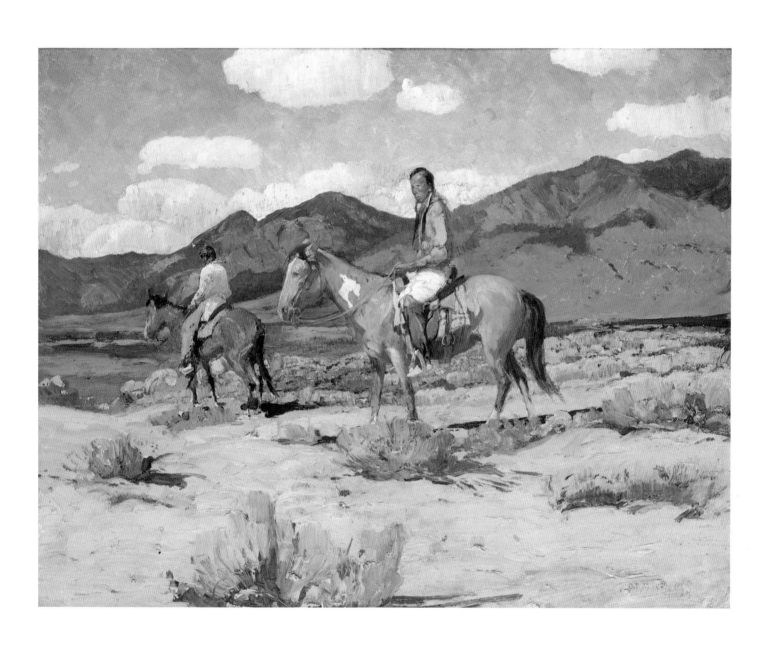

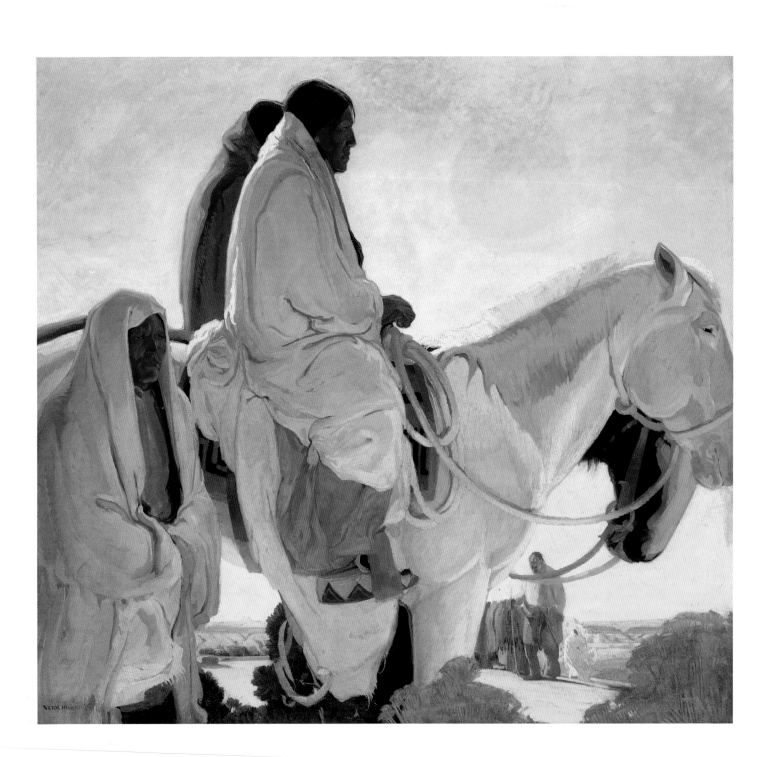

Fiesta Day, 1918
Oil on canvas, 52 × 56″ (132.08 × 142.24 cm.)
Signed, lower left
Museum purchase, 920-O-506

In 1918, Victor Higgins was awarded the First Logan Prize ($500) at The Art Institute of Chicago and the First Altman Prize ($1,000) at the National Academy of Design, New York, for *Fiesta Day* (*To the Fiesta*). These were to be among the most important prizes that the Shelbyville, Indiana-born artist would receive during a successful career in Taos, New Mexico.

In 1899, at age fifteen, Higgins went to Chicago, where he studied and worked until 1911. He then traveled to Europe, studying in England, Belgium, Germany, and France, returning to Chicago in the spring of 1913. While becoming established as an important figure on the Chicago cultural scene, he attracted the attention of Mayor Carter H. Harrison. In November of 1914, Harrison sponsored Higgins's first trip to the small town of Taos in northern New Mexico. It was a trip of great consequence, because for the remainder of Higgins's life, Taos would be the inspiration and Chicago a receptive market for his canvases. He became a member of the Taos Society of Artists along with E. Irving Couse, Joseph Henry Sharp, Oscar E. Berninghaus and others. However, Higgins was considered the "loner" in this group, as he preferred one-man shows of his nontraditional Southwest subjects over exhibiting with others of the Society.

Fiesta Day is a critical painting in the artist's career. In a 1917 *Chicago Sunday Herald* article, Higgins described the Taos Native Americans as "a people living in an absolutely natural state, entirely independent of all the world." He saw them as "self-supporting, self-reliant, simple and competent," and most important, as having "dignity in spite of their lack of riches, and nobility in spite of their humble mode of living."[1] Higgins undoubtedly began work on *Fiesta Day* the same year. An oil sketch and photograph from the estate of the artist's daughter,

Joan Higgins Reed, in the Museum of Fine Arts, Museum of New Mexico collection, supports the contention that he began the picture before 1918. It was exhibited for the first time in the *Twenty-second Annual Exhibition of Works by Artists of Chicago and Vicinity* (The Art Institute of Chicago, February 19– March 17, 1918).

Higgins seems to describe his subjects in *Fiesta Day* with his *Chicago Sunday Herald* words, however, he rejected the usual practice of romanticizing the Native American, so often evident in his colleagues' canvases. Rather, the figures are stripped of their heroic and idealized qualities. His pictures are as much about New Mexico light, composition, and the quality of the painted surface as they are about the Pueblo people.

The success of *Fiesta Day* was to affect the direction Higgins's art would take. An article in the *Chicago Examiner* of March 16, 1918, reveals that a controversy arose over its selection as the First Logan Prize winner. The writer, Marcus, reported heated battles over the painting's alleged flaws: "Fists used vociferously over its quality." As the critics pronounced the colors untrue and the anatomy of the horses ill-proportioned, supporters of Higgins praised the canvas as being "splendidly decorative" and creating an "exquisiteness of distance."[2] In truth, both sides of the controversy had failed to understand Higgins's intentions with the painting.

Following the completion of *Fiesta Day*, Higgins all but abandoned using the Native American as a subject. For the next three decades, as he explored forms of Impressionism, Cubism and Modernism, it was the townscape, still life, occasional portrait, and, in particular, the landscape that became his strength.

DEAN A. PORTER

Geraldine Lee #2, 1914
Oil on panel, 38×30″ (96.52×76.20 cm.)
Signed, lower right
Museum purchase, 941-O-101

Despite a career prematurely ended by acute appendicitis in 1925, George Bellows was arguably America's strongest realist painter in the first quarter of the twentieth century. His art serves as a worthy bridge between that of Winslow Homer and Thomas Eakins in the later nineteenth century, and of Edward Hopper and Andrew Wyeth in the mid-twentieth century. For all the energies of his subject matter and brushwork, however, he was outpaced by the new accelerations of modern life and art.[1] His career coincided with the development of motion pictures, the automobile, the airplane, Futurism, Einstein's Theory of Relativity and early rocket propulsion. All of these in different ways forever altered human understanding and experience of the natural world. Born in Columbus, Ohio, where his talent as an athlete almost led him into professional baseball, he returned throughout his painting career to vigorous sporting images: boxing, polo, and tennis. (Fig. 1). Although many of these showed figures in action, painted with a sense of the immediate moment, with vigorous brushstrokes and often new experimental theories of color, Bellows and a number of his contemporaries never fully grasped the profound new expressions of space, time and movement of this century.

During this turbulent period, which culminated with the outbreak of World War I, Bellows created a consistently personal and powerful body of art, largely centered on the human figure as a forceful physical or emotional presence. A warm-hearted family man, he was at his best painting relatives and friends. He moved to New York City just after the turn of the century, and was drawn into the circle of Robert Henri's friends and students. His earliest subjects are firmly in the Ashcan manner, ordinary city types painted quickly and in generally dark colors. Two circumstances had a critical impact on the development of his art: in 1911 Bellows spent his first summer on Monhegan Island off the Maine Coast, and two years later the Armory Show introduced the upheavals of European artistic modernism to New York and America. On the bold and isolated Maine island he found some of his starkest subjects in the formidable cliffs and churning surf, which he painted over the next few years with an eye to his famous Maine predecessor, Winslow Homer. To his portraits at this time he also brought Homer's example of strong brushwork and reductive form. Painted at Monhegan in August, 1914, *Geraldine Lee #2* is such a work.

The sitter was the daughter of a local fisherman, and Bellows first posed her for a portrait in July of that summer. In *Geraldine Lee #1* (1914, Washington University, St. Louis), her torso was turned in a slightly three-quarter view; subsequently, however, the canvas was cut down to more of a head-and-shoulders format.[2] In the second version, owned by the Butler Institute, she faces us directly, sitting virtually centered in the canvas, frontally aligned and parallel to the framing chair behind. Bellows's awareness of the new theories of color and design in the wake of the Armory Show is evident in the clearly calculated arrangement of echoing, nearly geometric shapes, the subdivision of the canvas surface into rectangles of color, and the palette of closely related purple and mauve hues.[3] Broad areas of the background (chair back, hanging drapery, and white wall) are painted thickly with wide brushes, and fit together almost like

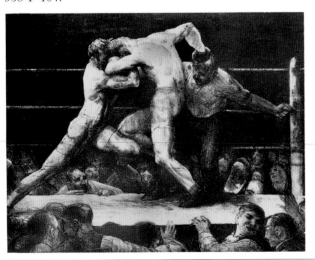

Figure 1. George Wesley Bellows. *Stag at Sharkey's*, n.d. Lithograph, 19×24″ (48.26×60.96 cm.). Unsigned. The Butler Institute of American Art. Anonymous gift, 958-P-104.

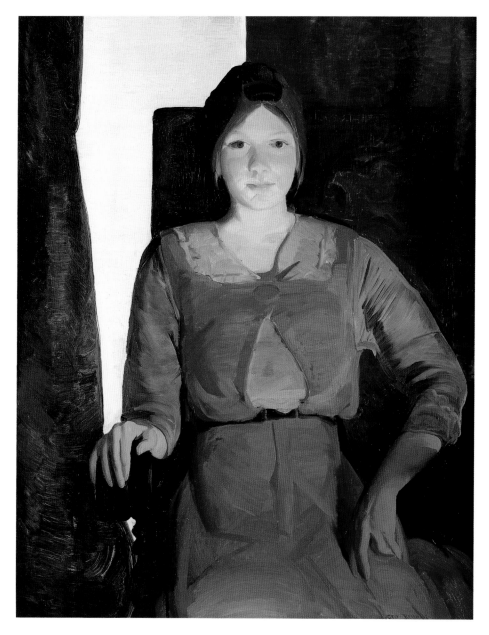

solidly textured blocks. But this is more than a mere color study or artful composition: there is an assured personality sitting before us, straightforward yet sympathetically seen. The alert solid face and elegant relaxed fingers suggest a complex character on the threshold between youth and maturity, which obviously held Bellows's scrutiny over much of that summer.

Bellows's portraits of this period reveal someone very much in control of his stylistic elements, creating variety and individuality in each adjustment of pose, coloring, and setting. To keep the figure of Geraldine Lee from being compressed into a two-dimensional grid he ingeniously painted her right arm extending towards us on the arm of the chair, in an unobtrusive tour-de-force of foreshortening.[4] Such a synthesis of technical bravura, awareness of human presence, and aesthetic coherence owes much to the three American masters for whom he acknowledged his overriding admiration: "Winslow Homer is my particular pet. And one other American or better, two, stand on the same pedestal with him, in my mind. . . . Thomas Eakins and Whistler."[5] We have already noted the appeal to Bellows of Homer's strong brushwork and solid realism; in turn, Eakins's later portraits of single figures in darkened settings offered penetrating examples of a sitter's inner life and character; while the portraits of James Abbott McNeill Whistler conveyed to Bellows a concern with the harmonies of formal arrangement. It is Bellows's singular achievement that his own work was no mere derivation or synthesis of his sources, but fresh and original in its own honesty of expression.

JOHN WILMERDING

ROBERT HENRI | 1865–1929

The Little Dancer, 1916–18
Oil on canvas, 40½ × 32½″ (102.87 × 82.55 cm.)
Signed, lower right
Museum purchase, 920-O-107

The son of a riverboat gambler, Robert Henri was born Robert Henry Cozad in 1865 and grew up in the small town of Cozad, Nebraska, which his father had founded. After his father killed a man and fled to avoid arrest for murder, the various members of the family took different names to avoid identification. Robert assumed the name of Robert Henri. The family resettled in Atlantic City, New Jersey, and shortly afterwards, in 1886, having decided to become a painter, Henri enrolled in the Pennsylvania Academy of the Fine Arts. From 1886 to 1900, Henri alternated his time between Paris and Philadelphia, making three trips to Paris and working in Philadelphia in the intervening periods.

It was in Paris, where he first studied at the Académie Julian and later formed a small art school of his own, that he grew to admire the dark palette and free brushwork of Edouard Manet, Frans Hals, and Diego Velazquez. Here he was exposed to Impressionism and was introduced to the daring, sometimes risqué realism of French authors. In 1899, a dark city snow scene he had painted was purchased by the Luxembourg Museum in Paris, a singular honor for an American artist. In Philadelphia, where he both studied and taught at the Pennsylvania Academy of the Fine Arts, he absorbed the sober realism of Thomas Eakins, as it had been passed on through the teachings of Thomas Anshutz. In addition, he formed a small coterie of young newspaper illustrators and would-be painters, including George Luks, John Sloan, William Glackens, and Everett Shinn, who were inspired by his emphasis on originality and truthful depiction of real life.

In 1900, Henri moved to New York, where he became an extremely popular teacher of such artists as Edward Hopper, Rockwell Kent, George Bellows, Stuart Davis, and Yasuo Kuniyoshi. He also became a strong advocate of adventurous styles in painting, particularly boldly slashed scenes of urban life and portraits of the urban poor. One by one, the young men who had admired him in Philadelphia also moved to New York and gathered around him. After several works by these young artists were rejected by the National Academy of Design, he organized a show of the rejected work, along with paintings of his own, in 1908, at the Macbeth Gallery. Titled simply *The Eight*, the exhibition created a sensation, was flooded with visitors, and was even a commercial success. The event is often considered the opening salvo of modern art in the United States.

Henri was particularly fond of painting portraits, often of different ethnic types—Irish, African-American, Native American, and Chinese. He also executed many portraits of dancers, and often referred to Isadora Duncan when explaining the principles of vital art. *The Little Dancer* belongs to a period when most of Henri's works were portraits of a similar type such as *Betalo Rubino, Dramatic Dancer* (1915, St. Louis Art Museum), and when he was actively involved in teaching and exhibitions.

The warm, reddish-brown colors and the delicate, feathery brushwork of *The Little Dancer* are slightly atypical of Henri. They specifically bring to mind the later work of Henri's pupil, William Glackens, who, beginning around 1910, had fallen under the influence of the French Impressionist, Auguste Renoir. Perhaps the implicit sensuality of the subject, a young woman in a very short dress, sitting coyly in a plush chair, inspired Henri to pay this indirect homage to Renoir, who was known for his paintings of seductive young women.

The model may well be the same as the one depicted in a striking oil sketch, *Isadora Duncan* (c. 1915, private collection, New York), which was exhibited at the New York Cultural Center in 1969, although the identification of the subject as Isadora Duncan is incorrect.[1] This work shows a slender dark-haired young woman in a dancer's pose, attired in an orange-red dress similar to the one in the Butler Institute's painting. In a letter to Joseph G. Butler, Jr., Henri described the model for the painting, noting: "The young girl who posed for the picture is not professional either as dancer or model, but because of love of that sort of expression is nevertheless a very beautiful dancer, and one whose postures in action or in repose are expressive of fine temperment [sic]. In the picture of course she is in repose, but unity existed in this pose equally with those of action, and it was on this motive of unity, expressive of a state of being, that the construction of the picture was based."[2]

HENRY ADAMS

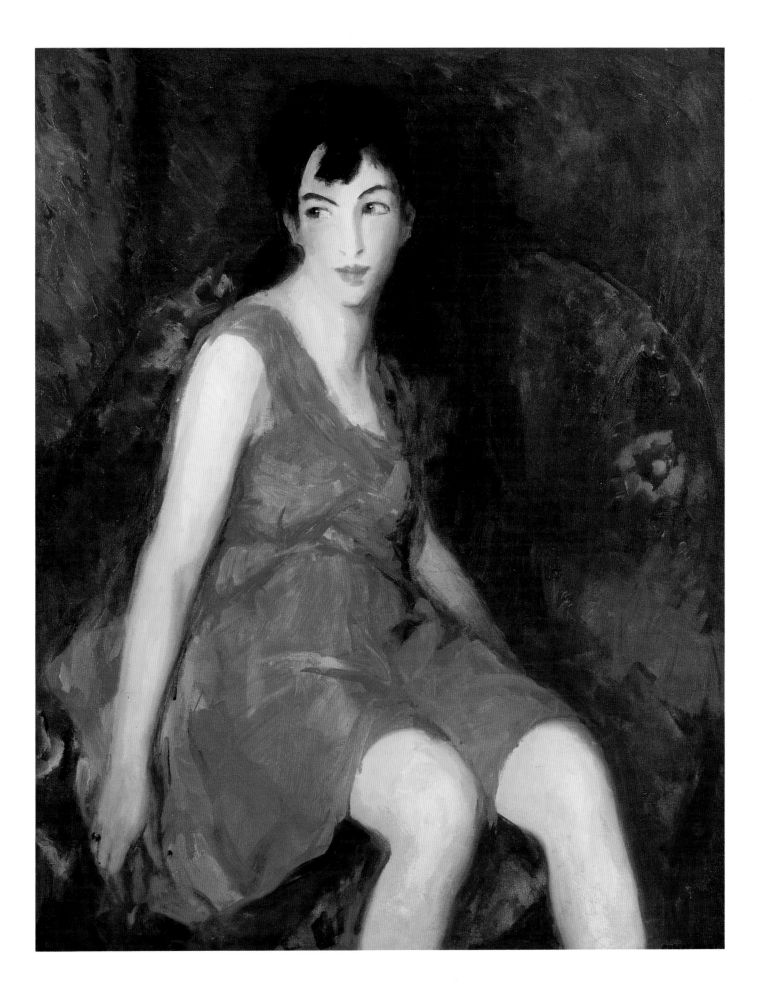

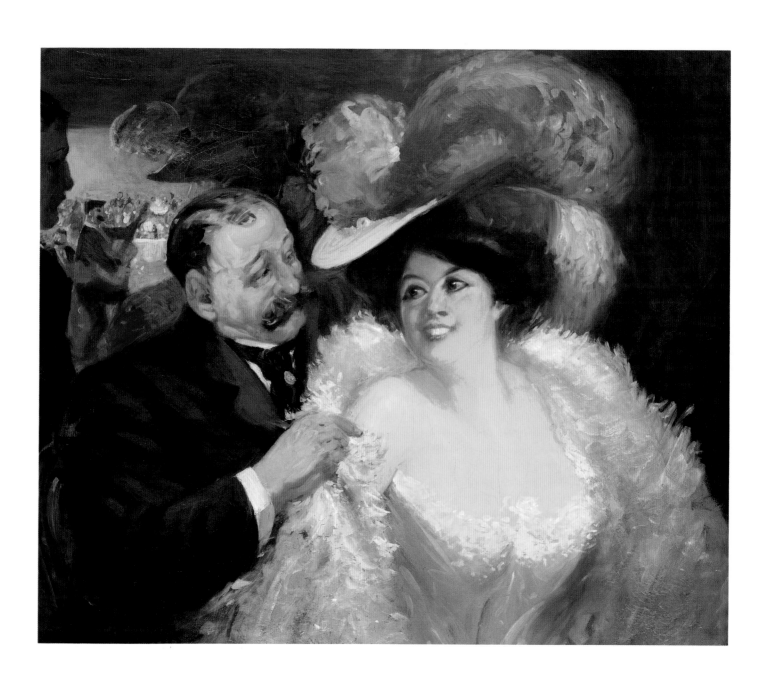

GEORGE LUKS | 1866–1933

The Cafe Francis, c. 1906
Oil on canvas, 36 × 42″ (91.44 × 106.68 cm.)
Signed, lower left
Museum purchase, 960-O-105

The joie de vivre animating *The Cafe Francis* also characterized its creator, popularly known as "Lusty Luks." Contemporaries spoke admiringly of both George Luks's art and his persona; "the vitality of him!" declared the New York critic James Huneker.[1] Luks, whose hard-drinking and pugnacious ways were legendary, fostered an image of himself that was larger than life. He claimed to be a professional boxer named "Chicago Whitey" and he confidently asserted that not only could he "paint with a shoestring dipped in lard," but that "there are only two great artists in the world—Frans Hals and little old George Luks!"[2]

It is not Hals, however, who lies behind *The Cafe Francis,* but Pierre-Auguste Renoir. Indeed, *The Cafe Francis* is one of Luks's most Impressionist compositions and differs from his better-known, more darkly colored scenes of lower-class urban life. Here the lighter palette, the feathery brushstrokes defining the woman, her dress and accessories, the cropping of figures—especially the shadowy figure at left—and the sense of immediacy all contribute to the Impressionist flavor. With its robust, beaming figures, *The Cafe Francis* conveys a bouyant optimism associated with Renoir's work, which Luks had admired when in Europe.[3]

Luks had little formal training; he had studied for a month at the Pennsylvania Academy of the Fine Arts in 1884 and traveled extensively in Europe during the early 1890s. In 1894, he joined the Philadelphia *Press* as an illustrator, and began meeting other newspaper artists including John Sloan, Everett Shinn, and William Glackens. Like them, he associated with Robert Henri and moved to New York by the end of the decade. There Glackens encouraged Luks to return to painting despite his successful career as an illustrator and cartoonist. When Luks composed *The Cafe Francis* he most likely had in mind Glackens's painting, *Chez Mouquin* (1905, Art Institute of Chicago).

In his work, Glackens, like Luks in his, depicts the powerful-looking James Moore with one of his "daughters" (Moore's euphemism for his female companions). Moore owned the Cafe Francis, which he advertised as "New York's Most Popular Resort of the New Bohemia." Located at 53 West 35th Street in New York City, the Cafe Francis rivaled Mouquin's as a restaurant popular with artists and writers. Luks, Glackens, and their friends patronized both establishments. Both Glackens's and Luks's compositions focus on a large-scale couple in a noisy, active restaurant setting, but Luks shows James Moore as older, suggesting that his painting followed the Glackens. Although not dated, *The Cafe Francis* probably was painted around 1906, after Glackens's composition and before the Cafe Francis closed in 1908.

1908 was also the year that Luks and seven of his peers exhibited at the Macbeth Galleries in New York as The Eight. Triggered by the rejection of a Luks painting from the 1907 National Academy of Design annual show, the eight artists—who besides Luks included Henri, Glackens, Sloan, Shinn, Ernest Lawson, Maurice Prendergast, and Arthur Davies—successfully mounted an anti-Establishment exhibition that signaled the demise of academic authority.

In the following years, Luks, who had had six works included in the 1913 Armory Show, garnered major awards from the Corcoran Gallery of Art and the Pennsylvania Academy of the Fine Arts. The Establishment embraced his once-considered-radical art. Still, Luks never ceased his outspoken manner and described himself in a talk given the year before his death in terms that resonate remarkably with the lively spirit portrayed in *The Cafe Francis:* "I'm George Luks, and I'm a rare bird. You people stick with me and you'll have a good time."[4]

MARK THISTLETHWAITE

JOHN SLOAN | 1871–1951

Recruiting in Union Square, 1909
Oil on canvas, 26 × 32″ (66.04 × 81.28 cm.)
Signed, lower left
Museum purchase, 954-O-140

John Sloan was born in Lock Haven, Pennsylvania and grew up in Philadelphia. He studied at the Pennsylvania Academy of the Fine Arts in 1892, first with Thomas Anshutz, and later with Robert Henri. Sloan's professional career as an artist began as an illustrator for Philadelphia newspapers, the *Enquirer* and the *Press*. Moving to New York in 1904, he continued working in commercial art until 1916 when he began a long association with the Art Students League as a teacher. Influenced by Henri and his teachings on realism, a group of eight artists, including John Sloan, rebelled against the National Academy of Design by organizing their own independent exhibition in 1908. Named The Eight by the press, these artists were a strong force in promoting a bold and unromanticized form of realism.

Street scenes were a natural subject for Sloan and the New York Realists. His New York paintings feature a capacity for rendering narrative, chronicling life in the form of visual anecdotes. The idea for *Recruiting in Union Square* was conceived on May 10, 1909 as Sloan noted in his diary, "loafed about Madison Square where the trees are heavily daubed with fresh green and the benches filled with tired 'bums' near the fountain is a U.S. Army recruiting sign, two samples of our military are in attendance but the bums stick to the freedom of their poverty. There is a picture in this. . . ."[1] Three days later Sloan embarked on the painting, as his diary entry for May 13, 1909 reads "painted in the afternoon. Started a City Square with Recruiting Service sign displayed among the 'bench warmers'."[2] The title of the work was transposed to "Union Square," though Madison Square was the locale which had originally inspired the subject. Pennsylvania Academy of the Fine Arts jurors Elmer Schofield, Robert Henri, Thomas Anshutz, and Charles Hawthorne selected *Recruiting in Union Square* for exhibition as the result of their studio visit on January 6, 1910.[3] The work was exhibited at the January, *1910 Pennsylvania Academy of the Fine Arts Exhibition*, the *1910 Exhibition of Independent Artists*, and numerous other exhibitions during Sloan's lifetime.

Under the influence of Robert Henri, Sloan became interested in formal theories of color and composition. Sloan's diaries first make mention of his introduction, by Henri, to the color system of Hardesty Maratta on June 13, 1909. This system created a highly structured, systematized formula for pigments and tonal relationships. *Recruiting in Union Square*, however, was painted before he began employing this system. He inaugurated use of the system on the next painting, which he began in the fall of 1909, and relied on it continually throughout his career.[4]

Recruiting in Union Square was painted about six months before Sloan became a member of the Socialist Party. Writing about the painting, he stated, "I saw a free man being tempted into monkey clothes, but my intention . . . had nothing to do with the Socialist doctrine—just my natural feeling about human freedom."[5] He reiterated that he felt no social obligation and attempted never to involve art with propaganda or politics, instead using his satirical cartoons and illustrations for political expression. However, on another occasion he stated, in contradiction to this, that there was an element of propaganda in *Recruiting in Union Square* that caused him discomfort. Although he made a conscious attempt to keep his political beliefs separate from his art, he felt they may have kept him from painting many more city pictures.[6]

While Sloan's work is commonly associated with urban views, he became interested in other themes and locales, producing many landscapes of Gloucester, Massachusetts and Santa Fe as well as numerous figurative subjects which comprise a large part of his oeuvre. Sloan continued painting New York scenes until the late 1940s, but city subjects became less appealing to him and he produced fewer in later years.

VALERIE ANN LEEDS

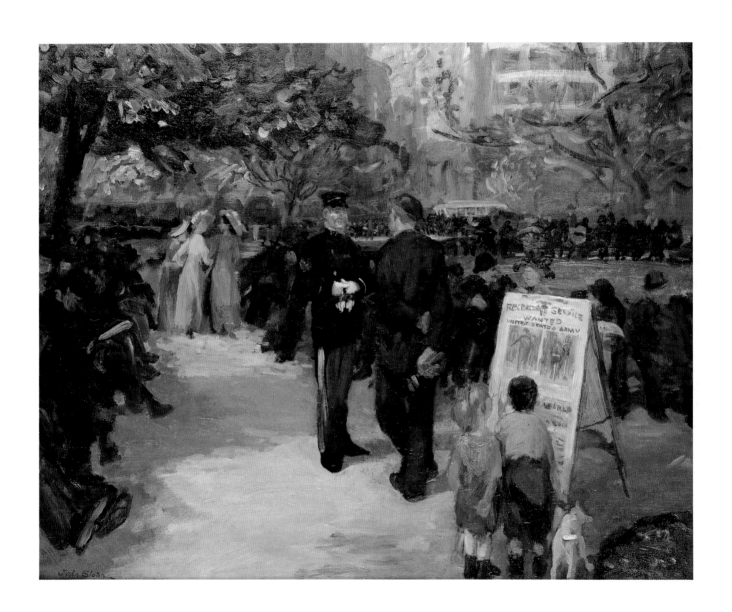

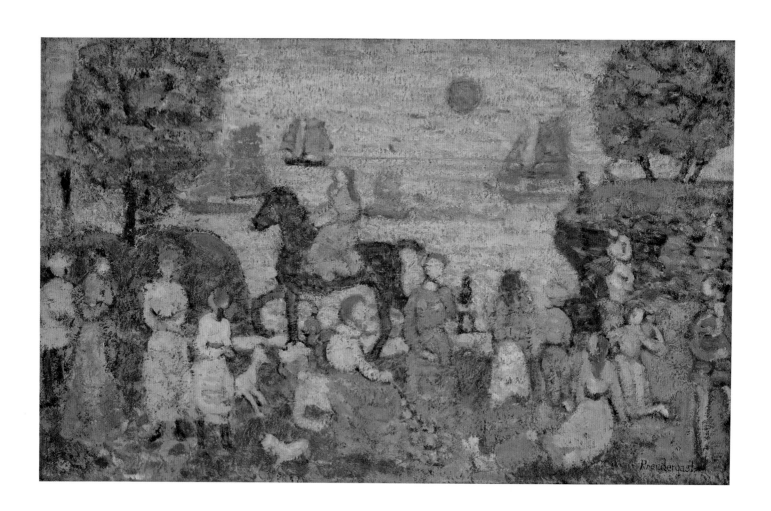

Sunset and Sea Fog, c. 1918–23
Oil on canvas, 18 × 29″ (45.72 × 73.66 cm.)
Signed, lower right
Museum purchase, 955-O-128

Warm, glowing colors and evocative imagery make *Sunset and Sea Fog* one of the greatest of Maurice Prendergast's late oil paintings. Prendergast, born in St. John's, Newfoundland and raised in Boston, had participated in the major avant-garde movements of his day. He was inspired by the art he saw as a student in Paris in the 1890s and first made his mark with Impressionist watercolors of park and beach scenes. After 1900, he spent more time in New York capturing the life of the city alongside his new friends, who would become known as the Ashcan School. A trip to Paris, in 1907, opened his eyes to Paul Cézanne, Henri Matisse, and modernist ideas about color and abstract form which he introduced immediately into his work and spent the rest of his life exploring.

When Prendergast was in his late fifties and early sixties, he painted a number of large canvases like *Sunset and Sea Fog* on the theme of the seaside park, which he felt evoked an idyllic world where opposites were reconciled: nature and civilization, past and present, movement and rest. The scene, based on Prendergast's many sketches of actual seaside parks along the Massachusetts coastline, is transformed into a fairy tale by the setting sun and a mysterious red-haired equestrienne. At this point in Prendergast's career, he was searching for artistic statements that were more monumental and lasting than the small-scale, naturalistic works of his early years. He was also at pains to create a style that was uniquely his own, one that would take advantage of the liberation of color and form that came with modernism but would not slavishly follow the succession of "isms" like Futurism, Cubism, and Synchronism, to which he saw other modernist artists falling prey. In 1913, he had been an organizer of the Armory Show, the forward-looking exhibition of contemporary European and American art, but he said with a chuckle that there was "too much—O my God!—art there."[1]

Prendergast's own style was based on a carefully adjusted combination of colors which were applied to the canvas in dots, patches, and layers. His compositions were typically laid out in horizontal zones that flattened forms and emphasized the richness of the surface texture. He stylized his figures, which were mostly female, into monumental goddesses, sometimes nude and sometimes clothed, who assume the stately poses of the antique but keep their humanity by playing with a dog or sporting a fashionable hat.

Sunset and Sea Fog was sold to the Washington collector Duncan Phillips in 1923.[2] It is impossible to tell when it was painted, but it has the tell-tale signs of having stayed in Prendergast's studio for some time. *Sunset and Sea Fog* was probably begun by the late teens but, as was Prendergast's practice if a work was not immediately sold, he would "peck away" at it, "eager and exhilarated as he 'punched up' a canvas that might have seemed perfect before but in which he saw possibilities of greater depth, a hardier build, or more of light and richness."[3] The result was a canvas of increasingly thick impasto and generalized form, or the "fog" of *Sunset and Sea Fog*.

NANCY MOWLL MATHEWS

227

ARTHUR BOWEN DAVIES | 1862–1928

Arethusa, 1901
Oil on canvas, 27½ × 22½″ (69.85 × 57.15 cm.)
Signed, lower left
Museum purchase, 923-O-103

Arthur Bowen Davies's contemporaries described him variously as the Enchanter, the Magician, and even the Alchemist in their efforts to explain the work of the most surprising advocate of modernism in America.[1] Indeed his haunting, enigmatic paintings set him apart from the other members of The Eight, aligning him instead with the suggestive, introspective art of the nineteenth-century American visionary, Albert Pinkham Ryder, and the European Symbolists.[2]

Arethusa, an early nude by Davies, dates from the period following the artist's return from Europe in 1895. It was during these critical years that Davies began to concentrate his creative energies on painting idyllic pastorals, populated with lithe, female figures, the subject with which he is now most closely identified. For Davies, who was a devoted admirer of both ancient Greece and the Renaissance, the female nude remained the embodiment of the abstract ideal of beauty.

Arethusa echoes Ingres's masterwork *The Valpincon Bather* (1808, Louvre), which Davies could well have seen in Paris. The pose of the two figures is nearly identical. Davies has adapted the exquisite contour of Ingres's bather to create the linear grace of his own figure. Nearly a century has passed, however, and in Davies's hand, Ingres's weighty, fully-modeled nude has become a delicate, decorative figure.

Like the European Symbolists, Davies was entranced by the world of ancient myth and legend. He named his farm The Golden Bough after James G. Frazer's 1890 study of comparative mythology. Though much of Davies's work seems to take place in a timeless, dream world, certain works are linked to specific myths.[3] Arethusa is a nymph whose story is told in Ovid's *Metamorphoses* and who is the subject of the 1824 poem, *Arethusa*, by Percy Bysshe Shelley. According to the myth, the river god Alpheius fell in love with Arethusa after she bathed in his waters. Pursued by Alpheius, Arethusa prayed to Artemis, the virgin goddess of the hunt, to save her. Artemis answered Arethusa by spiriting her off to the island of Ortygia and transforming her into a spring. Undeterred by Artemis's interference, Alpheius flowed under the sea to Ortygia, where he united with Arethusa by mingling his waters with hers in the spring.

From a tale filled with passion and high adventure, Davies characteristically chose to depict a moment of idyllic calm in which the human world exists in perfect harmony with nature. Arethusa is seen seated quietly, her back turned to the viewer, as she looks out across the water. The specifics of the narrative hold little interest for the artist. He is concerned with evoking a mood of tranquility and poetic reverie, a mood which parallels Shelley's lyric: "And gliding and springing,/ She went ever singing,/ In murmurs as soft as sleep;/ The Earth seemed to love her,/ And Heaven smiled above her,/ As she lingered toward the deep."[4]

Though frequently viewed as escapes into romantic fantasy, paintings such as *Arethusa* may well have possessed a contemporary resonance for the artist that has rarely been recognized. On seeing the frescoes at Pompeii for a second time in 1910, Davies exclaimed that he had seen paintings "which were perfectly thrilling—the finest things I have ever seen—as fresh as if painted yesterday. I . . . feel capable of far greater expression because of my own entente cordiale with Greek painters—so archaic—so great—so modern. . . . I cannot tell you how much these things mean to me."[5] If Davies believed, as proposed by Frazer in *The Golden Bough*, that myth held the key to the mysteries of the human imagination, he may have seen in his own work the potential to be simultaneously "archaic" and "modern," the opportunity to create a "universe of images that make the past present, that integrated man with nature, the sense with the mind, and that thus celebrated the new possibilities for man."[6]

NANNETTE V. MACIEJUNES

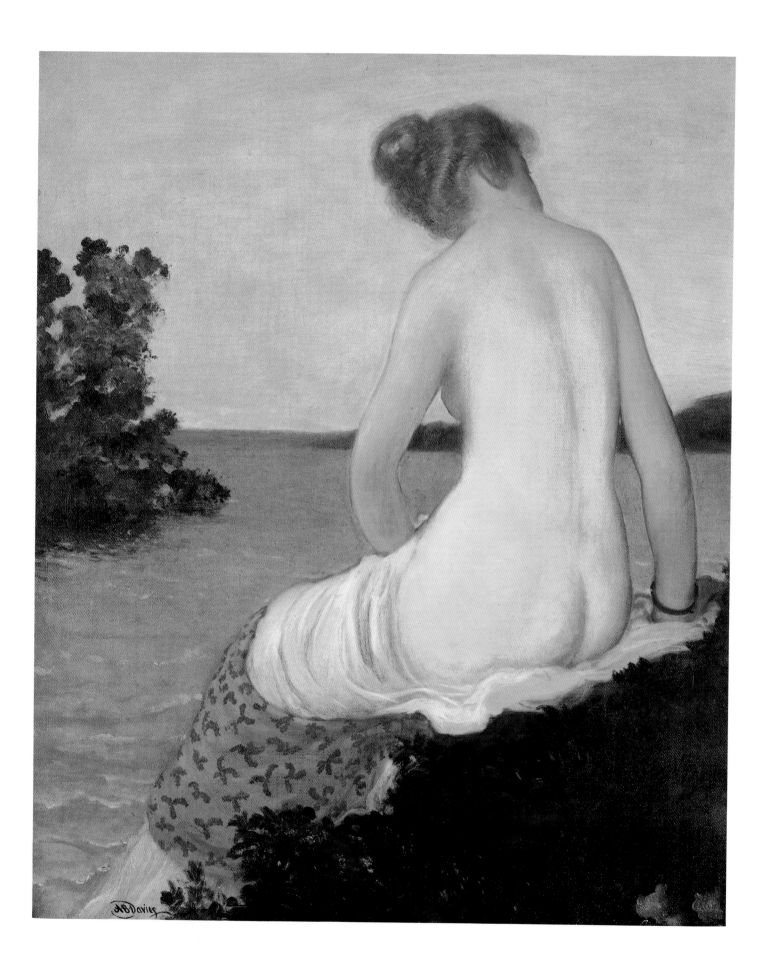

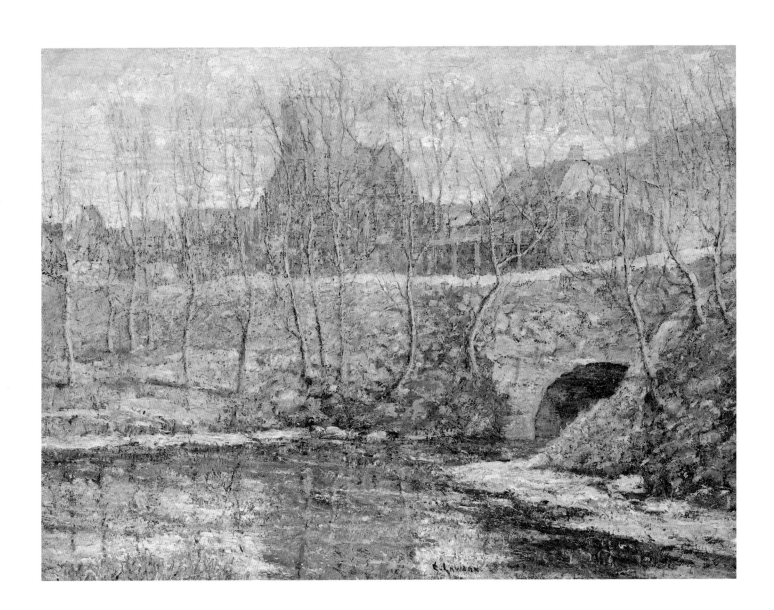

ERNEST LAWSON | 1873–1939

Misty Day in March, 1917
Oil on canvas, 30 × 40″ (76.20 × 101.60 cm.)
Signed, lower right
Museum purchase, 921-O-107

On February 3, 1908, an exhibition opened at Macbeth Gallery in New York City that announced a new generation of American artists. The organizers called it an exhibition of eight independent painters; later they would be known simply as The Eight or, as their critics preferred, "the revolutionary black gang," "the apostles of ugliness," and "the Ashcan School." Among these painters was Ernest Lawson, an Impressionist who had studied with John Twachtman and Julian Alden Weir as well as at the Académie Julian in Paris. Like his colleague, Maurice Prendergast, Lawson was dedicated to the high-keyed color and broken brushwork of Impressionism, but like all members of The Eight was also committed to independence from what he saw as the artificial constraints of the professional art world: their juried shows, their genteel manners, their self-appointed exclusivity.

Following the leadership of Robert Henri and Arthur B. Davies, all eight members envisioned a more democratic world of open, non-competitive exhibitions, all comers welcome—old and young, established and unestablished, conservative and rebellious, pleasant and unpleasant—mirroring the energies and conflicts of modern urban society. To include gritty realists like George Luks, idealistic visionaries like Davies, and Impressionists like Lawson was not to share a defining style so much as an attitude towards life; a spirit of good-natured defiance and a rough-and-tumble conviviality welded in place over food, drink, and amateur theatrics.

Lawson's background was dramatically different from the newspaper training of the Philadelphia artists in the group. He was born in San Francisco to a Canadian doctor and his wife while they were en route to Nova Scotia from Mexico, where Dr. Lawson had tended to the medical needs of mineworkers. Lawson spent much of his childhood in Mexico and began his artistic training there. When he finally settled in New York City in 1898, it was as an international citizen with an American passport.

What Lawson encountered in New York was a city in the throes of growth, spreading outward and upwards with each new wave of immigrants and each new tick in the markets. Both the growth and the accompanying decay entranced his eye: aqueducts soaring over the Hudson, apartments climbing the hillsides, abandoned shacks hard by sagging piers, all evidence of humanity using and sometimes overwhelming nature, and of nature's accommodations in response. All of this Lawson recorded with an unmistakable hand, stroke upon stroke of clean, unvarnished hue, building to surfaces that possessed the weight of tapestry and the solidity of stone.

Misty Day in March has the feel of a city park surrounded by buildings, today unidentifiable partly because of Lawson's own alterations. It is a larger version of a painting, *Misty Day* (1917, National Gallery of Canada), whose differences provide insight into Lawson's approach. Where the Butler Institute's painting shows a round-arched bridge crossing a park creek, the bridge in *Misty Day*, crossing the same creek at the same point, is a flat, horizontal span. In the Butler Institute's painting, the screen of trees that divides the creek from the buildings in the background is more pronounced; not only are there more trees, but they grow in more elegant lines, as though inspired by a Japanese screen. The buildings in the background of the Butler Institute's painting are also more distinct; a Dutch colonial house and a square-towered Norman Revival church dominate the skyline behind the park.

It was never Lawson's intent simply to be truthful, accurately recording every detail of topography or structure. Instead, he built on a motif, usually a dominant color, here the gray-green of a late winter sky that is matched by the color of snow melting over last year's grass, of the welling creek, and of the mist that pervades the whole.

BRUCE W. CHAMBERS

GEORGE AULT | 1891–1948

Sculpture on a Roof, 1945
Oil on board, 16 × 12″ (40.64 × 30.48 cm.)
Unsigned
Gift of Mrs. George Ault, 961-O-131

Born in Cleveland, Ohio, George Ault spent most of his childhood in London, where his father was engaged in ink manufacture. He received art training at the Slade School of Art and St. John's Wood School of Art, London, returning to the United States in 1911. Ault's early works were urban vistas similar to those of Joseph Pennell, although quite early in his career he became interested in night effects, a major theme in many of his later works.

In the early 1920s, as he gradually incorporated ideas from Cubism, Surrealism, and American folk art, Ault began to develop a modern style. His subject matter remained similar to that of his early work, but he deliberately employed flat shapes, strong geometric patterns, odd viewpoints and slightly skewed perspective effects. Ault also favored slightly unreal colors—teals, mauves, olive greens, oranges, and a cool sky blue—like those used in Art Deco decor. During this period, he established relationships with a number of progressive dealers and began to develop an artistic reputation. Although Ault is often grouped with Precisionists Ralston Crawford and Charles Sheeler, he did not idealize modern life as they generally did. Rather, his urban landscapes, filled with a sense of disquiet and psychic distress, echo both Giorgio de Chirico, the Italian Surrealist, and Albert Pinkham Ryder, the American romantic visionary.

By the mid-1920s, personal problems began to interfere with Ault's artistic progress. The home in which he had grown up was emotionally troubled; his mother died in a mental institution and three of his brothers committed suicide. By the time of his father's death in 1929, the family fortune was largely dissipated. These unfortunate circumstances may explain the increasing turbulence and unhappiness of Ault's personal life. Whatever the exact cause, during the 1920s, Ault grew neurotic and reclusive. He developed a severe case of alcoholism, almost blinding himself drinking poisonous bathtub gin. His behavior became so strange that his artist and dealer friends began to avoid him.

In 1937, hoping to create a new life and escape his alcoholism, Ault moved to Woodstock, New York. There he lived in a series of rented buildings, depending for income mainly on his wife, who worked for small town newspapers in the region. In this period Ault created his most haunting and powerful works. Though these were his finest works, he had difficulty selling his paintings and gradually slipped into ever greater emotional despair. On December 30, 1948, Ault committed suicide in Woodstock at the age of fifty-seven.

Sculpture on a Roof, a striking example of the flat, precise geometric compositions for which Ault is celebrated, is a continuation of a series of rooftop paintings which Ault began in 1931.[1] These images were all based on the roof of his building in New York City at 50 Commerce Street, where in 1935, Ault met his future wife, Louise Jonas, sunbathing. It seems likely that the fragments of classical sculpture—a headless female torso, the lower half of a male figure, and a disembodied head—serve to evoke this meeting, but in a manner which combines a hint of eroticism with a feeling of impotence. The female torso is based on a marble Aphrodite that Ault's father had purchased in London,[2] and thus refers not only to his meeting with Louise but to his childhood. The earlier canvases of this series were painted in New York, but *Sculpture on A Roof* was executed from memory in Woodstock in 1945. The arched windows and the fragments of classical sculpture allude to the work of de Chirico, although the small scale of these elements, the large area taken up by the empty sky, and the general coolness of the colors, endow the painting with an ominous coldness which is more northern and less Mediterranean in spirit, than are de Chirico's canvases. In its curious mix of eroticism and inhibition, modernism and nostalgia, the painting exemplifies the most fascinating qualities of Ault's work.

HENRY ADAMS

GEORGE GROSZ | 1893-1959

Resting, c. 1939–1941
Oil on canvas, 20 × 26″ (50.80 × 66.04 cm.)
Signed, lower right
Gift of Joseph Cantor, 960-O-123

By the time George Grosz decided to relocate himself and his family from Germany to the United States, he was already internationally known as the producer of bitterly sarcastic drawings and prints of German society during the interwar years. Allied with the brothers John Heartfield and Wieland Herzfelde of the politically radical publishing house, Malik Verlag, Grosz was committed to the belief that art could be a weapon in the struggle against the ruling classes. With the rise of National Socialism in his homeland, however, the artist sadly recognized the impotence of his work, and in 1933 accepted a teaching position at the Art Students League in New York.

Physical distance, however, did not keep Grosz's attention too far from events in Europe; both the fighting in Spain and the atrocities occurring in Germany were relayed to the artist by friends back home. Embittered, anxious, and yet finding his old artistic mode of protest ineffective, the artist decided that he ". . . was suddenly sick and tired of satirical cartoons and . . . had done enough clowning to last . . . a lifetime."[1] Faced with what he described as an "inner confrontation . . . with [his] . . . past"[2] that involved both personal and artistic choices, the artist turned to the sea for refuge. Beginning in 1936, Grosz and his family would spend the next several summers on Cape Cod, and it was here, sometime between 1939 and 1941, that the artist painted *Resting*.[3]

In the painting a female nude sits nestled within the protective curve of a rocky coast, overlooking the soft green shrubs, dollop-like sand dunes, and deep blue-green waters of the Eastern coast; large white, yet unmenacing, clouds hover in the blue above the horizon. With its brushy style, cool colors, and traditional subject, it is easy to understand that Grosz's colleagues and patrons reacted to *Resting* and other works of its kind with surprise and misunderstanding.[4] Typically, his oeuvre is split in two parts: one representing the fearless German social critic, the other embodying the weak and broken American producer of stylistically and thematically disparate watercolors and oils that never matched his earlier work. This, however, is far from accurate, and it is in paintings like *Resting* that we can find another reading of the artist's later work.

First, subjects like nudes, still lifes, and landscapes were not new for Grosz. Nudes had appeared, especially in watercolors, since the early 1920s, whether set in a metaphysical landscape, described with the accuracy of *Neue Sachlichkeit*, or carefully composed and colored for erotic appeal. Still lifes were common too, first figuring in larger, allegorical scenes and later as independent images. Landscapes (in addition to cityscapes) were important in his earliest work; in 1927 Grosz produced an oil series of naturalistic landscapes during a trip to France.[5]

Second, it is possible that paintings such as *Resting*, like the places they represent, function as a kind of artistic refuge. Confronting the seeming ineffectiveness of his art, Grosz may have turned to traditional subjects, styles, and media in an attempt to refocus his skills and intentions. By painting in oil, Grosz was able to concentrate on the basic elements and techniques of painting, perhaps feeling that his dismissal of them earlier had contributed to the failure of his work. It is not unusual that Grosz turned to subjects seemingly devoid of political content in the 1930s and 1940s; parallels can be found in the careers of both Otto Dix and Oskar Kokoschka. Landscape, a subject generally nonpolitical, could be infused with personal meaning and allegory.[6] Most importantly, the political and social works of Grosz's later career demonstrate that the artist did not renounce altogether such subject matter when he began his summer sojourns.

Resting, then, with its traditional composition, naturalistic description, and conservative subject matter, can be seen not as an aberration in the artist's oeuvre, but as a moment of reinterpretation before continuing a long and brilliant career.

STEPHANIE D'ALESSANDRO

ARTHUR G. DOVE | 1880–1946

Ice and Clouds, 1931
Oil on board, 19½ × 26¾″ (49.53 × 67.95 cm.)
Signed, lower right
Museum purchase, 961-O-134

New York critics reviewing Arthur Dove's 1931 exhibition at An American Place, which included *Ice and Clouds*, noted a new assurance in the artist's work: "It is a happy business to record that these latest abstractions are way ahead of anything that this painter has showed us before"; "Arthur Dove . . . comes forth with canvases more expansive, more commodious, than any from his brush that the writer has seen."[1] Apparently Dove had entered the decade with heightened resolve and confidence.

Raised in upstate New York, Dove studied law at Cornell University before deciding, in 1903, to pursue a career in art. He moved to New York City, securing work as a freelance magazine illustrator. A trip to Europe in 1908 introduced Dove to the vivid color and decorative patterning of Henri Matisse and the Fauves, as well as to the ordered pictorial structures of Paul Cézanne. Upon his return to New York, he joined the circle of progressive artists supported by Alfred Stieglitz, and began a series of small, daring non-objective paintings. These abstractions, first exhibited in 1912, presented observations and sensations distilled from the external world, rendered as bold, overlapping forms that denied illusionistic space while exuding a dynamic energy. Dove acknowledged nature as the basis of this art: "Then there was the search for a means of expression which did not depend upon representation. It should have order, size, intensity, spirit, nearer to the music of the eye. . . . One day I made a drawing of a hillside. The wind was blowing. I chose three forms from the planes of the sides of the trees, and three colors, and black and white. From these was made a rhythmic painting which expressed the spirit of the whole thing."[2]

Dove found support for his art from Stieglitz and Georgia O'Keeffe, but few others understood his abstractions, and even fewer purchased them. In 1921 Dove left his family and moved onto a houseboat with the artist Helen Torr; the next year, Dove and Torr moved onto a sailboat, which they kept in Huntington Bay on the Long Island Sound. After six years on the water, Dove and Torr found quarters in the Ketewomoke Yacht Club in Halesite, satisfying Dove's wish to enlarge his storage and work space without sacrificing the freedom of his unmoored life. As he wrote to Stieglitz in May 1929, "If we have no boat, I shall miss something of the storms and weather that seem to give me more."[3] The greater "commodious-ness" noted by critics of the artist's work in 1931 may have been related to this improvement in living and studio quarters. Yet secure housing was only one of the critical factors propelling Dove into the new decade. In September 1929, Dove's wife Florence died, leaving him free to marry Torr as well as to reunite with his nineteen-year-old son.[4] Late in 1929, Stieglitz opened a new gallery, An American Place, which focused especially on the work of three artists: John Marin, O'Keeffe, and Dove. And through the efforts of Stieglitz, in 1930 Dove found an enlightened patron in Duncan Phillips, whose interest in the artist later bore fruit in a monthly stipend. Several factors, then, combined to ease the tensions Dove must have felt in the previous decade, as well as to consolidate the artistic experiments he had made under highly inauspicious circumstances.

Ice and Clouds was painted in this climate of relative resolution. It was finished in February, only weeks before the artist delivered it to Stieglitz for inclusion in the 1931 show. The work was recognized as one of the most accessible works in the exhibition. Murdock Pemberton of *The New Yorker*, while expressing doubt that Dove would "ever be as much appreciated by the layman as he is by the painter,"

acknowledged that recently Dove had been "kindly turning out an occasional canvas so representative that even the casual visitor can admire it. This year it is his 'Ice and Clouds,' a soft study in blue."[5]

Indeed, *Ice and Clouds* seems to depict a more definite location, or at least a more representational vision of nature, than the more abstracted compositions that Dove exhibited in 1931 under such titles as *Dancing Tree* or *Two Forms*. Even so, Dove did not merely record facts about this landscape, but rather extracted the essential qualities of the scene he observed and remembered, simplifying his colors, shapes, and composition. Dove restricted his palette to tones of brown, blue, and white, brushing in the color with short parallel strokes that radiate a soft energy, especially in the sky and hills. Two white

clouds hover above this glowing atmosphere, just as two jagged ice floes straddle the surface of the water below. Low hills at the horizon form a closed, seemingly safe harbor, separating not only sky from water but also the soft brushstrokes and lighter colors of the upper composition from the flatter forms and denser pigments of the lower canvas. The rounded forms of these hills, like those of the clouds, contrast strongly with the sharply angular shapes of the ice in the foreground. More than "a soft study in blue," *Ice and Clouds* suggests the elemental contrasts of nature, and perhaps even the actual conflicts that Dove was facing and resolving around 1930.

SALLY MILLS

MARSDEN HARTLEY | 1877–1943

Birds of the Bagaduce, 1939
Oil on board, 28 × 22″ (71.12 × 55.88 cm.)
Signed, lower right
Museum purchase, 957-O-113

Birds of the Bagaduce is one of several paintings that Marsden Hartley produced in 1939 while staying with John Evans and Claire Spencer in West Brookville, Maine. On August 27, he wrote to the California painter Nick Brigante: "The friends I am staying with bought this pretty farm on the edge of the Bagaduce River which is around the point from the Penobscot & flows into the bay, & across the river is Castine, one of Maine's most historical cities. . . ."[1]

That same year, Hartley also used the name "Bagaduce" for another of his pictures, *Driftwood on the Bagaduce* (1939, The Saint Louis Art Museum). It was only two years earlier, in the summer of 1937, that Hartley finally returned to paint in his native state. Despite the many years since he had left Lewiston, where he was born, Hartley maintained an intimate and powerful bond to the Maine landscape and seashore.

Hartley's decision to paint sailboats at sea beneath a dramatic sky with emphasized clouds reflects his admiration for the work of Albert Pinkham Ryder. He had not forgotten Ryder, whom he had met years earlier, since about this time he painted from memory *Portrait of Albert Pinkham Ryder* (1938–39, The Metropolitan Museum of Art) and wrote an essay on Ryder in 1936: "Will the ships ever reach a psychical, let alone a physical haven, do they not seem to be held in perpetuity to the hard business of roaming from one indifferent wave to another. . . . That is the look of the pictures, two small marines, of which I am thinking, having looked this afternoon for probably the hundredth time in the Metropolitan Museum, I see no hope for their ships ever reaching a prescribed safety."[2] Hartley had first seen the works of the eccentric Ryder in New York in 1909 and painted a series of dark landscapes under his influence. In contrast, *Birds of the Bagaduce* is filled with light, yet the relationship of ship to cloud suggests Ryder's *Under a Cloud* or *Toilers of the Sea* (both n.d., both The Metropolitan Museum of Art).

Hartley often represented sailboats at sea beneath large solid clouds in a vast sky. The personal meaning of these elements can be found in his life experiences. By 1939, he had twice lost close friends to tragedies at sea. He memorialized the poet Hart Crane's suicide at sea in his 1933 painting *Eight Bells Folly, Memorial for Hart Crane* (1933, University Art Museum, University of Minnesota, Minneapolis).[3] Only three years later, while he was living in Nova Scotia, Alty Mason, the handsome young fisherman whom he adored, was drowned at sea.

In its own way, *Birds of the Bagaduce* treats the same theme as Hartley's poem, "Fishermen's Last Supper," in his 1940 collection *Androscoggin*:

Murder is not a pretty thing
yet seas do raucous everything
to make it pretty—
for the foolish or the brave,
a way seas have.[4]

The immense area that Hartley allocated for sky and clouds in this picture suggests the power of nature. In contrast, man's boats are small and vulnerable. The birds of the Bagaduce seem free as they fly above the water. For Hartley, however, they can also be the victims of storms, as some of his pictures which depict dead birds make clear.

GAIL LEVIN

GEORGIA O'KEEFFE | 1887–1986

Cottonwood III, 1944
Oil on canvas, 19½ × 29¼″ (49.53 × 74.30 cm.)
Unsigned
Museum purchase, 990-O-111

Georgia O'Keeffe, the first American woman artist of major stature, achieved a mythic presence in American art, both through the photographs of her by Alfred Stieglitz and others, and through her remarkable paintings. She was the last surviving member of the small group of pioneering modernists that Stieglitz gathered around him. Born in Sun Prairie, Wisconsin, O'Keeffe studied art at The Art Institute of Chicago, the Art Students League in New York, and the University of Virginia. Early in her career, she taught art in the public schools in Amarillo and at West Texas State Normal School in Canyon.

Through Alan Bemont, a disciple of the nineteenth-century art educator Arthur Dow, she had been exposed to the idea that art consisted not in representation, but design, in "filling a space in a beautiful way."[1] She explored this idea in a series of abstract and nearly abstract drawings and watercolors. These attracted the attention of the photographer Alfred Stieglitz, who showed them in his New York gallery, 291, in May of 1916. Deeply moved by the mysterious forms in these drawings, which seemed to him to express a uniquely feminine sensibility, Stieglitz is said to have remarked, "At last, a woman on paper."[2] In that same month, O'Keeffe traveled East to meet Stieglitz, they became romantically involved, and in 1924, they married. During the 1920s, Stieglitz exhibited many photographs for which she posed, both clothed and in the nude, which fostered her unique mystique and presented her as a force of nature. During this time she produced a particularly dramatic series of close-ups of flowers, generally larger in scale than her earlier work, which was widely interpreted as possessing sexual symbolism, and was regarded as revealing the essence of the female soul.

In 1929, O'Keeffe was invited to New Mexico by Mabel Dodge Luhan, a patron of the Taos Artists Society. During this visit, O'Keeffe was drawn to the Southwestern landscape because of its restful qualities of stillness and solitude as well as the austere clarity of its strong shapes, clear light, and lack of atmosphere. In 1930, following a nervous breakdown, O'Keeffe began spending large parts of each year in New Mexico, where she painted desiccated landscapes and portraits of cow skulls and bones. Many of these paintings, such as *Black Cross, New Mexico* (1929, Art Institute of Chicago) and *Cow Skull—Red, White and Blue* (1931, Metropolitan Museum of Art), possess an iconic quality, and they often show objects levitating in improbable but visually compelling ways.

Cottonwood III, executed in 1944 and first exhibited at An American Place in 1945, depicts the New Mexico landscape, here the ubiquitous cottonwood trees that line the riverbed of Abiquiu, the town which became O'Keeffe's winter home in 1945.[3] The composition of the painting differs from the more stark, dramatic work of the 1930s and adopts a less abstract, less geometric, more naturalistic approach. Although painted late in O'Keeffe's career, the technique of the piece refers to the work of the American Impressionist, William Merritt Chase, with whom O'Keeffe studied at the Art Students League in 1907–08. A master of outdoor Impressionism, Chase painted many beach scenes of Shinnecock, Long Island, which resemble *Cottonwood III*, both in their soft handling of form and in their use of green and blonde tonalities. While the forms have been simplified, *Cottonwood III* might almost be taken for a turn-of-the-century American Impressionist painting. O'Keeffe enjoyed her study with Chase, recalling that, "There was something fresh and energetic and fierce and exacting about him that made him fun."[4]

Cottonwood III relates not only to Chase's work, but to the early canvases which O'Keeffe produced under Chase's tutelage. In 1908, Chase awarded O'Keeffe a prize for the painting *Dead Rabbit and Copper Pot* (1908, Art Students League). This painting, executed very much in Chase's style, depicted a still-life, one of Chase's specialties. Although different in subject matter, there are many technical similarities between *Cottonwood III* and *Dead Rabbit and Copper Pot*. Both paintings are based on calculated contrasts between hard and soft forms, as well as clear and diffuse edges. In *Cottonwood III*, O'Keeffe recalls techniques she had developed years before, while studying with Chase.

HENRY ADAMS

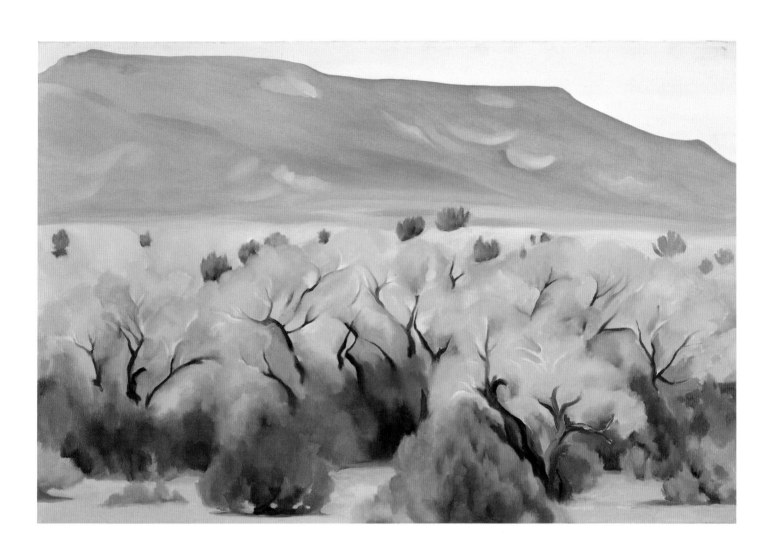

NILES SPENCER | 1893–1952

The Watch Factory, 1950
Oil on canvas, 28 × 42″ (71.12 × 106.68 cm.)
Signed, lower left
Museum purchase, 950-O-113

Niles Spencer received his formal training at the Rhode Island School of Design and in summer classes with Charles Woodbury in Ogunquit, Maine. Later he studied briefly with Kenneth Hayes Miller at the Art Students League, and with Robert Henri and George Bellows at the Ferrer School. However, the deciding influence on Spencer was a 1921 trip to Europe, where he was exposed to the work of Paul Cézanne, and the Cubism of Pablo Picasso, Georges Braque, and Juan Gris, which provided the basic vocabulary on which Spencer's uninhabited industrial landscapes are based. Primary among his American influences is Charles Sheeler, whose use of an exacting, geometric interpretation, also inspired by Cubism, is apparent even in Spencer's early work. *City Walls* (1921, Museum of Modern Art, N.Y.), a pivotal work in his career, shows an assimilation of Cubist principles. The typical simplification of form, flattened perspective, muted tonalities, and urban subject in *City Walls* were a prelude for Spencer, who would rework and explore these same elements in his art for the next thirty years. Captured with stark and elegant beauty, the reductive urban compositions of buildings, factories, and smokestacks became his signature. Along with Spencer, Charles Sheeler, Charles Demuth, and Preston Dickinson utilized similar elements in the formulation of a Precisionist style.

The Watch Factory, an important late work produced at the peak of Spencer's artistic maturity, is dominated by disciplined organization and an integrated compositional arrangement illustrating the artist's idiomatic approach: austere, controlled, intellectualized, and remote. The abstracted sense of space in this work presents one of his least representational subjects and was singled out by artist-critic Fairfield Porter in a review of the 1952 Downtown Gallery exhibition.[1] Spencer's late works are contrived abstractions of architectural space, relying less on literal reality. Articulating the philosophy behind his work, he stated in 1941 that

"the deeper meanings of nature can only be captured in painting through disciplined form and design. The visual recognizability is actually irrelevant. It may be there or not."[2]

Deliberate in his working method, using studies and preparatory drawings to work out tonal relationships and formal arrangements of delicately balanced compositions, Spencer produced at least two works related to *The Watch Factory: Factory, Sag Harbor* (c. 1950, The Newark Museum) and *The Watch Factory No. 2* (c. 1950, The Regis Collection, Minneapolis).[3] The subject of these works is a factory in Sag Harbor, Long Island, where Spencer purchased property and spent time beginning in 1948. Titles and dates in his work are often subject to dispute, with sequences and chronologies uncertain. Though *The Watch Factory No. 2* is titled as the second version, it would appear to be an earlier work. Subtle variations between the two versions are perceptible, the changes providing clarity, depth, and definition of spatial ambiguity in the larger finished painting. The tonal modulation in *The Watch Factory* is more subdued, and the tightened spatial configuration produces a more resolved composition. The artist has toned and lightened some areas to bring forth details and make other areas recede, as well as altering shadows, alignment of angles, and placement of windows.

Highly regarded by both colleagues and critics, Spencer's classical industrial landscapes, understated and remote, combined with his personal reticence, did not further his popular reputation or make his work more accessible to the public. He attempted occasional portraits, but apart from some notable still lifes, modernistic views of the landscape were his primary and most successful expressive vehicle. Unconcerned about artistic convention, the quiet contemplative mood of Spencer's work cannot be separated from the spirit in which it was created.

VALERIE ANN LEEDS

Steam Turbine, 1939
Oil on canvas, 22 × 18″ (55.88 × 45.72 cm.)
Signed, lower right
Museum purchase, 950-O-111

In 1938, Charles Sheeler was commissioned by *Fortune* magazine to produce six paintings extolling America's industrial power. Sheeler visited power stations across the nation, photographing selected sites which became the basis for the paintings.[1] These paintings, known collectively as Power, were reproduced in a portfolio supplement to the December, 1940, issue of *Fortune* and exhibited from December 2 to December 21, 1940 at Edith Halpert's Downtown Gallery.[2] The text of the Power portfolio claimed that Sheeler depicted machines not as "strange, inhuman masses of material, but exquisite manifestations of human reason," because the machine was to the present what the figure had been to the Renaissance. *Steam Turbine*, the fifth in the series, was based on one of the turbines at the Hudson Avenue Station of the Brooklyn Edison Company, New York, then the world's largest steam power plant. The curving, steam-filled loop dominates the composition; in the foreground are other machines such as heat exchangers, pumps, and automatic valves. Sheeler concentrated on the geometric perfection and implicit power of the forms, as he had done since his first big industrial commission, photographing Henry Ford's River Rouge Plant outside Detroit, in 1927.

Sheeler, who was born in Philadelphia in 1883, first succeeded as a painter. However, in 1912, after studying at the School of Industrial Art and the Pennsylvania Academy of the Fine Arts in Philadelphia, he began to support himself as an architectural photographer. From 1910 to 1919 he spent weekends in Bucks County where his interest in the beautiful expression of function in vernacular art and architecture, particularly that of the Shakers, became a subject for both paintings and photographs. In the 1920s, while working as a commercial photographer for Condé Nast, he was associated with artists who are now called Precisionists for the precise way in which they treated their themes, particularly industrial subjects. After a solo exhibition at the Downtown Gallery in 1931, he was known primarily as a realist painter, though beginning in the 1940s he sought to capture the overview of images as seen by the moving eye in semi-abstract paintings. Sheeler's

achievement was that he was both a distinguished painter and photographer and found a rationale for "machine art" between the world wars.

In 1928, Sheeler was commissioned to photograph the ocean liner, the *U.S.S. Majestic*. His work, *Upper Deck* (1929, Harvard University Art Museums, Fogg Art Museum), based on that photograph, was a turning point because, for the first time, Sheeler discovered how to achieve photographic qualities in paint. As he later recalled, "Starting with *Upper Deck* I have sought to have a complete conception of the picture established in my mind, much as the architect completes his plans before the work of bringing the house into existence begins."[3] Theodore E. Stebbins and Norman Keyes noted that in *Upper Deck*, "for the first time he did nothing to disguise or alter his photographic source."[4] In the case of both *Upper Deck* and the Power series, he used the photograph, rather than a sketch, as a preliminary study because a photograph gave "actuality" and "greater definition."[5]

Sheeler consciously sought an architectural structure and an impersonal surface, devoid of temperamental slashes of paint or layers suggesting sequences of time. He did not underpaint. He wanted to eliminate "the means to the end, meaning the technique as far as possible and to present the subject in itself without the distraction of the means of achieving it . . ."[6] But in Sheeler's best paintings, the impersonal surface shimmers; it is like a still reflection in a pond, not just a reflection of a single, unified image but an image of concentration.[7] In *Steam Turbine*, the precision of the geometric structure, the subtlety of the paint surface, and the nuances of color simultaneously convey both the information of a photograph and the qualities of a painting.

Critics were not always pleased with the obvious relationship between photographs and paintings in Sheeler's work. Milton Brown, perhaps his strongest critic, noted in his review of the Power series that the paintings were probably the most photographic of Sheeler's works, lacking the abstract quality of some of his earlier paintings. Brown found the color "cold and unexpressive." His severest criticism was that the paintings failed to capture the "dynamic energy

hidden within these engines of power, the potentialities of movement, creation, or destruction." But in saying that there was "no longer a question of any such principle as the relation of art to nature,"[8] Brown misunderstood Sheeler, because for Sheeler the detailed "exactitude" of photography offered the most complete view of nature and thus the best source for his art.[9]

MARLENE PARK

STUART DAVIS | 1894–1964

Gloucester Harbor, 1924
Watercolor and crayon on paper, 12¾ × 18″ (32.39 × 45.72 cm.)
Signed, lower right
Museum purchase, 967-W-101

Born in Philadelphia, Stuart Davis was to become one of the pivotal American painters of the twentieth century. From 1910 to 1913, Davis was enrolled in Robert Henri's New York art school, where he acquired his lifelong devotion to urban themes. In 1913, Davis exhibited five drawings in *The International Exhibition of Modern Art*, known as the Armory Show, where he received his first look at the insurgent art from Europe. The work of European artists Vincent Van Gogh, Pablo Picasso, and Henri Matisse, included in the exhibition, would influence and inspire Davis in his lifelong pursuit of building a new, American art style.

In 1915, Davis began to vacation in Gloucester, Massachusetts. There, in 1924, he produced *Gloucester Harbor*, which clearly shows the influence of Synthetic Cubism, especially in the broad planes and shallow space of the painting. The painting is divided into three distinct segments based upon a very strict horizontal alignment. Davis reorganized the elements in the scene, taking particular care to emphasize their geometric shapes. The uppermost section forms a grid, combining horizontal lines of clouds with the vertical elements of a clock tower, steeples, chimneys, and masts, all accomplished in a severe and highly stylized manner. Both upper and lower registers obey the artist's dictum, "The process of making a painting is the art of defining two-dimensional space on a plane surface."[1] The stylization and pallidness of these two components are counterpoints to, and thus help define, the painting's central section, which depicts, in the same plane, the doorway into and the roof of the Gloucester fish market. The awning of the fish market is converted into a staccato line of alternating gray and white stripes, providing a firm geometric base to the bottom third of the painting.

Consistent with all of Davis's work of this period, color follows the tenets of Synthetic Cubism and is subservient to the overall design. The use of color in this painting, concentrated in the red and yellow of the center panel, is quite subdued, but by the early 1930s, Davis's colors would brighten considerably and achieve the prominence for which they are known today.

The artist started working in collage in the early 1920s. Following the example of the Cubists, Davis initially glued onto his canvases pieces of paper containing various words and letters, but soon thereafter made the important change to painting the motifs. This gave him much more latitude in determining the scale and color of the lettering, and increased greatly its design possibilities. Davis's early collage experiments led to a lifelong incorporation of words, letters, and numbers into his work. These elements, traditional habitants of the printed page and devoid of mass, he used to emphasize the surface of the painting. In *Gloucester Harbor*, the 'FISH' sign is centered above the front of the fish market, and not coincidentally, at the center of the painting. Davis would continue to refine this technique, culminating in such works as *The Paris Bit* (1959, The Whitney Museum of American Art), where words and numbers, completely separated from any contextual connection, act as independent elements in the structure of the work.

While other artists preceded him in exploring the new art of Europe, it was Davis who imbued it with a distinctly American vitality, creating a body of work that places him among the preeminent artists of the twentieth century.

ROBERT KURTZ

THOMAS HART BENTON | 1889–1975

Chilmark, 1938
Watercolor on paper, 13 × 17″ (33.02 × 43.18 cm.)
Signed, lower left
Museum purchase, 938-W-101

Chilmark is a small community in southwest Martha's Vineyard, an island off the east coast of Cape Cod, Massachusetts. The terrain is rather hilly and looking westward toward the mainland, broad sandy areas with trees and shrubs are evident, as are the smooth blue waters of the vast Menemsha Pond in the near distance. In this very handsome watercolor titled *Chilmark* by Thomas Hart Benton, the view caught was topographically accurate when the work was painted in 1938. But ensuing years brought about many changes as the trees and bushes grew and in time obscured the view of the little white cottage, the low white enclosure wall, and much of the edge of the pond itself.[1] The setting must have had strong sentimental value to Benton, for at one time the white cottage was his summer residence.

During the 1930s Thomas Hart Benton was perhaps the best known of the so-called triumvirate of Midwestern Regionalist painters: Grant Wood, John Steuart Curry and Benton.[2] Like many other painters of the Great Depression era, Benton devoted himself largely to producing American Scene works that glorified the American way of life in both the past and the present.[3] Such a viewpoint fundamentally represented a conservative and highly nationalistic approach in contrast to the concomitant and more widely prevalent attitude of social protest which existed at the time. However, this work, executed during the late years of the Great Depression, does not overtly embody American Scene criteria such as a sense of social stability and permanence, strong nostalgic nationalism and glorification of American character, or the lucid

expression of dominant social values typical of a given geographic area. Instead, *Chilmark* is pure landscape painting, documenting the momentary and steadily shifting qualities of a natural setting. Instead of celebrating tradition and the American character, Benton has merely sketched the tranquil topography of a specific location, emphasizing those formal aspects which loomed large in his view when he studied the site in preparation for his sketch. For the subject here is transitory and doomed to change through the normal processes of growth and seasonal transitions.

In the context of Benton's oeuvre, this particular painting is hard to classify. Although it is a superb work, inspired by a specific location, it cannot be neatly fitted into any stylistic category. When we analyze this piece, we recognize it as a masterful abstraction of broad horizontal stretches of contrasting dark and light color masses and varying shapes and textures, all interlocking across the compositional field. The work is essentially non-objective, with scattered dashes, lines, extended masses, color densities, and all other forms and shapes except the cottage, seeming to lack literal representational identity. This creates ambiguity, inviting visual interpretations of all formal elements and their relationships. The contours of some of the forms echo one another, creating a compositional unity of diverse shapes. This in turn strengthens the internal dynamics of the piece, intensifying its visual interest and delight.

HOWARD E. WOODEN

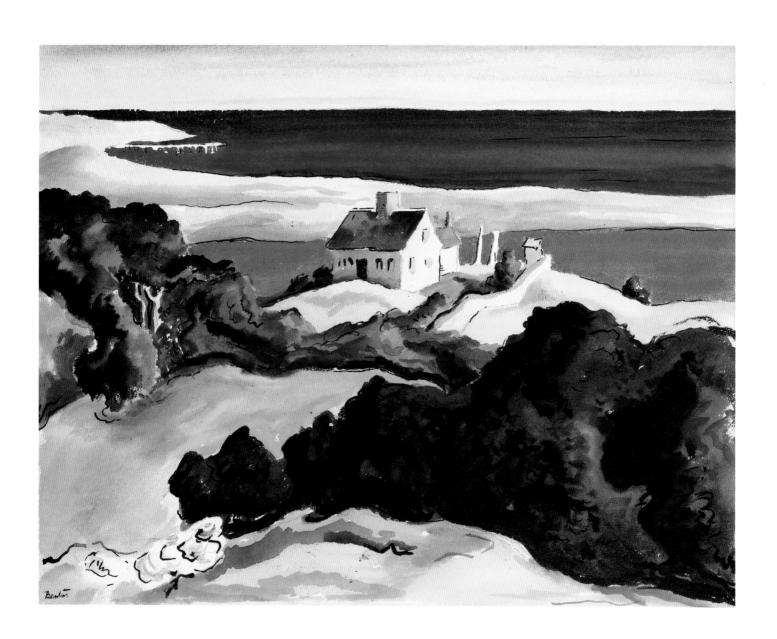

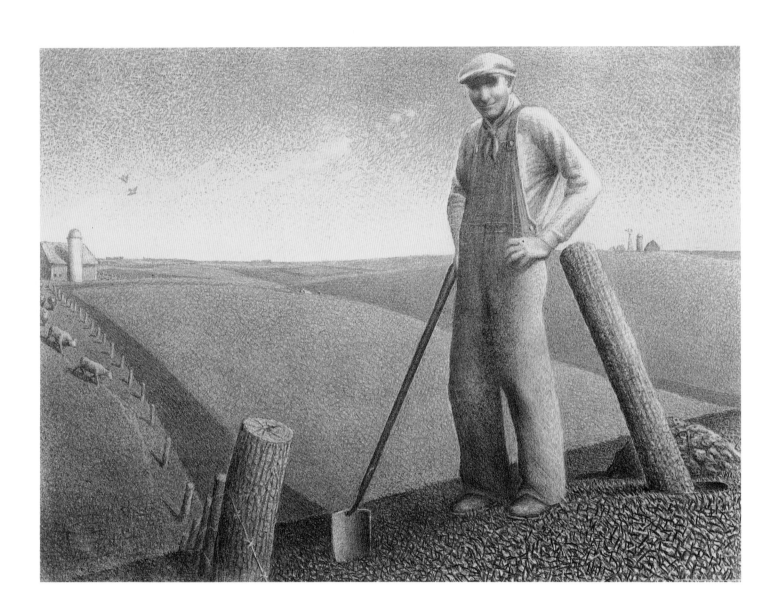

GRANT WOOD | 1891–1942

In the Spring, 1939
Pencil on paper, 18×24″ (45.72×60.96 cm.)
Signed, lower right
Museum purchase, 942-D-101

Grant Wood was one of the noted triumvirate of American Regionalist painters who first attained prominence during the years of the Great Depression. Wood, like the other two members, Thomas Hart Benton and John Steuart Curry, was born in the Midwest, and both his art and his personal philosophy reflected the values and traditions of this area, whose way of life, in the eyes of many, appeared to be seriously threatened by the industrial and technological advancements of the early twentieth century. Wood voiced his philosophy in an essay titled *Revolt Against the City*, written and published in 1935.[1] Although best known for such engaging paintings as *American Gothic* (1930, The Art Institute of Chicago), *Daughters of Revolution* (1932, Cincinnati Art Museum), and *Parson Weems' Fable* (1939, Happy Y. and John B. Turner, II Collection), some of Wood's most significant and technically accomplished works are a series of lithographs commissioned by the Associated American Artists in New York toward the end of the 1930s.[2] Even more important are the handsome preparatory pencil drawings which he executed for those lithographs.

In the Spring is one of the finest and most interesting of those original drawings. In this work, Wood glorifies the rich farm land and clearly displays his respect for the American farmer, shown standing proudly in the foreground, momentarily resting from his task of digging post holes for the installation of a new fence. Compositionally, the farmer functions as a *repoussoir* figure, calling attention to the vast flat land behind him, stretching deep into the distance without interruption except for the slight elevation of terrain at the right and the barn and a few cattle seen along the far left edge of the drawing.

Here Wood's drawing technique is precise. While pencil is the sole medium, the variations in value and texture which he is able to achieve are remarkable. But the most noteworthy aspect of this work is the underlying theme, which appears in almost every work by Grant Wood. Wood was dedicated to the natural environment, especially to the open space of the Midwest, where the interdependent relationship of man and nature was strikingly obvious as an ever-present reality. This theme is the subject of Wood's splendid drawing *In the Spring* and of the lithographs which derived from it. Indeed, in his essay *Revolt Against the City*, Wood went so far as to declare unapologetically, "To the East, which is not in a position to produce its own food, the Middle West today looks a haven of security."[3]

Wood also found particular delight in the rhythmic cycle of the seasons and therefore he perpetuated in his art the ancient mystical relationship between the appropriate labors of the four seasons and the seasonal changes themselves.[4] It is understandable that Wood chose Spring as the theme of this work, since Spring is seen as a time of rebirth, a time when the farmer's toil contributes to the renewal and the beginning of a new cycle of life. It is of interest that the last painting which Wood completed before his death was titled *Spring in Town* (1941, The Sheldon Swope Art Museum, Terre Haute, Ind.).

HOWARD E. WOODEN

251

JOHN STEUART CURRY | 1897–1946

Sanctuary, c. 1936
Watercolor on paper, 14 × 21″ (35.56 × 53.34 cm.)
Signed, lower right
Museum purchase, 941-W-106

John Steuart Curry was born on a farm just outside of Dunavant, Kansas. Early in his youth he developed an attachment and respect for farm animals as well as an understanding of how weather conditions can affect farm life, both for humans and animals alike. At the age of nineteen he began to study at various art centers, including the Kansas City Art Institute, 1916, the Art Institute of Chicago, 1916–18, and Geneva College, New York, 1918–19. In 1926, he spent a year in Paris, where he became acquainted with the works of the old masters, especially Peter Paul Rubens, Gustave Courbet and Honoré Daumier. Soon after his return to the United States he settled in New York City, taught at the Art Students League and Cooper Union, and for a brief time traveled with the Ringling Brothers Circus. Throughout his life he remained closely associated with the Midwest and made frequent visits to his family and friends in Kansas. Indeed, the bulk of his painting is closely associated with Kansas farm life where, in the natural setting, he found action and excitement and often terror and disaster.

Curry's painting, *Sanctuary*, was inspired by a disastrous flood of the Kaw River in 1929 near Lawrence, Kansas.[1] Serious damage was widespread, and losses were enormous. Entire farms were inundated, homes were swept away, and farm animals were drowned. Curry witnessed the effects of this tragedy, which apparently left an indelible impression on his mind. Four years later in 1933, and many times thereafter, he expressed his compassion in compositions consisting of a small island of high dry land, standing out in the midst of high waters.

Curry produced numerous versions of this same motif, including pencil and pen sketches, watercolors, and lithographs, almost down to the time of his death. These compositions were titled *Sanctuary*, for they portrayed the site where a group of farm animals, including a mule, a mare, three cows, and two hogs, had found refuge from a flood. Amusingly, Curry also included a family of drenched skunks, trailing along the edge of a log from the waters onto dry land. The Butler Institute's *Sanctuary* is an undated but finished watercolor, possibly executed about 1936.[2]

In terms of loss and survival, closely associated with this composition are two matters that deserve mention. First, as we have already seen, the composition reflects the widespread concern over the disasters of major flooding. Not only in Kansas was there fear of a possible repetition of the 1929 Kaw River flood, but there were also clear recollections nationally of the Mississippi River flood of 1927, which had resulted in an estimated loss of $270 million and which Herbert C. Hoover, then United States Secretary of Commerce, had called ". . . the greatest peacetime disaster that the United States has ever known."[3] Those concerns inevitably found symbolic expression in another composition by Curry, who interpreted tragic loss and the human urge toward survival in terms of the Biblical story of Noah and the Ark. Curry, recalling the 1927 Mississippi flood, produced a lithograph titled *Mississippi Noah* (1932), as well as a tempera painting of essentially the same composition titled *Mississippi* (1935, St. Louis Art Museum). Both of these depict an African-American family who have taken refuge atop a wooden shack, which appears to be floating down the flooding river. Conceptually, these two works make the same essential statement as the various works titled *Sanctuary*.

Second, the earliest version of *Sanctuary* was drawn in 1933, at the height of the Great Depression, when, in broadest terms, the notion of relief and sanctuary was of utmost concern throughout the nation. And in the Midwest, sanctuary was often identified with the farm and the capability of the farm to produce food, both grain and animals, and thus ensure human sustenance, a realization widely voiced by the Regionalists and particularly by Grant Wood and his close associate John Steuart Curry.[4]

It is also noteworthy how an artwork such as *Sanctuary* so fully mirrors the social and economic characteristics of its time, and how powerful the image was to Curry for him to have repeated it so often throughout his life.

HOWARD E. WOODEN

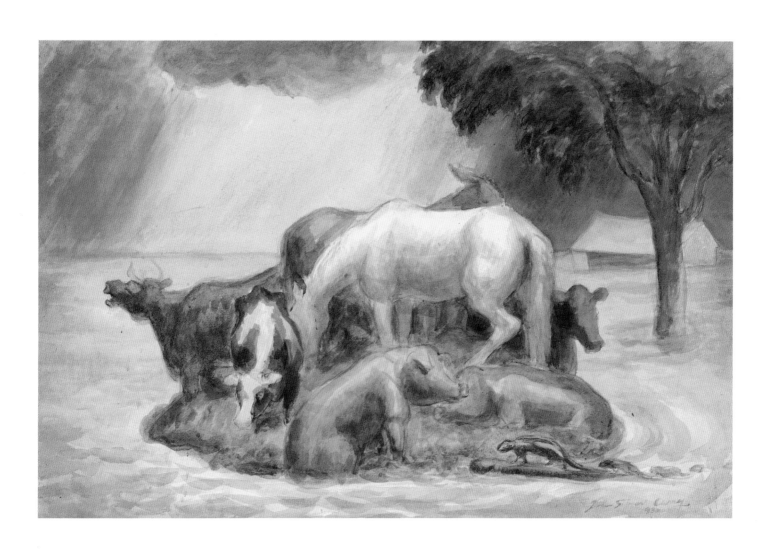

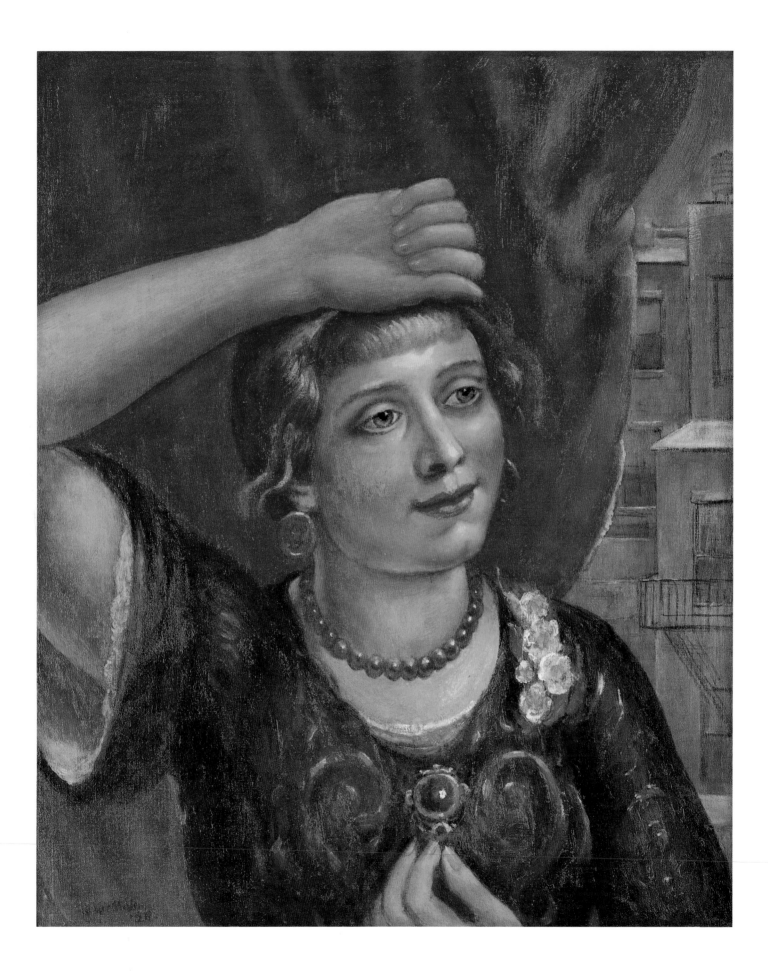

KENNETH HAYES MILLER | 1876–1952

By the Window, 1928
Oil on canvas, 24×20″ (60.96×50.80 cm.)
Signed, lower left
Museum purchase, 991-O-108

Kenneth Hayes Miller became a committed painter of the American scene in 1923 when he moved his New York studio to the bustling neighborhood of shops and restaurants on East Fourteenth Street near Union Square. From that moment on his canvases are dominated by aspiring middle-class women whose lives he saw played out in the streets outside his studio windows. Miller tried to depict women objectively, refusing either to idealize their beauty or satirize their existence. In response to the young Reginald Marsh's complaint that the people on Fourteenth Street, whom Miller had encouraged his pupil to paint, were ugly, the artist replied simply, "They are ugly; they are people. Buy a pair of field glasses."[1]

Though prettier than most, the young woman in *By the Window* is typical of the robust, plump-faced women who populate Miller's mature paintings. Lost in a moment of reflection, the woman faces the viewer, pressed close to the surface of the picture plane, her back to the window from which one can easily imagine she has just turned and back through which she continues to cast a sad-eyed gaze. The stark glimpse of crowded buildings with a fire escape visible beyond the edge of the lush red drapery not only establishes the necessary urban setting for Miller's intimate drama, but helps create the picture's mood of lonely reverie.

The painting is filled with an air of both expectation and disappointment. Dressed up, perhaps to go out, the young woman waits longingly by the window. That for what or for whom she waits is quite probably linked to romance is subtly implied not only by the wistful attitude of the figure but by the way the woman lightly fingers her brooch, around which the shape of a heart has been created out of the swirling gold patterns on her dress.[2] That the young woman calls to mind the countless women in paintings since the Renaissance who have waited for their destiny to find them is far from fortuitous.

Miller saw himself as far more than a simple, contemporary realist. A fierce defender of what he always referred to as "the Great Tradition" of Western art, he considered his paintings to be a continuation of a living tradition that stretched back through the Italian Renaissance to Classical Greece. He intended his figures to be seen simultaneously as the embodiment of modern American womanhood and the descendants of the women of Titian, Peter Paul Rubens and Pierre-Auguste Renoir. As a young painter still studying at the Art Students League, Miller had been inspired to this lofty aim by the work of the nineteenth-century French painter, Eugène Delacroix: "His paintings proved to me that it was possible to bridge the gulf between the old masters and moderns, and that is what I have been trying to do ever since."[3] Miller's emulation of tradition even extended to his painting technique, which utilized the time-honored practice of building up the weight and solidity of his figures with layers of pigment and glazes.

Though critics often lamented Miller's refusal to give his paintings any decorative charm and many simply dismissed his "attempt to make Titian feel at home on Fourteenth Street and crowd Veronese into a department store," Miller was considered a leading urban realist by his contemporaries.[4] He was one of the first artists to have his work represented in the collection of the Museum of Modern Art after its founding in 1929. As the central figure of the coterie of realist artists that became known as the Fourteenth Street School, Miller left a vital legacy through the work of his students Isabel Bishop and Reginald Marsh.[5]

NANNETTE V. MACIEJUNES

255

ISABEL BISHOP | 1902–1988

Laughing Head, 1938
Mixed media on panel, 13 × 12″ (33.02 × 30.48 cm.)
Signed, lower right
Museum purchase, 940-O-104

B orn in Cincinnati and raised in Detroit, Isabel Bishop came to New York at age sixteen to study illustration at the New York School of Applied Design for Women. She soon transferred to the Art Students League, studying under Kenneth Hayes Miller and Guy Pène du Bois, and, in 1934, she leased a studio on Union Square where she worked for the remainder of her career. Sometimes grouped with Miller and Reginald Marsh as the Fourteenth Street School, at other times associated with artists like Edward Hopper and Raphael and Moses Soyer, Bishop remains America's most distinctive depicter and visual poet of urban working women.

Isabel Bishop has been described by the painter R. B. Kitaj as "the best female artist America produced (aside from Cassatt)."[1] Like Mary Cassatt, Bishop's greatest creative strength was an extraordinary drawing ability. Though successfully harmonized, her color is characteristically muted and subordinate to effects of luminosity, expressed in her later work as a kind of flickering syncopation suggesting the complex motion of the city. Bishop stated that her earlier work was about the capacity for movement, while her later works portrayed movement itself.[2]

Among Bishop's greatest inspirations were the Baroque painters of the seventeenth century, and some of her early works involve a close study of extreme and unflattering facial expressions in the tradition of the youthful Rembrandt van Rijn's self-portrait etchings.[3] In the 1930s and 1940s, Bishop drew, painted, and etched a series of close-ups which capture the female face in unexpected poses: flashing perfect teeth while applying lipstick, tightening a cheek to touch up a blemish, opening a mouth wide to bite a hot dog, or grimacing while reaching deep to test an afflicted tooth. However, what especially distinguished Bishop's work from the Baroque

masters is the fact that her principal subject matter was always women. Her individual heads, her nudes and especially her interacting female couples sound a rare and distinctive modern note in both American and European art.

In the original drawn study for this painting,[4] five different heads appear. Two incline to the right and three others, one of which is disposed quite similarly to the painting, lean more gradually to the left. The Butler Institute also owns a print of the same subject,[5] which offers an interesting comparison. Extending the vertical length of the composition, the etching loses the painting's four-square focus. At the same time, the normal compositional reversal of the print implies a glance directed more pointedly outward than the gaze in the painting, whose more complex contrapposto and wistful, equivocal smile suggest greater inward reflection.

Within the nearly-square boundary of the painting, Bishop gave her *Laughing Head* the casually dominant shape of a Venetian nobleman, and tilted her subject's face into a three-quarter pose evoking the dynamism of a Peter Paul Rubens sketch, whose blond tonalities her technique also echoes. *Laughing Head* is among the earliest of Bishop's expressive faces, though the expression it renders is one of the most elusive and complex she ever undertook. From archaic korai to the Mona Lisa, the female smile has been a male metaphor for mystery, seduction, and alarming secrets. Bishop's image has replaced the sinister smirk of the fatal woman or the sensual come-hither of the pin-up model and odalisque with the more authentic, less dramatic miracle of daily laughter: the face of an ordinary, plump woman, spontaneously illuminated by a smile.

JAMES THOMPSON

REGINALD MARSH | 1898–1954

The Normandie, 1938
Watercolor on paper, 30 × 50″ (76.20 × 127.00 cm.)
Signed, lower right
Museum purchase, 962-W-115

Reginald Marsh is best known for his paintings of New York City: burlesque shows, Coney Island, the Bowery, movie houses, and elevated trains. His favorite place was Coney Island, where he rapidly sketched and photographed the bathers, an endless source for him of anatomies, postures, and compositions. But in the mid-1930s Marsh was engaged in mural painting, often depicting scenes of ships in New York Harbor. In 1936 he executed two panels for what is now the Federal Building in Washington, D.C. In August, 1936, the Treasury Relief Art Project hired him to paint the ceiling panels of the great hall of the Custom House on Bowling Green, New York City, designed by the architect Cass Gilbert. Between September 18 and December 21, 1937, he painted in *fresco secco*, or on dry plaster, eight small and eight large panels, the latter chronicling the arrival of three ocean liners in New York: the American *Washington*, the British *Queen Mary*, and the French *Normandie*.[1]

In 1938, he executed three closely related easel paintings inspired by his work for the Custom House, in particular by the French Line's newest, fastest, and most luxurious transatlantic liner, the *Normandie*. One, an etching and engraving, of which Marsh printed twenty impressions on June 30, 1938, is entitled *Battery (Belles)*, and shows a woman striding from the left side, holding her hat against the wind. Beyond the railing are a Dalzell Company tug, identified by the company "D" on its stack, and the unmistakable three stacks of the great ship. The harbor is identified by the Statue of Liberty in the far left background.[2] Another, a large tempera (30 × 40 inches) entitled *Belles of the Battery* (The Sheldon Swope Art Museum, Terre Haute, Ind.), depicts a similar Battery view, except that the Statue of Liberty is between the figures and the tugboat stack, and the tug has an "M" to identify the company. The Butler Institute's *The Normandie* is the third of this series. It is a larger watercolor, also originally entitled *Belles of the Battery*, and shows two women in the left foreground, one in the same striding, hat-holding posture as in the etching. As in the etching, there is a Dalzell tug. Marsh was in the habit of painting in the daytime and working on prints or photographs in the evening, so he was probably working on the print and the paintings at the same time. But when compared

to the other two compositions, the watercolor *The Normandie* seems more spontaneous, more full of movement, suggesting it was executed first. The watercolor is also the closest to a rapidly executed sketch, showing two women walking by the tug with the *Normandie* in the background. Marsh's accuracy in representing modern ships is comparable to that of nineteenth-century marine painters such as Fitz Hugh Lane, who made the elaborate rigging of sailing ships part of their design.

As Lloyd Goodrich noted, the more crowded earlier compositions gave way, after his experience as a mural painter, to "more deliberate design," compositions with fewer figures and deeper spaces.[3] *The Normandie*'s composition bears out this observation, and also provides a transition between his earlier mural work and the large, finished watercolors upon which Marsh concentrated in 1939 and 1940. The transition to simpler, somewhat more colorful watercolor compositions such as *The Normandie* may also have been stimulated by criticism of Marsh's temperas. Though critics noted that the temperas in his 1938 solo exhibition at the Frank K. M. Rehn Galleries, New York, were more colorful and better composed, they still noted a "veil of murkiness over each of the pictures."[4]

A publicity photograph by Fritz Henle from Black Star Publishing Company among Marsh's papers at the Archives of American Art shows Marsh in his ninth floor studio at One Union Square. He holds brushes and palette in one hand and in the other, binoculars with which he observes the figures and crowds below. On the easel is *The Normandie*.[5] The photograph is a key to the contrasts in Marsh's background and interests; for he was at once the recorder of the crowds of ordinary people in New York, and a well-educated and well-traveled admirer of the Old Masters.

The son of the artists Fred Dana Marsh and Alice Randall, Reginald Marsh was born in Paris, but the family settled in New Jersey when he was two. After graduating from Yale University in 1920, Marsh moved to New York where he worked as an illustrator for *The Daily News*. It was Kenneth Hayes Miller, with whom he studied at the Art Students League in 1927 and 1928, who opened his eyes to the possibilities of making the subjects of his drawings

Figure 1. Reginald Marsh. *Two Girls on Boardwalk*, 1934. Tempera on canvas, 16×12″ (40.64×30.48 cm.). Signed, lower right. The Butler Institute of American Art. Museum purchase, 962-O-129.

the subjects of his art. Marsh was a great draughtsman, but did not think he would be a painter, for as he recalled, "Painting seemed to me then a laborious way to make a bad drawing . . ."[6] He disliked oil, but of watercolor he said, "Watercolor I took up and took to it well, with no introduction." In late 1929 Thomas Hart Benton and Denys Wortman introduced him to egg tempera on a gesso ground, which "opened a new world to me" because it was the perfect medium for a draughtsman.[7] In 1930, having found his subjects and his techniques, Marsh joined the Frank K. M. Rehn Galleries and enjoyed artistic success and recognition for the rest of his life.

MARLENE PARK

September Wind and Rain, 1949
Watercolor on paper mounted on board, 22×48″ (55.88×121.92 cm.)
Signed, lower right
Museum purchase, 953-W-102

Charles Burchfield was a keen observer of nature, who, as he said "early formed the habit of wandering off to the woods and fields by myself, or accompanied only by a dog, in search of wild flowers in the spring, or colored leaves in the fall. . . ."[1] He kept a journal as full of poetic and moving nature imagery as are his paintings. He also kept portfolios with notes on his observations for each month of the year. Of September he noted: "Nature . . . has forsaken her secluded haunts, the woods, and has gone forth boldly to the fields."[2] Burchfield's memories of childhood and his imaginative fantasies were as important as his naturalist's observations.

Unlike his inward life, his outward life was deceptively simple, one of work, first to support himself and later his family. After his father's death the family moved to Salem, Ohio, where he attended public schools and worked from the seventh grade onward. After graduation from high school, he attended the Cleveland School of Art (1912–16), intending to become an illustrator, but while there decided to be a painter. After serving as a camouflage artist in the army, he moved to Buffalo in 1921 and for almost a decade designed wallpaper. In 1929, when Frank K. M. Rehn became his dealer, he was able to devote himself to painting. John I. H. Baur, with Burchfield's concurrence, saw in his work an early period from 1915–21, when he treated landscape in realistic, decorative or fantastic ways; a middle period, 1921–43, when he painted the Middle West more realistically; and a late period, when he returned to fantastic landscapes. Baur called him the last of the pantheists.[3]

Burchfield valued the intensity of his work and avoided dissipating it: "My instinct has always been to shut off all means of self-expression except the brush, so that its product might be all the more intense."[4] For the same reason he avoided making color sketches because "It takes a little bit of the edge off what you want to create." Watercolor was his favorite medium, and he worked in "any one of three different ways. I go out and paint directly from a subject—or use a subject to improvise; or I work, and then bring the work into the studio and complete it; or, I sketch, and then do the whole picture in the studio." (Fig. 1)[5] In watercolors such as *September*

Figure 1. Charles Ephraim Burchfield. *September Wind and Rain*, n.d. Ink and conte on paper, 5½×13½″ (13.97×34.29 cm.). Signed, lower left. The Butler Institute of American Art. Museum purchase, 958-D-104.

Figure 2. Charles Ephraim Burchfield. *Late Winter Radiance*, 1961–62. Watercolor on paper, 44×26½″ (111.76×67.31 cm.). Signed, lower left. The Butler Institute of American Art. Museum purchase, 962-W-113.

Wind and Rain, he did not use a traditional watercolor technique. "I use a dry paper and what is called a dry brush, which isn't dry, of course, in that it has the minimum amount of water on it, and I stand them up just like that is on the easel there and work on it just like . . . painting an oil painting. . . ." This technique had two advantages, one, that he could make changes: "I would take a sponge and wipe that out and do it over again . . . and the way it is done you wouldn't know that it wasn't put there originally." The other advantage was that he could sit back and study large pictures: ". . . I put something on, then I come back and sit—and look at it—did it work? Or didn't it?"[6]

In 1949, the year that he painted *September Wind and Rain*, he taught for the first time during the summer session at the University of Minnesota at Duluth. Describing teaching as a "major disturbance,"[7] he nonetheless taught a special class at the Art Institute of Buffalo and continued to serve as a member of the Board of Trustees of the American Academy in Rome, Italy.[8] Teaching, though disturbing, gave him the income he needed to produce his much admired later works. While teaching at Duluth, he began to enjoy the Finnish writers recommended to him by a Finnish editor in Duluth: "Thus was I introduced to a whole new world of literature: Alexis Kivi–*The Seven Brothers* . . . F. E. Sillanpää–*The Maid Silja*, Unto Seppänen–*Sun and Storm*, Sally Salminen–*Katrina*. The great charm for me in these works is not only the able characterization of the human beings involved, but also . . . for the remarkable descriptions of landscapes, nature, seasons, and weather."[9] The Finnish writers struck a responsive chord because Burchfield had always been fascinated by the weather, recalling: "I like the drama of the progression of the seasons. . . . I've been interested in weather since I was a little kid. When I was in the third grade, at the end of each day, I'd write down on my mother's big kitchen calendar what kind of weather we had that day."[10]

The 1940s marked the transition from Burchfield's middle to third period, the return to fantastic landscapes. Baur described this as the return of the spirit of 1917, when Burchfield's youthful fantasies were at their height.[11] By 1949, this return was not unconscious, for in his journal Burchfield wrote that some unfinished works "must increase their fantasy character still more and reduce or even eliminate my realistic approach. They must be distilled into pure art forms. The blend of realism and conventionalized fantasy is a compromise and they lose power for that reason."[12] *September Wind and Rain* has all the power he desired in its suggestive black lines and shapes, contrasting with patches of white, gray, blue, green and yellow, the echoing shapes symbolizing as much as representing wind and rain. Such loosely painted shapes and patches create a surface pattern of great ingenuity and vitality. In the midst of this drama of the approach of winter, an orange butterfly seems unaffected, perhaps symbolizing not only the brevity and fragility of life, but its continuity.

MARLENE PARK

261

EDWARD HOPPER | 1882–1967

Pennsylvania Coal Town, 1947
Oil on canvas, 28 × 40″ (71.12 × 101.60 cm.)
Signed, lower left
Museum purchase, 948-O-115

Shoshone Cliffs, Wy. (Fig. 1) is one of three watercolors that Edward Hopper painted during an automobile trip to the West Coast in 1941.[1] He and his wife, the painter Josephine Nivison Hopper, spent eight nights in Shoshone Valley, Wyoming. There, on July 9, Hopper began this picture at the base of the Holy City rock formations. The dramatic red sandstone rocks prompted him to work outdoors, near the river at the bottom of the escarpment, rather than to paint in his parked car as was his custom.[2] His progress on what was an atypical subject for him was disturbed by rainy weather. Three days passed before he could return to the site. Finally, on July 15, Hopper was able to finish his watercolor and he and his wife headed back to the East Coast. In addition to this drive to the West Coast in 1941, Hopper had traveled in the Midwest as an exhibition juror. Such trips prompted him to turn from his usual locations in New York City and New England to focus on the look of other regions. Fiction set in regional America also aroused his imagination. When an interviewer asked what he thought of the work of Theodore Dreiser or Sherwood Anderson, he had replied, "They're a little too Midwestern for me."[3] On another occasion, although he called Sinclair Lewis "a fathead," he admitted that Dreiser was "all right," and he expressed unusual enthusiasm for Anderson, pronouncing him "a good writer."[4]

Hopper's fascination with the abstract shapes of *Shoshone Cliffs, Wy.* recalls the many oil paintings of Monhegan Island's rocky shore that he had produced in Maine during the late 1910s.[5] He had not then found his mature style and he did not choose to show these panels in later years. Yet in both this watercolor and in these earlier Monhegan scenes, the dramatic contrasts of light and shadow on the rugged natural shapes must have been what appealed to him.

While his watercolors were always painted on location, Hopper's mature oils were often imagined scenes based on various places. Hopper finished his canvas *Pennsylvania Coal Town* in his New York studio on April 23, 1947. This picture depicts the figure of a bald man raking leaves by the side of a nondescript house. The scene is the closest Hopper ever came to expressing sympathy with the masses. It brings to mind Hopper's student sketch after Jean-François Millet's *Man with a Hoe* (1863, Musée du Louvre).[6] In her husband's record book, Josephine Hopper noted that the grey steps were dark and that the terrace was sooty; she identified the glum, lonely figure of a man with red hair as a Pole, picking an immigrant ethnic working-class group of that region.[7]

Pennsylvania Coal Town brings to mind Sherwood Anderson's 1917 novel *Marching Men*, set in the Pennsylvania coal region in a town called Coal Creek. The novel, which Anderson dedicated "To American Workingmen," comments on the oppressive

Figure 1. Edward Hopper. *Shoshone Cliffs, Wy.*, 1941. Watercolor on paper, 20 × 25″ (50.80 × 63.50 cm.). Signed, lower right. The Butler Institute of American Art. Museum purchase, 954-W-112.

routine of workers' lives.[8] Anderson described the town as "hideous . . . a necessity of modern life."[9] Hopper's painting of the man with the rake recalls Anderson's description: "An Italian who lived in a house on a hillside cultivated a garden. His place was the one beauty spot in the valley. . . . When a strike came on he was told by the mine manager to go on back to work or move out of his house. He thought of the garden and of the work he had done and went back to his routine of work in the mine. While he worked the miners marched up the hill and destroyed the garden. The next day the Italian also joined the striking miners."[10] In fact, Hopper suggests the "Italian" ethnicity of the man with the rake by including an unexpectedly elegant object at the front of the otherwise dreary house: a classical terra cotta urn on a stand, an Italianate garden ornament illuminated by the same sunlight that shines on the man's bald head. Although Josephine Hopper referred to the figure in Hopper's painting as a Pole, instead of an Italian, the novel also discusses Polish immigrants:

"In little Polish villages the word has been whispered about, 'In America one gets much money. . . .'"[11]

Hopper shared certain expressive qualities with Anderson. Both knew how to be suggestive rather than literal. By refusing to be explicit, both the writer and painter were able to call upon the imaginative powers of the audience. Both were selective and indefinite, rather than inclusive, precise, and demonstrative. Before becoming established, Anderson had written advertising copy and Hopper had been forced to earn his living as a commercial illustrator. Hopper subsequently rejected illustration and did not want to paint anecdotal pictures. Instead he chose to express a mood or feeling. He described his aim rather well when he responded to a question about "what he was after" in a later painting, *Sun in an Empty Room* (1963, private collection): "I'm after ME."[12]

GAIL LEVIN

WILLIAM GROPPER | 1897–1977

Youngstown Strike, c. 1937
Oil on canvas, 20 × 40″ (50.80 × 101.60 cm.)
Signed, lower right
Museum purchase, 985-O-106

During the years of the Great Depression, industrial strikes and incidents of strike-breaking occurred across the country, especially in the coal mining and steel production centers. Indeed, this was a time when social unrest had spread to all trades and crafts throughout America. By the mid-1930s, the nation had suffered more than 2,000 strikes.[1] It is understandable, then, that the strike theme appeared so frequently in the art produced by socially-conscious artists of the period.

New York artist William Gropper, who was actively engaged in support of the organized labor movement throughout his career, produced some of the most gripping social protest works of the period. *Youngstown Strike* is one of Gropper's most compelling works, apparently prompted by the extended strikes staged in 1936–37 by workers at the Youngstown Sheet and Tube Company, Youngstown, Ohio. During these years chaos frequently reigned throughout much of the city. In one incident, following a savage confrontation with police guards by workers and their families, the police tear gassed and shot at the workers; two strikers were killed and twenty-eight injured. Gropper visited Youngstown during this period, and commented on the incident in an article and a series of descriptive action sketches published in *The Nation*.[2]

What is particularly significant, however, is the fact that this painting depicts not the 1937 strike, but rather a similar incident that occurred in an early 1916 steel strike in Youngstown. This fact reflects the long-term commitment of Gropper, and of many other artists of the Great Depression, to depict past incidents that could logically serve to illustrate primary causal forces for the social disruptions of the 1930s.

The 1916 strike at the Youngstown Sheet and Tube plant was declared on January 6 by the 8,000 employed workers, seemingly as a result of wage demands as well as the employees' wretched housing conditions. On the following day, January 7, the strikers' wives and other members of their families joined in protest outside the factories. In an attempt to disperse them, company guards employed tear gas bombs and thereafter fired into the crowd; three strikers were killed and twenty-five others were wounded.[3] Gropper's painting depicts the chaotic moment immediately after the shootings when the dead workers are lying on the ground and the shocked crowd expresses its outrage at the atrocity. The similarity between the conditions which led to this tragedy and those which had continued to prevail during the ensuing decades constituted Gropper's message of anger and dismay at this crucial moment.

In portraying this 1916 incident twenty years after it had occurred, Gropper demonstrated his active sympathy for the cause of American labor. Indeed, Gropper apparently looked upon the incident of 1937 as a replay of the 1916 strike. In painting *Youngstown Strike* in 1937, he portrayed the workers of 1916 and their families as if they had returned from the past to re-enact their tragedy, reminding the viewer, as well as the exploited laborers themselves, of the falsity of management's assurances. The movements of the excited figures appear artificial, yet it is by the use of such rhetorical gestures that Gropper could best express his outrage. At the same time, the figural organization, the strong colors, the body gestures and facial expressions, the powerfully bright light, abruptly contrasting with the almost black background and, above all, the heavy impasto with its energetically restless movement, effectively echo the miasmic diabolism of the incident, and the suffering and desperation of the period. *Youngstown Strike* is a powerful work that forcefully communicates the mood of despair which so characterized the Great Depression.

HOWARD E. WOODEN

264

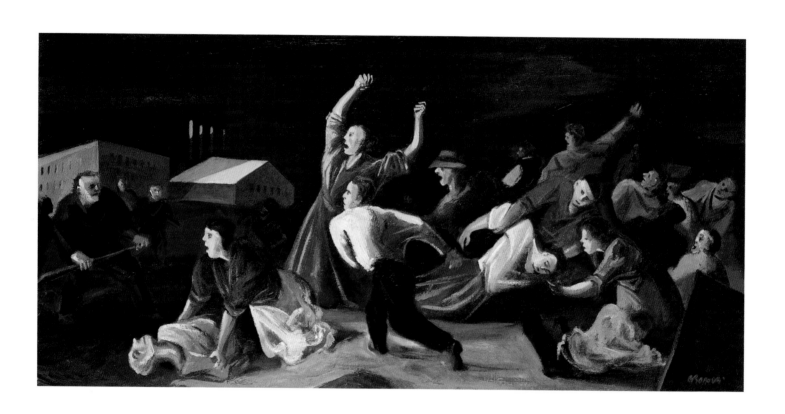

BEN SHAHN | 1898–1969

Inside Looking Out, 1953
Casein on paper, 17 × 15″ (43.18 × 38.10 cm.)
Signed, lower right
Museum purchase, 954-W-120

Ben Shahn was one of America's most intellectual artists of the twentieth century. Born in Lithuania in 1898, he settled permanently in the United States in 1906. His compassionate understanding of socio-economic and political issues throughout his career, especially during the Great Depression, was given powerful expression in many of his well-known Social Realist compositions, such as *The Passions of Sacco and Vanzetti* (1931–32, The Whitney Museum of American Art) and *Parade for Repeal* (1933, Museum of the City of New York), which clearly illustrate the significance of content in his art.[1] Shahn painted his ideas, whether they were expressions of social protest or philosophical thoughts. In essence, Shahn was always a teacher. He wrote lucidly and convincingly and through his paintings tried to induce the spectator to participate in the action depicted and thereby discover new meanings and truths. The spontaneity of his brushstroke emphasized the importance of the subject. *Inside Looking Out* is a carefully devised composition which invites a variety of interpretations, one of which is an exploration of the mysterious effect of spatial relationships in communicating meaning. In this work, the artist presents conflicting views of interior space, and in so doing tricks the eye of the spectator.

The form which catches attention at first glance is the large bureau standing against a dark green wall, surmounted by a tall framed mirror. To the right is an open view of an adjacent room with a black and white checkerboard tile floor, suggestive of contemporary Op Art design. With the exception of an old-fashioned treadle sewing machine on a wrought iron stand, the room appears to be entirely empty. As we view the composition more carefully, we note that detail is used sparingly but sufficiently to divert attention momentarily from the most significant element of the work: the mirror reflection of a young woman dressed in gray. She is seated on a slender chair with her back to the viewer, apparently writing and simultaneously peering out of a rectangular window shaded by a half-drawn dark blue window blind. This reflection is the key to understanding the formal significance of the painting.

At first glance the woman appears to be within the pictorial field of vision, her reflection as far from the spectator as the sewing machine. Closer analysis reveals that in reality she must be located at a considerable distance behind the viewer, while the sewing machine is in front of him. Finally, the exterior space into which the seated woman appears to be gazing is not adjacent to the sewing machine room as it seems at first, but is on the opposite side of the house altogether. It is especially interesting that all elements in this painting are inert, with the exception of the woman, who is projected into the pictorial space as a reflection from behind the viewer. Thus, the mirror and its reflections expand the pictorial space, giving visibility to the unseen. Philosophically, the painting focuses specifically on the question of what is real and what is merely illusion. This is the central issue of the painting.

The use of a mirror to create ambiguous spatial relationships occurs frequently in earlier periods of art history. Notable examples include *Giovanni Arnolfini and His Bride* (The National Gallery, London), by the fifteenth-century Flemish painter Jan van Eyck, *The Bar at the Folies-Bergères* (Courtauld Institute, London), by Edouard Manet. Both comprise intentionally built-in ambiguities and demand active participation and careful analysis on the part of the spectator, who must unravel the formal conflicts that trick the eye.

The same is true in Shahn's *Inside Looking Out*. Although the compositional elements of the setting are familiar and readily identified, their spatial relationships are intentionally confusing and contradictory, a deliberate denial of communicative clarity that demands participative involvement. This is the visual equivalent of an observation made by Shahn himself, shortly after completing the painting: "One does not judge an Einstein equation by its communicability, but by its actual content and meaning."[2]

HOWARD E. WOODEN

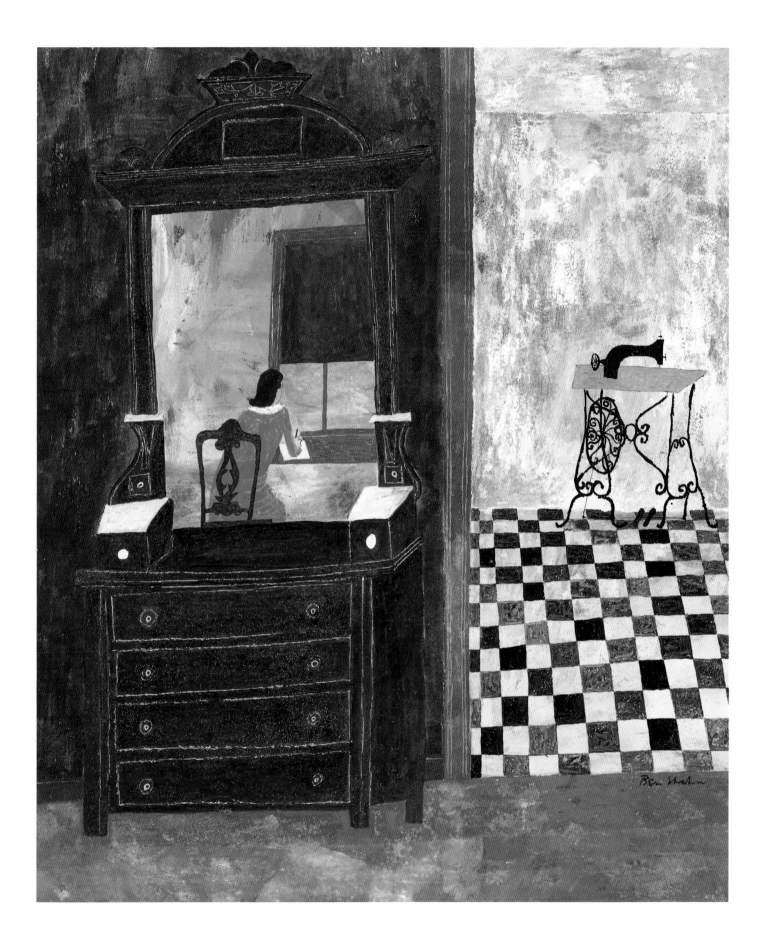

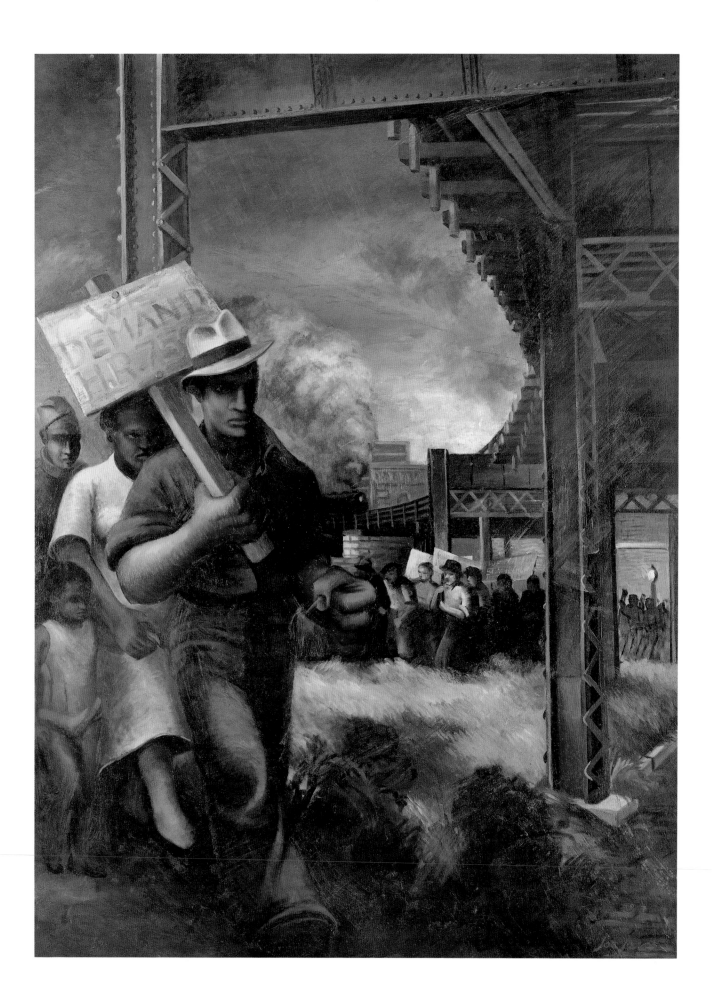

JOE JONES | 1909–1963

We Demand, 1934
Oil on canvas, 48 × 36″ (121.92 × 91.44 cm.)
Signed, lower right
Gift of Sidney Freedman, 948-O-110

Considering the grim economic hardships encountered by industrial workers during the turbulent years of the Great Depression, it is understandable that labor's demand for social and economic change was one of the dominant issues facing the nation. During the early years of Roosevelt's New Deal Administration, many of the existing problems were alleviated through legislative action by the government. One of the most significant actions was the right granted labor under the NIRA in 1933 to organize and bargain.[1] This was a gigantic step forward and one that suggested that at least some of labor's long-term goals were finally being achieved. The mood of protest was certainly not new, but now such protest was legal, and as a result, strikes were regularly called across the country, especially in the coal mining, steel production and transportation industries. Nevertheless, fear, unfair practices in the industrial workplace, violence and strike-breaking persisted for many years. As early as 1930, the mood of social protest began to assume major thematic proportions in American art, the subject of strikes in particular appearing often as the 1930s progressed.

One of the most provocative artistic statements produced during these years, and one promptly recognized and appreciated when it was first publicly exhibited, is *We Demand*.[2] Here at a glance the subject of protest is entirely understandable, however, the most powerful and convincing qualities of this composition are achieved through color organization and formal geometry. In particular, the sweeping curve of the elevated tracks bearing a train roaring from the distance onto the frontal plane of the composition is complemented by the reverse curve of the arcuated path of marching protesters beginning at a distant point in the background and proceeding to the left edge of the frontal plane. The massive clenched fist of the leader seen in the foreground expresses the anger and determination of the marchers, and fittingly echoes the unyielding strength of the tracks and the steel I-beams supporting them. Moreover, the fact that the group of protesters is racially integrated is of special note in view of the early date of this painting.[3]

On a placard carried over the shoulder of the protest leader are the words "We Demand" in bold black letters beneath which, printed in red, is the partially visible designation of a congressional bill. The portion readily recognized reads "H.R. 75—" with the final two digits of the bill hidden by the protest leader's hat. A small portion of red pigment seen immediately above the hat suggests that the third number may be a "9," in which case the entire number might refer to the Lundeen Bill, "House Resolution 7598," introduced in 1934 by Minnesota Congressman Ernest Lundeen, proposing unemployment insurance.[4] This painting might therefore document the widespread support of workers at all social levels, professional and non-professional, for enactment of Federal unemployment insurance and social security legislation.

Jones was born in St. Louis in 1909. Many of his early paintings are typical Midwestern Regionalist works, yet, while quite young he demonstrated strong protest leanings and became involved in Communist activities, for which he earned adverse criticism. As a result, he left St. Louis in 1935 and moved to New York City, where his social protest activities and the art which they inspired were readily accepted and indeed won him much fame. Jones was one of the leading artists of the social protest movement throughout the Great Depression and until the end of World War II.

HOWARD E. WOODEN

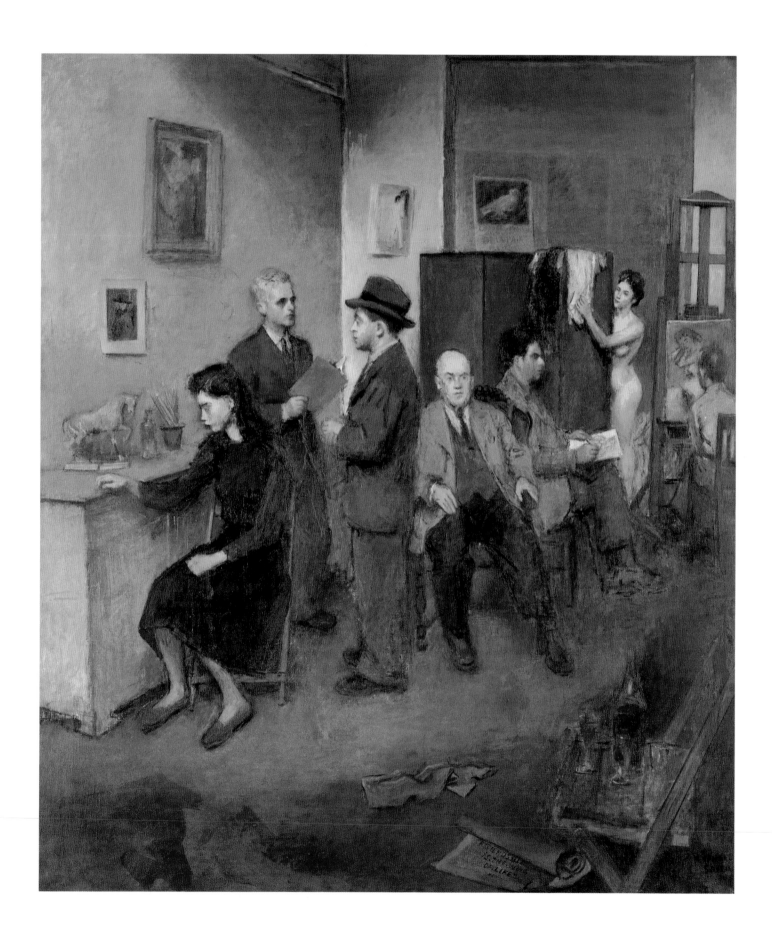

RAPHAEL SOYER | 1899–1987

My Friends, 1948
Oil on canvas, 70 × 60″ (177.80 × 152.40 cm.)
Signed, lower right
Gift of the artist, 963-O-103

Regarded as America's leading advocate of realism, Raphael Soyer devoted his long, productive life to "painting people . . . in their natural context—who belong to their time."[1] During the 1930s, Soyer's poignant portrayals of New York City's office workers and the unemployed secured his reputation as a major Social Realist. The painting *My Friends* reflects the shift in Soyer's work of the 1940s from urban environments towards interior scenes. In this work, he has combined two common themes of his oeuvre: intimate studies of solitary women, often nudes, and portraits of fellow artists, reflecting his great affection and admiration for them. In 1941 his show, *My Contemporaries and Elders*, featured portraits of Raphael himself, his twin Moses Soyer, Chaim Gross, and David Burliuk. All four artists, along with Nicolai Cikovsky, later appeared in *My Friends*, one of Soyer's largest paintings. Represented in Soyer's studio, from left to right, are Cynthia Brown, Cikovsky, Moses, Burliuk, and the figurative sculptor Gross. In the background, Raphael is seated at his easel, painting an unidentified nude model. A scroll in the foreground proclaims, "Friendship is the wine of life." Among Soyer's closest friends were the painters Cikovsky and Burliuk, who shared his Russian heritage. Soyer's favorite artist-model was the pioneering cubo-futurist Burliuk, who is seated in the center of *My Friends*.

Since 1917, Soyer's most frequent model was himself, often with pencil or brush in hand. "I always paint myself appearing introverted. . . . I never make myself entirely like myself. I always appear older-looking, or unshaven, or all alone. It's the result of looking a little bit more deeply."[2] Like Soyer, his friends are, in his works, portrayed as introspective, "dissociated from one another even when they're painted together."[3] He felt that this interpretation derived not only from looking at the world from his perspective but also as a result of New York City's "certain coldness and hardness and dissociation," which compelled him "to dig, to scrape, to unearth the beauty."[4] Soyer appreciated this combination of aloofness and penetration in the work of Edgar Degas, which he regarded as a reflection of the artist's personality and profound psychological modernity. Soyer was "fascinated by the art of Degas—worldly, analytical, refined."[5] The casual cropping of the nude model behind the space-dividing screen recalls Soyer's appreciation of Degas's compositional devices. Likewise, the subtle color scheme, the disassociation of carefully arranged, introverted figures, and the sense of the honest, unguarded moment in *My Friends* all suggest Soyer's admiration of such Degas group compositions as *The Belleli Family* (1858–67, Musée d'Orsay, Paris) and *Portraits in an Office (New Orleans)* (1873, Musée des Beaux-Arts, Pau).

My Friends pays homage to the venerable tradition of group portraiture.[6] According to Soyer, "the two greatest portrait groups ever painted" were Rembrandt van Rijn's *The Syndics* (1661, Rijksmuseum, Amsterdam) and Diego Velazquez's *Las Meñinas* (1656, Nacional Museo del Prado).[7] Velazquez's masterpiece reminded him of another work with the artist at his easel, Gustave Courbet's *The Painter's Studio* (1855, Musée d'Orsay, Paris). Soyer admired Courbet's "eloquent . . . restrained color harmony" and "complete absence of melodrama."[8] *My Friends* was featured in the major exhibition, *Painting in the United States 1948*, and in a solo show, both at the Carnegie Institute, Pittsburgh, that year. Reviewing this exhibition, Robert M. Coates praised Soyer's "design [which] in such pieces as the large studio group called *My Friends* . . . has become at once sounder and bolder."[9]

GAIL STAVITSKY

271

JOSEPH HIRSCH | 1910–1981

Invocation, 1966–69
Oil on canvas, 90×62″ (228.60×157.48 cm.)
Signed, lower left
Museum purchase, 969-O-152

Joseph Hirsch's evolution as an artist was affected by significant developments in early twentieth-century American art. Before his birth, a small band of painters calling themselves The Eight championed the ordinary individual and everyday activity as subjects for art. Their influence extended into the 1920s and 1930s, when American Scene Painting challenged the pre-eminence of abstraction. During the Great Depression, American Scene artists continued to depict common people and events in New York City, finding their subjects on the streets of Greenwich Village and at the amusement park at Coney Island. A distinguishing aspect of this American Scene Movement was its rejection of International Modernism in favor of social consciousness as a central impetus.[1]

Early in his career, Hirsch studied with one of The Eight, George Luks. Under his tutelage, Hirsch received an introduction to painting derived from daily observation and experience. Subsequently, he suffered the rigors of economic hardship personally. Living in a Northeast urban environment hit hard by the contraction of business and economic growth, Hirsch was made aware of the sharpened differences between rich and poor people. Given both his artistic and personal backgrounds, it is not surprising that he turned to social commentary as a primary topic of interest.

Invocation was completed in the late 1960s, a period of political upheaval and civil disturbance. Although at this time most artists were primarily concerned with abstract and conceptual issues, Hirsch continued to pursue his brand of visual editorialism. And if his style was not au courant, his concern for social issues decidedly was.

Typical of Hirsch's oeuvre, *Invocation* is arranged along frontally layered planes. Two foreground figures positioned along the side of a speaker's platform seem to occupy the viewer's space. Behind them is a focal group of black robed figures standing before flags and a background wall. At the top of the painting, a canopy re-establishes the picture's actual surface. Through these formal devices, the painting seems to oscillate between outer peripheral and inner, illusionistic space. Here also, Hirsch has displayed his characteristic predilection for frontal orientation, establishment of planar spatial zones, and placement of an introductory area relating the viewer to the primary subject of the painting.

Also typical of Hirsch is his portrayal of people dressed for their life's role. In his depictions, business, military, or academic regalia cover, but do not hide, the wearer's subjugation to time and circumstance. The careful description of the faces reveals the inevitable decay of flesh and the distortion of features dependent upon each particular personality. In Hirsch's interpretation, a sense of gravity, even pompousness, has molded his subjects' outer demeanors, as it has governed their existence.

In response to a direct query about the painting, Hirsch wrote that it, ". . . followed the college's commencement ritual, which I witnessed when the oldest of my three sons graduated."[2] A ceremonial occasion such as this one suited the artist's predilection for revealing the insubstantial and fragile human condition behind pomp and circumstance. There is a photographic sense of stopped motion, capturing a momentary and vulnerable state of humanity.

For Hirsch, the gestures and placement of human subjects served as a guide for the viewer's response. Though a certain event might inspire him, he left its meaning open to various interpretations. Thus, to Hirsch, Realism was intended to stimulate varying reactions, depending on the viewer's own experience. *Invocation* exemplifies his interest in painting thought-provoking human actions and events.

JUDY COLLISCHAN

JACOB LAWRENCE | b. 1917

The Street, 1957
Casein on paper, 30½ × 22¼" (77.47 × 56.51 cm.)
Signed, lower right
Museum purchase, 986-W-111

Busy New York City street corners were favorite subjects for Jacob Lawrence, who began painting African-American genre pictures as a young man in Harlem during the Depression. An incident as commonplace as the gathering of mothers was probably witnessed often by Lawrence on the avenues of the Bedford Stuyvesant district of Brooklyn where he was living when *The Street* was painted.

The Street, revealing the lyrical side of Lawrence's art, is lighter in tone than his social commentary painting series, one of which, *The Struggle* (1955–56), he had recently completed.[1] Still, it is rich with personal symbolism. Aside from the affectionate portrayal of day-to-day maternal rituals, *The Street* is truthful in deeper ways: Lawrence often espoused the idea of the heroic woman as a vital and nurturing force, a belief based on a devoted memory of his own mother, who had single-handedly raised him in Harlem, and on the intense kinship he felt with his artist-wife Gwen.[2] In *The Street*, Lawrence also asserts the notion of the resilient African-American woman as a fortress against the racism and poverty that continue to beleaguer his people.

Like other American Scene painters, Lawrence was thrown on the defensive by the Abstract Expressionist tide that washed over New York in the 1950s, but he tenaciously clung to the belief in figurative art with liberal humanistic meaning. He told an audience of artists and art students at the time:

Maybe . . . humanity to you has been reduced to the sterility of the line, the cube, the circle, and the square; devoid of all feeling, cold and highly esoteric. If this is so, I can well understand why you cannot portray the true America. It is because you have lost all feeling for man. . . . And your work shall remain without depth for as long as you can only see and respect the beauty of the cube, and not see and respect the beauty of man—every man.[3]

Lawrence, son of a Pennsylvania coal miner, came to Harlem with his mother when he was three. During the 1930s he studied with the pioneer African-American artist, Charles Alston, and with Anton Refregier at the American Artist's School. These mentors, along with Lawrence's occasional work on W.P.A. projects, helped deepen the artist's social consciousness. He thrived on the company of budding African-American writers and artists still in Harlem even after the Harlem Renaissance had become another victim of the Great Depression. More fortunate than most of these Harlem friends, he enjoyed early recognition. His tempera and gouache series on African-American history, *Toussaint L'Ouverture* (1937–38), *Frederick Douglas* (1938–39), *Harriet Tubman* (1939–40), *The Migration of the Negro* (1940–41), and *John Brown* (1941–42) were praised by established critics and purchased by museums.[4] Numerous individual paintings, some of lyrical and fantasy themes, also attracted favorable notice during the early 1940s.

Lawrence's style grew more complex in the 1950s. The figures of *The Street* are larger in size and prominence than those of the series paintings. The drawing is curt; the angled edges seem sharp enough to slide through the paper they are painted on. The colors are less brilliant and saturated than before, possibly because of the casein medium. An intricate pattern of darting shapes defines the women, the buggy, the pavement, the buildings, the fish balloons, and the sky. The background attains a force and energy equal to the figures. The individual features appear as if they could be pealed off the paper surface; the effect of the cadence of shredded patterns is an unexpected unity, a medley of dynamic design and poetic resonance.

Such sophisticated picture-making can be attributed to Lawrence's deepening knowledge of modern art. Working alongside Josef Albers at the Black Mountain College of Art in 1946 had a major effect on Lawrence's art through the 1950s, as did Pablo Picasso's Synthetic Cubist paintings and Ernst Kirchner's dagger-like Expressionism. Close contact with fellow artists Ben Shahn and Stuart Davis at Edith Halpert's Downtown Gallery did much to build his confidence and broaden his aesthetic outlook.

Two extended trips to Nigeria in the early 1960s and the events of the Civil Rights Movement brought a new social awareness to Lawrence's paintings after 1960. He became a professor of art at the University of Washington in Seattle, where he lives and works today.

RICHARD COX

275

WALT KUHN | 1877–1949

Green Pom-Pom, 1944
Oil on canvas, 30 × 25″ (76.20 × 63.50 cm.)
Signed, lower right
Museum purchase, 986-O-108

Though he was an accomplished landscape and still-life painter, Walt Kuhn's mature career as an artist is almost exclusively identified with his haunting portraits of circus and vaudeville performers, like *Green Pom-Pom*.[1] Kuhn was completely at home in the world of show business. His mother had introduced him to theater as a child and he went on to discover the delights of vaudeville, burlesque, and the circus on his own. In fact, from 1922 to 1926, wary that becoming financially dependent on the sale of his work would make him vulnerable to undue influence from dealers and critics, Kuhn earned a successful living designing and directing touring stage revues.

The performers depicted in Kuhn's paintings were not merely models but individuals he knew professionally.[2] Yet Kuhn's paintings are not true portraits in the traditional sense. He was less concerned with the individual personalities of his sitters than with presenting them as timeless metaphors of the human condition.[3] Beneath the mask of theatrical make-up and the tawdry glitter of the costumes, each figure asserts a somber human dignity. Kuhn's entertainers are the heirs of Watteau's Gilles from the *commedia dell'arte*, descended through the dancers and cabaret performers of Edgar Degas and Henri de Toulouse-Lautrec. Indeed, a contemporary critic observed that one "gradually realizes . . . the unbroken chain of French figure painting" had found its "last representative in Walt Kuhn, an American."[4]

Green Pom-Pom is the last in a series of three-quarter length portraits of show girls that the artist began in 1938.[5] Distinct from Kuhn's other images of show girls, these figures are dressed in close-fitting, military-style costumes. Each of the women probably helped select her own costume from the large rack Kuhn kept at his studio—costumes which he designed and his wife made. According to Kuhn, he often encouraged models to choose their own attire as a way of helping him preserve the "freshness of his seeing," just as he insisted on continuing to work directly in front of a model because he needed "the challenge of the physical fact in front of him."[6]

The young entertainer in *Green Pom-Pom* confronts the viewer with the startling frankness typical of Kuhn's figures. Her heavily mascaraed and shadowed eyes gaze at us from an expressionless face, with a deliberate dispassion that seems at once candid and unimaginably remote. Her sullen sensuality imbues the picture with the inescapable disquiet of broken dreams. Stylistically, the painting possesses the quiet authority and spare grandeur that characterize Kuhn's best work after 1940. The figure has an insistent monumentality. The brassy, dissonant color that still attracted the artist in earlier paintings has been abandoned in favor of the subtle richness of a limited palette. The pallid flesh tones and cream-colored vest direct the viewer's attention to the powerful drama of the figure's head, further accentuated by the exaggerated epaulets that project from the girl's shoulders and form the base of a compositional triangle culminating with the green pom-pom.

Kuhn considered the classic concern for the sculptural reality of the human form to be the dominant theme of his mature work. His observation about another of the paintings in this series applies equally to *Green Pom-Pom*, "A lump of weighted form, the one, the universal substance of art. Trying to get it makes art history. The Greeks had it, lost it; Rubens caught it, then it slipped through Van Dyck's fingers. Cézanne chopped it up to see how it is made; his followers fooled with the pieces. Here it is whole again."[7]

NANNETTE V. MACIEJUNES

GUY PENE DU BOIS | 1884–1958

Trapeze Performers, 1931
Oil on canvas, 25 × 20″ (63.50 × 50.80 cm.)
Signed, lower left
Museum purchase, 964-O-113

The circus was still a vital part of contemporary life, in both Europe and America, in the 1920s. For the generation of American artists who came of age in the shadow of the dancers and cabaret performers of Impressionism, and who had been instilled with Robert Henri's maxim "art for life's sake," the circus presented a perfect subject. A testament to its popularity was the success of the Whitney Studio Club's 1929 exhibition, *Circus in Paint*, which included, among numerous others, the work of Guy Pène du Bois. In his review, Lloyd Goodrich proclaimed the exhibition, which was installed in an elaborate circus setting replete with a sawdust covered floor and a big top canopy, "the gayest and most original show of the season."[1]

Pène du Bois turned to the subject of the circus on more than this one occasion, most notably in *Carnival Interlude* (1935, private collection), which won a prize at the 1936 National Academy of Design Annual. *Trapeze Performers* was done the year following the artist's return from a five year sojourn in France. Significantly, the painting draws on Pène du Bois's memories of Europe and depicts a French, rather than an American, circus.[2]

Pène du Bois had been happy as an American in Paris. His return to the United States in 1930 had been both abrupt and reluctant, necessitated by the collapse of the stock market, which made it impossible for his dealer to continue his support. During his years in France, the artist had been freed for the first time from the demands of his dual career as an artist and New York critic. He had been able to concentrate on painting, refining his mature style. However, his return brought this fruitful period to an end. Faced once more with financial difficulties, Pène du Bois was forced to return to teaching and writing criticism. He found the country to which he returned considerably changed. Like his friend, Marsden Hartley, who had returned from Europe the same year, Pène du Bois felt estranged from an America characterized by a newfound nationalism, too often expressed in isolationist and xenophobic terms. Four months after his return, he complained that he felt "like a complete stranger" in New York.[3]

The haunting, enigmatic mood that pervades *Trapeze Performers* is characteristic of much of Pène du Bois's work, as is the simplified, highly-stylized figure style used to portray the three aerialists. The painting, however, possesses a particularly disturbing undercurrent that may well be related to the psychological and emotional anxiety the artist felt on his return to New York. Quite literally, the picture could be seen as a metaphor of the high wire act that Pène du Bois no doubt felt his life had once again become. This metaphor was one with which many modern artists identified. They saw in themselves the skill and desire to push to the limits of human potential in their own quest for artistic perfection.[4]

A great part of the visual tension in the painting is created by the handling of space, which juxtaposes the three frozen figures compressed into the immediate foreground with a dramatic plunge to the circus ring below. Moreover, the interlocking figures are only partly visible, cut off by the edges of the canvas. They are suspended in midair, with the artist denying the viewer even a reassuring glimpse of a trapeze or platform. Here, as in so many of his paintings of high society, Pène du Bois invites us to play the not-altogether-comfortable role of the voyeur. He offers us a disquieting intimacy with the performers, a view quite different from that of the distant, barely visible spectators below. We experience not the thrill of a daring performance but the precariousness of the aerialists' life.

NANNETTE V. MACIEJUNES

JOHN MARIN | 1870–1953

Schooner Yachts, Deer Isle, Maine, 1928
Watercolor on paper, 16×22″ (40.64×55.88 cm.)
Signed, lower right
Museum purchase, 967-W-119

Old Mistress—Maine—
. . . Maine—makes or breaks/ Maine demands and rivets
—A painter man—here—if—of—her breed or her adoption—
 must needs
conform—[1]

John Marin believed he had to know a place intimately before he could paint it. When he executed *Schooner Yachts, Deer Isle, Maine*, he had been painting on the coast of Maine for fifteen summers. A particularly vocal opponent of what he considered the "self-indulgence" of pure abstraction, Marin tried to imbue each painting with his love of the visible world.[2] A critic's observation that Marin painted from an inner vision offended the artist deeply, and was summarily dismissed by him as rubbish. Marin could not conceive of an art of consequence that was not grounded in the act of seeing. To Marin, "seeing" was a "repetition of glimpses" and each painting an opportunity to capture in a single, striking image the "eye of many lookings."[3] Instilled with a modernist's distrust of illusionism, however, he drew on the resources of his own form of Cubism to explore his response to what he saw and experienced. Marin always insisted that his paintings be both celebrations of the visible world and flat, two-dimensional objects: "I demand of [my paintings] that they are related to experiences . . . that they have the music of themselves—so that they do stand of themselves as beautiful—forms—lines— and paint on beautiful paper or canvas."[4]

This painting epitomizes Marin's work of the 1920s, during which he truly made watercolor his own. Marin longed to imbue his watercolors with the breadth and power which are traditionally associated with oil painting; in fact, *Schooner Yachts, Deer Isle, Maine* dates from the year Marin began to complement his work in watercolor with his first serious experiments in oil. Frustrated with the limits imposed by traditional watercolor technique, Marin increasingly chose to ignore the medium's luminous properties. *Schooner Yachts, Deer Isle, Maine* is dominated by opaque strokes of saturated color which Marin then mixed with charcoal and graphite. The rugged vigor that characterizes the work, achieved at times by scrubbing and reworking the surface, belies the delicate beauty still associated with the artist's watercolors of the previous decade.

Maine symbolized for Marin the power and dynamism of nature. In *Schooner Yachts, Deer Isle, Maine* Marin energizes the surface of the paper with an expressive power that evokes the essence of a place and moment he had experienced. As is true of so many of Marin's paintings, the work embodies the artist's search for the equilibrium he believed could be achieved between the forces of dynamism and those of stability and order. The painting, particularly its seemingly empty center, is filled with a taut energy created by the pull of the two schooners against the demands of the balanced composition. Marin conveys and controls the scene's explosive vitality through a rich concert of brushwork: bold strokes, dense patches of color, fluid washes, and deft lines. There is a breathless swiftness about the work as a whole, which will always make it seem as if the paint has just dried.

NANNETTE V. MACIEJUNES

LOUIS BOUCHE | 1896–1969

Self Portrait with Helmet, 1959
Oil on canvas, 24 × 20″ (60.96 × 50.80 cm.)
Signed, upper left
Museum purchase, 965-O-170

Born in New York City to French parents, Louis Bouché was encouraged as a child to draw. His father, Henri L. Bouché, an architectural decorator, worked with the major turn-of-the-century architects designing interiors, such as the Breakers in Newport, Rhode Island and the Oak Room in the Plaza Hotel, New York City, primarily for very wealthy and socially prominent families. After his father's death, Louis and his mother moved to Europe where they lived from 1909 to 1915. In Paris, Louis attended classes or sketched at the Académie de la Grande Chaumière, Colarossi, the Ecole des Beaux-Arts and several ateliers. Upon returning to New York, Bouché studied at the Art Students League, exhibited at the Whitney Studio, and worked as a camouflage artist for the Navy during World War I. At the Penguin Club in New York City, he and Alexander Brook associated with Walt Kuhn, Jules Pascin, George "Pop" Hart and the patron, John Quinn. His first solo exhibition was praised by the critic Henry McBride.[1] Because he often included Nottingham lace in his pictures, this early period was called his "Nottingham lace curtain manner."

From 1922 to 1926 he directed the Belmaison Gallery, New York City, part of Wanamaker's Gallery of Decorative Arts, afterwards pursuing a profitable career painting interior murals. During the Great Depression, however, he returned to easel painting. He referred to this as his "corkynuts" period because his painterly canvases featured objects he picked up on the beach. The compositions, however, were not traditional still lifes but modernist arrangements. His second solo exhibition in 1932 at the Valentine Gallery received mixed reviews. *The New Yorker* critic noted "a certain lack . . . of the cohesion that is usually present in the work of men who have been painting seven days a week." But he also observed a lifting of color and a loosening of technique, and praised Bouché's subtle color sense, finally concluding that, "Most of his compositions are happy, and some have humor, a trait that is almost absent in our native painting."[2] The work was too abstract for other critics, who commented on its resemblance to Georges Braque, André Lurçat, Pablo Picasso and Giorgio de Chirico,[3] or compared it to the *disjecta membra* of the Surrealist school.[4] Partly due to these criticisms, Bouché began to paint American subjects more realistically, in keeping with the general direction of American art in the 1930s.

In addition to resuming easel painting, in the 1930s Bouché painted several murals, executed panels for the Pennsylvania Railroad, and was associate director of the New York School of Interior Decoration. In 1936 he had the first of many exhibitions at Kraushaar Galleries in New York. The following year Harry Salpeter profiled him in Esquire as the "Boulevardier of Art." Bouché, a very large man, delighted in well-tailored suits, and his daughter recalled that the various merchants " . . . of Savile Row and St. James' Street jointly contrived to give him the appearance of a successful banker."[5]

Self-portraits were not a staple of his work, but in the later 1950s Bouché painted several, including *Self Portrait with Helmet* (1958, private collection). This work, slightly larger than the Butler Institute's *Self Portrait with Helmet,* also shows him in the butcher's apron he wore when painting. However, the earlier self-portrait is bust-length and has details of bookcases and a picture on the background wall. Both self-portraits have the fine color, humor, and sartorial elegance for which Bouché was known, evidenced in the first self-portrait by a pith helmet, decorated with a gold, glittery emblem, and in the second a pink scarf—the stuff of costume parties.[6] The Butler Institute's self-portrait was reproduced in *American Artist* in 1960 with an appreciative comment: "Louis Bouché . . . painted this histrionic portrayal, dated 1959, in which the artist plays a role in honest realism—pith helmet, walrus mustache, tortoise-shell glasses perched on nose—a strait-backed conception of a British officer gone Bohemian. Here is a dramatic perception and presentation of an urbane, educated artist whose style stems from what he has digested of the past and present and shows a feeling for paint and an innate love of the art of painting."[7]

MARLENE PARK

JACK LEVINE | b. 1915

Carnival at Sunset, 1984
Oil on canvas, 60 × 48″ (152.40 × 121.92 cm.)
Signed, lower right
Museum purchase, 988-O-117

Exposure of the high and mighty had become second nature to Jack Levine by the time he painted *Carnival at Sunset*. The action is loosely set in a lower Manhattan neighborhood that swarms with stock Levine characters: the politician, the show girl, the street vendor, and the artist. The mock-heroic farce is probably a variation on one of Levine's persistent themes in recent years—the sham of the Greenwich Village/Soho art scene with its abundance of money, chic, and self-importance.

Levine spent a hardscrabble youth in Roxbury, Massachusetts, before studying painting at the Museum of Fine Arts in Boston. *The Feast of Pure Reason* (1937, Museum of Modern Art, New York), Levine's landmark painting, grew out of firsthand impressions of the unsavory doings of local politicians, cops, and gangsters from the tough wards of south Boston. This satire gave Levine notoriety as the *enfant terrible* of the Social Realist School. After three years in the army during World War II, Levine launched a second shocker, *Welcome Home* (1946, The Brooklyn Museum), a painting dripping with irony and anti-Establishment sass. It brought him further acclaim among artists and irate criticism from government officials.[1] Through the 1950s and 1960s, Levine positioned himself against new targets—Florida mobsters, corporation bigwigs, movie stars, and generalissimos. In between these satires were spoofs of classical myths and mournful paintings of Old Testament subjects from an unconventional Jewish perspective.[2] Living in New York, Levine met the surge of Abstract Expressionism head-on; those of the new vanguard who belittled his social commentary art found a foe eager to return their scorn measure for measure.

Like other American narrative artists, Levine's heroes were the Old Masters. He did share the Abstract Expressionist's gestural brushwork and fractured surface, but the heavy chiaroscuro, shimmering light, complex play of opaque and transparent paint, extreme foreshortening, tilting compressed space, and triangular compositions of *Carnival at Sunset*, reveal debts to Mannerist and Baroque artists rather than to the Cubist and Surrealist mentors of the Action Painters. In its crowded format and caustic moral tone, *Carnival at Sunset* is nearly a parody of Flemish genre painting. Here Levine revives one of his old themes, the melancholy reality of commercialized sex in the mass media culture. The voluptuous physiques covered by stylish bikinis fail to hide the wear and tear on the starlets' carnal attractions. Even so, the show girls might also be read as an updated version of beauties on parade, a good natured put-on of Titian and Peter Paul Rubens, the great painters of human flesh whom Levine revered. It is the men, however, who feel the full cut of Levine's satire. Dominating the front plane is the fop, of uncertain age, extravagantly coiffured and decked out in Sergeant Pepper chic, who represents the trendy art scene. Nearby is his partner in crime, the politician-gangster, who bears a striking resemblance to Chicago's former mayor, Richard Daley.[3] Their smug, corroded faces and carnivorous smiles, combined with the adjacent wounded buildings colored in funeral parlor brown, lend a genuine nastiness to the picture which is only partly relieved by the airy prancing of the show girls and by the midway in the background. Typically, Levine's virtuoso paint handling curiously increases the satirical irony: "The elegance and delicacy of [Levine's] brushwork seems to caress its subject and set up a kind of poetic countervoice to the harsh image it serves."[4]

RICHARD COX

HORACE PIPPIN | 1888–1946

Zachariah, 1943
Oil on canvas, 11 × 14″ (27.94 × 35.56 cm.)
Signed, lower right
Museum purchase, 951-O-120

Prior to its acquisition in 1951, Horace Pippin's *Zachariah* had been on public view only once, in Pippin's solo exhibition, in 1944, at Edith Halpert's Downtown Gallery in New York.[1] Unsold, it was returned to Pippin's primary dealer, Robert Carlen, in Philadelphia. Two years later, Carlen received a letter with a two hundred dollar check from Carl Dennison, a young Ohio collector. Noting that he had heard about Pippin from his friend, the painter Robert Gwathmey, Dennison indicated his interest in purchasing a painting, leaving the choice up to Carlen.[2] By 1947, when Selden Rodman published the first book on Pippin, *Zachariah* was listed in Dennison's collection. Four years later he sold it to the Butler Institute.

During World War I, Pippin, an African American, served in a segregated regiment. Shot in the shoulder by a German sniper, he subsequently rekindled his boyhood interest in art, teaching himself painting as therapy for his injury. In 1938, four of his works were included in the Museum of Modern Art's *Masters of Popular Painting*. The Philadelphia collector, Dr. Albert Barnes, championed his work after seeing Pippin's solo exhibition, in 1940, at Philadelphia's Carlen Gallery.

As in *Christ and the Woman of Samaria* (1940, The Barnes Foundation) and *Cabin in the Cotton III* (1944, private collection), Pippin used his favored sunset sky for the setting of *Zachariah*. If the artist had a source for the narrative action of this painting, he never spoke of it for posterity. *Zachariah* depicts an elderly African American man standing stalwart in the center of the composition, supporting the weight of a wounded and ragged white man with one arm while, with his outstretched arm, he signals with a white cloth. It may be coincidental that the old man's bald crown and ring of fluffy white hair resemble illustrations of Joel Chandler Harris's fictional storyteller, Uncle Remus. More relevant to Pippin's portrayal of an African American assisting a white man is its close thematic parallel to a sculpture by John Rogers, *The Wounded Scout—A Friend in the Swamp* (1864, New-York Historical Society), which depicts the rescue of an injured Union soldier by a runaway slave. It is not certain whether Pippin had seen Rogers's bronze sculpture because the characterization and placement of his figures are distinct from those of the sculpture, but the theme of assistance is similar.

Although Pippin painted numerous works showing the everyday activities of African Americans, except for *The Whipping* (1941, Reynolda House Museum of American Art, Winston-Salem, N.C.) and *Mr. Prejudice* (1943, Philadelphia Museum of Art), he created relatively few images showing the abuses of slavery or the effects of racial prejudice. His 1942 series of paintings about the fiery abolitionist John Brown, as well as the Abraham Lincoln paintings done in 1942–43, attest to his abiding interest in the history of emancipation. Significantly, all of these works were done during World War II, at a time when African Americans were again fighting for their country in segregated regiments, and when increased racial tensions were erupting at home in such incidents as the Detroit race riots of 1943. It seems likely that Pippin's motives for painting *Zachariah* were not dissimilar from the sentiments expressed by the poet Lydia Maria Childs, who on seeing Rogers's *The Wounded Scout—A Friend in the Swamp*, wrote: "There is more in that expressive group than the kind Negro and the helpless white, put on an equality by danger and suffering; it is a significant lesson of human brotherhood for all the coming ages."[3]

JUDITH E. STEIN

287

IVAN LE LORRAINE ALBRIGHT | 1897–1983

Self Portrait in Georgia, 1967, 1967–68
Oil on panel, 20 × 16″ (50.80 × 40.64 cm.)
Signed, lower right
Museum purchase, 969-O-150

Born in 1897 outside Chicago, both Ivan Le Lorraine Albright and his twin brother Malvin Marr Albright became artists, not a surprising development given that their father was a painter who gave his children middle names of artists he revered. The senior Albright's picturesque canvases were of less lasting value than his real estate investments, which offered a safety net for his sons as well as a life that included frequent travel. Ivan Albright's marriage in his forties to a cultivated socialite, Josephine Medill Patterson Reeve, brought additional security and the experience of parenthood.

Albright's artistic preoccupations changed little from the time he graduated from The Art Institute of Chicago in 1923 to his death sixty years later. The inexorable passage of time and the mortification of the flesh were his constant themes. Albright thought of himself as an individualist unrelated to contemporary art movements. He was deeply involved with the theory and craft of painting and opposed to the new currents of both abstraction and socially-engaged art that developed around him. In the Butler Institute's self-portrait, and especially in others done at the very end of his life, he explored a highly traditional format that consciously refers to Francisco Goya, Rembrandt van Rijn, and even earlier to Raphael.

Albright had produced seven self-portraits in various media when he began *Self Portrait in Georgia, 1967,* several months after his seventieth birthday.[1] His best known works were painted in the studio from close observation of elaborate arrangements of objects and models. This self-portrait, however, was painted outdoors, with the artist standing before the weathered clapboard of a studio he had built on his wife's Georgia plantation. It is a relentless investigation of his aging face. Few artists could have as eagerly anticipated growing old as much as Albright, for seeing in himself the evidence of aging was to personally experience his lifelong fascination with the mutability and decay of matter. The self-portrait depicts a man both painfully resigned to death and staunchly proud of his life's accomplishment. "All life is strong and powerful, even in the process of dissolution," he explained.[2] This exploration of opposites within one work was the artist's conscious design; it creates a tension that keeps the image from becoming maudlin, a weakness Albright did not entirely avoid in his career.

Self Portrait in Georgia, 1967 oddly combines different styles of painting within a single work. In 1940, Albright had painted several impressionistic landscapes using a loose, broken brushwork. For the most part, he abandoned this approach, but it crept back into his work at various times. Here, the loosely painted grays, whites, and blacks of the shirt contrast with the precise strokes of color that comprise the head and face. These parts of the painting are quintessential Albright; the detail is almost microscopic, as seen in the tiny hairs around the upper lip and cheeks. Each eyelash is painted separately, and a single lash may go through permutations of color, depending on how it catches the light. Throughout the painting, muted colors are paired so as to be practically fluorescent, seething as if alive. Add to these factors the discordant element of the boldly-colored circles and squares behind the artist, and the result is a surface that fulfills Albright's desire to make the observer "realize that objects are at war, that between them there is constant movement, tension and conflict."[3] The colored shapes challenge the viewer's attempt to focus on the face. Without them, Albright would have had a much more harmonious—and perhaps successful— painting. But harmony is not his goal. He strives to disconcert the viewer; and if the nails in the clapboard remind one of miniature daggers hurled at a target by a knife thrower in a circus, then all the better.

It is possible that the bright shapes have a purpose beyond the technical feat of disrupting the surface. They represent colorful wands that Albright had fabricated in the 1940s when he was studying the effects of complementary colors against one another in preparation for a highly publicized portrait of the fictional Dorian Gray, commissioned for a Hollywood movie. The wands thus recall a time thirty years earlier when Albright was celebrated enough to be written up in *Life* magazine, long before his achievement had been eclipsed by Abstract Expressionism, Pop Art, and Minimalism. In 1967, abstraction was closely identified with the avant-garde.

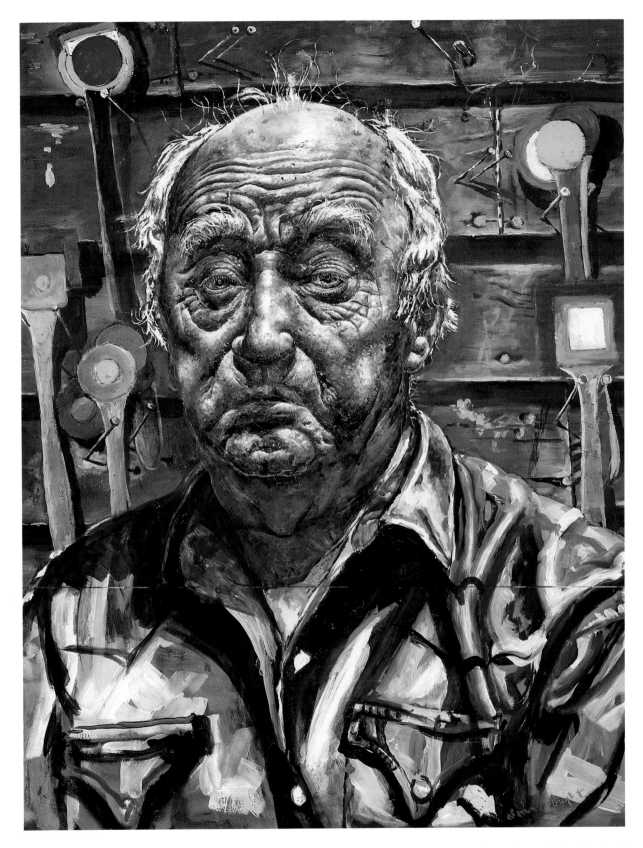

Albright's placement of abstract shapes in the background creates a witty parallel to Hans Hofmann's famous theory of "push and pull," but Albright asserts that pure forms and colors are merely tools for the artist, not an end in themselves. He thus offers an explicit rebuke to artists ranging from Hofmann to Ellsworth Kelly and Frank Stella. At the center of our vision, instead of the lyrical colors of formalist abstraction, Albright places the human visage, beleaguered but noble.

MITCHELL D. KAHAN

ROBERT GWATHMEY | 1903–1988

Children Dancing, c. 1948
Oil on canvas, 32 × 40″ (81.28 × 101.60 cm.)
Signed, lower right
Museum purchase, 948-O-114

Few artists in American history have pursued the depiction of African-American life with such fidelity as Robert Gwathmey. *Children Dancing* is one of many subjects painted by Gwathmey over a long and productive life. More importantly, few artists of any race have rendered a more positive and informed view of African-American life in the Old South, without playing upon the myths that are associated with the themes of slavery and its prolonged impact on the region.

Born in Richmond, Virginia at a time when slavery remained a subject of great importance, Gwathmey digested the visual world around him without romanticizing the lingering ethos of a racially divided society. He observed the world around him without bias and was able to portray in his art an informed view of African-American life available only to those considered to be inside observers. From the time he returned to his home in Virginia after pursuing formal art studies at the Maryland Institute in Baltimore in 1925, Gwathmey began making visual records of the people in Richmond who lived in separate black and white worlds, viewing these worlds with the discerning eye of a critic whose aim was to comment visually on the social circumstances of the races.

Children Dancing crosses the narrow line between races and comes through strongly as a theme of universal significance. While depicting African-American life in an ideal setting, the composition takes the viewer beyond the subject of race to the safe haven all children experience in the company of loving parents. Each figure in the composition is assigned a special role in the family. The father strums away at a rhythm that encourages the unity of dance and play among the three children, his music providing the context for the joyous occasion. While the children form a circle among themselves, their steps and cadence are conditioned by the clapping hands of the mother, who towers over all. Unlike many of Gwathmey's compositions that address social issues such as racial injustice, segregation, and poverty, *Children Dancing* is focused on life at its best. A strong palette of reds, green, blue, and white against a yellow background plainly silhouettes the figures, who stand on a simple gray foreground, the base for all activity within the composition.

Over the years, the rural South has been looked upon as a place where people of many backgrounds have found comfort in a simple yet fulfilling way of life. Gwathmey was a visionary of exceptional perception in his ability to see the richness of cultural diversity long before the term multi-culturalism was in vogue. In *Lullaby* (1945, private collection), the artist transforms the subject of an African-American mother rocking her child to sleep into the theme of a madonna and child without the fanfare of religious symbols. *Sunny South* (1944, private collection) brings together rich and poor, black and white, under the shadow of the fading image of Southern aristocracy. Gwathmey, a Southern white artist, painted these themes, often while living in the North, which upon first glance may appear to be painted by an artist of African ancestry. Gwathmey's unusual voice as a painter of a harsh social order noted for racial discord, places him in the company of Jacob Lawrence, Ben Shahn, and Philip Evergood, whose art addresses social issues as well as a compelling aesthetic agenda.

Profoundly simple, yet meaningfully creative in his painterly overview of the Old South, Gwathmey painted with consummate skill a changing social order, one in which even child's play, as in *Children Dancing*, could be looked upon as an important model for the universal in familial unity, beyond the subject of race and class.

DAVID C. DRISKELL

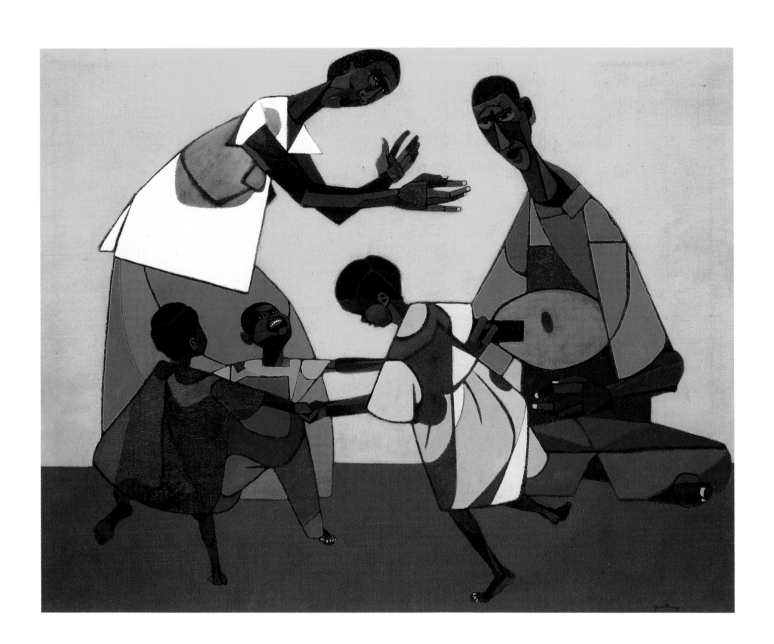

WALTER MURCH | 1907–1968

The Wall, 1959
Oil on canvas, 21¼ × 31″ (53.98 × 78.74 cm.)
Unsigned
Museum purchase, 968-O-177

"I think a painter paints best what he thinks about the most. For me, this is about objects—objects from my childhood, present surroundings, or a chance object that stimulates my interest, around which accumulate these thoughts. I suppose you could say I am more concerned with the lowly and forgotten object, the one people discard because they are finished with it or see it in a certain logical-automatic way that I would like to break."[1]

This general statement made by Walter Murch about his work is particularly relevant to *The Wall*. Over the course of his career, Murch chose as subjects such fragments as a clock mechanism, a manifold, and a light bulb and combined these with conventional still-life objects such as oranges, apples, or eggs. His rendering of these items emphasized the process of painting.

Murch's mature period as an artist occurred in the 1950s and 1960s, during the heyday of such contemporary styles as Abstract Expressionism, Pop Art, and Super Realism. While each of these was touted in turn for its significance to the development of art, Murch doggedly pursued an individual aesthetic that could be seen as coinciding with one artistic fashion while possibly inspiring another. His interest in the act of painting aligned his style with Abstract Expressionism, while his fascination with common objects related some of his work to Pop Art.[2] In spite of these coincidences, Murch's mode was unquestionably his own, and it has continued to defy clear categorization.

The Wall exemplifies Murch's idiosyncratic manner in its concentration on an ordinary object, its painterly atmosphere and dramatic light effects, its relatively small scale, and its frontal composition. His choice of a wall fragment heightens the importance of this cast-off article. Both as a refutation and a continuation of the academic tradition of the noble subject, this seemingly undistinguished bit of civilization's detritus is elevated to importance through its position in the painting. There is a Dadaist cast to Murch's inclusion of the ignoble ready-made in the realm of art. In depicting his subject on canvas rather than actually presenting the object itself, he attains a surrealistic sense of disorientation and fantasy. Transcending time, the fragment appears as an archaeological specimen signifying a past life.

In contrast to the work of many contemporary artists, who preferred painting on a large scale, especially Abstract Expressionist Jackson Pollock, Murch's paintings are intimate in size. Since Murch showed in the Betty Parsons Gallery at the same time as Pollock, there is justification for comparison. Although there was a dramatic difference in the degrees of abstraction, both artists used accidental effects to achieve a painted atmosphere. Even though Pollock's mature work is completely abstract, paintings by these two artists have in common a loose application of pigment, ultimately establishing independent universes on canvas. Murch, like Pollock, also tended to honor the flat properties of canvas; Murch's subject matter is inevitably lined up along a frontal plane. Moreover, each artist exploited the properties of paint to achieve surface textures and movement.

The Wall exemplifies Murch's own concern for creating relationships with the picture plane. The flat form of the fragment itself is positioned parallel to the painting's surface. Even though it is only a fragment, the artist has endowed it with emphatic monumentality. An accompanying pear draws the viewer's eye across the surface on another horizontal trajectory, and also functions as a natural counterpoint to the manufactured item. This juxtaposition, coupled with the enhanced importance of two mundane objects situated centrally, establishes a sense of unusual presence. A feeling of preciousness is heightened by a warm luminosity that picks out these humble subjects. This extraordinary emphasis on otherwise overlooked articles creates an unreal or mystical aura.

Thus, *The Wall* is characteristic of Murch's mature oeuvre in subject matter, technique, and content. Meticulous attention paid to the lowly object in terms of visual and tactile sensation lends a unique and memorable mood to this artist's work. Just as he held his own ground during his life, his paintings have continued to appear unique, original and, thereby, important.

JUDY COLLISCHAN

ADOLF DEHN | 1895–1968

Big Mountain, 1956
Casein on panel, 36 × 48″ (91.44 × 121.92 cm.)
Signed, lower left
Museum purchase, 957-O-108

Adolf Dehn was a life-long enthusiast of the mountains. During the 1920s, he went on numerous climbing and sketching trips in the Alps and began painting watercolors of the Rocky Mountains in 1939. *Big Mountain* is a composite image based on fifteen-year-old sketches of the rugged peaks and mining areas near Colorado Springs.

Born and raised in rural Minnesota, Dehn spent three years at the Minneapolis Institute of Art and eight months at the Art Students League before he was drafted by the Army during the final months of World War I. He spent nearly all of the 1920s in Europe, working almost exclusively as a lithographer. In his prints he alternated between poetic landscapes and satires of Jazz Age follies: Vienna cafes, Berlin opera houses, and Paris brothels. Settling in New York in late 1929, Dehn spent the next decade making spoofs of Manhattan nightclubs, as well as lyrical studies of Central Park, rural New York, and Minnesota. A Guggenheim fellowship enabled him to work with Boardman Robinson and Lawrence Barrett at the Colorado Springs Fine Art Center School during the early years of World War II. The mountains dazzled Dehn and even the gasoline and rubber shortages could not keep him from driving into the high ground of the eastern ridge of the Rockies, making sketchbooks that he would consult for inspiration over the next twenty years of his career.[1]

In *Big Mountain*, painted in casein instead of his preferred medium, watercolor, Dehn hoped to get more robust color and a fuller sense of the mountain's looming mass.[2] He polished the painting with pieces of absorbent cotton to achieve a deep resonance. Even so, the aesthetics are essentially those of his drawings and watercolors: a muted palette of greens and grays, carefully modulated tones, and a variety of subtle textures, including the scratching and gouging of the surface that made his lithographs of the 1920s and 1930s so distinctive. Dehn, alert to the mercurial weather changes of the Colorado mountains, knew storms could arise without warning. At these moments, the mountains turn into gray, intimidating fortresses, closed in and inaccessible. The generalized, remembered shapes and patterns suggest the influence of Oriental art, and his passion for the Southwestern landscape, freely interpreted, leads to a semi-abstract style that links him indirectly to the art of Milton Avery and Georgia O'Keeffe in the 1950s.

Dehn's late paintings, such as *Big Mountain*, are more somber and contemplative than the pre-World War II works. Nature images came to outnumber the satires. The landscape forms became more elusive and mysterious. Carl Zigrosser, Dehn's long-time dealer, once said: "[Dehn's] aim never was to produce a mirror-image of nature but to make a picture grow organically. . . . He feels his way into it. He lets the picture, as elusive as life, grow before his eyes . . . but he knows when it comes to life, when it clicks or is in tune."[3]

RICHARD COX

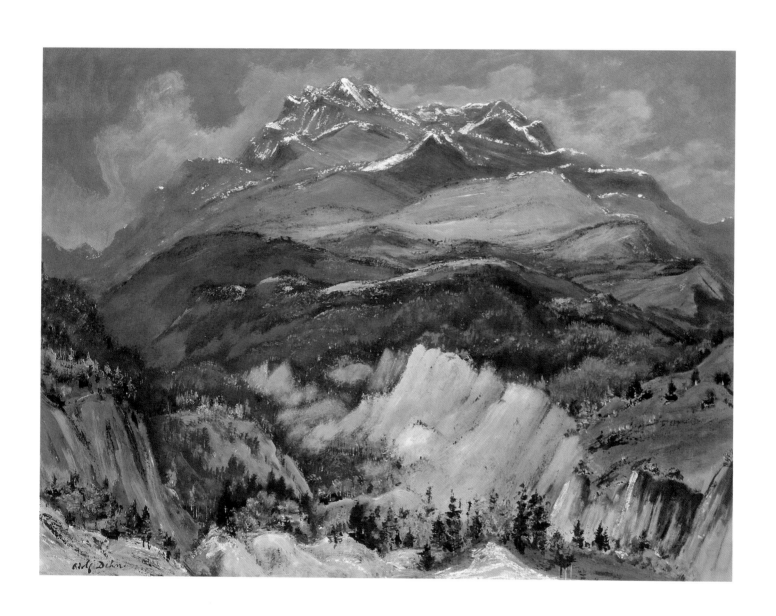

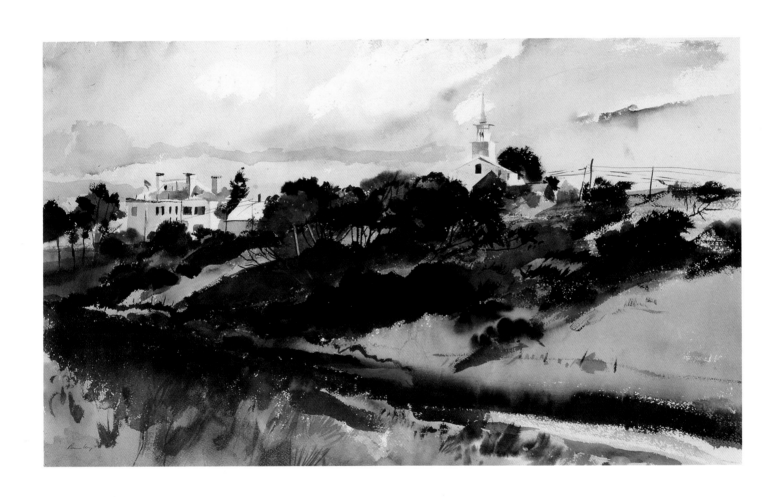

ANDREW N. WYETH | b. 1917

The General Knox Mansion, 1941
Watercolor on paper, 19 × 29¼″ (48.26 × 74.30 cm.)
Signed, lower left
Museum purchase, 942-W-102

During the summer of 1941 Andrew Wyeth was twenty-four years old and working in Maine. He had developed the habit of painting in Chadds Ford, Pennsylvania in the winter months and around Muscongus Bay in Maine during the summer. Solo exhibitions of his work had appeared at the Art Alliance in Philadelphia, the Currier Gallery of Art in New Hampshire, and the Wilmington Society of the Fine Arts, now the Delaware Art Museum. In that year, eighteen of his works were shown at the Art Institute of Chicago, and the Corcoran Gallery of Art gave him and his brother-in-law, Peter Hurd, a special exhibition.

Although he had been painting for several years in egg tempera, later his major medium, in 1941 he was known primarily as a watercolorist, one who had mastered the medium at an early age. *The General Knox Mansion* demonstrates well his personal, unmistakable style of the time, a very fluid style which the artist later dismissed as "just clever . . . lots of swish and swash."[1] The swish and swash are evident, but they are deliberate and very controlled. The work shows Wyeth's clear sense of the medium's many possibilities and demonstrates his care in composition. Despite the many watercolors from this period and in this general style, those more familiar with his later work often express surprise at the bright greens and blues and free washes that are found here. Through later years, color became spare and brushwork tightened. He eventually adopted drybrush as a technique used by itself or in combination with more fluid applications.

Contrary to what is often said, Andrew Wyeth has never felt compelled to include in his work every detail he surveys. *The General Knox Mansion* exemplifies this point; large areas of the paper are left untouched and are used to move our eye and focus our attention. There is suggestion of detail, but actually very little paint on the paper. The artist gives us only rather loose forms. There are several inches of finished art along the bottom edge which Wyeth chose to cover when matting the work because, he says, "The stream falls away to the right too much."[2] Cropping emphasized the composition's horizontality, which encourages the viewer's eye to move along the stream valley and makes the buildings more dominant than they would otherwise be. The triangular shapes and strong lines keep our eye moving from right to left, back to the mansion, despite the downward motion of the stream valley from left to right.

The house in this picture is a replica of the General's original mansion called Montpelier which was in a different location in the town of Thomaston, Maine. The pictured house is on a hill outside of town overlooking Mill River, a tributary of the St. George River. The church, long in disrepair, has since been razed. It was an extraordinary example of New England ecclesiastical architecture and was the General's church. Andrew Wyeth, engrossed in American military history, has a great interest in the fascinating Henry Knox, first Secretary of War, and in his house and its site in Thomaston. From 1939 through 1955, he did at least five other works showing one or both of these buildings from a variety of perspectives, including an interior of the church belfry. Like nearly all of his works, *The General Knox Mansion* documents a moment in time, something important now passed, but the utility poles and lines on the hill prevent the work from being misunderstood as historical, pastoral, or merely sentimental.

JAMES H. DUFF

CHEN CHI | b. 1912

High Noon, New York, 1986
Watercolor on paper, 38 × 35″ (96.52 × 88.90 cm.)
Signed, lower left
Gift of the artist, 990-W-101

Chen Chi was born in Wusih, a small community near Shanghai, China. Due to his father's financial difficulties in the silk business, in 1926, Chen Chi moved to Shanghai where he was employed in an oil pressing factory. The owner of the factory, having children the same age, allowed Chen Chi to attend their classes. In 1931, he enrolled in an art school that emphasized western techniques rather than traditional Chinese painting. The establishment of the Chinese Republic, in 1912, coupled with the opening of China to the West, which had begun in the nineteenth century, heightened his awareness of Western ideas and art trends. Chen Chi, recalling his early training stated, "We were wanting a more modern painting. . . . There was already this direction in the modern cultural movement. And with art, we did not want to go back to the Chinese traditional style, although we had such a strong tradition of it. . . . I belonged to the younger generation, and we wanted . . . the modern style."[1]

Chen Chi came to the United States in 1947 and became a citizen in 1964. New York City, his home since arriving in the United States, and his extensive travels to many parts of the country provide an inspiration for his work. Pearl Buck, in speaking of Chen Chi stated, "Few artists can be transplanted from their own culture and find new inspiration in an environment originally strange to them. Chen Chi is one of the very few. Preserving the essentials of Chinese tradition in technique, he has enriched that technique while he has absorbed and mastered new subject matter. In short, he is a mature and exciting artist and his works are significant in symbolic thought as well as in beauty."[2]

High Noon, New York is a study in movement. The swirling wind seems to push the hurrying pedestrians and automobiles through the canyon of Manhattan skyscrapers. The flags ripple and snap, further emphasizing the vitality and movement of the busy thoroughfare. *High Noon, New York* is typical of Chen Chi's highly personalized watercolors that merge Eastern brushstroke technique with the Western conception of color.

Chen Chi has painted scenes of Washington, D.C., Chicago, New Orleans, and San Francisco, but his main source of inspiration has always been New York City. In 1958, he began painting a series of watercolors picturing performances at the Metropolitan Opera House, the most notable being *On The Stage, The Old Metropolitan Opera-House, New York* (1958, private collection). His paintings of Central Park under a blanket of snow are pictorially successful as simplified impressions of nature, as are his variations of spring, summer, and autumn.

Chen Chi's merging of the Orient and the Occident continues to be traditionally beautiful. "We Chinese value beauty in aesthetic terms, as we value peace, tranquility, purity, harmony, innocence, simplicity, humility, love, joy, qualities of the heart which artists in their work express to people."[3]

CLYDE SINGER

COLLEEN BROWNING | b. 1929

Telephones, 1954
Oil on plywood, 14 × 32½″ (35.56 × 82.55 cm.)
Signed, lower right
Museum purchase, 955-O-107

Although a major American realist of the latter half of the twentieth century, Colleen Browning was born in Cregg, County Cork, Ireland. From earliest years, she hoped to be a painter.[1] In due course, Browning attended London's Slade School of Art from 1946 to 1948. Her marriage to the English novelist Geoffrey Wagner in 1949 first brought her to the United States. The following year, the couple settled in New York where Browning taught at City University.[2] Early in her career, Browning's talents were recognized and honored. In the 1950s, she began showing at the Edwin Hewitt Gallery in New York and since then has won numerous annual exhibition awards, from the Rochester Memorial Art Museum to the Carnegie *International*. Her work was included in the National Academy of Design's yearly exhibitions, and she has exhibited at the Museum of Modern Art, the Whitney Museum of American Art, the Pennsylvania Academy of the Fine Arts, and the Kennedy Galleries in New York. She was elected a National Academician in 1966, and has served as an officer at the Academy.

Browning's distinctive brand of figurative painting, with subjects ranging from eerie worshipers in a Guatemalan church to graffiti-covered Harlem subway cars to the surrealist still life *Fruits and Friends* (1978, Harmon-Meek Galleries, Naples, Fl.), displays definite affinities with both the Social Realism of Jack Levine and the "magic realism" of Philip Evergood and George Tooker. Nevertheless, Browning developed and maintains a wry, multi-hued personal stamp to her painting which for almost four decades has set it apart from prevailing fashion. "I have tried to evoke the magical from reality by an accurate visual reconstruction of the facts, so that the viewer can share my aesthetic shock in unexpected revelations."[3] Surely no Browning canvas fills this bill as completely as her early work, *Telephones*, which won Honorable Mention at the Butler Institute's 20th *National Midyear Exhibition* in 1954.

Telephones is a tragicomic study in urban energy and rootlessness. The then purely Manhattan phenomenon of a six-booth row of pay phones must have both delighted and mystified Browning, only four years a resident of New York when she painted it. The canvas is relatively small, but into it Browning has managed to fit "six phoners in search of an answer" in surprisingly unclaustrophobic fashion. The composition is basic, the booths establishing six strong vertical rectangles, some with doors folded perilously inward, some with doors ajar, all creating a fascinating visual counterpoint to the more rounded, amorphous forms of human beings catching up on their calls. The figures, through Browning's acute sense of human drama, catch and hold our attention, isolated yet drawn together by these six booths, which one critic of the day referred to as "part confessional, part coffin."[4] Individual poses are artfully, informally juxtaposed: a dressy woman in green with orange purse and fancy yellow gloves leads off the unpassing parade to the far left; a woman with tightly curled, orangey hair and low-cut summer dress is seen next to her, full figure. The next of the callers is a natty man in spotless white shirt and lemon yellow pants, writing something down on the phone counter, an umbrella propped up against the glass door. The next two figures are a teenager in modish silk team jacket and jeans, feet crossed, hand on hip—we get the sense of a romantic date being made—and hip as can be; and a haute-1950s woman, back to us, with a long ponytail down her back, her little girl struggling to open the door. The figure to the far right is the narrative kicker to the opus: a nondescript, yet somehow elegant, woman in a pink blouse and blue skirt, her head turned away from us to the right as if she were seeing the approach of the person she meant to call.

Narrative is the key to this painting; there is narrative implied here—in fact, six separate narratives—but the viewer simply is not let in on the profundities and prolixities of the one-sided human exchanges taking place. In *Telephones*, Colleen Browning found a telling metaphor for city existence: noiseless, wordless, sound and fury, signifying nothing we can define, but all the more revelatory for that.

GERRIT HENRY

MILTON AVERY | 1885–1964

The Baby, 1944
Oil on canvas, 44 × 32″ (111.76 × 81.28 cm.)
Signed, lower left
Gift of Mr. and Mrs. Milton Lowenthal, 955-O-103

Considered the "American Matisse" by many critics, Milton Avery was never a slavish follower of the French master's work. Avery's *The Baby* subtly transforms Henri Matisse's style into a distinctly American one through gentle parody and quiet understatement. Here, Avery plays with the aspects of both the Fauvist and Nice period Matisse by transforming his seductive abstract nudes into an infant wearing a pink ruffled dress, who kicks up one leg in a frolicsome fashion. In place of the exotic appurtenances of a harem found in many Matisse paintings, Avery places the child in an ebonized Charles Eastlake style Victorian lady's chair, similar to a piece in the Avery's household. Instead of using Matisse's highly saturated colors, teamed in often startling combinations, Avery chose lambent areas of golden tones to create an embracing background for the complementaries of orange and blue making up the blanket and child. The slightly sprawling and embracing chair in which the head of the baby comfortably nestles serves as a surrogate grandmother. This piece of furniture establishes a sense of continuity, and the baby a sense of hope for the future. These feelings were particularly pertinent in 1944, since the Allied invasion of Europe had led to an escalation of the war effort and the hope that World War II would soon be over.

In 1944 Avery's work began to achieve some critical success. In January, his first solo museum exhibition opened at the Phillips Memorial Gallery in Washington, D.C. In the following year an exhibition of his paintings opened in the Rosenberg and Durand-Ruel galleries in New York City, closing shortly before his sixtieth birthday. For Avery, a late-comer to the art world, this dual showing represented an important opportunity to reinforce the direction he had chosen, and he consequently created some of his most important works during that year. These shows also provided an occasion to respond to the 1943 letter to *The New York Times* written by his two close friends, Adolph Gottlieb and Mark Rothko, who indirectly condemned his type of art. Even though they preferred "the simple expression of the complex thought . . . [and] the large shape because it has the impact of the unequivocal," they were convinced that "only that subject-matter is valid which is tragic and timeless."[1] At the time that this letter was published Avery and his family were summering in Gloucester, Massachusetts where they saw the Gottliebs and Rothkos on a daily basis. Known for his wit and taciturnity, Avery probably did not remark on the implicit criticism of his art that his friends' letter represented. In characteristic fashion, he let painting be his mouthpiece, and *The Baby*, together with such remarkable works of the same year as *Seated Girl with Dog* (1944, Collection of Mr. and Mrs. Roy B. Neuberger, New York) and *Mother and Child* (1944, private collection), responded to his friends' quest for a mythic and timeless art by asserting the equally meaningful significance of daily life. The success of Avery's undertaking can be ascertained in the ways that he has taken both the anonymity and abstraction of modern life and made them both as fresh and familiar as an infant cavorting in a favored heirloom Victorian lady's chair.

ROBERT HOBBS

JOHN KOCH | 1909–1978

Music, 1956–57
Oil on canvas, 48 × 60″ (121.92 × 152.40 cm.)
Signed, lower right
Museum purchase, 962-O-112

John Koch, born in Toledo, Ohio, is best known as a painter of fashionable Manhattan and New England mansion dwellers. As Koch himself stated, "I am quite visibly a realist, occupied essentially with human beings, the environments they create, and their relationships."[1] He remained aloof from the cross-currents of abstract and experimental fashions of the day, continuing his own steady path toward success as a figurative painter, using as his setting his own elegant fourteen-room apartment facing Central Park West. The figures who people his canvases are those whose presence permeated the everyday life of the Kochs: Mrs. Koch, an eminent pianist and instructor, her students, Koch's models, artists, and other friends. In defense of this seemingly "upper-crust" subject matter, Koch once stated, "I have great affection for . . . dishonored subject matter . . . [because of] the arbitrary . . . way in which it has been dismissed. *Have* (sic) the sensuous, the lyrical elements really been expelled from modern life? Of course not. Is modern man exclusively occupied with his own tragic plight, his neuroses, his destruction? This . . . is as much the sentimentality of our day as was the sweetness and light for which we so tirelessly berate the Victorians."[2]

Koch's early training was minimal. He attended two summers at the artists' colony at Provincetown, Massachusetts, where he was influenced by the work and theory of Charles Hawthorne. After graduating from high school, he went to Paris, where he stayed for four years painting on his own, never under a teacher. As he later recalled, "the Louvre taught me

my major lessons."[3] He won his first award in the 1929 *Salon de Printemps*; more awards and representation in major museums began arriving in the 1930s.

Music was awarded the Benjamin Altman Figure Prize at the 1959 National Academy of Design Exhibition, and both the First Award in Oils and the John J. McDonough Award at the Butler Institute's 1962 *National Midyear Exhibition*, where it was subsequently purchased. *Music*, one of Koch's finer interior scenes, pictures Koch's wife, Dora Zaslovsky, teaching her student, the well-known musician Abbey Simon. A combination of outdoor and artificial light, used by Koch since 1950, imbues the scene with a clear light. The diagonal line created by the direction of Simon's gaze and Mrs. Koch's gesture connects the two sides of the scene, which is divided by the glass shelves in the middle. The positions of the two people are echoed by the terra cotta figurines on each side of the bottom shelf. This symbolic and compositional relationship between objects and people is characteristic of Koch, and is used by him often.[4]

Though Koch is generally viewed as a painter of the rich and famous, he was not a superficial "society painter." His work evokes the quiet, intimate interiors of Jan Vermeer, whose seventeenth-century upper-class Dutch activities he transcribed with clarity and feeling into the world of twentieth-century Manhattan.

CLYDE SINGER

Seer, 1947
Oil on masonite, 30 × 24″ (76.20 × 60.96 cm.)
Signed, lower left
Gift of Samuel M. Kootz, 947-O-114

"Today," wrote Adolph Gottlieb in 1947, "when our aspirations have been reduced to a desperate attempt to escape from evil, and times are out of joint, our obsessive, subterranean, and pictographic images are the expression of the neurosis which is our reality."[1] These words suggest the impact of the historical conditions under which Gottlieb worked: World War II, the Holocaust, the atomic bomb. His Pictographs, mysteriously symbolic paintings such as *Seer*, occupied him throughout the 1940s. They represent a unique response to the problem that plagued many of his contemporaries in the New York School: in a world riddled by conflict and unbearable cruelty, what is the proper subject matter for art? The realist paintings Gottlieb had previously produced proved inadequate as global strife escalated in 1941. American Scene painting seemed too limited, while the more progressive geometric abstraction appeared to him devoid of content.[2] Thrown into a crisis over what and how to paint, Gottlieb sought a new pictorial language to express his deepest human concerns. With the Pictographs, he found his subjects in antique myths, and his stylistic vocabulary in the forms of tribal art.

Inspired by Jungian theories of the collective unconscious learned from the Russian emigré artist John Graham, Gottlieb looked to ancient myths for basic psychological truths that transcended time and place. By invoking the legends of Oedipus, Persephone, or Theseus and the Minotaur, Gottlieb hoped to address the fears and desires of all human beings. He wanted his paintings to fulfill the purpose of art as Graham had defined it, "to re-establish a lost contact . . . with the primordial racial past . . . in order to bring to the conscious mind the throbbing events of the unconscious."[3] In his Pictographs, Gottlieb relied on the evocation, not the illustration, of myths; as the decade advanced, moreover, his allusions to specific legends gave way to more ambiguous references in titles like *Seer*.

The format of *Seer* is exemplary of the Pictographs in general, as are the graphisms and cryptic motifs arranged on the canvas like prehistoric signs on a cave wall. Most striking is the resemblance of Gottlieb's compositions to the Northwest Coast Native American art and Southwest sand paintings he greatly admired. Such associations to Native American art, part of the larger primitivizing tendencies of the New York School, were for Gottlieb pointed and self-conscious: "If we profess kinship to the art of primitive man," he explained, "it is because the feelings they expressed have a particular pertinence today."[4] Projecting his own anxieties onto remote peoples, whom he imagined as the modern artist's kindred spirits, Gottlieb contended that "all primitive expression reveals the constant awareness of powerful forces, the immediate presence of terror and fear . . . as well as the eternal insecurities of life."[5]

If Gottlieb's stylistic models included indigenous American artifacts, he also depended on European sources. For the grids that subdivide the Pictographs, the artist acknowledged the example of Piet Mondrian, whose structured fields originated in the linear scaffolding of Cubism. More directly related to Gottlieb's habit of partitioning the painted surface was his interest in early Italian polyptychs, with their multiple panels and predellas treated as discrete areas for narratives and devotional scenes.[6] The improvised cursive lines Gottlieb inscribed within and over the grids, recalling the calligraphy of Paul Klee and Joan Miró, were also akin, the artist stated, to the automatic writing of the Surrealists.[7] Finally, the Pictographs bear strong compositional analogies to Gottlieb's own beach still lifes, like *The Sea Chest* (1942, Solomon R. Guggenheim Museum), in which a bottle crate turned on its side serves as a compartmentalized container for various shell forms.

Seer is thus surprisingly complex and overdetermined, despite its rudimentary formal language. Simple shapes—egg, chevron, triangle, arrow, lozenge—are not meant to be individually decoded but rather to suggest a symbolic program. The numerous eyes release a chain of associations, to Tiresias, for example, the Theban seer of Greek mythology.[8] A tragic figure, Tiresias was blinded by the gods for watching Athena bathe and was also punished for observing two serpents mating; but he received in compensation the gift of prophecy. Curiously, the profile at the left of Gottlieb's painting has the aura of a witness, while the snaking white

lines that meander through the picture recall what Tiresias should not have seen. Gazing at Gottlieb's canvas, one senses the eyes eerily staring back, until the painting's title becomes polysemous, and "seer" refers at once to the artist, his subject, the viewer, and the work of art.

SUE TAYLOR

JOAN MITCHELL | 1926–1992

Untitled, c. 1950s
Oil on canvas, 17 × 16″ (43.10 × 40.60 cm.)
Signed, lower left
Gift of Marilynn Meeker, 986-O-115

Throughout her life, Joan Mitchell, daughter of a poet, alluded to poetry as the art form most nearly like her own. Lyricism is what she admired, whether in the poetry of the nineteenth-century Romantics or the painting of Jackson Pollock. Her work consistently addressed the evocation of feelings. The specific subject that called up that feeling was most often landscape. Or, perhaps a better term would be "inscape," an invention of the nineteenth-century English poet, Gerard Manley Hopkins, who meant by it melody, as in music, and design and pattern, as in painting. The clear implication of abstraction in Hopkins's view is echoed by Mitchell in a statement made around the time *Untitled* was painted: "I paint from remembered landscapes that I carry with me—and remembered feelings of them, which of course become transformed."[1]

From her early adolescence, Mitchell had plunged herself into a close study of the painters who moved her, building a painting culture that was fully amplified when, from 1944 to 1947, she studied at the Art Institute of Chicago. She was particularly affected by the intensity of Vincent van Gogh's landscapes and the great synthesizing of Paul Cézanne. In 1947, Mitchell spent some months in New York, where she was able to see the work of artists who were coming to the fore as adventurers in a new idiom that came to be called Abstract Expressionism. It was Arshile Gorky who most deeply influenced her, particularly his late works, in which he had thinned his paints, made effective use of the light of the bare canvas, and alluded to the natural forms he found in the fields and woods of Virginia. Shortly thereafter, Mitchell entered fully into the life of the vanguard New York painters, visiting the studios of Franz Kline, Willem de Kooning and Philip Guston, and becoming friendly with artists of her own generation who were clustered around Hans Hofmann.

With a quick visual intelligence, Mitchell absorbed the spirit of abstraction and the freely imaginative ways of composing typical of painting in New York during the 1950s, without ever losing her own distinct intention of transforming her memories of landscapes. If Gorky's long, elegantly curving lines, or de Kooning's emphatic accents on the rectilinear plane, or Pollock's arabesques were adapted to her needs, they never muffled Mitchell's own lyrical voice that spoke of water, sighing trees, skies, and light.

By the mid-1950s, Mitchell's command of her means was evident. The light of the canvas, often left bare, was figured with coursing strokes that sometimes clustered, sometimes darted apart, creating an animated surface on which hints of foliage, trees, skies, and water were dispersed. Often, as in *Untitled*, Mitchell would shift from ambiguous spaces built with flurries of small strokes to boldly assertive spaces, measured off with emphatic bars—in this case, the black and red rectangular structures—fully articulating the illusion of recession. All the years of study, the keen appreciation of Cézanne, and her immersion in the work of forceful contemporaries had led her to a way that would articulate the strong lyrical feelings she harbored before nature. For the rest of her life, Mitchell would return to the authentic memories of places, such as her childhood home on Lake Michigan, in order to retrieve the peculiar heightening of feeling that characterizes the lyrical temperament.

DORE ASHTON

308

ANDY WARHOL | 1931–1987

Paul Jenkins, 1979
Acrylic and silkscreen on canvas, 40 × 40″ (101.60 × 101.60 cm.)
Signed, on reverse
Gift of Paul and Suzanne Donnelly Jenkins, 986-O-109

The tradition of portraiture in American art can be traced back to Colonial times, when limners traveled throughout the East doing commissioned portraits of leading citizens and their families. In this century, the Pop Art portraits of Andy Warhol have preserved the images of leading contemporary figures; except that here, the artist has gone further, extending the discourse to challenge notions of fame and identity in modern society.

Unlike traditional portraiture, Warhol relied exclusively on photography to capture the image of his subject. Often using commercial photos from magazines and newspapers, he used photo-mechanical reproduction techniques to enlarge and transfer the image onto a canvas. The use of photo-silkscreen allowed Warhol to transfer single, double, or multiple images onto the support, repeating the single photograph or series of views, again and again, reiterating his theme and presenting his subject in new ways. He then painted strong patches and banks of color to enliven the flat surface and to personalize the painting.

Warhol had painted portraits of pop media icons like Jackie Kennedy, Elizabeth Taylor, Elvis Presley, and Marilyn Monroe, in addition to a number of self-portraits, in the 1960s; but, it wasn't until 1972 that he devoted as much attention to portraiture.[1] In 1979–80, the Whitney Museum of American Art mounted the exhibition, *Andy Warhol: Portraits of the 70s*, which showed the immense output of work done by Warhol in this genre. Portraits of well known art world and media celebrities filled the walls, earmarked by the straightforward, candid photo image, highlighted with strong color areas—often with a sense of being off-kilter—that gave added dimension to the flat, high-contrast photography. Although wanting to capture the subject candidly, without comment or judgment, through his masterful detachment and diffidence, Warhol, nevertheless, captured the spirit of the time and the fleeting nature of fame in a modern, disposable society.

The portrait of painter *Paul Jenkins* is a wonderful example of the process undertaken by Warhol to create a fully realized portrait. Taking into account the painting style of his subject, Warhol used Jenkins's spontaneous brushwork as a backdrop for the photographic image. The contrast between the stark black and white photo-image and the painterly bands of color highlights the two disjunctive modes of representation at work. This jarring portrait underscores the duality inherent in the painting as a portrait of the man and as a portrait of the artist. Warhol simplified the subject's features, creating a strong, iconic presence; he is a celebrity, and the Warhol portrait validates this fact.

Paul Jenkins was originally one panel of a two-panel portrait of the artist.[2] This panel shows Jenkins slightly recessed with large color areas silkscreened in a rainbow effect giving subtle changes in coloration across the pictorial surface of the painting. The graphic, silkscreened image and the freely applied acrylic paint do not mesh together, but instead create a jarring, disjunctive visual field. A specific moment in time has been captured, unemotional but dignified in presentation, offering a respectful look at this painter without commentary and without apology. Carter Ratcliff states that Warhol, "appropriates the image to leave it blunter, more stark."[3] Warhol had said on many occasions that what you see on the surface is all there is.

Warhol always strove to flatter his subjects. He sensed that this was an important aspect of his engagement with them, and further verified his fascination with the banal nature of celebrity and fame. A Warhol portrait is not only a portrait of the subject but also one of the artist himself who, through his highly individual style and masterly manipulation of the media, made a significant contribution to this genre, in which he documented the leading figures of his day.

NANCY MALLOY

316

SIDNEY GOODMAN | b. 1936

The Artist's Parents in the Store, 1973–75
Oil on canvas, 58½ × 77″ (148.59 × 195.58 cm.)
Signed, lower right
Museum purchase, 982-O-176

Since he reached his signal style in the early 1970s, Sidney Goodman's paintings have always been an odd, riveting mixture of the physical with the metaphysical, of the everyday with the macabre, often the grotesque. Over the years, his oeuvre has included drawings of nude women writhing with painful pregnancies, a charcoal "giant" playing with in-color, futuristically-dressed Barbie dolls lined up before his eager face, or a man with a heavily bandaged head in an ambiguous, hospital/charnel-house interior. An example of his mature work is the large oil *Room with Light* (1986, Collection of Malcolm Holzman, New York). Against grayish beige, eerily-lit walls sits a nun, impassive and mandarin-like; beside her on either side are two nude women engaging in private sexual athletics with Graeco-Roman nude male statuary. Such canvases have earned him a reputation as "a modern master of the horrific . . . [whose paintings contain] indecipherable yet depressing and disturbing messages."[1]

Ironically, for one with so ripe an aesthetic imagination, Goodman intended to be a baseball player while in high school. Born in Philadelphia, where he continues to live, paint, and teach, most recently at the Pennsylvania Academy of the Fine Arts, Goodman says, "I was seriously thinking of going to college to become a gym teacher. . . . But all along, I always drew."[2] In 1954, he was admitted to the Philadelphia College of Art, graduating in 1958. After a period of neo-expressionist experimentation, Goodman chose to remain with figurative painting, flying directly in the face of the prevailing mode of Abstract Expressionism. By 1962, the stylistic tide was turning, and Goodman garnered plaudits for *Find a Way* (1961, Museum of Modern Art, New York), featuring a bloated male figure dressed in a hospital gown, floating in midair. The work was purchased in 1961 by the Museum of Modern Art and shown in their 1962 exhibition, *Recent Paintings USA: The Figure*.

The Artist's Parents in the Store is both characteristic and uncharacteristic of Goodman—uncharacteristic in that he usually worked with models rather than family or friends. The artist, whose parents were first-generation Russian-Jewish immigrants, called it "a kind of homage to my parents."[3] The Butler Institute also purchased a charcoal study for the painting (Fig. 1). Set in his father's Philadelphia fur shop, the scene is characteristic of Goodman's larger body of work in that the shop, with its gleaming vaults, smooth display tables, and backroom cutting table heaped with cloth, is endowed with a four-way mirror that brings a keen metaphysical edge to the formal dynamics of the painting. Goodman's father is seen plainly enough resting against a table, lean and a little fearsome, in the loosely belted white coat of his trade. It is around the image of the artist's mother that the metaphysics revolve; she sits heavily in a silver arm chair, plump, matronly in pink and white, her presence reflected in the mirrors. Beyond her mirror image we are presented, a little jarringly, with the scene outside the shop as caught by the mirrors: a diminutive slice of urban outdoors almost hallucinatory in its ambiguities. We see a stretch of street, what seems to be a light-wood wall rather arbitrarily and mysteriously placed beyond that, and the gable and roof of a house rising behind. While *The Artist's Parents in the Store* is a fairly conservative work for Goodman, it is still not without large traces of the artist's more radical departures from reality. Its beauties, however, are plainer than usual, and its dislocations less jarring and disturbing than what might have been expected. Austere "homage" is more the key to the painting than hapless horror.

GERRIT HENRY

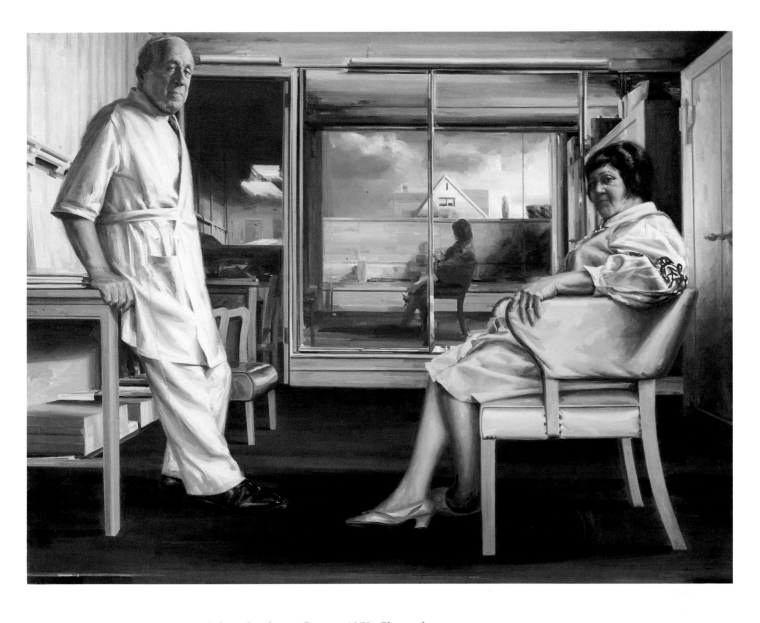

Figure 1. Sidney Goodman. *Parents*, 1972. Charcoal on paper, 29 × 36″ (73.66 × 91.44 cm.). Signed, lower right. The Butler Institute of American Art. Museum purchase, 991-D-109.

CHUCK CLOSE | b. 1940

Georgia, 1984
Handmade paper, 56×45″ (142.24×114.30 cm.)
Signed, lower right
Gift of American Academy and Institute of Arts and Letters, 986-W-109

The stark, monumental portraits by Chuck Close gained recognition in the early 1970s. Ideologically, art critics align Close with the Photo Realists because his portraits are not paintings of people but are of photographs of people. Conceptually, the portraits are linked to the ready-mades of Marcel Duchamp, in that they were taken with a Polaroid camera, the images occurring almost instantaneously. The final paintings, however, are developed by transposing increments of marks through the labor-intensive use of a Renaissance grid system. By manipulating the system for making these marks, Close is able to alter the viewer's perception of reality. The images become, therefore, as much about abstraction as they are systems for decoding information about the photographs and the subjects.

Syntax has become an issue of paramount importance to Close. He has stated, "How an artist chooses to do something is often as important as what the artist chooses to do."[1] For Close, the processes that are chosen, whether mezzotint, oil, airbrush, or pulp collage are often the most arduous and time-consuming imaginable. He feels that resistance is important. Also of importance is the dialogue between the processes, or how one technique informs the other.

The portrait *Georgia*, an editioned handmade paper piece, is an excellent example of this synthesis. Close began to work with handmade paper in 1981. He was approached by Joe Wilfer, master printer and papermaker, who felt confident that the paper medium could be controlled to produce representational images. The first images employed a plastic template as a compression mold forcing the pulp to fill the cavities of the grid. During editioning, chips of pulp were often pressed out, assuring uniformity of the pulp values. Close took this by-product of dry chips back to the painting studio where the original collage of *Georgia* (1984, Collection of Chuck Close) was created. From the collage of *Georgia*, a tracing was made, and Close asked Wilfer to construct a brass shim template, an oversized "cookie cutter," that could be used to repeat the image as an edition. The editioned *Georgia* incorporates thirty-six separate gray values. The paper pulp was left to air dry, which reproduced the tactile spirit of the original collage.

Close does not paint commissioned portraits. "Anyone vain enough to want a nine-foot portrait of themselves," he stated, "would want the blemishes removed."[2] His subjects over the years have been friends and family and most recently his friends who are artists. The portrait *Georgia*, Close's daughter, assaults the viewer with its imposing scale and texture, but also poses a paradox because of the sensitive familial intimacy with which the portrait was nurtured.

JAMES PERNOTTO

39/35 Georgia II R. Close 1982

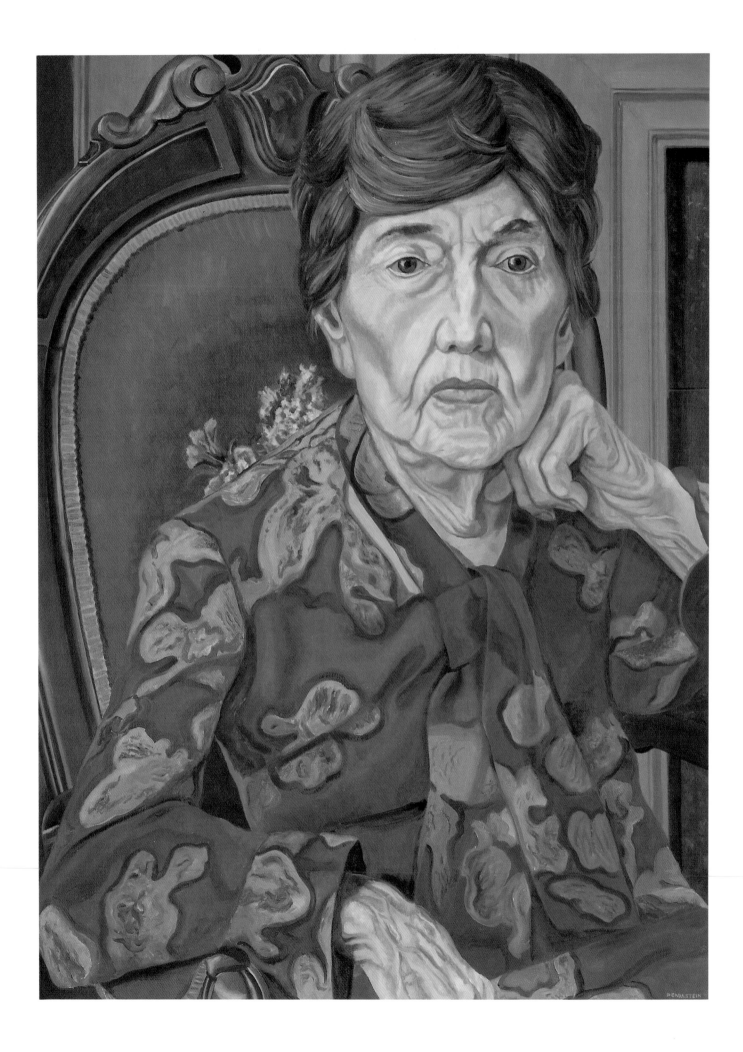

PHILIP PEARLSTEIN | b. 1924

Portrait of Mrs. Florence S. Beecher, 1988
Oil on canvas, 30 × 40″ (76.20 × 101.60 cm.)
Signed, lower right
Museum purchase, 988-O-116

During the 1950s, figurative artists, like their Abstract Expressionist colleagues, worked in an Expressionist or gestural manner. In 1961, Philip Pearlstein, a member of this figurative group, reacted to and challenged painterly figuration by developing a tough-minded factual or specific realism, based on the painstaking depiction of what the eye sees. He did so in order to rescue "the human figure from its tormented, agonized condition given it by the expressionistic artists and the cubist dissectors and distorters of the figure, and at the other extreme . . . from the pornographers, and their easy exploitation of the figure for its sexual implications. I have presented the figure for itself, allowed it its own dignity as a form among other forms in nature."[1] Pearlstein sensed that this move, later labeled New Realism, would revitalize figurative art in the face of the dominant abstract art and the newly emergent Pop Art.

Pearlstein's work was related to that of the Pop artists and Photo Realists, who appeared around 1965, because they all prized literal representation, but unlike Andy Warhol or Roy Lichtenstein, he did not copy pre-existing advertisements or comic strips, and unlike Chuck Close or Richard Estes, he did not simulate the look of photographs, or use them in any other way. Indeed, Pearlstein spurned the camera, considering it a crude and imperfect machine whose lens distorted reality. He relied on his eye, an organ of extraordinary complexity and sophistication, infinitely superior as a tool of perception, a scanning organism, continually adding information. Indeed, Pearlstein's painted figures look rounded and animate, unlike the flat and frozen images recorded by a camera.

Pearlstein's primary subject is the female nude, a central theme in Western art. While acknowledging the earlier Realism of Gustave Courbet and Edouard Manet, he has separated his painting from what came before, striving to be even more perceptual, more factual. He attempts to eliminate all interpretation, but he knows that this is impossible since, as the window of the brain, the eye cannot help but interpret what it sees. To emphasize his literalist intention, Pearlstein starts a picture in a novel way, focusing on an anatomical detail close-up. He then develops the rest of the figure, stopping arbitrarily at the canvas edges, often cutting off the eyes, the most expressive of human features. As he views it, any slice of reality is as worthy of representation as any other.

Intent on objectivity, Pearlstein is uninterested in personal expression. Still, his paintings are distinguished by critical pictorial decisions about size, scale, medium, surfacing, lighting, and vantage point, which are by nature subjective, intuitive or even inspired. His pictures, moreover, are distinguished by the quality of his painting, the quality that separates realist painting from realistic illustration. As Charles Rosen and Henri Zerner have written, realist painting entails "the acceptance of trivial, banal material and the refusal to ennoble it, idealize it, or even make it picturesque. . . ."[2]

Pearlstein's *Portrait of Mrs. Florence S. Beecher* differs somewhat from his other portraits, in that it reverts to Expressionism. In part this was unintentional. The picture was painted in Mrs. Beecher's house, which was highly humidified; the damp and warm atmosphere caused the paint to remain wet, and for this reason, Pearlstein worked in a looser manner than usual, a manner commonly identified with Expressionism. Moreover, Mrs. Beecher herself looked like an Expressionist subject. At ninety, her hands were gnarled; she was wearing a favorite dress, now too large for her, bought many years earlier on a trip to Indonesia. But Pearlstein relaxed his own previously rigorous matter-of-factness. During the long hours in which she posed for him, Pearlstein had grown fond of his subject and admired a certain heroic quality in her. This was a woman who was dignified and proud, of her life and of her family; she spoke often of her family history.[3] In the *Portrait of Mrs. Florence S. Beecher*, Pearlstein caught this heroic quality.

IRVING SANDLER

JAMES VALERIO | b. 1938

Ruth and Cecil Him, 1982
Oil on canvas, 92¼ × 80¼″ (234.32 × 203.84 cm.)
Unsigned
Museum purchase, 991-O-234

James Valerio was born in Chicago, Illinois, and received his formal art training at the Art Institute of Chicago. He began exhibiting his large figurative works in the mid-1970s and by 1980 had developed his mature style and was receiving critical attention as an important emerging artist.

Ruth and Cecil Him is typical of Valerio's mature style. All elements of the composition are carefully arranged. Each detail is painted as if it were closely observed. Valerio's eye, in this regard, is non-roving, similar to a photographic lens which stills motion. As in a photography studio, Valerio controls his light from above and behind in order to spotlight the portrait as well as backlight it.

The attention to detail is the key to the painting. Atmosphere has been sucked out, eliminated so as not to hinder or interfere with surfaces. Even in the shadows, details are considered as if they were illuminated by light. Here, Valerio continues the tradition of the artist as meticulous observer, begun by the artists of Renaissance Flanders.

The best viewing distance for *Ruth and Cecil Him* is between six and fifteen feet. From more than six feet away the viewer loses the suggestion of the artist's hand and the detail becomes blunted. At a very close distance, the brushwork, especially on the collar of the male figure and on the floral curtain, can be detected. Valerio has, however, concealed his technique in most parts of the canvas.

The viewer becomes a surrogate for the artist, as the couple in the painting seem to gaze at a point about seven feet from the canvas, well within the optimal viewing distance. They appear to be focusing on, and conscious of, the painter—now the viewer. They probably would have a similar self-consciousness if they were posing for a camera. Playing against the stiffness of the sitters' gaze, are the endearing qualities of the hand holding—obviously posed by the artist—and the subtle touching of the knees beneath the quilt, perhaps conspired by the sitters.

Like all realists, James Valerio inadvertently reveals the social class of his subjects. For Valerio, this is, as in *Ruth and Cecil Him*, invariably upper middle class.

ROBERT GODFREY

JACK MENDENHALL | b. 1937

Romantic Dining Room, 1977
Oil on canvas, 63 × 77″ (160.02 × 195.58 cm.)
Unsigned
Museum purchase, 977-O-148

Lush, red flowers in a silver vase, a burning candle, two glasses of wine, half-filled, a pair of slightly rumpled dinner napkins, all carefully arranged atop an elegantly set table for two, hint at an intimate and romantic evening. The stark white tablecloth draped over a rich, brown satin undercloth, that shimmers and falls in deep folds onto the floor, stands out in the darkened interior. Through this meticulous visual description, photo-realist Jack Mendenhall elicits calculated responses and associations that propel the subtle narrative of *Romantic Dining Room.*

Romantic Dining Room, based on a photograph,[1] shows an intimate dining area on the veranda just off the master bedroom of a luxurious apartment. Although there is no human presence here, the still-life objects act as surrogates for the couple and give a thorough and incisive look at the occupants and provide a scenario for the unfolding action.[2] Muted clues are contained in the careful arrangement of objects and in the mood that is created with the lighting and color. The passage of time is implied by the half-burned candle and the partially drunk wine. The artist captures a precise moment in the evening that suggests that two people have shared a drink and then moved to another part of the room, out of view, for a romantic interlude. The sensuousness of the flowers, the satin cloth, and the private setting lead to natural conclusions of romance and intimacy.

At the same time, the remote handling of the interior and the table still life has been objectified by the sharp focus of the camera. Unlike painting directly from nature, the use of the photographic image flattens and outlines each object in an impersonal and detached way. Photo Realists used the photograph, not as a departure point for the new, integrated reality, but simply, as the reality itself.[3] This heightened photographic experience creates a hyper-reality which, through the camera's precise articulation, renders the image impenetrable and remote. The complex spatial plan is almost abstract in its flatness and saturated color. Mendenhall offers the work without comment, like the Pop artists did, but through the manipulation of the recognizable and familiar, he constructs a remote world filled with references to the social values of the time.

The painting rejects emotion and instead, relies on a photographic exactitude that gives a veracity to the work. We see the carefully rendered, pristine room frozen in time, a moment that only the quick click of the camera's lens can capture, a visual experience that transports the viewer to another reality. The large scale of the painting gives the photographic element another dimension. The interior is receptive to and can accommodate the people and invites participation in the cool world created. The use of the pulled-back drape adds depth to the flat surface by showing the dark silhouette of the skyline in the distance. The metal slat chair reflects objects on the table, creating another layer on the flat surface. The silver and glass on the table shine and add dimension to the still life, and the flat, dark shadows of the plants contrast with the shiny surfaces, creating a pattern effect. The color, photo-like in its saturated tones and dark shadows, is seductive but strangely cold, uninviting though comfortable in its familiar associations.

The optical richness of *Romantic Dining Room* offers an intense visual experience, one that is idealized and removed but, nevertheless, intriguing in its coded message. In the opulent interior that hints of intimacy and romance, is also a world that is detached and alienated, a world that has the accoutrements of feeling and belonging, without really making that personal connection.

NANCY MALLOY

ALFRED LESLIE | b. 1927

View Over Holyoke, Massachusetts, 1983
Watercolor on paper, 36 × 53″ (91.44 × 134.62 cm.)
Unsigned
Gift of the artist, 984-W-101

Alfred Leslie's career reversed the familiar legend of how a twentieth-century painter set off as a realist but became himself only by effacing the seen world. When only twenty-two, he was already painting abstract works inspired by Willem de Kooning, but individual enough to be included in a new talent show selected by Clement Greenberg and Meyer Schapiro;[1] and had he stuck to these abstract guns, like his contemporaries Joan Mitchell and Michael Goldberg, he could have continued this distinguished career for a lifetime. But in 1963, he was stricken by so overwhelming a need to wipe his and modern art's slate clean that he began his life as an artist anew, painting with freshly opened eyes and fierce urgency the living models before him. This conversion coincided with other reversals in American art, of which the invasion of Pop imagery is most conspicuous. Leslie's realism, however, was based not on photography or commercial illustration, but on intense perception. "I wanted," he later said, "to put back into art all the painting that the Modernists took out by restoring the practice of pre-twentieth-century painting."[2] Beginning with single portraits rendered with the confrontational symmetry of many Pop formats, he then expanded into multi-figured groups, whose sculptural firmness and tenebrist light resurrected the realist reforms Leslie admired in Caravaggio and Jacques-Louis David. And as his range grew, he depicted not only the people he knew but the American landscape.

Starting in 1977, when he was resident artist at Youngstown State University, Leslie, whether at home in Western Massachusetts or from the car he drove across the United States, constantly made drawings of the realities he saw. Then, back in his studio, he would rework these records into more carefully controlled watercolors, which in 1983 were ordered into a series, *100 Views Along the Road*, and exhibited across the country. Perhaps surprisingly for its tough American theme, this anthology has a strong Japanese inflection. It not only refers to the road and landscape views of Hiroshige and Hokusai (whose *100 Views of Mont Fuji* is evoked); but it explores the Japanese aesthetic of "Notan," which Leslie had already used in 1967 as a word to describe his goal of an equilibrium between extremes of black and white.[3]

View Over Holyoke, Massachusetts is typical of the whole. Depicting hilly terrain observed through a windshield, this seemingly on-the-spot document of the artist's own neck of the woods near Holyoke puts us in the driver's seat, forcing a close-eyed examination of a commonplace we may be startled to find so visually fascinating and, though depleted of people, so dramatically pregnant. Reasserting the pre-modern convention of the picture as a window view, Leslie perches us on the brink of discovery as we reach the top of a road about to be transformed into a panoramic valley vista familiar to American Romantic landscape painting. However, Thomas Cole's Promised Land, which Leslie had already repainted in 1971–

72 at the site of the Connecticut River's Oxbow,[4] has now been polluted. Slowly, we discern the hazy rectilinear silhouette of an industrial town on the horizon instead of the Heavenly City of Jerusalem. The static view of an innocent past has become dynamic and motorized, regimented by a strip of curving road, no-pass double lines, repeated telephone poles, and square signage all rapidly cutting into the distance like the proverbial railway tracks of traditional one-point perspective. Against this geometric rigor, Leslie plays the disorder of nature, with the close-up clumps of trees and the shifting movement of distant clouds. Recalling the principle of "Notan," this watercolor transforms what at first seems a deadpan account of nowhere in particular into a complex visual organism that juggles patches of velvety darkness against liberating vistas of luminous expanses. No wonder these watercolors have been referred to as "realist abstractions."[5]

In retrospect, this work, like the whole series,

belongs to broad traditions of modern art. As a picture within a picture, the windshield view had already been explored by artists as diverse as Henri Matisse and Stuart Davis. But more to the point, the American road, captured by Edward Hopper, was a growing motif in Leslie's generation, beginning with Jack Kerouac's novel, *On the Road* (1957), and continuing with George Segal's and Edward Ruscha's gas stations as well as Allen d'Arcangelo's *Highway* series, launched in 1963.[6] But if Leslie shares these artists' and writers' awareness of the American road's mysteries, he also transforms these familiar sights into his own unique fusion, creating masterly balances of darkness and light that seem at once as documentary and impersonal as a surveyor's photograph and as breathlessly expectant as a dream of escape and adventure.

ROBERT ROSENBLUM

NEIL WELLIVER | b. 1929

Briggs Meadow, 1977
Watercolor on paper, 29½ × 30¼″ (74.93 × 76.84 cm.)
Signed, lower right
Gift of Friends of American Art, 979-W-106

Neil Welliver, born in Millersville, Pennsylvania, studied at the Philadelphia Museum School (now University of the Arts) and at Yale University with Joseph Albers. By the mid-1970s, Welliver had established a national reputation as a major landscape painter.

Briggs Meadow is part of the ongoing dialogue that Welliver has had with the Maine woods. This particular piece is also one of the series of works the artist customarily uses in fully developing a subject. Welliver drives around the Maine countryside until a motif is set in his visual memory. From that point, small oil studies are made, from which large studio paintings are developed. Like the large oils, Welliver developed *Briggs Meadow* from a limited palette, with a reduced range of colors. Watercolors, such as *Briggs Meadow*, spring from certain special motifs and are usually conceived after the larger works are completed. In both media, Welliver also works from a developed cartoon which underlies the finished piece. In *Briggs Meadow*, hints of this pencil composition can be seen below the watercolor.

In *Briggs Meadow*, line and light are keys to understanding the painting's underlying structure. As in his oil studies and studio paintings, Welliver exhibits in this watercolor an accomplished sense of Baroque light layered with dark underpinnings.

Atmospheric perspective has been eliminated in order to give foreground, middle ground, and background equal emphasis. This lack of atmosphere also intensifies the linearity of brush stroke and is an accurate assessment of the pristine Maine air.

Welliver pays homage to his early training as a modernist in the manner in which he treats the picture plane. The foreground barrier which, at first glance, seems a labyrinth of foliage, can be worked through by following the diagonals subtly leading to the ribbon of river which abstractly divides and balances the foreground and background.

There is a calmness and serenity to *Briggs Meadow* despite the ribbed rows of clouds and sky, which reverse positions, and the serrated coniferous trees and jagged stumps, which should indicate visual jumping and jogging. The birch trees in the right side of *Briggs Meadow* both stabilize the composition and point metaphorically to the sky, as if to indicate where knowledge resides.

There is no evidence of civilizing in Welliver's Maine woods. The stumps are a result of natural rot, or beavers, rather than human forces of deforestation. *Briggs Meadow* is a comment on Welliver's concern for keeping the environment whole.

ROBERT GODFREY

HELEN FRANKENTHALER | b. 1928

Viewpoint II, 1979
Acrylic on canvas, 81¼ × 94½″ (206.38 × 240.03 cm.)
Signed, lower right
Gift of Paul and Suzanne Donnelly Jenkins, 989-O-108

Helen Frankenthaler was born in New York City. She received her formal education at Bennington College and continued additional art studies in the studios of Ruffino Tamayo, Wallace Harrison, and Hans Hofmann.

Two major aspects of Frankenthaler's work are her contribution to modernism and her allusion to naturalism. Most obvious is her contribution to modernism. In the early 1950s she developed a painting technique of wedding paint to the weave of canvas to form a single saturated matrix. Through these experiments, she, along with artists such as Morris Louis and Kenneth Noland, enabled the Minimalists of the next generation to reach the pinnacle of reductionism.

However, just as important as her contribution to modernism through her investigations into stain painting are Frankenthaler's allusions to naturalism. In *Viewpoint II*, painted almost thirty years after her breakthroughs in abstraction, there is an indication or suggestion of landscape; a beach and sky represented through the horizontal division of the picture plane, the warm grays and the saturated atmosphere. The stained surface, with thicker overpainting, also anticipates figuration.

From a distance, the space within *Viewpoint II* moves in and out: it breathes. It is laden with representational history, sometimes suggesting the modernist works of watercolorist John Marin and, at other times, emitting a transcendental light akin to the nineteenth-century luminists.

Looking closely at *Viewpoint II*, the viewer can experience the arabesque of Frankenthaler's mark-making, which appears considered or planned and, at the same time, accidental. It is the lyricism of a conscious stroke moving across the surface that intensifies the more moody temporal grays and warm muted reds of the stained canvas.

The results of these seemingly contradictory impulses of abstraction and representation in *Viewpoint II* are complex. The viewer can sense, on one hand, the control that a traditional easel painter has and, on the other, the gestural freedom that an expressionist possesses. What comes through in the end, however, is essence over matter.

ROBERT GODFREY

PAUL JENKINS | b. 1923

Side of St. George, 1968, 1968
Oil on canvas, 37 × 60″ (93.98 × 152.40 cm.)
Signed, lower right
Gift of David Kluger, 968-O-205

The paintings of Paul Jenkins have come to represent the spirit, vitality, and invention of post-World War II American abstraction. Employing an unorthodox approach to paint application, Jenkins's fame is as much identified with the process of controlled paint-pouring and canvas manipulation as with the gem-like veils of transparent and translucent color which have characterized his work since the late 1950s.

Born in Kansas City, Missouri in 1923, Jenkins was raised near Youngstown, Ohio. Drawn to New York, he became a student of Yasuo Kuniyoshi at the Art Students League and ultimately became associated with the Abstract Expressionists, inspired in part by the "cataclysmic challenge of Pollock and the total metaphysical consumption of Mark Toby."[1] An ongoing interest in Eastern religions and philosophy, the study of the I Ching, along with the writings of Carl Jung prompted Jenkins's turn toward inward reflection and mysticism which have dominated his aesthetic as well as his life.

Side of St. George, 1968 typifies the mature, developed style of the artist. It was created when Jenkins was celebrated as a cornerstone of Post Painterly Abstraction, that umbrella term applied by Clement Greenberg to describe the post-Abstract Expressionist approach to painting characterized by "color fields." These architectonic works were generally cool and even minimalistic, lacking the highly personal linear gestures and tactile surfaces associated with abstract painting in the fifties.

Jenkins's employment of titles, although generally intended to "secure an attitude toward the painting rather than provoke visual effect"[2] might, in the case of *Side of St. George, 1968*, suggest a more literal interpretation. In structure, the broad pours and linear elements subtly recall the classical Christian metaphor of good versus evil and the striking movement of the sword of the British Knight, St. George, as he slays the fire-breathing dragon. Formally, the work's rather symmetrical composition is not unlike St. George's cross which serves as the identifying emblem of the flags of the United Kingdom.

But while *Side of St. George, 1968* in title and structure might encourage such narrative interpretation, it is more about formal interplay, the dynamics of color and the nuances of edge. In many ways Jenkins's paintings from this period extend the explorations of Leonardo da Vinci, who, in his last years, examined such unseen forces of nature as wind and ocean currents. *Side of St. George, 1968*, so typical of the artist's work of this period, might be thought of as a visual poem that brings to light both the physical and the spiritual forces which guide man and his creative energies. Jenkins's art has always served to respond to the larger questions which confront us.

LOUIS A. ZONA

337

RALPH HUMPHREY | 1932–1990

Loner, c. early 1980s
Casein and modeling paste on plywood, 60¼ × 37¼″ (153.03 × 94.61 cm.)
Unsigned
Museum purchase, 983-O-104

The title of Ralph Humphrey's construction is in certain ways inapt. Although named *Loner*, the work establishes a direct, undisguised, and compelling relationship with its observers. Its wistfully contemplative colors—dour but sybaritic purples, blues, lavenders, muffled reds, browns, dunnish grays, and darkling isabelline yellows—invoke the captivating reminiscences of a personal journey made through metaphysical landscapes, of a companionable kinship forged with the ethers of the sky and the evanescences of the sea. Its tectonic structure, enunciated assertively with a protrusive frame, suggests a habitation fashioned expressly for individual experiences of inner and outer worlds.

Loner is as digressive as it is focused, as enigmatic as it is lyrical, and as elusive as it is immediate. Its pictorial paradoxes dissemble what they pretend to reveal, its aesthetic contradictions obscure what they claim to clarify, and its philosophical ironies inhibit what they presume to liberate. This is accomplished through the shifting formal devices used by the artist. While the alluring polychromatic palette romances through its seductive and cajoling colors, its structure, informed by a stark frontality, an austere geometry and an authoritarian frame, defiantly countervails the complaisance of the colors and the lusty impasto surfaces. One appeals to the imprecision of mood and the other to the exactitude of reason. However, Humphrey knew that such antitheses exist only in the mind for taxonomical purposes. In reality, they are one, coextensive in a world of equipoise. Thus, opposites are conciliated in a seamless entity where rigor does not gainsay reverie but complements it, where the rational and irrational, the intuitive and the verifiable are all part of the same cosmic membrane.

The work abounds in other complementary contrasts. The ragged and threadbare edges of the casein and modeling paste at the sides of the work blend into the stringent construction of the plywood beneath it. The atmospheric tonal strategies of the front of the work flow into the irregular brushstrokes on the jambs. *Loner* is at times insistent on its literalness as an object of art and at other times suggestive of its use as a threshold of metaphorical interpretations. Are we meant to see it as a hybrid of the architectural, sculptural, and painterly or as a gate or window that projects us onto a transilient other world? Are we meant to see it as a statement about the formalities of the minimal at one with the romantic or as a psychological see-saw of the physical and metaphysical, the real and illusory, the tangible and transcendental? Its spaces, viewed from the front, are absolute and intransigent; seen from the sides, they are relative and comparative as they transmute into changing configurations. The fixed and the ephemeral are converses of each other. And, there is as well the lingering thought that it all might be a mordant spoof on those who would reach beyond empirical realities for empyreal meanings. Recognition of the visual data could be the *raison d'etre* of the piece.

Ralph Humphrey's artistic achievement was considerable and would have reached a loftier magnitude had he not died at the early age of fifty-eight. His unflinching adherence to his own vision made him a devotee of no artistic currency but his own. Although some have adduced aesthetic affinities to Minimalism and Pop Art, filtered through a romantic sensibility, it is a thankless pursuit to find art works that have the inimitably distinctive look of this artist's. Created in the early 1980s, *Loner* is a mature embodiment of the "frame paintings" the artist had begun many years before, a developed refinement of the essences of those works that mark one of his significant contributions. Had he created only *Loner* in his lifetime, it would have been a consummate homage to a singular spirit.

DAVID L. SHIREY

Bisected Red Violet, 1977
Acrylic on canvas, 60 × 72¼″ (152.40 × 183.52 cm.)
Unsigned
Gift of Mr. and Mrs. J. J. Cafaro, 983-O-105

When Richard Anuszkiewicz had his first New York exhibition in 1960 the art world was not prepared for so complete a reversal of the aesthetic values that had characterized the Abstract Expressionist movement. The critics reacted to his juxtaposition of colors of equal value, sometimes with shock. They said that his works "make havoc with normal vision,"[1] that they stun the viewer and "dazzle and perplex the eye,"[2] that his paintings are "so intense as to make one wince,"[3] that "the effect is like putting your finger in an electric socket,"[4] and that "the effect is dizzying as though the viewer's eyes had gone out of focus."[5] But, unmentioned by these critics, were elements in his art even more disturbing to the critics' ingrained acceptance of what they considered to be the inherent value of Expressionism.

Anuszkiewicz's paintings were intellectual and planned rather than impulsive and expressive; he did not intend to convey his personality as the Expressionists had done, through brushstroke, speed, or violence, or through changes of design left visible as the painting progressed. His paintings utilized a uniform surface without brushstroke, without gradation, with a sudden abrupt edge between colors.

Previously, the composition of paintings had been based upon the concept that asymmetry expressed vitality and life. Anuszkiewicz introduced symmetry into his compositions and permitted the color juxtapositions to express those qualities. In his paintings the energy of color is released as two lines of different colors approach each other in measured relationships. His paintings state in visual form the mystery of the relationship between the order created by humans and the pulsing life of nature.

In other styles of contemporary art, balance was determined by a concept of the weight and gravity that one experienced through size, density, color, and placement. Anuszkiewicz defied this concept of gravitational balance by a composition of "tensegrity," a web of tensions on the skin of a painting that holds the composition together without any distinction between the top and the bottom of the painting, or between foreground and background. In his paintings, there is no dominance or subordinance of imagery: every element has an equal value. It is a most democratic form of art in its lack of hierarchy.

Previously, art was valued for its uniqueness. Each brushstroke itself was unique; but Anuszkiewicz introduced into his paintings the concept of repetition, frequently utilizing a grid structure. In so doing, his art became an art of imposed geometry and order rather than personal expression. It represented a desire for perfection and finality. No one can argue with geometry, for it is as elemental and self-preserving as it is self-creating. It is so final as a statement that it might even be considered to be the end of art.

The mathematical rigidity of geometry would not seem to allow for any further development of change; but Anuszkiewicz's development lies in his evolving exploration of color. Geometry defines itself without evaluation. It is so impersonal that all the artist needs to do is to plan the work and it can then be executed with mechanical devices, masking tape, and pre-mixed paints, even by assistants under the artist's supervision. This concept is essentially the one proposed in the early Renaissance by Filippo Brunelleschi and Leon Battista Alberti: the artist as thinker and planner, rather than merely as craftsman.

Anuszkiewicz's preference for the straight line, which is the most ordered form and must be consciously constructed, is not a product of impulse or spontaneity, but the result of thought and skill and the imposition of the intellect. His art is self-created, pure, and cerebral; by solving the problems he sets in one painting he is led logically to the problems of his next painting.

Anuszkiewicz's concept of unity is additive, displaying maximum unity and maximum variety. Everything is related to everything else, and everything is different from everything else, an observation about the structure of life itself.

Bisected Red Violet is characteristic of Anuszkiewicz's artistic concerns. The painting contains a pattern of fine horizontal lines of varying but regularly patterned lengths that run from the top to the bottom of the canvas like lines of a thermometer, registering the temperatures of the colors.

Anuszkiewicz studied Gestalt psychology as applied to visual perception and became aware of the effects of color perception on the emotions. His paintings have a strong emotional impact in spite of their

intellectual plan and impersonal execution. The colors in this painting are established in the red spectrum by the scales of lines which create stability against which one can measure the dynamic movement of color in the center of the painting. Based upon the perception that complementary colors seek out, as well as repel, each other, in this painting a lateral movement that is created by the red-green antithesis is in contrast to the vertical movement created by the yellow-violet complementary colors.

According to Gestalt principles, the only occasion temperature can be felt in color—that is, when colors seem to be either hot or cold—is when colors are moving from one end of the spectrum to the other. Pure isolated colors are neither intrinsically warm nor cold, but if a color is moving from one end of the spectrum to the other, movement towards red can be dfelt as warm, while movement towards violet can be felt as cold. Thus, the center of this painting contains such a movement through the use of violet and yellow, the vertical movement of which contrasts with the horizontal movement between red and green.

This complex painting is, therefore, not only about the optical effects of juxtaposed complementary red and green, though there is the emotional effect of the tension created by red and the relaxation created by green. It is a painting about the illusion of the movement of colors on a stable surface, delineated by a gauge of lines that ends in a quiet expanse of pure flat red.

KARL LUNDE

RAFAEL FERRER | b. 1933

El Sol Asombra, 1989
Oil on canvas, 60 × 72″ (152.40 × 182.88 cm.)
Signed, lower left
Gift of Neita and Debra Burger in memory of Irving Burger and museum purchase, 990-O-106

The exotic, mysterious world of the tropics is explored in Rafael Ferrer's *El Sol Asombra*, a striking painting of an isolated landscape dominated by brilliant light and vivid color. Ferrer's highly individual vision comes from his sharp powers of observation and his reservoir of poignant personal experiences, memories, and desires; raw materials which he transforms into a distinctively expressive painting style rich with visual detail.

A master of compelling, although ambiguous, narrative, Ferrer first came to prominence with his inventive, loosely assembled temporary installations, associated with Process Art. These messy environments, organized without hierarchy, were created from such diverse materials as grease, leaves, hay, ice, neon, and corrugated metal. In the late 1970s, the artist turned to easel painting, concentrating on expressively rendered figures. Since the early 1980s, he has painted Caribbean subjects. Born in Puerto Rico in 1933, Ferrer traveled widely before choosing to return to the Caribbean. Now he splits his time equally between Philadelphia and the Dominican Republic, the inspiration for *El Sol Asombra*.

In *El Sol Asombra*, nature and light as well as perceptive understanding of place are the essential subjects of a flamboyant composition depicting several houses located in an overgrown landscape. A centrally positioned but architecturally simple dwelling, brilliantly colored in yellow, pink, and blue, dominates the scene. The relationship between this large structure and the location and scale of the flaking houses creates a slightly unsettling perception of space. Adding to the feeling of isolation is the dense arrangement of lush green plants and irregularly shaped foliage surrounding the domestic buildings. Despite the depiction of illusionary space, Ferrer maintains a surface flatness through simplified and flattened shapes and tonally even colors. Overall, the sensation of heat and moisture permeates the work. Ferrer has subtly altered the quiet mood and feeling of seclusion of the tropical environment by including two small figures, one seated and the other standing behind an open window. Placed in dark shadow, their presence, although barely visible, adds to the enigma of the scene. One is uncertain about the role of these figures. Are they the observers or has their privacy been invaded?

Ferrer's deft use of light overwhelms and energizes the complex compositional layout and the puzzling narrative of this painting. The intensity of the sun's rays pouring through the trees is balanced by a startling array of bold shadow patterns. Wonderfully independent, abstract, dark, flat planes rhythmically cover much of the foreground. Additionally, wandering, somewhat figure-like shadows dance over the buildings, suggesting the fleeting presence of light. The work's title translates roughly as "the sun with shade or shadow," which embodies a play on words that often characterizes Ferrer's titles. Descriptively accurate, it refers to a duality in the work in a number of ways. *El Sol Asombra* is at once light and dark, isolated and accessible, open and impenetrable, a southern subject, but in a northern painting style.

For some time, landscape has been a key element in Ferrer's painting. In a 1984 interview, he explained his fascination with this subject matter. "The landscapes come from geographic locales that have the most intensely erotic connotation from my

childhood: going to deserted beaches when I was little; going through palm groves which are endless. . . . There is this combination of what you see and what you imagine. I include the kinds of houses you find in the tropics. . . ."[1] Travel throughout the Caribbean and Mexico has significantly enriched his repository of visual imagery. These lush, real and remembered environments provide compatible forms for Ferrer's distinctive brushstrokes: thick, fluid, and forceful. Despite the vividness of his memories, the artist relies on photographs to construct his tropical vistas. "I now have tons of photographs: palm groves, beaches with the ocean in different conditions, cloud formations, banana groves, all these things."[2] His goal is a dense visual richness.

Ferrer's expressive, straightforwardly representational style appears primitive—he is primarily self-taught—but is rooted in and enriched by the artist's knowledge of the history of painting. The faux-naive paintings of Paul Gauguin and Henri-Julien Rousseau come immediately to mind as sources of inspiration. In the end, however, there is a compelling energy, unleashed by the lively paint surface in Ferrer's work. By stressing simplified forms, rhythmic flattened surfaces, and the supremacy of light and atmosphere, Ferrer allows his lavish pictorial surfaces and colors to simmer with emotion.

TOM E. HINSON

343

JOSEPH RAFFAEL | b. 1933

Paper Mill, 1974
Oil on canvas, 83 × 120″ (210.82 × 304.80 cm.)
Signed, on reverse
Museum purchase, 992-O-112

Joseph Raffael began his Water Series of oils and watercolors during his years in San Geronimo, California. *Paper Mill* is an outstanding example of this Series, which has evolved from 1973 to the present. During this period, reminiscent of his childhood summer experiences on Long Island Sound, Raffael gravitated toward the solitude of nature, especially the effect of light upon water and the spirit of water. Raffael received his artistic training at Cooper Union and Yale University. After study in Florence and Rome he moved in 1968 to California and in 1986 to France, where he has resided since. The resonance between nature and his inner self was heightened during Raffael's two year study with Josef Albers at Yale University. This resonance brought about a deep awareness of color and light as reflective of one another, and an understanding of aloneness and being true to self as essential to art, a philosophy Raffael defined as "Alone, not isolated. Alone in the sense of 'all one' . . . left alone to do what you wish."[1]

The need of solitude and silence, enhanced by the wonderment of nature, deepened Raffael's experience of the intangible, the consciousness of a precious moment in time, a threshold into something beyond the visual eye. When asked to reflect on the painting *Paper Mill* Raffael stated, "The two o'clock sunlight, slanting through the pines and redwoods greeted me and directed my eye and heart to the water in Paper Mill Creek. It was a moment in time, of nature's turning, never repeating itself, and my sense of aloneness with it, and its eternal, ever-moving dance going on before me, and its abundance and generosity and beyond-human-ness touched me. It is in fact an image . . . quieting the world's buzz and its tumbleness. . . ."[2]

The desire to be at one with nature and oneself became the essence of his creativity. Seldom exploring nature without his camera, Raffael treated its lens as a picture frame through which the scene before him evoked a potential painting. In the late 1960s, intrigued by the expanded imagery of films on the movie screen, he chose to magnify his selected photograph to larger than life proportions. This image was then projected onto a specially-prepared oversized canvas with eight to nine coats of gesso, each layer individually sanded. The result was an opaque finish with the oil paint resting on its surface, the color becoming translucent and the intensified white gesso acting as a light behind the canvas. The transparencies of these rich tones, affecting each other as shimmering jewels, created a surface which simultaneously moves inward and outward, reflective of his philosophy that the world is one of ebb and flow, of receiving and offering.

The feeling of participation in the sensuous surface and its mystical essence is paramount in Raffael's paintings. His palette is luminescent and his luxurious colors attain a radiance that inspires other images. Through this many-layered meaning *Paper Mill* symbolizes more than an evocation of nature. The correlation between nature and its symbolic essence represents, on a deeper metaphysical level, the quintessence of Raffael's truth that "painting is borne out of images from daily experiences which become as a personal journal of the painter's deepest feelings at the time of creativity."[3] In his Water Series, each painting is subjective and synonymous with his ideals and inspirations. Raffael's intention of invoking the material world of nature to reveal the hidden, transcendental realm of the unconscious initiates a seeing beyond the form, suggestive of more than the surface appearance of nature itself. In the words of Lao-Tse "Water never rests, neither by day or night. When flowing above, it causes rain and dew. When flowing below, it forms streams and rivers. Water is outstanding in doing good. If a dam is raised against it, it stops. If way is made for it, it flows along the path. Hence it is said that it does not struggle. And yet it has no equal in destroying that which is strong and hard."[4] This dynamic dance between nature and the mysterious may well be considered the eloquence of *Paper Mill*.

JOYCE PETSCHEK

NASSOS DAPHNIS | b. 1914

Palace in Minos, 1988
Enamel on canvas, 75 × 90″ (190.50 × 228.60 cm.)
Unsigned
Gift of Alexander and Helen Avlonitis, 994-O-101

Although Nassos Daphnis associated with the most influential painters on the American scene during his developmental years, he was never identified with a school or trend. During the 1940s and early 1950s, Balcomb Greene's American Abstract Artists, Fritz Glarner, Ilya Bolotowski, John Ferren and others, were formulating their theories of geometric abstraction. In style and approach, Daphnis's work, characteristically similar, was substantively different. The artists of the New York School, Jackson Pollock, Franz Kline, and Willem de Kooning, although friends, were not professional allies. The emotionally fired Abstract Expressionism with its spontaneity and seemingly unbridled technique was as foreign to Daphnis as academic art, which he also rejected as shallow and commercial.

Born in Krokeia, Greece, near Sparta, at age sixteen Daphnis departed for America from Athens, where for the first time he experienced the art of classical Greece and fell under the spell of the perfection and pure geometry of the Parthenon, a unique moment that would remain as a source of inspiration throughout his life.[1] Once in the United States, his early success as a Surrealist painter was interrupted by service in World War II. The Post-War era brought about a biomorphic phase which appeared as a natural outgrowth of his Surrealist period. These works, such as *3-F-51* (1951, The Butler Institute of American Art), were purely abstract and predicted the hard-edged surfaces, orderly composition, and exploration of color that would become the essence of Daphnis's work. Like the Dutch painter Piet Mondrian, who found strength in the use of primary colors, Daphnis admires pure red, yellow, and blue for the energy which they seemed to intrinsically convey, and he focuses on color as a principal element. His color plane theory, though based upon exhaustive perceptual investigations, possessed strong spiritual implications as well.[2]

In 1988, a trip to Crete inspired the Aegean Series, a return to the geometry of the square and rectangle. Clearly the architecture and setting of Crete provided the organizational framework as well as inspiring the character of line, shape, and color within this group of paintings. The series underscores the consistent technical facility of Daphnis, who pioneered a masking technique for which he has long been identified. *Palace in Minos*, a key painting from the series, employs his color plane theory in structuring a strong architectural space. The dominant black presses forward much like a great protective roof as vertical white lines visually separate color areas and support and balance the uppermost color masses. The painting's architectonic construction and organizational complexity recalls the Cretan Palace of Minos, a maze which is vast and intricate in design and constructed with no preconceived plan.[3] The artist refers to the mythological thread, which can lead one out of the maze, seen in the small yellow area, and further suggests that the colors black and yellow possess dynamic visual qualities to similarly connect and assist other visual elements in the work.

LOUIS A. ZONA

SAM GILLIAM | b. 1933

Mars at Angles, 1978
Acrylic on polypropylene, 232 × 186″ (589.28 × 472.44 cm.)
Signed, on reverse
Museum purchase, 989-O-106

After receiving a Master's degree in painting from the University of Louisville, where he spent his childhood, Gilliam moved to Washington, D.C. in 1962, where Jackson Pollock's legacy was very much alive. From the mid-1950s Morris Louis had been engaged in an adventure inspired by Jackson Pollock's innovative techniques. Louis worked with huge lengths of canvas spread on the floor from wall to wall, pouring acrylic paints, folding over his canvases and staining forms, in a spontaneous process. Around him in Washington gathered several younger artists, including Sam Gilliam, who soon entered into the new spirit. Toward the late 1960s, he, too, abandoned stretchers and frames, and began to work with poured surfaces. From the beginning, in this new experimental mode, Gilliam displayed immense vitality. His colors seethed on the canvas, and his ability to control large formats was obvious.

It soon became apparent to Gilliam that, having freed himself from the quadrilateral plane of traditional painting, he could move at will into three-dimensional space. With the aid of new materials, such as polypropylene, Gilliam was able to bring his billowing images off the wall, or stand them, sometimes on wooden armatures, as though they were sculptures. But in fact, Gilliam's images are always envisioned as paintings, albeit paintings that like topological descriptions could be infolded, draped, or given virtual cavities and real cavities, depending on his pictorial intention. By 1967 he had achieved sufficient mastery of his new techniques to be offered a one-man exhibition at the Phillips Gallery, Washington, D.C.

During the next decade, Gilliam not only extended his work to the installation of large, flexible painted canvases in outdoor settings, but had begun to think of his paintings as occupying specific spaces. Certain exhibitions during the 1970s were conceived as installations for the museum or gallery spaces he was offered. When he exhibited at the J. B. Speed Art Museum, Louisville, Kentucky, in 1976, one of his most perceptive critics, Walter Hopps, marveled at the "delicate balance between improvisation and structure and a sense of chaos controlled."[1]

Like the early Russian master Vladimir Tatlin, Gilliam was keenly aware of the spatial advantages of the triangular form implicit in corners, or, as the title of this work suggests, angles. In *Mars at Angles*, he takes full advantage of the shadowy space secreted behind his painting. The gorgeous panoply of color cascading from a single point in the ceiling, and attached at the two angles of the walls, suggests a hidden axis in the very depths of the corner. The flow of Gilliam's drapes, so suggestive of a Renaissance baldacchino, a canopy of richly woven fabric, seems free of the composer's intention, but in fact, is carefully controlled to offer structural coherence. There are hidden geometric axes and diagonals here that are quite as explicitly structural as a painting by one of the great Renaissance masters of drapery, such as the Venetian, Paolo Veronese. Despite its three-dimensional aspect, this work is fundamentally a painting, in which earlier conventions are revitalized in a free experimental spirit.

DORE ASHTON

349

NOTES

NEHEMIAH PARTRIDGE *(p. 14)*

1. Illustrated in Emma Ten Broeck Runk, *The Ten Broeck Genealogy* (New York: The De Vinne Press, 1897), 87.
2. *60 Years of Collecting American Art* (Youngstown, Oh.: The Butler Institute of American Art, 1979), n.p.
3. Jonathan Tenney, *New England in Albany* (Boston: Crocker & Co., 1883), 27.
4. Information on the Ford and Willard Families is taken from *Albany City Directories (1813–1869)*; Joel Munsell, *The Annals of Albany*, vol. 10 (Albany: J. Munsell, 1859); *New York Census Index* 1790, 1800, 1810; and the Ford and Willard plots at Albany Rural Cemetery, Menands, New York. A source for genealogical data was Stefan Bielinski, Director, Colonial Albany Project, The New York State Museum.
5. Mary Black, "Contributions Toward a History of Early Eighteenth Century New York Portraiture: The Identification of the Aetatis Suae and Wendell Limners," *The American Art Journal*, 12:4 (Autumn 1980): 4–32.
6. Ibid., 31.
7. Runk, *Ten Broeck*, 56–8.
8. Ibid., 85–7.
9. Edwin Brockholst Livingston, *The Livingstons of Livingston Manor* (New York: The Knickerbocker Press, 1910), 562–3.
10. Runk, *Ten Broeck*, 86–7.

RALPH EARL *(p. 17)*

1. Elizabeth Kornhauser, *Ralph Earl: The Face of the Young Republic* (New Haven: Yale University Press, 1991), 92–3.
2. Hopper Striker Mott, *The New York of Yesterday* (New York: G. P. Putnam's Sons, 1908), 121, 346 identifies Ann (1781–1862) as the older and Winifred (1782–1860), the younger sister. The sisters' last name is spelled "Striker" rather than the Dutch "Stryker," in accordance with Mott, a family descendant.
3. Elizabeth Kornhauser, "Ralph Earl: Artist-Entrepreneur" (Ph.D. diss., Boston University, 1988), 324.
4. For example, *Houses Fronting New Milford Green* (c. 1796, The Metropolitan Museum of Art).

JOSEPH BADGER *(p. 18)*

1. Rea's account books are preserved in Baker Library, Harvard Business School. In Mabel M. Swan, "The Johnstons and the Reas—Japanners," *The Magazine Antiques*, 43 (May 1943): 211–3, the entry is corrected to say "a Pitcher [picture] and painting Buckets 1/13."
2. For the first list of works believed to be by Badger see Lawrence Park, "An Account of Joseph Badger, and a Descriptive List of His Work," *Proceedings of the Massachusetts Historical Society*, 51 (December 1917): 158–201.
3. Edward G. Perkins, Curator, The Butler Institute of American Art, to Jules D. Prown, August 11, 1964, The Butler Institute of American Art Archives. "The changes in attribution were due to Mrs. Barbara N. Parker of the Boston Museum, who in 1938 thought that 'Although these facts seem to point to Copley as the author of the picture, the style exhibits a certain quaint stiffness and a tightness of brushstroke, which is not characteristic of the typical Copley portrait.' In the *Boston Museum Bulletin*, XL in 1942, she mentioned an X-ray taken by Mr. Alan Burroughs, which showed under-painting with none of the top layer's stiffness and proved conclusively that no painter but Copley was competent enough to have modelled the strong head."

JOHN SINGLETON COPLEY *(p. 21)*

1. S. Morton Vose, President, Vose Galleries, to Richard Ulrich, February 23, 1972, The Butler Institute of American Art Archives.
2. Barbara Parker, "Problems of Attribution in Early Portraits by Copley," *Bulletin of the Museum of Fine Arts, Boston*, 40:239 (June 1942): 57.
3. Alan Burroughs, *Limners and Likenesses: Three Centuries of American Painting* (Cambridge, Mass.: Harvard University Press, 1936), 67.

JACOB EICHHOLTZ *(p. 22)*

1. Russel, "Eichold [sic] the Painter," *Port Folio* 5, (April 1811): 340–2.
2. John Calvin Milley, "Jacob Eichholtz, 1776–1842 Pennsylvania Portraitist" (M.A. thesis, University of Delaware, 1960), 69.
3. See Rebecca J. Beal, *Jacob Eichholtz 1776–1842 Portrait Painter of Pennsylvania* (Philadelphia: Historical Society of Pennsylvania, 1969).
4. Beal, *Portrait Painter*, 53.
5. See William Dunlap, *History of the Rise and Progress of the Arts of Design in the United States*, 2 vol. (New York: George P. Scott and Co., 1834), 1: 278.

BENJAMIN WEST *(p. 25)*

1. John Galt, *The Life, Studies and Works of Benjamin West*, 2 vols. (London: T. Cadell and W. Davies, 1820; reprint, Gainesville Fla.: Scholars' Facsimiles and Reprints, 1960), 1:53. The project, involving thirty huge Biblical scenes, lasted from 1779–1801. West completed eighteen canvases which were exhibited at the Royal Academy.
2. See Helmut von Erffa and Allen Staley, *The Paintings of Benjamin West* (New Haven and London: Yale University Press, 1986), 363–70, nos. 360, 367, 369.
3. This work is lost although an oil sketch and engraving survive. See von Erffa and Staley, *West*, 370–1, no. 373.
4. Allen Staley, *Benjamin West: American Painter at the English Court*, exhibition catalog (Baltimore, Md.: Baltimore Museum of Art, 1989), 72.

GILBERT STUART *(p. 26)*

1. The most noticeable repaint occurs along the eyebrows, at the far corner of the more distant eye, at the far corner of the lips, under and along the lips, and under the chin.
2. See Thomas Bodkin, *Hugh Lane and His Pictures* (London: Stationery Office for an Arts Council, 1932, 1956).
3. Charles Merrill Mount, *Gilbert Stuart, A Biography* (New York: W.W. Norton & Company, Inc., 1964), 93, 359. Mount is influenced by the fact that there is a missing portrait of William Temple Franklin that is mentioned in a letter of November 9, 1784 from William to Benjamin. Mount rejects the given title in a letter to Clyde Singer, June 24, 1962, The Butler Institute of American Art Archives, claiming that Sir Hugh assigned the name Webb to more than one of his portraits. However, the likeness does not resemble the documented likenesses of Temple Franklin, see Benjamin West's *American Commissioners of the Preliminary Peace Negotiations with Great Britain* (c. 1783, Henry Francis Du Pont Winterthur Museum).
4. See William T. Whitley, *Gilbert Stuart* (1932; Cambridge: Harvard University Press, 1969).

5. See David Mannings, "A Well-Mannered Portrait by Highmore," *Connoisseur*, 189:760 (June 1975): 117.

CHARLES WILLSON PEALE *(p. 28)*
1. Peale to Russell, June 20, 1784, The Butler Institute of American Art Archives.
2. See *The American Tradition Part I: Paintings of the Eighteenth and Nineteenth Centuries*, exhibition catalog (Kennedy Galleries: New York, 1982) nos. 8, 9.
3. Norris Harris Church Register, Maryland Historical Society.
4. Jairus Barnes has pointed out that the chair profiles and elaborate scrolls are probably free inventions after an armchair design in the 'French' manner from Thomas Chippendale's *Director*, first published in 1754.
5. See David Mannings, "A Well-Mannered Portrait by Highmore," *Connoisseur*, 189:760 (June 1975): 116–9.
6. This conceit was probably the sitter's. In the letter cited in n.1, Peale reported having forgotten whether these replicas were to be head size (23×19″) or the same size as the originals. While Russell's response does not survive, he apparently ordered paintings that were the same size as the originals (a decision that facilitated including the held paper) and specified the wording; an extant letter to Thomas from William concludes "Yor Reall Freind & Aff:te Brother/Will:m Rusell" (September 9, 1767), The Butler Institute of American Art Archives.
7. See Michael W. Robbins, *The Principio Company: Iron-making in Colonial Maryland, 1720–1781* (New York & London: Garland Publishing, Inc., 1986).

REMBRANDT PEALE *(p. 30)*
1. See Lillian B. Miller and Carol Eaton Hevner, *In Pursuit of Fame: Rembrandt Peale, 1778–1860* (Washington, D.C.: National Portrait Gallery, 1992).
2. Ibid., 10.
3. Ibid., 280.
4. Rembrandt Peale, "The Person and Mien of Washington," *The Crayon*, 3 (April 1856): 100–2.
5. Ibid.
6. Peale, ". . . Washington," 101.

JOHN JAMES AUDUBON *(p. 33)*
1. The majority of Audubon's work was done in watercolor which was later translated into engravings.
2. Audubon once referred to a fox in explaining his studio technique: "No one, I think, paints in my method; I, who have never studied but by piecemeal, form my pictures according to my ways of study. . . . I am now working on a Fox; I take one neatly killed, put him up with wires, and when satisfied with the truth of the position, I take my palette and work as rapidly as possible; the same with my birds. If practicable, I finish the bird at one sitting. . . of fourteen hours,—so that I think they are correct, both in detail and composition." Audubon, quoted in John Chancellor, *Audubon* (New York: The Viking Press, 1972), 121.

ATTRIBUTED TO JAMES PEALE *(p. 34)*
1. See Charles Coleman Sellers, "James Peale: A Light in Shadow 1749–1831″ in *Four Generations of Commissions, The Peale Collection of the Maryland Historical Society* (Baltimore, Md.: The Maryland Historical Society, 1975), 28–33.
2. William H. Gerdts and Russell Burke, *American Still Life Painting* (New York, Washington, London: Praeger, 1971), 17.
3. Ibid., 24.

4. William H. Gerdts, *Painters of the Humble Truth, Masterpieces of American Still Life 1801–1939* (Columbus and London: Philbrook Art Center with the University of Missouri Press, 1981), 62.
5. This painting does not share all stylistic elements of the known, signed still-life paintings by James Peale and it is therefore impossible to state with certainty that it is his work. Peale is thought to have produced over one hundred still-life paintings including a number of replicas. Members of the Peale family continued to paint from his still-life subjects after he was deceased, further complicating the question of attribution. See Charles Elam, *The Peale Family, Three Generations of American Artists* (Detroit: The Detroit Institute of Arts and Wayne State University Press, 1967), 118.
6. Two other versions of this composition are known: *Grapes and Apples* (n.d., White House, Washington, D.C.) and *Still Life: Apples and Grapes* (n.d., Sheldon Memorial Art Gallery, University of Nebraska, Lincoln). Of the three paintings, *Still Life: Apples and Grapes* is the most loosely painted, varied in hue, and different in numbers and placement of the grapes and leaves. On the basis of these elements it has been attributed by William H. Gerdts to Mary Jane Peale. See Norman A. Geske and Karen Janovy, *The Sheldon Memorial Art Gallery: The American Painting Collection* (Lincoln, Neb.: University of Nebraska Press, 1988), 319; Karen Janovy, Catalog Project Assistant, University of Nebraska Sheldon Memorial Art Gallery to the author, November 18, 1986. However, William Kloss does not agree with this attribution. See William Kloss, et al., *Art in the White House, A Nation's Pride* (Washington, D.C.: White House Historical Association, 1992), 273.

ALVAN FISHER *(p. 37)*
1. William Dunlap, *History of the Rise and Progress of the Arts of Design in the United States*, 3 vols. (1834; reprint, New York: Benjamin Blom, 1965), 3:32.
2. Thomas Cole, "Essay on American Scenery," in John W. McCoubrey, *American Art 1700–1960* (Englewood Cliffs, N.J.: Prentice-Hall, Inc., 1965), 106.
3. Thomas R. Lewis, "The Landscape and Environment of the Connecticut River Valley," in *The Great River: Art & Society of the Connecticut Valley, 1635–1820* (Hartford: Wadsworth Atheneum, 1985), 11, 13.

JOSHUA SHAW *(p. 38)*
1. Francis James Dallett, "The Barkers of Bath in America," *Antiques* (May 1968): 655.
2. Mrs. Ralph G. Strother to Joseph G. Butler, III, June 27, 1968, The Butler Institute of American Art Archives.
3. See Miriam Carroll Woods, "Joshua Shaw: A Study of the Artist and His Paintings," (M.A. thesis, University of California, Los Angeles, 1971), 66–8.
4. See Ibid., chap. 4.
5. See *On the Susquehanna* (1839, Museum of Fine Arts, Boston) and *American Forest Scenery* (1843, The Newark Museum).
6. Dallett, "Barkers"; John Neagle, "Lessons on Landscape Painting. . . ," 22, manuscripts, American Philosophical Society; and "Receipts," 55, 57, 77, manuscripts, American Philosophical Society.

SETH EASTMAN *(p. 41)*
1. Quoted in Peter H. Hassrick, et.al., *American Frontier Life: Early Western Painting and Prints* (New York: Abbeville Press for the Amon Carter Museum and the Buffalo Bill Historical Center, 1987), 21.

2. This painting has been published under the title *View of the Highlands from West Point* in John Francis McDermott, *Seth Eastman, Pictorial Historian of the Indian* (Norman, Okla.: University of Oklahoma Press, 1961), pl. 21.

3. Seth Eastman, *Treatise on Topographical Drawing* (New York: Wiley and Putnam, 1837), 32.

4. John Francis McDermott, *The Art of Seth Eastman. From the Smithsonian Report for 1960* (Washington, D.C.: Smithsonian Institution, 1961), 580. The Butler Institute work has been assigned a date of 1834, its inscription could also be read as 1839. Eastman exhibited several landscapes that could quite possibly be this one. Their titles and exhibition dates were: *View of the Highlands, from West Point*, 1836; *View of West Point, Looking Toward Newburgh*, 1839; *View from West Point*, 1840; and *View on the Hudson, Near West Point*, 1841.

JUNIUS BRUTUS STEARNS *(p. 42)*
1. "Mere Mention—George Washington at Home," *The Home Journal*, 720 (26 November 1859): 2.

2. "Washington's Marriage in 1759," *Alexandria Gazette*, 49 (30 September 1848): 2. Arlington House was owned by George Washington Parke Custis, step-grandson of George Washington.

3. Stearns to Executive Committee of the American Art-Union, November 15, 1849, American Art-Union Collection (Letters from Artists), The New-York Historical Society, New York.

4. The works are: *Washington as Statesman, at the Constitutional Convention; The Marriage of Washington; Washington as a Captain in the French and Indian War; Washington as a Farmer, at Mount Vernon* (1856, 1849, c. 1851, 1851, Virginia Museum of Fine Arts); *Washington on His Deathbed* (1851, Dayton Art Institute).

5. Stearns to Merrick, July 17, 1853, The Butler Institute of American Art Archives. That the Butler Institute's painting served as the source for the print is evident in the appearance of the African-American couple on the far right in both.

THOMAS SULLY *(p. 44)*
1. See Monroe H. Fabian, *Mr. Sully, Portrait Painter. The Works of Thomas Sully (1783–1872)*, (Washington, D.C.: National Portrait Gallery, 1983). See also Edward Biddle and Mantle Fielding, *The Life and Works of Thomas Sully (1783–1872)* (Philadelphia: Wickersham Press, 1921).

2. John Vanderlyn to John Vanderlyn, Jr., March 9, 1833, Hoes Collection, Senate House State Historic Site, Kingston, N.Y.

3. Although Sully's *Mother and Child* for the *Albany* is not listed in Biddle and Fielding, Sully mentions the painting in his manuscript, "Thomas Sully's hints for pictures, 1809–1871," 137, entry for 16 January, 1827, Yale University Library, New Haven, Conn.

4. For a list of the *Albany's* paintings see Samuel F. B. Morse, *Academies of Arts. A Discourse, Delivered on Thursday, May 3, 1827, in the Chapel of Columbia College, before the National Academy of Design, on Its Anniversary* (New York: G. C. Carvill, 1827), 53. I am indebted to Linda Kornheim Kramer, who provided me with a copy of her essay "The Decoration of the Steamboat *Albany*," unpublished manuscript.

5. Biddle and Fielding, *Sully*, 371. In Sully's hand-written "Register of paintings executed by him between the years 1801 and 1871," New York Public Library, 52, the date of completion is listed as August 3, 1837, but this may well be an error; all the other pictures listed on that page were completed in the same year they were begun. *The Albany's Mother and Child* on panel is presently at the Richard York Gallery, New York, N.Y.

6. Thomas Sully, "Register of Paintings executed by Thomas Sully be-

tween 1801–1871," 52, typescript copy in The New York Public Library.

7. The panel for the *Albany* was still with Sully on March 11, 1827, when one of a group of ladies knocked it from the easel. "Journal of Thomas Sully's activities May 1792–1793, 1799–December 1846" entry for March 11, 1827, 48, typescript copy in The New York Public Library.

8. "D.," "Notes and Queries," *The Crayon*, 4 (May 1857): 181.

ROBERT W. WEIR *(p. 46)*
1. See Lauretta Dimmick, "Robert Weir's *Saint Nicholas*, A Knickerbocker Icon," *The Art Bulletin*, 66:3 (September 1984): 465–83.

2. Washington Irving, *A History of New York From the Beginning of the World to the End of the Dutch Dynasty; Containing, Among Many Surprising and Curious Matters, the Unutterable Ponderings of Walter the Doubter, the Disastrous Projects of William the Testy, and the Chivalric Achievements of Peter the Headstrong—the three Dutch Governors of New Amsterdam; Being the Only Authentic History of the Time that Ever Hath or Ever Will be Published. By Diedrich Knickerbocker*, 2 vols. (1809; ed. and intro. by Stanley T. Williams and Tremain McDowell, New York: 1927).

3. "The Fine Arts, The National Academy of Design," *New-York Mirror*, 14, 17 June 1837, 407.

4. Other known *Saint Nicholas* works are in the collections of: New-York Historical Society; National Museum of American Art; two in private collections, and Sheldon Swope Art Gallery, Terre Haute, Ind.

5. See Dimmick, "Robert Weir. . . ," 475–6.

JOHN F. FRANCIS *(p. 49)*
1. Bruce Weber, *John F. Francis: Not Just Desserts*, exhibition catalog (New York: Berry-Hill Gallery, 1990).

2. James Thomas Flexner, *That Wilder Image: The Native School from Thomas Cole to Winslow Homer* (New York: Dover Publications, 1970), 237.

3. There are at least two nearly identical variations on the Butler Institute painting.

4. Flexner, *Image*, 239.

CHARLES BAUM *(p. 50)*
1. Judith Hansen O'Toole, "Search of 1860 Census Reveals Information on Severin Roesen," *American Art Journal*, 16 (Spring 1984): 90–1.

2. Richard B. Stone, "'Not Quite Forgotten' A Study of the Williamsport Painter, S. Roesen," *Lycoming Historical Society Proceedings and Papers*, 9 (November 1951): 28–9; Judith Hansen O'Toole, *Severin Roesen* (Lewisburg, Pa.: Bucknell University Press; London and Toronto: Associated University Presses, 1992), 73–6.

3. The artist may be the Charles Baum identified in 1852 as a boathouse keeper living in New York City at Castle Garden, in John Trow, *Trow's New York City Directory* (New York: John F. Trow, 1852–53), 48; the listing was repeated in the Directory the following year. This is the only Charles Baum in the Directory. There is also the possibility that this was the same Charles W. Baum who worked as a clerk at 12 Broad Street in Jersey City from 1854–6, who then disappears from the Directory listings.

THOMAS COLE *(p. 52)*
1. See Ellwood C. Parry, III, *The Art of Thomas Cole: Ambition and Imagination* (Newark: University of Delaware Press; London and Toronto: Associated University Presses, 1988).

2. Among many examples is *Scene from the Last of the Mohicans, Cora Kneeling at the Feet of Tamenud* (1827, Wadsworth Atheneum, Hartford, Conn.).

3. Edward C. Pinckney, "Italy," in Rufus Wilmot Griswold, *The*

Poets and Poetry of America (Philadelphia: Parry and McMillan, 1856), 288.

4. Though exhibited as *The Improvisator* (referring to the musician), Cole had initially titled the work *Italian Landscape*. See Parry, *Cole*, 218.

5. Paraphrased from a Boston *Daily Advertiser* review of *Dream of Arcadia*, 17 July 1838, cited in Parry, *Cole*, 204.

6. Thomas W. Parsons, "The Shadow of the Obelisk," in Griswold, *Poets*, 561.

7. James Russell Lowell, "The Poet," in Griswold, *Poets*, 568.

ASHER BROWN DURAND *(p. 54)*

1. John Durand, *Life and Times of A. B. Durand* (New York: Charles Scribner's Sons, 1894; reprint, New York: Da Capo Press and Kennedy Graphics, Inc., 1968), 192–5.

2. Quoted in Durand, *Durand*, 202.

3. Until 1856 the Fields had been Durand's neighbors on Amity Street, Durand at number 91, the Fields at number 50. *The New York Times*, 18 March 1893, 1.

4. E.g., *The Solitary Oak* (1844, New-York Historical Society).

THOMAS DOUGHTY *(p. 56)*

1. *The Crayon*, 3 (May 1856): 159.

2. John Alan Walker, "Thomas Doughty (1793–1856)," *Fine Art Source Material Newsletter*, 1:1 (January 1971), 17, 20.

3. Henry T. Tuckerman, *Book of the Artists. American Artist Life. Comprising Biographical and Critical Sketches of American Artists: Preceded by an Historical Account of the Rise & Progress of Art in America* (1867; New York: James F. Carr, 1967), 506.

4. Assistance courtesy Claude Epstein, Professor of Environmental Studies, Stockton State College, Pomona, N.J.

5. Frank H. Goodyear, Jr., *Thomas Doughty, 1793–1856: An American Pioneer in Landscape Painting*, exhibition catalog (Philadelphia: Pennsylvania Academy of the Fine Arts, 1973), 18.

THOMAS HILL *(p. 59)*

1. "California Painters in Yosemite," San Francisco *Chronicle*, 8 October 1899, 3.

2. David Jacks, "Diary from California to Ithaca, New York, May to September 1885," 15, David Jacks Family Papers, Huntington Library, San Marino, Cal.

3. "Art in San Francisco," *Alta California*, 27 March 1870, 2.

4. Thomas Hill, "Business Notebook from 1884–1887," Hill Memorabilia Collection, Crocker Art Museum, Sacramento.

5. Henry D. Hill, Berry-Hill Galleries, New York, to Joseph G. Butler, III, April 11, 1969, The Butler Institute of American Art Archives.

GEORGE CALEB BINGHAM *(p. 60)*

1. E. Maurice Bloch, *The Painting of George Caleb Bingham* (Columbia, Mo.: University of Missouri Press, 1986). The Cravens portrait is no. 123.

2. See Nancy Rash, *The Painting and Politics of George Caleb Bingham* (New Haven, Conn.: Yale University Press, 1991).

3. An inscription on the back of the Cravens portrait (now covered by a lining canvas) reads: "Jas. H. Cravens/Born Rockm Co. Va./Aug. 12th 1802/Portrait Painted/Aug. 1842/By/G. Bingham." Of the 430 datable, extant, and recorded Bingham paintings published by Bloch, *Bingham*, only a tiny number bear any inscription on the back and none as lengthy. The inscription is probably later than 1842.

4. *Biographical Directory of the United States Congress 1774–1989* (Washington, D.C.: United States Government Printing Office, 1989), 842.

WORTHINGTON WHITTREDGE *(p. 63)*

1. Worthington Whittredge, *The Autobiography of Worthington Whittredge*, ed. John I. H. Baur (Brooklyn, N.Y.: The Brooklyn Museum, 1942), 37.

2. Ibid., 38–9.

3. Doyle Galleries, New York, 24 October, 1984, lot 62.

4. Julius Rodman to the Butler Institute, January 19, 1965, The Butler Institute of American Art Archives.

5. Whittredge, *Autobiography*, 32.

JAMES E. BUTTERSWORTH *(p. 64)*

1. There is little known documentation available on James E. Buttersworth's origins. In *J.E. Buttersworth: 19th Century Marine Painter* (Mystic, Conn.: Mystic Seaport, 1975), Rudolph J. Schaefer states that Buttersworth was born in Middlesex County, England, and was the son of the artist Thomas Buttersworth. In *American Marine Painting* (New York: Harry N. Abrams, Inc., 1987), John Wilmerding states that Buttersworth was born on the Isle of Wight and that he may have been the grandson of Thomas Buttersworth.

2. Schaefer, *Buttersworth*, 14.

JAMES HAMILTON *(p. 67)*

1. S. G. W. Benjamin (1879), (Philadelphia) Public Ledger, 1878; quoted in Arlene Jacobowitz, *James Hamilton, 1819–1878: American Marine Painter*, exhibition catalog (Brooklyn: Brooklyn Museum, 1966), 9, 26.

2. Jacobowitz, *James Hamilton*, 12, 21–6.

3. See John Wilmerding, "The Luminist Movement: Some Reflections," in *American Light: The Luminist Movement, 1850–1875*, exhibition catalog (Washington, D.C.: The National Gallery of Art, 1980), esp. 131–2.

4. *From Sail to Steam* was given its present title after its purchase in 1968. Hamilton generally titled his works by reference to a specific place, occasion, time of day, or mood. To judge from the sale and exhibition records (which do not conclusively identify this work), Hamilton might have given this painting a title such as *Marine—Sunset*.

EDWARD MORAN *(p. 68)*

1. Hugh W. Coleman, "Passing of a Famous Artist, Edward Moran," *Brush and Pencil*, 8:4 (July 1901): 191.

2. Ibid.

3. Information courtesy of Kathleen Bratton, Director, New Castle Historical Society.

WILLIAM TYLEE RANNEY *(p. 71)*

1. The signed and dated 1850 work is in a private collection, another sold at Sotheby's in 1991, and the other is part of the C. R. Smith Collection of Western Art at the University of Texas at Austin. Because of compositional variations it appears unlikely that this painting served as the source for the print.

2. From *The Literary World* (4 May 1850), cited in Francis Grubar, *William Ranney, Painter of the Early West*, exhibition catalog (Washington, D.C.: Corcoran Gallery of Art, 1962), 35.

3. "Sketchings—Exhibitions," *The Crayon*, 5 (December 1858), 355.

FITZ HUGH LANE *(p. 72)*

1. John Wilmerding, *Robert Salmon, Painter of Ship and Shore* (Salem, Mass.: Peabody Museum of Salem; Boston: Boston Public Library, 1971).

2. Rob Napier, "The Colors of Northern Light," *Nautical Research Journal*, 36:4 (December 1991): 209–13.

3. Among the best known examples are *The "Britannia" Entering*

Boston Harbor (1848, private collection), *Clipper Ship "Southern Cross" Leaving Boston Harbor* (1851, Peabody Museum of Salem, Salem, Mass.). For color illustrations see John Wilmerding, et al., *Paintings by Fitz Hugh Lane*, exhibition catalog (Washington, D.C.: National Gallery of Art, 1988), 57, 58.

4. My thanks to Erik A. R. Ronnberg, Jr., of Rockport, Mass., a marine architecture specialist, for the comparison of the two Lane images of the *Starlight*. Ronnberg to Wilmerding, May 28, 1992.

5. See Howe and Matthews, *Ships*, 626–30. They note that "all of her passages outward from New York or Boston were to San Francisco." The likely location of the scene is Boston. Certainly, with the *Starlight's* anchor down, and two other two-masted brigs faintly visible, this is a large and busy harbor. But by this point in Lane's career, he was less interested in the facts of the here-and-now than in a private image of reflection.

6. For an analysis of Lane's highly conscious and calculated design formulas, see Lisa Fellows Andrus, "Design and Measurement in Luminist Art," in John Wilmerding, et al., *American Light: The Luminist Movement, 1850–1875*, exhibition catalog (Washington, D.C.: National Gallery of Art, 1980), 31–56. Regarding the technical changes, see "Report on Condition," July 31, 1985, and "Treatment Record," July 1985–January 1986, Intermuseum Laboratory, Oberlin, Ohio, The Butler Institute of American Art Archives.

JOHN MCAULIFFE *(p. 75)*

1. *The New York Times*, 10 December 1900.

2. Melvin L. Adelman, "The First Modern Sport in America: Harness Racing in New York City, 1825–1870," in *The Sporting Image: Readings in American Sport History*, ed. Paul J. Zingg (Lanham, Md. and London: University Press of America, 1988), 109.

3. Ibid., 114.

4. Ibid.

5. A second version of this painting exists in a private collection. The author thanks Nettie Oliver of Louisville, Kentucky for assisting with Louisville history and Ernest and Ann Dickinson Dale of Princeton, New Jersey for identifying details in the painting.

6. See "Federal Writer's Project," *The WPA Guide to New York City* (New York: Pantheon Books, 1982).

ARTHUR FITZWILLIAM TAIT *(p. 76)*

1. Warder Cadbury and Henry F. Marsh, *Arthur Fitzwilliam Tait Artist in the Adirondacks* (Newark, Del.: University of Delaware Press, 1986), 25.

2. Patricia C. F. Mandel, "English Influences on the Work of A. F. Tait," in *A. F. Tait, Artist in the Adirondacks* (Blue Mountain Lake, N.Y.: The Adirondack Museum, 1974), 16–7.

3. Arthur F. Tait, Register, The Adirondack Museum, Blue Mountain Lake, N.Y.

4. Walter Shaw Sparrow, *British Sporting Artists from Barlow to Herring* (1922; London: Spring Books, 1965), 229.

5. Cadbury and Marsh, *Tait*, 154, no. 60.38.

6. Ibid., 146, no. 59.7.

7. Maria Naylor, ed., *The National Academy of Design Exhibition Record, 1861–1900*, 2 vols. (New York: Kennedy Galleries, Inc., 1973), 150, no. 353.

8. The Tait Register cites the amount paid for *Barnyard* as 'EZZ.' A letter from Henry F. Marsh to the Butler Institute, July 11, 1966, The Butler Institute of American Art Archives, states that, ". . . 'EZZ' is Tait's code for $500.00. . . . The amount was incorrectly recorded as $50.00 in Cadbury and Marsh, 155, no. 60.40.

9. Sparrow, 244.

ROBERT SWAIN GIFFORD *(p. 79)*

1. Wendy Dathan, Curator, Grand Manan Museum, to author, July, 1993.

2. Richard C. Kugler, Director, Old Dartmouth Historical Society and The Whaling Museum, to Joseph G. Butler, III, August 5, 1974, The Butler Institute of American Art Archives.

3. William Howe Downes, "R. Swain Gifford," *Boston Evening Transcript*, 18 January 1905.

FREDERICK RONDEL *(p. 80)*

1. See Roxana Barry, *Land of Plenty Nineteenth Century American Picnic and Harvest Scenes* (Katonah, N.Y.: The Katonah Gallery, 1981).

2. Rebecca E. Lawton, Curator of Collections, The Frances Lehman Loeb Art Center, Vassar College, to author, July 19, 1993. Vassar, who once owned Cottage Hill Seminary in Poughkeepsie, probably helped Rondel get hired in 1867–68. *Prospectus of Cottage Hill Seminary*, 1867–68, Special Collections, Vassar Library, Poughkeepsie, N.Y.

3. An inscription on the back of the work, now covered, states, "The Picnic was painted for Henry S. Frost by Frederick Rondel," Accession Record, The Butler Institute of American Art.

4. Dorothy E. Wilson, Collections Manager, Kent State University Museum, to author, April 16, 1993. "The costume elements in the painting. . .could be narrowed to 1864–1866."

5. See Patricia C. F. Mandel, *Fair Wilderness American Paintings in the Collection of The Adirondack Museum* (Blue Mountain Lake, N.Y.: The Adirondack Museum, 1990), 101.

6. Rondel has also included himself in the Adirondack Museum work. Both figures bear a similarity to his self-portrait, *Frederick Rondel* (1862, National Academy of Design).

ALBERT BIERSTADT *(p. 82)*

1. Gordon Hendricks, *Albert Bierstadt, Painter of the American West* (New York: Harry N. Abrams, Inc., 1974), 63.

2. Gordon Hendricks, "The First Three Western Journeys of Albert Bierstadt," *The Art Bulletin*, 46 (September 1964): 335.

3. Nancy Anderson and Linda S. Ferber, *Albert Bierstadt: Art & Enterprise* (New York: The Brooklyn Museum, 1990), 144; *Harper's Weekly*, 13 August 1859, 516.

4. Anderson and Ferber, *Bierstadt*, 177.

5. Ibid., 172.

6. The 1863 route passed through Denver, then across Bridger's Pass in southern Wyoming to Salt Lake and across the deserts of Utah and Nevada to Lake Tahoe and San Francisco. The painter and writer spent over four weeks in Yosemite, and then traveled north through California and Oregon to Portland. The trip west by Overland stage had been so arduous that they decided to return home by ship via San Francisco and Panama to New York, arriving by mid-December after a trip of over seven months.

7. Fitz Hugh Ludlow, *The Heart of the Continent: A Record of Travel Across the Plains and in Oregon, with an Examination of the Mormon Principle* (New York: Hurd & Houghton, 1870), 110.

8. Ibid., 183.

9. Ibid., 184, 186. Stone paid $15,000 according to a bill of sale dated 15 November, 1868.

10. Thelma Carmody, whose husband's grandfather, Horace Kimball Fulton, purchased the picture from Bierstadt, to Joseph G. Butler, III, August 16, 1964.

11. Samuel Bowles, *Across the Continent: A Summer's Journey to the Rocky Mountains, the Mormons, and the Pacific States, with Speaker Colfax* (New York: Hurd & Houghton, 1865), 14.

12. See William H. Truettner, ed., *The West As American;*

Reinterpreting Images of the Frontier (Washington, D.C.: National Museum of American Art, 1991).

ALEXANDER HELWIG WYANT *(p. 85)*
1. New York, Kende Galleries at Gimbel Brothers, *Oriental Art, French Period and Other Furniture, Paintings by American Artists from Private Collections and an Educational Institution*, 25 January, 1947, 42, no. 251 (not illustrated). An annotated copy of the catalog in the Frick Art Reference Library, New York City, cites the "Educational Institution" as Smith College Museum, Northampton, Mass. Telephone conversations with Louise La Plante, Registrar, Smith College Museum of Art, May 13–14, 1993, corroborate the catalog annotation. The painting had been a gift from Dwight William Tryon. See Henry C. White, *The Life and Art of Dwight William Tryon* (Boston and New York: Houghton Mifflin Company; Cambridge, Mass.: The Riverside Press, 1930), 24, 108–9, 120.
2. Eliot Clark, *Alexander Wyant* (New York: privately printed, 1916), 39–40.
3. Ibid., 40.
4. Ibid.
5. Ibid., 56.
6. Ibid., 60, 61.
7. Frederic F. Van de Water and Milo M. Quaife, eds., *Lake Champlain and Lake George* (New York: The Bobbs-Merrill Company, 1946), ill. opp. p. 222.
8. Ibid., ill. opp. p. 95.
9. Robert S. Olpin, "Register of Alexander H. Wyant Paintings in American Public Collections," in *A. H. Wyant* (Salt Lake City: University of Utah, 1968), n.p.
10. Clark, *Wyant*, 12.

EASTMAN JOHNSON *(p. 86)*
1. Reginald G. Haggar, *A Dictionary of Art Terms* (New York: Hawthorne Books Inc., 1962), 131. "Fancy pictures" was "A term invented by Sir Joshua Reynolds (1788) to describe Gainsborough's pictures of 'little ordinary beggar-children' . . . he created in them a rustic pictorial Arcadia."
2. Henry T. Tuckerman, *Book of the Artists: American Artist Life Comprising Biographical and Critical Sketches of American Artists: Preceded by an Historical Account of the Rise & Progress of Art in America* (1867; New York: James F. Carr, 1967), 467.
3. No such painting is listed in James T. Yarnell and William H. Gerdts, *The National Museum of American Art's Index to American Art Exhibition Catalogues From the Beginning Through the 1876 Centennial Year*, 6 vols. (Washington, D.C.: G. K. Hall, 1986).
4. In studying Johnson's work, I find that such paintings were often second versions of a composition. Johnson would use a tracing technique to transfer a previous image to the canvas; the sure graphite lines indicate guidelines for these subsequent versions, which are rarely exact replicas. See John J. H. Baur, *Eastman Johnson, 1824–1906: An American Genre Painter* (Brooklyn, N.Y.: Institute of Arts and Science, 1940), and Patricia Hills, *The Genre Paintings of Eastman Johnson: The Sources and Development of His Style and Themes* (New York: Garland Publishing, Inc., 1977).

CLYDE SINGER *(p. 90)*
1. Clyde Singer, interview by Louis A. Zona in *Clyde Singer's New York*, exhibition catalog (Youngstown, Oh.: The Butler Institute of American Art, 1987), n.p.

JOHN GEORGE BROWN *(p. 93)*
1. Illustrated in Martha J. Hoppin, *Country Paths and City Sidewalks, The Art of J. G. Brown*, exhibition catalog (Springfield, Mass.: George Walter Vincent Smith Art Museum, 1989).

2. "The Picture That First Helped Me to Success," *The New York Times*, 28 January 1912.
3. They include: *A Jolly Lot* (1885, private collection); *Shine Sir?*, (1885, private collection); *The Bootblack I* and *The Bootblack II* (both 1885, locations unknown), nos. 6 and 7, sales catalog, American Art Association, 14 December, 1933; *Two Boys* (private collection); and probably *A Tough Story* (1886, North Carolina Museum of Art).
4. *The Commercial Advertiser*, New York, 17 March 1900.
5. One of the earliest members of the American Watercolor Society, Brown served as its president from 1887 to 1904.
6. Its reproduction as a wood engraving was published in William M. Laffan, *Engravings on Wood by Members of the Society of American Wood-engravers* (New York: Harper and Bros., 1887), 16. The engraving is signed on the block: J.G. Brown N.A./1885 (lower left) and, R.A. Muller sc/1886 (lower right). *I'm Perfectly Happy* may be the painting titled *Perfectly Happy* in Brown's studio sale, Fifth Avenue Art Galleries, *Catalogue of Paintings by J. G. Brown, N.A.*, 26–7 January, 1892, (New York: Ortgies and Co., 1892), n. 114, measuring 24 × 17".

JASPER F. CROPSEY *(p. 94)*
1. *Jasper F. Cropsey 1823–1900*, exhibition catalog (Washington, D.C.: National Museum of American Art, 1970), 33.
2. William S. Talbot, *Jasper F. Cropsey, 1823–1900* (New York: Garland Publishing, 1977), 222.
3. Ibid., 209.
4. Ibid., 228.

WINSLOW HOMER *(p. 97)*
1. For a discussion of the versions and the changes among them, see Natalie Spassky, et al., "Snap the Whip," *American Paintings in the Metropolitan Museum of Art*, vol. 2 (New York: The Metropolitan Museum of Art in Association with Princeton University Press, 1985), 457–61.
2. Jules D. Prown, "Winslow Homer in His Art," *Smithsonian Studies in American Art*, 1:1 (Spring 1987): 31–45.
3. John Wilmerding, "Winslow Homer in the 1870s" and "Winslow Homer's *Dad's Coming*," *American Views: Essays on American Art* (Princeton: Princeton University Press, 1991), 195–208, 209–22.
4. Nicolai Cikovsky, Jr., "Winslow's School Time: 'A Picture Thoroughly National'," in *Essays in Honor of Paul Mellon, Collector and Benefactor*, ed. John Wilmerding (Washington, D.C.: National Gallery of Art, 1986), 47–69.
5. Henry Adams, "Mortal Themes: Winslow Homer," *Art in America* (February 1983): 113–26.

FREDERIC EDWIN CHURCH *(p. 102)*
1. Stephen Jay Gould, "Church, Humboldt, and Darwin: The Tension and Harmony of Art and Science," in Franklin Kelly, *Frederic Edwin Church* (Washington, D.C.: National Gallery of Art, 1990), 97.
2. Mignot's *Landscape in Ecuador* (1859, North Carolina Museum of Art), is so close in view and style that a Mignot authorship has been suggested for the Butler Institute picture despite the Church signature. Any conclusion must, however, await not only technical investigation, but also better knowledge of Mignot's imperfectly known oeuvre which includes many pictures markedly different from Church in subject and manner.
3. Kelly, *Church*, 57.

ALFRED THOMPSON BRICHER *(p. 105)*
1. Jeffrey R. Brown and Ellen W. Lee, *Alfred Thompson Bricher 1837–1908*, exhibition catalog (Indianapolis: Indianapolis Museum

of Art, 1973), 32, and, Daniel E. Sachs, letter to author, August 27, 1993. An inscription in pencil on the upper stretcher bar identifies the subject as: *The Landing, Bailey I Me.*, correctly giving the island's name as Bailey and not Bailey's, as do many records.
2. Bricher sketchbook, pencil on lined paper, Karolik Collection, Museum of Fine Arts, Boston, and, Jeffrey R. Brown, verbal communication with author, September 14, 1993.

JOHN FREDERICK KENSETT *(p. 106)*
1. "Domestic Art Gossip," *The Crayon*, 2 (July 1855): 57.
2. The Suydam work measures $36 \times 29''$. In comparing it (and the Lyman Allyn Art Museum version) to the Butler Institute's canvas, the latter appears somewhat truncated on each side, an indication that it may have been cropped to its present dimensions.
3. Carol Troyen in *American Paradise: The World of the Hudson River School*, exhibition catalog (New York: The Metropolitan Museum of Art, 1987), 153.
4. See Dianne Dwyer, "John F. Kensett's Painting Technique," in *John Frederick Kensett, An American Master*, exhibition catalog (Worcester, Mass.: Worcester Art Museum, 1985), 163–80.

WILLIAM BRADFORD *(p. 109)*
1. Elisha Kent Kane, *Arctic Explorations* (Philadelphia: Childs and Petersen, 1857), extensively illustrated with engravings by the painter James Hamilton; Louis L. Nobel, *After Icebergs with a Painter* (New York: D. Appleton and Co, 1861), the account of an Arctic excursion of 1859; *William Bradford, 1823–1892* (Lincoln, Mass.: DeCordova Museum, 1969), 16.
2. *Bradford*, 16.

WILLIAM KEITH *(p. 110)*
1. "Art Jottings," *San Francisco News Letter and California Advertiser*, 27 April 1878.
2. "Art Notes," *San Francisco Chronicle*, 8 July 1877. The work was titled *Oaks of California at Evening Glow* when purchased by Vose Galleries in 1915. Vose Galleries shortened this to *Evening Glow* prior to its purchase by The Butler Institute of American Art.
3. "The Art Exhibition Again," *Alta California*, 9 March 1879.
4. "Art Notes," *San Francisco Chronicle*, 27 April 1879.
5. "Art Matters," *San Francisco Chronicle*, 9 February 1879.

MARTIN JOHNSON HEADE *(p. 112)*
1. See Theodore E. Stebbins, Jr., *The Life and Works of Martin Johnson Heade* (New Haven and London: Yale University Press, 1975).
2. The other key coastal views in this series include *Storm Clouds on the Coast* (1859, William A. Farnsworth Library and Art Museum, Rockland, Me.), *Rye Beach* (1863, William Benton Museum of Art, University of Connecticut, Storrs), *Coastal Scene with Sinking Ship* and *Hazy Sunrises at Sea* (both 1863, Shelburne Museum, Vt.), *Stormy Sea* (c. 1863, private collection), and *Thunderstorm at the Shore* (c. 1870, Carnegie Institute, Pittsburgh). See Stebbins, *Heade*, nos. 32, 53, 54, 55, 57, 130.
3. John Wilmerding, et al., *American Light: The Luminist Movement, 1850–1875*, exhibition catalog (Washington, D.C.: National Gallery of Art, 1980).
4. See Stebbins, *Heade*, nos. 50, 118, 120, 124, 125.
5. The metaphor of opposing forces is of course not far from the realities of national strife at the time, and has literary parallels in the balanced and concentrated paragraphs of President Lincoln's greatest speeches of the same date, most notably the Gettysburg Address and the Second Inaugural. See Wilmerding, *American Light*, 98; and Garry Wills, *Lincoln at Gettysburg: The Words that Remade America* (New York: Simon and Schuster, 1992).

WILLIAM LOUIS SONNTAG *(p. 114)*
1. Nancy Dustin Wall Moure, *William Louis Sonntag: Artist of the Ideal 1822–1900* (Los Angeles: Goldfield Galleries, 1980), 17.

HARRISON BIRD BROWN *(p. 115)*
1. Dictionary of American Painters Project, Vose Archive Inc., Brookline, Massachusetts, to author, May 22, 1993.
2. *Landscape in Maine 1820–1970* (Waterville, Me.: Colby College, 1970), 30.
3. Clara E. Clement and Lawrence Hutton, *Artists of the Nineteenth Century and Their Works* (Boston: Houghton, Mifflin and Company, 1880), 102.
4. Dictionary of American Painters Project, Vose Archive Inc., Brookline, Massachusetts, to author, May 22, 1993.
5. Martha R. Severens, "Recent Accession: Painting by Harrison Bird Brown," *Bulletin, Portland Museum of Art* (May–June 1988): n.p.

WILLIAM TROST RICHARDS *(p. 119)*
1. Linda S. Ferber, *William Trost Richards (1833–1905): American Landscape and Marine Painter, 1833–1905*, exhibition catalog (New York: The Brooklyn Museum, 1980), 299.

THOMAS COWPERTHWAIT EAKINS *(p. 120)*
1. See Lloyd Goodrich, *Thomas Eakins*, 2 vols. (Washington, D.C., Cambridge, Mass. and London: Harvard University Press for the National Gallery of Art, 1982).
2. Gen. George Cadwalader, 1806–79, a Pennsylvania militia officer, served in the United States Army and served as a Presidential advisor to Lincoln during the Civil War. Stewart Sifakis, *Who was Who in the Civil War* (New York: Facts on File Publications, 1988), 99–100.
3. Most of these are reproduced in Goodrich, *Eakins*, figs. 175, 176, 182, 250.
4. See Nicolai Cikovsky, Jr., "The Art Student (Portrait of an Artist)," *American Paintings from the Manoogian Collection*, exhibition catalog (Washington, D.C.: National Gallery of Art, 1990), 126–30, no. 46, and John Wilmerding, "Thomas Eakins's Late Portraits," *American Views: Essays on American Art* (Princeton, N.J.: Princeton University Press, 1991), 244–63.

WILLIAM MICHAEL HARNETT *(p. 122)*
1. The other versions are: version 1 (1883, Huntington Gallery, San Marino, Cal.); version 2 (1883, Columbus Museum of Art, Columbus, Ohio); and version 4 (1885, Fine Arts Museums of San Francisco). For ordering of the versions, see Elizabeth Jane Connell, "After the Hunt," in *William M. Harnett*, eds. Doreen Bolger, Marc Simpson, and John Wilmerding (New York: Harry N. Abrams, Inc. with the Amon Carter Museum and The Metropolitan Museum of Art, 1992), 284.
2. Braun's hunt photographs, their similarity of subject and composition, as well as their widespread recognition in Germany during Harnett's sojourn there, suggests Harnett's direct indebtedness to them as sources for his After the Hunt series. See Douglas R. Nickel, "Harnett and Photography," in Bolger et al., *Harnett*, 179.
3. See Kenneth L. Ames, *Death in the Dining Room and Other Tales of Victorian Culture* (Philadelphia: Temple University Press, 1992), 44–96; illus. 2.15 and 2.16.
4. "Aus dem Kunstverein," clipping from the *Handelsblatt*, 1884 (otherwise unidentified), Blemly scrapbook, frame 335, quoted in Alfred Frankenstein, *After the Hunt: William Harnett and Other American Still Life Painters, 1870–1900* (Berkeley and Los Angeles: University of California Press, 1969), 69.

CLAUDE RAGUET HIRST (p. 125)

1. Philip R. Adams to Joseph G. Butler, III, October 28, 1978, The Butler Institute of American Art Archives.

2. See Maria Naylor, ed., *Exhibitions of the National Academy of Design*, vol. 1 (New York: Kennedy Galleries, 1973).

3. Quoted in Alfred Frankenstein, *After the Hunt: William Harnett and Other American Still Life Painters 1870–1900* (Berkeley and Los Angeles: University of California Press, 1953), 153.

4. Frank Linstow White, "Younger American Women in Art," *Leslie's Popular Magazine*, November 1893, 538.

GEORGE COPE (p. 126)

1. Thaddeus Norris, "What and Who Is an Angler?," *The American Angler's Book* (Philadelphia: Porter and Coates, 1864), reprinted in Terry Brykczynski and David Reuther, eds., *The Armchair Angler* (New York: Charles Scribner's Sons, 1986), 275.

2. See Scott A. Sullivan, *The Dutch Gamepiece* (Totowa, N.J.: Rowman & Allanheld Publishers; Montclair, N.J.: Abner Schram, Ltd.; Woodbridge, Suffolk: The Boydell Press, 1984).

3. The author thanks Don Wittekind of Dame Juliana, Inc., Columbus, Oh., for his assessment of the equipment Cope portrays.

4. Joan H. Gorman and Gertrude Grace Sills, *George Cope, 1855–1929*, exhibition catalog (Chadds Ford, Pa.: Brandywine River Museum, 1978), 17.

JOHN FREDERICK PETO (p. 128)

1. John Wilmerding, *Important Information Inside: The Art of John F. Peto and the Idea of Still-Life Painting on Nineteenth-Century America*, exhibition catalog (Washington, D.C.: National Gallery of Art, 1983).

2. Nicolai Cikovsky, et al., *Raphaelle Peale Still Lifes*, exhibition catalog (Washington, D.C.: National Gallery of Art, 1988).

VICTOR DUBREUIL (p. 131)

1. Marc Shell, *Art and Money* (Chicago: The University of Chicago Press, in press), 98–9. Used by permission of the author.

2. *New York Herald*, 23 January 1898, 2–3.

CHARLES A. MEURER (p. 132)

1. Alfred Frankenstein, *After the Hunt: William Harnett and Other American Still Life Painters 1870–1900* (Berkeley, Los Angeles, London: University of California Press, 1953), 154.

2. Frankenstein, *Hunt*, rev. ed., 155. *A Doughboy's Equipment* was included in an exhibition of works inspired by Harnett's *After the Hunt* which Frankenstein organized at the California Palace of the Legion of Honor, San Francisco, in 1948.

3. Clippings files, Randy and Michelle Sandler, Cincinnati Art Galleries and Mary Haverstock, Ohio Artists' Project, Oberlin College. Of particular note is Richard E. Kerley, "Putting Snap Into Still Life," *The Cincinnati Commercial Tribune*, 8 August 1921.

4. See Bruce Chambers, *Old Money: American Trompe l'Oeil Images of Currency* (New York: Berry-Hill Galleries, 1988).

5. *A Doughboy's Equipment* was still in the artist's hands at his death and was purchased from the estate by Lyman Johnson of Minneapolis. In the late 1950s Elmer G. Engel of New York presented the still lifes as gifts to West Point and the Butler Institute.

6. The military memorabilia used was borrowed from Colonel Peter Traub of Ft. Thomas and Colonel Simon Ross of Cincinnati. All the army equipment, with the exception of the doughboy's campaign hat, that appears in *A Doughboy's Equipment* also appears in *Memories*, and must belong to Colonel Traub or Colonel Ross.

7. Ibid., Kerley, 6.

8. *More Than Meets the Eye: The Art of Trompe l'Oeil* (Columbus, Oh.: Columbus Museum of Art, 1985), 78.

ALBERT PINKHAM RYDER (p. 134)

1. "The picture by A. P. Ryder, 'Meeting on the Road,' was a gift from the artist to his mother. . . . At her death (1892) it came back to Mr. Ryder. . . ." Louise Fitzpatrick to Roland Knoedler, September 1917, The Butler Institute of American Art Archives.

2. The illustration from the 1898 edition of Scott's novel is in Elizabeth Broun, *Albert Pinkham Ryder* (Washington, D.C.: Smithsonian Institution Press, 1989), 281.

3. Lloyd Goodrich to Joseph G. Butler, III, March 12, 1948, The Butler Institute of American Art Archives. This change is readily visible in the X-ray, and can be discerned faintly on the painting's surface as a pentimento.

4. See Broun, *Ryder*, 150.

5. See Doreen Bolger Burke, et al., *In Pursuit of Beauty; Americans and the Aesthetic Movement* (New York: Rizzoli for the Metropolitan Museum of Art, 1986).

6. Broun, *Ryder*, 150–1.

RALPH ALBERT BLAKELOCK (p. 136)

1. Frederick W. Morton, "Work of Ralph Albert Blakelock," *Brush and Pencil*, 9:5 (February 1902): 257. William Macbeth alerted readers to Blakelock fakes in "Macbeth Gallery Art Notes," 22 (May 1903), 343.

2. *Twilight* is listed in the University of Nebraska Blakelock Inventory as no. 161. For the development of Blakelock's style, see Norman Geske, *Ralph Albert Blakelock, 1847–1919*, exhibition catalog (Lincoln, Neb.: Sheldon Memorial Art Gallery, University of Nebraska, 1975).

3. "Art News," *The Evening Post: New York*, 21 February 1903, 3.

4. The authorship of these lines is questionable. Blakelock's father, also named Ralph Albert, was an avid amateur poet. The painter may have appended his father's words to the frame.

ELBRIDGE AYER BURBANK (p. 138)

1. H[erb S]. Hamlin, "Burbank the Great Contributor," *Pony Express Courier*, vol. 9, 7:103 (December 1942): 3.

2. "E. A. Burbank," *A Portfolio of Ten of His "Red Head" Indian Sketches from the J. L. Hubbell Collection—Ganado, Arizona* (Ganado, Ariz.: Hubbell Trading Post National Historic Site, n.d.), n.p.

3. Burbank to Edward Ayer, February 22, 1902, Youngstown, Oh., The Butler Institute of American Art Archives.

4. The Butler collection includes 114 oils and 127 red crayon drawings. Other collections include: Newberry Library, Chicago, 1,242 drawings, 25 oils; Hubbell Trading Post National Historic Site, 189 drawings, 59 oils, 3 prints.

5. E. A. Burbank, *Burbank Among the Indians*, as told by Ernest Royce, ed. Frank J. Taylor (Caldwell, Id.: The Caxton Printers, Ltd., 1944), 37–8.

6. Quoted in Randall Henderson, "He Painted the Apaches," *The Desert Magazine*, May 1941, 31–2.

7. Quoted in Burbank, *Burbank*, 178. Reprinted in H. Hamlin, "Chief Joseph's Trek and Surrender," *The Pony Express*, vol. 14, 4:160 (September 1947).

8. Ibid., 18–9, 22.

9. "Indian Studies by Mr. Burbank," *Los Angeles Times*, 13 September 1907.

10. Similar canvases exist for all three of the works discussed here.

11. Burbank to Butler, October 24, 1911, Hubbell Trading Post,

Ganado, Ariz., The Butler Institute of American Art Archives. Two other genre scenes are *Navajo Gamblers* and *Leaving Home for the Carlisle Indian School* (both 1911, Hubbell Trading Post National Historic Site).

12. "Indian Studies by Mr. Burbank."

THOMAS MORAN *(p. 141)*

1. Thurman Wilkins, *Thomas Moran: Artist of the Mountains* (Norman, Okla.: University of Oklahoma Press, 1966), 198.

2. Moran first visited the north rim of the Grand Canyon in 1873 with the surveying party of Major John Wesley Powell. He had been overwhelmed by the canyon's scale, colors, and especially the effects of a thunderstorm which he incorporated into the work, *The Chasm of the Colorado*, 1873, purchased by the United States Congress. See Wilkins, *Moran*, 84, 93.

3. Ibid., 204.

4. Ibid., 205; and Joni Louise Kinsey, *Thomas Moran and the Surveying of the American West* (Washington, D.C.: Smithsonian Institution Press, 1992), 134.

GEORGE INNESS *(p. 142)*

1. "Mr. Inness on Art-Matters," *The Art Journal*, 5 (1879): 376.

2. Ibid., 377.

3. Quoted in George W. Sheldon, *American Painters* (New York: D. Appleton and Co., 1879), 34.

4. Ibid., 31.

5. George Inness to Thomas B. Clarke, Montclair, N.J., December 30, 1892, Princeton University Library.

6. George Inness to Thomas B. Clarke, Tarpon Springs, Fl., February 12, 1893, Archives of American Art, Smithsonian Institution.

7. *New York Mail and Express*, 28 December 1894.

8. *Boston Evening Transcript*, 28 December 1894.

9. *New York Sun*, 15 February 1895.

FORMERLY ATTRIBUTED TO
JAMES ABBOTT MCNEILL WHISTLER *(p. 144)*

1. Martin Hopkinson, Hunterian Art Gallery, University of Glasgow to Lauretta Dimmick, January 12–13, 1984, The Butler Institute of American Art Archives.

2. Clyde Singer, Curator, The Butler Institute of American Art, to Andrew McLaren Young, University of Glasgow, September 28, 1972, The Butler Institute of American Art Archives.

3. E. R. and J. Pennell, *The Whistler Journal* (Philadelphia: J. B. Lippincott Company, 1921), 97.

4. E. R. and J. Pennell, *The Life of James McNeill Whistler*, 2 vols. (London and Philadelphia: J. B. Lippincott Company, 1909), 106–8.

5. Andrew McLaren Young, Margaret MacDonald, and Robin Spencer, *The Paintings of James McNeill Whistler*, 2 vols. (New Haven and London: Yale University Press, 1980), 1:xv.

6. These Greaves works were "discovered" by William Marchant in 1911, who gave Greaves a solo exhibition at the Goupil Gallery, London. See Michael Parkin, *Walter Greaves (A Pupil of Whistler) and the Goupil Gallery* (London: Michael Parkin Fine Art, Ltd., 1984).

7. Tom Pocock, *Chelsea Reach: The Brutal Friendship of Whistler and Walter Greaves* (London: Hodder & Stoughton, 1970), 143–6, 152–3.

CECILIA BEAUX *(p. 147)*

1. Beaux was awarded top prizes from the Pennsylvania Academy of the Fine Arts, National Academy of Design, Carnegie Institute, and the Corcoran Gallery of Art. She won a gold medal in the international exposition in Paris, 1900.

JOHN SINGER SARGENT *(p. 148)*

1. Carlyle Burrows, "Another Sargent Arrives," *New York Herald Tribune*, 26 May 1929, sec. 7, 10; other notices in *The New York Times*, 26 May 1929, photogravure sec; *The Magazine of Art*, 20 (July 1929): 395; *The Art News*, 27 (25 May 1929): 1.

2. See William Howe Downes, *John S. Sargent: His Life and Work*, vol. 2 (Boston: Little, Brown, and Company, 1925) for notes on various group portraits.

3. *Mrs. Knowles and Her Children*, Photography Archive, Frick Art Reference Library, New York.

4. John Singer Sargent to Mrs. Curtis, June 13, 1907, quoted in Stanley Olson, *John Singer Sargent: His Portrait* (1986; reprint, London: Barrie & Jenkins, 1989), 157.

DANIEL RIDGWAY KNIGHT *(p. 153)*

1. See Peter Bermingham, *American Art in the Barbizon Mood*, exhibition catalog (Washington, D.C.: National Collection of Fine Arts, Smithsonian Institution, 1975), 74–86.

2. See David Sellin, *Americans in Brittany and Normandy* (Phoenix: Phoenix Art Museum, 1982), 195.

3. George Sheldon, *Recent Ideals in American Art* (New York and London: D. Appleton & Co., 1881), 24–5.

4. See Ridgway B. Knight in *A Pastoral Legacy: Paintings and Drawings by the American Artists Ridgway Knight and Aston Knight*, exhibition catalog (Ithaca, N.Y.: Herbert F. Johnson Museum of Art, Cornell University, 1989), n.p.

JOHN LA FARGE *(p. 154)*

1. Ernest Fenollosa, *Epochs of Chinese and Japanese Art* (London: W. Heineman, 1912), 2:50.

2. Cited by Clyde Singer to Gudmund Vigtel, June 15, 1956, The Butler Institute of American Art Archives.

3. Paul Bourget, *Outre Mer* (New York: Charles Scribner's Sons, 1895).

4. The photograph is in the Peter Juley Collection, National Museum of American Art, Smithsonian Institution, Washington, D.C.

MARY STEVENSON CASSATT *(p. 157)*

1. See Achille Ségard, *Mary Cassatt, Un Peintre des enfants et des mères* (Paris: Ollendorff, 1913).

2. Marcel Guerin, ed., *Degas Letters* (Oxford: Oxford University Press, 1947), 117.

3. See Nancy Mowll Mathews, "Mary Cassatt and the 'Modern Madonna' of the Nineteenth Century" (Ph.D. diss., New York University, 1980), 143–176, 189–95.

4. Ibid., 156.

5. See Nancy Mowll Mathews, *Mary Cassatt* (New York: Harry N. Abrams, Inc., in association with Williams College Museum of Art, 1989), 75.

6. Georges Lecomte, *L'art Impressioniste d'après la Collection Privée de M. Durand-Ruel* (Paris, 1892), 172–3, quoted in Mathews, "Mary Cassatt . . . ," 164. This pastel, also shown as *Sollicitude maternelle*, was owned by Durand-Ruel until 1905 and was exhibited in New York in 1893 as part of a large display of Cassatt's mothers and children.

ROBERT VONNOH *(p. 159)*

1. See May Hill, *Grez Days Robert Vonnoh in France* (New York: Berry-Hill Galleries, Inc., 1987).

2. Jonathan Benington, "Roderic O'Conor (1860–1940), the Development of His Art up to 1913" (M.A. thesis, Courtauld Institute of Art, London University, 1982), 3, 7, 8.

3. See S. C. de Soissons [Guy Jean Raoul Eugène Charles

Emmanuel de Savoie-Cavignan, Comte de Soissons], *Boston Artists A Parisian Critic's Notes* (Boston: n.p., 1894), 26–7.
4. See Mrs. Schuyler Van Rensselaer, "Fine Arts. The French Impressionists. II," *Independent*, 38 (29 April 1886): 523–4.
5. Hill, *Grez Days*, 43.
6. E. V. Lucas, *Edwin Austin Abbey, Royal Academician: The Record of His Life and Work*, 2 vols. (London: Methuen and Company; New York: Charles Scribner's Sons, 1921), 1:159; Edwin H. Blashfield, "John Singer Sargent," *North American Review*, 221 (June 1925): 195; Candace Wheeler, *Content in a Garden* (Boston and New York: Houghton Mifflin and Company; Cambridge, Mass.: The Riverside Press, 1901), 96–7.
7. "Robert Vonnoh," *National Cyclopaedia of American Biography*, 63 vols. (Clifton, N.J.: James T. White, 1888–1894), 7:1897, 462.
8. Richard Muther, *The History of Modern Painting*, 3 vol. (London: Henry and Co., 1896), 491.
9. "The Art of Robert Vonnoh," *The New York Times*, 3 February 1896, 8.
10. The original signature and date are known from a photograph taken of the picture in Munich in 1892.
11. J. Massey Rhind to Joseph G. Butler, Jr., January 29, 1919, The Butler Institute of American Art Archives. Rhind reported Vonnoh's approval of the change. The actual lines of the poem, published in *Current Opinion* (New York), 8 December, 1915, are:
In Flanders fields the poppies blow
Between the crosses, row on row.

THEODORE ROBINSON *(p. 164)*
1. Guest Register for the Hotel Baudy, 1887–1900, Philadelphia Museum of Art.
2. For example, *La Vachère* (1888, The Baltimore Museum of Art).
3. Extant volumes (4) of Robinson's Diary cover the years, 1892–6 and are in the Frick Art Reference Library, New York.
4. Theodore Robinson, Diary, New York, January 23, 1893.
5. Theodore Robinson, Diary, Townshend, Vt., October 1, 1895.

FREDERICK CARL FRIESEKE *(p. 166)*
1. Clara MacChesney, "Frieseke Tells Some of the Secrets of His Art," *The New York Times*, 7 June 1914, sec. 6, 7.
2. Phyllis Derfner, "New York Letter," *Art International*, 19 (20 February 1975): 41.
3. This painting was entitled *La Vicina* when it was reproduced by Vittorio Pica, "Artisti Contemporanei: Frederick Carl Frieseke," *Emporium*, 38 (November, 1913): 331. The Butler Institute's picture was shown as *In the Doorway* in the *Exhibition of Painting and Sculpture Contributed by the Founders of the Galleries*, held at the Grand Central Art Galleries in New York City in 1923. *Good Morning* appears to be a recent designation. The author thanks Nicholas Kilmer, the artist's descendant, for much information on this painting, including its original title.
4. MacChesney, "Frieseke."
5. See Bram Dijkstra, "The High Cost of Parasols: Images of Women in Impressionist Art," in Patricia Trenton and William H. Gerdts, *California Light 1900–1930* (Laguna Beach, Cal.: Laguna Art Museum, 1990), 33–52.

WILLIAM MERRITT CHASE *(p. 168)*
1. Duncan Phillips, "William Merritt Chase," *American Magazine of Art* (December 1916): 49–50.
2. "Anonymous Notes on William Merritt Chase," A. Milgrome, "The Art of William Merritt Chase" (Ph.D. diss., University of Pittsburgh, 1969), 138.
3. *Art Amateur* (February 1896): 56.

FRANK WESTON BENSON *(p. 171)*
1. David Malcolm, quoted in Trevor J. Fairbrother, "Painting in Boston, 1870–1930," in Trevor J. Fairbrother, et al., *The Bostonians: Painters of an Elegant Age, 1870–1930* (Boston: Museum of Fine Arts, 1986), 72.

WILLARD LEROY METCALF *(p. 172)*
1. Jack Duncan, "Foreword," *Paintings by Willard L. Metcalf*, exhibition catalog (Washington, D.C.: Corcoran Gallery of Art, 1925), as cited by Elizabeth G. deVeer, "Metcalf," typescript for forthcoming publication. The actual quote is "poet laureate of these homely hills."
2. deVeer, "Metcalf," 127.

JOHN HENRY TWACHTMAN *(p. 175)*
1. Judging by its color scheme and brushwork, the painting may have been painted earlier than 1889.
2. Dorothy Weir Young, *The Life and Letters of J. Alden Weir* (New Haven: Yale University Press, 1960), 190.

JULIAN ALDEN WEIR *(p. 176)*
1. Weir to Mr. and Mrs. Robert W. Weir, April 15, 1877, cited in Dorothy Weir Young, *The Life & Letters of J. Alden Weir* (New Haven: Yale University Press, 1960), 123.
2. See Gabriel P. Weisberg, *Beyond Impressionism: The Naturalist Impulse* (New York: Harry N. Abrams, Inc., 1992).
3. Weir to his mother, June 22, 1875, cited in Doreen Bolger Burke, *J. Alden Weir: An American Impressionist* (Newark: University of Delaware Press Book, An American Art Journal Book, 1983), 70.
4. Weir to his mother, July 5, 1876, cited in Young, *Weir*, 98.
5. Weir to his father, July 11, 1876, cited in ibid., 99.
6. Ibid.
7. Weir to his mother, July 4, 1875, cited in ibid., 78.
8. See Burke, *Weir*, 79–83.
9. Weir to John Ferguson Weir, after July 23, 1875, cited in Burke, *Weir*, 74.
10. "The Academy Exhibition," *Art Journal*, 3 (May 1877): 160.

CHILDE HASSAM *(p. 179)*
1. Ilene Susan Fort, *The Flag Paintings of Childe Hassam* (New York: Harry N. Abrams, Inc., 1988), 84–92.
2. Donelson F. Hoopes, *Childe Hassam* (New York: Watson-Guptill Publications, 1979), 54.
3. Ulrich W. Hiesinger, *Impressionism in America, The Ten American Painters* (Munich: Prestel-Verlag, 1991), 208.
4. Fort, *The Flag Paintings*, 108–13.

ABBOTT HANDERSON THAYER *(p. 182)*
1. "A Record of American Art," *Magazine of Art*, 12 (London 1889): xxix.
2. Ross Anderson, *Abbott Handerson Thayer* (Syracuse, N.Y.: Everson Museum, 1982), 61.
3. Ibid., 20–3.
4. See Ann Douglas, *The Feminization of American Culture* (New York: Alfred A. Knopf, Inc., 1977).
5. Anderson, 69–72. Bessie Price was the model for *Seated Angel* (1899, Wadsworth Atheneum, Hartford, Ct.), and the Stevenson Memorial (1903, National Museum of American Art).
6. Joshua Taylor, *The Fine Arts in America* (Chicago and London: University of Chicago Press, 1979), 130.

EDWARD HENRY POTTHAST *(p. 187)*
1. *Afternoon Fun* was the title of the painting when purchased by

the Butler Institute from the Cincinnati Art Galleries. The work had been exhibited as *Picnic at the Beach* in the Grand Central Art Gallery show, *Impressionism and Post-Impressionism*, March–May, 1988.
2. Lois Marie Fink, *American Art at the Nineteenth-Century Paris Salons* (Cambridge, Mass.: Cambridge University Press, 1990), 274.
3. Annette Blaugrund, et al., *Paris 1889: American Artists at the Universal Exposition* (New York: Pennsylvania Academy of the Fine Arts and Harry N. Abrams, Inc., 1989), 199.
4. See Arlene Jacobowitz, "Edward Henry Potthast," *Brooklyn Museum Annual*, 9 (1967–68): 113–28; William H. Gerdts, *American Impressionism* (New York: Abbeville Press, 1984), 244.

CHARLES WEBSTER HAWTHORNE (p. 188)
1. Leila Mechlin, "Charles W. Hawthorne, 1872–1930." *The American Magazine of Art*, 23:2 (August 1931), 96.
2. *Hawthorne Retrospective*, exhibition catalog, (Provincetown, Mass.: The Chrysler Art Museum, 1961).
3. A. Seaton-Schmidt, "Charles W. Hawthorne," *Art and Progress*, 4:3, (January 1913), 824.
4. George A. Keck, "Hawthorne: Robust Painter, Great Teacher," *Weatherspoon Bulletin*, (1975–6): 6.
5. *Hawthorne Retrospective*, 14.

SOREN EMIL CARLSEN (p. 191)
1. Eliot Clark, "Emil Carlsen," *Scribner's*, 66 (December 1919): 769–70.
2. Robert McIntyre to Mr. Joseph G. Butler, Jr., January 26, 1923; and Joseph G. Butler, Jr. to Henry A. Butler, January 27, 1923, The Butler Institute of American Art Archives.
3. Elisabeth Luther Cary, "A Survey of the Art of the Late Emil Carlsen," *The New York Times*, 10 January, 1932, sec. 8, 11.

GARI MELCHERS (p. 192)
1. Melchers was named Julius Garibaldi Melchers for his father, Julius Theodore Melchers, and for his godfather, the Italian patriot Garibaldi. See *Gari Melchers: A Retrospective Exhibition*, eds. Diane Lesko and Esther Persson (St. Petersburg: Museum of Fine Arts, 1990).
2. Melchers to Joseph G. Butler, Jr., January 24, 1923, The Butler Institute of American Art Archives. Melchers titles this work *My Garden* and in subsequent letters from Mrs. Melchers it is referred to by this title.
3. Annette Blaugrund, et al., *Paris 1889: American Artists at the Universal Exposition* (Philadelphia: Pennsylvania Academy of the Fine Arts; New York: Harry N. Abrams, Inc., 1989), 186.
4. See Ronald Van Vleuten, "Egmond Remembers Gari Melchers," in Lesko and Persson, *Melchers*, 159–63.
5. Such as *Unpretentious Garden* (1903–09, Telfair Academy of Arts and Sciences, Inc., Savannah).
6. See Lesko and Persson, *Melchers*, 203, no. 30, and 32, pl. 14.

JOHN WHITE ALEXANDER (p. 194)
1. See H. Barbara Weinberg, *The Lure of Paris: Nineteenth-Century American Painters and Their French Teachers* (New York: Abbeville Press, 1991).
2. See Martha Banta, *Imaging American Women: Ideas and Ideals in Cultural History* (New York: Columbia University Press, 1987).

FRANKLIN DE HAVEN (p. 197)
1. William H. Gerdts, *Art Across America: Two Centuries of Regional Painting, 1710–1920*, 3 vols. (New York: Abbeville Press, 1990), 1:121.

2. Franklin De Haven to Joseph G. Butler, Jr., 1918, The Butler Institute of American Art Archives.
3. Whittier Montgomery, "The Art of Frank De Haven," *Brush and Pencil*, XVII:5 (May 1906): 185.

WILLIAM MCGREGOR PAXTON (p. 198)
1. R. H. Ives Gammell, *The Boston Painters 1900–1930* (Orleans, Mass.: Parnassus Imprints, Inc., 1986), 118.
2. *Boston Transcript*, April 1918.
3. *Boston Sunday Post*, 23 November 1941.
4. William Shakespeare, *Two Gentlemen of Verona*, Act IV, Scene 2.

EDWARD WILLIS REDFIELD (p. 201)
1. Edward W. Redfield, interview by Robert H. Lippincott, March 4, 1963, tape recorded, Thomas Folk Archives, Bernardsville, N.J.

FREDERICK JUDD WAUGH (p. 202)
1. Quoted in "F. J. Waugh is Dead; Marine Artist," *The New York Times*, 11 September 1940, 25, col. 1.
2. Ibid.; see "Frederick Judd Waugh," *The New York Times*, editorial, 12 September 1940, 24, col. 3.
3. Frederick J. Waugh, "Some Works on Sea Painting," *Palette and Bench* (November 1910), quoted in George R. Havens, "Frederick J. Waugh: America's Most Popular Marine Painter," *American Artist* (January 1967): 37.
4. George Havens, *Frederick J. Waugh, Marine Painter* (Orono, Me.: University of Maine Press, 1969), 107–8, 112–3.
5. Joseph G. Butler, III to Coulton Waugh, February 25, 1947, The Butler Institute of American Art Archives.

ELIHU VEDDER (p. 205)
1. Regina Soria, *Paintings and Drawings by Elihu Vedder*, exhibition catalog (Washington, D.C.: Smithsonian Institution Traveling Exhibition Service, 1966), 4.
2. Elihu Vedder, *The Digressions of V.* (Boston and New York: Houghton Mifflin Co., 1890), 372–4.
3. Elihu Vedder to Elihu Vedder, Sr., August 6, 1860, Elihu Vedder Papers, Archives of American Art, Smithsonian Institution, Washington, D.C.
4. See Theodore E. Stebbins, Jr., et al., *The Lure of Italy: American Artists and the Italian Experience, 1760–1914*, exhibition catalog (Boston: Museum of Fine Arts, 1992), 364.
5. Regina Soria, Joshua Taylor, et al., *Perceptions and Evocations: The Art of Elihu Vedder*, exhibition catalog (Washington, D.C.: Smithsonian Institution Press, 1979), 71.

JOSEPH HENRY SHARP (p. 206)
1. See Joseph Henry Sharp, "The Harvest Dance of the Pueblo Indians of New Mexico," *Harper's Weekly*, 14 October 1893, 982–83; and "An Artist Among the Indians," *Brush and Pencil*, 4 (April 1899): 1–7.
2. Joseph G. Butler, Jr. to J. Massey Rhind, November 8, 1919.
3. Forrest Fenn, *The Beat of the Drum and the Whoop of the Dance* (Santa Fe, N. Mex.: Fenn Publishing Co., 1983), 168.
4. Ibid., 159.

EANGER IRVING COUSE (p. 208)
1. See Virginia Couse Leavitt, *Eanger Irving Couse: Image Maker for America* (Albuquerque: The Albuquerque Museum, 1991), 236–9.
2. William H. Truettner, "The Art of Pueblo Life," *Art in New Mexico, 1900–1945: Paths to Taos and Santa Fe* (New York: Abbeville Press, 1986), 77.
3. Couse to Blackton, May 8, 1916, Couse Family Archives. Cited in Leavitt, *Couse*, 234, n. 93.

4. Leavitt, *Couse*, 177.
5. Ibid.
6. Related sketches and photographs: "A Vision of the Past," 1913, sketchbook 246, 19; composition sketch, 1913, sketchbook 248, 13; Jerry Mirabal, photograph; Francisco Gomez, photograph; Ben Lujan and children, photograph, The Couse Family Archives.

WILLIAM VICTOR HIGGINS *(p. 213)*
1. J. Keely, "Real American Art–At Last!," *Chicago Sunday Herald*, 25 April 1917.
2. Marcus, *Chicago Examiner*, 16 March 1918.

GEORGE WESLEY BELLOWS *(p. 214)*
1. John Wilmerding, "The Art of George Bellows and the Energies of Modern America," in Michael Quick, et al., *The Paintings of George Bellows* (Fort Worth and New York: Harry N. Abrams, Inc., 1992), 1–7.
2. See Jane Myers, "'The Most Searching Place in the World': Bellows's Portraiture," in Michael Quick, et al., *The Paintings of George Bellows* (Fort Worth and New York: Harry N. Abrams, Inc., 1992), 194–9.
3. For an analysis of Bellows's theoretical interests and technical practices, see Michael Quick, "Technique and Theory: The Evolution of George Bellows's Painting Style," in Michael Quick, et. al., *The Paintings of George Bellows* (Fort Worth and New York: Harry N. Abrams, Inc., 1992), especially 42–55.
4. Bellows employed a similar device in another portrait from that summer of a comparable size and pose: *Florence Davey* (1914, National Gallery of Art, Washington, D.C.).
5. Quoted in Charles W. Morgan, *George Bellows: Painter of America* (New York: Reynal and Company, 1965), 272.

ROBERT HENRI *(p. 216)*
1. Alfredo Valente, *Robert Henri*, exhibition catalog (New York: New York Cultural Center, 1969), no. 67 (illustrated in color).
2. Robert Henri to Joseph G. Butler, Jr., June, 1920, The Butler Institute of American Art Archives.

GEORGE LUKS *(p. 219)*
1. *George Luks: An American Artist*, exhibition catalog (Wilkes-Barre, Pa.: Sordoni Art Gallery, Wilkes College, 1987), 7. According to a description (unidentified, c. 1960) in The Butler Institute of American Art Archives, an X-ray of the painting reveals the head of Huneker, sketched beneath the shoulder of the woman.
2. *George Luks 1866–1933*, exhibition catalog (Utica, N.Y.: Munson-Williams-Proctor Institute, 1973), 8, 6.
3. *American Artist*, 61.
4. *American Artist*, 43.

JOHN SLOAN *(p. 220)*
1. Bruce St. John, ed., *John Sloan's New York Scene: from the diaries, notes and correspondence 1906–1913* (New York: Harper & Row, Publishers, 1965), 311.
2. Ibid.
3. Ibid., 372.
4. Rowland Elzea, *John Sloan's Oil Paintings: A Catalogue Raisonné* (Newark: University of Delaware Press, 1991), 23.
5. From John Sloan's unpublished notes, page 298, quoted in Elzea, *Sloan*, 98. See Van Wyck Brooks, *John Sloan: A Painter's Life* (New York: E. P. Dutton & Co., 1955), 100.
6. Ibid.

WILLIAM JAMES GLACKENS *(p. 223)*
1. Ira Glackens to Joseph G. Butler, III, August 20, 1967, The

Butler Institute of American Art Archives.
2. Richard Wattenmaker to Joseph G. Butler, III, October 31, 1967, The Butler Institute of American Art Archives. The painting was included in a retrospective at Rutgers in 1967.
3. Ira Glackens, *William Glackens and The Ashcan Group* (New York: Grosset and Dunlap, 1957), 69.
4. See William Gerdts, *American Impressionism* (New York: Abbeville Publishers, 1984), 278–81.
5. Leslie Katz, "The Pertinence of William Glackens," in *William Glackens in Retrospect* (St. Louis: City Art Museum of Saint Louis, 1966), u.p.

EVERETT SHINN *(p. 224)*
1. Proposal For Treatment Record, Intermuseum Laboratory, Oberlin, Oh., April 18, 1985, The Butler Institute of American Art Archives; Victor D. Spark to The Butler Institute of American Art, June 3, 1957, The Butler Institute of American Art Archives. The painting shows a pentimento indicating the position of the dancer's right arm before the 1952 touch-up.

MAURICE BRAZIL PRENDERGAST *(p. 227)*
1. Ira Glackens, *William Glackens and The Eight* (New York: Horizon Press, 1957), 183.
2. Phillips subsequently traded it with the Kraushaar Gallery for another Prendergast in 1945, and in 1955, it entered the collection of The Butler Institute of American Art.
3. Walter Pach, *Queer Thing, Painting* (New York: Harper & Brothers Publishing, 1938), 225.

ARTHUR BOWEN DAVIES *(p. 228)*
1. Davies exhibited with The Eight in 1908 and was the chief organizer of the Armory Show in 1913.
2. Davies was instrumental in establishing Ryder as one of the heroes of modernism at the Armory Show. See Charles C. Eldredge, *American Imagination and Symbolist Painting* (New York: Grey Art Gallery And Study Center, New York University, 1979), 4.
3. Davies's 1897 exhibition at New York's Macbeth Gallery included paintings portraying Pomona and Flora as well as Arethusa. Royal Cortissoz lists only one painting entitled *Arethusa* in his catalog of known paintings by the artist, *Arthur B. Davies* (New York: American Artists Series, Whitney Museum of American Art, 1931). Although he gives the date of the work as 1910 and in the collection of Mr. C. J. Sullivan, New York, the reference is probably to the Butler Institute's painting, simply misdated. A later work with the same title as the Butler Institute's picture may exist.
4. William Heath, ed., *Major British Poets of the Romantic Period* (New York: The MacMillan Co., 1973), 916–7.
5. Davies to William Macbeth, 1910, Macbeth Gallery Records, Archives of American Art, cited in Joseph S. Czestochwski, *The Works of Arthur B. Davies* (Chicago: University of Chicago Press, 1979), 7.
6. Elizabeth Johns, "Arthur B. Davies and Albert Pinkham Ryder: The "Fix" of the Art Historian," *Arts Magazine* (January 1982): 70–4.

GEORGE AULT *(p. 232)*
1. The work closest in subject and theme to the Butler Institute painting seems to be *New York Rooftop* (1940, Collection of Raymond J. Learsy). This shows a rooftop terrace, based on 50 Commerce Street, which Ault painted from memory. Rather than containing sculpture, *New York Rooftop* contains the figure of a nude woman, turned away from the spectator.
2. This torso appears in several other Ault paintings, including

Nude and Torso (1945, Collection of Virginia M. Zabriskie), and *The Artist at Work* (1946, Whitney Museum of American Art).

GEORGE GROSZ *(p. 235)*

1. George Grosz, *The Autobiography of George Grosz: A Small Yes and a Big No*, trans. Arnold J. Pomerans (London and New York: Allison & Busby, 1982), 184.
2. Ibid., 185.
3. See M. Kay Flavell, *George Grosz: A Biography* (New Haven and London: Yale University Press, 1988), especially 204–6, no. 67.
4. Felix Weil to Grosz, October 29, 1941, in Flavell, *Grosz*, 213–4, n. 21. "I would understand if you said you had to paint nudes, landscapes, and still lifes for purely economic reasons. . . . But you seem . . . to be making a virtue out of a necessity . . . Is there . . . something left of the Grosz of 1916–1926?"
5. For such images see *George Grosz: Works in Oil* (Huntington, N.Y.: Heckscher Museum, 1977).
6. See Werner Haftmann, *Verfemte Kunst: Bildende Künstler der inneren und ausseren Emigration in der Zeit des Nationalsozialismus* (Cologne: DuMont Buchverlag, 1986), especially 217–22.

ARTHUR G. DOVE *(p. 236)*

1. "Arthur Dove: An American Place," *Art News*, 29:25 (21 March 1931): 12; [Edward Alden Jewell], "Dove Again: A Movement Toward Larger Design," *The New York Times*, 15 March 1931.
2. Arthur Dove to Samuel Kootz, 1910s; cited in Barbara Haskell, *Arthur Dove*, exhibition catalog (San Francisco: San Francisco Museum of Modern Art, 1974), 134.
3. Arthur Dove to Alfred Stieglitz, May 20, 1929, Noroton, Conn., cited in Ann Lee Morgan, ed., *Dear Stieglitz, Dear Dove* (Newark: The University of Delaware Press, 1988), 208.
4. See Ann Lee Morgan, *Arthur Dove: Life and Work, with a Catalogue Raisonné* (Newark: University of Delaware Press, 1984), 25.
5. Murdock Pemberton, "The Art Galleries: New Doves," *The New Yorker* 7, (21 March, 1931): 68–9.

MARSDEN HARTLEY *(p. 239)*

1. Marsden Hartley to Nick Brigante, August 27, 1939, Collection of American Literature, Beinecke Library, Yale University.
2. Gail Scott, ed., *On Art by Marsden Hartley* (New York: Horizon Press, 1982), 264.
3. See Gail Levin, "Marsden Hartley and Mysticism," *Arts Magazine*, 60 (November 1985): 16–21.
4. Gail R. Scott, ed., *The Collected Poems of Marsden Hartley, 1904–1943* (Santa Rosa, Cal.: Black Sparrow Press, 1987), 271.

GEORGIA O'KEEFFE *(p. 240)*

1. Laurie Lisle, *Portrait of an Artist, A Biography of Georgia O'Keeffe* (Albuquerque: University of New Mexico Press, 1986), 51.
2. Lisle, *O'Keeffe*, 63.
3. Roxana Robinson, *Georgia O'Keeffe, A Life* (New York: Harper & Row, Publishers, 1989), 478. According to Barbara Buhler Lynes of The Georgia O'Keeffe Catalogue Raisonné, the painting was executed in 1944, and once bore a label on its backing to that effect. It was first exhibited at An American Place in New York, January 22–March 22, 1945, checklist number 3, titled *Cottonwood III*. The painting was subsequently consigned to the Downtown Gallery in New York and was sold in 1959 to Louise G. Raphael. The painting was offered for sale by Sotheby's, New York on May 24, 1990, lot 240, designated as "Property of Louise G. Raphael," but did not sell. It was acquired by the Butler Institute later that same year.
4. Lisle, *O'Keeffe*, 35.

NILES SPENCER *(p. 243)*

1. Fairfield Porter, "Niles Spencer," *Art News*, 51 (November 1952): 46.
2. Quoted in Richard B. Freeman, *Niles Spencer*, exhibition catalog (Lexington, Ky.: University of Kentucky Art Museum, 1965), 11.
3. Freeman, *Spencer*, 36. Two studies for *The Watch Factory* were shown in this exhibition: *Factory, Sag Harbor*, cat. no. 109 (gouache on cardboard, 10 1/2 × 16″), and *The Watch Factory No. 2*, cat. no. 114 (oil on board, 10 1/4 × 15 3/4″). The author thanks Wendy Jeffers for identifying the present location of *Factory, Sag Harbor*.

CHARLES SHEELER *(p. 244)*

1. Theodore E. Stebbins, Jr. and Norman Keyes, Jr., *Charles Sheeler: The Photographs* (Boston: Museum of Fine Arts, 1987), 41–3.
2. The others were *Primitive Power* (1939, The Regis Collection, Minn.), *Suspended Power* (1939, Dallas Museum of Art), *Conversation—Sky and Earth* (1940, The Regis Collection, Minn.), *Rolling Power* (1939, Smith College Museum of Art), and *The Yankee Clipper* (1939, Museum of Art, Rhode Island School of Design). In the catalog of the Downtown Gallery exhibition, *Sheeler, Steam Turbine* was listed first. Exhibition dates, December 2–21, 1940.
3. Charles Sheeler, "A Brief Note on the Exhibition," *Charles Sheeler* (New York: Museum of Modern Art, 1939), 11.
4. Stebbins and Keyes, *Sheeler*, 39.
5. "Interview: Charles Sheeler Talks with Martin Friedman," *Archives of American Art Journal*, 16:4 (1976): 18.
6. Charles Sheeler, interview by Martin Friedman, June 18, 1959, tape 1, trans. p. 9, Archives of American Art, New York.
7. Ibid., 15.
8. Milton Brown, "Sheeler and Power," *Parnassus*, 13 (January 1941): 36.
9. Sheeler, *Sheeler*, 11.

STUART DAVIS *(p. 247)*

1. Stuart Davis, quoted in Barbara Rose, *American Art The Twentieth Century* (New York: Rizzoli, 1986), 40.

THOMAS HART BENTON *(p. 248)*

1. Benton to Joseph G. Butler, III, April 9, 1970.
2. See Matthew Baigell, *Thomas Hart Benton* (New York: Harry N. Abrams, Inc., 1973), and Henry Adams, *Thomas Hart Benton: An American Original* (New York: Alfred A. Knopf, 1989).
3. See Matthew Baigell, *The American Scene* (New York: Praeger, 1974), 90–103.

GRANT WOOD *(p. 251)*

1. Grant Wood, *Revolt Against the City* (Iowa City, Ia.: Frank Luther Mott, 1935), reproduced in James M. Dennis, *Grant Wood—A Study in American Art and Culture* (New York: Viking Press, 1975).
2. See Sylvan Cole, Jr., *Grant Wood: The Lithographs* (New York: Associated American Artists, 1984).
3. Dennis, *Grant Wood*, 232.
4. Howard E. Wooden, "Grant Wood—A Regionalist's Interpretation of the Four Seasons," *American Artist* 55: 588 (July 1991): 58–64.

JOHN STEUART CURRY *(p. 252)*

1. Laurence E. Schmeckebier, *John Steuart Curry's Pageant of America* (New York: American Artists Group, 1943).
2. Based on a stylistic comparison with numerous other versions, the Butler Institute's *Sanctuary* was probably executed in 1936.

3. In 1940, Curry was commissioned by *Life* to execute a painting titled *Hoover and the Flood*. See *Life* 8:19, 6 May 1940, 58–61.
4. See Grant Wood, *Revolt Against the City* (Iowa City, Ia.: Frank Luther Mott, 1935). Reproduced in James M. Dennis, *Grant Wood* (New York: Viking Press, 1975), 229.

KENNETH HAYES MILLER *(p. 255)*
1. Reginald Marsh, "Kenneth Hayes Miller," *Magazine of Art* (April 1952): 170.
2. According to Miller, "Hands are decisive. When they are hidden in a painting, something incredibly important is lost. The raising of a finger can enliven the action of an entire body," quoted in Lincoln Rothschild, *To Keep Art Alive: The Effort of Kenneth Hayes Miller, American Painter (1876–1952)* (Philadelphia: The Art Alliance Press, 1974), 72.
3. Quoted in Rothschild, *Miller*, 24.
4. Robert Coates, *The New Yorker*, 3 October 1953, 104, 106–7.
5. Miller is now best remembered as one of the century's leading teachers. By the end of his teaching career in 1952 at both the New York Art School and the Art Students League, he numbered among his students and the younger contemporaries he had influenced Rockwell Kent, Marsden Hartley, Reginald Marsh, Isabel Bishop, and Edward Hopper. See Hilton Kramer, "The Unhappy Fate of Hayes Miller," *The New York Times*, 11 March 1979, 31, 37.

ISABEL BISHOP *(p. 256)*
1. R. B. Kitaj, "Isabel Bishop," *Modern Painters*, 2:2 (Summer 1989): 116.
2. *Isabel Bishop: Portrait of an Artist*, directed by Patricia Depew (New York Film Company, 1977).
3. Bishop's facial studies also suggest an informal modern counterpart to the systematic sequence of heads put into artist's pattern books by Charles Lebrun in seventeenth-century France to embody various emotional states, although they are visually more akin to Rembrandt's faces than to Lebrun's heroes.
4. Quoted in Helen Yglesias, *Isabel Bishop* (New York: Rizzoli, 1989), 74.
5. Ibid. The print is *Laughing Girl*, 1938, etching, 5 × 4″, signed, lower left. Museum purchase, 967-P-174.

REGINALD MARSH *(p. 258)*
1. Lloyd Goodrich, *Reginald Marsh* (New York: Harry N. Abrams, Inc., 1972), 141.
2. Norman Sasowsky, *The Prints of Reginald Marsh* (New York: Clarkson N. Potter, Inc., 1973), 218, no. 177.
3. Goodrich, *Reginald Marsh*, 161.
4. See "Marsh Speaks Anew of the 'Common People,'" *Art Digest*, 13 (1 December 1938): 11. Marsh did not exhibit either Battery picture in his solo exhibition at the Frank K. M. Rehn Galleries, exhibition dates, November 21–December 10, 1938. Marsh sent the tempera to the Carnegie Institute, Pittsburgh, *International Exhibition of Painting*, no. 66. Exhibition dates, October 13–December 4, 1938.
5. Reginald Marsh Papers, Archives of American Art, New York, reel 2708, no frame numbers.
6. Ibid., 293, referring to the early 1920s.
7. Goodrich, *Reginald Marsh*, 33, gives late 1929 as the date.

CHARLES EPHRAIM BURCHFIELD *(p. 260)*
1. Charles Burchfield, "On the Middle Border," *Creative Art*, 3 (September 1928): 25.
2. Charles Burchfield, September 13, 1913, Salem, Oh. Published in Charles Burchfield, *Charles Burchfield's Journals: The Poetry of Place*, ed. J. Benjamin Townsend (Albany, N.Y.: State University of

New York Press, 1993), 364.
3. John I. H. Baur, *Life and Work of Charles Burchfield, 1893–1967: The Inlander* (Newark: University of Delaware Press, 1984). See also Townsend, *Journals*, xix, 503, 527.
4. Burchfield, *Creative Art*, 25.
5. Belle Krasne, "A Charles Burchfield Profile," *Art Digest*, 27 (15 December 1952): 21.
6. Charles Burchfield, interview by John D. Morse, August 19, 1959, transcript, Archives of American Art, New York, 13–5.
7. University of Arizona Art Gallery, *CB: His Golden Year: A Retrospective Exhibition of Watercolors, Oils and Graphics by Charles E. Burchfield*, exhibition catalog (Tucson: University of Arizona Press, 1965), 64.
8. *Charles Burchfield: Catalogue of Paintings in Public and Private Collections*, essay by Joseph S. Trovato (Utica, N.Y.: Museum of Art, Munson-Williams-Proctor Institute, 1970), 233.
9. *CB: His Golden Year*, 65.
10. Krasne, *Art Digest*, 21.
11. Baur, *Life and Work*, 194.
12. Charles Burchfield, 29 January, 1949, Gardenville. Published in Baur, *Life and Work*, 212, n. 31.

EDWARD HOPPER *(p. 262)*
1. Hopper's record book II, 57, Whitney Museum of American Art.
2. See Gail Levin, *Hopper's Places* (New York: Alfred A. Knopf, 1985), 9.
3. Brian O'Doherty, "Invitation to Art," WGBH-TV Boston, April 1, 1961.
4. Brian O'Doherty, *American Masters: The Voice and the Myth* (New York: Universe Books, 1988), 20.
5. See Gail Levin, *Edward Hopper: The Art and the Artist* (New York: W. W. Norton, Inc., 1980), 33–4.
6. See Levin, *Art and the Artist*, pl. 67.
7. Josephine N. Hopper, in Hopper's record book III, 23, Whitney Museum of American Art.
8. Sherwood Anderson, *Marching Men* (New York: John Lane Co., 1917), 9.
9. Ibid., 38–9.
10. Ibid., 39–40.
11. Ibid., 155.
12. Edward Hopper quoted in O'Doherty, *American Masters*, 26.

WILLIAM GROPPER *(p. 264)*
1. See Irving Bernstein, *Turbulent Years: A History of the American Worker, 1933–1941* (Boston: Houghton Mifflin, 1970), 217–18.
2. Cf. William Gropper, "Gropper Visits Youngstown," *The Nation*, 145:1 (3 July 1937): 14–15.
3. See George P. West, "Youngstown," *The New Republic*, 5:65 (29 January 1916): 330–2.

BEN SHAHN *(p. 266)*
1. See Bernarda Bryson Shahn, *Ben Shahn* (New York: Harry N. Abrams, Inc., 1972), 66–71, 131–49.
2. Ben Shahn, *The Shape of Content* (New York: Vintage Books, 1957), 122.

JOE JONES *(p. 269)*
1. The National Industrial Recovery Act was passed by Congress in 1933 to encourage industrial recovery and help combat widespread unemployment.
2. Lewis Mumford, "The Art Galleries," *The New Yorker*, June 1935, 57.
3. Patricia Hills, *Social Concern and Urban Realism* (Boston: Boston University Art Gallery, 1983), 60.

4. See *Art Front*, 1:3 (February 1935): 3. See also *The Nation*, 142:3678 (1 January 1936): 9.

RAPHAEL SOYER *(p. 271)*
1. Israel Schenker, "Raphael Soyer: I consider myself a contemporary artist who describes contemporary life," *ARTNews*, 72 (November 1973): 56.
2. Ibid., 55.
3. Ibid.
4. Ibid.
5. Raphael Soyer, *Raphael Soyer* (New York: American Artists Congress, Inc., 1946), 2.
6. Other large-scale group portraits by Soyer include *Homage to Eakins* and *Portraits at a Party* (1964–65; 1973–74, both Hirshhorn Museum and Sculpture Garden).
7. Raphael Soyer, *A Painter's Pilgrimage* (New York: Crown Publishers, Inc., 1962), 72.
8. Soyer, *Diary*, 14, 147–8.
9. Robert M. Coates, "The Art Galleries," *The New Yorker*, 13 March 1948, 62.

JOSEPH HIRSCH *(p. 272)*
1. John I. H. Baur, *Revolution and Tradition in Modern American Art* (Cambridge, Mass.: Harvard University Press, 1951), 21.
2. Hirsch to Alice B. Goldcamp, November 26, 1969, The Butler Institute of American Art Archives.

JACOB LAWRENCE *(p. 275)*
1. *The Struggle* series contained thirty paintings now held in various museums.
2. Ellen Harkins Wheat, *Jacob Lawrence, American Painter* (Seattle and London: University of Washington Press, 1986), 68–9.
3. Jacob Lawrence, untitled speech, c. 1953, Jacob Lawrence Papers, Syracuse University.
4. The series are held in, respectively: Amistad Research Centers' Aaron Douglas Collection; Hampton University Museum, Hampton, Va.; Hampton University Museum, Hampton, Va.; various collections; Detroit Institute of Arts.

WALT KUHN *(p. 276)*
1. See Philip Rhys Adams, *Walt Kuhn, Painter: His Life and Work* (Columbus, Oh.: The Ohio State University Press, 1978).
2. Ibid., 272. Adams identified the model for *Green Pom-Pom* as Ruth Ester. Many of Kuhn's models were among the artist's fiercest supporters, resentful that Kuhn had not received the true measure of critical and popular acclaim they believed he deserved.
3. Ibid., 158, 141. The painting *Juggler* (1934, Nelson-Atkins Museum of Art, Kansas City, Mo.) was later referred to by Kuhn as a portrait of self-pity.
4. Rosamund Frost, "Walt Kuhn Clowns in a Great Tradition," *Art News* (1 May 1945): 11.
5. Other works include: *Grenadier* (1935, private collection), *Lancer* (1939, Currier Gallery of Art, Manchester, N.H.), and *Tricorne* (1939, Whitney Museum of American Art). Kuhn sent *Green Pom-Pom* to the 1947 Whitney *Annual*.
6. Adams, *Kuhn*, 118.
7. Kuhn quoted in ibid., 191.

GUY PENE DU BOIS *(p. 279)*
1. Lloyd Goodrich, "Exhibitions in New York," *The Arts*, 15:5 (May 1929): 325, cited in Betsy Fahlman, *Guy Pène du Bois: Artist About Town* (Washington, D.C.: Corcoran Gallery of Art, 1980), 16.
2. Fahlman, *Pène du Bois*, 32. Fahlman identifies the painting as having been inspired by a circus performance that the artist saw either in Paris or Garnes, where Pène du Bois primarily lived while in France.
3. Pène du Bois to Royal Cortissoz, August 3, 1930, Collection of American Literature, Bienecke Rare Book and Manuscript Library, Yale University.
4. *Center Ring The Artist: Two Centuries of Circus Art* (Milwaukee, Wis.: Milwaukee Art Museum, 1981), 25.

JOHN MARIN *(p. 280)*
1. Cleve Gray, ed., *John Marin by John Marin* (New York: Holt, Rinehart and Winston, 1970), 47.
2. See John I. H. Baur, *Watercolors by Charles Burchfield and John Marin* (New York: Kennedy Galleries, 1985), n.p.
3. Gray, *Marin*, 44–69.
4. Marin to Alfred Stieglitz, Addison, Me., August 31, 1940, cited in Ruth E. Fine, *John Marin* (Washington, D.C.: National Gallery of Art, 1990), 271.

LOUIS BOUCHE *(p. 283)*
1. Louis Bouché, interview by W. E. Woolfenden, March 13, 1963, tape 2, p. 21, Archives of American Art, New York.
2. Murdock Pemberton, "The Art Galleries: Back to Easel—Six Young Men," *The New Yorker*, 2 April 1932, Bouché Papers, Kraushaar Galleries, New York.
3. Harry Salpeter, "Louis Bouché: Boulevardier of Art," *Esquire* (November 1937): 249.
4. Clipping, Bouché Papers, Kraushaar Galleries, New York.
5. Jane Bouché Strong, in *Louis Bouché (1896–1969)* (New York: Kraushaar Galleries), n.p. exhibition dates, December 5–29, 1989.
6. Louis Bouché Papers, reel 3956, frame 0299, Archives of American Art. The Butler Institute's picture was shown in the exhibition, *Louis Bouché* (Albany Institute of History and Art: Albany, N.Y.), exhibition dates, April 28–May 31, 1963.
7. *American Artist*, 24 (June 1960): 33.

JACK LEVINE *(p. 284)*
1. See Frank Getlain, *Jack Levine* (New York: Harry N. Abrams, Inc., 1966), 16. The painting was singled out by government leaders as the most offensive of many objectional works by American social commentary painters in the State Department exhibit that was yanked from its scheduled tour of Eastern European museums in 1949.
2 . See Kenneth W. Prescott, *Jack Levine Retrospective Exhibition: Paintings, Drawings, Graphics* (New York: Jewish Museum Publications, 1978).
3. Mayor Daley had been lampooned by Levine several times previously, most distinctly in a caustic satire on the 1968 Democratic convention.
4. Hodding Carter, "The Vanities Afire: Jack Levine," *Art in America* (May 1991): 144. *On the Block* (1986–1990, Midtown Payson Gallery) was featured at Levine's solo exhibition which Carter was reviewing. *Carnival at Sunset* may have led into this even more savage satire of the art crowd, demonstrating the undiminished power of this maverick American Expressionist painter.

HORACE PIPPIN *(p. 287)*
1. See *Horace Pippin: Exhibition of Paintings* (New York: The Downtown Gallery, 1944). *Zachariah* is #19 in the checklist.
2. Carl L. Dennison to Robert Carlen, March 15, 1946, Robert Carlen Papers, Archives of American Art, Smithsonian Institution.
3. Lydia Maria Childs, in *The Independent*, December 1965, quoted in David H. Wallace, *John Rogers, The People's Sculptor* (Middletown, Conn.: Wesleyan University Press, 1967), 212.

IVAN LE LORRAINE ALBRIGHT *(p. 288)*
1. Michael Croydon, *Ivan Albright* (New York: Abbeville Press, 1978), 261.
2. Katharine Kuh, *The Artist's Voice: Talks with Seventeen Artists* (New York: Harper & Row, 1962), 23.
3. Ibid., 24.

WALTER MURCH *(p. 293)*
1. Ernest W. Watson, "Walter Murch, Painter of the Impossible," *American Artist*, 19:8 (October 1955): 61–2.
2. See Judy Collischan Van Wagner, *Walter Murch*, catalogue raisonné (Ph.D. diss., Iowa City: University of Iowa, 1972).

ADOLF DEHN *(p. 294)*
1. See Richard Cox, "Adolf Dehn: The Life" in *The Prints of Adolf Dehn, A Catalogue Raisonné*, Joycelyn Lumsdaine and Thomas O'Sullivan, comps. (St. Paul: Minnesota Historical Society Press, 1987), 16. Dehn's sketchbooks are in the collection of The Butler Institute of American Art.
2. Virginia Dehn, interview with the author, Santa Fe, N.M., March 25, 1993.
3. Carl Zigrosser, *Adolf Dehn Drawings* (Columbia, Mo.: University of Missouri Press, 1971), 7.

ANDREW N. WYETH *(p. 297)*
1. Richard Meryman, "Andrew Wyeth: An Interview," *Life*, 14 May 1965, 108.
2. Andrew N. Wyeth, conversation with the author, May, 1993.

CHEN CHI *(p. 298)*
1. Martina Roudabash Norelli, *East Meets West: Chen Chi Watercolors*, exhibition catalog (Columbus, Ga.: The Columbus Museum, 1989), 11.
2. *Chen Chi*, exhibition catalog (New York: Grand Central Galleries, 1958), n.p.
3. *Chen Chi*, exhibition information sheet, The Butler Institute of American Art Archives, 1.

COLLEEN BROWNING *(p. 301)*
1. "Medal of Merit at Butler Institute," *The Ohio Art Graphic* (November 1974).
2. Bill Keagy, "Butler Hosts Retrospective of Colleen Browning's Work," *The Jambar*, 3 December 1991.
3. Quoted by Robert Kurtz in *Colleen Browning*, exhibition catalog (Youngstown, Oh.: The Butler Institute of American Art, 1991), 5.
4. "The People of Our Town," *The New York Times Magazine*, April 1964, 33.

MILTON AVERY *(p. 302)*
1. Adolph Gottlieb and Mark Rothko to Alden Jewell, art critic for *The New York Times*, June 7, 1943; published in *The New York Times*, 13 June 1943, sec. 2, 9.

JOHN KOCH *(p. 305)*
1. John Koch, quoted by Mario Amaya in *John Koch*, exhibition catalog (New York: The New York Cultural Center, 1973), 5.
2. John Koch, interview by Leslie Cheek, Jr. in *John Koch in New York*, exhibition catalog (New York: Museum of the City of New York, 1964), 11.
3. Ibid., 15.
4. See *Two Models* and *Model Undressing* (1965 and 1962, private collections), illustrated in *Models and Moments Paintings and Drawings by John Koch*, exhibition catalog (University Park, Pa.: The Pennsylvania State University, 1978), illus. 27, 20.

ADOLPH GOTTLIEB *(p. 306)*
1. Adolph Gottlieb in "The Ides of Art: The Attitudes of 10 Artists on Their Art and Contemporaneousness," *The Tiger's Eye*, 1:2 (December 1947): 43.
2. "The Portrait and the Modern Artist," interview with Gottlieb and Mark Rothko broadcast on "Art in New York," Radio WNYC, October 13, 1943. Published in Sanford Hirsch and Mary Davis MacNaughton, *Adolph Gottlieb: A Retrospective* (New York: The Arts Publisher, Inc., in association with the Adolph and Esther Gottlieb Foundation, Inc., 1981), 171.
3. John Graham, *System and Dialectics of Art* (New York: Delphic Studios, 1937; Baltimore: Johns Hopkins University Press, 1971), 95.
4. Gottlieb, "The Portrait and the Modern Artist," 171.
5. Ibid.
6. See Mary R. Davis, "The Pictographs of Adolph Gottlieb: Synthesis of the Subjective and the Rational," *Arts*, 52 (November 1977): 142.
7. Davis, *Arts*, 142, 147, n. 27.
8. Significantly, Tiresias figures in part three of T. S. Eliot's "The Waste Land," a poem Gottlieb evoked in a painting of the same title in 1930, illustrated in Miriam Roberts, *Adolph Gottlieb Paintings 1921–1956* (Omaha, Neb.: Joslyn Art Museum, 1980), 15.

JOAN MITCHELL *(p. 308)*
1. John I. H. Baur, *Nature in Abstraction* (New York: Whitney Museum of American Art, 1958), 75.

ROMARE BEARDEN *(p. 312)*
1. A group of artists, called Spiral, formed to discuss their contribution to the Civil Rights Movement. Bearden proposed a group project using collage and, despite the others' unwillingness to participate, produced one of his more successful painting/collage series, *Projections*, in 1964. See Myron Schwartzman, *Romare Bearden, His Life and Art* (New York: Harry N. Abrams, Inc., 1990), 209–16, illus. on 211.
2. Romare Bearden, "Rectangular Structure in My Montage Paintings," *Leonardo*, 2 (1969): 11–9.
3. See Albert Murray, "The Visual Equivalent of the Blues," in *Romare Bearden: 1970–1980* (Charlotte, N.C.: Mint Museum, 1980), 17–28. Also see John Vlach, *The Afro-American Tradition in the Decorative Arts* (Cleveland, Oh.: Cleveland Museum of Art, 1978), 55–75.

ANDY WARHOL *(p. 316)*
1. In 1968 Warhol nearly died after being shot in his studio by Valerie Solanis. His recuperation during the next four years saw him devote most of his time to his films.
2. The Butler Institute's work is the left-hand panel. The other panel is the same photograph, cropped slightly differently, with color bands running diagonally.
3. Carter Ratcliff, *Andy Warhol* (New York: Abbeville Press, 1983), 103.

WILL BARNET *(p. 319)*
1. Prescott Schutz in *Will Barnet New Paintings*, exhibition catalog (New York: Hirschl & Adler Galleries, Inc., 1981), n.p.
2. John D. Morse, ed., "Will Barnet," *Art Students League News*, 2:6 (April 1949): 3.

SIDNEY GOODMAN *(p. 320)*
1. Richard Porter, *Sidney Goodman: Paintings, Drawings, Graphics, 1959–79*, exhibition catalog (Philadelphia: Commonwealth of

Pennsylvania Council on the Arts, 1981), 3.
2. Janet Wilson, "Sidney Goodman: When the hand touches the canvas, that's the real ball game," *ARTnews* (March 1980): 75.
3. Sidney Goodman, telephone conversation with author, April 28, 1993.

CHUCK CLOSE *(p. 322)*
1. Chuck Close, taped conversation with the author and Joe Wilfer, New York, N.Y., 1989.
2. Chuck Close, interview by Sylvia Chase in "A Close Encounter," *Prime Time Live*, ABC-TV, August 27, 1992.

PHILIP PEARLSTEIN *(p. 325)*
1. "Philip Pearlstein: A Statement," in *Philip Pearlstein; Zeichnungen und Aquarelle: Die Druckgraphic*, exhibition catalog (Berlin-Dahlem: Staatliche Museum, 1972), 15.
2. Charles Rosen and Henri Zerner, "What Is, and Is Not, Realism?" *The New York Review*, 18 February 1982, 25.
3. Philip Pearlstein, interview by author, January 23, 1993.

JACK MENDENHALL *(p. 329)*
1. *Architectural Digest* (March 1976).
2. Frank H. Goodyear, Jr., *Contemporary American Realism* (Boston: New York Graphics, 1984), 166.
3. Ibid., 27.

ALFRED LESLIE *(p. 330)*
1. The show, *Talent 1950*, was held at the Samuel Kootz Gallery, New York.
2. *Alfred Leslie*, exhibition catalog (New York: Allen Frumkin Gallery, 1975), n.p.
3. *100 Views Along the Road*, exhibition catalog (Youngstown, Oh.: The Butler Institute of American Art, 1983), n.p.
4. *View of the Connecticut River as Seen from Mount Holyoke* (Aachen, Neue Galerie der Stadt), is a reprise of Cole's famous *View from Mount Holyoke, Northampton, Massachusetts, after a Thunderstorm (The Oxbow)* (1836, The Metropolitan Museum of Art), and is pivotal in the development of Leslie's roadside comparison of the old poetic fictions of American landscape painting with the unvarnished truths of late twentieth-century America.
5. See David Shapiro, "15 Notes on Alfred Leslie's Art of Multiplicity," in *Alfred Leslie's Art, 1951–1991* (Hartford, Conn.:

Joseloff Gallery, University of Hartford, 1991), n.p.
6. For more roadside imagery, See Sidra Stich, *Made in U.S.A.; An Americanization in Modern Art, the 50s and 60s* (Berkeley, Cal.: University at California Press, 1987), 64–75.

PAUL JENKINS *(p. 337)*
1. Gerald Nordland, quoted in Jay Jacobs, "Paul Jenkins," *The ART Gallery Magazine* (December 1971): 56.
2. Jean Cassou, *Jenkins* (Stuttgart: Verlag Gerd Hatje, 1963), 14.

RICHARD ANUSZKIEWICZ *(p. 340)*
1. Stuart Preston, *The New York Times*, 2 April 1961.
2. Stuart Preston, *The New York Times*, 4 March 1963.
3. John Gruen, "'Americans 1963' at Modern Museum," *New York Herald Tribune*, 22 May 1963.
4. John Gruen, *New York Herald Tribune*, 26 May 1963.
5. Miles A. Smith, *Daily American*, 4 July 1963.

RAFAEL FERRER *(p. 342)*
1. Ferrer, interview by Marie-Rose Charité Velazquez, in "Diamonds on the Street: Rafael Ferrer's New Work," *Arts Magazine*, 58 (February 1984): 72.
2. Ibid.

JOSEPH RAFFAEL *(p. 345)*
1. Joseph Raffael, conversation with the author, France, 1993.
2. Joseph Raffael to Joyce Petschek, 1992.
3. Joseph Raffael, conversation with the author, France, 1993.
4. J. E. Cirlot, "Lao-Tse," trans. Jack Sage, *A Dictionary of Symbols*, 2nd ed. (London: Routledge & Kegan Paul, 1971), 366.

NASSOS DAPHNIS *(p. 346)*
1. Nassos Daphnis, interview with author and Evangelos Stamatopoulos, October, 1992, The Butler Institute of American Art Archives.
2. Valerie Kontakos, *A Quality of Light*, interview with Nassos Daphnis, 1989, videotape transcript, The Butler Institute of American Art Archives.
3. Daphnis, interview, October, 1992.

SAM GILLIAM *(p. 349)*
1. Walter Hopps, *Sam Gilliam, Painting and Works on Paper*, exhibition catalog (Louisville, Ky.: J. B. Speed Art Museum, 1976).

CONTRIBUTORS

Henry Adams is Curator of American Art at the Nelson-Atkins Museum of Art, Kansas City, Mo.
Dore Ashton is Professor of Art History at Cooper Union, New York City, and Associate Editor of *Art Digest*.
Peter Bermingham is Director and Chief Curator of the University of Arizona Museum of Art, Tucson, Ariz.
Doreen Bolger is Director of the Museum of Art, Rhode Island School of Design, Providence, R.I.
H. Daniel Butts, III is Director of The Mansfield Art Center, Mansfield, Oh.
Bruce Chambers is an independent art historian and art dealer in Hamden, Conn.
Nicolai Cikovsky, Jr. is Curator of American and British Paintings and Deputy Senior Curator of Paintings at the National Gallery of Art, Washington, D.C.

Judy Collischan is Director of the Hillwood Art Museum, Long Island University, Brookville, N.Y.
Elizabeth Jane Connell is an independent curator in Providence, Ut.
Richard Cox is Professor of Art History and Head of the Art History Division of the School of Art at Louisiana State University, Baton Rouge, La.
Stephanie D'Alessandro is Associate Curator at The David and Alfred Smart Museum of Art, The University of Chicago, Chicago, Ill.
Carl David is Director of David David, Inc., an art gallery in Philadelphia, Pa.
Lauretta Dimmick is the Gates Foundation Curator of Paintings and Sculpture at the Denver Art Museum, Denver, Colo.
David C. Driskell is Professor of Art at the University of Maryland, College Park, Md.

James H. Duff is Director of the Brandywine River Museum and Executive Director of the Brandywine Conservancy, Chadds Ford, Pa.

Dorinda Evans is Chairman of the Art History Department at Emory University, Atlanta, Ga.

Barbara Dayer Gallati is Associate Curator of American Painting and Sculpture at the Brooklyn Museum, Brooklyn, N.Y.

William H. Gerdts is a Professor in the Ph.D. Program in Art History, The City University of New York, N.Y.

Kathleen Gibbons is Director of Education at The David and Alfred Smart Museum of Art, The University of Chicago, Chicago, Ill.

Robert Godfrey is the Head of the Department of Art at Western Carolina University, Cullowhee, N.C.

Alfred C. Harrison, Jr. is Director of The North Point Gallery, San Francisco, Cal.

Eleanor Jones Harvey is Associate Curator of American Art at the Dallas Museum of Art, Dallas, Tex.

Gerrit Henry is a contributing editor for *ARTnews* magazine, New York, N.Y.

Patricia Hills is Professor of Art History at Boston University, Boston, Mass.

Tom E. Hinson is Curator of Contemporary Art at The Cleveland Museum of Art, Cleveland, Oh.

Robert Hobbs is the Rhoda Thalhimer Professor of American Art History at the Virginia Commonwealth University, Richmond, Va.

Martha J. Hoppin is Curator of American Art at the Museum of Fine Arts and the George Walter Vincent Smith Art Museum in Springfield, Mass.

Sam Hunter is Professor Emeritus in the Department of Art and Archaeology, Princeton University, Princeton, N.J.

Anthony F. Janson is an art historian living in Apex, N.C.

Sona K. Johnston is the Curator of Painting and Sculpture Before 1900 at The Baltimore Museum of Art, Baltimore, Md.

Mitchell D. Kahan is Director of the Akron Art Museum, Akron, Oh.

Joseph Keiffer is an appraiser and art dealer in New York, N.Y.

James Keny is Director and co-owner of Keny Galleries, Columbus, Oh.

Robert Kurtz is Assistant Curator at The Butler Institute of American Art, Youngstown, Oh.

Ellen Lee is Chief Curator of American and European painting from 1800 to 1945 at the Indianapolis Museum of Art, Indianapolis, Ind.

Valerie Ann Leeds is Curator of Nineteenth and Early Twentieth-century American Art at the Orlando Museum of Art, Orlando, Fla.

Diane Lesko is Assistant Director/Senior Curator at the Museum of Fine Arts, St. Petersburg, Fla.

Gail Levin is Professor of Art History at Baruch College, and The Graduate School, The City University of New York, New York, N.Y.

Karl Lunde is Professor of Art History at The William Paterson College of New Jersey, Wayne, N.J.

Nannette V. Maciejunes is Curator of American Art at the Columbus Museum of Art, Columbus, Oh.

Mary Alice MacKay is Research Associate at the Albany Institute of History and Art, Albany, N.Y.

Nancy Malloy is on the staff at the Archives of American Art, Smithsonian Institution, New York, N.Y.

Patricia C. F. Mandel is a teacher, curator, and author in New York, N.Y.

Nancy Mowll Mathews is the Eugénie Prendergast Curator at the Williams College Museum of Art, Williamstown, Mass.

Sally Mills is a Ph.D. candidate at Princeton University, Princeton, N.J.

Sarah J. Moore is a visiting lecturer in art history at the University of Arizona, Tucson, Ariz.

Harold A. Nelson is Director of the Long Beach Museum of Art, Long Beach, Cal.

Barbara Novak is the Altschul Professor of Art History, Barnard College and Columbia University, New York, N.Y.

Edward J. Nygren is Director of Art Collections at The Henry E. Huntington Library and Art Gallery, San Marino, Cal.

Kate Nearpass Ogden is Assistant Professor of Art History at Stockton State College, Pomona, N.J.

Marlene Park is Professor of Art History at the John Jay College of Criminal Justice and The Graduate Center, City University of New York, New York, N.Y.

Sharon F. Patton is Associate Professor at the University of Michigan with a joint appointment in the Center for Afroamerican and African Studies and the History of Art, Ann Arbor, Mich.

James Pernotto is Curator of Prints at The Butler Institute of American Art, Youngstown, Oh.

Joyce Petschek is an author and lecturer in London, England.

Ronald G. Pisano is an art historian and former Director of the Parrish Art Museum, Southampton, N.Y.

Dean A. Porter is Director of the Snite Museum of Art and Associate Professor of Art at the University of Notre Dame, Notre Dame, Ind.

Robert Rosenblum is Professor of Fine Arts at New York University, New York, N.Y.

Irving Sandler is Professor of Art History at the State University of New York, Purchase, N.Y.

Julie Schimmel is Associate Professor at Northern Arizona University, Flagstaff, Ariz.

David L. Shirey is Chairman of the Master of Fine Arts Program at the School of Visual Arts, New York, N.Y.

Linda Crocker Simmons is Associate Curator of Collections at the Corcoran Gallery of Art, Washington, D.C.

Clyde Singer is Curator/Associate Director at The Butler Institute of American Art, Youngstown, Oh.

Gail Stavitsky is an independent art historian in Brooklyn, N.Y.

Judith Stein is Adjunct Curator at the Pennsylvania Academy of the Fine Arts, Philadelphia, Pa.

David Steinberg is Assistant Curator of Paintings at The Cleveland Museum of Art and Assistant Professor at Case Western Reserve University, Cleveland, Oh.

Diana Strazdes is Curator of American Art at the Stanford University Art Museum, Palo Alto, Cal.

Daniel Strong is a Ph.D. candidate at Princeton University, Princeton, N.J.

Irene S. Sweetkind is the Grants Writer/Editor at The Butler Institute of American Art, Youngstown, Oh.

William S. Talbot is Deputy Director of The Cleveland Museum of Art, Cleveland, Oh.

Sue Taylor is an art historian in Chicago, Ill.

Mark Thistlethwaite is Professor and Coordinator of the Art History Program at Texas Christian University, Fort Worth, Tex.

James Thompson is Associate Professor of Art at Western Carolina University, Cullowhee, N.C.

John Wilmerding is the Sarofim Professor in American Art at Princeton University, Princeton, N.J., and Visiting Curator at the Luce Center, The Metropolitan Museum of Art, New York, N.Y.

M. Melissa Wolfe is Assistant Curator at the Columbus Museum of Art, Columbus, Oh.

Howard E. Wooden is Director Emeritus of the Wichita Art Museum, Wichita, Kans.

Louis A. Zona is Director of The Butler Institute of American Art, Youngstown, Oh.

INDEX

Page numbers in *italics* indicate pages on which illustrations appear.